The George Eastman House Collection

A History
of Photography

From 1839 to the present

Editors:
Therese Mulligan and David Wooters
Authors:
William S. Johnson, Mark Rice, Carla Williams
Editorial Coordination:
Therese Mulligan, David Wooters, and Amy Winward,
George Eastman House
Ann H. Stevens, East River Editorial
Image Reproduction:
Barbara Puorro Galasso, Head of Photographic Services,
George Eastman House

To stay informed about upcoming TASCHEN titles, please
request our magazine at www.taschen.com or write to
TASCHEN America, 6671 Sunset Boulevard, Suite 1508,
USA-Los Angeles, CA 90028, Fax: +1-323-463.4442. We will
be happy to send you a free copy of our magazine which is
filled with information about all of our books.

© 2005 TASCHEN GmbH
Hohenzollerning 53, D-50672 Köln
www.taschen.com

Original edition: 1999 Benedikt Taschen Verlag GmbH
© for the illustrations: George Eastman House, Rochester,
NY, VG Bild-Kunst, the photographers, their agencies, and
estates

Editing and Layout: Simone Philippi, Cologne
Editorial Coordination: Gimlet & Partner, Cologne
Production: Martina Ciborowius, Cologne
Cover design: Sense/Net, Andy Disl and Birgit Reber,
Cologne

Printed in Singapore
ISBN 3–8228–4777–1

The George Eastman House Collection

A History of Photography

From 1839 to the present

TASCHEN

KÖLN LONDON LOS ANGELES MADRID PARIS TOKYO

Contents

Foreword

This is a book that leads toward investigation. Heuristic rather than definitive, it proposes possible ways of approaching the George Eastman House collection for pleasure or scholarship, providing just one structure and arrangement out of many that are possible. This book, presented in the museum's 50th anniversary year, is an invitation for discovery, as discovery is vital to the museum's mission.

Therese Mulligan, curator of photography, has led the process of selecting and interpreting the images. The categories she has used to group the images, while comprehensive in spirit, make propositions about the collection without defining it. Informed by scholarship, wisdom, and the strengths of the collection, Ms. Mulligan's choice of images and her essay are intellectually and emotionally satisfying *because* they are contingent and personal. And while each of the pictures may be considered to be a representation of the collection as a whole, the selection is in no way proportionate to the sum of the collection.

David Wooters, the photo archivist for nearly two decades, often speaks of the invitation to discovery the collection offers its visitors. In this way the collection is a lure that summons the joy of interpretation, and this book extends a special invitation to that educational process. Mr. Wooters' essay suggests the pleasures of looking, and looking repeatedly, viewing a selection of images in such a way that a history is reflected as it was created – with purpose and at random, always with surprise.

A close reading of the text with reflection upon the images points to the very human narrative of how this collection was developed, assembled through a series of contingencies and opportunities, through both chance and plan. The result of collecting over the past 50 years is a body of work that stands for quality not only because of its aesthetic or educational value, but also because of its diversity. Its value ascribed through breadth as well as depth, social content as well as cultural

invention, the George Eastman House photography collection derives special interest and influence. Great collections, it seems, are not formed by following the rules, but by being open to discovery.

On behalf of the Board of Trustees, I wish to acknowledge and thank the entire staff of George Eastman House for their constant contributions and to say that it is our pleasure to present through Benedikt Taschen the treasures and pleasures of George Eastman House.

ANTHONY BANNON
Director

The photography collection at George Eastman House is justly world famous, unrivaled in both its scope and depth. Its strength is magnified by its place among the other great image-related collections at the museum: motion pictures, technology, and library. The restored home and gardens of George Eastman, who made photography accessible to the general public, complete the collections that *are* the museum.

From the beginning, the Museum's strength has been rooted in its foundation of multiple collections of international artifacts. The seminal Gabriel Cromer collection set the tone, quality, and diversity of the institution. Rare and often unique camera apparatus, pamphlets, and books, as well as hundreds of the finest early European daguerreotypes and prints were acquired from other collections and became the basis for this interrelated research facility. All four of the collections related to photography have excellent representations of American artifacts, including magazines, movies, photographs, and equipment, many from the earliest times that the medium was practiced in this country.

In 1950 the Dryden Theatre was added to the complex to allow the growing number of motion pictures in its collection to be shared with the public. The motion picture collection's silent film collection is unsurpassed. Other highlights include all the surviving films of Greta Garbo and Louise Brooks, a large holding of German Weimar cinema, and the MGM Studio collection, including their Technicolor negatives. The private collection of director Martin Scorsese, which includes hundreds of fiction features from post-World War II American art cinema is another important acquisition. Like the other collections, motion pictures is aggressively seeking both rare and contemporary items to add to its archive.

The photographic technology collection is one of the largest in the world. It embraces all aspects of photographic and cinematographic equipment and accessories. The oldest item in this collection is an 18th-

century camera obscura. The world's first commercially manufactured camera, the famous Giroux, is also here. This pristine artifact is said to have been made for Daguerre himself and bears the photographer's signature across the manufacturer's label. The Bemis daguerreotype camera and outfit from Boston, built in 1840, is preserved here, complete with its bill of sale. The Edison Kinetoscope from 1894, a viewer for individuals to watch a three-minute film loop, also resides in the technology collection. The collection includes modern technology as well; selected examples of digital imaging technology have been acquired as gifts from manufacturers.

The Richard and Ronay Menschel Library is the axis where all the collections meet. No other library has the breadth and depth of coverage of all aspects in the history, aesthetics, and technology of photography and cinema combined. Not only is it a collection of artifacts, but it is an informational resource to the general public and scholars alike. Here one can find *Humphrey's Journal*, the first American periodical on photography, among other rare and historical books and periodicals. This collection covers the optical and chemical advances that preceded the invention of photography as well as books by contemporary artists.

Because the collections share interlocking issues, such as history, period styles, changes brought on by evolving camera and projector design, and public taste, the visitor can conduct research across the artificial boundaries of collection management. The idea and representation of the expansive American West or the impetus towards documentary style, for example, can be traced through the period literature, images (both fictional and factual), and the technology that made a particular point of view and way of working possible.

The collections are maintained in a modern facility dedicated to public access. They reach the public through the museum's continuing program of changing exhibitions; shows that travel throughout the country

and the world; educational outreach; viewing, screening, or study rooms for each collection; and two theaters that present film series nearly every day of the week.

Because of the museum's commitment to educate the public and share the wealth of its collections, the conservation and preservation lab and schools were established to train a new generation of specialists. The L. Jeffrey Selznick School of Film Preservation and the Andrew W. Mellon Advanced Residency Program in Photograph Conservation form a vital part of the institution's life.

The collections at George Eastman House could be seen as discreet groups of artifacts, but this would be missing their vital strength as an interwoven whole. Whether used as a resource to explore the world of George Eastman, his enterprises, and the times in which he lived, or to examine the history of motion pictures and photography, the sum of these collections is truly greater than their individual parts.

MARIANNE FULTON
Chief Curator

A Legacy in the Making

The publication of this collection guide marks the 50th anniversary of the opening of George Eastman House in 1949 as a collecting institution. Though it was only the second museum dedicated to photography – Louis Walton Sipley's American Museum of Photography holds the distinction as the first – it was the first to unite photography and technology with its sister art of motion pictures. While this alone secures the museum's place in history, more important, it became a prominent feature in the shifting landscape of American photography, which had yet to be mapped by singular institutional missions, marked by an academic imprint, or recognized by a burgeoning marketplace. The founding of George Eastman House would change all that, irrevocably shaping American photographic practice and thought with a mission devoted to preservation, education, and interpretation.

Given the fitful economy of postwar America, the museum's origin can, in part, be traced to a question of the future use of the home of George Eastman. The founder of Eastman Kodak Company, George Eastman had bequeathed his home and its surrounding twelve acres to the University of Rochester as a residence for its presidents: indeed, he never made a provision for a museum. But the rising costs of its upkeep and the shift of the campus' location led university officials to reconsider maintaining the property. On June 3, 1948, nine men assembled at the offices of Eastman Kodak Company to hold the first meeting of the Board of Trustees of George Eastman House, Inc. Comprised of prominent Rochesterians, including the presidents of the university, Eastman Kodak, and Bausch and Lomb, the board undertook to transform the home of George Eastman into a museum, citing in an incorporated charter an institutional mission to found a "museum of photography and allied pursuits" that would "establish a graphic and continuing history of photography," by teaching "photography by demonstration and exhibition." While the museum's charter was far-reaching in its language,

its impetus was clear and sprung from a deep resolve: to create a memorial to George Eastman, still a primary mandate of the museum's mission today.

At the same June meeting, the trustees named Dr. C. E. K. Mees, the head of Kodak's Research Laboratory, as president of the museum and General Oscar Solbert, a Kodak public relations executive, as its director. In the hands of these two men, the museum and its early mission took shape, with Mees actively involved in aspects of photography and technology, and Solbert involved in those relating to motion pictures. The trustees also appointed the museum's first curator – the photographic historian Beaumont Newhall.

The decision to hire Newhall was not without its twists and turns. He was well known to Kodak executives, in particular Dr. Walter (Nobby) Clark who, in 1939, engaged Newhall to catalogue the Gabriel Cromer collection, which had recently been acquired as part of Kodak's Eastman Historical Photographic Collection (EHPC). Newhall had maintained close contact with Clark, who later played an important advisory role at the new museum, counseling Clark on acquisitions for the EHPC. At this time, Newhall was curating photographic exhibitions at the Museum of Modern Art, where he worked as the librarian, and in 1940, led the initiative to establish that museum's department of photography, the first of its kind in the United States. Yet Newhall was not appointed head of the department; that position went to the photographer Edward Steichen. And although Steichen had once been considered as a candidate for the curatorial position at George Eastman House, it was Newhall who was unanimously chosen. He held the role for ten years, until the death of Gen. Solbert in 1958, at which time he became the museum's second director.

As curator and director during its formative years, Newhall did more than any other person to define the character of George Eastman House

and its mission. His strongly held opinions as to the aesthetic possibilities of photography, clearly iterated in his seminal *History of Photography*, did much to form the newly emerging fields of photographic scholarship and connoisseurship. Although often the subject of dispute and reevaluation, Newhall's modernist teleological approach created a historical framework for photography grounded in institutional authority. In exhibitions, he posited an art history of photography, converting rooms in Eastman's home into monuments of aesthetic interpretation. Similarly, he built a vast collection, richly diverse in its holdings, organized along the lines of master works by master photographers. In these ways, Newhall firmly posited the museum at the center of photographic discourse, formulating its presence as the primary voice of the study of photography both nationally and internationally.

To fill the museum's curatorial ranks, Newhall engaged individuals who not only shared his institutional philosophy and ambitions, but who were also strong forces on the contemporary photographic scene. His wife, Nancy Newhall, a well-respected writer on photography, played a significant role at the museum. In collaboration with her husband, she advocated for contemporary acquisitions, exhibitions, and publications, including those of long-time acquaintances and close friends Ansel Adams, Margaret Bourke-White, Alfred Stieglitz, Paul Strand, and Edward Weston.

In 1953 Beaumont Newhall invited the photographer Minor White to the museum to assist in editing the museum's journal, *Image*. White, editor of the periodical *Aperture,* which he founded in 1952 with support that included the Newhalls, had earlier declined an offer for a curatorial position at the Museum of Modern Art. White moved to Rochester and for twelve years called it home. The first three years were spent at George Eastman House as editor of *Image*, and then, as a curator. He left in 1956 to teach in Rochester Institute of Technology's newly

established photography program. While his tenure at the museum was short-lived, White's influence in curatorial and educational matters was nonetheless profound. It accompanied the period of the 1950s and 1960s, often called the museum's "golden age."

As his initial responsibility White helped shape the pictorial and textual content of *Image* as a journal of the art and science of photography, technology, and motion pictures. An educational arm of the museum, the journal delved into the archives, presenting a history of the media in critical essays and fine art reproductions. It reported on museum exhibitions, research, and collection resources while keeping in touch with current trends in photography occurring beyond the museum's walls through reviews and editorials. For editors Newhall and White, *Image* became a primary vehicle for the museum to present itself and its encompassing activities to a larger national and international audience. Outside of the museum, White continued editing *Aperture*, relocating its production to Rochester. *Image* and *Aperture* constituted the most significant interpretive periodicals of the day, and, as a consequence, reinforced the status of the museum and the city of Rochester as a critical site for photography. This status was enhanced by the exhibitions White curated, as well as those who were drawn to study and work at the museum with Newhall and him.

In thematic exhibitions such as *Camera Consciousness, The Pictorial Image,* and *Lyrical and Accurate,* White united image and word in intellectually designed didactic displays. Ever the educator-philosopher, he realized in his curatorship a public forum for his theoretical views of photography, which he concurrently advanced in *Aperture*. White reveled in the purely rendered photograph that could be "read" in terms of its psychological, metaphorical, or spiritual messages. Like Newhall, White endeavored to release photography from its traditional documentary role in order to champion its aesthetic potential. Such a view, while

certainly not new to the medium, struck a deep chord among many young American photographers who regarded photography as a means of self-expression and exploration. For many, George Eastman House was a training ground as well as a public venue for the most contemporary photographic practices and thought.

In the late 1950s and 1960s the number of staff, interns, and students at the museum grew with photographers, historians, and critics: Peter Bunnell, Walter Chappell, Robert Doty, Harold Jones, and Nathan Lyons. With the departure of White, Chappell and Lyons assumed curatorial and editorial responsibilities, especially as Newhall, then director, turned his attention to administrative and personal publishing demands. It was Lyons who most directly determined the curatorial course of the museum during the 1960s. In exhibitions and publications, he looked to the present and future of photographic practice. But most important, he imagined the institutional realm of the museum, its galleries and collections, as a radical space of investigation and education.

With contemporary acquisitions, Lyons leveled, in part, Newhall's authorial hierarchy of photographic masters. His ground-breaking contemporary surveys and group exhibitions, such as *Photography 63, Photography 64, Toward a Social Landscape,* and *Vision and Expression,* introduced a new generation of photographers who pushed beyond the traditional boundaries of technique and subject, many illuminating the current social and political conflicts in the United States or probing the photograph's role in mass media as a cultural commodity. Lyons' exhibitions were the most provocative and influential of their time, as was his exhibition design. In the 1968 exhibition *Conscience: The Ultimate Weapon,* he conceived, in his words, "a thematic environmental experience" that engaged the audience with both sight and sound. In this exhibition, part performance, part traditional wall display, Lyons merged slides (from 11 projectors) of the political documentary photographs of Ben Fernandez

with synchronized sound to create a consuming multimedia experience. Such exhibitions and their design, now commonplace, were at the time radically new, especially when cast within the traditional halls of a museum. In his curatorial work, Lyons realized that the world of the museum and the world that lay beyond the museum walls were not mutually exclusive, but inextricably bound one to the other in cultural and communicative necessity.

Like Newhall and White, Lyons used his curatorial position to promote his educational aspirations for photography. In 1962, he organized the first meeting of the Society for Photographic Education (SPE), a group of university and college photography educators. Drawing inspiration, in part, from Minor White, whose workshops and classes had served numerous photographers and educational professionals, SPE became a reality due to the coordinating abilities of Lyons, who was its chair. He saw within the educational scope of SPE a mission that fit well with that of the museum. As in all his activities, Lyons sought a direct and deeper reciprocal relationship between educational institutions and photographic practitioners. Under Lyons' direction the educational objectives of SPE would bear fruit in the form of extension programs, symposia, fellowships, and a museum training program at George Eastman House. SPE grew to a position of prominence in the 1960s and 1970s as an acknowledged representative of photography's changing role in the United States, especially the acceptance of the medium within educational institutions.

During the 1970s photography experienced nothing less than an explosion in popular, professional, and institutional awareness in the United States. Museums and galleries dedicated solely to photography were founded, like the influential Light Gallery in New York, whose director, Harold Jones, had been a curator at George Eastman House. Art museums began to establish photographic collections, and universities

and colleges collected photographs for study, display, and as accompaniments to emergent photographic history or applied curriculums. Concurrent with these developments, the market for photography rapidly escalated, leading auction houses to establish departments and seasonal sales devoted to the medium. From its origins, George Eastman House had advanced this future of photography, where the aesthetics and the history of the medium would be prized, critically studied, and practiced.

Now, the museum did not hold this institutional vision alone. Throughout the 1970s and into the 1980s, it expanded and refined its mission of preservation, education, and interpretation. It established a conservation department that in ensuing years assumed a teaching function, enrolling students from around the globe. The museum's internships and fellowships included many individuals who would emerge as many of photographic history's most important scholars.

Lyons left the museum in 1969 to create Visual Studies Workshop, and Newhall left for a teaching position at the University of New Mexico in 1970. Still the museum employed curatorial staff who were not only historians, critics, and writers, but working photographers as well. The photographer-curator, long a mainstay in photographic interpretation, would with this generation reach its apex. Due to the professionalization of the field, the photographer-curator became eclipsed by curators who specialized in the discipline of photographic history.

As active photographers, museum curators, including Thomas Barrow, Robert Fichter, and William Jenkins, sought to maintain the museum's pivotal role as an interpretive site for new trends in contemporary photography. Barrow and Fichter belonged to a loosely knit circle of local colleagues – Betty Hahn, Joan Lyons, Bea Nettles, and John Wood – whose interest in neglected 19th-century photographic processes, which they revived, and new technologies of mass reproduction, such as xerography, which was developed in Rochester, merged photogra-

phy's past and present in a new and experimental approach to picture-making. Broad in scope, their influential work drew on prevailing issues of the time: feminism, autobiography, political conflicts, and the persuasive role of the photograph in mass culture.

Simultaneously, Jenkins, with the assistance of photographer Joe Deal, who had also joined the museum's staff, identified a group of contemporary photographers who carried on the time-honored theme of photographing the American landscape. Jenkins' 1975 exhibition *New Topographics: Photographs of a Man-Altered Landscape,* characterized a dominant movement in photography that addressed the changes in the American landscape due to industry, new technologies, and population migration. Well versed in photography's past and pictorially aligned with its landscape traditions, this influential movement dismantled the myth of the American landscape as a national metaphor of promise and prosperity and put in its place concerns of environmental abuse and suburban sprawl.

In the late 1970s and 1980s the curatorial vitality with which the museum addressed contemporary issues in photography was met with a similar spirit for rediscovering and exploring photography's various histories in past eras – science, popular culture, and journalism. In two major exhibitions, Janet Buerger, curator of 19th-century photography, drew upon the museum's Gabriel Cromer collection to reveal how French practitioners of the daguerreotype and calotype defined the formative years of photography and its future cultural applications. Curators Robert Sobieszek and Marianne Fulton, each following a personal course of investigation, turned their attention to photography's central role in the rise of popular culture and media. In 1989, Sobieszek's *The Art of Persuasion: A History of Advertising Photography,* and Fulton's *Eyes of Time: Photojournalism in America,* pointed to photography's predominance as a cultural vehicle of mass communication, propaganda, and consumerism.

At the close of the 1980s, the museum encountered monumental challenges that would cause a reevaluation of its interpretive pursuits, and most important, its mission. In part, these challenges were a result of broader cultural questions concerning the institutional purpose of museums and the place of photography within them. Among the issues at hand were the museum's interpretive and educational functions, as well as its direct relationship to audiences. For George Eastman House, the question of future interpretation, which sought greater public access to the collections, led to a revitalization, especially in the nature of museum facilities. Like many institutions of the day, the museum faced the financial challenge to preserve its collections for posterity amidst the declining economy of the late 1980s. As they had done in its initial years, Rochester's corporate, civic, and private donors generously supported the museum, resulting in the 1992 inauguration of a new building, adjoining the restored Eastman mansion, to serve as the public site for its library, conservation department, collections, and new galleries.

Over the course of the last 50 years, George Eastman House helped transform photographic thought and practice. Today, the museum and its continuing mission of preservation, interpretation, and education are transformed by the history it helped create. Where once it was one of the few institutions in the world devoted to photography, it now numbers among many. Its early objective to attain for photography a recognized status equal to that achieved by other visual arts, the museum embraces a cultural discourse that addresses how public and private institutions – like itself – have influenced and shaped the aesthetics of the medium and its public reception. Building upon its past, the museum also recognizes that photography's history is no longer singular nor exclusive, but consists of multiple, intertwining histories. Aspects of these histories are revealed not only in the photography collection, but also in the museum's collections of technology, motion pictures, and library, as

well as in two recently established collections – landscape and the George Eastman Archive. It is the sum of these collections – how they inform one another and touch the human experience – that will write the museum's next 50 years of history. For like the medium to which it is dedicated, George Eastman House's legacy is one of continuous invention and transformation.

THERESE MULLIGAN
Curator of Photography and Co-editor

One of the great joys of working in the Eastman House photography collection is never knowing what questions the collection will be asked to answer on any given day. The photograph that only yesterday served as a specimen of albumen printing is today an example of Timothy O'Sullivan's work and tomorrow may be an illustration of wet plate photography or of Manifest Destiny. Photographs are not fixed in meaning, and neither can collections of them be. Rather, they are amorphous things whose shape is dictated by the questions they are asked.

This shape-taking begins early in a collection's life. Collections are formed to answer questions. The question the Eastman House collection answers so well is, "What does the practice of photography look like?" Such a broad question, one that encompasses not only the photograph's physical appearance but also its technical applications and social manifestations, requires an equally broad range of answers. To help formulate these answers, over time Eastman House has acquired a number of disparate collections.

In 1939, ten years before Eastman House opened its doors as a public museum, Eastman Kodak Company purchased the Gabriel Cromer collection. Cromer was a Frenchman who was educated in the law but whose life was immersed in photography. A practicing photographer and a collector, Cromer was highly regarded for his portraiture and known as a master of carbon printing. It is, however, his collection, not his own photography, that has become his legacy.

With a keen interest in and broad knowledge of photographic history, Cromer amassed nearly 6,000 photographs, a substantial library of photographic books, and a collection of apparatus that filled the rooms of his home outside Paris. With 19th-century French photography as the body and soul of Cromer's collection, its heart is Louis-Jacques-Mandé Daguerre. Creating a veritable shrine to the man, Cromer gathered portraits of Daguerre, his drawings, paintings, diorama-related material,

personal ephemera, a daguerreotype signed by Daguerre, and a Giroux camera Cromer believed had belonged to Daguerre. These objects were, it seems, as much relics for Cromer as they were artifacts. Five hundred daguerreotypes, nearly all French, completed Cromer's homage to Daguerre.

Early French paper photography is also well represented in Cromer's collection and includes Baldus' photographic albums, Le Gray's seascapes, and Le Secq's paper negatives, while later photographers such as Disdéri, Adolphe Braun, and Delmaet and Durandelle represent the course of photography through the 19th century.

Cromer's enthusiasm for photography is evident in the breadth of his collection. Cartoons and cameras are as much a part of his collection as photographic prints. Crossing the boundaries between images and apparatus with ease, and collecting pre-photographic engravings along with photomechanical specimens, only one boundary seemed to confine Cromer's interest, the border of his own country.

The French photo-historian, Georges Potoninée, prefaced his 1924 *History of the Discovery of Photography* with the bold statement, "The history of photography is essentially French." The bulk of Cromer's collection supports this rather nationalistic claim, providing excellent examples of the practice of photography in France. Though there are notable exceptions, for the most part Cromer did not focus on photographic activity outside of his own country.

Cromer's dream that his collection would become the cornerstone of a national museum of photography faded with his death in 1934 and the growing threat of war. His widow, unable to find a suitable offer for the collection in France, sought other options. An Eastman Kodak Company scientist, Dr. Walter Clark, who had established the Kodak Research Laboratories at Harrow, England, before coming to the United States, took a great interest in Cromer's collection. With his prompting, Eastman

Kodak Company purchased for $13,000 what would become the foundation of the George Eastman House photography collection.

Though Cromer's collection was the largest and most notable acquisition for Kodak's Eastman Historical Photographic Collection, it was not the first. Early in the century the company had begun collecting examples of photographic apparatus, both of their own and others' manufacture. To this they added, in 1920, a number of items belonging to the Austrian photographic scientist and historian Josef Maria Eder. Eder's many contributions to improving the sensitivity of photographic materials, his prolific writing, and his monumental *History of Photography* (1905) made him a world-renowned figure in photography. In the course of his work he had gathered many specimens of photographic and photomechanical processes. From this material Eastman Kodak Company purchased a selection of predominantly photomechanical prints. To these two collections the Cromer collection was added.

Kodak continued to collect: Samples of color photography, Hill and Adamson salt prints, early Kodak snapshots, and Crimean War photographs by Roger Fenton all found a place in their collection. The Eastman Historical Photographic Collection was thus able to present, according to *The New York Times*, a "reasonably comprehensive history of photography from the days of Daguerre to the present time" when 300 items from it were exhibited at the New York Museum of Science and Industry in Rockefeller Center in 1940. The entire collection was transferred to Eastman House in 1948.

This broad approach to collecting continued for more than 20 years under the direction of Beaumont Newhall, the museum's first curator and later director. Dozens of important acquisitions were made during Newhall's tenure. American daguerreotypes from a California high school teacher, Zelda Mackay; 5,000 stereos from collector Fred Lightfoot; Civil War photographs from Philip Medicus; Eadweard Muybridge's

Animal Locomotion studies; 500 photographs by Atget; nearly 10,000 photographs by Lewis Hine; and collections of work by Newhall's friends and colleagues, Ansel Adams, Alvin Langdon Coburn, László Moholy-Nagy, Charles Sheeler, Alfred Stieglitz, and Edward Weston.

With these collections, a solid foundation for the study of photography was being laid. Newhall's name will always be associated with the textbook history that introduced a generation of students to the history of photography. In the 1964 edition of his *History of Photography*, Newhall also introduced that generation to the Eastman House collection, with half of his nearly 200 illustrations coming from the museum. This stands in sharp contrast to both the earlier and later editions of the same history in which less than 15 percent of the illustrations are drawn from the museum's collection. Today, with the large number of photograph collections available to historians and the broader view of what constitutes photographic history, it is unlikely that any single photograph collection will ever again be so closely identified with the history of photography as the Eastman House collection was during that time.

The history Newhall wrote and the collection he curated became interwoven in many instances. However, his collecting had a much broader range than his *History*, which focused on photography as one of the visual arts. This will not surprise anyone who remembers that Newhall also authored *The Daguerreotype in America* (1961) and *The Airborne Camera* (1969), as well as a variety of articles in the museum's own *Image* magazine, revealing his broad understanding of the practice of photography. Consequently, in addition to acquiring work by photographers such as Stieglitz and Weston, Newhall also acquired work that would never find its way into his *History* – early color screen plate processes, salon photographs, and commercial photography. Advertising photography, omitted from Newhall's *History*, is well represented at Eastman House with sizable collections acquired during Newhall's

tenure, with work by two of New York's most successful commercial photographers, Victor Keppler and Nickolas Muray.

Newhall's willingness to acquire and preserve such a broad range of photographic practice that did not fit the scope of his own *History* has served today's historians well. Much of this material is now being used in the writing of new histories, histories that expand the narrative of photography to include such previously overlooked practices as advertising photography or camera club pictorialism. Ironically, while today's historians construct their histories, pointedly aware of Newhall's omissions, many often overlook the fact that the very material they are studying was acquired for Eastman House by Beaumont Newhall. This is one of the challenges and pleasures of a public collection: to be open to many interpretations, and to preserve not only the icons of a chosen history, but the contradictions as well.

Such an open approach to the practice of photography is best seen in one of the largest collections to come to the museum during Newhall's years, the collection of Alden Scott Boyer. Stories of Boyer are the stuff of legend. A wealthy perfume manufacturer living in Chicago, Boyer housed his diverse collections in what had been an old bank building. Here he spent his days among his slot machines, high-wheeled bicycles, and photographic books, images, and apparatus. Though the extent of his interest in slot machines and bicycles is not known to us, Boyer's love of photography is evident in his collecting and the enthusiastic notes that mark his books. In his own copy of Newhall's *History* he enthused over images with his green pen. "Jesus!" "Get this!" And, for the most part, Boyer did "get this," and that, and more.

Boyer's collection of more than 13,500 photographs as well as a rich photographic library and equipment collection came to Eastman House after a very brief negotiation in which Boyer asked Newhall if he wanted to buy the collection or receive it as a gift. When Newhall answered

that he wanted it as a gift, Boyer responded, "That's what I like, plain talk. When are you coming out to pack up?" Boyer's collection, a semi-trailer full of photographs, books, and apparatus was delivered to Rochester and registered as part of the Eastman House collection on April 27, 1951.

The Boyer collection is as intriguing as its creator. The familiar names of Blanquart-Evrard, Julia Margaret Cameron, Maxime DuCamp, P. H. Emerson, Roger Fenton, Francis Frith, H. P. Robinson, and Boyer's beloved Hill and Adamson are well represented, while his 1,000 daguerreotypes by Southworth and Hawes and 260 paper negatives by the Irish photographer John Shaw Smith constitute an embarrassment of riches.

Though these names are almost recitations from Newhall's canon, Boyer did not shape his collection to fit Newhall's history. He threw a wider net around photography, including Fischer & Brothers' early American views of the U. S. Naval Academy, an 1863 Harvard Yearbook, and a small album titled *The Story of a Sunkist Orange.* Boyer embraced 19th-century photographic practice in a more international way than Cromer had. But as broad as Boyer's interests were, he had little concern for 20th-century photography. Acquisitions in this area would be made by Newhall and many other curators at Eastman House.

Straying from Newhall's historical path by collecting with an eclectic and open attitude towards photography has always been more the norm than the exception at Eastman House. This was epitomized by the acquisition of the Sipley/3M collection. Louis Walton Sipley operated his American Museum of Photography from 1940 until his death in 1968. Though Sipley had a boyhood interest in photography and, as an adult, a professional interest in images, he literally stumbled across the photographic history that grew to become his museum.

As part of the visual education movement that gained momentum in

the 1920s, Sipley produced filmstrips for schools and universities. In 1930, in order to acquire images for these educational projects, Sipley purchased one of America's oldest photographic businesses, the Caspar W. Briggs Company. In addition to 10,000 stock negatives of religious and historical illustrations, Sipley found himself with the remnants of what had been America's largest lantern slide manufacturer, and consequently, with a growing interest in photographic history.

Just as Cromer's collection focused on France, Sipley's museum concentrated on American photography, with Philadelphia, the location of Sipley's museum, taking pride of place. Here, beyond the pages of any photographic history yet written, was the work of George Schreiber and Sons, commercial photographers specializing in animal photography; Samuel Fisher Corlies, member of the Photographic Society of Philadelphia; Elias Goldensky, the Russian immigrant who became Philadelphia's pictorialist portrait photographer; as well as examples of the short-lived lenticular stereo "VitaVision," thousands of lantern slides, and a substantial collection of 20th-century photomechanical specimens.

The story of Sipley's collection after his death is strikingly similar to that of Gabriel Cromer's collection. Sipley's widow, like Cromer's, was unsuccessful in her attempts to find a home for the collection. And Sipley's collection, like Cromer's, was then purchased by a large American corporation – in this case, 3M – to add to their historical collections. After plans for a museum of their own were abandoned, in 1977 3M gave Sipley's collection to Eastman House.

The size of the collection was staggering – 61,000 photographs and photomechanical reproductions, the majority falling outside the scope of traditional photographic history. Of course, Sipley's collection was not outside the scope of his own history, *A Half Century of Color Photography* (1951). It is here that Frederic Ives, Lejaren à Hiller, Anton Bruehl, and Fernand Bourges are all prominently mentioned. And while pieces

by Robert Cornelius, F. Holland Day, William Henry Jackson, Gertrude Käsebier, and William and Frederick Langenheim were among Sipley's holdings, it is the work of William Jennings, Schreiber and Sons, and Henry Troth that more accurately characterize the collection.

The museum's interest in the many forms photography can take has not waned since the acquisition of the Sipley/3M collection. In 1979, at the bequest of Joanna Steichen, Eastman House received more than 3,000 photographs by Edward Steichen, predominantly portraits of celebrities from his *Vanity Fair* years. Other smaller, but equally notable, gifts have come from The Associated Press and the American Society of Magazine Photographers. More recently, Donald Weber has given the museum his collection of daguerreotypes, ambrotypes, and tintypes and has expanded its holdings of stereo photography with his substantial collection of Viewmaster views.

The breadth of the Eastman House photo collection is only suggested in this publication, and in several instances the depth of particular holdings is noted to give the reader a better guide to the collection. Still, this is only a glimpse. For every photograph illustrated here, more than 500 are not. Even with the 743 illustrations contained within this volume, describing the Eastman House photo collection is still very much like the story of the five blind men, each trying to describe an elephant. Whichever part of the elephant each man bumped into, whether it was a leg, an ear, or the trunk, that part became his understanding of the elephant. Each was both right and wrong in his interpretation. And so it will always be with any description of the Eastman House collection.

It may be easier to understand this collection by first looking at its purpose rather than its photographs. Purpose is what gives a collection its character, its shape. Because Cromer, Boyer, and Sipley all differed in purpose, their collections differ in content. So too, the museum's purpose shapes its collection. This shaping is more than metaphorical.

The physical shape the collection is given, its acquisitions and arrangement, grows out of the collection's purpose.

The primary purpose of this collection – to preserve examples of what the practice of photography looks like – is quite different from simply being a picture collection with drawers of photographs arranged by subject. Illustrating subject matter is not the primary concern. If it were, the collection would be something very different. The museum has focused more on the how and the why and the who of photography. Attention to subject matter in photographs grows out of those interests. That the museum has photographs of what is now Yellowstone National Park is of less consequence than knowing that these photographs were made by William Henry Jackson for a U.S. government survey, and that Jackson's photographs were part of the visual evidence submitted to Congress during its debate over whether to designate Yellowstone a national park. With that knowledge, one's attention is then particularly drawn to an albumen print (page 208) that shows Jackson's negative was retouched, changing a daytime scene into a starry night and making Yellowstone appear as strange and otherworldly as popular written accounts described it.

This fascination with the practice of photography grows out of viewing photographs not simply as transcriptions of the world, but as the products of an interaction between the world, the photographic medium, the photographer, and even the audience. To see photographs only as windows onto the world and to miss their richer story would be a disservice to the collection. It is this outlook that guides the collection, that distinguishes Eastman House as a photography museum and not a stock photo agency.

For the picture researcher interested in using the collection, cataloging records provide access to the subject matter in photographs. Subject headings are assigned so researchers looking for photographs

of airplanes, for example, can know if the collection holds any. Ironically, this type of access requires that photographs be narrowly defined, which actually limits their possibilities. Placing images into pigeonholes using words can have a greater influence on the photograph's use than the image itself, as they end up being perceived as nothing more than a collection of nouns – boats, cats, dogs, and trains – rather than a collection of photographs.

This is unfortunate because photographs are about more than their nominal subjects, richer and deeper in meaning than simple nouns can ever capture. Personal associations, nuances of presentation, or the idiosyncrasies of a photographer's vision create a world of possibilities within each frame. Photographs are, indeed, more like oracles than inventories, as much about what is implied as what is delineated. This is what keeps them alive, what makes a collection part of the present, not merely a record of the past.

Like in a tightly woven tapestry, there is always something to discover in a photograph if one is willing to look. Photographs are full of promise, but they are at the viewer's mercy. Viewed without insight, they become dull. If the viewer is mired in old histories, so are they. Photographs and photographic collections challenge us to ask better questions and to look at old pictures in new ways. By doing so, we are rewarded with new understandings of ourselves, our world, and the transformative power of photography.

DAVID WOOTERS
Photo Archivist and Co-editor

Acknowledgements

We are greatly indebted to those individuals who generously gave their talent, time, and energy to this publication. In particular, we gratefully acknowledge the photography collection staff, whose unflagging commitment and good humor saw this complex project through to its successful realization. We cannot sufficiently thank these staff members for their professional assistance and abiding friendship: Amelia Hugill-Fontanel, curatorial assistant; Del Zogg, senior cataloguer; Janice Madhu, assistant archivist and manager of rights and reproduction; and Joseph Struble, assistant archivist. We offer special thanks to Barbara Puorro Galasso, head of the museum's photographic services department , for her expertise in creating the reproductions for this publication.

Our deep appreciation goes to William S. Johnson, Mark Rice, and Carla Williams, who authored this publication. With consummate skill and collegiality, they met the many challenges required, not the least of which were editorial demands and looming deadlines. Their scholarship and dedication led to new research and fresh insights. For their contributions we are truly grateful.

We would also like to extend our thanks to this publication's editor, Ann Stevens. She brought to the project both a critical eye for exacting detail and an understanding of its subject. We are deeply appreciative of her skillful work and guidance.

During the book's preparation, professional colleagues offered important assistance and advice. We wish to express our gratitude to Grant Romer, director of the museum's conservation department; Amy Winward, art director; and photographic historians Thomas Barrow, Eugenia Parry, Larry Schaaf, and Roger Taylor.

The support of the museum's Publication Trust and the German publisher Taschen together allowed this book to become a reality. We especially thank Taschen's Simone Philippi and Susanne Uppenbrock

for their invaluable assistance and collegial spirit throughout the book's production.

Finally, we wish to recognize the generous encouragement of our families. We are particularly thankful to Charlie Wooters for his insights and his weekends, and Jack and Margaret Mulligan for their constant and enduring support.

THERESE MULLIGAN and DAVID WOOTERS

About This Publication

The George Eastman House's photography collection holds 400,000 artifacts. While no one volume can adequately address a collection of such enormity and diversity, it is the goal of this publication to provide a survey of the scope and depth of the photography collection for a varied audience. Organized thematically and chronologically, images, both familiar and unknown, offer a view into the collection, with its multitude of subjects, genres, and processes. These images reveal the boundless story of photography and its history, from its pre-photographic origins to its present-day cultural, aesthetic, and personal manifestations. The accompanying text relates aspects of this story, while furnishing information about the depicted work and/or its maker.

In many instances, the text provides information pertaining to particular collection holdings, including their number and subject. Where appropriate, the library, technology, and motion picture collections are noted within the text as being the repositories of depicted work and associative materials.

Each image in this publication is accompanied by a caption that indicates maker (when known), nationality, life dates, title, date, process, source, and the museum's accession number for reference. Often works shown here were given no title by their maker. In such cases, a descriptive title is given in italics.

Due to the limitations of space, the original sources – albums, books, and portfolios – do not appear in the caption. These sources, as well as other important information about particular holdings in the photography collection, are available through the museum's on-line catalogue. This database can be accessed via the museum's World Wide Web address at: www.eastman.org. The photography collection staff can be contacted by writing to: Photography Collection, George Eastman House, 900 East Avenue, Rochester, New York, 14607, U.S.A.; or by telephone at: (716) 271-3361.

The Photographs

All Things under the Sun

In 1839 the invention of two distinct photographic processes, the daguerreotype by Louis-Jacques-Mandé Daguerre and the negative/positive process by William Henry Fox Talbot, were almost simultaneously announced in France and England. Daguerre's process produced a one-of-a-kind, highly detailed image on a silver-coated copper plate, while Talbot's was a paper-based negative/positive process that could produce multiple prints from a single negative. Both are based in two fundamental principles of chemistry and physics: the reaction of particular chemical compounds to light, and the creation of an image when light passes through an aperture in a dark room or box. The light sensitivity of certain chemicals had been experimented with as early as 1727 by the German natural philosopher Johann Heinrich Schulze. Experimentation with optical principles can be dated back to the 4th century BC and the writings of Aristotle. Long before the invention of photography, artists utilized the "camera obscura," a Latin phrase meaning dark room, as a drafting aid. Light entering a dark box or room through a small hole is reflected on the opposite side as an upside-down, backward image of the scene outside. Its orientation is corrected with a mirror. An engraving from an article in Denis Diderot's *L'Encyclopédie* (ca. 1751) (right) identifies a variety of camera obscuras and illustrates their functions.

Unidentified artist
French?,
active ca. 1800

The Miraculous
Mirror, ca. 1800

Engraving
72:0079:0088

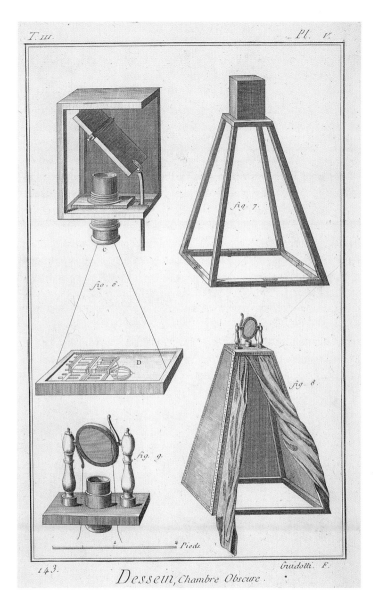

T. III.

Pl. V.

fig. 7.

fig. 6.

c

D

fig. 8.

fig. 9.

1 2 Pieds.

143.

Guidotti. F.

Dessein, Chambre Obscure.

F. Guidott
French, active 1700s

Dessein, chambre
obscure (Drawing of
a Camera Obscura),
ca. 1751

Engraving
MUSEUM PURCHASE
84:0962:0002

Applying another basic optical principle of shadow and form, the silhouette portrait, named for the French government official and amateur profile maker Étienne de Silhouette, became popular in the late 18th century as a growing middle class began to clamor for more affordable – and reproducible – likenesses of themselves. To create a silhouette, a light source is placed in front of a subject, and the outline of their profile is traced onto a paper placed behind them, as demonstrated in this 1774 engraving, "Professor Charles' Experiment."

Taking silhouette art a step further, Gilles-Louis Chrétien invented the physionotrace drawing in 1786. To create the physionotrace, "the sitter's profile was traced through a movable sight connected by levers to a stylus that recorded on a reduced scale its every movement in ink on a copper plate, which was then engraved." In 1807 English scientist William Hyde Wollaston designed the camera lucida, a clear prism suspended on a brass rod at eye level over drawing paper. "Looking through a peephole centered over the edge of the prism, the operator saw at the same time both subject and drawing paper" and traced the reflected image, with all of its shading and nuance, onto the paper. But all of these methods still involved the hand of man, and inevitably, some drafting skills were required. The invention of photography would ultimately unite chemistry and optics, permitting the light itself to draw the image, and creating a new artistic medium.

Unidentified artist
French?,
active 1780s

*Professor Charles'
Experiment*, ca. 1774

Engraving
GIFT OF EASTMAN
KODAK COMPANY,
EX-COLLECTION
GABRIEL CROMER
72:0079:0089

J. H. Schwartz
German,
active ca. 1787

*Silhouette Portrait of
a Man*, ca. 1787

Silhouette
83:1610:0020

Jean Fouquet
French,
active ca. 1790

A. J. A. Ruihiere chef de la division de cavalerie
de la garde nationale parisienne né l [sic] 6 jan-
vier 1731. Dess. P. Fouquet. Gr. P. Chrétien inv.
du physionotrace cloître 3D honoré à Paris
(A. J. A. Ruihiere Leader of the Cavalry Division
of the National Guard of Paris. Born January 6,
1731. Drawing by Fouquet. Engraving by
Chrétien, Inventor of the Enclosed Physio-
notrace 3D. Honored in Paris), ca. 1790

Physionotrace engraving
72:0079:0074

Jean-Baptiste Sabatier-Blot
French, 1801–1881

Louis-Jacques-Mandé Daguerre, 1844

Daguerreotype
GIFT OF EASTMAN
KODAK COMPANY,
EX-COLLECTION
GABRIEL CROMER
76:0168:0043

Louis-Jacques-Mandé Daguerre
French, 1787–1851

Promenade dans les pins (Walk in the Pines), ca. 1830s

Pencil drawing
GIFT OF EASTMAN
KODAK COMPANY,
EX-COLLECTION
GABRIEL CROMER
83:2125:0002

Daguerre and the Daguerreotype

Louis-Jacques-Mandé Daguerre was apprenticed to an architect at age 13 after showing an early talent for drawing. Following a brief career as a revenue officer, he became a set designer and painter. This small pencil drawing, the "Promenade dans les pins," is an example of Daguerre's early, pre-photographic imagery of which the Eastman House holds 13 drawings and paintings. From 1822 until 1850, in partnership with Charles Marie Bouton (1781–1853), he ran the highly successful Dioramas in Paris and London. The Dioramas were exhibitions of pictorial views with various effects induced by changes in lighting. About 60 of Bouton's drawings and five watercolors are in the Eastman House collection. Daguerre also painted the illusionistic canvases used in the displays with the aid of the camera obscura, and his involvement with the Diorama's optical illusions soon led to photographic experimentation.

In 1829 he entered into a partnership with Joseph Nicéphore Niépce (1765–1833), who is credited with making the first permanent photograph, or "heliograph," of rooftops from his window around 1826 or 1827. Daguerre experimented for over a decade with Niépce and his son, Isidore, and in January 1839 the French Academy of Science published an announcement of the invention of the daguerreotype process. The French government purchased the formula for the public's use, and while both Isidore and Daguerre received lifetime government pensions, it was Daguerre's name that became associated with the invention. In August the Academy of Science publicly disclosed the instructions for

making daguerreotypes in a joint meeting with the Academy of Fine Arts. "Daguerreotypemania" swept through Europe, and the daguerreotype became the premier method of making photographs around the world.

Daguerre was made an officer of the Legion of Honour; his Order of Merit rosette is preserved in the Eastman House collection. It is somewhat ironic that Daguerre, one of the inventors of photography, frequently declined to have his portrait made. The Eastman House contains an early photographic portrait of Daguerre, an 1844 daguerreotype by Jean-Baptiste Sabatier-Blot. Daguerre appears anxious to have the entire ordeal over with, yet Sabatier-Blot

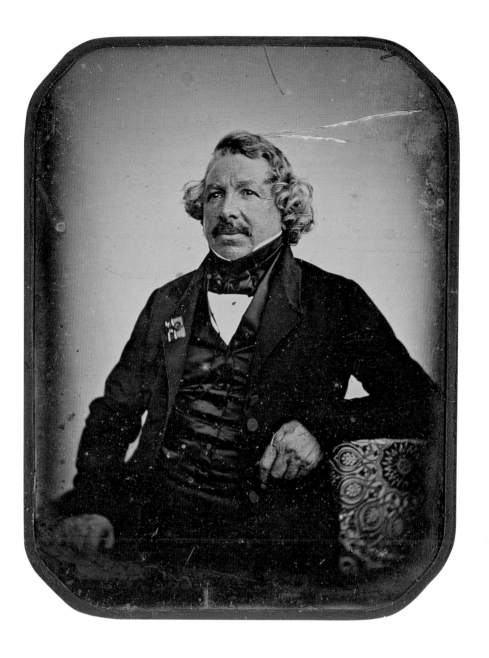

Louis-Jacques-Mandé Daguerre
French, 1787–1851

Portrait of an Artist, ca. 1843

Daguerreotype
GIFT OF EASTMAN
KODAK COMPANY,
EX-COLLECTION
GABRIEL CROMER
76:0168:0151

Louis-Jacques-Mandé Daguerre

Ruines de l'abbaye de Jumièges. Côte du nord, 1820

Lithograph
GIFT OF EASTMAN
KODAK COMPANY,
EX-COLLECTION
GABRIEL CROMER
84:0377:0001

captured an agreeable likeness of him, appropriately using his own invention to immortalize him.

From 1820 until 1833, while still experimenting with photography, Daguerre made ten lithographs that illustrate Baron Isidore-Justin-Séverin Taylor's *Voyages pittoresques et romantiques dans l'ancienne France*. All of Daguerre's illustrations, including this 1820 lithograph of the Ruines de l'Abbaye de Jumièges on the Côte du Nord in Brittany, are preserved in the museum's collection. Taylor's multivolume publication included more than 3,000 lithographs illustrating notable medieval monuments in nine French provinces. Daguerre's atmospheric rendering of clouds and ruins against a threatening sky evokes the drama of his Diorama work. It is, however, photography and the portrait for which Daguerre is best remembered. Although the first portrait daguerreotypes in 1839 required exposure times of 15 to 20 minutes in bright sunlight, improvements in the chemistry had reduced sitting times to a more manageable few seconds by the time Daguerre made his "Portrait of an Artist." This is one of only three extant portraits by Daguerre and the only one in an American collection. The artist, possibly Charles Arrowsmith or Hippolyte Sebron, poses against a landscape backdrop that Daguerre probably painted. Sporting an artist's smock and holding a palette and brushes, he embodies the Romantic ideal of the artist, his faraway glance connoting an artist's vision.

In addition to its large collection of materials by and relating to Daguerre, Eastman House holds approximately 500 French daguerreotypes. This rivals that of the Cabinet des Estampes in the Bibliothèque Nationale, the largest collection in Paris. Among the finest examples of the medium at Eastman House is a portrait of a young girl by Sabatier-Blot (page

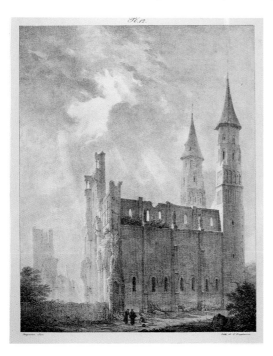

**Jean Baptiste
Sabatier-Blot**
French, 1801–1881

*Portrait of a Young
Girl (Sabatier-Blot's
Daughter?)*, 1852

Daguerreotype
GIFT OF EASTMAN
KODAK COMPANY,
EX-COLLECTION
GABRIEL CROMER
76:0168:0022

44). A dozen Sabatier-Blot portraits in the collection are of the artist's
wife and child and are exquisitely intimate, relaxed family portraits. The
choice of a round format in which to frame the sweet-faced child, who is
clearly at ease in front of the camera, focuses attention on her large
round eyes and intense gaze. In a similar use of a framing device, the
oval shape of a dual portrait by Legendre of a seated woman and stand-
ing boy holding a horn emphasizes the interaction between the sitters
and eliminates the distraction of blank space behind them. It also
mimics the shape of their open, oval faces, which clearly reveal that they

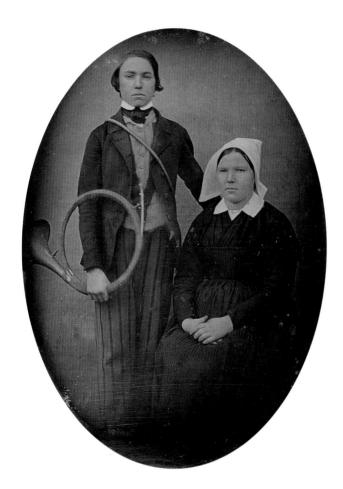

Legendre
French,
active ca. 1850s

*Portrait of Boy
and Woman*, 1853

Daguerreotype
GIFT OF EASTMAN
KODAK COMPANY,
EX-COLLECTION
GABRIEL CROMER
76:0168:0009

regarded the daguerreotype sitting as a solemn occasion. The modesty
of their dress further supports the notion that the luxury of having their
likenesses made was not something to be taken for granted.

Although portraiture became the daguerreotype's most popular appli-
cation once exposure times were shortened, other genres were success-
fully explored using the young medium. Louis Jules Duboscq-Soleil con-
structed his "Still Life with Skull" (page 46), a photographic memento
mori using the traditional iconography of a skull and hourglass as sober-
ing reminders of human mortality. The addition of a crucifix connotes a

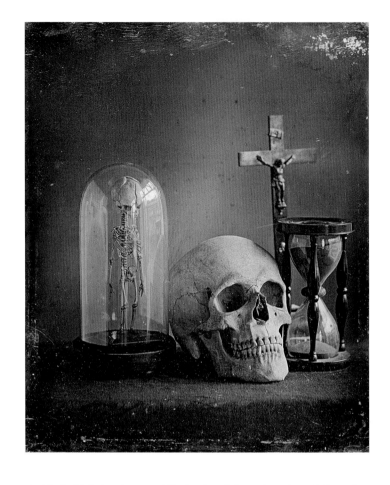

Louis Jules Duboscq-Soleil
French, 1817–1886

Still Life with Skull,
ca. 1850

Daguerreotype
GIFT OF EASTMAN
KODAK COMPANY,
EX-COLLECTION
GABRIEL CROMER
70:0001:0187

decidedly Christian theme, while the tiny skeleton in a glass vitrine references the natural sciences that were highly popular in the mid-19th century, presaging the debate between creation and evolution. In stark contrast, this sumptuous nude study of a woman reclining on a lace-draped divan is both a celebration of the fleshy pleasures of life and a study of form and shape. Artists in other media such as painting and sculpture used such photographic images as aids in modeling the female figure.

Occasionally daguerreotypes were more explicit in exploring the female body. Imagine this immodestly draped – if somewhat bored-looking – nude model (page 49) brought to life when viewed through a

Unidentified photographer
French?,
active ca. 1840s

Odalisque, ca. 1840s

Daguerreotype
70:0001:0184

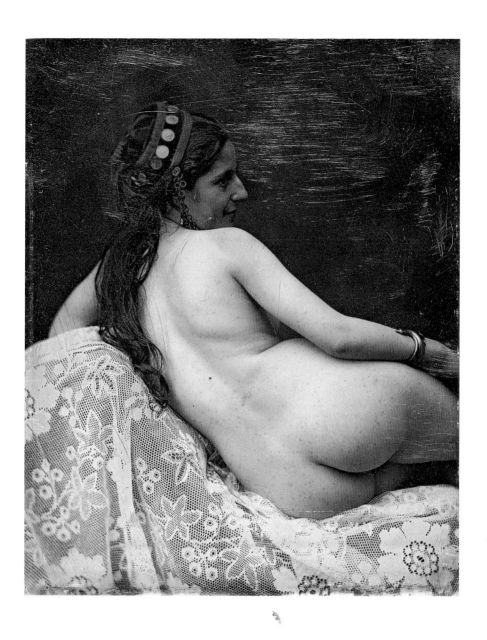

Unidentified photographer
French?,
active 1850s

Female Nude,
ca. 1858

Stereo daguerreotype with applied color
GIFT OF EASTMAN
KODAK COMPANY,
EX-COLLECTION
GABRIEL CROMER
76:0168:0137

Louchet
French?,
active 1850s

Woman in Exotic Costume, ca. 1855

Stereo daguerreotype with applied color
GIFT OF EASTMAN
KODAK COMPANY,
EX-COLLECTION
GABRIEL CROMER
76:0168:0103

stereograph viewer, her flesh highlighted with handcoloring to achieve a closer approximation of her natural complexion.

Popularized in the early 1850s, the stereograph was composed of two nearly identical photographs made from slightly different angles to approximate binary vision. When seen together through a viewer that superimposed the two, the photograph appears in vivid three-dimension. A more modest example, by Louchet, of a woman in exotic costume provides its salacious appeal through the vaguely ethnic drapery and accoutrements surrounding the model. The dangerously bared shoulder was acceptable in a non-European guise (even though the model was likely European), and provided ample provocation for a genteel but curious 19th-century consumer. The female form was not the only focus of the photographer's lens. Antoine Claudet's portrait of his bare-chested, muscular son Francis George Claudet shows him nude to the waist and posed holding a pulley rope. As much a study of flexed musculature as a kind of occupational, if fictional, portrait of a laborer, this image is one-half of a stereograph and was thus also intended for close-up, intimate viewing.

At least as seductive as the exploration of the human form was the ability to record in vivid detail a cityscape that had previously been interpreted only through the painter's brush or draftsman's pencil. The engraver Friedrich von Martens' view of Paris is a panoramic daguerreotype achieved by using a special panoramic camera that von Martens

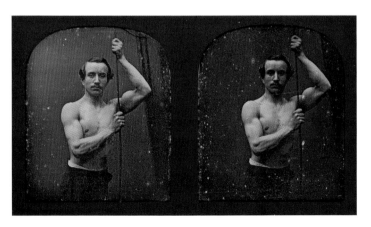

Antoine Claudet
English, b. France,
1797–1867

Francis George Claudet as a Model,
ca. 1855

Stereo daguerreotype
GIFT BY EXCHANGE
OF MRS. NORMAN
GILCHRIST
76:0168:0117

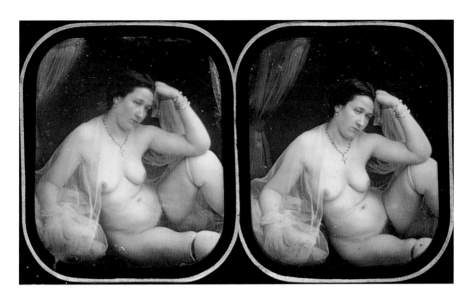

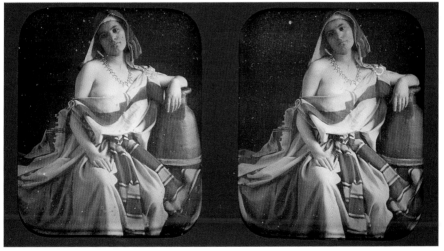

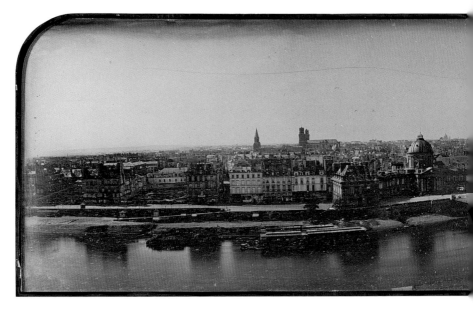

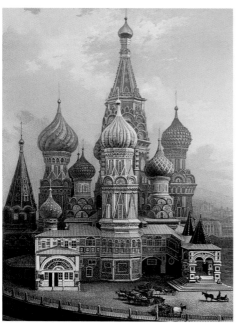

Nöel-Marie-Paymal Lerebours
French, 1807–1873

Russia. Saint Basil's Church at Moscow, 1842

Engraving from daguerreotype
GIFT OF ALDEN SCOTT BOYER LIBRARY COLLECTION

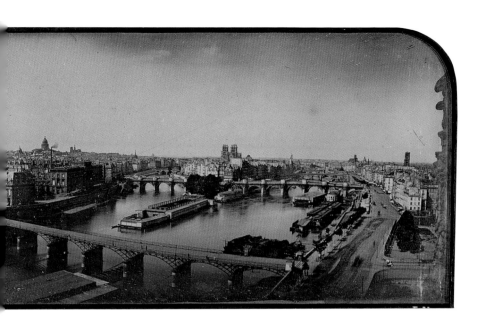

created himself it could capture a broad vista on a single daguerreotype plate. In order to make this exposure, von Martens positioned his camera atop one of the Louvre Museum pavilions. In vivid detail the cityscape is laid out before the viewer, with a delicate precision. Easily recognizable in the distance on the right are the Pont Neuf and cathedral of Notre Dame encased in scaffolding. The veracity of the photographic image locates every landmark in accurate relation to the next. Equally compelling was the ability of travelers to record views previously accessible only through the written word. Because daguerreotypes were one of a kind, this view of Saint Basil's Church at Moscow, Russia, was made into an engraving and published in Lerebours' book *Excursions Daguerriennes*, an early photographic travelogue of engravings made after daguerreotypes of many faraway, "exotic" locales.

Cromer's Amateur is an unidentified daguerreotypist, named after collector Gabriel Cromer. The Eastman House collection contains around 100 daguerreotype plates made between 1845 and 1851 by this extraordinarily talented, albeit unknown, amateur photographer. Taken as a whole, the collection provides a rare, personal glimpse into mid-century Parisian life, encompassing genre scenes, landscapes,

Friedrich von Martens
French, b. Germany, 1809–1875

La Seine, la rive gauche et l'île de la cité (The Seine, the Left Bank and L'île de la Cité), ca. 1845

Panoramic daguerreotype
GIFT OF EASTMAN KODAK COMPANY, EX-COLLECTION GABRIEL CROMER 76:0168:0136

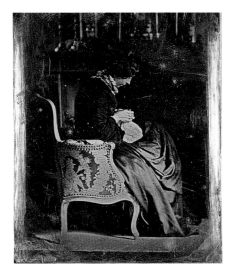

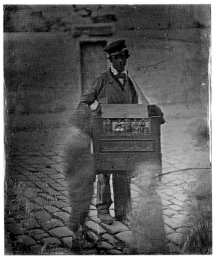

Cromer's Amateur
French?, active
1840s–1850s

*Interior with a
Woman Sewing,*
ca. 1850

Daguerreotype
GIFT OF EASTMAN
KODAK COMPANY,
EX-COLLECTION
GABRIEL CROMER
76:0168:0079

Cromer's Amateur

*Organ Grinder on
Street with Children
Passing,* ca. 1850

Daguerreotype
GIFT OF EASTMAN
KODAK COMPANY,
EX-COLLECTION
GABRIEL CROMER
76:0168:0050

portraiture (including numerous possible self-portraits), and still lifes. The image of an interior with a woman sewing is an exceptional early accomplishment in daguerreotypy, given the exposure restrictions required by the necessity of ample available light. The subtle yet sophisticated lighting illuminates the recessed space, giving the image considerable depth and revealing details of the fireplace mantle, silver candlesticks, and ornate mantle clock in the background. At the same time, the lush upholstery of the chair in which the woman sits is highlighted in crisp detail. The image is a privileged glimpse into a private, wealthy world that was most likely that of the photographer, as the time and money needed to practice daguerreotypy were considerable.

Stepping outside of his personal realm, Cromer's Amateur directed his attention to the street, capturing a spontaneous scene of daily life in this portrait of an organ grinder at work, as passing children dissolve among the cobblestones into spectral blurs during the long exposure. Making yet another compositional departure, Cromer's Amateur made a still life of a vase of flowers, transforming the eclectic bouquet into a tower of cascading sunflowers, daisies, and softly wilting roses. Striking in its simplicity against a mottled background that swirls out of focus, the daguerreotype demonstrates an almost modernistic attention to form and texture. One of the most arresting portraits among the group

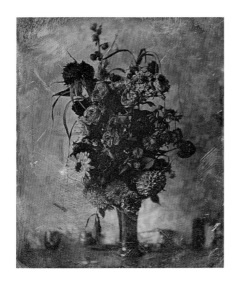 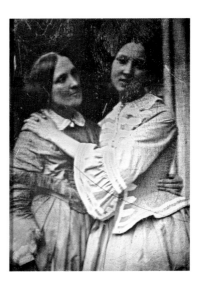

is an affectionate grouping of two women, possibly a mother and daughter and probably from the photographer's family. With a steady arm around her companion's waist, the older woman looks lovingly at the young girl who, in turn, engages the photographer directly with a familiar smile. These women appear again in several other daguerreotypes with different groupings of women and children that also suggest a familial context. The group of images is one of the largest extant bodies of nonprofessional artistic work in the daguerreotype medium and is remarkable for its "snapshot"-like casualness and ardent enthusiasm to record disparate aspects of the daily world unfolding before the camera's eye.

Amidst a burgeoning interest in the physical sciences in the mid-19th century, the photographer E. Thiesson traveled to Sofala, Mozambique, a Portuguese colony in Southern Africa, in order to photograph the local population. There he made a seated profile portrait of a Sofala woman, age 30, her short-cropped hair prematurely white (page 54). The use of the profile became a standard of ethnographic photography, whose objective was to document physical types from every angle in order to show difference. The woman is seated in a high-backed, European-style caned chair, removed from her cultural context and photographed against a plain backdrop that contrasts with her half-naked, presumably

Cromer's Amateur

Still Life, Bouquet of Flowers, ca. 1850

Daguerreotype
GIFT OF EASTMAN
KODAK COMPANY,
EX-COLLECTION
GABRIEL CROMER
76:0168:0068

Cromer's Amateur

Portrait of Two Women, ca. 1850

Daguerreotype
GIFT OF EASTMAN
KODAK COMPANY,
EX-COLLECTION
GABRIEL CROMER
76:0168:0069

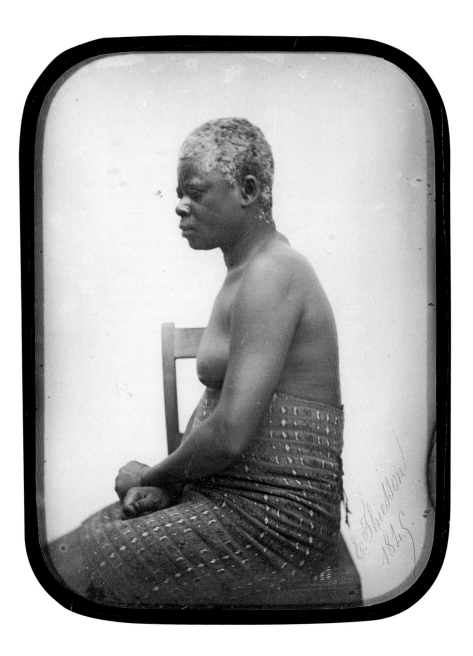

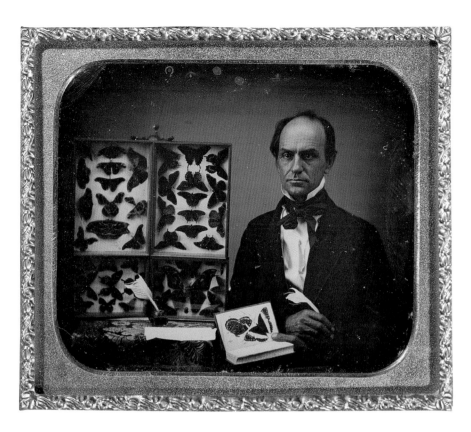

E. Thiesson
French, active
ca. 1840s

Native Woman of
Sofala (Mozam-
bique), 30 Years Old
with White Hair, 1845

Daguerreotype
GIFT OF EASTMAN
KODAK COMPANY,
EX-COLLECTION
GABRIEL CROMER
69:0265:0140

**Unidentified
photographer**
American,
active 1850s

Butterfly Collector,
ca. 1850

Daguerreotype
79:3292:0001

native costume. A similar example of photography as record-maker is an image of a man displaying his butterfly collection, which catalogs specimens from the insect world (page 55). He holds a book illustrated with images of butterflies and a quill pen, indicating his position as either a scientist or a student of science. Both images are examples of the early use of photography as a cataloguing tool.

In America – a young democracy eager to see itself reflected on the mirrored plate – daguerreotypes enjoyed their greatest popularity through the mid-1850s. The unflagging belief in photographic "truth" was a powerful tool that could easily be exploited by photographers. Occasionally, fictionalized "documents" were made, intended as records after the fact or for illustrative purposes. In "Dr. Macbeth in the Costume in Which He Crossed the Plains, Fleeing from the Cholerea [sic] of Which He Died," Dr. Macbeth poses in the studio in the wardrobe and with the iconography of the western adventurer. A pickax rests beside him on an elegant white pedestal, a standard photographic studio prop incongruous in this context. The photographer paid careful attention to recording the symbols of his subject's life, especially the tools and weapons with which he hoped to forge a new life.

In keeping with the prevalent 19th-century interest in things scientific, Robert Cornelius made this self-portrait. It is compositionally unconventional, with the photographer's hand almost obscuring his face. It is the activity depicted that is important here, not the subject's likeness. Though not an actual scientist, Cornelius holds a beaker in either hand and pours the unknown chemical substances into a funnel on a stand. As an obvious indication that the scene is staged, he is seemingly unmindful

Unidentified photographer
American, active 1840s

Dr. Macbeth in the Costume in Which He Crossed the Plains, Fleeing from the Cholerea [sic] of Which He Died, ca. 1849

Daguerreotype with applied color
GIFT OF
DR. JOHN RECHT
78:1706:0013

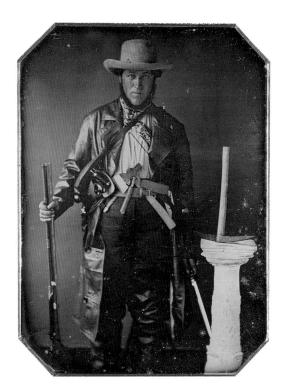

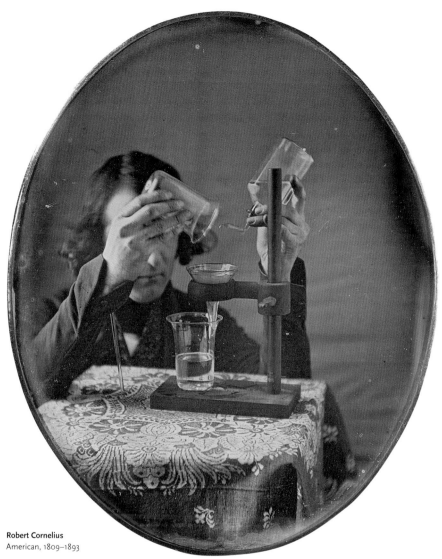

Robert Cornelius
American, 1809–1893

*Self-portrait with
Laboratory Instruments*, 1843

Daguerreotype
GIFT OF THE 3M COMPANY,
EX-COLLECTION LOUIS
WALTON SIPLEY
77:0242:0003

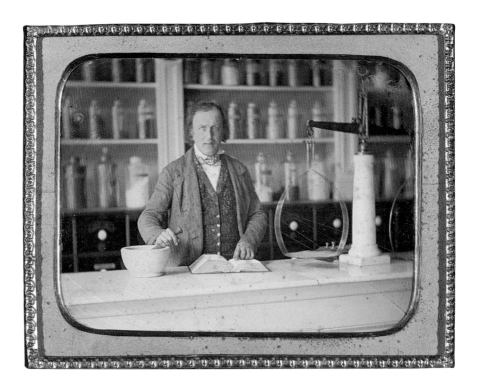

**Unidentified
photographer**
American,
active 1850s

*Apothecary, Interior
View with Chemist
at Work,* ca. 1852

Daguerreotype
GIFT OF GREG
FRENCH
97:0856:0001

of the fancy damask cloth that covers the table, which would surely not
have been present during an actual experiment. The image was likely
used as the basis for an engraved illustration that appeared in an *Encyclo-
pedia of Chemistry* article by Hans Martin Boye, a chemist colleague of
Cornelius's who was also photographed by him during this same sitting
and whose portraits are also in the Eastman House collection.

Artisans, craftspeople, and professionals shown in their own studios
or shops was a popular genre of portraiture. The subject would often
commission such a portrait in order to commemorate his or her
achievement or to advertise a particular skill. An interior view of an
apothecary shop shows a chemist standing at his table. His right hand
grips a pestle resting in its mortar, while his left hand is poised over the
page of an open book. Rather than the blank backdrop of the studio,
bottles and jars of chemistry, tools of his trade, line the shelves and
frame the chemist in his natural setting.

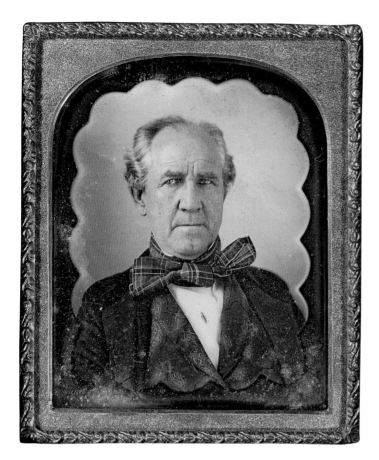

Unidentified photographer
American,
active 1850s

Sam Houston,
ca. 1850–1855

Daguerreotype
GIFT OF ALDEN
SCOTT BOYER
78:0758:0001

If the portrait subject was a public figure, reproductions of his or her likeness were valued and collected by the public as emblems of the subject's achievement. Samuel Houston (1793–1863), a lawyer and politician, led the triumphant battle at San Jacinto, which secured the independence of Texas from Mexico. Houston was elected president of the Republic of Texas, and once Texas was admitted to the Union in 1845, he was elected one of the state's first two senators. This daguerreotype, taken about ten years after the end of his senatorial term, is the forceful portrait of a man who had influenced the course of a nation.

Stephen Arnold Douglas (1813–1861) was a gifted orator and Illinois

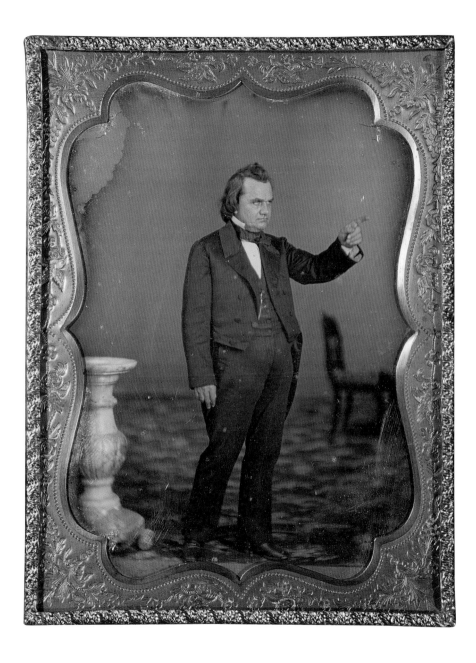

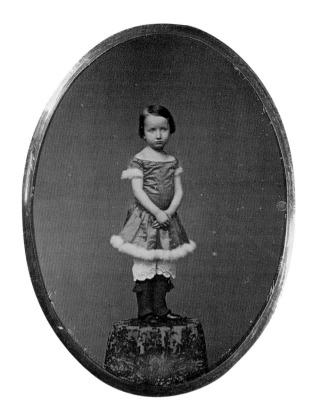

Marcus Aurelius Root
American,
1808–1888

Small Girl Standing on Table, ca. 1850

Daguerreotype
with applied color
GIFT OF MRS. J.
LESLIE CROWELL
79:3144:0001

senator who was defeated in his bid for the presidency by Abraham Lincoln. Heavyset and only five feet four inches tall, Douglas was dubbed the "Little Giant" by his contemporaries. This daguerreotype depicts Douglas in the dynamic posture for which he was best known. Although the pedestal on his right gives a sense of scale regarding his diminutive size, his steady gaze and gesticulating left index finger emphatically underscore the strength of his implied oration. Even the empty chair in the background suggests his unwillingness to "take a seat" regarding the hotly debated issues of the day.

On the other side of the portrait spectrum, Marcus Aurelius Root's image of a small girl is a sweet, yet forlorn, likeness of its young subject. Standing atop a table in an unusual costume of fur-trimmed, satin, off-the-shoulder dress and scalloped pantaloons, she appears rather like a miniature circus performer, isolated on her stage against an empty

Unidentified photographer
American,
active 1840s

Stephen A. Douglas,
ca. 1845

Daguerreotype
MUSEUM PURCHASE,
EX-COLLECTION
ZELDA P. MACKAY
69:0201:0037

Unidentified photographer
American,
active ca. 1850

Girl with Flowered Hat Leaning on Table, ca. 1850

Daguerreotype
79:3273:0012

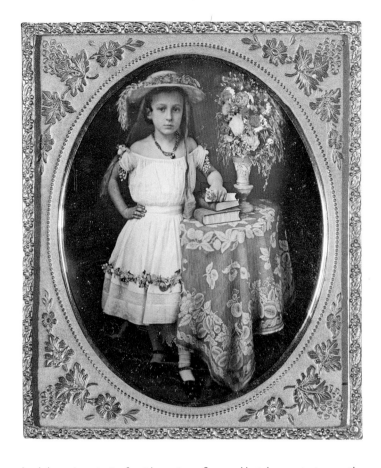

Charles Evans
American, active
1854–1856

Girl with Doll, Holding Mother's Hand,
ca. 1854–1856

Daguerreotype
GIFT OF THE 3M
COMPANY, EX-
COLLECTION LOUIS
WALTON SIPLEY
77:0240:0024

backdrop. A portrait of a girl wearing a flowered hat demonstrates another, more casual approach to photographing children. She leans on a table, her arm resting on a pile of books. While the inclusion of books may suggest her literacy, it is more probable that the books supported her during the lengthy exposure. With her right hand on her hip and her left foot thrust forward, she conveys an easy comfort with the camera.

Charles Evans' portrait of a girl holding a doll in her right hand evokes the familial relationship through a simple gesture. Sparing her child the discomfort of a head clamp or other such awkward sitting apparatus, the mother insinuates her presence in the frame as she steadies and comforts her child for the portrait sitting by firmly grasping her hand.

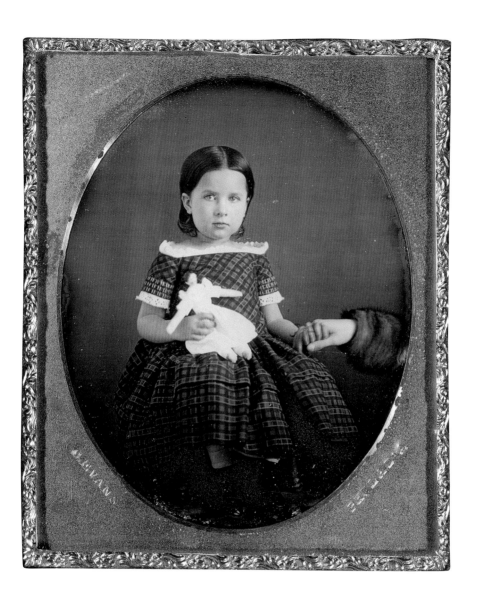

Samuel Leon Walker
American,
1802–1874

*The Photographer's
Daughter, Possibly
Josephine Walker,*
ca. 1847–1854

Daguerreotype
MUSEUM PURCHASE
78:0150:0004

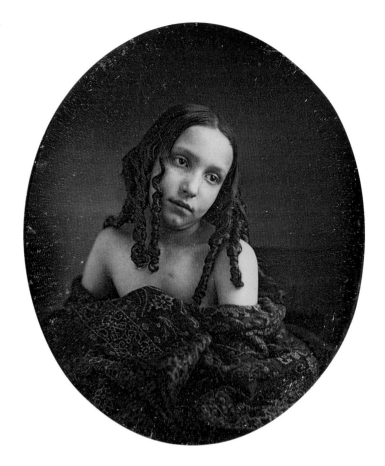

**Unidentified
photographer**
American,
active ca. 1850s

*Portrait of Blind
Man Holding a Cat,*
ca. 1850

Daguerreotype
MUSEUM PURCHASE,
EX-COLLECTION
ZELDA P. MACKAY
69:0201:0012

The availability of family – husbands, wives, daughters, and sons – proved irresistible to early photographers who were often still struggling with the daunting task of successfully rendering any image on the silvered copper plate. Samuel Leon Walker's portrait of one of his daughters, likely Josephine, displays a child's comfort and trust toward a parent. Trust was also surely a factor in another portrait sitting, which resulted in a striking portrait of a blind man and his cat. Unable to experience the daguerreotype magic for himself, the subject nevertheless understood the importance of having his likeness made and relied fully on the photographer to make a faithful and sympathetic portrayal.

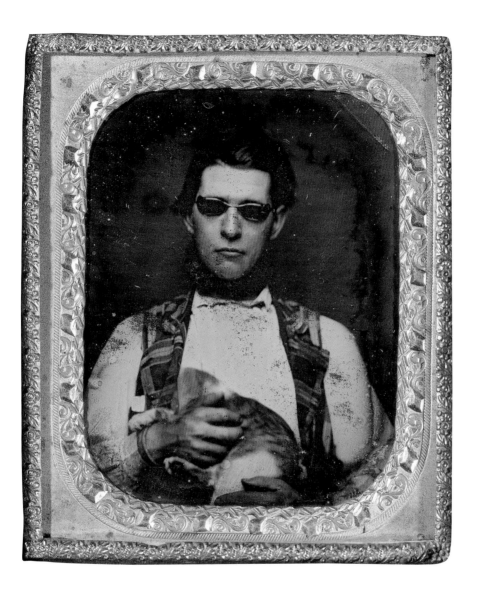

Unidentified photographer
American,
active ca. 1850s

Post-Mortem Portrait, Woman Holding Baby, ca. 1855

Daguerreotype with applied color
GIFT OF DONALD WEBER
94:1436:0001

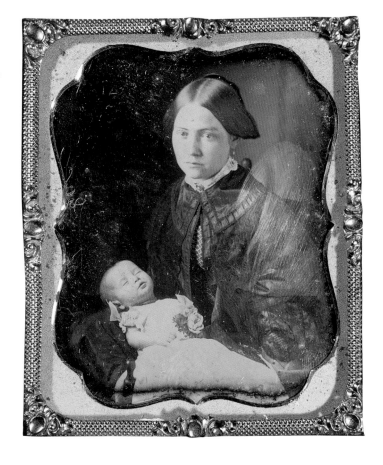

Sometimes portraits were made of those tiny members who had barely assumed their places in the family before succumbing to one of the myriad illnesses that claimed countless infants in the 19th century. This post-mortem portrait, a common subject in photography through the early 20th century, depicts a mother with a vacant gaze holding her deceased child as if it were sleeping upon her lap, reconstructing a tender scene from a life of which they were cruelly and prematurely deprived.

In another portrayal of the familial relationship, Luther Holman Hale's portrait of a couple turns gender convention on its head by showing the man seated and the woman standing above and beside him.

Luther Holman Hale
American, 1823–1885

Portrait of Man and Woman, ca. 1860

Daguerreotype
MUSEUM PURCHASE
70:0078:0001

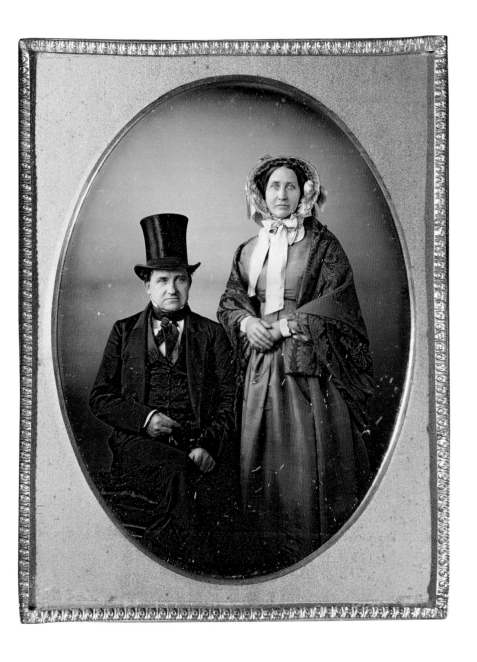

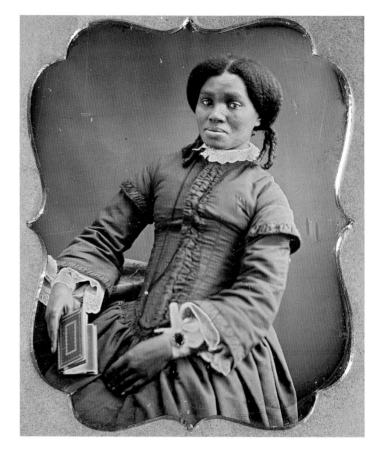

A portrait of a black woman, taken about 13 years before emancipation, reveals from the sitter's handsome dress and grooming that she was probably a free woman. Furthermore, the small, open book that she holds in her right hand suggests she was literate, a rare achievement for 19th-century blacks, who were systematically denied access to learning. She presents herself confidently to the camera, her steady gaze commanding the viewer's respect and attention and conveying the intensity and strength of her character. A solo portrait, this daguerreotype was probably intended as a rare keepsake for family members who could be assured of the woman's well-being and prosperity, probably in the North.

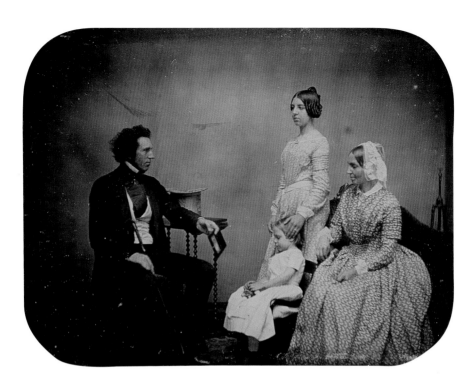

This group portrait of the Webb family depicts the patriarch, George James Webb, seated and holding a daguerreotype, facing his wife and two daughters. An animated presence, he rests his arm on a table, while the oldest daughter carefully holds her sister's head steady. So rigid are they in their attempts to remain still during the exposure that they reveal little interaction with or emotion toward one another.

Still, there were other inventive ways to make family portraits, even when not every member of the family could be present for the sitting. The woman in the portrait on page 70 holds a daguerreotype of a man, presumably her husband. Whether he had passed away or was simply not available for this particular sitting, the image preserves a record of their relationship as well as both their likenesses on a single plate.

Even when family members posed for daguerreotypes, a true likeness of the sitter was not always the daguerreotypist's goal. Dubbed "The Poet Daguerrean," actor and painter Gabriel Harrison made a daguerreotype titled "The Infant Saviour Bearing the Cross" (page 71).

Unidentified photographer
American,
active 1840s

Mr. George James Webb, Mrs. Webb, Mary Isabella Webb, Caroline Elizabeth Webb, ca. 1845

Daguerreotype
MUSEUM PURCHASE
79:3297:0001

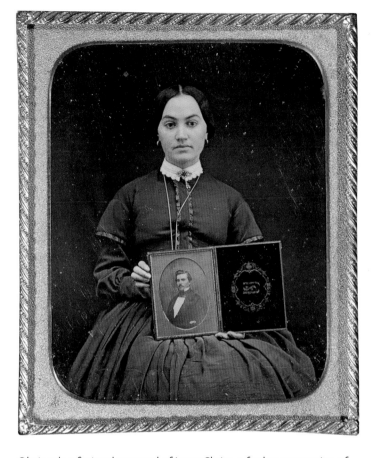

**Unidentified
photographer**
American,
active ca. 1850

*Woman Seated,
Holding Daguerreo-
type,* ca. 1850

Daguerreotype
GIFT OF UEDA
L. BURKER
79:3300:0001

Obviously a fictional portrayal of Jesus Christ, a further suspension of
disbelief is required by the viewer since the boy pictured, Harrison's son
George Washington Harrison, is far from an infant. Best known for his
allegorical imagery, Harrison utilizes the drape to connote the swad-

Gabriel Harrison
American, 1818–1902

The Infant Saviour
Bearing the Cross,
ca. 1850

Daguerreotype
GIFT OF CLARA
L. HARRISON
81:1660:0001

dling of the Christ child in the manger and the cross that is emblematic
of Christ's suffering and death in order to condense the time frame of
his life into a photographic icon of Christianity. Thus, his image evokes
a familiar theme while exercising poetic license in its execution.

 While an image like Harrison's seeks to portray an idea rather than
depict a truthful representation, the portrait of a family posing in front
of a log cabin (page 72) is the exact opposite, identifying a group in

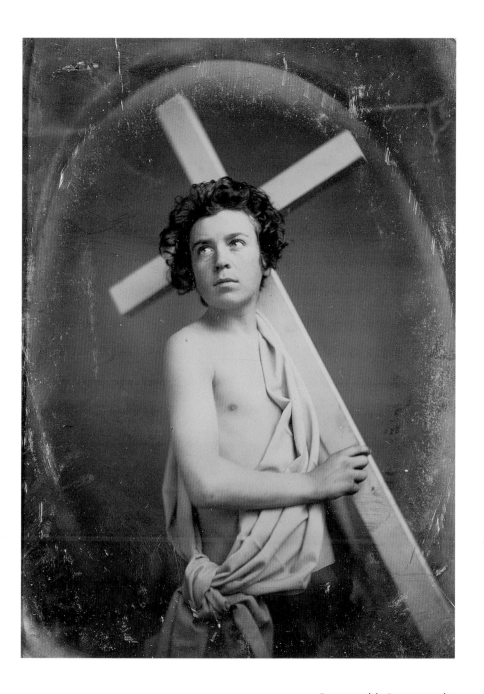

direct relation to their living conditions. Solidly placing them in a particular time and location, this image was probably made to commemorate their pride of ownership. Like a valued member of the family, the house unifies the bond between the men, women, and children as they assemble around the doorway for the camera. Moreover, the image plainly illustrates their circumstances at the time the photograph was made. The house represents the result of their hard work and determination to stake their claim in the uncharted West. This picture is a valuable document of some early settlers. Given the rural locale, it was probably the work of an itinerant daguerreotypist who traveled the country with a portable daguerreian studio in search of customers eager to see themselves immortalized.

Hard work and the pioneer spirit are nearly synonymous with the sturdy men and women who ventured west to make their fortunes during the California gold rush. A smattering of prospectors near a sluice at a dig site provides a glimpse into an often rough and difficult world that was created seemingly overnight by the discovery of gold by a carpenter at Sutter's Mill near San Francisco in 1848. By 1853 more than a quarter

Unidentified photographer
American,
active ca. 1850s

Family Posing in Front of Log Cabin,
ca. 1850

Daguerreotype
MUSEUM PURCHASE
68:0134:0003

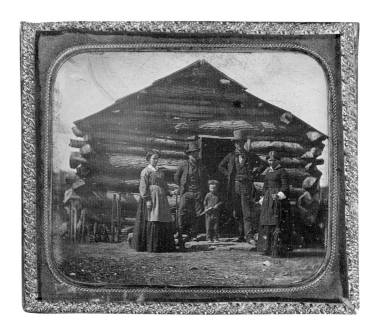

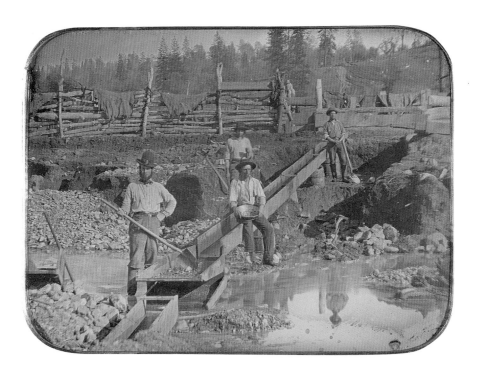

million had found their way to California in search of their fortune, including Albert Sands Southworth, whose considerable photographic achievements are discussed on page 78. Most of them never found it. This daguerreotype, made around the peak of the gold rush, shows the primitive conditions that existed in the field. It is all the more remarkable, then, that an intrepid photographer, with the heavy, bulky equipment required to make daguerreotypes, was present to make group portraits such as this. A testament to the desire to use the medium as record-maker, such an image now immortalizes the early American adventurers and opportunists whose voracious greed for the nearly two billion dollars worth of precious metal eventually taken from the hills forever transformed the region's geography.

Man's engineering of nature has always been an integral element of European settlement in America. In the late 18th century, the use of water power was found to be more cost-efficient than steam, and major bodies of water across the country were harnessed to provide power to

Unidentified photographer
American,
active ca. 1850s

Gold Miners at Dig,
ca. 1850

Daguerreotype
MUSEUM PURCHASE
79:3157:0001

William Southgate Porter
American, 1822–1889

Fairmount Waterworks, 1848

Eight whole-plate daguerreotypes
GIFT OF 3M COMPANY, EX-COLLECTION LOUIS WALTON SIPLEY
77:0503:0001

the burgeoning American cities. William Southgate Porter's "Fairmount Waterworks," made at Fairmount Park in Philadelphia, Pennsylvania, is a spectacular seven-plate panoramic daguerreotype of the waterworks, a pumping station built in 1815 on the Schuylkill River. In 1828 the city purchased 24 acres of land around the site and created a picturesque retreat for public use. The park soon became a popular destination for visitors, and images of it were commemorated on china and in engravings. However, the veracity and detail of the daguerreotype provided a far more vivid image of the scene than previous media could claim. As a testament to the extraordinary range that Porter captured, the dam spans four of the whole plates, while the neoclassical millhouse fills another two. In a gesture of authenticity, Porter mounted atop the panorama a daguerreotype of the "[p]oint from which this view was taken," perceptually extend-

MOUNT

W. S. PORTER.
AY 22d 1848.

ing the panorama beyond 180°. The use of elaborate framing with gold-edged columns between each section skillfully hides the seams between the plates while maintaining the continuity of the entire scene. The additional decorative elements of the impressive frame complement the grandeur of the photographic spectacle, providing a fitting presentation for this photographic masterpiece. Later the same year, Porter repeated this success, creating a prize-winning daguerreotype panorama of the Cincinnati waterfront with his partner Charles Fontayne.

Farther north, Platt D. Babbitt captured the spectacle of natural water power in his images made from the American side of Niagara Falls. Although industry had already blighted the landscape surrounding the falls by the mid-1850s, Babbitt managed to capture the purity of the natural setting, intruded upon by only a handful of adventurous tourists

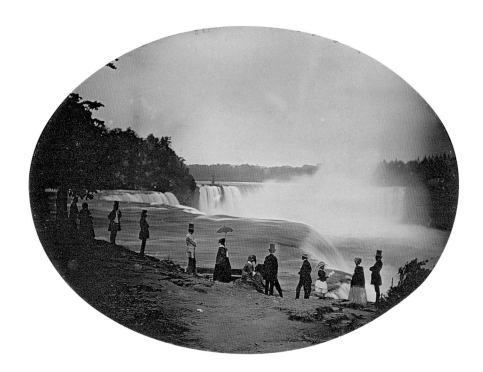

Platt D. Babbitt
American, d. 1879

Tourists Viewing
Niagara Falls from
Prospect Point,
ca. 1855

*Daguerreotype
with applied color*
GIFT OF EASTMAN
KODAK COMPANY,
EX-COLLECTION
GABRIEL CROMER
78:0608:0001

standing precariously close to the edge. Indeed, in this daguerreotype, one of four in the Eastman House collection made by Babbitt at the falls, a young girl, third from right, appears to have ventured into the water itself. Although countless photographers had made their way to Niagara over the years (and over 1,000 of their images have made their way into the Eastman House collection), Babbitt was the first photographer-in-residence at the American Falls. A colorful character and tenacious businessman, he controlled the lucrative pavilion at Point View. There he set up his camera and photographed tourists against the spectacular natural backdrop, selling them their daguerreotype likenesses. Who could resist such a stunning memento of their holiday?

As tourism blossomed in the 19th century, the ability to record scenes found on holiday or of places that many people would never see firsthand was further enhanced by the advent of the camera. Breathtaking images of distant locales were brought home into parlors and sitting rooms. From 1853 to 1854 Edward Meyer Kern was a daguerreotypist

and artist aboard the sloop *Vincennes,* accompanying an exploration group and survey of the China Seas and Bering Straits. This daguerreotype of the American Cemetery at the Gyokusen-Ji Temple was likely made by him during the survey, around the time that the Japanese signed their first treaty with a Western nation. The Treaty of Kanagawa resulted from pressure by American Commodore Matthew C. Perry, who sailed into Tokyo Bay and demanded that the Japanese open their ports to U. S. ships for supplies. The 1854 treaty marked the end of Japan's period of isolation and established a U. S. consul at the port city of Shimoda where this image was made. The existence of the cemetery is evidence of a sustained American presence in Japan before the treaty was signed, and the image provides a rare view of a previously undocumented American presence there.

Attributed to
Edward Mayer Kern
American, 1823–1863

*American Cemetery,
Gyokusen-Ji Temple,
Shimoda, Japan,*
ca. 1853–1854

Daguerreotype
MUSEUM PURCHASE,
EX-COLLECTION
ZELDA P. MACKAY
69:0201:0057

Southworth and Hawes

"We aim in our profession to please Artists, and those whose taste for the fine arts has been cultivated and refined," read a mid-1850s advertisement from the Southworth and Hawes studio. Albert Sands Southworth and Josiah Johnson Hawes are without question the finest American portrait photographers of the 19th century, and the Eastman House collection contains about 1,200 daguerreotypes by the partners. Both men, unbeknownst to one another, had learned the daguerreotype process while attending a series of lectures in Boston given by Daguerre's pupil François Gouraud in 1840. They entered into partnership in 1843, and until 1861 their studio at 5-1/2 Tremont Row was situated in the heart of Boston's artistic and literary community. Rather than hire operators, as most large studios did, Southworth and Hawes were unique in that they made all of their studio's images themselves. Pages from Hawes' sitters book from around 1864 show albumen print examples of his work and suggest the scope of patronage, even though most of the once-prominent faces catalogued within are now forgotten. Luckily, the faces of Southworth and Hawes themselves endure, as they periodically turned the camera on one another. This unusual portrait of Southworth, the only portrait of him and the only vignetted male portrait by the pair in the Eastman House collection,

Josiah Johnson Hawes
American, 1808–1901

Pages from Sitters Book, ca. 1864

Albumen prints
LIBRARY COLLECTION

Albert Sands Southworth & Josiah Johnson Hawes
American, 1811–1894 & American, 1808–1901

Albert Sands Southworth, ca. 1848

Daguerreotype
74:0193:1129

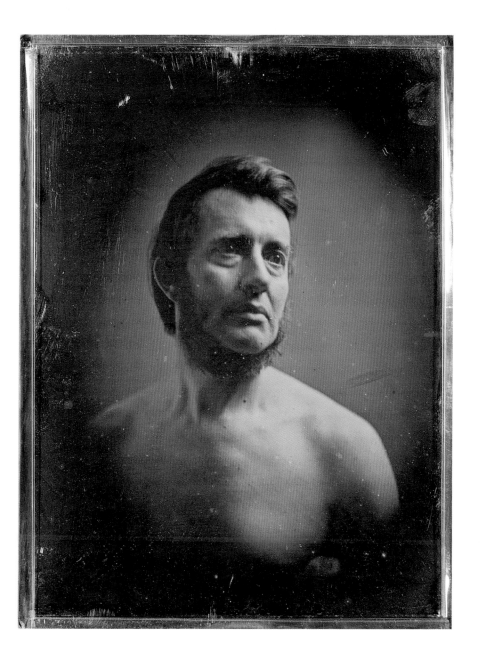

**Albert Sands
Southworth & Josiah
Johnson Hawes**
American, 1811–1894
& American,
1808–1901

Unidentified Female,
ca. 1850

Daguerreotype
74:0193:0400

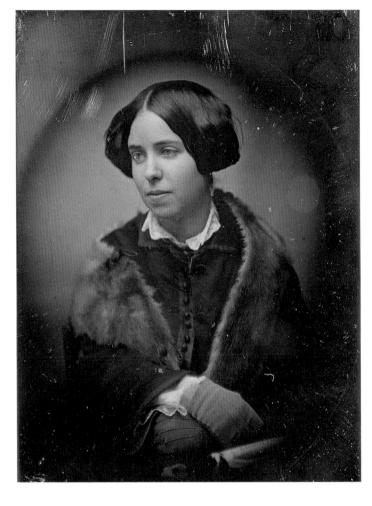

**Albert Sands
Southworth & Josiah
Johnson Hawes**

Rollin Heber Neal,
ca. 1850

Daguerreotype
GIFT OF ALDEN
SCOTT BOYER
74:0193:0141

is radical for its early depiction of the nude male body. Two daguerreo-type portraits of Hawes are also in the collection.

The bulk of their portrait work was with the fashionable citizens of Boston, such as this unidentified young woman draped in a fur stole, as well as prominent public personalities like Rollin Heber Neal, pastor of the First Baptist Church in Boston. In keeping with the partners' belief that daguerreotypy was an art form, the process of sitting for a South-worth & Hawes daguerreotype portrait was an elaborate, somewhat

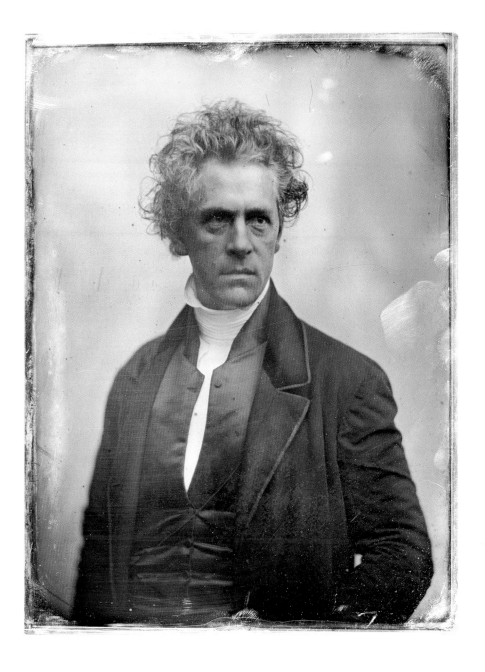

formal experience. One's first stop upon entering the studio was to become prepared for the sitting. For the female clients, there were available (according to a Southworth & Hawes invoice), "two Ladies ... [to assist] in arranging their dress and drapery, and consult them as to colors most appropriate and harmonious for the Daguerreotype process." Among those women who helped arrange the sitters was Nancy Niles Southworth, Albert's sister, who became Hawes' wife in 1849. She also hand-colored daguerreotypes for the studio.

To ensure that they maintained an elite clientele, a Southworth & Hawes whole-plate portrait daguerreotype, such as this one of a well-dressed young woman, cost $15, compared with an average cost of $2 for a standard 1/6-plate size elsewhere. Oversized plates, which were used more rarely, could cost as much as $50.

Southworth and Hawes' families were also frequent subjects. As their children were constant fixtures around the studio, they consequently made many portraits of them, including 12 of the Hawes' daughters, which are in the Eastman House collection. This portrait of Josiah and Nancy's daughter, either Marion Augusta or Alice Mary Hawes, is among the finest examples of the photographers' special sensitivity in rendering children sympathetically. The soft, modeled lighting illuminates the child, bathing her in a gentle glow.

Albert Sands Southworth & Josiah Johnson Hawes
American, 1811–1894 & American, 1808–1901

Unidentified Female, ca. 1850

Daguerreotype
74:0193:0028

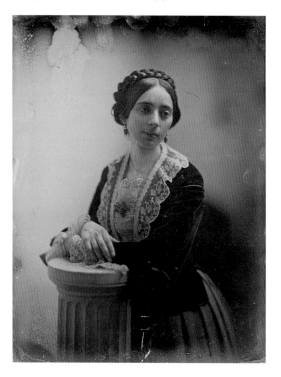

Albert Sands Southworth & Josiah Johnson Hawes

Marion Augusta Hawes or Alice Mary Hawes, ca. 1852

Daguerreotype
GIFT OF ALDEN SCOTT BOYER
74:0193:0823

Although the young girl was undoubtedly well versed in the necessity of maintaining her composure during an exposure, her contemplative expression is subtly evocative and poignant without dramatic excess.

Southworth and Hawes were equally successful at portraying the sweetness and spontaneous charm of very young children. In this portrait of a young girl, the camera is pulled back to reveal a small child illuminated in dappled sunlight. Her diminutive size is emphasized by framing her in the large, undefined space.

"A picture more lovely than this have ye not, / Softly gaze – softly breathe – and ye pause on the spot; / Then veil the fair figure, like Isis of old, / And keep the young heart in the vows it hath told" waxed one poetic enthusiast after seeing the bridal portraits displayed in the Southworth & Hawes studio. Photographs of brides, such as this example of a young woman resplendent in her wedding dress, have long been a staple of the commercial photographer's income. The grandeur of the whole-plate-sized portrait aptly preserves the commemorative importance of the occasion.

Southworth & Hawes' lesser-known images are their landscapes, marine views, and interiors. Mount Auburn Cemetery was the favored resting place for proper Bostonians. As a logical extension of their portrait work, this daguerreotype of plots at Mount Auburn (page 86) may have served as a treasured record of loved ones buried there. The emphasis on the lush, tranquil setting provides a comforting scene of eternal rest.

Albert Sands Southworth & Josiah Johnson Hawes

American, 1811–1894 & American, 1808–1901

Portrait of a Young Girl, ca. 1852

Daguerreotype
GIFT OF ALDEN SCOTT BOYER
74:0193:1122

Albert Sands Southworth & Josiah Johnson Hawes

Unidentified Female in Wedding Dress, ca. 1850

Daguerreotype
74:0193:0006

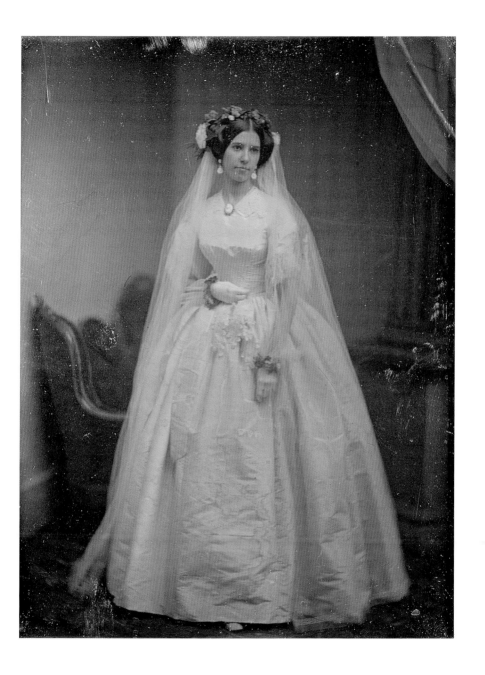

**Albert Sands
Southworth & Josiah
Johnson Hawes**
American, 1811–1894
& American,
1808–1901

*Mount Auburn
Cemetery*, ca. 1850

Daguerreotype
GIFT OF ALDEN
SCOTT BOYER
74:0193:0107

The view of the second-floor reading room at the Boston Athenaeum is one-half of a Grand Parlor stereoscopic pair. Natural light illuminates the scene of men gathered around the reading tables. The Eastman House technology collection includes the Grand Parlor Stereoscope from the Southworth & Hawes studio, one of only three ever made, which attracted tremendous publicity for the studio. The partners patented their creation in 1855, which was priced at an astronomical $1,160.

Progress of the 19th century was also captured by Southworth and

Hawes. The image of a sloop of war in dry dock at the Boston navy yard (page 88) is as much a portrait of the dock, an engineering feat that took five years to construct, as it is of the sailing vessel. The Niagara Suspension Bridge (page 89), completed in 1855, emerges from the wintry landscape like beacons of progress in the bleak surroundings. In addition to the impressive collection of daguerreotype images, 2,310 individual items of photographic ephemera are now part of the Southworth & Hawes manuscript collection in the Menschel Library at Eastman House.

Albert Sands Southworth & Josiah Johnson Hawes
American, 1811–1894 & American, 1808–1901

Sloop-of-War in Boston Dry Dock, ca. 1852

Daguerreotype
MUSEUM PURCHASE
74:0193:1128

Albert Sands Southworth & Josiah Johnson Hawes

The Niagara Suspension Bridge, March 8, 1855

Daguerreotype
GIFT OF ALDEN
SCOTT BOYER
74:0193:0180

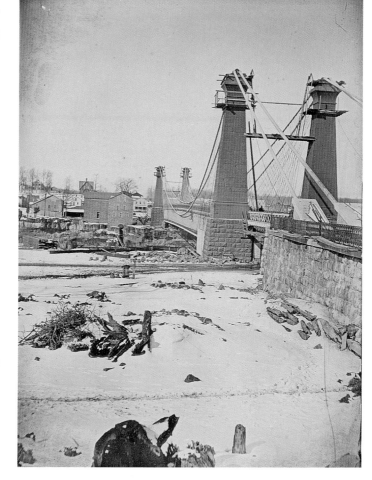

Talbot and the Paper Negative

Although immediately popular and available without patent restriction from the very beginning, the daguerreotype was not the only photographic medium announced in 1839. William Henry Fox Talbot, an amateur scientist in England, had been corresponding with his friend and colleague, the scientist Sir John Herschel (1792–1871), about their mutual discoveries using the cameras obscura and lucida, and their experiments with light sensitivity. In January 1839, stirred to action by the announcement of Daguerre's invention, Talbot announced the development of his "photogenic drawings," with which he had his first success in 1835. In fact, Talbot became the first to show his photographs to the public on January 25, 1839, exhibiting his early experiments at the Royal Institution in London. A month later, he published the complete instructions for his process. Although photogenic drawings initially required long exposures, Talbot continued to improve upon the process, increasing their sensitivity, and two years later he dubbed the improved process, "the calotype," from the Greek *Kalos* meaning beautiful and fine, and *typos* meaning outline or sketch. Talbot patented his calotype process in 1841 and began to charge rather high fees for its use, effectively curtailing its potential popularity. Unlike the daguerreotype, his process utilized a single negative image from which multiple positive prints could be made. This process would become the basis for photography as it is most commonly practiced today. For some, however, the soft focus of the calotype print on paper was no match for the crisp clarity of the daguerreotype image, which sat glimmering on the surface of a polished metal plate.

In 1844 Talbot published *The Pencil of Nature*, the first major book to be illustrated with origi-

William Henry Fox Talbot
English, 1800–1877

Cover of *The Pencil of Nature*, 1844

Lithograph
MUSEUM PURCHASE, EX-COLLECTION ALDEN SCOTT BOYER LIBRARY COLLECTION

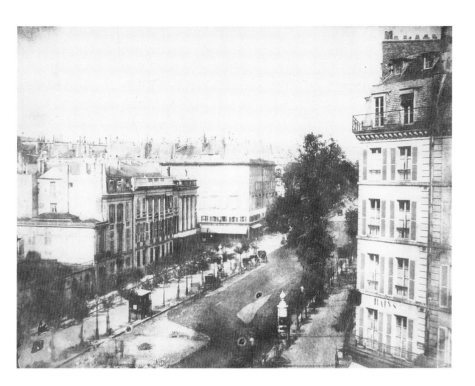

nal photographs. The publication was comprised of six fascicles with a total of 24 plates and was published over a two-year period between June 1844 and April 1846. The Menschel Library at Eastman House contains two copies. In order to produce the volume of prints necessary for the publication, Talbot set up a printing studio, called the "Reading Establishment," at Reading, England, in 1843. This was run by his assistant Nicholas Henneman (1813–1898). Plate II in the volume was Talbot's "View of the Boulevards at Paris," made from the window of his hotel room. It was no coincidence that Talbot brought his process to Daguerre's home turf to make photographs – he had traveled there with Henneman in order to introduce the calotype to France. His photographic achievements in Paris rivaled the best daguerreotypes. Carriages line the otherwise empty boulevard at the center, and every roof spire and window mullion is delineated by light in this highly detailed image. Talbot wrote vividly of the scene in his accompanying text: "The spectator is looking Northeast. The time is the

William Henry Fox Talbot

View of the Boulevards at Paris, ca. 1844

Salted paper print
GIFT OF ALDEN
SCOTT BOYER
LIBRARY COLLECTION
81:2835:0002

afternoon. The sun is just quitting the range of buildings adorned with columns: its façade is already in shade, but a single shutter standing open projects far enough forward to catch a glimpse of sunshine. The weather is hot and dusty, and they have just been watering the road. ...” However vivid, the evocation of the scene through words is no match for all of the details made visible by this new invention.

"Articles of China," an assembly of Talbot's teacups and statuary, became plate III in *The Pencil of Nature*. In his accompanying text, Talbot extolled photography's ability to "[depict] on paper in little more time than it would take ... to make a written inventory" the entire contents of a china collection. Presciently, he immediately identified the medium's evidentiary usefulness "should a thief afterwards purloin the treasures," thus foreseeing its future use by law enforcement. Talbot also demonstrated the medium's capacity for revealing the particularities of the china itself as the distinct personality of each piece comes

forth in the photograph. Regarding the potential interest for the collec-
tor in this new medium, Talbot wrote, "The more strange and fantastic
the forms of his old teapots, the more advantage in having their pictures
given instead of their descriptions." To this end, Talbot also included
calotypes of shelves of glassware and shelves of books as separate
plates in the book.

Before completing the final installment of *The Pencil of Nature,* Talbot
decided to photograph, as he wrote, "scenes connected with the life and
writings of Romantic author Sir Walter Scott," by whom he was greatly
influenced. Talbot made a trip to Scotland in October 1844 to photo-
graph Scott's home in Abbotsford and other locations mentioned in
Scott's writings. Talbot produced a new book of 23 "sun pictures," as he
called them, of views in Scotland. Unlike *The Pencil of Nature, Sun Pic-
tures in Scotland* was exclusively pictorial and was the second book print-
ed at the Reading Establishment. Talbot's view of Loch Katrine, plate 16

**William Henry
Fox Talbot**

Loch Katrine, 1844

Salted paper print
GIFT OF ALDEN
SCOTT BOYER
LIBRARY COLLECTION
74:0044:0011

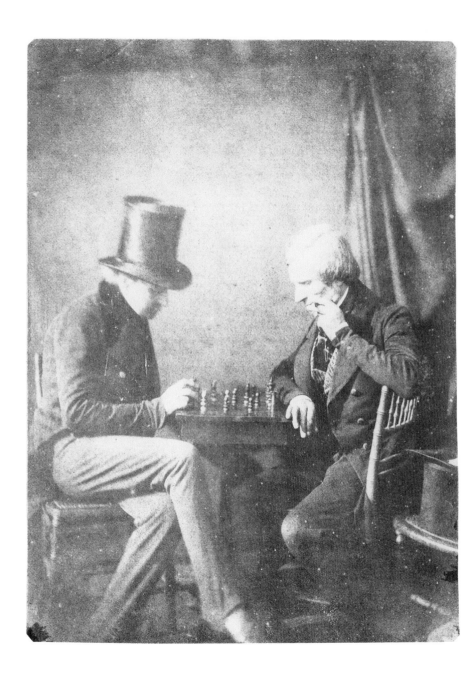

in the book, depicts the glassy stillness of the lake and the picturesque, remote landscape reflected in its smooth surface. Queen Victoria was among the 103 subscribers to the publication, but the Reading Establishment ultimately proved to be a bad business venture. The problem of fading prints persisted, and after only three more publications, Henneman closed shop in 1846 and moved to London.

Another subscriber to *Sun Pictures* was the Reverend Calvert Richard Jones, the son of a Welsh landowner who was a marine painter, draftsman, and daguerreotypist before turning to the calotype. "The Chessplayers," showing Antoine Claudet at left and possibly Jones on the right, is attributed to the circle of Talbot, although variant prints from the same sitting have been attributed to Claudet or another photographer in Talbot's circle. Clearly posed, the scene is nevertheless casual and fun, indicating the nature of the gentlemen's relationship. It also suggests the level of interaction between these early amateur practitioners, who shared ideas and images freely. In September 1845 Jones visited Talbot at Lacock Abbey, where Talbot made a portrait of him seated at the ancient Vestry at Talbot's ancestral estate. "... [T]o make a good figure in a photographic picture requires considerable steadiness of

character but only for the fraction of a minute. This valuable quality, together with many others too long to mention, my friend possesses in an eminent degree," wrote Talbot of this sitting with Jones, in a text that was to have accompanied this image in a future, unrealized installment of *The Pencil of Nature*. Jones is barely distinguishable from the surrounding stone, recognizable only by the prominent shape of his top hat.

Simple objects and close observations were frequently the subjects of Talbot's early photographs as he continued to experiment with perfecting the recalcitrant medium, shortening exposure times and increasing the permanency of the calotype prints. "Window Tracery and Detail Arc de Triomphe" is a photoglyphic engraving from the late 1850s. Architectural details and sculpture were favored subjects for Talbot, including this detail of the lower half of the Arc de Triomphe de l'Étoile in Paris. The detail of arch and window below it is also clearly delineated. Similarly, the intricate texture of lace proved to be a perfect subject, as every stitch reveals its structure under the camera's scrutinizing eye. This positive print was made from a negative photogram without the use of a camera. Talbot laid the lace on the sensitized paper and exposed it to light. The pattern of lace was thus transferred onto the photographic paper in relation to the areas of density. In the original photogram, the lace appeared white against a black ground. Either was acceptable as a finished image to Talbot. As he wrote, "The picture ... is but a succession or variety of stronger lights thrown upon one part of the paper, and of deeper shadows on another. Now Light, where it exists, can exert an action." By printing the negative, Talbot more accurately reproduced

Unidentified photographer, plate by William Henry Fox Talbot
English, 1800–1877

Window Tracery and Detail Arc de Triomphe,
ca. 1858–1860

Photoglyphic engraving
GIFT OF THE
SMITHSONIAN
INSTITUTION
67:0048:0009

William Henry Fox Talbot

Lace, early 1840s

Salted paper print
GIFT OF DR. WALTER CLARK
81:2836:0001

the object's original appearance while maintaining the detail of its web-like construction.

Because Talbot's patent restricted its use, the calotype had limited use in the United States. Brothers William and Frederick Langenheim wrote to Talbot after seeing a copy of *The Pencil of Nature*. Initially they indicated that they wished to act as Talbot's agents in the United States and to teach the calotype process. William traveled to London to negotiate with Talbot, and the Langenheims purchased the U.S. patent to the calotype process in 1849. The Langenheims had begun their photographic partnership in 1843 and ran a successful daguerreotype studio at various addresses in the Mercantile Exchange in Philadelphia. "Merchant's Exchange, Philadelphia" is a calotype of the building that housed their studio. Calling their print a "Talbotype from Nature," the Langenheims sent this print to Talbot as an example of their work using his process. Eastman House acquired the print as a gift in 1952 – it had been sold to its previous owner by Talbot's granddaughter. Talbot held onto the work, no doubt encouraged by the Langenheims' aesthetic success.

Recognizing the calotype's potential, an article in a Washington, D.C., newspaper informed its American audience that "... independently of each other, Daguerre and Talbot found out the art of fixing upon metal and upon paper the light of the sun. The former has obtained the more immediate success; but the other has, perhaps, hit upon the better form of the discovery." Sadly ahead of their time, the Langenheims failed to realize that the fervent popularity of the daguerreotype, with its extraordinary detail, had in 1849 yet to wane in the United States. Having sold only five licenses in six months, the brothers begged Talbot to postpone payments on the balance of the $6,000 purchase of the patent. Talbot apparently never responded, which led to bankruptcy for the brothers. They were not alone. Even in England, studios were unable to sustain a profitable business using the calotype. Still, the Langenheims continued to use the process, producing calotypes that were exhibited at the Crystal Palace exhibition in London in 1851. The studio eventually closed in 1874 following William's death. The Eastman House collection contains a broad range of the Langenheims' work, including daguerreotypes, negatives, glass stereographs, microphotographs, and their own invention, the "Hyalotype," a modification of the albumen on glass process. The Menschel Library also holds a small amount of manuscript material relating to the Langenheims' studio.

William & Frederick Langenheim
American, b. Germany, 1807–1874 &
American, b. Germany, 1809–1879

Merchant's Exchange, Philadelphia, ca. 1849

Salted paper print
GIFT OF HAROLD WHITE
81:2914:0001

Hill and Adamson

The patent that Talbot had taken on the calotype process in England and Wales did not, fortunately, apply to Scotland. This allowed for Scots David Octavius Hill and Robert Adamson to create some of the most outstanding calotype images ever made. The Eastman House collection contains more than 400 prints and five negatives made by Hill and Adamson during their five-year partnership.

Within days of first exhibiting his photogenic drawings in London, Talbot sent examples to his friend Sir David Brewster (1781–1868), who was principal of the United Colleges at St. Andrews University in Scotland. Brewster introduced the calotype to his pupil, John Adamson, who became an accomplished photographer in his own right. He in turn instructed his brother Robert, an engineering student. In 1843 Robert moved to Edinburgh and opened a studio. D. O. Hill, Adamson's elder by nearly 20 years, was a well-known landscape painter and secretary of the Scottish Academy of Painting. A watercolor view of St. Andrews seen in the distance demonstrates Hill's early training and draftman's skill, which he later applied to the photographs he and Adamson made of the Scottish countryside. In an early portrait by the partners, Hill is pictured standing in a doorway.

Their brief partnership was tragically cut short by Adamson's premature death at age 26. Although it was initially believed that, because

David Octavius Hill
Scottish, 1802–1870

St. Andrews, ca. 1850

Watercolor
MUSEUM PURCHASE,
EX-COLLECTION
PETER POLLACK
66:0029:0001

**David Octavius Hill
& Robert Adamson**
Scottish, 1802–1870
& Scottish,
1821–1848

D. O. Hill, ca. 1843

Salted paper print
GIFT OF ALDEN
SCOTT BOYER
81:2398:0002

of their respective training, Adamson performed the mechanics of the calotype process while Hill contributed the aesthetic expertise, further study of their work reveals that they were equal partners in composition and form.

On May 18, 1843 Hill attended a meeting of the General Assembly of the Church of Scotland, at which 155 ministers resigned to establish the Free Church of Scotland. Deeply moved by the turn of events, Hill decided to create a grand-scale commemorative portrait of the signing, five days later, of the Act of Separation and the Deed of Demission. In order to produce likenesses of the 457 ministers and members of Edinburgh society that were present, Brewster suggested to Hill that he utilize the calotype process, and put him in contact with Adamson. Thus began their prolific partnership. This portrait of Doctor Abraham Capadose of The Hague, a physician and Calvinist writer, is one of those portrait studies. Reflecting Hill's painterly training and demonstrating a sophisticated use of light and shadow, the photograph utilizes the classic pictorial convention of a three-quarter pose as well as the iconography of a book to indicate that the sitter is a learned man. Although Hill completed the painting based on the photographs some 20 years later, the photographic portrait is a truer likeness and a more nuanced portrait study than the painted version, in which Capadose appears as a tiny bobbing head in a sea of faces. It is fitting that Hill also included a self-portrait in the canvas as well as a posthumous portrait of Adamson at his camera amidst the crowd.

Their portrait work extended beyond the massive Free Church project to other members of Edinburgh society, as well as to the workers in the fishing village of Newhaven. Hill and Adamson's portrait of Lady Mary Hamilton (Campbell) Ruthven (page 104) takes the radical positioning of its subject with her back to the camera from fashion illustrations in contemporary ladies' magazines. Rather than show Ruthven's likeness, this portrait demonstrates her *au courant* stylishness as well as her upper-class status. The photograph of a seated Mrs. Elizabeth Johnstone Hall (page 105), on the other hand, depicts a fisherwoman of Newhaven in an occupational portrait holding her basket. Hill sometimes captioned this photograph "A Newhaven Beauty," suggesting that, at least aesthetically, class did not determine his affinities.

Nor, however, did traditional portraiture exclusively define Hill and Adamson's subject matter. Their body of work includes landscapes and

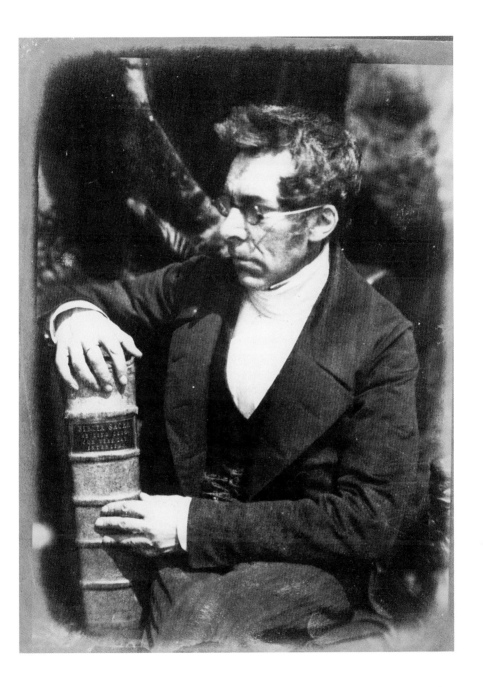

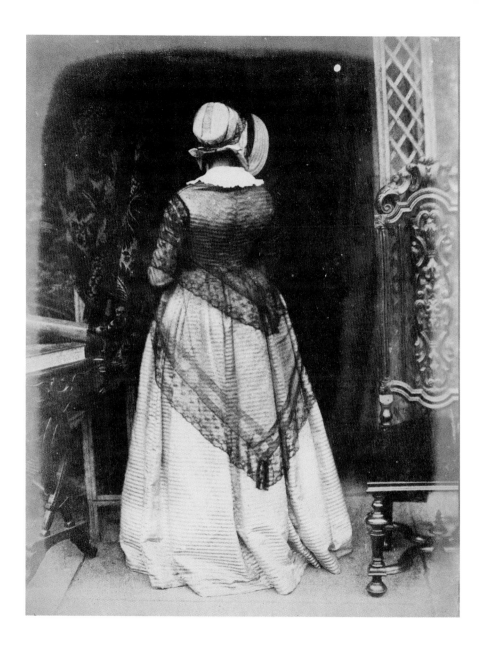

**David Octavius Hill
& Robert Adamson**
Scottish, 1802–1870
& Scottish,
1821–1848

Lady (Mary
Campbell) Ruthven,
ca. 1843–1847

Salted paper print
GIFT OF ALDEN
SCOTT BOYER
81:2398:0042

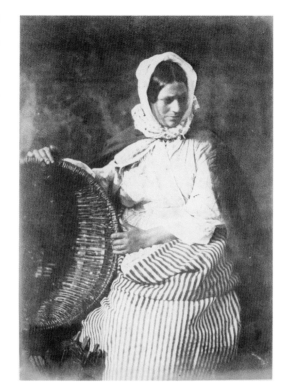

**David Octavius Hill
& Robert Adamson**

Mrs. Elizabeth
Johnstone Hall,
ca. 1845

Salted paper print
GIFT OF ALDEN
SCOTT BOYER
81:2389:0005

genre scenes, and all manner of patrons sat for portraits at their outdoor studio at Rock House, Calton Hill. In the popular Victorian tradition of *tableaux vivants,* the pair constructed the elaborate "Medieval Group" (page 106), in which Hill participates at right, strumming a lyre. The attention to costume details and theatricality is also evident in "The Porthole, Edinburgh Castle" (page 107), which shows guards at the royal residence standing beside a cannon. The Finlay children – Arthur, John Hope, and Sophia – are depicted leisurely fishing at the minnow pool (page 108). Their youthful attentions are focused on the goings on below. An image of the Martyrs' Memorial and McCulloch monument (page 109) in Greyfriars' churchyard shows a standing Hill and a seated woman, possibly one of the Misses Watson, alongside a tomb as if visiting the grave of a dearly departed soul. Like Talbot, Hill and Adamson succumbed to the lure of Romantic subject matter and made numerous images in Greyfriars. More than a dozen of these are in the Eastman House collection.

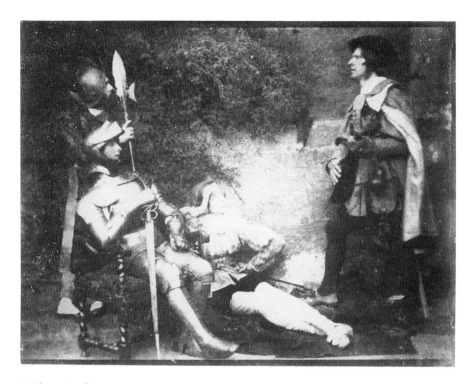

David Octavius Hill
& Robert Adamson
Scottish, 1802–1870
& Scottish,
1821–1848

A Medieval Group,
ca. 1843–1847

Salted paper print
GIFT OF ALDEN
SCOTT BOYER
81:2396:0032

David Octavius Hill
& Robert Adamson

The Porthole,
Edinburgh Castle,
April 9, 1846

Salted paper print
GIFT OF 3M COM-
PANY, EX-COLLEC-
TION LOUIS
WALTON SIPLEY
77:0502:0002

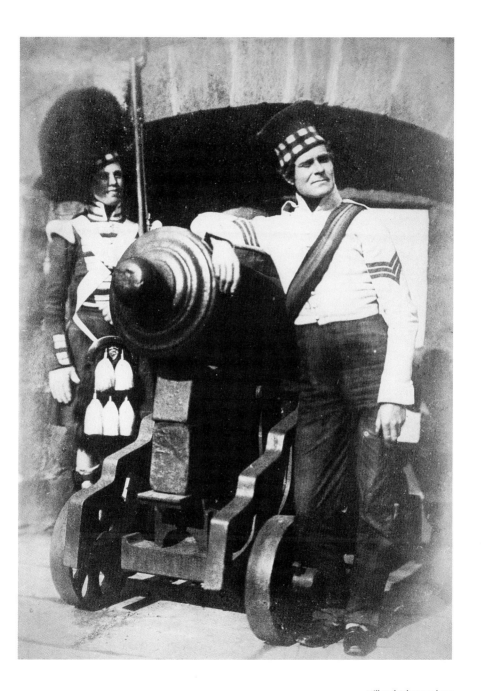

**David Octavius Hill
& Robert Adamson**
Scottish, 1802–1870
& Scottish,
1821–1848

Finlay Children,
ca. 1845

Salted paper print
GIFT OF ALDEN
SCOTT BOYER
81:2396:0014

**David Octavius Hill
& Robert Adamson**

Greyfriars' Church-
yard, the Martyrs'
Memorial & the
McCulloch Monu-
ment, ca. 1844

Salted paper print
GIFT OF ALVIN
LANGDON COBURN
67:0083:0004

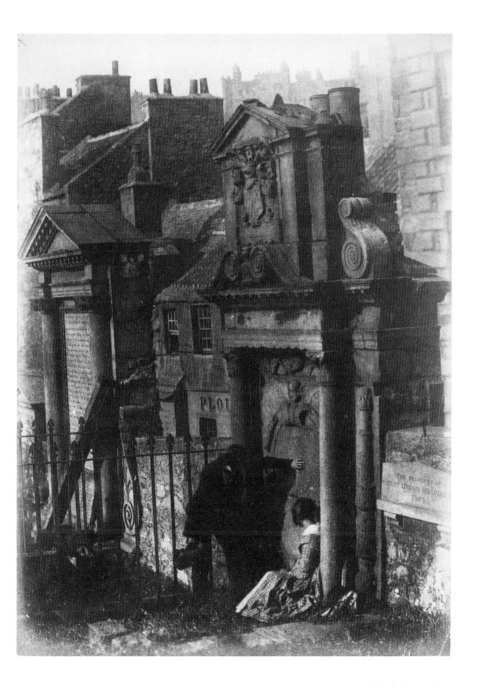

**Unidentified
photographer**
English, active 1850s

*Flowers in Vase and
Bird's Nest,* ca. 1851

Salted paper print
MUSEUM PURCHASE
81:1304:0010

Amateur photographers also took to the calotype process with enthusiasm and success, recording the world around them with great sensitivity and accomplishment. An arrangement of flowers in a vase alongside a bird's nest filled with eggs is a striking still life of the natural world. Naturalism was applied to scenes of casual repose as well; this unknown photographer focused his camera upon the Reverend J. and Mrs. Arrowsmith and Susan Bridges reading beneath the shade of a tree. A church, presumably Arrowsmith's, is visible in the background. Although certainly posed for the camera, the effect is entirely natural as each sitter appears thoroughly enthralled by their reading material, as though the photographer stumbled upon this scene of quiet contemplation and, unbeknownst to them, stopped to preserve it.

The surgeon and gynecologist Dr. Thomas Keith of Edinburgh was an accomplished amateur photographer who is thought to have learned

Unidentified photographer
English, active 1850s

Revd. J & Mrs. Arrowsmith and Susan Bridges, ca. 1851

Salted paper print
MUSEUM PURCHASE
81:1304:0032

the calotype process from his friend D. O. Hill. Keith specialized in ar-
chitectural and landscape views in and around Edinburgh in the early
1850s. Professional commitments limited his photographing time to be-
fore 7:00 A. M. and after 4:00 P. M., and remarkably, he further limited
his photographing to a few weeks in midsummer when light was opti-
mal, explaining that "[t]he light is then much softer, the shadows are
longer, and the half tints in your picture are more perfect and the lights
more agreeable." In total, Keith photographed only for about three
years, at which time his medical duties took precedence.

"Woman in Doorway" shows an elaborately carved portal from 1633 in
which a woman stands raked by sunlight, lending a human element and
scale to the architectural study. The detail view of an ancient archway is
similarly cast in deep shadow, evoking a mystery surrounding what lies
within. Both images are platinum prints made around 1915 by Alvin
Langdon Coburn, who prepared prints from ten of twelve waxed paper
Keith negatives, all of which are in the Eastman House collection.

The Calotype in France

Nowhere was the calotype more embraced than in France, but it was not precisely Talbot's process that was used. Although Talbot had visited Paris in 1843 in order to gain support for his process, only one calotype patent was sold in France in 1844. Still, there were numerous experimenters who had developed their own variations on the paper negative process. In 1847 Louis-Desiré Blanquart-Evrard, a cloth merchant from Lille, bypassed the patent restrictions by modifying Talbot's process – much to Talbot's consternation – and thus revolutionized the use of the paper negative. By reversing Talbot's sensitizing procedure, Blanquart-Evrard discovered a way to saturate the paper to increase tonal range and detail, and, significantly, to reduce exposure times by about 75 percent. However, negatives had to be exposed when wet, necessitating the use of a dark tent and chemicals immediately prior to exposure. Three years later, Blanquart-Evrard developed a dry negative paper that could be prepared in advance.

In addition to his early experimentation that revolutionized paper print technology, Blanquart-Evrard became most renowned for his printing, both of his own images and those of other photographers. As Talbot had done with his Reading Establishment, in 1851 Blanquart-Evrard set up a manufactory, the Imprimerie Photographique, at Loos-les-Lille, France, to produce large numbers of photographic prints for publications. Until its closure in 1855, Blanquart-Evrard's printing business produced 24 volumes of images by many of the most prominent French photographers of the day, including Maxime Du Camp, Auguste Salzmann, Charles Marville, Henri Le Secq, and J. F. Michiels. The Eastman House collection includes several prints from Blanquart-Evrard publications.

Artists above all else favored the paper negative and its poetic possibilities. Around 1850 the painter and photographic experimenter Gustave Le Gray introduced the dry "waxed" paper negative, which meant that the negative paper could be coated and kept up to two weeks before exposure and did not have to be developed for a couple of days after exposure. Le Gray was exceedingly influential in promoting the calotype in France, instructing any who made their way to his rural studio and home in Clichy. Ironically, British photographers were greatly influenced by the advancements made in France after French calotypes were displayed at the Great Exhibition of the Works of Industry of All Nations held in the Crystal Palace in 1851. Although Talbot's invention

was then being widely used, it was the French innovators who received the credit for perfecting the technique.

André Giroux was a painter whose father Alphonse (active 1840s) manufactured Daguerre's equipment. The technology collection at Eastman House contains two of these cameras made by Giroux, one bought by Boston dentist Samuel Bemis from Daguerre's agent, François Gouraud, and both featuring Daguerre's signature and Giroux's official seal. Giroux frequently painted directly on his paper negatives to render soft, atmospheric effects, even when he began to use collodion on glass negatives, treating the negative almost like a printing plate. His extremely manipulated style was rare in 19th-century French photography. He was schooled in the picturesque, Romantic landscape tradition, which lent itself well to his chosen subject matter. Seeking to obliterate the mechanical hand of photography, Giroux anticipated the pictorialist style that became popular around the turn of the century. A landscape

André Giroux
French, 1801–1879

Landscape, ca. 1855

Salted paper print
MUSEUM PURCHASE
76:0020:0062

scene of a river running through a bucolic French town is a delicate example of Giroux's *très pittoresques* images, although, despite his efforts, the photographic clarity of the print is nevertheless apparent and inviting.

With more than 100 prints and negatives, Eastman House has one of the largest collections in the world by painter and antiquarian Henri Le Secq. The son of a local politician, Le Secq studied painting under Paul Delaroche and specialized in genre scenes, using photography initially to make preparatory sketches for his paintings. He quickly shifted his interest to architecture and became a self-appointed preserver of Parisian monuments, taking it upon himself to photographically document the vanishing old city. In 1851 he became one of five photographers hired by the Commission des Monuments Historiques (founded in 1837) to create a photographic record of historically significant French buildings.

Henri Le Secq
French, 1818–1882

Rosheim, 1851

Salted paper print
MUSEUM PURCHASE
81:1465:0026

Le Secq was assigned to the regions of Alsace, Lorraine, and Champagne. His oeuvre included architectural studies, "académies," landscapes, still lifes, portraits, documentation and reproduction of works of art, as well as experiments using non-silver processes.

"Rosheim" is one of the images Le Secq produced for the commission of the local church in the Alsace region of northeastern France. He specialized in architectural details, prompting one critic to remark that Le Secq's photograph was better to study than the actual building! This detail of the 12th-century Gothic statues atop the support columns on Chartres Cathedral bears out such a claim, as Le Secq's camera captured details not easily visible to the casual observer. The print is from a rare

Henri Le Secq

Chartres Cathedral,
Detail, Jamb Statues
Supporting
Columns, 1852

Photolithograph
MUSEUM PURCHASE
79:2634:0002

Henri Le Secq
French, 1818–1882

Fantaisies *Still Life*,
ca. 1855

*Print by Gabriel
Cromer, ca. 1930
Gelatin silver print
from paper negative*
GIFT OF EASTMAN
KODAK COMPANY,
EX-COLLECTION
GABRIEL CROMER
81:1481:0004

portfolio in the Eastman House collection, *Fragments: Architecture et sculptures de la Cathédrale de Chartres,* which contains 25 photolithographs made using the *encre grasse* process invented by Thiel Aine and Co., of Paris. The Commission des Monuments Historiques published this portfolio, although by and large it did not publish or make use of any of the photographs it commissioned. Le Secq documented Chartres extensively, and the portfolio is a unique, intact collection of those images.

Le Secq also created a series of still life compositions. The frontispiece
for a portfolio of his still lifes is perhaps one part self-portrait and one part
symbol of his beloved France. A camera lens, wine bottle, and two filled
glasses beckon invitingly, albeit with an air of mystery. "Fantaisies/clichés
par/H. Le Secq" reads the bottle's label, leaving no doubt as to the artist's
identity. Gabriel Cromer, whose collection included 15 Le Secq paper nega-
tives, made this print from the original negative in the 1930s.

A cyanotype of a farmyard scene near St.-Leu-d'Esserent north of
Paris is one of five cyanotype prints by Le Secq in the museum's collec-
tion. A process invented around 1848 by Sir John Herschel, the cyan-
otype is relatively simple to make, as it involves only two chemical
compounds: ferric ammonium citrate and potassium ferricyanide.
Cyanotypes, as their name suggests, are distinctively blue in color.
In this picturesque, rustic view, the blue tone of the print contributes
to the evocative quality of the scene. Dominated by a large central
shadow, the photograph demonstrates the photographer's "habit of
making memoranda of the shapes of shadows ... wholly without indi-
cation of their cause." Light creeps in at either side rather tentatively,

Henri Le Secq

Farmyard Scene,
near St.-Leu-
d'Esserent, ca. 1852

Cyanotype
MUSEUM PURCHASE
81:1465:0007

Charles Negre
French, 1820–1880

Arles: Porte des
Châtaignes, 1852.

Salted paper print
GIFT OF EASTMAN
KODAK COMPANY,
EX-COLLECTION
GABRIEL CROMER
80:0521:0001

insinuating its presence by sketching the windows and thatches on roofs and ground.

Le Secq's garden scene of a single urn upon a pedestal balancing the lower center of the frame is a "found object" variation on the composed still life. The haphazard arrangement of forms in nature suggests a scene that Le Secq stumbled upon and stopped to frame for the camera. A ladder appears midway through the right edge of the image and promptly disappears into the foliage; a sign is seemingly turned away from the path it is meant to mark. Moreover, the leaves cascade across the top of the urn as if this small pot holds the origins of the massive tree, its roots otherwise obscured. Favoring the paper negative exclusively, Le Secq virtually gave up photography after 1856 when collodion on glass became the preferred medium.

Like Le Secq, Charles Negre was trained as a painter with Delaroche and took up photography as a complement to his painting. Negre and Le Secq had even photographed together in Chartres; one of Negre's most famous images is of Le Secq on the tower there. Already part of the tradition of genre painting, Negre initially used the daguerreotype and became known for genre photographs that he made on the streets of Paris. Eventually, he would earn his reputation as a photographer of architecture. Each summer he photographed his home region, the Midi,

Henri Le Secq
French, 1818–1882

Garden Scene,
ca. 1855

Salted paper print
MUSEUM PURCHASE
81:1465:0008

Unidentified photographer
French, active 1850s

Church of
Saint Martin,
Candes, ca. 1851–1855

Salted paper print
GIFT OF EASTMAN
KODAK COMPANY,
VINCENNES, VIA THE
FRENCH SOCIETY OF
PHOTOGRAPHY,
EX-COLLECTION
HENRI FONTAN
81:1115:0019

where he made hundreds of negatives that he eventually published as *Le Midi de la France, sites et monuments historiques photographies.* Unlike Le Secq, Negre was concerned less with the preservation of crumbling monuments than with the rich atmosphere of living places. His town-scape view of the Porte des Châtaignes at Arles is accented by the human presence of two villagers sitting atop the wall, as well as another figure barely discernable at the top of the path leading down to the water's edge. Rather than focus on the crumbling architecture of the gate, Negre incorporates past with present by pulling back the camera to show a still-active port despite the inevitable, visible ravages of time.

Often some of the finest examples of calotypes from this period remain unattributed. The Eastman House collection contains a group of 123 paper negatives and 90 salt and albumen prints of architectural views and studies of Normandy and other regions of France, as well as some scenes in Belgium, which are believed to have been made by

either a single photographer or group of photographers. Included among them are these two images, one of the Church of Saint Martin at Candes and the other an urban view "Une des arcades du pont de pierre livre au public en 1829" at Rouen. The image of the church was made from relatively close up on the façade, eliminating the sky in favor of particular details in the architecture of the main building and its surrounding structures. Unlike the scene by Negre, this one is unpopulated, leaving the viewer to speculate about the present and future of this local church. The opposite visual approach was taken in this long view of one of the arcades of the Pierre Bridge as it arches across the river. The original bridge, constructed in 1812, had been replaced in 1829, no doubt to accommodate the construction of the railroad that would facilitate modern travel. Evidence of further modernization is seen at right in the tarpaulin-covered pile.

The photographic work of Édouard-Denis Baldus revolved, in part,

Unidentified photographer
French, active 1850s

Rouen. Une des arcades du pont de pierre livre au public en 1829. (Rouen. One of the Arcades of the Stone Bridge Given to the Public in 1829.), ca. 1851–1855

Calotype negative
GIFT OF EASTMAN KODAK COMPANY, VINCENNES, VIA THE FRENCH SOCIETY OF PHOTOGRAPHY, EX-COLLECTION HENRI FONTAN
81:3198:0008

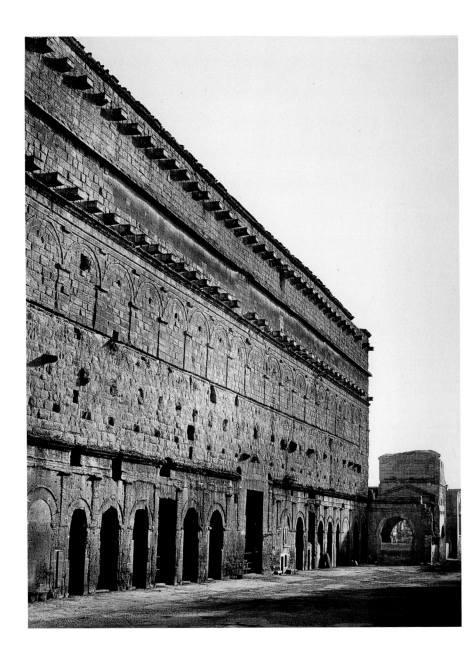

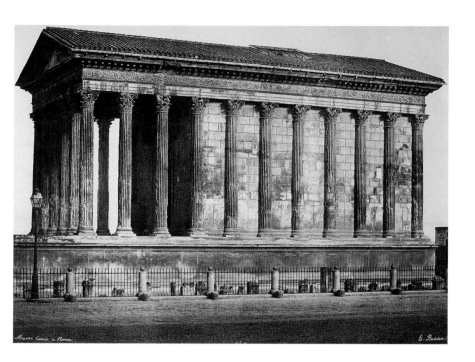

around the expansion of the railroad in France, and the commission he received to document their routes. The Prussian-born Baldus was trained as a painter and began his career in photography the same year he became a naturalized French citizen, 1849, just as paper negatives were becoming popular. At the height of his career, Baldus was the most successful photographer in France, specializing in views of architectural monuments and landscapes. The Eastman House collection contains more than 200 photographs and 140 photogravures by this master. Like Le Secq, he received a heliographic mission from the Commission des Monuments Historiques. The most extensive mission given, Baldus' ranged from Paris to Fontainebleau, Burgundy, the Rhône Valley, Arles, and Nîmes.

In 1861 the Administrative Council of the Southern Region of the Compagnie du Chemin de Fer de Lyon à la Mediterranée commissioned Baldus to produce a collection of photographic views along the train line from Lyons to Marseilles and Toulon. A copy of the album he produced, *Chemins de fer de Paris à Lyon et à la Mediterranée,* is now in the Eastman

Édouard-Denis
Baldus
French, b. Prussia,
1813–1889

Maison Carrée à
Nîmes, ca. 1855

Salted paper print
GIFT OF EASTMAN
KODAK COMPANY,
EX-COLLECTION
GABRIEL CROMER
74:0050:0017

Édouard-Denis
Baldus

Orange. Théâtre
antique, ca. 1861

Albumen print
MUSEUM PURCHASE
74:0055:0023

Attributed to Louis-Desire Blanquart-Evrard
French, 1802–1872

Peasant Family at Rest in Front of a Thatched Shed, 1853

Salted paper print
GIFT OF ALDEN SCOTT BOYER
81:1100:0003

House collection. It includes this view at Orange of the exterior of the Théâtre Antique. Radically angled to encompass the entire façade, Baldus's composition energizes the architecture and exaggerates the sense of movement across its front. Ten years earlier at Nîmes, Baldus demonstrated a similar precision of framing, photographing the Maison Carrée at an angle to show both its front and side views. In an earlier unretouched view, the buildings in the distance were clearly visible, but Baldus later painted on the negative to isolate the structure within its surroundings, including the road in the foreground, transforming it into a piece of monumental public sculpture (see page 125).

An image attributed to Blanquart-Evrard, "Peasant Family at Rest in Front of a Thatched Shed," is from his 1853 publication, *Études photographiques.* Although some of the subjects are at repose, not all of them are idle. The two men, standing on either side of the frame with their backs to the camera, appear to be concentrating on their tasks at hand.

It is a richly detailed scene of rural life poetically composed for the camera.

Charles Marville was known as a landscape and architectural photographer, and in the late 1850s the city of Paris commissioned him to document its rapidly vanishing ancient quarters. In 1862 he was named Paris' official photographer. This image, "Cabane des moutons au Jardin des Plantes à Paris," is attributed to Marville, and was published in another Blanquart-Evrard volume, *Mélanges photographiques, complément des nouvelles instructions sur l'usage du daguerréotype.* The first half of the album shows reproductions of artworks, while the second half is a mixture of Parisian views and paintings. This photograph is characteristic of Marville's approach, in which he centers the composition around a strong vertical line, placing the primary structures at the edges of the frame.

Attributed to
Charles Marville
French, 1816–1879

Cabane des moutons au Jardin des Plantes à Paris (Lamb Shed at the Jardin des Plantes, Paris), ca. 1851

Salted paper print
GIFT OF ALDEN
SCOTT BOYER
81:1108:0006

Auguste Salzmann
French, 1824–1872

Temple Wall: Triple
Roman Portal, 1854

Salted paper print
MUSEUM PURCHASE
79:2893:0001

Painter Auguste Salzmann traveled to Jerusalem to make photographic records of Greek and Judaic architecture. The Ministry of Public Instruction had commissioned him to photograph monuments and make archaeological discoveries of the Holy Land. Salzmann created more than 200 negatives of the architecture there, documenting Arab, Turkish, Byzantine, Latin, and Romanesque influences. Seventy-two images were published by Blanquart-Evrard in 1854 under the title *Jerusalem, époques judaique, romaine, chretiénne, arabe, explorations photographiques par A. Salzmann,* including this print of "Temple Wall: Triple Roman Portal" in the Eastman House collection. The close-up photograph is divided horizontally between ground and brick, with any reference to scale obliterated in favor of a more graphic, detail-oriented approach.

Marville's "Cathédrale de Chartres, Grandes figures des pilastres du portail septentrional" shows a sculptural detail on Chartres Cathedral, which Le Secq and Negre had also documented. The two lifelike figures atop the ornate pillars stand in stark juxtaposition with the plain brick construction and wooden fence running in the background. In this,

Charles Marville
French, 1816–1879

Cathédral de Chartres, Grandes figures des pilastres du portail septentrional (Chartres Cathedral, Large Pilaster Figures on the Northern Portal), ca. 1853–1855

Salted paper print
GIFT OF EASTMAN KODAK COMPANY, EX-COLLECTION GABRIEL CROMER
81:1530:0008

Marville contrasts the expressive beauty of the past with the practical functionality of the present. This, too, appeared in a Blanquart-Evrard publication, *L'Art religieux. Architecture. Sculpture. Peinture.*

Undoubtedly inspired by the great successes being achieved with the calotype in France, many photographers from other European nations went there to practice photography.

Ladislas Chodzkiewicz
Polish, active
ca. 1850s

Fontainebleau: la
Cour de Chasse, 1853

Salted paper print
GIFT OF EASTMAN
KODAK COMPANY,
EX-COLLECTION
GABRIEL CROMER
81:2935:0001

Fourteen prints and nine negatives by Ladislas Chodzkiewicz are in the Eastman House collection, the only public collection with works by this little-known photographer. He was possibly a wealthy amateur, which afforded him the time and money to travel and make views of the French countryside. In 1851 he contributed 20 francs for a monument honoring Niépce and Daguerre, which indicates that he was aware of the importance of preserving photography's history, even though it had not yet existed for very long. He also subscribed to *La lumière,* originally the weekly journal of the Société Héliographique, yet he was not a member of the organization. Mounted and with engraved titles, his 13 views of the royal chateau at Fontainebleau were accorded great care in their presentation.

Calotypists working elsewhere in Europe contributed images to Blanquart-Evrard's publications, suggesting the scope of the small community

that existed of working photographers. Johann Franz Michiels was a German photographer who specialized in architectural views. "Lateral View of the Franc de Bruges" is from the Blanquart-Evrard publication, *Variétés photographiques*. The view across the river toward the Pont du Moulin in Belgium, reveals the medieval charm of the city carefully drawn in minute detail against the blank sky.

From 1849 until 1851 the French Ministry of Public Instruction sent writer and critic Maxime Du Camp, accompanied by Gustave Flaubert, to the Holy Land and Egypt to photograph archaeological sites. Du Camp was also a painter and champion of all things modern, declaring of photography, "My only master is the light of day ... I have only to look at the most difficult contours and intractable drawings ... Painters on the road, I seize nature and place it in your hands!" It is somewhat ironic, then, that this modernist is best known for the passionately detailed photographs he made of these ancient ruins.

J. F. Michiels
Prussian,
b. Belgium,
1823–1887

Lateral View of the
Franc de Bruges
Taken from the Pont
du Moulin, ca. 1853

Salted paper print
GIFT OF EASTMAN
KODAK COMPANY,
EX-COLLECTION
GABRIEL CROMER
81:1640:0001

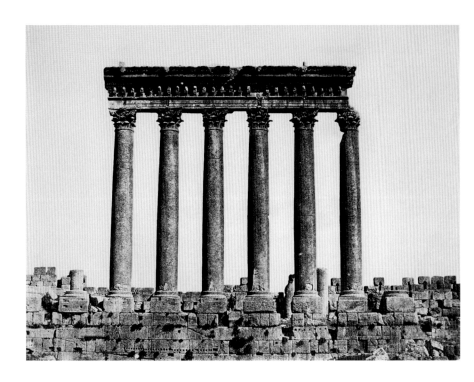

Maxime Du Camp
French, 1822–1894

Syrie. Baalbeck [*sic*]
(Héliopolis) Colon-
nade du Temple di
Soleil (Syria. Baalbek
(Heliopolis) Colon-
nade of the Temple
of the Sun),
1849–1851

Salted paper print
GIFT OF EASTMAN
KODAK COMPANY,
EX-COLLECTION
GABRIEL CROMER
LIBRARY COLLECTION
79:0031:0054

Du Camp built his early reputation on his travels and made this trip having learned photography from Le Gray. The calotype process was lighter and more portable than the daguerreotype and was well suited to expeditionary photography. Initially his attempts met with technical failure, until a fellow traveler introduced him to Blanquart-Evrard's improvement on the calotype, which improved his results considerably. In 1852 Blanquart-Evrard published Du Camp's *Egypte, Nubie, Palestine et Syrie; dessins photographiques recueilles pendant les années 1849, 1850, et 1851, accompagnes d'un texte explicatif et précédes d'une Maxime Du Camp ...*, in which 125 photographs by Du Camp appeared. These views, "Syrie. Baalbeck (Héliopolis) Colonnade du Temple du Soleil," and "Thèbes. Palais de Karnak. Piliers Devant le Sanctuaire de Granit," were included in volumes two and one, respectively, of the publication, now housed in the Menschel Library. The photographs made on this trip were Du Camp's only foray into photography.

Maxime Du Camp

Thèbes. Palais de
Karnak. Piliers de-
vant le Sanctuaire
de Granit (Thebes.
Palace of Karnak.
Pillars in Front of the
Granite Sanctuary),
1849–1851

Salted paper print

Genevieve-Elisabeth Disdéri, née Francart, was the wife of André-Adolphe-Eugène Disdéri, inventor of the carte-de-visite photograph. They were married in 1843, and the family moved to the seaside town of Brest in 1848, where A.-A.-E. Disdéri opened his first photographic studio. Mme. Disdéri collaborated with her husband on portrait sittings. After he left Brest in 1852, she ran her own studio until the late 1860s, producing cartes-de-visite with the assistance of employees and other family members. She is one of France's few known female photographers whose work has survived, and Eastman House, with 28 photographic prints, is the only public collection with holdings of her work. Evidencing her considerable talent, in 1856 Mme. Disdéri published these two images, "Cimetière de Plougastel, groupe de paysans," of a group of peasants visiting loved ones' graves; and "Interior of St. Mathieu" in the portfolio *Brest et ses environs*. In 1872 Mme. Disdéri moved to Paris and set up a studio in competition with her husband's. She maintained this studio until her death in 1878.

Genevieve-Elisabeth Disdéri
French, ca. 1817–1878

Cimetière de Plougastel, groupe de paysans (Cemetery of Plougastel, Group of Peasants), 1856

Albumen print
GIFT OF EASTMAN KODAK COMPANY, EX-COLLECTION GABRIEL CROMER
80:0256:0020

Genevieve-Elisabeth Disdéri

Interior of St. Mathieu, ca. 1856

Albumen print
GIFT OF EASTMAN KODAK COMPANY, EX-COLLECTION GABRIEL CROMER
80:0256:0018

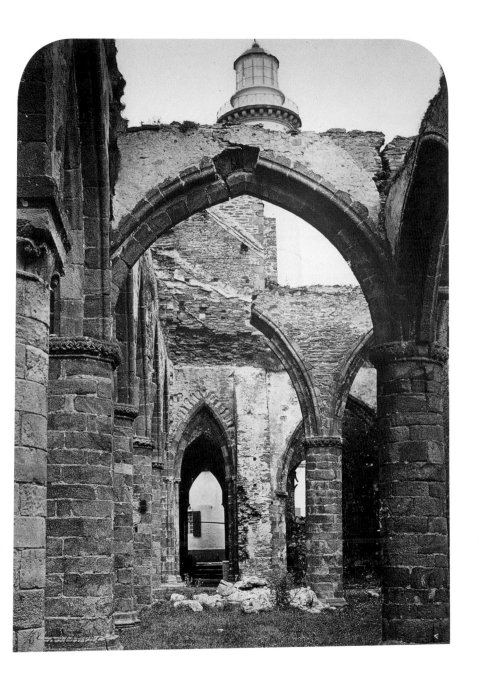

Giacomo Caneva
Italian, 1810–1890

Landscape, ca. 1855

Salted paper print.
79:1998:0003

Italian artist Giacomo Caneva moved to Rome from Venice in 1838. He originally used the daguerreotype process and first gained recognition for his photography around 1850. Caneva was associated with a group of amateur photographers including Count Frederic A. Flacheron and Eugène Constant, who met at the Caffe Greco in the Piazza di Spagna to exchange information and ideas about photography. Caneva later turned professional, selling his views of Rome and its environs, which he published in 1855. He also published a practical treatise on photographic processes and compiled a catalogue of Tommaso Cuccioni's photographic material after Cuccioni's death. Ten calotypes of Italian views by Caneva are in the Eastman House collection, including this landscape of a still lake surrounded by bare winter trees, which fits into the Romantic picturesque tradition of landscape.

The precise clarity of collodion on glass negatives began to replace the slower, more nuanced calotype paper negative in the mid-1850s, especially following the Universal Exposition in 1855, where the Bisson

Frères won a first-class medal for their albumen prints from glass negatives. Commercial tastes hungered for the glass negative, and photographers rose to meet the demand. Albumen prints followed soon thereafter, replacing salt prints as the preferred medium. Édouard Fierlants, also known as Edmond, was a Belgian photographer specializing in topographical and architectural views. The Eastman House collection contains 17 such works by Fierlants, primarily scenes in Brussels, and more than 100 reproductions of works of art. Fierlants was the first in Belgium to reproduce paintings photographically, and he founded the Société Royale Belge de Photographie around 1861. His photograph of the Hôpital St. Jean in Bruges shows the chapel of the medieval hospital reflected in the canal, which has risen to flood levels around it. Charles Baudelaire called Bruges a "phantom city, mummified city," and this haunting image evokes his description.

The Bisson Frères were Louis-Auguste and Auguste-Rosalie. Louis-Auguste, an architect, had learned daguerrotypy directly from Daguerre

Édouard Fierlants
Belgian, 1819–1869

Hôpital St. Jean,
Bruges,
ca. 1860–1862

*Albumen print,
varnished with gelatin*
GIFT OF EASTMAN
KODAK COMPANY,
EX-COLLECTION
GABRIEL CROMER
70:0049:0021

himself and soon after established one of the earliest professional studios, Bisson Père et Fils, in Paris. He used the daguerreotype through the 1850s and went directly to the large-format, glass-negative processes in 1853, bypassing paper negatives entirely. In 1858 and 1860 the brothers unsuccessfully attempted to ascend Mont Blanc (at 15,781 feet the highest peak in the Alps) to photograph its summit, providing its audience with a spectacular view of a world that few people would ever experience firsthand. Nevertheless, they made photographs during the 1860 expedition, including "Pyramide de l'Impératrice, Mer de Glace," which they published in the album *Haute-Savoie, Le Mont Blanc et ses glaciers, souvenir du voyage de LL. M. M. L'Empereur et L'Impératrice.* A copy of the album, consisting of 24 views created to commemorate Emperor Napoleon III and Empress Eugenie's 1860 visit to Switzerland, is in the Eastman House collection. At one time, this album was in the library of the empress and emperor's palace at Campeigne.

Auguste-Rosalie Bisson made "Ascension au Mont-Blanc" during his first successful ascent, with the assistance of a guide and 25 porters to carry his photographic equipment, including a portable darkroom tent. Because of the treacherous conditions, he made only three exposures at the summit. The brothers sold their studio in 1864; Louis-Auguste retired, and Auguste-Rosalie went to work for other photographers.

An Even Greater Measure

Italy – Rome

The subject of these two views, the Roman Forum, was at the heart of the Roman Empire. Nearly 2,000 years later Rome had become the center of a large tourism industry due to its historical importance. A cultural magnet for scholars, artists, and tourists, the city was able to support almost 750 photographers who made at least part of their living by selling views of the city to the never-ending stream of visitors between 1840 and 1915. The Eastman House collection contains more than 1,000 photographs of Rome taken during that time, ranging from daguerreotypes and paper negatives to lantern slides and snapshots. Competition was fierce, and at times it seems as if view photographers were placing their tripod legs into the holes created by previous photographers at favored sites, which lends a generic quality to much of this work. Nevertheless, the work of some photographers did stand out.

James Anderson
Italian, b. England,
1813–1877

Foro romano,
ca. 1860

Albumen print
MUSEUM PURCHASE,
EX-COLLECTION
WADSWORTH
LIBRARY
76:0336:0032

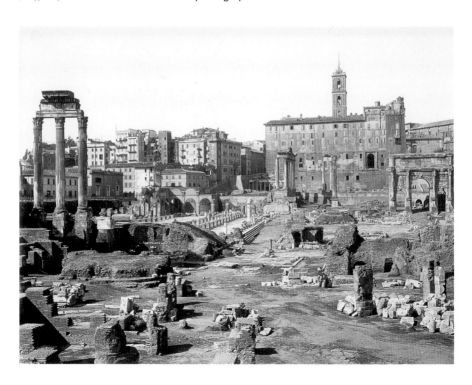

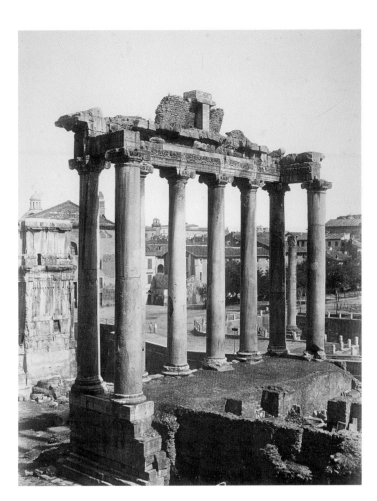

**Unidentified
photographer**
French?,
active ca. 1880s

Temple de la
Fortune, ca. 1880

Albumen print
GIFT OF EASTMAN
KODAK COMPANY,
EX-COLLECTION
GABRIEL CROMER
73:0208:0006

James Anderson studied painting before moving to Rome to make
miniature bronze copies of the city's sculptures. In 1853 he opened
a studio to make photographic reproductions of Rome's many
works of art as well as photographs of the city's monuments and
views, which he did with diligence and skill through the remainder
of the century.

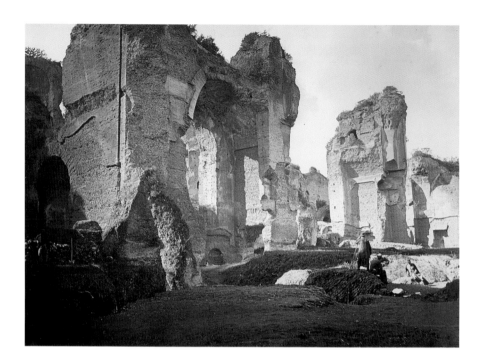

Attributed to
**Gioacchino Altobelli
& Pompeo Molins**
Italian, 1825–1878 &
Italian, 1827–ca. 1893

Ruins of the Ther-
mae of Caracalla,
ca. 1865

Albumen print
MUSEUM PURCHASE,
EX-COLLECTION
WADSWORTH
LIBRARY
76:0020:0005

This picturesque view of a group standing amid the ruins of Cara-
calla's Baths reveals Gioacchino Altobelli and Pompeo Molins's artistic
training. Both had studied to be painters before taking up photography
and forming a commercial partnership that lasted from 1858 to 1865.
Their Piranesiesque compositions and dramatic use of light and shade
impart an artistic quality that raises their photographs beyond topo-
graphic description. Altobelli and Molins provided a Romantic air of
faded grandeur to their depiction of Rome's ruins, a mood sought out
by many of Rome's visitors.

Highly demanded by tourists, images of the ruins of the classical past
were first in priority for view makers. These photographs were followed
in popularity by views of ecclesiastical or Renaissance architecture and
monuments and copies of the many works of art gracing the city. Views
of the modern city of Rome would come much later and were a minor
part of this body of the topological genre.

This wonderful view of a modest shop tucked into the corner of the
much grander architectural remains of the Theater of Marcellus was

Robert MacPherson
Scottish, 1811–1872

The Theatre of
Marcellus, from the
Piazza Montanara,
ca. 1858

Albumen print
MUSEUM PURCHASE,
EX-COLLECTION
WADSWORTH
LIBRARY
76:0020:0038

made by Robert MacPherson about 1858, approximately seven years
after he had taken up the craft that he would later turn into an art and
would become his life's endeavor.

MacPherson studied medicine, then painting, in his native Scotland
before visiting and falling in love with Rome in 1840. He settled there,
converted to Catholicism, and became an active part of the arts

community that flourished there at the time. After he married in 1851 MacPherson learned the new system of photography on glass to "better his fortunes." He quickly established himself as a leading photographer of Roman antiquities and Italian landscapes. Over the next decade MacPherson built up a collection of views of Rome and vicinity, as in the dramatic view of the "Temple of the Sibyl" and the mysterious image of the "Grotto of the Sibyl," which are among the 61 photographs by MacPherson held by the museum. His photographs lent a feeling of grandeur to the remains of the classical past, and so they were well received by those schooled in a Romantic aesthetic sensibility. His work gained an international reputation among the more sophisticated tourists visiting Rome, and at mid-century his work was always considered superior to the average: "... the subjects chosen with fine taste and the pictures executed with skill and delicacy ... Mr. MacPherson's name alone is sufficient guarantee for their artistic excellence."

Unlike the growing list of dozens of topographic view photographers in Rome, many of whom would establish large commercial companies in the 1860s and 1870s, MacPherson continued to operate on an individual, almost personal level. He never released or sold his negatives to distributors or indulged in the other mass marketing or distribution schemes that expanded and commercialized photographic practice in the 1860s. MacPherson's career flourished through the 1860s, and his home was the lively center of a constant stream of artists, patrons, and foreign and Italian visitors. But his good fortune began to wane towards the end of the decade. He seems to have often been ill and needed money. He died in 1872, "... leaving no provision for his wife and family," however his work remains still some of the best photographs ever taken of The Eternal City.

John Shaw Smith
Irish, 1811–1873

Basilica Ruins,
September 1851

Calotype negative
GIFT OF ALDEN
SCOTT BOYER
81:1683:0148

Italy – Pompeii

During the 19th century Pompeii drew its share of wealthy foreign visitors who were on the Grand Tour, an extended trip to monuments and sites that were considered to be the greatest achievements of Western civilization. Photographers, therefore, were eager to provide a bounty of images for tourists to take home. These two photographs convey some of the range of Pompeii's attractions to an ever-increasing tourist class.

John Shaw Smith was a wealthy Irish landowner whose amateur avocation of photography apparently did not survive the decade of the 1850s. More than 300 of the approximately 370 images known to have been made by Smith were taken in the early 1850s during his two-year tour down the Italian coast and through the Mediterranean region, Egypt, and the Holy Land. The museum holds 22 calotype negatives made by Smith during his visit to Pompeii in 1851.

This view depicts a Victorian gentleman lounging comfortably amid the

rows of elegant columns that embody the idea and the authority of the classical past – history that was literally dug up and recovered in time to help define and buttress the aspirations and ideals of the major industrialized nations of Western Europe, many of which were intent on empire building.

The second photograph was made by the highly regarded professional photographer Giorgio Sommer, a German who opened a commercial studio in Naples in 1857. He and his employees traveled all over Italy, Malta, Tunisia, Switzerland, and Austria during the next 50 years, making thousands of views for the tourist trade. Sommer photographed Mt. Vesuvius and Pompeii several times between 1865 and 1885. The museum holds 100 of these views among its total collection of 350 Sommer photographs in the form of album-sized albumen prints, stereo cards, cabinet cards, and lantern slides.

By the 1880s steamships and railroads had made travel available to people from a wider range of socioeconomic backgrounds. And for those

Giorgio Sommer
Italian, b. Germany,
1834–1914

Impronte umane.
Pompei (Human
Imprint, Pompeii),
ca. 1880s

Albumen print
GIFT OF MRS.
V. NEUSCHELER
87:0344:0002

Giorgio Sommer
Italian, b. Germany,
1834–1914

Loggia dei Lanzi,
Firenze, ca. 1880

Albumen print
GIFT OF 3M COM-
PANY, EX-COLLEC-
TION LOUIS
WALTON SIPLEY
77:0194:0001

tourists with less regal concerns and aspirations than Smith's Victorian
gentleman, there is Sommer's spectral floating figure, a bizarre example
of a sculptural casting technique that provides its own *frisson*. Pompeii,
historically famous as a site of destruction and death since 79 A.D., al-
lowed tourists to experience the darker fringes of a Romantic sensibility.

Italy – Florence

This view of classical sculpture littering a square in Florence (above)
is another example of the type of photograph that brought financial
and critical success to Giorgio Sommer's studio.

Fratelli Alinari
Italian, active
ca. 1854

Il portico degli Uffizi
e il Palazzo Vecchio,
ca. 1860

Albumen print
MUSEUM PURCHASE,
EX-COLLECTION
WADSWORTH
LIBRARY
76:0020:0023

By the 1880s photographic technologies had improved to the extent
that it was possible to successfully capture all the tones and qualities
and most of the moving figures in this complex, layered image and pre-
sent them with deceptively straightforward simplicity. At that time there
were so many competing views of the various buildings and monuments
of every Italian city that Sommer was forced to pursue the idiosyncratic
viewpoint from which he made this charming image, even though his
studio already had 10, 20, or an even greater number of more "informa-
tional" views of this area, its buildings, and its sculptures in stock.

Carlo Naya
Italian, 1816–1882

Venezia. Portico
of the Fondaco
(Warehouse) dei
turchi and Palace
Vendramin on the
Grand Canal, 1875

Albumen print
78:0662:0013

The photograph of the Uffizi Gate (page 149) is one of 500 prints in the museum's collection taken by the Fratelli Alinari – three brothers, their sons, families, dependents, and employees – who opened a small studio in Florence in 1852 and built it into a major family-owned business, employing over 100 people by 1880. The concern became a major producer and distributor of topographic views and photographic reproductions of art and architecture in Italy. Nearly 400 of the museum's Alinari prints are reproductions of art objects. Many came as part of the Alvin Langdon Coburn collection.

Italy – Venice
Venice was one of the key cities on the Grand Tour and had drawn a steady stream of tourists since the 18th century. Generations of artists had made their livings by creating and selling views of the city. In the mid-1850s photographs, being easier and cheaper to produce, gradually began to supplant the earlier printing technologies of etching and

lithography. For the most part, camera operators simply recapitulated earlier subjects, viewpoints, and interpretations as best they could with the new medium. These two views of Venice are from the album *Ricordo di Venezia* published by Carlo Naya in 1875. The 20 photographs in this album complement the 150 other photographs by Carlo Naya owned by the museum. Carlo Naya, the son of a wealthy landowner, took a degree in jurisprudence at the University of Pisa in 1840, then traveled with his brother for 15 years throughout Europe, Asia, and Africa. After his brother's death and when he was over 40 years old, he moved to Venice in 1857. At some point during these travels, Naya practiced photography as an amateur.

After settling in Venice, Naya decided to become a professional photographer. He briefly published and distributed his views of Venice through the established studio of Carlo Ponti, a business arrangement that did not last long and ended badly, with both parties litigious until Naya's death in 1882. In 1868 Naya opened a larger photographic shop

Carlo Naya

Venezia. Palaces Foscari, Giustinian and Rezzonico, on the Grand Canal, 1875

Albumen print
78:0662:0010

in the Piazza San Marco, and his business grew to rival Ponti's. Edward Wilson, possibly the most experienced and knowledgeable writer on photography of that era, briefly described Naya's studio at his death in 1882 as: "... the largest establishment we think we ever saw devoted to photography, in an old palace on the other side of the grand canal." Naya and Ponti's firms were considered the leading photographic concerns in the city throughout the second half of the century. Naya employed a large staff, including Tommaso Filippi, his principal cameraman, who probably took many of the photographs in Venice after the 1860s, while Naya continued to travel and photograph throughout Italy.

Attributed to Carlo Ponti
Italian, b. Switzerland, ca. 1823–1893

Detail of the Ducal Palace, Venice, ca. 1862

Albumen print
MUSEUM PURCHASE
76:0020:0078

The photographs on this and the three following pages are among the 85 attributed to Carlo Ponti in the museum's photography collection. They show something of the range of Ponti's work, a range that would have been considered very broad by his contemporary viewers, who were precisely aware of different "categories" of landscape. The "Detail of the Ducal Palace" and "Bridge of Sighs" (page 155) would have been read as architectural views and considered to be almost technical studies; the "View of the Wharf and Ducal Palace" would have been regarded a picturesque landscape to be viewed for pleasure, and the day and night views of St. Mark's Square (page 154) would have been deemed as entertainment for tourists.

Carlo Ponti moved from Switzerland to Venice in the early 1850s and sold optical and photographic instruments, some of his own design. He also became the first major dealer of photographic views in Venice. Like the more famous Mathew Brady, it is possible that Ponti may have taken very few of the photographs that bear his name. Rather, he organized a large and efficient printing, distribution, and sales system for photographic prints and frequently hired or

purchased negatives from other photographers and then distributed them under his own name, a customary practice. The Venetian photographers Giuseppi Bresolin, Giovanni Brusa, and Paolo Salviati, now virtually unknown, were a few of the actual makers of the photographic views that brought an early international fame to the Carlo Ponti studio.

Carlo Ponti developed and sold various devices for viewing photographs, all given such resounding names as the Alethoscope, the Graphoscope, and the Megalethoscope. The Megalethoscope, which won him a coveted gold medal in the 1862 World Exhibition in London, was a photographic viewer designed to display large prints that could be viewed first by reflected light, then by transmitted light from the back (see page 154). The 11 x 14-inch albumen prints were stretched over a wooden frame, with selected areas on the back of the print broadly painted or drawn upon by hand. When viewed from the front, the coloring could not be seen. Increasing the light behind the print made it translucent enough to allow the color and

Attributed to Carlo Ponti

Veduta del molo e palazzo ducale con la gondola (View of the Wharf and Ducal Palace by Gondola), ca. 1870

Albumen print
MUSEUM PURCHASE, EX-COLLECTION WADSWORTH LIBRARY
82:2007:0004

(above and left)
**Attributed to
Carlo Ponti**
Italian, b. Switzer-
land, ca. 1823–1893

Place St. Marc
avec l'église. Venise
(Square and Church
of St. Mark. Venice),
ca. 1875

*Albumen print with
applied color (Mega-
lethoscope slide)*
84:0852:0013

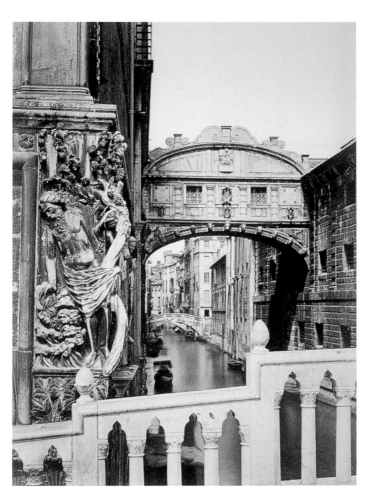

**Attributed to
Carlo Ponti**

*Bridge of Sighs, on
Canal of Canonica,*
1864

Albumen print
GIFT OF EASTMAN
KODAK COMPANY,
EX-COLLECTION
GABRIEL CROMER
81:0944:0017

drawing to show through, causing a visual transformation. The effect produced an illusion of change by simulating the passage of time, just as Daguerre's dioramas had done years before. These pictures could be especially vivid, as seen here in Ponti's imaginative view of a festive night scene, which photography was still incapable of recording. These novelties were popular with the tourist trade and were a valuable weapon in Ponti's arsenal in a business that was both crowded and competitive. The museum holds 135 Megalethoscope views, most of them Italian scenes.

B354 Ascent of Great Pyramid Cheops. The blocks are upwards 3 ft. in
height & the Traveller will find the assistance of guides acceptable.
Escorted usually by 3 Beduins, one holding each hand and a third
who pushes behind the traveller begins the ascent of the large granite
blocks. The space at the top measures about 12 sq. yds. in area

so that there is abundant room for a large party of visitors.

The Middle East – Egypt

Every European or American with an education felt that the foundations of their culture were based on the ideas of classical Greece and Rome and on the ideals of the Christian religion, which had sprung out of the rocky wastes fronting the Mediterranean Sea. Throughout the 19th century the force of religious belief pervaded the structure of educated thought in a way that is difficult to appreciate today. There was a literature of travelogues for the "Holy Lands," and tourists braved the difficulties to experience these significant places firsthand.

A flood of photographers washed through the Middle and Near East during the second half of the 19th century, and more than 250 of them are known to have photographed there before 1885. In the 1850s the first photographers tended to be either wealthy amateurs, such as John B. Greene, Leavitt Hunt, and John Shaw Smith, who could afford to support the expenses of both their trip and of their avocation of photography, or individuals, including Louis De Clercq and Maxime Du Camp, who received official or semi-official backing from various governmental or academic bodies.

During the 1860s and 1870s indigenous professional photographers, such as J. Pascal Sébah, opened shops in those cities that had become major tourist centers. This view by Sébah of tourists being pushed and pulled up Cheops' pyramid is from a set of four albums titled *Berlin to Cairo*, which were gathered together by a tourist to record their trip with photographs purchased at stops in each city along the way. Since the prosperity of these professional studios depended upon the quantity and variety of their picture files from which tourists would select the photographs that appealed to their specific tastes, the best of these studios steadily and continuously added images to their collections.

J. Pascal Sébah owned one of the largest studios in Constantinople from the 1870s to the 1890s, yet he also constantly sent photographers into Egypt or purchased negatives taken in Egypt until his stock of views reached over 400 items. The continued presence of indigenous studios, whose familiarity with local customs and languages allowed access not otherwise available to traveling tourists and photographers, expanded the corpus of imagery from these regions. Some of these studios, such as the J. Pascal Sébah Studio and the Abdullah Frères in Constantinople, or the Bonfils Studio in Beirut, gained acclaim and in effect became international businesses that often flourished into the 20th century.

J. Pascal Sébah
Turkish, 1838–1890

Ascension de la Pyramide Cheops, ca. 1885

Albumen print
GIFT OF MRS.
PHIL PORTER
86:0309:0094

John Shaw Smith
Irish, 1811–1873

Nile, ca. 1851–1852

Calotype negative
GIFT OF ALDEN
SCOTT BOYER
81:1683:0218

Photographic practice expanded enormously in the early 1850s as modifications and improvements made to Talbot's calotype process and, later, the development of a difficult but practical wet-collodion process brought many more photographers to the medium. The sovereign virtue of these various processes was that they, unlike the daguerreotype, produced a negative image from which multiple positive prints could be made and sold, thus making landscape photography a potentially viable business.

The George Eastman House collection holds almost 600 paper negatives taken by various photographers during the early 1850s. More than 260 of these and almost 100 salt or albumen prints made from those negatives are by John Shaw Smith, most of them taken during his trip through Italy and the Mediterranean basin from December 1850 to May 1852. This collection affords a unique opportunity to follow this early photographer's working methods.

A wealthy amateur, Smith could photograph whatever he liked, and he used his camera almost exclusively to document ruined buildings of the ancient past. There are only three or four landscapes without architecture, just as there are only three or four images containing human figures. Smith approached his viewmaking in an orderly fashion, often taking a distant view that situates the architectural structure in its surrounding terrain, then moving closer, then even closer for a detailed picture. He was attracted to strong, simple forms, which he balanced superbly within and against the borders of his pictures to achieve a perspective more forceful and frequently more graceful than the typical topographic view. The dynamic juxtaposition of the sails of the boat silhouetted against the sky, the shore, and the waters of the Nile forms a complex grouping of overlapping triangles. This conveys a sense of improbable and precarious balance, which might well have been what riding on the Nile in such boats felt like to Smith.

John Shaw Smith

Two Small Pyramids, Pyramid of Ekphrenes in Distance, February 1852

Calotype negative
GIFT OF ALDEN
SCOTT BOYER
81:1683:0156

The son of a wealthy American banker living in Paris, John B. Greene shared with many of France's artist-savants a passionate interest in Egyptology. In 1853 he set out on the first of three self-financed expeditions to Egypt and Syria to collect "archaeological, historical and geographic information of interest." On these trips Greene used Gustave Le Gray's waxed-paper process to make a few hundred paper photographs, which he divided into two categories, Monuments and Landscapes. Greene died unexpectedly in 1856, at age 24, during his third trip to Egypt.

Greene was either a very bad photographer or a very good one. Most new photographers, when first faced with the problem of photographing a large scene, place the central subject of the view so far away and surrounded by so much empty space that its emotional impact is diluted and lost. Every professional photographer knows tricks to overcome this problem by moving in closer, changing the angle to get a more dramatic perspective, or introducing an additional element to make a more exciting picture. In this photograph Greene accepted the huge empty skies, the barren horizons, the desolate ruins smothered in the drifting sands of the desert, the futile works of man overwhelmed by time and fate. And the soft, granular, faded quality of his salted paper print lends

John B. Greene
American, b. France,
1832–1856

Bords du Nil à Tèbes
[*sic*] (The Banks of
the Nile at Thebes),
1854

Salted paper print
MUSEUM PURCHASE,
CHARINA FOUNDA-
TION PURCHASE
FUND
92:0384:0001

Leawitt Hunt
American, active
1851–1852

Convent of
Mt. Sinai, ca. 1850

Salted paper print
MUSEUM PURCHASE
76:0020:0064

a feeling of time's passage as well. So, do these romantic, expressive images of a dead civilization result from bad technique and happy accident, or are they the crafted result of an exceptional young man with the vision to do all the wrong things to make all the right pictures?

Leawitt Hunt was the youngest of five children brought to Europe in the 1840s by their widowed, wealthy mother, described by a contemporary as "... a woman of rare mental power and force of character." For ten years the family, either all together or in shifting pairs, traveled and studied extensively throughout Italy, France, England, Switzerland, and Germany.

Leawitt Hunt, 21 years old in the winter of 1851, cultured, and sophisticated, celebrated his obtaining a law degree at the University of Heidelberg in the manner customary to his family – by traveling. On this journey Hunt crossed the Mediterranean Sea to Egypt, then went on to the Levant and east to Damascus. An ardent practitioner of the newly fashionable hobby of photography, Hunt brought his camera and made the first photographs taken in Egypt by an American. Leawitt's older brother Richard Morris Hunt, who would become one of the leading American architects of the 19th century, followed his brother's itinerary a year later, also bringing a camera and making photographs of ancient sites.

Francis Frith
English, 1822–1898

Interior Hall of
Columns, Karnac,
ca. 1857

Albumen print
GIFT OF MRS. ALDEN
SCOTT BOYER
LIBRARY COLLECTION
81:1338:0037

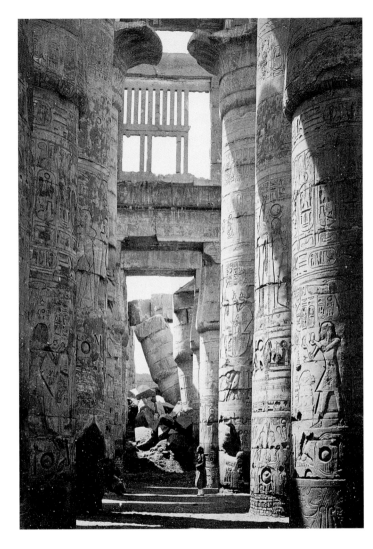

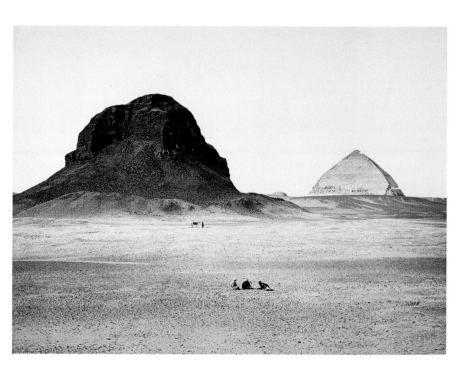

Starting at 16 as an apprentice in Liverpool, Francis Frith proved to be an excellent businessman who established and then sold several businesses to his advantage, so that in 1856, at age 34, he was able to retire from business comfortably well off. During this time he had also become an amateur photographer. Freed from his business concerns and financially able to support his new pursuit, Frith decided to take a photographic tour through Egypt and the Middle East. "I have chosen as a beginning of my labours, the two most interesting lands of the globe – EGYPT and PALESTINE." Preparing for the arduous travel ahead, Frith bought a steam yacht, then equipped himself with thousands of pounds of photographic equipment and supplies – fragile glass plates, lenses, bottles of chemicals, and all the other apparatus necessary to successfully photograph hundreds of miles away from any resources or support. Afterwards he spent almost two years on a frequently uncomfortable and occasionally dangerous journey photographing under very difficult conditions.

Frith's photographic endeavors proved to be another extraordinarily astute business decision. The photographs from his first trip to Egypt in

Francis Frith

The Pyramids of Dahshoor, from the East, ca. 1858

Albumen print
MUSEUM PURCHASE,
EX-COLLECTION
HELMUT GERNSHEIM
LIBRARY COLLECTION
79:0068:0005

Francis Frith
English, 1822–1898

Egyptian Idol at
Thebes, ca. 1857

Albumen print
MUSEUM PURCHASE
LIBRARY COLLECTION
75:0037:0016

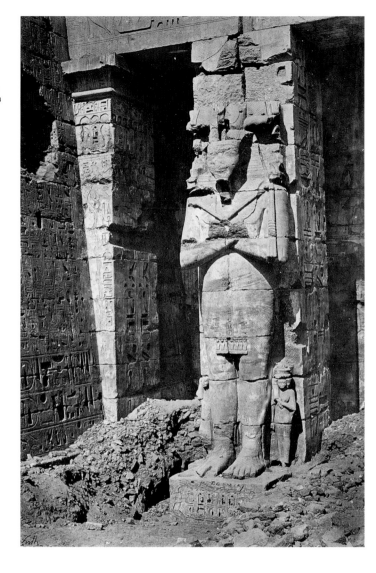

1856 and 1857 attracted great attention and many favorable reviews. His work was distributed in stereo views and then published in a book illustrated with original prints. *Egypt and Palestine Photographed and Described by Francis Frith* formed the keystone for what became an exceptional publishing activity and an extraordinarily successful photographic career throughout the rest of the century. Frith returned to the Middle East twice before 1860 and took photographs in Palestine, Syria, and Egypt. He published nine more books of photographs from these three trips. George Eastman House holds eight of Frith's publications from his Middle Eastern trips, which together contain more than 450 photographs.

 Considered to be one of the premier landscape photographers of his generation, he founded the firm Francis Frith & Co., which became one of the largest photographic concerns of the century. By 1870 Francis Frith and other photographers working for the company had taken more than 1,000,000 views throughout the British Isles and continental Europe, and these were published and widely distributed in the form of stereo cards or prints, which were sold singly, in portfolios, or in illustrated books, and were later reproduced as postcards.

Francis Frith

Greek Tablets at Wady Kardassy – Nubia, ca. 1857

Albumen print
GIFT OF MRS. ALDEN SCOTT BOYER
LIBRARY COLLECTION
93:0648:0022

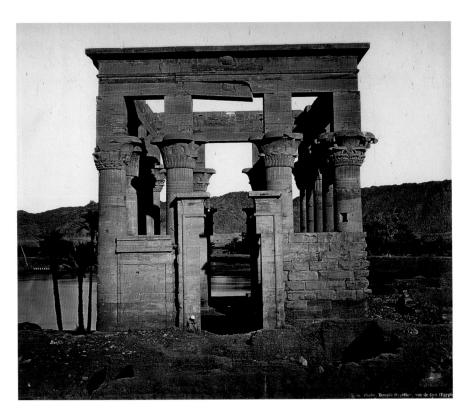

Félix Bonfils
French, 1831–1885

Phyle, Temple
Hypère, vue de face
(Egypte), 1877–1878

Albumen print
MUSEUM PURCHASE
73:0074:0043

Félix Bonfils was born in Saint Hippolyte du Fort, France, in 1831. His son Adrien was born there as well in 1860. Félix had served in the French army occupying Lebanon in 1860. He liked the area and later decided to emigrate. The Bonfils family moved permanently to Beirut in 1867 and opened a photographic studio there. Félix traveled and photographed often throughout Egypt, Palestine, Syria, Greece, and Jerusalem, and by 1871 the studio claimed a stock of 15,000 prints and 9,000 stereo views from almost 600 negatives. The Maison Bonfils grew into a large, active, and financially successful business with branches in Alexandria and Cairo in Egypt, and even in France. Like many such business concerns, they sent their views throughout the 1870s and 1880s to international expositions in Paris, Brussels, and elsewhere, where they won awards. And they published catalogs and retailed their work through dealers in the larger cities of Europe and

America so that the Bonfils' name was one often associated with Middle Eastern views to the Western viewer. George Eastman House holds 635 photographs by the Bonfils Studio, among them 350 lantern slides.

In 1878, at age 17, Adrien took charge of photographing while his parents managed the studio, and, of course, as did all larger concerns, the studio hired other photographers to work for them. As is also often seen in the work of other commercial studios, the later photographs bearing the Bonfils name seem to be both more professional in their technical execution and less interesting as images. The earlier Bonfils photographs made by Félix, just as the earlier photographs of Francis Frith or Francis Bedford (even when they are of the same or similar subjects) seem somehow infused with a quality of exploration, a sense of energy, or a simple love of the medium that is not found as frequently in the later work of their studios.

Félix Bonfils

Antinoe. Sheikh Abaddeh's Palm Tree. (Egypt), ca. 1867–1876

Albumen print
MUSEUM PURCHASE
73:0074:0021

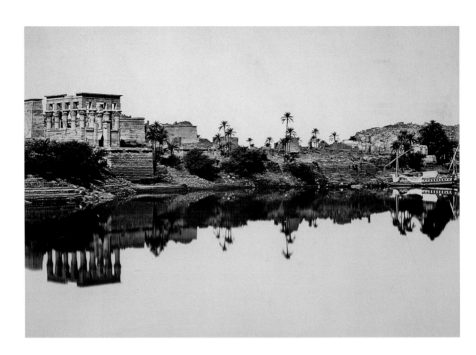

Antoine Beato
Italian,
ca. 1825–1903

Island of Philae,
ca. 1870

Albumen print
MUSEUM PURCHASE,
EX-COLLECTION
A. E. MARSHALL
79:0067:0017

The Middle East – Palestine and Syria, Baalbek, Palmyra, Jerusalem
This serene, distant, and lovely view of the Egyptian temples on the island
of Philae was made by Antoine (Antonio) Beato. The museum holds 50
views of Egypt by Antonio Beato, ranging from architectural details to
scenic landscapes. Antonio was the younger brother of Felice Beato and
the brother-in-law of James Robertson, both photographers of note who
formed a partnership and photographed in Constantinople, Athens, the
Crimea, Malta, and the Holy Land from about 1851 until about 1857. It
seems probable that Antonio joined the partnership towards the latter
1850s, then followed his brother to Calcutta in 1858 and opened a studio
there while Felice traveled throughout India, photographing in the wake
of the British army. Antonio returned to open a studio in Cairo in 1860 and
1861. In 1862 he moved to Luxor, which was situated near a series of major
archeological digs. Antonio's studio at Luxor flourished until his death
around 1905, and he became one of the best-known and most respected
photographers of the Middle East while building up a stock of 1,500 nega-
tives, working with archaeologists documenting sites under excavation,
and photographing new finds as well as making views for tourists.

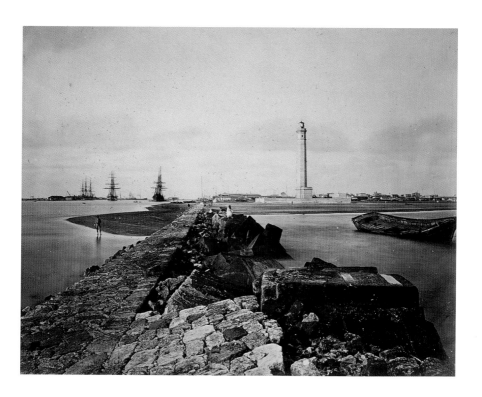

Hippolyte Arnoux established himself as a commercial photographer in Port Said, Egypt, in the mid-1860s and worked there at least through the 1870s. With photographs such as this along with more commonplace scenes of the port and architectural views of Muslim mosques and other buildings, Arnoux established a special niche for himself in the field of view photography. Port Said, at the head of the Suez Canal, was under construction at the time. The building of the Suez Canal was a feat of modern engineering and construction, as important to the expanding world of commerce as the building of the Union Pacific Railroad in the United States, then stretching across the Western frontier.

Arnoux transformed a boat into a floating darkroom from which he periodically documented the construction of the canal until its completion in 1869. The scale of the project made the canal itself a tourist attraction, and Arnoux's photographs of the modern engineering marvel (in effect, a form of industrial photography) could in some measure

Hippolyte Arnoux
French, active
1860s–1880s

Phare de Port-Said,
ca. 1869

Albumen print
MUSEUM PURCHASE,
EX-COLLECTION
A. E. MARSHALL
79:0056:0006

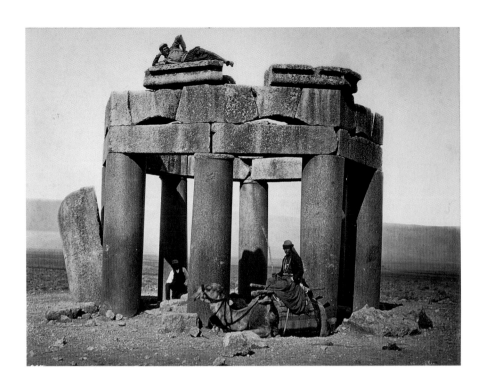

Félix Bonfils
French, 1831–1885

Baalbek. Chapel
of Douris,
ca. 1861–1871

Albumen print
MUSEUM COLLEC-
TION, BY EXCHANGE
74:0196:0073

compete with the more traditional views of the ancient ruins, then the staple diet of the tourist. The museum holds an album of 25 photographs, *Album du Canal, Port Said,* published by Arnoux.

Generations of tourists drawn to Syria and Palestine seem to have had a similar response – dismay at the present condition of these countries mingled with awe at their rich and varied past. "The land has sadly declined, its commerce depreciated, and its industries and high civilization no longer exist ...", but nevertheless, tourists still came. "Palestine will always continue an object of sacred interest, as the land of the Bible, of the Prophets, Patriarchs and Kings, the land where our Savior was born. ..."

Along with over 500 other photographs by the Bonfils Studio, the museum holds an album published in 1878 titled *Souvenirs d'Orient. Album pittoresque ... Photographie par Félix Bonfils,* which has this statement in the foreword: "The Orient, with the most splendid ruins in the world,... is here revealed in all its splendor. Grandiose conceptions of the Pharaohs, places made famous by the Prophets, Christ and his

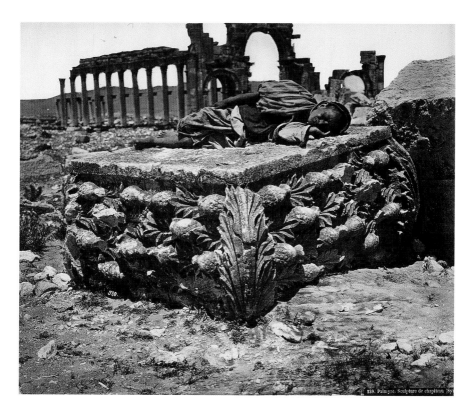

239. Palmyre. Sculpture de chapiteau (Sy...

Apostles, colossal structures of Baalbek, vast horizons of Palmyra; such is the immense field where the reproducer of so many marvels takes our vision. ..." While the language is exalted, in fact this listing of marvels is actually a rather narrow range of subjects, which is far from comprehensive of all that could have been photographed at the time. "Baalbek. Chapel of Douris," one of 81 prints in the album *Palestine and Syria* held by the museum, and "Palmyra. A Sculptured Capital, Syria" are both excellently conceived – even novel – photographs of subjects already thoroughly known and frequently depicted. The "... vast, world-famous ruins of Baalbek ..." were first known to Europeans in the 16th century. A book on Palmyra was published in London in 1696, and at least five scholarly books on that site alone came out between 1819 and 1877. The author of the 1874 edition of *Harper's Hand Book for Travellers* claims that there had been more than 200 books written about the

Félix Bonfils

Palmyra:
A Sculptured Capital,
Syria, ca. 1867–1876

Albumen print
MUSEUM PURCHASE
73:0074:0006

so-called Holy Lands. In other words, the subject matter of Bonfils' photographs had been determined for him well before he was born and before photography was invented.

Bonfils – and every other commercial landscape photographer who wished to stay in business – had to photograph what his customers, the tourists, wished to purchase. And the tourists wanted to see the well-known, established sites. They also wanted to purchase photographs of what they had already seen. Furthermore, they were not looking for images that interpreted those sites too creatively. They wanted the emotional charge from the photograph to reside in their memory of the subject, not in some other person's response to that scene. They wanted a distinct and clearly transcribed image or representation of the objects that they had spent so much time, money, and energy to visit.

So, if both the content (the subject) and its mode of interpretation (the style) of the photographs were defined by criteria outside the photographer's control, how then could a professional excel in his work? First, he had to display the virtues of any good businessperson by providing a good, well-made, and inexpensive product at the right place

Félix Bonfils
French, 1831–1885

Jerusalem.
Damascus Gate,
ca. 1870

Albumen print
MUSEUM COLLEC-
TION, BY EXCHANGE
74:0196:0020

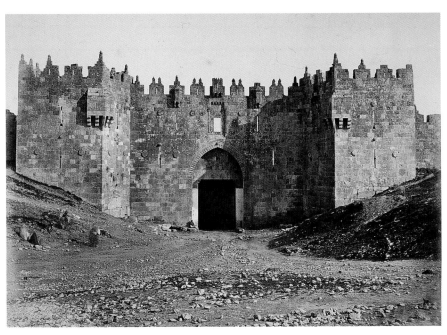

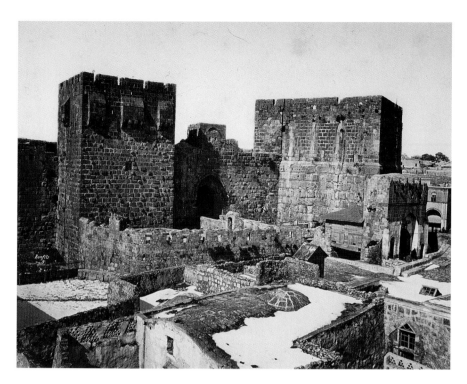

and at the right time. All of the really successful studios were in the big cities, near the hotels and shops that the tourists frequented, and the studios all had exceptionally well-organized mail-order distribution systems in place. The photographer also needed to provide a wide variety of stock to select from, with more and better views of more places, for different tastes and moods. Beyond having those sound business practices, good topographic photographers had to be, in a sense, unobtrusive. They had to place their own private interpretation of a subject aside and adopt a very transparent style or mode of presentation. Their images were there to help define an experience and to enhance a memory of that experience. The best photographers could do this by making the image itself interesting, well composed, and sharply seen, in such a fashion that it allowed viewers a clearer, more coherent, more helpful recollection of what they had experienced or hoped to experience.

Félix Bonfils

Jerusalem. Tower of David, ca. 1870

Albumen print
MUSEUM COLLECTION, BY EXCHANGE
74:0196:0007

Abdullah Frères
Turkish, active
1850s–1890s

Bain Turc (Vieux
Serail) (Turkish
Bath [Old Harem]),
ca. 1869

Albumen print
MUSEUM PURCHASE
77:0005:0081

The Middle East – Turkey

Three Christian Armenian brothers named Biraderler opened a studio in Constantinople in 1858. They soon converted to Islam and took the name Abdullah Frères after being appointed photographers to the court of the Sultan Abdul Aziz in 1862. The Abdullah Studio specialized first in portraiture, however architectural views that were sold to the tourist trade also made up a portion of their income. These two images of complexly patterned architectural details are from an album of 96 photographs titled *Constantinople ancienne et moderne*, by Abdullah Frères. The Abdullah Frères and Hippolyte Arnoux also participated in another kind of "topographic" photography. These "types and costumes" photographs formed a secondary body of salable images for the commercial photographer, becoming an important staple in the studio's income. These genre portraits were often made by bringing the subjects into the photographer's studio, sometimes even using available "models," dressing them in different clothes, and posing them in "representative" activities.

Abdullah Frères

Corridor aboutifsant [sic] à Kherkhai-Sherif (Vieux Serail) (Abutting Corridor at Kherkhai-Sherif [Old Harem]), ca. 1869

Albumen print
MUSEUM PURCHASE
77:0005:0084

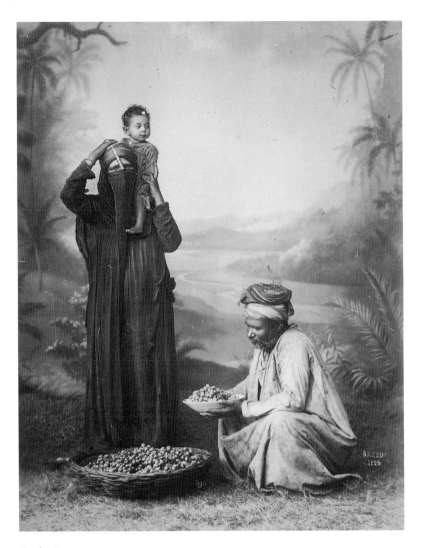

Hippolyte Arnoux
French, active 1860s–1880s

Date-Grower and
Family, ca. 1875

Albumen print
MUSEUM PURCHASE, EX-COLLECTION
FRED S. LIGHTFOOT
80:0112:0002

Unidentified photographer
French?, active 1880s

North African (?) in Costume,
ca. 1880

Albumen print
GIFT OF ALDEN SCOTT BOYER
83:1367:0001

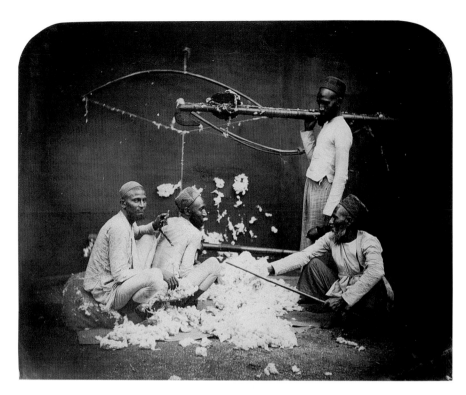

Johnson &
Henderson
English?,
active 1850s

Costumes and
Characters of
Western India:
Group of Pinjaras,
or Cotton-Carders,
ca. 1857

Albumen print
MUSEUM PURCHASE,
EX-COLLECTION
A. E. MARSHALL
79:0065:0012

India

This group of pinjaras, or cotton carders, were demonstrating their craft
and trade to the camera of the photographic team of Johnson & Hen-
derson in Bombay sometime in the mid-1850s. During the 1850s, a time
of huge expansion of photographic practice, India was under British
rule, and the first photographers there were usually British administra-
tors or military officers who took up the medium as a useful hobby or
as a tool to aid them in their ethnological or archaeological research.

One such individual, William J. Johnson of the Bombay Civil Service,
was a founding member (in 1854) of the Photographic Society of Bombay.
He was also co-editor, with W. Henderson, of the *Indian Amateurs Photo-
graphic Album*, a work they published in fascicles each month from 1856 to
1868. Each unit contained three original prints by various photographers.
George Eastman House holds a cumulated and bound album of this
publication, containing 73 photographs by 12 photographers.

Lala Deen Dayal was an extraordinarily intelligent and talented man who, born to a family of modest wealth and position in India in 1844, became recognized as the most accomplished Indian photographer of the 19th century. Dayal entered Thompson's Civil Engineering College in Roorkee in the mid-1860s, successfully completing the five-year course in three years, and, on merit, he obtained a position as an estimator and draftsman in the British administered Public Works Department in the princely state of Indore in Central India. He taught himself photography in 1874, and, with the patronage of top British officials, he was permitted to make portraits of British dignitaries, including the Viceroy of India and, in 1875 and 1876, the visiting Prince of Wales. These photographs brought him local fame and support from the British and Indian upper classes. Broadening his photographic activities, Dayal also took a series of landscapes and views of Indian temples. Building upon his success, Dayal took a two-year furlough to photograph archaeological sites and monuments throughout India. This work was seen and used widely, and prints were accepted by the Archaeological Survey of India and published in several scholarly books as well as in numerous albums, including the album of 124 prints held at George Eastman

Lala Deen Dayal
Indian, 1844–1910

Kalka Temple,
ca. 1890

Albumen print
GIFT OF THE
UNIVERSITY OF
ROCHESTER LIBRARY
82:2736:0111

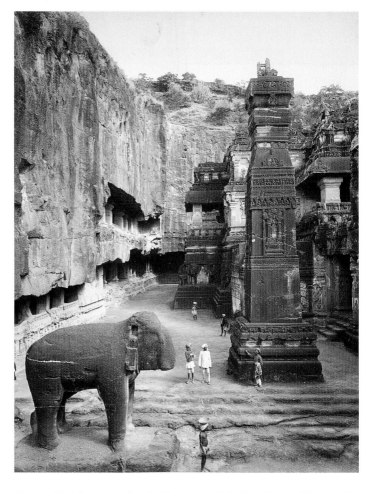

House titled *Ancient Indian Architecture by Lala Deen Dayal, Photographer to H. H. Nizam, Hyderabad, Deccan 1893.*

In 1878 Dayal founded his first studio in Indore, and in 1880 opened shops in Hyderabad and Bombay. More importantly, in the Anglo-Indian social structure of that time, he obtained a continued series of letters of appointment to various high-level dignitaries of the British government, to the court of the Maharajah of Indore, and finally, in 1884, to the court of the Nizam of Hyderabad – the wealthiest, most powerful prince in India. Dayal's court appointment produced a wide range of work

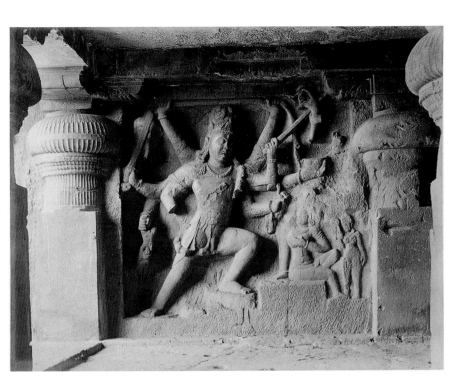

including formal portraits, photographs of official events and functions, and an extensive documentation of activities such as army maneuvers, railroads under construction, and government relief efforts during periods of famine. In 1894 the Nizam bestowed on Dayal the title of Raja Bahadur Mussavir Jung, and in 1896 Dayal opened an expansive studio in Bombay. At the height of Dayal's career, he employed 16 operators, most notably his sons Gyan Chand and Dharam Chand, and 35 additional people in his various studios.

The two images on pages 182 and 183 are among the 354 prints in a magnificent album entitled *Indian Photographs* in the museum's collection. The album, which offers a fascinating look into the diverse range of interests and activities of the upper-class ranks of the Anglo culture in 19th-century India, was probably compiled in the mid-1870s from photographs made by several individuals, among them the amateur photographer Lieutenant W. W. Hooper of the Madras Light Cavalry and the professional photographer Samuel Bourne. "Tiger Hunting – No. 5.

Lala Deen Dayal

Seeta Cave, Ellora, 1893

Albumen print
GIFT OF THE
UNIVERSITY OF
ROCHESTER LIBRARY
82:2730:0095

W. W. Hooper
English, active
ca. 1870s

Tiger Hunting –
No. 5. Buffaloe [*sic*]
Killed by Tiger.
(Kites, Vulture and
Crow, Feeding on
Carcass), ca. 1872

Albumen print
MUSEUM PURCHASE
79:0032:0072

Buffaloe [*sic*] Killed by Tiger ...” is one image in an unusual narrative sequence recreating the events of a tiger hunt in 12 posed scenes. The birds’ intent concentration on their potential dinner kept them fixed in the bright sunlight just long enough for the photographer to capture this unusually candid and arresting moment in nature. “Col. Michael ...” posed with the fossil of an extinct species, is arresting in its own way. This strange image embodies a profound paradigm shift, as it presents an example of the movement of educated practice away from discourse on divine revelation to the observation of the natural world.

The photograph of devastated buildings in Lucknow, India (page 184), was taken by Felice Beato in 1858. Eastman House holds 49 similar photographs taken by Beato during the aftermath of the Indian rebellion of 1858. Felice Beato was photographing in the Middle East when he heard about the uprising and immediately left for Calcutta. Upon his arrival, Beato found the city filled with rumors of incidents and massacres

Unidentified photographer
English?, active
ca. 1870s

Col. Michael, Military Secretary to Government, with Bones of the Leg of the Australian Dinornis, ca. 1872

Albumen print
MUSEUM PURCHASE
79:0032:0052

Felice Beato
British, b. Italy,
ca. 1830–ca. 1906

The Baillie
Guard Gateway
and Banquetting
Room, 1858

Albumen print
GIFT OF ALDEN
SCOTT BOYER
81:2937:0039

further upcountry where armed insurgents were still fighting for territorial advantage. Beato quickly joined the British forces in the field and followed the fighting from Cawnpore to Lucknow and back to Cawnpore. He photographed British and loyal Indian military units, the captured Indian prisoners, and the sites of earlier battles – in effect practicing an early form of photojournalism. The final campaign ended in December 1858, and Beato returned to Calcutta in March 1859. He spent the next year traveling throughout India, photographing in Agra, Simla, and Lahore before returning to Calcutta again in February 1860 to accompany the Allied Anglo-French military expedition leaving for North China and the Second Opium War.

This peaceful pastoral (right) was taken in Kashmir by Samuel Bourne in 1864, and is from the album of his works titled *Indian Photographs* now held at George Eastman House. This album contains 41 prints, divided between landscape views and portraits of various ethnic groups in

Northern India. Over 100 photographs by Bourne appear in a variety of albums owned by the museum. "Kashmir. Up the Jhelum,..." shows all the felicitous points of a picturesque landscape that calls to mind views of the Lake District in Britain. In fact, it was taken on a 10-month photographic expedition to the area around the Vale of Kashmir in 1864, during which Bourne made almost 500 negatives. He found the region around Srinagar particularly stimulating, as its climate and landscapes reminded him of his homeland. Bourne quit clerking in a Nottingham bank in 1863 and sailed for India to work as a professional landscape photographer, where he traveled and photographed almost incessantly until 1869, before he returned to England and abandoned professional photography.

Samuel Bourne
English, 1834–1912

Kashmir. Up the Jhelum, from below the Island, 1864

Albumen print
GIFT OF EASTMAN
KODAK COMPANY,
EX-COLLECTION
GABRIEL CROMER
79:0004:0035

B 1134 NEW YEAR DEILL OF JAPANESE FIRE BRIGADE.

**Attributed to
Kusakabe Kimbei**
Japanese, active
1890s

New Year Deill [*sic*]
of Japanese Fire
Brigade, ca. 1890

*Albumen print with
applied color*
MUSEUM COLLEC-
TION, BY EXCHANGE
74:0034:0016

The Far East – Japan
George Eastman House holds over 500 hand-colored views of Japan.
They are difficult to date accurately because earlier negatives were fre-
quently acquired and reissued by later photographers. The genres of
both "landscape" and "costume or type" portraiture remained stylis-
tically stable over several generations, and accurate chronologies
of Japanese photographers are still being investigated by scholars.

Felice Beato opened the first photographic gallery in Japan in 1863, specializing in "depicting the noted places, scenery, and dress of Japan." In 1866 fire destroyed many of his negatives, but he was still able to publish two volumes of views of Yokohama in 1868. In 1870 he reopened as F. Beato & Co., the studio operated by John Goddard, H. Woolett, and several Japanese photographers during Beato's frequent travels. Beato sold this studio and stock in 1877. The museum owns an album of 51 prints by Beato, including "Public Gardens at Uyeno – Tokiyo."

Kusakabe Kimbei probably worked for Felice Beato in the 1860s and then for his successor in the 1870s before opening his own studio in Yokohama in the 1880s. His photograph of the New Year's drill of the Japanese fire brigade is not only visually exciting and technically adept, it also extends a long tradition of visual documentation of such festivals by the woodblock artist Hokusi and others. Costume

Attributed to Felice Beato & Co.
Italian, 1870–1877

Public Gardens at Uyeno – Tokiyo, ca. 1875

Albumen print with applied color
MUSEUM PURCHASE
79:0059:0036

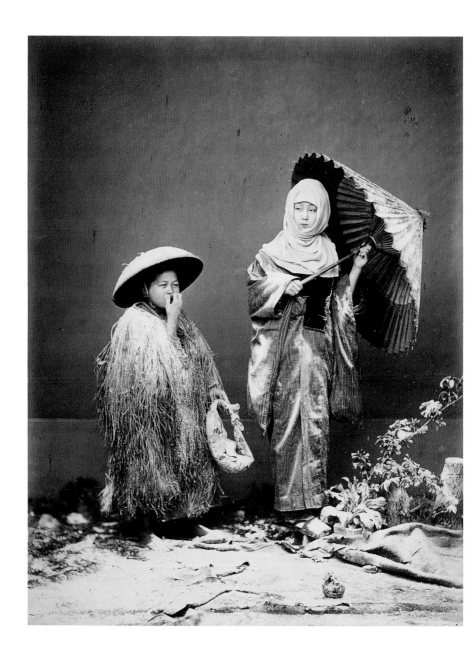

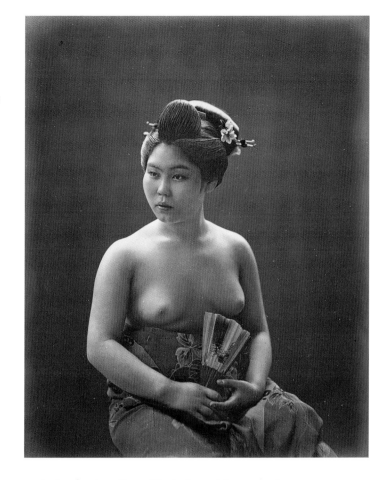

portraits of various "types," including geishas and actresses, were also a staple in the Japanese woodblock tradition. Photographers adeptly incorporated Japanese visual heritage into their photographic work, often with hand-applied color of great range and delicacy.

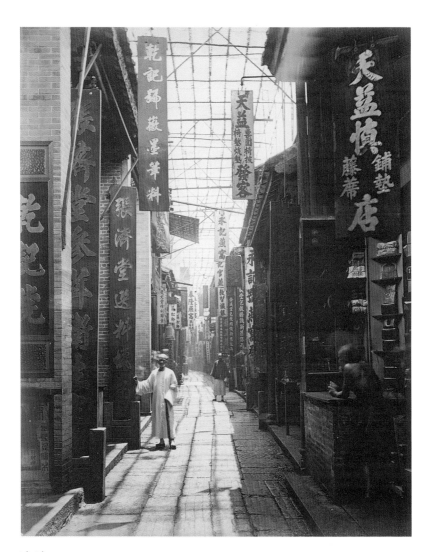

John Thomson
Scottish, 1837–1921

Physic Street,
Canton, ca. 1869

Albumen print
GIFT OF ALDEN
SCOTT BOYER
73:0219:0091

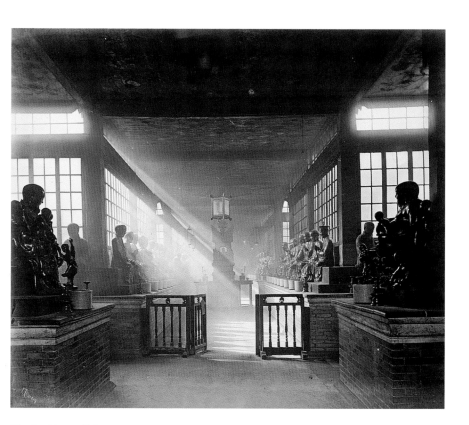

The Far East – China

John Thomson left Scotland for the Far East in 1865 and spent a decade traveling and photographing in Malaysia, Indochina, Cambodia, and China. Thomson published numerous albums and books including *The Antiquities of Cambodia* and *Illustrations of China and Its People*, both in the museum's Menschel Library. His work in China combines elements of an indefatigable energy, an extremely broad range of cultural interests, and a beautiful visual sensibility for the exotic, making his documentation of this culture both unique and extraordinary. These two photographs demonstrate both Thomson's mastery of light and his ability to transform detailed and complex scenes into well composed and elegant pictures. The raking light of this interior view is illuminating the famous Hall of Saints of the Hua-lin-szu (Wah Lum Chu), or Magnificent Forest Temple, in Canton, noted for containing 500 statues of Buddhist saints.

John Thomson

Wah Lum Chu,
Canton, ca. 1869

Albumen print
GIFT OF ALDEN
SCOTT BOYER
73:0219:0066

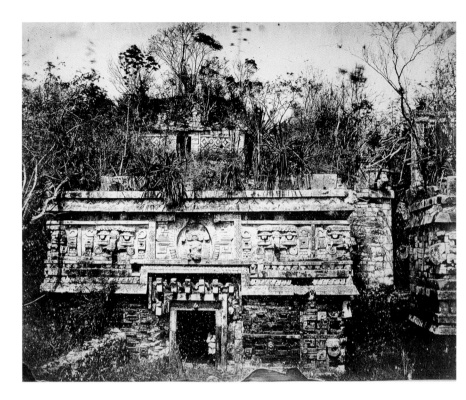

Désiré Charnay
French, 1828–1915

Main Facade of
the Nunnery of
Chichen-Itza,
ca. 1857–1861

Albumen print
GIFT OF EASTMAN
KODAK COMPANY,
EX-COLLECTION
GABRIEL CROMER
73:0199:0014

The Americas

These two temples representing an ancient and mighty culture at Chichen-Itza in the Yucatán Peninsula also attracted archeological attention, as Egypt's remains had done for generations. Further removed from European culture, both in miles and in heritage, this interest was followed up by fewer individuals but was still pursued with equal passion. Reports of the earliest discoveries and first explorations were accompanied by drawings that seemed inadequate and confusing, particularly since the visual syntax of Meso-American culture was so different from established and well-known European forms.

Désiré Charnay, born and educated in France, was teaching school in New Orleans, Louisiana, in 1850 when he read John Lloyd Stevens' popular accounts of travel in Central America. Enticed by what he read, Charnay first journeyed to France where he learned to photograph and acquired the support of the French Ministry of Public Instruction to

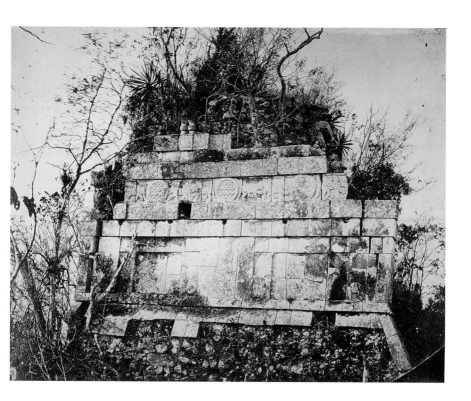

make a trip to the Yucatán. Then, in 1857, he spent eight months travel-
ing around the United States before leaving for Mexico, which was in
the midst of a civil war. Charnay spent ten months in Mexico City before
arriving at his long-sought destination, the Yucatán, where in 1858 and
1860 he photographed the pre-Columbian ruins. In 1861 he returned to
France and published a portfolio titled *Cités et ruines américaines, Mitla,
Palenque, Izamal, Chichen-Itza, Uxmal*. George Eastman House holds a
variant of this work, containing 31 views, including those on these pages.

Spurred on by his passion for little-explored but culturally rich
places, Charnay spent the rest of his life visiting distant countries.
Later, he wrote popular novels based on these experiences. He returned
to Mexico in the mid-1860s and lived there until 1867, when the
Maximilian government collapsed. In 1880 he returned to the Yucatán
yet again and spent two years excavating and photographing pre-
Columbian ruins.

Désiré Charnay

Tiger's Bas-Relief
on a Portion of Ball
Court of Chichen-
Itza, ca. 1857–1861

Albumen print
GIFT OF EASTMAN
KODAK COMPANY,
EX-COLLECTION
GABRIEL CROMER
73:0199:0002

Ricardo Villalba is considered to be one of the most creative photographers working in Peru during the 19th century. He produced a fine album of views of the Southern Railroad, which ran from the coastal plains to the highlands in Peru. He is thought to have run a portrait gallery in Arequipa, Peru, in the mid-1870s. He also made several hundred portraits of working-class subjects – porters, servants, soldiers, etc. – which were sold as "types" in the popular carte-de-visite format and collected in Peru and throughout the world. In the 1870s, he created a rare album of indigenous subjects, now at George Eastman House. This album, identified only with a penciled note as "Indians of Peru & Bolivia – Types & Costumes ...," consists of 192 carte-de-visite-sized prints mounted side by side, two per page. At first the portraits all seem to have been taken in a studio, with either a painted or a plain backdrop amid various items of studio furniture and props, even including a neck brace. Closer scrutiny reveals that many were taken at different times in the streets of various towns in southern Peru and Bolivia. This was a project involving planning, patience, and an extended effort, with a duration and consistency that makes it an exceptional volume.

The print from this album of a man looking in the mirror demonstrates Villalba's ethnographic pursuits. He had to photograph the subject from the rear to show the braids, the woven pouches, and the characteristic attributes he wanted to display in this "type." Yet Villalba also wanted to make an interesting portrait. The man's startled glance in the

Attributed to
Ricardo Villalba
Peruvian?,
active 1870s

Man Looking in Mirror, ca. 1875

Albumen print
MUSEUM PURCHASE
71:0010:0086

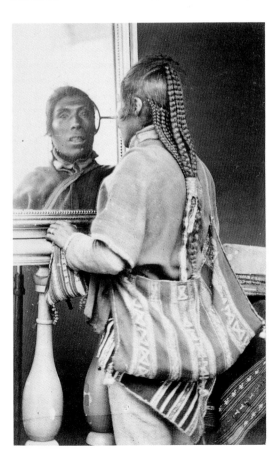

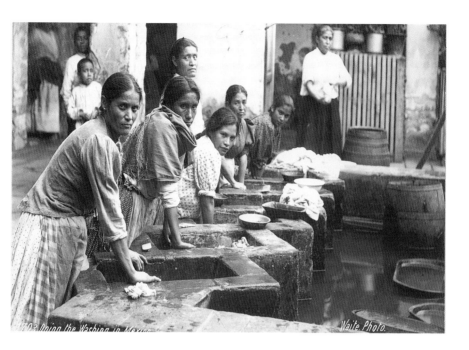

mirror and the casual arm placed against the rail, which lends a sense of movement while actually providing the stability needed during the long exposure, all combine to give this portrait a sense of spontaneity and intimacy unusual for this time and photographic genre.

"Doing the Washing in Mexico," by Charles B. Waite, a professional photographer working in Los Angeles, California, in the mid-1890s, also contains both a sense of place and a feeling of activity that allow the viewer to believe in the scene and share something of the mood. The difference is that Waite, who took photographic trips through the American Southwest and Mexico in search of picturesque scenes, is working with a photographic technology that is far more flexible than Villalba's. Waite's improved lenses and glass plates allowed him to photograph out-of-doors, to include groups of people without fear that one or more would move and blur the image, and to compose his photograph with a depth of field far deeper than the shallow space found in most portraits from the 1870s. Waite used all these advantages very well in his Mexican photograph, an ethnographic tourist image, emphasizing cultural difference and the "exotic."

Charles B. Waite
American, active
1890s–1900s

Doing the Washing
in Mexico, ca. 1900

Albumen print
GIFT OF JOHN
SEARS WRIGHT
83:1296:0017

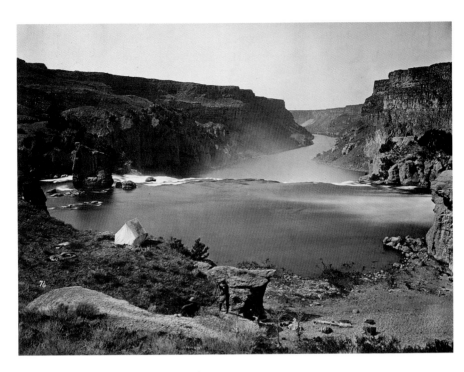

**Timothy H.
O'Sullivan**
American, b. Ireland,
1840–1882

Shoshone Falls,
Looking over
Southern Half of
Falls, September,
1868

Albumen print
GIFT OF HARVARD
UNIVERSITY
81:1887:0055

The American West

This photograph of Shoshone Falls, Idaho, was taken by Timothy O'Sullivan in September 1868 as he made photographs for the Geological Explorations of the Fortieth Parallel under Clarence King, United States Geologist-in-Charge. The King Survey was the first of a number of post-Civil War scientific expeditions mapping the American West that were sponsored by the federal government. O'Sullivan was the first of several respected photographers hired to photograph these surveys. He is known to have photographed at Shoshone Falls two different times, making at least 50 glass-plate negatives of the area. This photograph conveys why it was a favored spot of O'Sullivan's. The image is divided into four distinct visual layers, moving from bottom to top, near to far. The closest layer presents men encamped and resting at the edge of a cliff, overlooking water pooled to gain energy before racing over another edge, the dramatic drop of the falls. Then the river winds picturesquely between the cliffs and into the distance. The final layer is the blank and distant sky. The image visually embodies the idea of a restful stop before an arduous journey, a peaceful calm followed by dangerous movement, and ultimately the classic journey of exploration from the mundane, the known, to the unknown infinite.

From the very beginning the American wilderness – felt to be an unspoiled Eden with a heady mixture of freedom, opportunity, and danger – seemed to physically embody the American ethos. By the 19th century that wilderness had become the American frontier, always shifting westward and filled with landscapes of such extraordinary dimensions that they fostered a sense of special favor and pride within the American citizenry. Throughout the century these lands were explored and described by dozens of survey expeditions sponsored both by the government and by private capital. Beginning with the 1803 Lewis and Clark expedition and continuing into the 1880s, these expeditionary parties of armed men had to be self-sufficient for months on end until their return to a distant "civilization." A misjudgment or accident so far away from any possible assistance might prove fatal, and, indeed, did so often enough, as more than one explorer on these forays into the wilderness died from starvation, illness, or hostile attack. Nevertheless, many artists and photographers were so attracted to the Western landscape that they braved a considerable number of hardships and dangers in order to depict this extraordinary scenery for their fellow citizens.

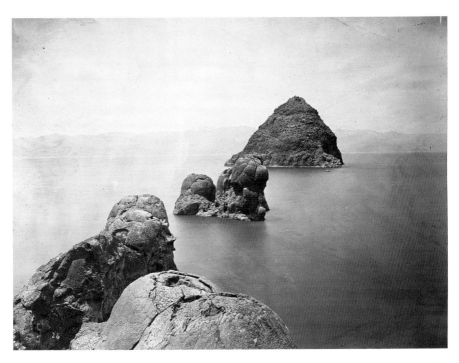

Timothy H. O'Sullivan
American, b. Ireland, 1840–1882

"Pyramid", Pyramid Lake, Nevada, 1868

Albumen print
GIFT OF HARVARD UNIVERSITY
81:1887:0015

The American government had used the documentary properties of photography as early as the summer of 1840, when Edward Anthony took several daguerreotype views in Maine to assist in settling a boundary dispute with Canada. Several other expeditions used daguerreotypists, most notably when Eliphalet Brown, Jr., accompanied Commodore M. C. Perry's expedition to the China Seas and Japan from 1852 to 1854. But a serious body of landscape photography was not created in the United States until after the wet-collodion process became widely established during the final half of the 1850s. Even then, photographers did not become a standard component of most of the government-sponsored survey expeditions until after the end of the American Civil War. The post-war geological and geographical expeditions became laboratories in which more accurate tools of scientific measurement and interpretation of the physical world were pioneered or adopted while new scientific ideas and methodologies were brought to the public through the extensive publications resulting from the surveys. As photographic technology improved to the point where field photography was

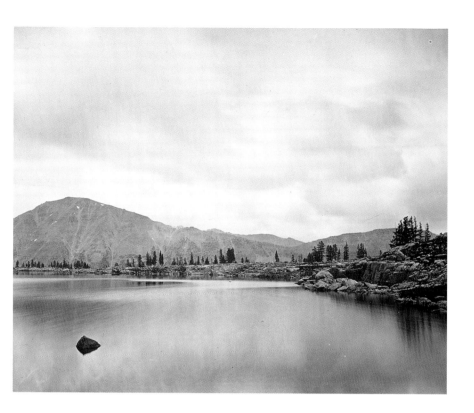

practical, even if extraordinarily difficult by present-day standards, many of these expeditions regularly used photographs as part of the increasingly rigorous scientific structure of their practice.

Timothy O'Sullivan had been an active field photographer during the Civil War and at its end was one of the most experienced outdoor photographers in the country. He joined Clarence King's survey in 1867 and photographed on King's expeditions during the next two years, covering western Nevada and eastern California, then north to Idaho, and in 1869, traveling to northern Utah and southern Wyoming. O'Sullivan rejoined King again in 1872, where he photographed in Nevada and Utah, then the Green River area in Wyoming and Colorado. The museum holds over 130 photographs from the King surveys, ranging from distant landscapes to detailed views of specific and sometimes startling geological formations, along with photographs of mineral deposits and

Timothy H. O'Sullivan

Uintah Mountains, 1869

Albumen print
GIFT OF HARVARD UNIVERSITY
81:1888:0027

mining operations. O'Sullivan continued as an expeditionary photographer until 1874, taking more than 1,000 photographs of the American West while working for King and for Lieutenant George Wheeler's expeditions on the Colorado River as well as to Arizona, New Mexico, Nevada, Utah, and California in 1871, 1873, and 1874.

O'Sullivan proved brave, resourceful, and steady, an altogether valuable companion to have on these arduous ventures, and most of the comments about his work written by members of these expeditions reflect his steadfast reliability. Although this was probably considered of secondary importance to the expeditionary members, O'Sullivan proved to be far more than just a reliable companion and a competent craftsman. He became one of the best photographers ever to interpret the American landscape.

There is nothing in the historical record to fully explain how or why this happened. Throughout O'Sullivan's career he simply did his job. It is only within the actual borders of his photographs, where O'Sullivan intuitively

**Timothy H.
O'Sullivan**
American, b. Ireland,
1840–1882

Gould and Curry
Mill, Virginia City,
1867

Albumen print
GIFT OF HARVARD
UNIVERSITY
81:1886:0026

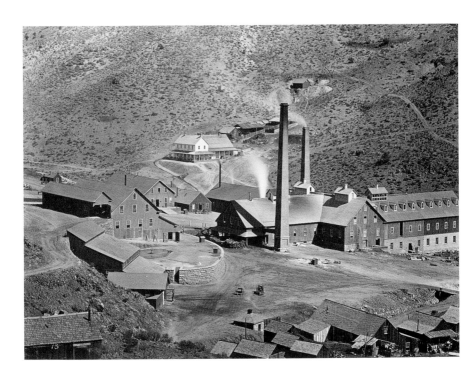

balanced subject and form to achieve the visual strength that imbues
his images with emotion and the possibility of additional meaning, that
O'Sullivan ever made any statement about being an artist. Every compe-
tent stereo view maker knew the trick of placing the camera so that there
was an interesting object or shape in both the foreground and in the far
background of the composition and composing the image with a rela-
tively open or clear middleground space, or even better, with a structure
or shape presenting a strong receding diagonal line between the fore-
ground and background. This generates a sense of distance in the view
and a sense of depth in the image when seen through a stereo viewer.
O'Sullivan used these tricks as often as any other view photographer, but
he was somehow able to infuse those conventions of composition and
framing with sufficient authority and power so that his photographs have
a presence that transcends the simple delineation of their subject.

**Timothy H.
O'Sullivan**

Crushed Timbers,
Gould and
Curry Mine,
January–February,
1868

Albumen print
GIFT OF HARVARD
UNIVERSITY
81:1887:0001

Modern research confirms that O'Sullivan consciously and deliberately worked with those tools available to him to achieve the best possible photograph. He was known to wait, for hours if necessary, to get the best light. He would make several slight variations of the same subject from different angles (not an easy task with the cumbersome wet-collodion system) while looking for the photograph that "worked" the best – the one in which the various landscape elements came together into the strongest composition. This could include tilting his camera to alter his horizon line to bring objects into less accurate but more dramatic visual relationships.

All of these are tactics used by modern photographers but not commonly discussed in the photographic literature of O'Sullivan's time. In fact, if O'Sullivan had ever written about his manner of approaching photographic practice (which he never did), most of his peers would not have understood what he was trying to do. The photographs taken at the Gould and Curry Mine in Virginia City, Nevada, show these practices. The outside view of the mine is composed so that no horizon line exists, and the strongest device tying these buildings together across the flattened surface of this image is their visual relationship to each other and to the borders of the image. In other words, a relationship of form is established that rivals any possible content relationship existing in the picture.

In 1871, 1873, and 1874 O'Sullivan accompanied the Army Corps of Engineers's Lieutenant George Wheeler's exploration and surveys west of the 100th meridian, missing the 1872 expedition because he was back

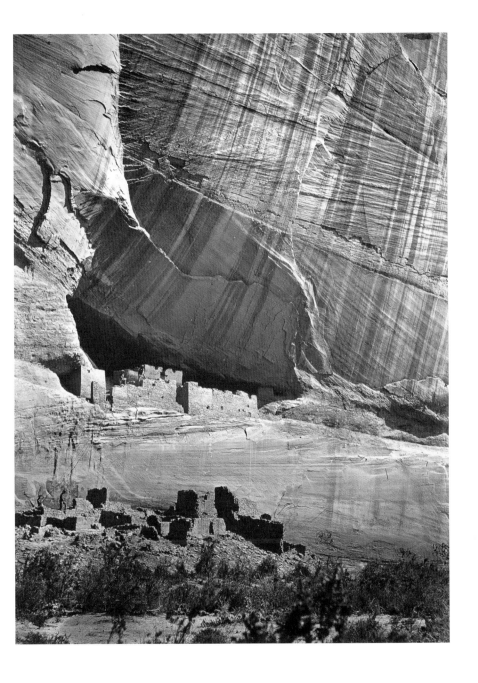

William Bell
American,
b. England,
1830–1910

Perched Rock,
Rocker Creek,
Arizona, 1872

Albumen print
MUSEUM PURCHASE,
EX-COLLECTION
PHILIP MEDICUS
79:0014:0030

working for King in that year. George Eastman House owns an album of 50 albumen prints assembled in 1875 to accompany a few special copies of the seven-volume final report of the Wheeler survey. This work contains prints from each survey in the years 1871, 1872, and 1873. Thus, 15 prints taken by William Bell in 1872 (including the one above) are sandwiched between 35 prints taken by O'Sullivan in 1871 and 1873.

The two O'Sullivan photographs on pages 202 and 203 are from the 1873 expedition, when the party explored northern Arizona and New

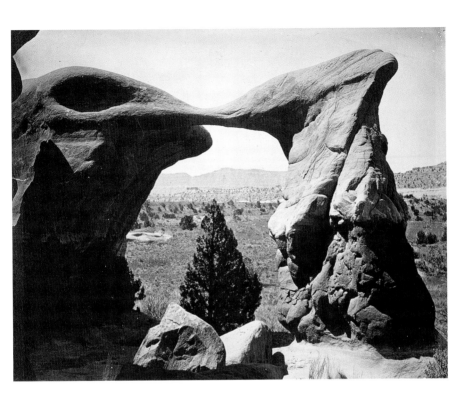

John K. Hillers
American,
b. Germany,
1843–1925

Goblin's Archway,
ca. 1875

Albumen print
78:0768:0001

Mexico. In this expedition the photographer focused his camera on ethno-
graphic issues, photographing the Apaches in the Sierra Blanca Moun-
tains in Arizona, the Navajos and Zunis of New Mexico, the historical re-
minders of the Spanish Conquistadors, and the even older Anasazi ruins
at Canyon de Chelly.

O'Sullivan could handle both the very near object and the very distant
landscape equally well. The "Historic Spanish Record of the Conquest"
displays the qualities of a formal still-life rendering. By imposing a visual
clarity and coherence on ordinary, everyday objects, he invested his pho-
tographs with an attraction that complements and extends the interest
engendered from the content of the subject alone. O'Sullivan could also
bring this skill and authority to essays of larger scope. Other photogra-
phers and even O'Sullivan himself made more informational images
of the ruins at Canyon de Chelly, when the light displayed the structures
more fully, and where the camera position revealed more of the relation-

ships between the ruins and the surrounding terrain. In this photograph, by choosing a vertical composition, placing the camera so that the ruins in the cliff echo the ruins on the canyon bed, and framing his subject so that the gracefully sweeping, dramatic lines of water seepage lift the eye up, O'Sullivan created an image capable of evoking a sense of wonder. He has, in fact, transformed these pictures from documents into creative statements – or from records into art.

William Bell of Philadelphia is often confused with another William Bell also photographing out west in the early 1870s. The Philadelphia Bell served in the Union Army, fought at Antietam and Gettysburg, and was the chief photographer of the Army Medical Museum in Washington, D. C., from 1865 to 1869. This Bell went on only one western expedition, when he replaced O'Sullivan, who was again photographing for Clarence King, on Lieutenant George Wheeler's 1872 trip down the "Grand Gulch" of the Colorado River. Thus O'Sullivan missed the Grand Canyon and gave Bell a chance to make his way into western (and photographic) history with images that excellently convey the spectacular nature of the scenery of the Grand Canyon region in Arizona. Bell used a 10 x 12-inch camera and a lens that flattened the visual space in his pictures. He often chose vertical compositions, giving an intense, even claustropho-

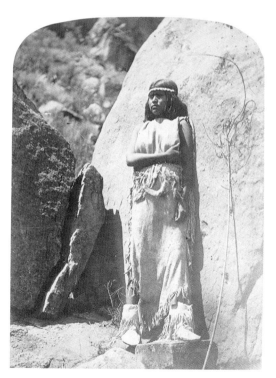

John K. Hillers
American,
b. Germany,
1843–1925

Kaibah Paiute.
"Ku-ra-tu," ca. 1875

*Albumen print
stereograph*
MUSEUM PURCHASE,
EX-COLLECTION
FRED S. LIGHTFOOT
81:0967:0116

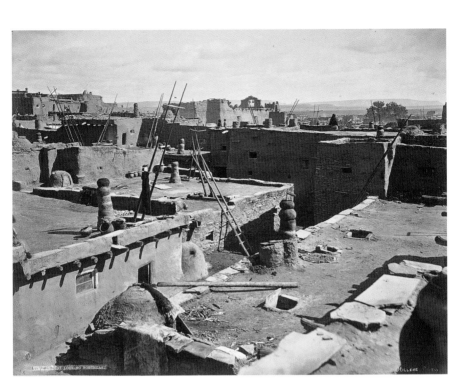

bic, feeling to many of his landscapes, which was both unusual and effective for his views.

John K. (Jack) Hillers was hired by John Wesley Powell to replace a boatman on Powell's second survey of the Green and Colorado Rivers in 1871. Hillers, born in Germany but raised in the United States, had fought for the Union in the battles of Petersburg, Cold Harbor, and Richmond, then reenlisted in the army after the war and served on the frontier until 1870. In 1871 Hillers was working as a teamster in Salt Lake City when he and Powell, another army veteran, met and began a friendship that lasted the remainder of their lives. During the 1871 canyon voyage, Hillers assisted the expedition's photographer, E. O. Beaman, until Beaman left the expedition. Then Hillers helped Beaman's replacement, James Fennemore, who taught him photography in the field. When Fennemore became ill and had to leave the expedition in 1872, Hillers took over all photographic duties. He also photographed for all of Powell's later expeditions until those surveys ended in 1879. In 1881 J. W. Powell was

John K. Hillers

View in Zuni,
Looking Northeast,
ca. 1875

Albumen print
MUSEUM PURCHASE
70:0148:0007

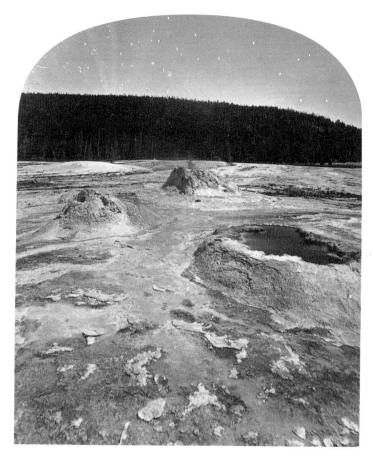

William Henry Jackson
American, 1843–1942

Hot Spring Basin, Upper Fire Hole, 1872

Albumen print
MUSEUM PURCHASE
74:0041:0337

made the head of the U.S. Geological Survey, and Hillers was made its photographer, a position he held until his retirement in 1900. This position was based in Washington, D.C., and although Hillers did take occasional trips back to the West, most of the work of his final years was done in the government studios in Washington.

Hillers was the first to photograph the Grand Canyon, and he participated in ethnographic studies of American Indian tribes in the Southwest. It's in his views of the pueblos that Hillers' photography grows into a mature vision, when he is capable of assembling the complex shadows and shapes created by the pueblo dwellings into dynamic and interesting photographs. His portraits of various Ute and Paiute

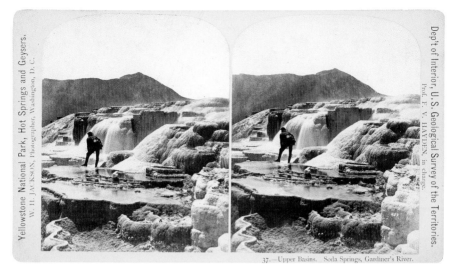

37.—Upper Basins. Soda Springs, Gardiner's River.

tribes in Utah, on the other hand, are almost naively simple, and they seem tainted to the modern eye. It is now known that Powell brought clothing from an ethnological museum collection back to Utah to dress tribesmen for these staged photographs. George Eastman House owns approximately 130 stereo views and 48 photographic prints by Hillers.

William Henry Jackson was widely considered one of the best landscape photographers of the western United States during most of his professional career from the 1870s through the turn of the century. He won this reputation with his resourcefulness and skill, his luck, his capacity for hard work, his longevity, and his talents as a photographer and a businessman. Jackson could and often did create images of the Western landscape that were large in size and grandiose in scale, confirming the grandest ideals of those exponents of America's Manifest Destiny. His mountain ranges were longer and higher, his vistas stretched farther, his terrains were wilder, more rugged, and more filled with a sense of wonder than conventional topographic views, highlighting a wilderness that was waiting to be tamed and made available to the American citizen.

Ferdinand Hayden, director of the U. S. Geological Survey of the Territories from 1870 to 1878, employed Jackson each year to join the large self-contained expeditions into still uncharted parts of the American

William Henry Jackson

Upper Basins. Soda Springs. Gardiner's River, 1871

Albumen print stereograph
82:1582:0001

West. The survey's most famous expedition was its 1871 trip into the Yellowstone region, where the spectacular nature of the scenery attracted national media. Many articles in journals and newspapers brought Hayden and even Jackson a measure of celebrity. Their 1875 and 1877 trips into Colorado, New Mexico, and Arizona generated reports of the ancient abandoned cliff dwellings, which again stirred popular interest in the expeditions and in the photographs.

George Eastman House holds over 900 prints and more than 220 stereo views taken by William Henry Jackson during every phase of his long career, including an extraordinary compilation album of more than 400 small prints once owned by Henry Gannett, an astronomer and topographer for the Hayden surveys, showing the activities and personnel of the survey parties, as well as scenes and views of the territory. The museum also has an elegant presentation album of 37 photographs, *Photographs of the Yellowstone National Park and Views in Montana and Wyoming Territory*, printed by the Government Printing Office in 1873. This, according to legend, helped persuade members of Congress to establish the National Park System.

William Henry Jackson
American, 1843–1942

John, the Cook, Baking Slapjacks, 1874

Albumen print
MUSEUM PURCHASE
74:0041:0212

While Jackson was the master of the eloquent public statement, as in the view of Mystic Lake (right), he was also able to make images that appear personal, conveying a sense of casual informality otherwise absent from 19th-century photographs. His image "John, the Cook, Baking Slapjacks," which is from the Gannett album, pulls the viewer into the very heart of the mundane daily activities of a group of men on a long camping trip, who also happen to be a part of the very fabric of the history of the developing American West. Since the cameras of the 1870s simply could not capture the quick movement of the flipping pancake, nor, for that matter, the poetic light of the "star-filled"

skies over the Yellowstone geyser at "Hot Spring Basin, Upper Fire Hole" (page 208), Jackson had to help his image by painting those items onto his negatives by hand. Jackson occasionally manipulated other prints by combining negatives to create a panoramic print to get the scale and sweep of the large vista he needed, or scratching in an outline of the occasional bird or tourist to balance the composition, or combining negatives to make a composite print, later even rearranging the topography of the famous Mountain of the Holy Cross to make a better picture. But he did this with the authority of someone who had actually been there and had seen it, who was a real witness to those scenes of the making of the Western frontier.

Jackson lived to be nearly 100 years old. His career – or more accurately, careers – could be regarded as a paradigm for the role commercial landscape photographers played, and thus the types of landscape photography made, in America from the 1860s until after the turn of the century. Working for eight years in the 1870s as a member of various

William Henry Jackson

Mystic Lake, 1872

Albumen print
GIFT OF GEORGE
H. CANNAN
81:2245:0022

government-sponsored survey teams, Jackson had at least a partial mandate to photograph expansively, to speak with a public voice, to find and depict the spectacular and the unusual aspects of the scenery of America. When these government positions ended at the close of the decade, Jackson returned to private entrepreneurship. He moved to Denver, Colorado, and made his living by selling views to tourists and making publicity photographs for the railroads, the remaining sponsors of this type of imagery. He also sold stock photographs to the new market of inexpensive illustrated books and periodicals that exploded into publication after the improvements in photoengraving technologies were developed in the 1880s. They enabled inexpensive halftone screen reproductions from photographs to appear on the same page as letterpress copy.

The photograph "High Bridge in the Loop. Near Georgetown (page 214)." is a dramatic image of the exciting train ride available for the adventurous traveler visiting Colorado. By 1885 probably every other photographer in Colorado and even a few photographers just passing through the state had also taken this view, and most of them were willing to sell a print for less than what Jackson charged. To survive and prosper, the Jackson studio had to become a sort of stock picture agency,

William Henry Jackson
American, 1843–1942

"Tea Pot" Rock, 1870

Albumen print
MUSEUM PURCHASE
74:0041:0087

William Henry Jackson

Waterfall Gorge, ca. 1890

Albumen print
GIFT OF
3M COMPANY,
EX-COLLECTION
LOUIS WALTON
SIPLEY
77:0533:0011

constantly gathering an increasing number of views of more diverse places. Jackson hired photographers such as William H. Rau and purchased negatives from other photographers, including those made by Adam Clark Vroman and Ben Whittick. Here he followed an established pattern. Jackson traveled constantly on the expanding network of railroads throughout the United States, venturing into Mexico and traveling up the eastern seaboard of the United States. These railroads hired Jackson to provide them with photographs of the landscapes along their routes and allowed him access to views, hoping to attract tourists.

The financial panic of 1893 severely damaged Jackson's business. He still traveled extensively, even around the world in 1895 and 1896, accompanying the World Tour of the Transportation Commission of the Field Columbian Museum. In 1898 Jackson folded his business into the Detroit Publishing Company, a firm that printed and distributed post cards and inexpensive photolithograph prints to an ever larger and more diffuse market. But by then Jackson was working as a commercial photographer, and his latter photographs are no longer filled with the sweep and grandeur of the older expeditionary pictures that he had taken when his camera was one of the first to document the Western landscape.

William Henry Jackson

American, 1843–1942

High Bridge in the Loop. Near Georgetown, ca. 1885

Albumen print
74:0013:0316

California and the Far West

The California Gold Rush in 1849 brought a flood of adventurers, settlers, and even photographers to California. The Yosemite Valley was discovered by these settlers in the mid-1850s, and almost instantly Yosemite joined Niagara Falls in the American pantheon symbolizing the beauty, richness, and promise of its land. Yosemite was visited by a steady stream of tourists, artists, and photographers such as Charles L. Weed, Carleton E. Watkins, and Eadweard Muybridge. Charles Weed carried a stereo view camera and apparatus into the valley for the first time in 1859. Watkins followed in 1861, and Muybridge, in his turn, attempted to create images of a size to match both the scale and emotional dimensions of the place toward the end of the decade.

Thomas Houseworth & Co. was a large commercial gallery that flourished in San Francisco in the 1860s and 1870s. Its major business was portraiture, but the gallery also was a publisher and distributor of stereo

William Henry Jackson

Cañon of Grand River. Utah, ca. 1885

Albumen print
GIFT OF HARVARD
UNIVERSITY
81:2248:0038

views and other views, which it printed from negatives purchased from various photographers. Among the views represented were Charles L. Weed's of Yosemite taken in the early 1860s. The museum holds six large, "mammoth"-sized photographic prints of Yosemite, as well as more than 140 stereo views, 68 landscape cartes-de-visite, and six portraits from the Houseworth Studio in its collection.

Isaiah West Taber opened one of San Francisco's major photographic studios in 1871. Taber was a skilled photographer, he hired many operators to work for his gallery, and he also acquired negatives from other photographers. The museum holds 300 prints from the Taber Studio in its collection. In 1874 Taber purchased Carleton E. Watkins' gallery, photographic equipment, and some 15 years' worth of accumulated negatives of landscape views in a bankruptcy sale and then frequently reprinted them under his own trademark name throughout the 1880s. Though imprinted with Taber's name, it is possible that the Yosemite view "The Vernal Fall ..." was from a negative taken by Watkins in the 1860s.

Thomas House-worth & Co.
American, active
1866–1874

The Domes from
Merced River,
Yo-Semite Valley,
ca. 1874

Albumen print
GIFT OF HARVARD
UNIVERSITY
81:1353:0004

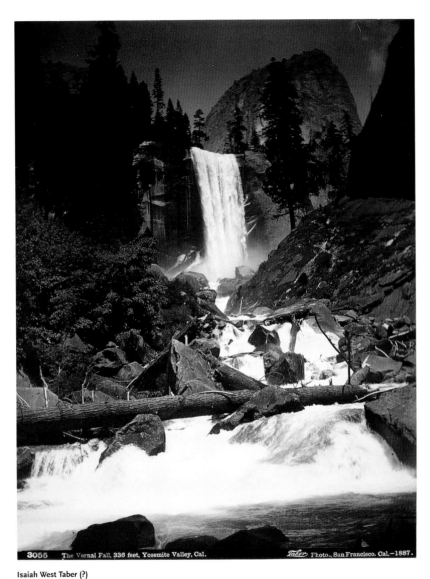

3055 The Vernal Fall, 336 feet, Yosemite Valley, Cal. *Taber* Photo., San Francisco. Cal.–1887.

Isaiah West Taber (?)
American, 1830–1912

The Vernal Fall 336 Feet, Yosemite Valley, Cal., ca. 1885

Albumen print
GIFT OF ALDEN SCOTT BOYER
81:2265:0015

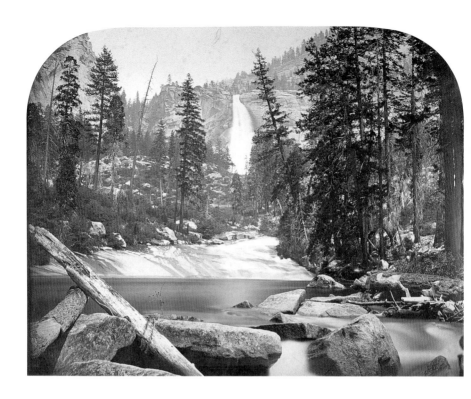

Carleton E. Watkins
American, 1829–1916

Yo-Wi-Ye or Nevada
Falls, 1861

Albumen print
GIFT OF ALDEN
SCOTT BOYER
81:2899:0024

Carleton E. Watkins began his long and extraordinary photographic career in 1854, making daguerreotype and then ambrotype portraits. By 1856 photographers in California were experimenting with the new wet collodion process, which made taking landscape views a much more feasible, practical, and economical activity. Watkins learned the new process and by 1858 was using it to establish his reputation as a field photographer. Some of his earliest and best work was in the Yosemite Valley, which he first visited in 1861 and returned to again and again during the next 20 years, often rephotographing the same scenery from the same spot. George Eastman House has 25 large Yosemite views by Watkins among the more than 150 photographs and more than 300 stereos in its collection.

Eadweard Muybridge began working as a landscape photographer in California in 1867. He created dramatic landscapes with an operatic grandeur that matched the wondrous vistas he was photographing.

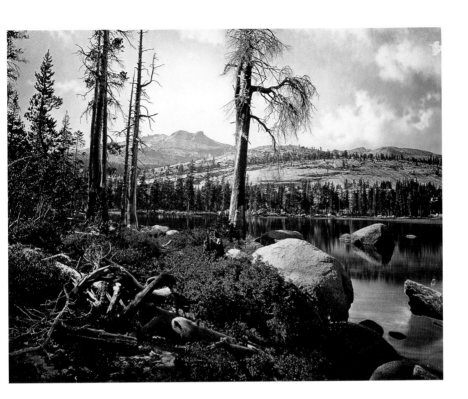

His photographs featured the play of light on steam or clouds. These transitory events were very difficult to capture with the camera, and Muybridge often achieved these effects by double printing negatives of clouds into the blank white skies dictated by the blue-sensitive photographic chemicals of the day. Sophisticated critics acclaimed these views to be more expressive and artistic than the photographs of previous photographers. The museum holds 25 large views by Muybridge in its collection.

While the spectacular scenery of northern California seemed to call forth very large and spectacular photographic prints, it should be remembered that the largest number of scenic views were sold in the form of stereos, or, less often but more frequently than the mammoth prints, in the form of cartes-de-visite. Though smaller in scale and therefore possessing less visual impact, many of these images are excellent photographs. The "Bridge at the Second Crossing of the Truckee River ..."

Eadweard J. Muybridge
American, b. England, 1830–1904

Mount Hoffman, Sierra Nevada Mountains, from Lake Tenaya, ca. 1870

Albumen print
GIFT OF HARVARD UNIVERSITY
81:2377:0011

Attributed to
Charles Leander
Weed
American,
1824–1903

Bridge at the
Second Crossing of
the Truckee River,
Nevada, Central
Pacific Railroad,
ca. 1865

Albumen print
carte-de-visite
MUSEUM PURCHASE
81:3822:0068

is one such image, composed so as to take advantage of every part of its available space. (The image shown here is almost twice the size of the original print.) The photographer has achieved an improbable balance between the rigid, busy linearity of the bridge and the ideal natural setting of the river. The museum holds 68 landscape cartes-de-visite issued by Thomas Houseworth & Co. The photographer of this work is thought to be Charles L. Weed. Weed had been photographing in California since 1854 and was the first photographer in the Yosemite Valley. In 1864 Weed formed a business arrangement with Lawrence & Houseworth, precursor of Thomas Houseworth & Co., and rephotographed the Yosemite Valley with both stereo and mammoth-plate cameras. Weed continued his relationship with the Houseworth Studio throughout the 1870s and photographed widely through the American West, even traveling to Hawaii, Hong Kong, and Japan.

This stereo view of two boys fishing off the bridge at the "First Crossing of the Truckee River" has several charming features. The photographer's own shadow is visible in the lower right corner of the image, and the little white dog lends the image an unusual sense of spontaneity and presence. Research has revealed that both the dog and the shadow belonged to the photographer Alfred A. Hart, although for years this print was

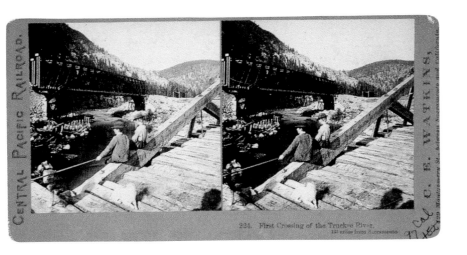

published under Carleton Watkins' name. Carleton E. Watkins knew the frustration of losing his negatives to other photographers who then sold prints of his images under their own names. But Watkins had done this as well. In the late 1860s, in what seems to have been an act of pure favoritism, Watkins was hired to be the official photographer of the Central Pacific Railroad, replacing Alfred A. Hart in that position. Starting in January 1866, Alfred A. Hart had documented the construction of the Central Pacific Railroad across the Sierra Nevada mountains to its famous juncture with the Union Pacific at Promontory Point, Utah, in 1869. These stereo negatives were turned over to Watkins when he replaced Hart, and Watkins then sold copies of this work under his own name throughout the early 1870s. The museum collection holds over 25 stereos from this series. Alfred Hart, who had been at various times a painter of portraits, landscapes, and religious scenes; a creator of panoramas; a daguerreotypist; a merchant of picture frames, engravings, and photographic supplies; as well as an author and publicist for the railroad, simply gave up photography and returned to painting for the remainder of his life.

Frank Jay Haynes made the photograph of the Cap of Liberty and Mammoth Springs Hotel in Yellowstone Park (page 222) probably no more than 15 years after William Henry Jackson's first photographs of Yellowstone helped bring international attention to that previously unknown and mysterious area. The museum holds 175 photographs,

Alfred A. Hart
American, 1816–1908

First Crossing of
the Truckee River,
ca. 1869

*Albumen print
stereograph*
MUSEUM PURCHASE,
EX-COLLECTION
RICHMOND
W. STRONG
81:6003:0002

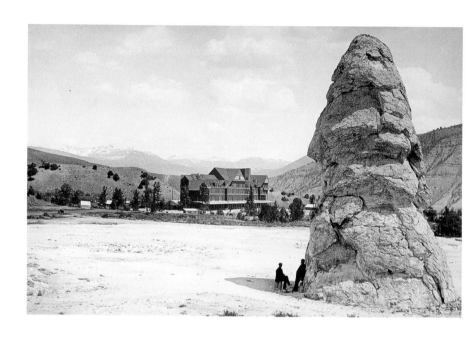

Frank Jay Haynes
American, 1853–1921

Cap of Liberty and
Mammoth Springs
Hotel, ca. 1885–1916

Albumen print
MUSEUM PURCHASE
70:0181:0004

220 stereographs, and 50 lantern slides by Haynes. Frank Jay Haynes
opened his first photographic studio in Minnesota in 1876 and began
photographing in the Yellowstone area for the first time in 1881. By then
Yellowstone had been made into a national park and was the center of a
growing tourist trade, swelled by the completion of the Northern Pacific
Railroad in 1883. Haynes became the park photographer and even built
a studio at the site of the Old Faithful geyser and worked there until his
retirement in 1916. This photograph delivers a complex message to its
viewer. First, Haynes foregrounds the startling and extraordinary scenery
of the Yellowstone area by featuring the giant cone towering over the
two human figures dwarfed in its shadow. But by placing the hotel, se-
curely nestled in the surrounding hills, in the visual center of the picture
so that the horizontal weight of that building is balanced against the
vertical thrust of the cone, Haynes delivers the message that any tourist
can enjoy this spectacular scenery in the utmost comfort.

The three photographs on pages 223 to 225 are from an album titled
North American Indians, which contains 26 photographs of Northern
Plains tribes in western Canada in the 1880s and 1890s. Nine of the
photographs of Blackfeet and Cree were taken by a Notman Studio

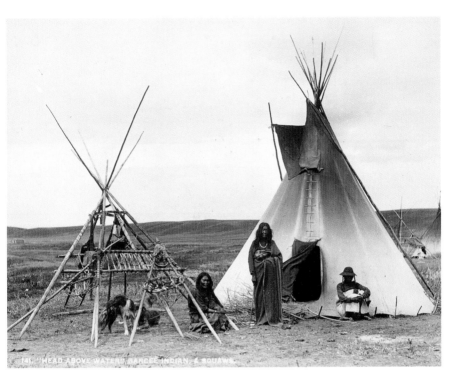

photographer. Fourteen portraits of the Sarcee Indians in Calgary, North West Territory (now Alberta) were taken by Boorne & May. In 1886 W. Hanson Boorne, an immigrant from England, set up a photography studio in Calgary with his cousin Ernest May. An 1892 article describes the gallery this way: "[Boorne & May own] a large building devoted to the production of stock photographic views and numerous specialties, souvenir albums, lantern slides, etc. Besides this, they occupy a portrait studio and art repository ... [which] is well worth a visit by tourists and other travellers,... well stocked with engravings, pictures and art goods of all descriptions, including the numberless photographic views of ranching, prairie and mountain scenery ... besides these, a large variety of articles of buckskin and beadwork, manufactured by the native Indians. ..."

Eight of Boorne's photographs of "the native Indians" are documents of the Sarcee tribe, dressed in their everyday mixture of native and Euro-pean clothing, with their teepees and dogs, camped on the prairie near

Boorne & May
Canadian, active
1880s–1890s

"Head above Water",
Sarcee Indian &
Squaws, ca. 1889

Albumen print
MUSEUM PURCHASE,
EX-COLLECTION
A. E. MARSHALL
75:0087:0008

Boorne & May
Canadian, active
1880s–1890s

Sarcee Indians, 1891

Albumen print
MUSEUM PURCHASE,
EX-COLLECTION
A. E. MARSHALL
75:0087:0014

Calgary. But seven of the photographs in the album were taken during a one-day session in Boorne's studio. These are "costume portraits" of a small group of young men posed in several contrived and stilted tableaux before a painted studio backdrop. Even the "articles of buckskin and beadwork" that they wore were probably supplied by Boorne. In one portrait two men are sitting companionably side-by-side, while a second view, shown here, presents them awkwardly posed in the melodramatic and patently fictional depiction of a fight. Boorne's Indian portraits were not made for the sitter, but for the "tourists and other travellers." So individual sitters are altered into stereotypes, and the photographic oeuvre is transformed from portraiture (where the emphasis is placed upon delineating individual character) to costume genre (where the emphasis is placed upon delineating attributes or roles thought to define the general nature of the culture).

Boorne & May

Sarcee Indian, 1891

Albumen print
MUSEUM PURCHASE,
EX-COLLECTION
A. E. MARSHALL
75:0087:0009

The 19th century thrived on such typology: the act of categorizing and classifying anything and everything – from rocks and butterflies to groups of people – then attempting to extract scientific data from these unified categories to establish guidelines for directing useful behavior, which led to such disciplines as physical anthropology. The same impulse also led to such popularized semi-scientific pursuits as phrenology. The "costume portrait" seems to fall somewhere in between anthropology and phrenology – in part hard science, in part popular scientism. These portraits may have found their way into schools and museums, where they could be used for research and teaching, but the photographer's major customers were the tourists, who collected these images like stamps to remind them of the varied and exotic peoples and places they had visited.

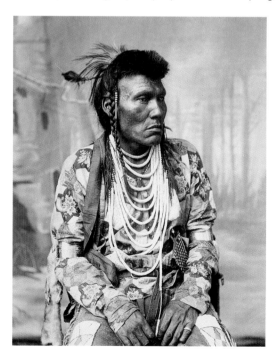

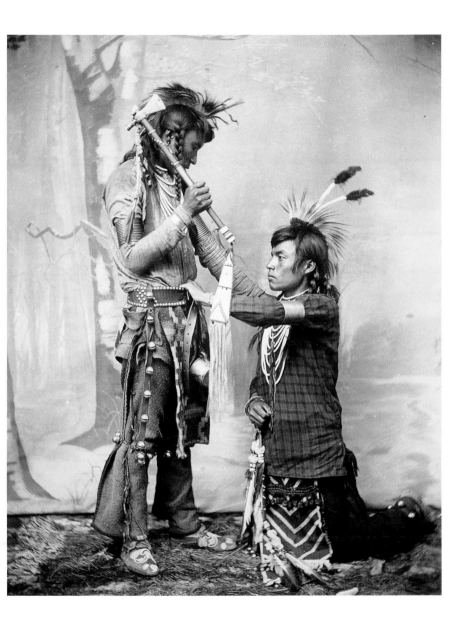

Technology and War

Technology

Philosophical instruments (right), as well as the vacuum apparatus and group of metallic barometers pictured on the following page, were all on display at the Exhibition of the Industry of All Nations held in London in 1851. Popularly known as the Crystal Palace Exhibition, it brought together a large number of consumer goods, ranging from artworks to wallpaper, crafted or manufactured by almost 14,000 exhibitors to be seen by well over 6,000,000 people during the exhibition's duration of 140 days. Almost immediately the exhibition became a key symbol defining at least one aspect of what the modern world should look like, while simultaneously solidifying the position of Britain as the leading industrialized nation. Thus the event accrued cultural, social, and even political significance far greater than its ostensible purpose. It was the first international trade fair, which by tying together art, education, and industrial

Attributed to
Claude-Marie
Ferrier or Friedrich
von Martens
French, 1811–1889 &
French, b. Germany,
1809–1875

View of East End
of Building
Crystal Palace, 1851

Salted paper print
MUSEUM PURCHASE
LIBRARY COLLECTION
90:0667:0044

Attributed to Claude-Marie Ferrier
French, 1811 – 1889

Philosophical
Instruments, 1851

Salted paper print
MUSEUM PURCHASE
LIBRARY COLLECTION
90:0667:0032

Attributed to
Claude-Marie Ferrier
French, 1811–1899

Vacuum Apparatus,
1851

Salted paper print
MUSEUM PURCHASE
LIBRARY COLLECTION
90:0667:0019

production, set a conceptual pattern for international exhibitions and fairs that continues to the present day. Almost overlooked in the success of the exhibition is that it was also a key event in Victorian socio-cultural ideology. It became an icon in the liberal/reform argument that art and education should be extended to the working classes. The project's controversial and embattled beginning, overcome only through the determination, will, and effort of the populist Prince Albert and his ministers, has slipped from many histories of this exhibition.

The exhibition produced a flurry of articles and books, many of them illustrated with hundreds of "engravings of works exhibited." And, on a "suggestion from the throne," a commemorative publication illustrated with actual photographs of the displayed objects was published in 1852 to "be forwarded to every foreign country which has participated in this universal exhibition." The museum's Menschel Library holds a copy of this lavishly illustrated four-volume work, the *Exhibition of the Works of Industry of All Nations, 1851. Reports by the Juries on the Subjects in the*

Thirty Classes into Which the Exhibition was Divided, which contains over 150 salted paper prints. Four or five photographers may have been involved in the project, though the majority of the negatives was taken by the British photographer Hugh Owen, who used the calotype process, and the French photographer Claude-Marie Ferrier, working with an albumenized glass process. Approximately 140 copies of this lavishly illustrated work were produced and distributed as commemorative gifts.

The museum holds 79 albumen prints taken between 1855 and 1857 documenting the construction of the ocean steamship officially named the *Great Eastern* but also known as the *Leviathan*. These prints are from an album of that title and are all the work of the Photographic Institution, an important London concern that fostered the publication of photographically illustrated books, owned in partnership by Joseph Cundall and Robert Howlett. The earlier images in this album were taken by Cundall and the later, more visually interesting photographs are by the younger partner Howlett. The *Leviathan* was a massive ship of 32,000 tons displacement, nearly ten times that of any other

Attributed to Claude-Marie Ferrier

Metallic Barometers, 1851

Salted paper print
MUSEUM PURCHASE
LIBRARY COLLECTION
90:0667:0038

contemporary ship, and a source of great interest, speculation, and patriotic pride for the British public. The popular press avidly followed the ship's construction, and both the *Illustrated London News* and the *Illustrated Times* published frequent articles, illustrated with wood engravings, in many cases drawn from Cundall's and Howlett's photographs. Howlett's skill as a photographer is amply demonstrated in the images on these pages. Both of these images go beyond mundane documentation or reportage. By posing Isambard Brunel, the ship's engineer and builder, in front of its huge anchor chains, Howlett found a backdrop that functions both visually and symbolically, extending the connotative and emotional range of the image. Brunel fought through enormous difficulties and against many doubters to build this ship, and his cocky confidence and indomitable will are all embodied in this portrait.

Howlett was typical of the first generation of British photographers. He, like Roger Fenton and Philip H. Delamotte, was from the upper middle class and was well educated in both the sciences and the arts. He took up photography in the 1850s first as an avocation, then as a way

Robert Howlett
English, 1831–1858

Isambard Kingdom
Brunel, Builder of
the Great Eastern,
the Largest
Steamship, ca. 1855

Albumen print
MUSEUM PURCHASE
81:1647:0079

Robert Howlett

Construction of the "Great Eastern" at John Scott Russell's Yard, Milwall, 1855

Albumen print
MUSEUM PURCHASE
81:1647:0055

to make a living, when the medium was still an exciting and new art/science and a profession worthy of gentlemanly pursuit. Howlett always preferred outdoor photography, and by the mid-fifties he was an acknowledged specialist in "instantaneous pictures," using advancements in photographic materials for a more spontaneous approach to picture-making. The museum holds 10 other landscape or architectural prints by Howlett in addition to those of the *Great Eastern* under construction. In 1856 the British painter William Powell Frith drew on Howlett's expertise when he commissioned him to photograph the crowds attending the horse races on Derby Day, which the painter later used as studies for his large painting of the same title. In 1856 Cundall and Howlett published the series *Crimean Heroes and Trophies*, taken not in the studio but at the military hospital at Woolwich.

In 1858 Howlett died suddenly at age 27; some of his friends believed

Thomas Annan
Scottish, 1829–1887

Mugdock Reservoir,
Looking towards
Glasgow, ca. 1877

Albumen print
MUSEUM PURCHASE
LIBRARY COLLECTION

that his death was hastened by overwork and his extended exposure to photographic chemicals.

Thomas Annan's Glasgow photographic studio was an important publisher of photographically illustrated books and albums from the early 1860s until after 1910. Many of these were commemorative volumes for a number of Glasgow cultural or historic organizations. George Eastman House holds over 220 photographs in five of these books. "Close, No. 193 High Street" is from an extensive documentary effort for the Glasgow City Improvement Trust, which hired Annan in 1868 to photograph buildings important "from a historical point of view" in the city's slums before they were torn down. The Annan studio published an album of 40 carbon prints in 1878 and 1879 titled *Photographs of Old Closes and Streets of Glasgow Taken 1868–1877*.

Commissions from public institutions and organizations, as well as from the developing national or international businesses, provided

Thomas Annan

Close, No. 193 High
Street, ca. 1868–1877

Carbon print
MUSEUM PURCHASE
75:0054:0009

Bisson Frères
French, active
1841–1864

The Locomotive,
"La Vaux,"
ca. 1854–1858

Albumen print
GIFT OF EASTMAN
KODAK COMPANY,
EX-COLLECTION
GABRIEL CROMER
81:1009:0003

additional sources of income for many professional photographers of
the 1850s and 1860s. They expanded their practice beyond portraiture
and landscape views to include other commercial-oriented subjects
such as architectural and industrial photographs. Howlett's photo-
graphs of the *Great Eastern* extolled Britain's shipbuilding industry,
the source of its sea power, as photographers in France and America
recorded the railroads, which were the most manifestly visible exam-
ples of new industrial engineering and commerce in these countries.
This photograph taken by the Bisson Frères, a leading professional
studio in Paris, of the sleek, streamlined, absolutely "modern" loco-
motive *La Vaux* is an example of this new type of photographic prac-
tice. This practice demanded a new kind of vision that displayed a
different, more modern character as well as a new photographic style
to convey that vision. Earlier softer, picturesque landscapes began
to give way to photographs with harder-edged compositions, sharper
delineations of space, and harsher contrasts of tonalities within the
print. This new look was perceived as being more accurate and thus
more appropriate for the new modernizing age. By the end of the
century, the hallmark of style for a professional photographer – in
portraiture as in landscape practice – was a detailed, sharply ren-
dered image.

"Paysage près du Viaduc de Chantilly" presents the viewer with the beauty of one of France's new industrial landscapes. This bridge is at once elegant and dramatic, as functional and modern as tomorrow and yet evocative of France's storied past, its arches replicating the graceful passages of the picturesque Roman aqueducts that could still be seen throughout southern France. The photograph is from the *Chemin de fer du Nord: Ligne de Paris à Boulogne* album, one of five albums in the George Eastman House collections that record the expansion of the railroads throughout France during the Second Empire. The *Chemin de fer du Nord* is an elegant album, with a printed title page and letterpress captions for 50 large and beautiful prints. It was long thought to have been solely the work of the photographer Édouard-Denis Baldus. But recent scholarship has found that though many of the views of the stations and the towns along the railway are by Baldus, others were made by Auguste Collard. Collard, self-identified as Photographe des Ponts et Chaussées (Photographer of Bridges and Roads), specialized in topographical views of the many new bridges and streets under construction in and around Paris at mid-century. He set up a photographic studio in 1856 and within a year began to document new constructions springing up around the city. The Ministry of Agriculture, Commerce, and Public Works became a major client of Collard's, and for the next

Hippolyte-Auguste Collard
French, before 1840–after 1887

Paysage près du Viaduc de Chantilly (Landscape near the Chantilly Viaduct), 1858–1859

Albumen print
GIFT OF EASTMAN KODAK COMPANY, EX-COLLECTION GABRIEL CROMER
74:0051:0018

20 years his studio produced thousands of images of bridges and viaducts for them, as well as photographs of France's growing railway system.

At mid-century Édouard-Denis Baldus was widely regarded as one of France's best photographers. He seems to have learned to make photographs around 1848 or 1849, and by 1851 he had worked out his own variant of a paper negative process. It was described as having "the clarity of glass" and possessing "a depth and vigor of tone," both attributes serving him well when he began photographing for the Commission des Monuments Historiques in 1851, the first of his many government-sponsored assignments. From 1855 to 1857 Baldus was commissioned to document the building of the new Louvre and the renovation of the Tuileries. This architectural effort was the largest construction project of the Second Empire, in the heart of a city undergoing an immense urban renewal project under Baron Georges-Eugène Haussmann's direction to build the most modern city in the world. Baldus worked on this project for several years, ultimately making over 2,000 photographs of every aspect of the construction of the Louvre. The museum holds eight albumen prints from this series as well as others located in two albums of views of Paris, one with 32 prints, the other containing 35 prints. Baldus shifted from his paper negative process to making glass negatives when he started working on the Louvre series, which allowed him to make even larger, finer-detailed, and more spectacular architectural views. These deeply impressed his contemporaries and earned

Édouard-Denis Baldus
French, b. Prussia, 1813–1889

Pavillion de Flore, ca. 1871

Photogravure print
MUSEUM PURCHASE
LIBRARY COLLECTION
76:0036:0039

him an even greater reputation. However, after the mid-sixties, support from the government and private commissions began to dwindle. The large, splendid, and expensive photographs in which Baldus specialized were replaced by smaller, cheaper stereo views, cartes-de-visite, and smaller prints to fit into tourists' albums or the picture collections of schools and libraries.

From the 1860s to the early 1880s, Baldus invested a great deal of his time, energy, and money into perfecting a functional photogravure printing process to publish his work for a larger audience. He produced several volumes of works illustrated with his photogravure prints, including two of his three portfolios now in the museum's collections, titled *Palais du Louvre et des Tuileries,...* published in 1871 and containing 140 "heliogravures." But this work was not financially successful. By 1887 Baldus had to sue for bankruptcy, having already turned most of his stock of prints and plates over to his son-in-law. Baldus died in December 1889 in a suburb of Paris at age 76. Neither the photographic nor the national

Édouard-Denis Baldus

The Louvre, Detail, Windows of Upper Story, ca. 1855

Albumen print
GIFT OF EASTMAN KODAK COMPANY, EX-COLLECTION GABRIEL CROMER
74:0050:0001

Delmaet & Durandelle
French,
active 1862–1890

Construction of the Paris Opera, ca. 1866–1870

Albumen print
GIFT OF EASTMAN KODAK COMPANY, EX-COLLECTION GABRIEL CROMER
80:0099:0017

press recorded his death; his magnificent achievements of the 1850s and 1860s were forgotten even within the photographic community, which his vision had once so much impressed and influenced.

Despite a popular and persistent tradition (dating at least as far back as Gaston Leroux's 1910 novel) that insisted that the Paris Opera was inhabited by phantoms, the ghostly image inhabiting the lower corner of this photograph is no more than an employee who is working hard, thereby moving just a little too quickly to be fully captured by the slow photographic chemicals of the 1860s. On the other hand, the young man stiffly facing the camera in the middle of the image, and the others scattered across the iron girders of the Paris Opera's new roof, have managed to stay still long enough to be captured clearly for posterity.

Charles Garnier's Paris Opera is a major monument of European architecture. In 1862 Louis-Émile Durandelle, of the Parisian firm of Delmaet & Durandelle, began to photographically document key phases of the construction of this edifice. In 1865 this documentation expanded

Delmaet & Durandelle

Construction of the Paris Opera, Column Capital Detail, ca. 1866–1870

Albumen print
GIFT OF EASTMAN KODAK COMPANY, EX-COLLECTION GABRIEL CROMER
80:0099:0020

to include a comprehensive and exacting delineation of the many architectural flourishes and sculptures created to decorate the building. This was done apparently at the pleasure of the architect, who felt that once all the decorative fancies were put into their locations on the facades and ceilings, they would be hard to see and difficult to study.

Durandelle continued this documentation for 10 to 12 years, making approximately 200 photographs during this interval. Fifty of these photographs are in the museum's photography collection. Eventually, the architect Garnier wrote *Le Nouvel Opéra de Paris*, published in eight volumes from 1875 to 1881. It consisted of two volumes of text, two engraved and lithographed picture atlases, and four volumes containing 115 of

Louis-Émile Durandelle
French, 1839–1917

School for Infants, ca. 1885

Albumen print
MUSEUM PURCHASE
78:0693:0006

Durandelle's albumen prints of the sculptured decorations. Durandelle's studio made many similar documents of new public and private construction projects throughout Paris until his retirement in 1890.

These two images are from a group of photographs made by the Louis-Émile Durandelle studio in 1882 for Eschager Ghesquiere & Co., an industrial foundry located in northern France. George Eastman House has seven of these albumen prints, all of them large (in the range of 17 x 21 inches) and mounted on identical 24 x 28-inch boards with descriptive letterpress titles. The identifying series title for the group is *Fonderies et Laminoirs de Biache St. Vaast*. The large size, the texts, and the uniform presentation of the pieces all indicate that this body of work was designed for public display, either in the offices of the manufacturing company or in one of the large international industrial exhibitions that were held every few years throughout the century in France and the other major industrial countries.

Five of the prints in the museum's collection are either interior shots or exterior views of the company's factory buildings, while the other two depict company-built "workers' housing" and a "school for infants," pictured here. The latter decades of the 19th century saw the spread of many social and political problems stemming from industrialization. Both private and public sectors were brought into play in an attempt to eradicate or alleviate some of these ills. Political parties evolved, social reform movements were initiated, and organizations and institutions were formed and implemented to establish child labor laws and provide better education, health care, and appropriate housing for workers. Throughout Europe and America, certain progressive companies pioneered in addressing these issues, and it may well be that Eschager Ghesquiere & Co. was one of them, and further, was proud enough to hire a photographer to record their efforts.

Louis-Émile Durandelle

Bancs à étirer (Extrusion Benches), ca. 1885

Albumen print
MUSEUM PURCHASE
78:0693:0001

L. Lafon
French, active
ca. 1870s

Canon Hotchkiss à
tir rapide de 37 m/m
(Rapid-Fire 37mm
Hotchkiss Cannon),
1879

Albumen print
MUSEUM PURCHASE,
EX-COLLECTION
PHILIP MEDICUS
81:1191:0001

L. Lafon

Matériel de mon-
tagne, système
Hotchkiss (Military
Equipment for the
Mountains, Hotch-
kiss System), 1879

Albumen print
MUSEUM PURCHASE,
EX-COLLECTION
PHILIP MEDICUS
81:1191:0019

The images of a man aiming the rapid-fire Hotchkiss cannon and a stuffed mule bearing the weight of a packed Hotchkiss mountain gun are from a portfolio of 25 photographs depicting the factory and products of the Hotchkiss armaments company of Paris. The view of the gas and steam works is from a group of 15 photographs depicting the various buildings of the U. S. Naval Academy. These prints represent the evolution of commercial photography from its documentary roots using photographs as vehicles for advertising. Twenty or thirty different views of a subject could be made in the time it took a draftsman to make one or two, and photographs possessed the virtue of containing more complete and more accurate information than any artist could hope to capture. Entrepreneurs began to collect groups of photographs into albums to present more persuasive narratives about whatever they wanted to sell. Initially the purview of governments or international industries, this practice moved quickly into the hands of local photographers who soon were at the service of local businessmen.

Fischer & Brothers
American,
active 1850s–1860s

Gas and Steam
Works, U. S. Naval
Academy, ca. 1860

Salted paper print
GIFT OF ALDEN
SCOTT BOYER
80:0273:0003

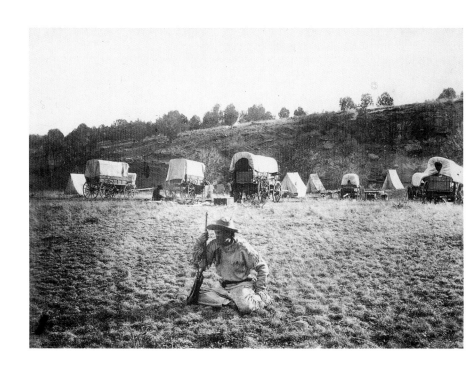

Dr. William A. Bell
English, 1839–1915

Camp of Surveying
Party at Russel's
Tank, Arizona,
ca. 1867–1868

Albumen print
MUSEUM PURCHASE
70:0075:0032

This buckskin-clad young man leaning on his new carbine rifle is kneeling at Russel's Tank, Arizona, exactly 1,271 miles west of the Missouri River. The people perched on the train sitting on the bridge crossing a wash near Fort Harker, Kansas, are 216 miles west of the Missouri River. And the bridge shown on page 246 is crossing Muddy Creek, Kansas, at a spot 162 miles west of the Missouri River. This detailed information giving the exact location where each of these photographs was taken is included in the letterpress on the mount of each print in a series published by Alexander Gardner in 1868 under the title *Across the Continent on the Kansas Pacific Railroad*. The museum has 39 photographs from this series. In its entirety, the series may have contained as many as 127 prints.

In 1867 Alexander Gardner was hired as the chief photographer for the Union Pacific Rail Way, Eastern Division, renamed the Kansas Pacific Railroad, and still later reborn as the Union Pacific Railroad. Gardner, his son Lawrence, and his friend and fellow photographer William Pywell all left Washington, D.C., for Kansas in September 1867 where

they, using both stereo and larger view cameras, photographed along the route of the railroad until mid-October when they returned to Washington. They included in their views the railroad, new boom towns such as "Hays City, Kansas, Aged Four Weeks," the cattle stockyards of Abilene, and marks of "civilization" along the way including "St. Mary's Mission, Kansas, Pottawatamie Indian School," as well as the open prairie landscapes they found along the way. At about the same time, a British physician named Dr. William A. Bell, hired by a different railroad official, had joined the engineering party surveying the best route for a transcontinental railroad along a southern route from Kansas to California. Bell photographed with this survey as it made its way west, following the 32d parallel from Kansas to New Mexico, then through Arizona into California. As was customary practice, Bell's photographs were turned over to Gardner, who, as chief photographer for the railroad, published both bodies of work as a single sequence of views under his own name.

Alexander Gardner
American, b. Scotland, 1821–1882

View Near Fort Harker, Kansas, 216 Miles West of Missouri River, ca. 1867–1868

Albumen print
MUSEUM PURCHASE
70:0075:0019

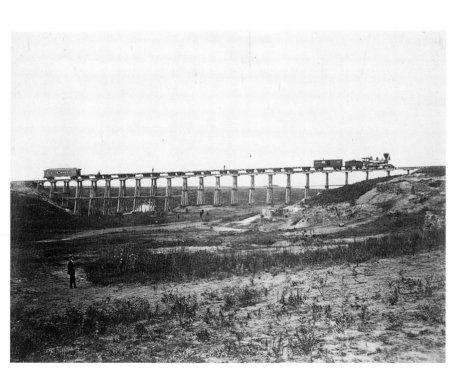

Alexander Gardner
American, b. Scotland, 1821–1882

Muddy Creek, Kansas, 162 Miles West of Missouri River, ca. 1867–1868

Albumen print
MUSEUM PURCHASE
70:0075:0015

The "O. & C. R. R., Loop Showing Three Trestles ..." is one of almost 300 photographs by the Isaiah West Taber Studio that are now housed at George Eastman House. Trestles, bridges, even looped tracks climbing difficult mountain passes became common icons in the genre of railroad scenic views. This photograph is a stark illustration of the conflicting national ideals that 19th-century Americans faced in a land that was being changed daily by the spread of industry and technology. The rolling waves of mountains in this view would remind many of Taber's contemporaries of the spectacular natural beauty of their country. They would also have responded with great pride to this pictorial evidence of the American engineering skills and the national drive that subdued the most rugged frontier and bent it to the service of mankind. The railroad became one of the most common icons symbolizing the power of modern technology. This photograph, like the ideology that produced it, skillfully keeps these two potentially incompatible ideals in a tenuous balance.

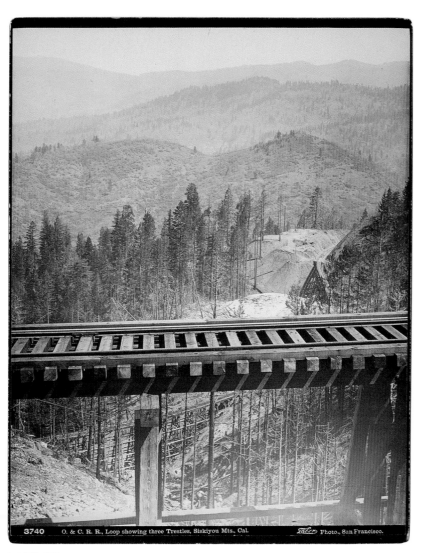

3740 O. & C. R. R., Loop showing three Trestles, Siskiyou Mts., Cal. *Taber* Photo., San Francisco.

Isaiah West Taber
American, 1830–1912

O. & C. R. R., Loop Showing Three Trestles,
Siskiyou Mts., Cal., ca. 1885

Albumen print
GIFT OF ALDEN SCOTT BOYER
81:2266:0002

William H. Rau
American, 1855–1920

Broad Street Station, Pennsylvania Railroad, Philadelphia, Pennsylvania,
ca. 1892

Modern gelatin silver print from original gelatin on glass negative, 1978
GIFT OF 3M COMPANY, EX-COLLECTION LOUIS WALTON SIPLEY
78:1267:0003MP

These two photographs are modern prints made from "mammoth" 18 x 22-inch glass plate negatives taken by William H. Rau about 1891 as part of his commission to document the Pennsylvania Railroad. The museum holds 11 variously sized glass plate negatives of railroads taken by Rau in the 1890s. The dramatic, swooping black curve in the sky of the image on page 249 is a reminder of the sad fate suffered by many glass plate negatives. Of the 650 plates Rau made for this project, only 11 are extant, all of which are held in the museum's collection.

In 1891 Rau was hired as the official photographer for the Pennsylvania Railroad and tasked with the mission to document "The Greatest Highway to the West," including the associated scenery, adjacent towns and cities, industries and businesses along its routes, as well as the railroad's rolling stock and stations. This work was first exhibited at the World's Columbian Exposition in 1893. The railroad furnished Rau with his own train and a specially designed photographic car with a living and working area, a darkroom (including a 300-gallon water tank), and space to store the glass plates, large cameras, and other equipment and supplies he used on these trips. A large platform was added to the roof of Rau's car to enhance the expansiveness of his views.

Rau began photography at age 13 as William Bell's assistant in Philadelphia, and learned photography so proficiently that by 1874, at only 19, he accompanied the United States Scientific Expedition to Chatham Island in the South Pacific off the coast of New Zealand to photograph the transit of Venus across the face of the sun. This expedition lasted well over a year, with the photographers using wet plates and requiring "tons of materials." Rau worked for Edward Wilson's Centennial Photographic Company at the great exhibition in Philadelphia in 1876, and then as an operator in studios in Philadelphia before moving to Colorado in 1881 to work for William Henry Jackson, photographing landscapes in Colorado and in New Mexico. In 1881 and 1882, Rau accompanied Edward L. Wilson on a well-publicized photographic tour to the Middle East when, as he later said, "... the weight of glass (dry plates) and outfit for 1,800 negatives was about 2,000 pounds...." By 1887 Rau, with a wide range of photographic experience, established himself as one of the leading photographic businesses in Philadelphia, where he continued to receive major commissions to photograph several railroads and international expositions. His prolific career stretched into the early decades of the 20th century.

Roger Fenton
English, 1819–1869

Plains of Balaklava,
1855

Salted paper print
MUSEUM PURCHASE,
EX-COLLECTION
ALDEN SCOTT BOYER
81:1238:0001

Crimea

This view of the desolate and barren plains of Balaklava is one of 91 salt-
ed paper prints at George Eastman House taken by Roger Fenton in the
Crimea in 1855. The Crimea was the major battleground of the war being
fought between Russia and the allied forces of England, France, and
Turkey. The war began in the spring of 1854 when the Russians crossed
the Danube into the Ottoman Empire, drawing England and France into
the conflict to protect the balance of power in the Balkans. In Septem-
ber 1854, in "one of the most gigantic military movements ever under-
taken," the allied armies launched an invasion force of 600 ships carry-
ing 57,000 troops into the Crimea. The forces secured the harbor of
Balaklava, then after a series of inconclusive battles, fell into the stale-
mate of a siege war punctuated with sharp, bitter, bloody skirmishes
lasting through the winter into 1855. Disease and exposure caused great
hardships for the ill-equipped allied troops, killing more soldiers than
enemy fire. The British public, informed of these problems by the first
newspaper war correspondents, began to question the policies and
leadership of the military and the government.

Other attempts had been made by the British government to attach a photographic unit to the Crimea Expedition, the first floundering when a hurricane sank the ship with all hands, the second when the hastily trained army officers could not master the extraordinary technical difficulties of photographing in inhospitable conditions. Finally the army approached the newly formed Photographic Society in London for help, and Roger Fenton, a leading force in British photography at the time, volunteered to go to the Crimea. He obtained financial support from Thomas Agnew & Son, a publisher of illustrated works on current events, and official support from both the Crown and the Secretary of War. Fenton then had a photographic van built, hired an assistant and a cook, furnished his expedition with 36 large crates and chests of equipment and supplies for the wet-collodion process he chose to use, and sailed for Balaklava in February 1855 where he became one of the first war photographers.

Fenton overcame many extreme difficulties in the Crimea, ranging from photographing at dawn to prevent his developing baths from boiling in the intense heat to avoiding the fire of the Russian artillery attracted to his distinctive and mysterious photographic van. He also had to face the more mundane, but still difficult, problems of finding a means for transporting his bulky van and supplies in a horse-starved army in chaos, or the harassment of British troops wanting to have their portraits made by this new and strange phenomenon in their midst. Fenton photographed the allied forces from March to the end of June before returning to England. Racked by the cholera that had already killed many British soldiers, Fenton was forced to leave Crimea before the decisive final battle for Sebastopol. Upon his return to England, Fenton found himself heralded as a celebrity. He was presented to the queen and, due to his illness, allowed to recline on a couch during the royal interview. His unprecedented photographs were displayed in several exhibitions that received extensive critical and popular acclaim. Thomas Agnew & Son began issuing sets of original prints mounted on boards with letterpress captions on a weekly basis from November 1855 to April 1856. The photographs gained even greater public attention when published as wood engravings in illustrated weekly magazines in England and America.

The museum's collection offers an unusual opportunity to see something of the range of Fenton's practice in the Crimea. Fenton made several types of photographs, including a series of formal or semiformal portraits of the military and political leadership of the allied forces.

These portraits compare favorably with the better studio portraiture of the day, in Fenton's ability to bring out the character of a sitter. They are otherwise distinguished by the photographer's care to fully illustrate the various allied forces that had come together on Crimea's barren plains. Taken out-of-doors, the second type of portrait appears more spontaneous. These portraits combine the veracity of the surrounding scene – the forceful truthfulness of the tents or rock huts under the harsh sun – with a slight degree of posing or role-playing by the subjects portrayed. Attempting to provide a fuller narrative of the war, Fenton created tableaux of valorous generals and soldiers, the camaraderie of the campsite during meals, and the tedium of standing watch, as seen here in "A Quiet Day in the Mortar Battery."

Fenton's Crimean landscapes are again divisible into several related categories. The first are views of the occupied port, the campsites of the various military forces, and British fortifications. These are, in a sense, news pictures designed to satisfy the public's curiosity about scenes and events that they had read about in the newspaper dispatches. Fenton also made some very distant views of the besieged city of Sebastopol and the surrounding terrain. These images set the "scene" of the conflict, and are handled with Fenton's usual consummate skill as a landscape photographer. Fenton captured with quiet drama the sweep and scale of this arid land with its vast, harsh skies. He was thus able to bring to his British audience, at home in the picturesque and verdant landscape of the British Isles, something of the inhospitable conditions of this foreign land and the tumultuous conflict that had cost so many British lives.

Roger Fenton
English, 1819–1869

General Bosquet, 1855

Salted paper print
MUSEUM PURCHASE,
EX-COLLECTION
ALDEN SCOTT BOYER
81:1238:0041

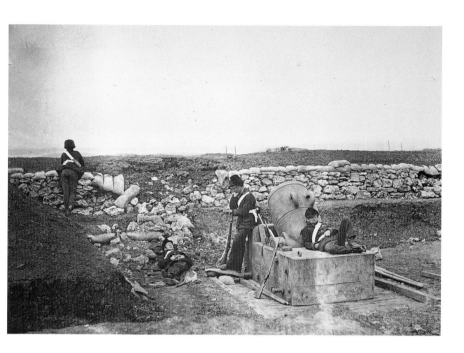

Fenton did not take any battlefield photographs of the dead, dying, or wounded soldiers. Nor did he take photographs of the hospitals or of the sick soldiers. Fenton's report of this war is singularly bloodless. This has raised the unanswerable question of whether this was done from some Victorian sensibility about what was proper to display in a public medium that would be seen by women and children, or whether Fenton worked as an apologist for the British government.

It is clear from all sources that Fenton's intent was to provide, as much as he could with his limited photographic technology, illustrative documentation of the peoples, places, and events of the war. His report was primarily intended to inform the citizenry about what was happening to everyone's fathers or sons in a distant land and to shape public opinion. In this sense, Fenton assumed the mantle of "public witness" – one who sees and reports events not through the focus of his individual perception, but rather as an observer, a stand-in for the general polity. Fenton was working in an age when photography's role as a mode of journalism was in the process of being forged, and national propaganda was one of its earliest applications. The public's strong belief in the "objective truth

Roger Fenton

A Quiet Day in the Mortar Battery, 1855

Salted paper print
MUSEUM PURCHASE,
EX-COLLECTION
ALDEN SCOTT BOYER
81:1238:0052

of photography" was fundamental to this type of journalistic practice. Perhaps it is easy for the contemporary viewer to overlook what may have been the most important quality of this work to its public, an audience that received most of its war news in the form of rhetorical, jingoistic prose or in overdramatized, romantic sketches and wood engravings. For all of its propagandist intent, the banal, unfinished, rough honesty of Fenton's views and portraits would have been revelatory of war's harsh realities.

These two photographs show the aftermath of war, though they were taken sufficiently after the battles so that the dead and wounded had already been removed. While "The Battlefield of Tchernaya" relies on its title to help the viewer comprehend the full range of emotional dimension that this otherwise deceptively bland landscape might convey, there is no chance of mistaking that some horrific event has visited the site of "The Barracks Battery." The tumbled cannon, the chaotic disarray of the scattered objects tell by themselves that some disaster has occurred. The photographs of this conflict by the British photographer James Robertson are drawn from a group of 59 salted paper prints in two albums held at George Eastman House, both albums originally having been in the possession of British military personnel who had served

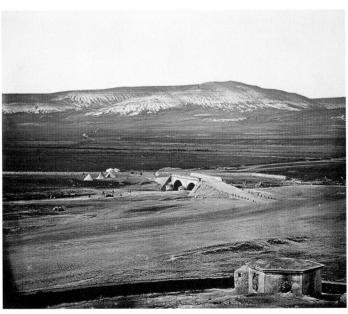

James Robertson
English, 1813–1888

The Battlefield of
Tchernaya, ca. 1855

Salted paper print
GIFT OF EASTMAN
KODAK COMPANY,
EX-COLLECTION
GABRIEL CROMER
79:0001:0037

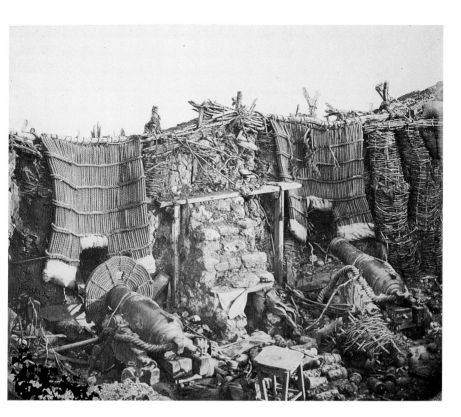

in the Crimea. Just after Roger Fenton had become ill and returned to England in September 1855, the war's long stalemate broke, and Sebastopol finally fell to the allied forces. James Robertson had joined his partner Felice Beato in the Crimea that summer, arriving from Constantinople, where he had been sketching and photographing troops at the major allied staging center for the Crimean campaign. Robertson was able to photograph the overrun Russian positions around Sebastopol and the gradual disbursement of the armies from the regions as the "Russian War" gradually dragged to an inconclusive and ragged end in 1856. A few of Robertson's views of Sebastopol were exhibited along with Fenton's in London in 1856. Robertson's work was also used to illustrate several books published about the war, including Henry Tyrrell's *The History of the War with Russia* and *Report on the Art of War in Europe in 1854, 1855, and 1856,* by Colonel Richard Delafield, U. S. Army.

James Robertson

The Barracks Battery, 1855

Salted paper print
GIFT OF EASTMAN KODAK COMPANY, EX-COLLECTION GABRIEL CROMER
79:0001:0045

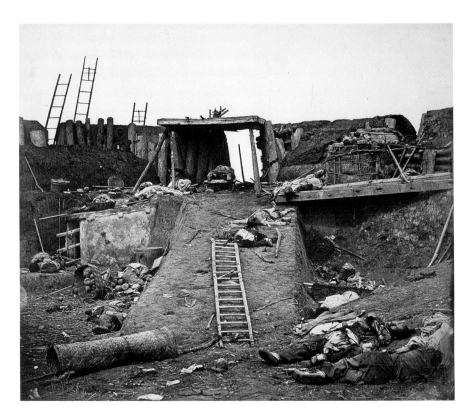

Felice A. Beato
British, b. Italy
ca. 1830–ca. 1906

Interior of English
Entrance. – Taku,
1860

Albumen print
MUSEUM PURCHASE
76:0134:0005

The Opium War
In March 1860 Felice Beato sailed from Calcutta for Hong Kong with
General Sir Hope Grant, commander of the British forces, to join the
Anglo-French Expeditionary Force marshaling to invade China. This mili-
tary invasion by allied British and French troops carried by warships and
transports was launched in late July against the fortress at Pei-tang
(Beitang) which fell on August 1. The allied forces then marched inland,
storming and taking T'ang-ku (Tanguu) Fort in mid-August, and moving
against the Taku (Dagu) forts, which formed the major line of defense for
the Chinese capitol of Peking (Beijing). On August 21 the Taku forts were
attacked. Under intense shelling, an ammunition magazine in the North
Fort exploded, breaching the walls, and the fort was taken. A contempo-
rary wrote that British troops entered the fort to "… a distressing scene
of carnage … with groups of dead and dying meeting the eye in every

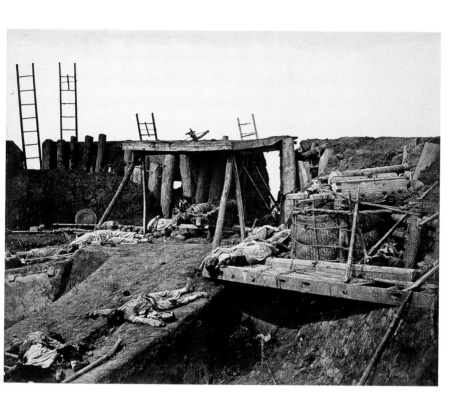

direction. ..." This was the horrifying scene that Beato encountered, as reproduced in the two images on these pages. They are among the seven views of this engagement that are owned by the museum, along with four other pictures taken by Beato in China during the course of the expedition. The allied forces continued on, taking and burning the emperor's summer palace outside of Peking, before the Chinese forces surrendered. Beato photographed both Allied and Chinese notables during and after the treaty discussions as well as views around Peking before returning to Hong Kong in mid-November. In all, Beato may have taken up to 95 photographs documenting the Anglo-French expedition, which brought what is variously known as the Second Opium War, or the Arrow War, to a conclusion. Beato also made approximately 200 stereo views of Canton, which were sold in England by the British stereoscopic firm Negretti & Zambra.

Felice A. Beato

Interior of Fort Taku Immediately after Capture, 1860

Albumen print
MUSEUM PURCHASE
75:0034:0004

Various photographers
American, active
1860s

*Panel of Cartes and
Tintypes, Received by
Post Office Dead Let-
ter Office,* 1861–1865

*Albumen prints
and tintypes*
MUSEUM PURCHASE,
EX-COLLECTION
PHILIP MEDICUS
85:1103:0001–35

The American Civil War

Scores of photographers were active during the American Civil War, most of them in temporary studios set up at the military encampments, where they made and sold inexpensive tintype or carte portraits of soldiers. The soldiers sent their portraits home to their loved ones and friends, and waited for similar portraits of their wives and children in the return mail. This was the most common use made of photography during this war.

This panel of photographs, comprised of cartes and tintypes received by the U.S. post office's dead letter office, is itself a poignant, haunting message of missed communications and lost hopes. In an age of high infant mortality, incurable diseases, and early death, and during a time of an uncertain and bloody war, each of these men was performing, however ritualistically, an act of mingled courage and fatalism: "I was here. Remember me when I'm gone." The literature of the age makes it all too clear how the memorializing function of photography was often

Unidentified photographer
American, active 1860s

U. S. Grant, ca. 1862

Albumen print
MUSEUM PURCHASE, EX-COLLECTION
CHESTER A. PHILLIPS
85:1081:0001

CAMP WINFI

Entered according to act of Congress, by GARDNER & GIBSO

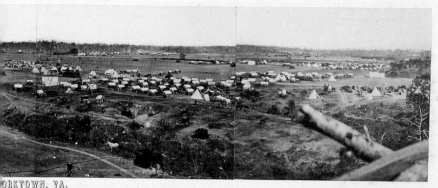

YORKTOWN, VA.
District Court of the United States for the District of Columbia.

called into service to commemorate a loved one's presence, no matter how fleeting, in this uncertain world.

Although hundreds of individuals photographed various aspects of the Civil War, the majority of the photographic documentation of the armies in the field was in the hands of a few dozen men. An even smaller number had the skills, determination, and opportunity to actually photograph events taking place between the two battling armies. Photographic processes were simply too slow and the equipment and procedures too cumbersome to record the heated exchange of battle, focusing instead on its prologue and aftermath. Still, a few photographers found the means to extend their craft beyond anything previously thought possible to bring a larger and more significant range of the experience of civil conflict under the camera's deliberate eye.

Alexander Gardner, James Gibson, and George Barnard were among the first and most capable of these photographers. Gardner & Gibson's panoramic view of Camp Winfield is an image made up of five separate negatives taken by Gibson in May 1862 during General McClellan's abortive Peninsula Campaign. In order to capture the sweeping dimensions of the military encampment, Gibson placed his camera on a hilltop and made a series of overlapping views across the face of the camp. Prints were then made from these negatives by Gardner, who positioned them and trimmed the prints to create an almost seamless panorama of McClellan's bivouacked troops.

Though portraits of soldiers posed with their weapons were common during the war, George Barnard's photograph on is more memorable

**Alexander Gardner &
James F. Gibson**
American, b. Scotland, 1821–1882 &
American, b. Scotland, 1828/9

Camp Winfield
Scott, Yorktown, Va.,
May 1862

*Albumen print
panorama*
MUSEUM PURCHASE,
MILLER-PLUMMER
FUND
86:0564:0001

George N. Barnard
American, 1819–1902

Fort Richardson, at
Quarleshouse, near
Fair Oaks, June 1864

*Albumen print
carte-de-visite*
MUSEUM PURCHASE,
EX-COLLECTION
PHILIP MEDICUS
82:0561:0012

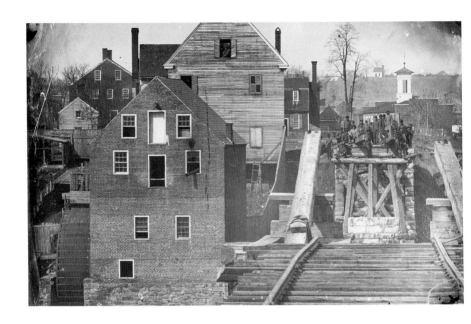

**Attributed to
Andrew J. Russell**
American,
1830–1902

Fredericksburg
End of Bridge,
December 13, 1862

Albumen print
MUSEUM COLLEC-
TION, BY EXCHANGE,
EX-COLLECTION
A. HYATT MAYOR
81:1081:0001

than most. By placing himself on a diagonal to the subject, by fore-grounding and cropping the cannon against the edge of his picture, by achieving a balance between the soldier holding the ramrod and the other soldiers scattered throughout the picture, Barnard has created a scene with a sense of impending action, a photograph not only of what was, but what was to come.

Nearly all of the best photographers of the Civil War were civilians. Captain Andrew J. Russell was an exception. In 1862 Russell enlisted in the 141st New York Volunteers and was assigned to the U.S. Military Railroad Construction Corps. Here Russell documented the bridge-building activities, railroad construction techniques, as well as the troops, battlefields, and the carnage of war. His technical skill, artistic sensibility, and dedicated workmanship provided some of the most enduring documentation of the war, including many striking photographs of the new technologies of transportation. Russell photographed at Marye's Heights during the battle of Fredericksburg, and at Petersburg, Alexandria, and the fall of Richmond. This view was taken at Fredericksburg during a lull in the siege. The close proximity of the armies is emphasized by Russell as he and his camera stand at the

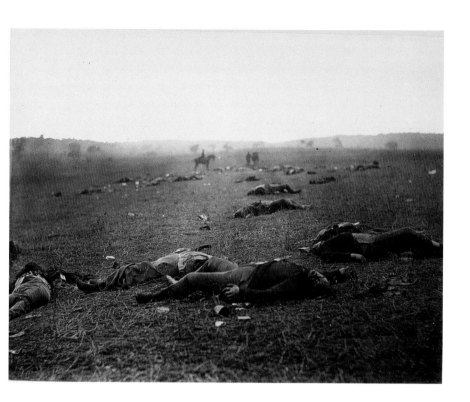

abrupt end of a damaged bridge, looking towards the town and the enemy troops that the Union army would soon engage. Russell's disjunctive positioning of the bridge and the stepladder arrangement of buildings with their constellation of windows flattens the compositional space while accentuating the anticipatory tension of battle.

This horrifying litter of bodies is the wrack left by the "high tide of the Confederacy" at Gettysburg. The bodies in this field mark the end of any further chance of offensive war by General Robert E. Lee's Army of Virginia and, effectively, the end of any hope of Confederate victory. The war would go on for almost two more years and kill many more young men, but its final result was determined here, during three days in July 1863.

It was unusual that Alexander Gardner and his employees Timothy O'Sullivan and James Gibson were nearby during the battle, as this war was not fought for the convenience of photographers. Gardner, learning

Timothy H. O'Sullivan
American, b. Ireland, 1840–1882

A Harvest of Death, Gettysburg, Pennsylvania, July 1863

Albumen print
MUSEUM PURCHASE
81:0004:0036

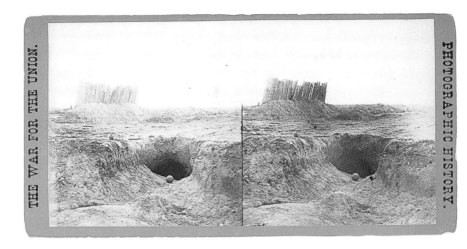

**Attributed to
Thomas C. Roche**
American,
1826/7–1895

Fortifications and
Bomb-Proofs, in
Front of Peters-
burgh, Va., 1865

*Albumen print
stereograph*
81:6547:0002

that a major battle was imminent near the school where his teenage
son was boarded, had rushed to Gettysburg to rescue his son, then
waited nearby for the battle to conclude. His group began to photograph
the battlefield immediately after the Union victory, before the dead
were buried and the debris of the battle was cleared away. This is the
second major battle aftermath that Gardner and his team had docu-
mented, and their photographs display the tragedy of war with great
force and immediacy.

In 1912 Thomas C. Roche was described in the *Photographic History of
the Civil War* as "... an indefatigable worker in the armies' train ...", but
scant other information is given. Roche was remembered with fondness
in a brief article written in 1882 by Captain Andrew J. Russell reminiscing
about the Civil War. Little else has been written about this important war
photographer, although throughout his lifetime he was always regarded
with great respect by his peers. Roche worked for E. & H. T. Anthony &
Co. as the war was starting and then worked with the Brady studio and
Alexander Gardner, perhaps as a consultant on the carte-de-visite print-
ing arrangements then in effect between the Anthony Company and the
Brady Studio. But Roche was soon photographing under General Meigs
in the Quartermaster Corps and may have worked with Captain Andrew
J. Russell later in the war. It is known that Roche photographed the bat-
tle of Dutch Gap Canal while under cannon fire and that he made pow-
erful images of dead Confederate soldiers in the trenches at Petersburg

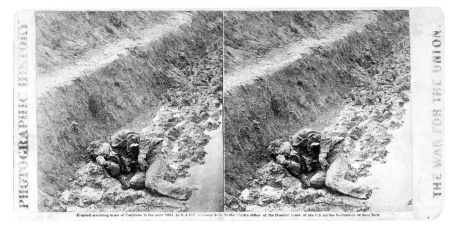

after it fell to the Union forces in April 1865. The Anthony Company printed these and others of Roche's stereo photographs throughout the war.

The stereo cards from the series *The War for the Union* printed on these pages are two of approximately 120 stereos depicting the war that are held by the museum. They forcefully display the quality most often remarked upon by Roche's contemporaries when viewing battlefield scenes – that photographs display the real, unglamorous face of war. Critics were impressed by the insistent factuality of photography and always came away from their viewing experiences in a somber frame of mind. It seems fairly certain, from many of the documents of the day, that the average American citizen had little notion that the Civil War would be so long, so difficult, and so devastating. Further, it seems clear that most Americans had little understanding of what war actually meant, and throughout the conflict their ideas about warfare evolved and changed. Certainly the patriotic rhetoric and romantic sentiment about the glamour of fighting for one's country and defending one's ideals was replaced by a more sober outlook as the war dragged on. An increasing demand by the American citizenry for more accurate and more factual descriptions of the war led to an expanded use of photography in the illustrated press by the end of the war, even though the photograph had to be translated into wood engravings to be printed. This same desire to better understand the grim reality of war's events is what helped to fuel the popularization of stereo cards, cartes, and albums.

Attributed to Thomas C. Roche

A Dead Rebel Soldier, As He Lay in the Trenches of Fort Mohone, 1865

Albumen print stereograph
GIFT OF 3M COMPANY, EX-COLLECTION LOUIS WALTON SIPLEY
79:1484:0046

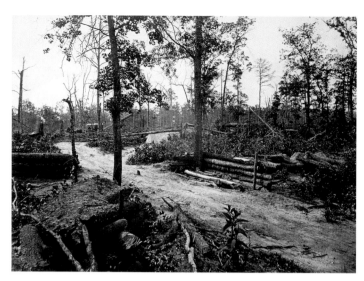

George N. Barnard
American, 1819–1902

Battle Field of New
Hope Church,
Georgia, 1866

Albumen print
MUSEUM PURCHASE,
EX-COLLECTION
PHILIP MEDICUS
81:0001:0025

George N. Barnard

Rebel Works in Front
of Atlanta, Georgia,
1864

Albumen print
MUSEUM PURCHASE,
EX-COLLECTION
PHILIP MEDICUS
81:0001:0041

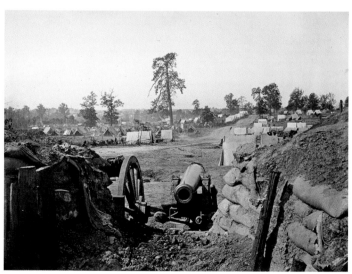

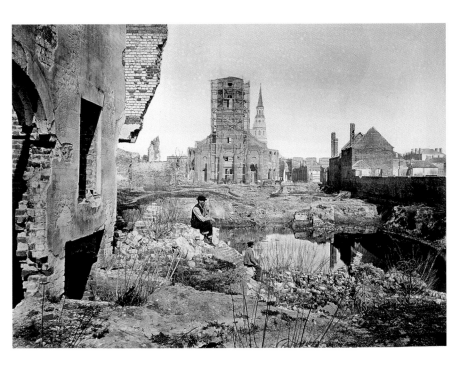

These three views are from a book published by George Barnard in 1866 commemorating General William T. Sherman's famous march to the sea. Attached to Sherman's command in 1864, Barnard photographed the fall of Atlanta, then followed Sherman's troops on their dash across Georgia to join with other federal forces in Savannah. That campaign moved too fast for Barnard to be able to take photographs, but he conceived the idea of combining some of his existing photographs with others that he would take on a return trip over the same route after the war. Barnard and his assistant, James W. Campbell, spent the spring of 1866 photographing sites of skirmishes and battles that he had not been able to take before. This elegant publication contains 61 large, beautifully crafted prints – some of them with clouds carefully overprinted onto the blank skies – organized to follow the army's course from Nashville, Tennessee, to Atlanta, Georgia, then on to Charleston, South Carolina, and ending symbolically at nearby Fort Sumter, where the war began.

The life and death of President Abraham Lincoln was portrayed to Americans in diverse popular genres, including mechanical lantern

George N. Barnard

Ruins of Charleston, S. C., ca. 1865

Albumen print
MUSEUM PURCHASE, EX-COLLECTION PHILIP MEDICUS
81:0001:0060

Alexander Gardner
American, b. Scotland, 1821–1882

Lewis Payne [*sic*], One of the Lincoln
Conspirators before His Execution, 1865

Albumen print
MUSEUM PURCHASE
72:0033:0032

Alexander Gardner
American, b.
Scotland, 1821–1882

Execution of the
Lincoln Assassina-
tion Conspirators.
The Scaffold, 1865

Albumen print
MUSEUM PURCHASE
72:0033:0023

slides (see page 268) and photographic albums. *The Lincoln Conspiracy*, an album compiled by retired Colonel Arnold Rand, 4th Cavalry Regiment of Massachusetts Volunteers, contains wood engravings and lithographs relating to Lincoln's assassination and the search, trial, and execution of the conspirators. Of particular note is a group of 25 photographs by Alexander Gardner and his assistants, made during the harrowing period following Lincoln's death.

During the course of the war, Alexander Gardner left Mathew Brady's studio to set up his own rival business in Washington, D.C. He gathered a small corps of the best war photographers around him and amassed an extensive document of the war. As a result, Gardner had established an excellent reputation among his peers and among the political and military leadership in Washington. It was because of this that he was asked by Colonel Lafayette Baker, chief of the Secret Service, to record the complex and difficult events following Lincoln's assassination.

The portrait of conspirator Lewis Payne [*sic* Paine] (page 269) was taken aboard the naval monitor U.S.S. *Saugus,* where he was held after

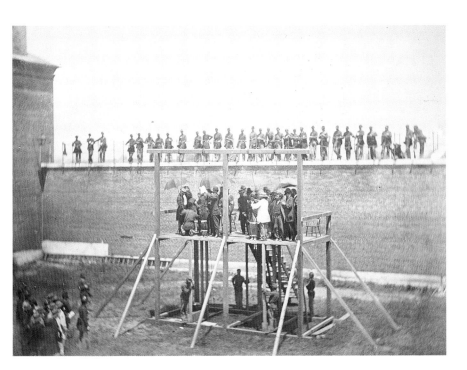

his capture by federal forces in April 1865. It is one of four similarly posed portraits of Paine by Gardner. In total, the album assembles 19 portraits of the eight suspected conspirators, including those of Paine. The two photographs of the gallows featured above are the first and fifth views in a sequence of at least eight images that Gardner, with Timothy O'Sullivan's assistance, took of the conspirators' executions on July 7, 1865. In a bravura performance of skill, the photographers were able to document the execution in a sequential manner – unusual for the day – thus rendering a disturbingly haunting narrative of the conspirators' final moments.

During the war, Gardner had established a working relationship with *Harper's Weekly,* one of the country's most popular illustrated journals. His war photographs, and later the conspirators' portraits, were translated into wood engravings for the publication. The extensive use of wood engraving in the popular press at this time prefigures later-day photojournalism as a dynamic visual record of memorable human events.

Alexander Gardner

Execution of the Lincoln Assassination Conspirators. Adjusting the Ropes, 1865

Albumen print
MUSEUM PURCHASE
72:0033:0035

A Matter of Fact

Photography was a child of science. Early photographers often came from scientific backgrounds. For example, William Henry Fox Talbot was an amateur scientist who made photogenic drawings of botanical specimens; and it was Sir John Herschel, a renowned astronomer, who coined the word "photography." The technical complexities of the early photographs precluded many other amateurs from using the medium with any degree of success. Furthermore, it was photography's early practitioners who made the constant, ongoing advancements to the medium: photographers with scientific backgrounds and knowledge tirelessly experimented with the medium in order to achieve optimum clarity of detail and permanence in the final image. It was the public's faith in photography as an accurate transcription of the natural world that made it more than simply another tool of science. Its perceived truthfulness bestowed on it the mantle of scientific proof.

Frederick Gutekunst
American, 1831–1917

Leaves and Flowers
of Cundurango de
Tumbo Grande,
ca. 1873

Albumen print
MUSEUM PURCHASE
LIBRARY COLLECTION

Anna Atkins
English, 1799–1871

Carix (America),
ca. 1850

Cyanotype
MUSEUM PURCHASE,
FORD MOTOR COM-
PANY & MORRIS
FOUNDATION FUNDS
95:2633:0001

Frederick Gutekunst was a Philadelphia photographer who became a leader in photomechanical reproduction. During the latter half of the 19th century, Gutekunst ran a photo-reproduction business selling portraits of famous Americans, an early version of the photographic stock house. He also made photographs of botanical specimens for a medical text on the therapeutic plant Cundurango, including an image of leaves and flowers of the species, which looks almost like a photogram in its direct presentation of the plant's basic forms (page 272).

Englishwoman Anna Atkins was a botanist who learned directly about the invention of photography through correspondence with Talbot. She took up photography to record botanical specimens for a scientific reference book, *British Algae: Cyanotype Impressions,* which became one of the first books to be illustrated with photographically derived images. The book's handwritten text and illustrations were created using the cameraless photogram technique with the cyanotype process. Atkins printed and published part one of *British Algae* in 1843, thus establishing photography as an accurate medium for precise scientific illustration.

Henry Troth was born into a Quaker family of chemists in Philadelphia. Specializing in landscapes and botanical studies, he exhibited his

(above)
Dr. James Deane
American, 1801–1858

Ichnographs, 1861

Salted paper print
GIFT OF ALDEN
SCOTT BOYER
LIBRARY COLLECTION

(right)
Lewis M. Rutherford
American, 1816–1892

Moon, March 4, 1865

Albumen print
MUSEUM PURCHASE, MARGARET T.
MORRIS FOUNDATION FUND IN MEMORY
OF DR. WESLEY T. "BUNNY" HANSEN
89:0403:0001

Louis M. Rutherfurd
New York March 4 1865

James Hall Nasmyth
English, 1808–1890

Normal Lunar Crater
Model, 1874

Woodburytype
MUSEUM PURCHASE
LIBRARY COLLECTION

photographs internationally around the turn of the century, and both Alfred Stieglitz and F. Holland Day exhibited his work. He became a professional photographer of architecture and outdoor scenes for popular magazines. Troth's images also illustrated volumes of poetry and essays on nature, as well as the botanical study *Phytogeographic Survey of North America*. The Academy of Natural Sciences used Troth's images in its records of flower studies. The uprooted lady fern (species Athyrium filix-femina) (page 274) was a large, feathery, mostly ornamental fern that Troth photographed as if suspended in space, its exposed roots dangling. "Tulip Poplar Blossoms" (page 275) displays an energetic arrangement of delicate flowers peeking out amidst a bevy of spiky leaves and demonstrates photography's capacity to simultaneously record information and render beauty.

 Dr. James Deane of Greenfield, Massachusetts, made drawings and photographs of footprint fossils in the stratified sandstone at the quarry at Turner's Falls (page 276). Deane's photographs of these "curious impressions" were published posthumously in *Ichnographs from the*

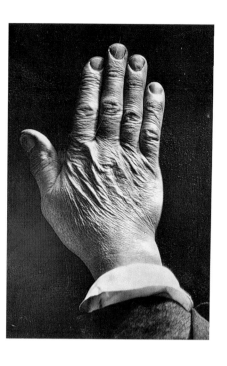
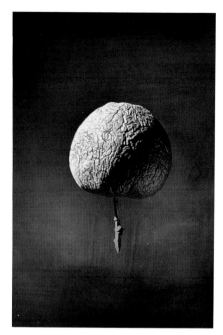

Sandstone of Connecticut River. In the volume's introductory text, Augustus A. Gould wrote: "We believe ... that these copies, rivalling [*sic*] as they do the actual specimens, will be really useful to those pursuing similar scientific investigations; they will also at least furnish a beautiful table-book, to excite an interest in the community in the marvels of nature."

Other photographer-scientists trained their lenses in the opposite direction, toward the heavens. Lewis Morris Rutherford was educated as a lawyer, but an interest in astrophysics and astronomical photography led him to abandon that profession in 1849. He became known for his photographs of the moon (page 277), especially his stereographs, which were sold by several publishers. Among his discoveries was a micrometer for the measure of astronomical photographs. In 1858, Rutherford became a founding vice president of the American Photographical Society, a group devoted to photographic amateurs with a scientific bent.

Scottish engineer James Hall Nasmyth was a founding member of the Manchester Photographic Society. James Carpenter, an astronomer at the Royal Observatory in Greenwich, England, collaborated with

James Hall Nasmyth

The Back of Hand and Wrinkled Apple, 1874

Woodburytype
MUSEUM PURCHASE
LIBRARY
COLLECTION

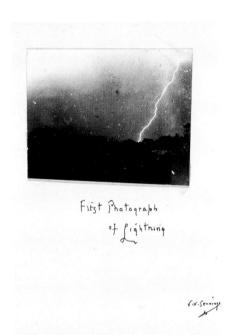

First Photograph of Lightning

R.N. Jennings

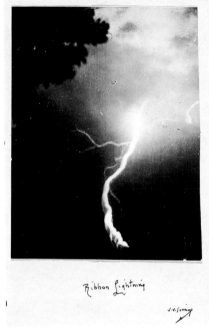

Ribbon Lightning

J.N. Jennings

William N. Jennings
American,
b. England,
1860–1946

First Photograph
of Lightning, 1882

Gelatin silver print
GIFT OF 3M COM-
PANY, EX-COLLEC-
TION LOUIS
WALTON SIPLEY
83:0679:0003

William N. Jennings

Ribbon Lightning,
ca. 1885

Gelatin silver print
GIFT OF 3M COM-
PANY, EX-COLLEC-
TION LOUIS
WALTON SIPLEY
83:0679:0006

Nasmyth on an 1874 publication, *The Moon: Considered as a Planet, a World, and a Satellite,* a 40-year culmination of lunar observation illustrated with Woodburytypes. The "Normal Lunar Crater" (page 278) is actually a photograph by Nasmyth of a plaster model of the moon. Nasmyth and Carpenter wanted to provide information about the moon's surface in all of "its marvellous [*sic*] details under every variety of phase in the hope of understanding its true nature as well as the causes which had produced them." The carefully detailed models helped bring the remote moon into closer view. In an attempt to expand the viewer's understanding, Nasmyth and Carpenter also included analogous photographs of more ordinary images such as a wrinkled hand and a rotten apple (page 279), because both exhibited richly textured and aged surfaces comparable to that of the moon.

An amateur photographer in Philadelphia during the early 1890s, William Nicholson Jennings became the first person to photograph lightning in 1882, thus defining the paths that lightning takes through the sky and undeniably refuting the commonly used "zigzag" design

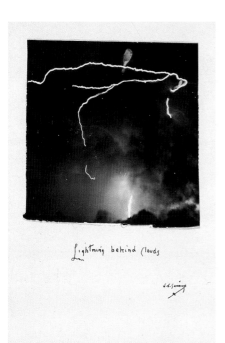

Lightning behind Clouds

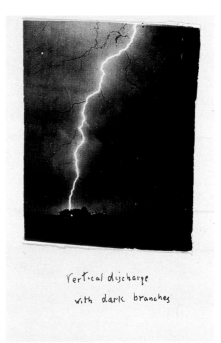

Vertical discharge with dark branches

that artists had long employed. In a series of views made around 1885 to 1890, Jennings documented the appearance of several different patterns of lightning in the sky: ribbon lightning, lightning behind clouds, and vertical discharge. The powerful bursts of electricity and light illuminate the recognizable shapes of trees, branches, and rooftops, which lends a compelling reality to the evidence. Jennings made early experiments with color photography, and later made photographs of artificial lightning, experiments that eventually led to the development of "flash" photography. He is also credited with unknowingly making the first x-ray in 1890.

Belgian Adolphe Neyt's "Photomicrograph of a Flea" (page 282) was made under a microscope. With the crisp clarity of the lines delineating every hair and joint on its legs and the subtle gradation of shading in its body providing depth, the image looks rather like a careful pencil and charcoal drawing, yet it carries the stamp of photographic veracity. Photomicrography was used as early as 1840 and became increasingly popular between 1850 and 1870, recording photographically for the first time that which is invisible to the naked eye.

William N. Jennings

Lightning behind Clouds, ca. 1885

Gelatin silver print
GIFT OF 3M COMPANY, EX-COLLECTION LOUIS WALTON SIPLEY
83:0679:0004

William N. Jennings

Vertical Discharge with Dark Branches, 1890

Gelatin silver print
GIFT OF 3M COMPANY, EX-COLLECTION LOUIS WALTON SIPLEY
83:0679:0005

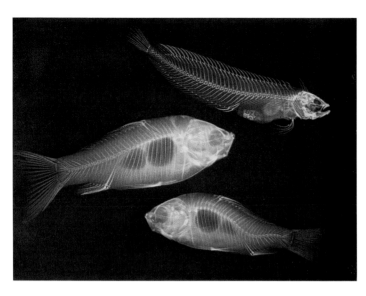

**Josef Maria Eder &
Edward Valenta**
Austrian, 1855–1944
& Austrian,
1857–1937

Zwei Goldfische und
ein Seefisch (Christi-
ceps Argentatus)
(Two Goldfish and a
Sea Fish [Christiceps
argentatus]), 1896

Photogravure print
GIFT OF EASTMAN
KODAK COMPANY,
EX-COLLECTION
JOSEF MARIA EDER
79:3352:0001

Adolphe Neyt
Belgian, 1830–1893

*Photomicrograph of
a Flea*, ca. 1865

Albumen print
GIFT OF 3M COM-
PANY, EX-COLLEC-
TION LOUIS
WALTON SIPLEY
77:0638:0015

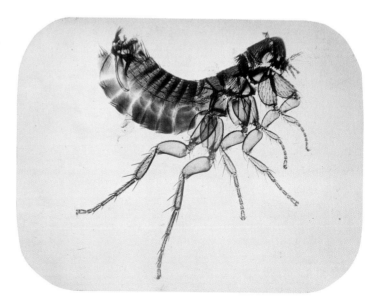

Dr. Guillaume Duchenne de Boulogne
French, 1806–1875

Faradisation du muscle frontal (Faradism of the Frontal Muscle), 1862

Albumen print
MUSEUM PURCHASE, FORD MOTOR COMPANY FUND
96:0598:0001

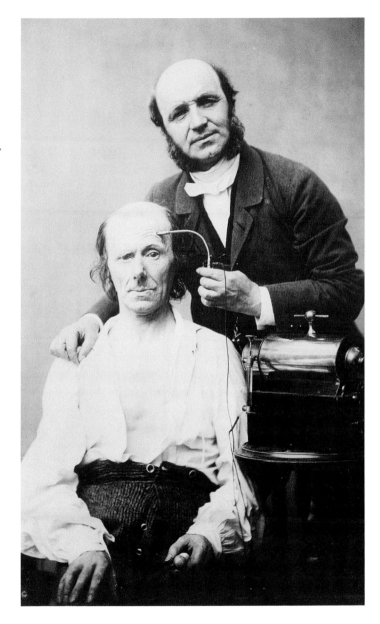

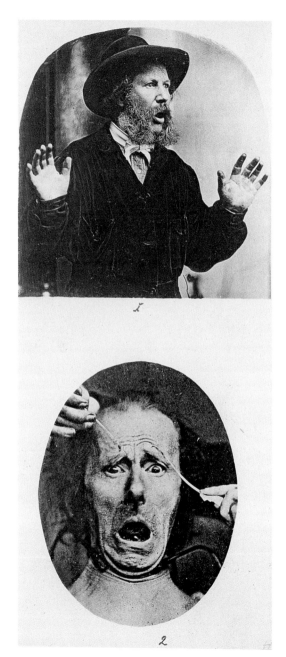

(top)
Oscar Gustav Rejlander
English,
b. Sweden 1813–1875

(bottom)
Dr. Guillaume-Benjamin Duchenne de Boulogne
French, 1806–1875

Illustrations from Charles Darwin's The Expression of the Emotions in Man and Animals, ca. 1862

Collotype print
LIBRARY COLLECTION

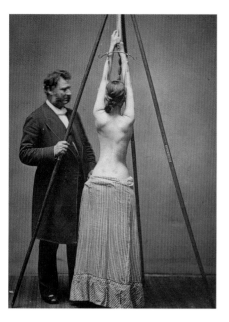
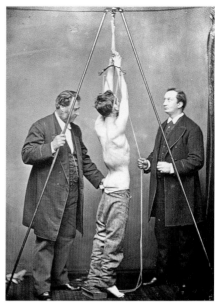

Josef Maria Eder and Edward Valenta were Viennese chemists who specialized in photographic chemistry. Eder was also a leader in the study of photographic technology. Revealing the complex beauty of the internal structure of simple goldfish, Eder and Valenta made an x-ray – or Röntgen photograph, as it was called after its inventor Wilhelm Röntgen – of three fish, their delicate, bony structures delineated with photographic precision (page 282). In 1896 they published a portfolio of 15 photogravures of x-ray images, *Versuche über Photographie mittlest der Röntgen'schen Strahlen*, or, *Experiments in Photography with Röntgen Rays*. Such photographic imagery provided invaluable information to scientists, enhancing their basic understanding of their subjects. It also provided artistic inspiration to later photographers; in the 1940s, Hungarian artist László Moholy-Nagy said of x-ray images: "... structure becomes transparency and transparency manifests structure."

Scientific photography was applied to many fields of medicine in its early years. Guillaume-Benjamin Duchenne de Boulogne was a medical doctor specializing in electrotherapy. In 1856 he began to photograph mental patients at the Salpêtrière Hospital where he worked in Paris. Adrien Tournachon, Nadar's brother, assisted him in taking the

Attributed to John Jabez Edwin Mayall
English, 1813–1901

Treatment for Spinal Curvature, ca. 1877

Woodburytypes
LIBRARY COLLECTION

**Attributed to
Luis Soler Pujol**
Spanish, active
ca. 1920s

*Still Life of Anatomic-
al Models*, ca. 1920s

Gelatin silver print
MUSEUM PURCHASE
76:0089:0009

photographs, which often featured a gaunt, elderly man as the subject. Duchenne de Boulogne's photographs were published in numerous volumes; the photograph depicting Duchenne applying electrodes to a patient, "Faradisation du muscle frontal" (page 283), originally appeared in *Album de photographies pathologique complementaire du livre intitulé de l'electrisation localisée* from 1862. Charles Darwin used a selection of these photographs by Duchenne de Boulogne and others by Oscar Gustave Rejlander to illustrate his 1872 book, *The Expression of the Emotions in Man and Animals.* Rejlander himself appears in the top image on page 284, expressing surprise in a manner that appears overly dramatic to the modern viewer, but in its day was believed to have been a helpful illustration of emotion. In the lower image by Duchenne de Boulogne, the elderly patient is subjected to an excruciating treatment: two electrodes are applied to his brow, contorting his soft flesh, while the camera records his reaction with shocking precision.

In 1877 Lewis Sayre, M. D., published the diagnostic medical text *Spinal Disease and Spinal Curvature: Their Treatment by Suspension and the Use of the Plaster of Paris Bandage.* Illustrated primarily with

**Attributed to
Luis Soler Pujol**

Anatomical Model,
ca. 1920s

Gelatin silver print
MUSEUM PURCHASE
76:0089:0006

Phot. d'après nature par Tournachon J^{ne}

SÉBASTOPOL,

— Né en 1852. — Son père, un étalon de pur sang Arabe. Sa mère, une Jument croisée Anglaise

I^r PRIX DES ÉTALONS, *Races diverses de demi-sang léger*

Adrien Tournachon
French, 1825–1903

Sébastopol,
ca. 1855–1860

Salted paper print
GIFT OF EASTMAN
KODAK COMPANY,
EX-COLLECTION
GABRIEL CROMER
79:0002:0033

engravings, it also included these Woodburytypes from photographs attributed to photographer John Jabez Edwin Mayall (page 285). Simple and direct, the images show a woman and man tied at the wrists to a tripod, their arms upraised. In these views, the patients' clothing is stripped down to the waist in order to show their spinal curvature while still retaining a modicum of modesty. In other photographs they are shown with the plaster casts applied.

Anatomical studies had appeared with some frequency in art for hundreds of years, and the most talented draftsmen were enlisted to give the truest rendering of the inner workings of human anatomy as aids to scientists and doctors. It is a testimony to the modeler's craft that their

RATTER-FILLY.

Née en 1851 *Son père,* Bolero, *pur sang Anglais, Sa mère,* Camargo, *par* Y. Rattler, *demi-sang*

1er PRIX DES JUMENTS, *Race Normande, de demi-sang léger*

renditions are so vivid and convincing. Luis Soler Pujol, a taxidermist and anatomical modeler working in the 1920s, made photographs of some of his models that he included in an illustrated price guide, which is stamped on the cover, "Luis Soler Pujol, Naturalista – Preparador, Barcelona." Under each image the price of the model is clearly indicated. Pictured on page 286, a head-and-shoulders bust is turned away from the camera, revealing a trellis-like deep cut where the flesh has been removed to expose tendons and muscles in the neck. Likewise, the top of the head has been removed to show the human brain resting in its cavity. There is a disconcerting aspect to the image, which unites the practical, scientific application of photography with the careful control of an artist's eye, leaving the viewer altogether uneasy with the

Adrien Tournachon

Ratter-Filly,
ca. 1855–1860

Salted paper print
GIFT OF EASTMAN
KODAK COMPANY,
EX-COLLECTION
GABRIEL CROMER
79:0002:0025

**Compte de Montizon
(Juan Carlos María Isidro De Borbón)**
Spanish, 1822–1887

Fish, ca. 1855

Albumen print
GIFT OF MR. H.H.
CLAUDET AND MRS.
NORMAN GILCHRIST
77:0742:0003

scene. A full-standing anatomical model of a male with flayed skin (page 287) is equally disarming, the liveliness of his stance contrasting sharply with a section of his chest and abdomen that has been cut away and rests on the table beside him.

Scientific applications, however, were not always gruesome renderings of inner realities, nor were they exclusively in the service of the natural sciences. Photography was employed frequently to document "types," whether of man or beast, and to visually reinforce distinctions within like species. Photographs of specimens proved to be valuable information, and all types of humans, animals, and plants were the focus of the photographer's eye. Adrien Tournachon made images for an album of horses, *Races Chevaline et Asine, Primés à l'Exposition de 1855, Photographies* (pages 288 and 289). Each image was mounted with a

description below it indicating the name of the animal, its birth date, parental lineage, and race history, while the photograph provided the satisfying visual "proof" of good breeding. Held steady by anonymous trainers, the animals were posed in profile against a simple backdrop, their magnificent forms revealed.

Humbler specimens, too, caught the photographer's eye. Compte de Montizon made numerous photographs of animals in zoos and parks, which preserved such accurate likenesses of the previously inaccessible creatures as to be true "portraits" of them. Beginning in the 19th century zoological parks and gardens provided the general public with the opportunity to view animals from all over the world, relatively close up, without having to travel great distances to find them. A pickerel swimming in an aquarium, betrayed as such by the shadows cast by the plant life against

Compte de
Montizon
(Juan Carlos María
Isidro De Borbón)

The Hippopotamus
at the Zoological
Gardens, Regent's
Park, 1852

Albumen print
GIFT OF MR. H. H.
CLAUDET AND MRS.
NORMAN GILCHRIST
77:0742:0004

Compte de
Montizon
(Juan Carlos María
Isidro De Borbón)
Spanish, 1822–1887

Giraffe, ca. 1854

Albumen print
GIFT OF MR. H.H.
CLAUDET AND MRS.
NORMAN GILCHRIST
77:0742:0005

the wall, could just as easily be some predatory distant cousin of the shark, its sleek body suspended in perfect stillness in the water, contemplating its next prey. Reference to scale is sacrificed to show the fish close-up in its habitat, its stripes and fins identifying its species. Compte de Montizon also photographed a slumbering hippopotamus at the Zoological Garden in Regent's Park, London. The prominent crack of the animal's mouth reads like a contented smile as onlookers watch the non–spectacle – and the photographer – through zoo bars. From the photographer's perspective, the closely huddled humans become the caged creatures while the seemingly carefree hippo, a gift to Queen Victoria from the Pasha of Egypt, relaxes alongside his wading pool, tranquil in his manufactured habitat, unmindful of their curious gaze.

Compte de Montizon's photograph of a giraffe seated at the center of the frame is as elegant as it is simple. With its characteristic long, spindly legs tucked neatly beneath it, the giraffe is transformed into a

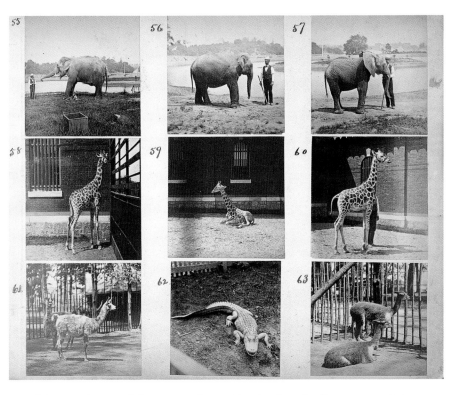

graceful, spotted swan adrift on a sea of grass. Despite the animal's regal posture, the vertical bars of the enclosure are visible in the distance as a reminder of its captive reality.

While useful as documents, de Montizon's images of animals are also lyrical likenesses of the individual animal, which transcend the circumstances of their habitats, restoring a modicum of their autonomous character. German-born Francis George Schreiber was the founder of Schreiber and Sons, the oldest photographic firm in America specializing in animal photography. Schreiber was a partner in the Langenheim Bros. firm in Philadelphia and continued that studio after the Langenheims retired before opening his studio. Schreiber is best known for photographs of domestic animals. He also photographed the exotic inhabitants of the local zoo. Nine photographs of these animals (pictured above) are mounted together on a page from an album of over 200 animal photographs. The numbered sequencing forms miniature

Francis George Schreiber
American,
b. Germany,
1803–1892

Photographs of Various Animals,
ca. 1890

Albumen prints
GIFT OF 3M COMPANY, EX-COLLECTION LOUIS WALTON SIPLEY
77:0250:0055–63

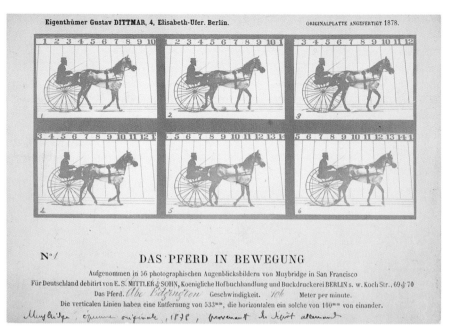

Eigenthümer Gustav DITTMAR, 4, Elisabeth-Ufer. Berlin. ORIGINALPLATTE ANGEFERTIGT 1878.

N° 1

DAS PFERD IN BEWEGUNG

Aufgenommen in 56 photographischen Augenblicksbildern von Muybridge in San Francisco
Für Deutschland debitirt von E. S. MITTLER & SOHN, Koenigliche Hofbuchhandlung und Buckdruckerei BERLIN s. w. Koch Str., 69 & 70
Das Pferd. *Abe Edgington* Geschwindigkeit. *104* Meter per minute.
Die verticalen Linien haben eine Entfernung von 533ᵐᵐ, die horizontalen ein solche von 100ᵐᵐ von einander.

Muybridge, épreuve originale, 1878, provenant le dépôt allemand

**Eadweard
J. Muybridge**
American,
b. England,
1830–1904

Das Pferd in
Bewegung, "Abe
Edgington" (The
Horse in Motion,
"Abe Edgington"),
1878

Albumen print
MUSEUM PURCHASE
73:0136:0002

narratives within the groups. The top three frames show a short-eared elephant along with his trainer in various postures near a watering hole. At left, the animal is seen at a distance facing left, possibly being fed; in the center, the camera has moved in closer, and the animal has turned to the right; and in the right frame, animal and man overlap. Similarly, the next three frames show a giraffe standing in its enclosure, which looks like a courtyard. Then it is shown seated in a pose reminiscent of the de Montizon, and standing again photographed somewhat closer up with a trainer alongside. Finally, and perhaps most intriguing, the bottom trio introduces a photograph of a predator in between two views of llamas and deer, extending the narrative structure beyond sequence into action. As simple as such pairings may seem, the overall effect of the sequencing and juxtaposition is to create a means of animating the animals' activity, and to draw relationships between frames that construct a story or movement.

No photographer, however, was more responsible for making still images move than Eadweard J. Muybridge. Born in Kingston-on-Thames, England, he moved to the United States in the early 1850s to make his

fortune. Although he first earned his reputation as a photographer of the western landscape, he is best remembered for the remarkable series of motion studies that he undertook, hired as the result of a legendary bet made by Leland Stanford, railroad magnate and ex-governor of California. Stanford contended that when a horse gallops, at some point all four of its feet are simultaneously off the ground. Étienne Jules Marey, a French physiologist and professor of natural history, had conducted studies that suggested the airborne phenomenon of a horse's gallop, and Marey's work came to Stanford's attention with the publication of his *Animal Mechanism, a Treatise on Terrestrial and Aerial Locomotion* in 1873. Muybridge worked with Stanford during the 1870s, refining his approach to the sequential presentation of motion. Using a system of electro-mechanical, trip-shutter, high-speed photography and 12 cameras,

Eadweard J. Muybridge

Two Models, 8 Drinking from Water-Jar on the Shoulder of 1, July 20, 1885

Gelatin silver printing out paper print
81:2379:0042

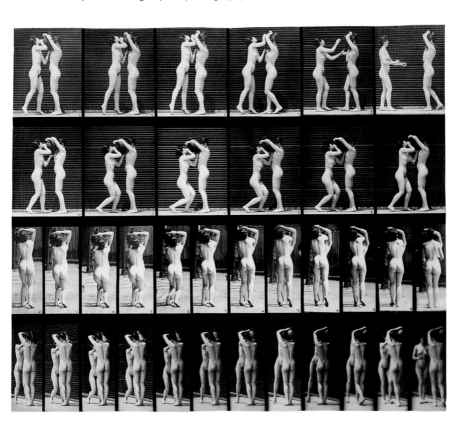

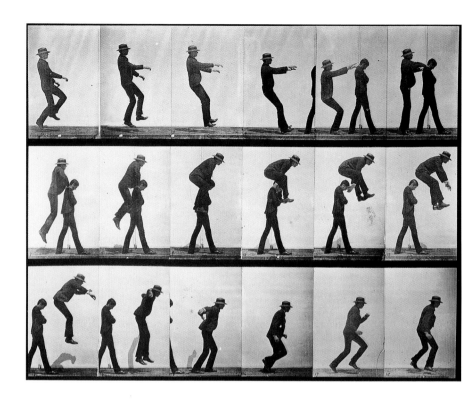

**Eadweard
J. Muybridge**
American,
b. England,
1830–1904

Jumping; Over Boy's
Back (Leap-Frog),
ca. 1884–1887

Collotype print
MUSEUM COLLEC-
TION, BY EXCHANGE,
EX-COLLECTION
LOU MARCUS
78:0802:0169

Muybridge photographed Stanford's purebred horse "Abe Edgington" at Palo Alto. As the animal galloped, the sulky wheels came in contact with wires stretched across its path, which instantaneously completed an electrical circuit and released the cameras' shutters in sequence. In effect, the horse photographed itself. The background was a white screen delineated by vertical stripes that measured the space. Marey was enthusiastic about Muybridge's triumph and was "lost in admiration." The German language on the mounting of this sequence of six frames indicates the international attention that Muybridge's groundbreaking work received.

After his success with racehorses, the photographer began to experiment with recording motion in humans and other animals. In 1884 the University of Pennsylvania commissioned Muybridge to conduct further studies in human and animal locomotion, fittingly in the city that had fostered so much earlier scientific photographic investigation.

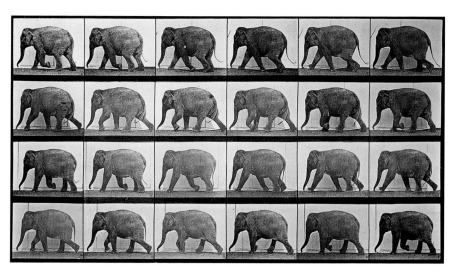

Enlisting the assistance of students and professional athletes as models, Muybridge completed the series of stop-action motion studies in 1887, which totaled more than 20,000 individual images. He published 781 motion sequences in the series titled *Animal Locomotion*, of which the Eastman House holds 683. The models' actions are simple, yet instructive in their simplicity: a nude woman drinks from a water jar that rests upon another nude woman's shoulder, the flexing and exertion of each muscle clearly visible due to the women's state of undress. The documentation was thorough – the activity was photographed from two angles, showing the models from the side and from the back. In another set of frames (above), an elephant lumbers along at its steady pace – every methodical step carefully recorded and measured by the camera. The barely discernible change in its movement is in stark contrast to the image of two boys at left – like silhouettes in dark suits and hats – playing leap-frog for the camera, their silly fun in serious service to scientific investigation.

Muybridge's photo sequences led to the development of motion pictures. In 1878 some of his sequences were published in the journal *Scientific American,* with the exhortation to readers to clip the frames and insert them into their zoetropes in order to create the illusion of movement. The zoetrope, or "wheel of life," was a popular parlor diversion in the late 19th century. It is simply a rotating drum with 12 or 13 evenly spaced slits. A corresponding number of sequential pictures are placed

Eadweard J. Muybridge

Elephant; Walking, ca. 1884–1887

Collotype print
MUSEUM COLLECTION, BY EXCHANGE, EX-COLLECTION LOU MARCUS
78:0802:0733

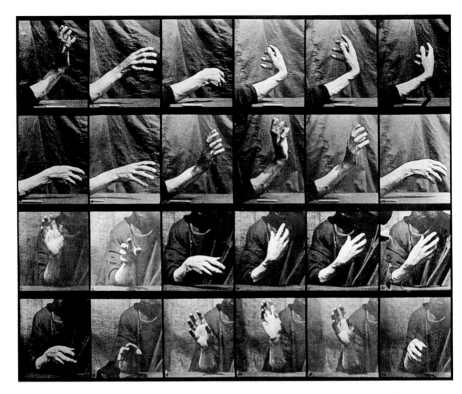

Eadweard J. Muybridge
American,
b. England,
1830–1904

Movement of
the Hand; Beating
Time, ca. 1884–1887

Collotype print
GIFT OF ANSCO
78:0802:0535

on the inner wall, and when the drum is turned, the images become animated, inducing the illusion of movement. In 1880 at the San Francisco Art Association, Muybridge, using a revolving disk and a lantern-slide projector he had created, projected in rapid succession still photographs of a horse's movements, thus making the first actual motion picture.

"All the necessary researches into animal locomotion can only be effected by men especially interested in these inquiries, and placed in a favorable circumstance to understand them," wrote Étienne Jules Marey in *Animal Mechanism*. Marey, whose research had started the second phase of Muybridge's career, invented chronophotography, which produced an entire sequence of motion on a single frame. In this method the actions overlap slightly, yet clearly establish the continuum within the given action, such as pole vaulting. To study the movement of birds in flight, Marey invented the chronophotographic gun. This camera, in the shape of a rifle, "shot" in succession 12 (and later up to

**Eadweard
J. Muybridge**

A, Striking a Blow;
B, Throwing Disc;
C, Heaving a 75-lb.
Stone; D, Throwing
a Ball; E, Throwing
Disc; F, Heaving
75-lb. Stone,
ca. 1884–1887

Collotype print
MUSEUM COLLEC-
TION, BY EXCHANGE,
EX-COLLECTION
GEORGE NITZSCHE
78:0802:0523

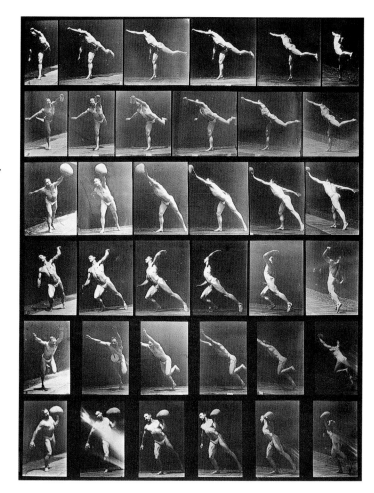

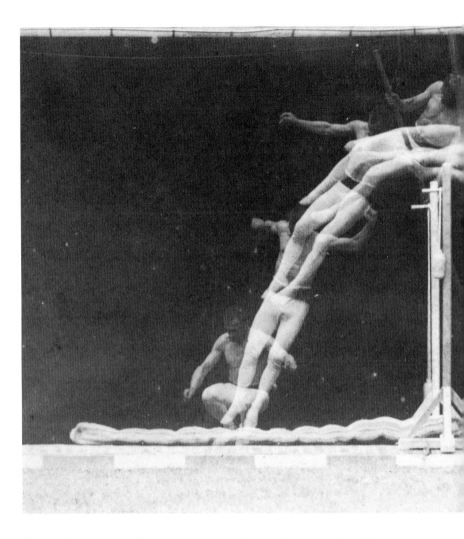

Étienne Jules Marey
French, 1830–1904

Chronophotographic
Study of Man Pole
Vaulting, 1890–1891

Albumen print
MUSEUM COLLEC-
TION, BY EXCHANGE
88:0795:0001

30) photographs per second, much faster than Muybridge had been able to accomplish. Like Muybridge, Marey projected these images in sequence, eventually abandoning cumbersome glass plates first for a strip of moveable paper film and later for Kodak flexible roll film that George Eastman used in his box cameras. Yet neither Muybridge nor Marey sought to reconstruct the continuous motion as would later be found in motion pictures; rather they wanted to stop it, frame by frame,

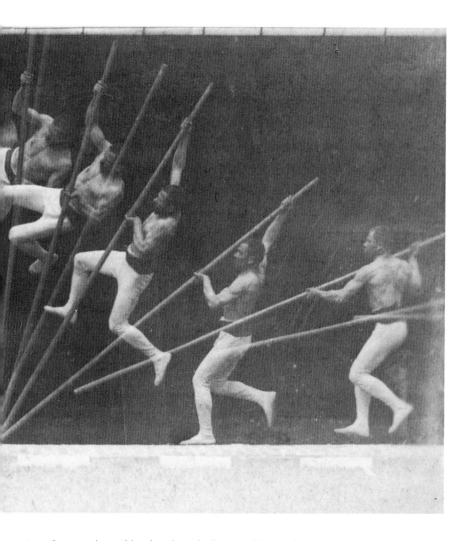

in order to make visible what the naked eye could never hope to see. While the work of Muybridge and Marey employed the special properties of photography in their attempts to record and analyze movement with the greatest accuracy, elsewhere scientist-photographers were working on ways to make the steadfastly monochrome medium resemble the real, color-saturated world. In 1862 Louis Ducos Du Hauron described in a letter to a friend several different methods for making color

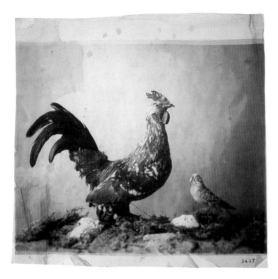

Louis Ducos Du Hauron
French, 1837–1920

Still Life with Rooster,
ca. 1869–1879

*Print ca. 1982, by
Eastman Kodak
Company.* Three-color
carbon transparency
MUSEUM PURCHASE
82:1568:0001

photographs. Hauron's processes involved the following: "If I take a picture given to us by nature, which appears singular, but which is in reality triple in terms of color, and disassemble it onto three distinct pictures, one red, one yellow and one blue; and if I obtain a separate photographic image of each of these three pictures which reproduces its particular color; it will be sufficient to join the three resulting images into a single image in order to possess the exact representation of nature, color, and modeling all together." A combination of three colors – red, blue, and yellow – could be made into transparencies and overlaid to produce a full-color image. While Ducos Du Hauron's work laid the foundation for color photography, it was not until 1873 that H. W. Vogel discovered that dyes added to photographic materials would make the plates sensitive to colors other than blue. Nevertheless, before 1879 Du Hauron produced "Still Life with Rooster," a three-color carbon transparency of a brown stuffed rooster with blue tail feathers and strawberry red crown, alongside a lemon-yellow parakeet standing amidst artificial rocks and vegetation. For all the work at achieving the reality of color, the scene is unreal; the birds posed facing one another as though in conversation.

Even more bizarre are Ducos Du Hauron's series of self-portrait deformations, or "transformations." Using a slit diaphragm, the technique distorted his features like a fun house mirror; here the front half

of the head is elongated while the back remains fairly proportionate, resulting in a disturbing self-presentation.

"The thing that differentiates this from all those other high speed things, like Muybridge's work, is that we move the light," Harold E. Edgerton explained in 1994 of the difference between his work and that of his stop-motion precursors. Edgerton's photographic work was featured in the 1994 Eastman House exhibition and publication, *Seeing the Unseen: Dr. Harold E. Edgerton and the Wonders of Strobe Alley*. The Eastman House collection includes more than 300 prints by Edgerton. Strobe Alley – a 300-foot corridor at Massachusetts Institute of Technology (M.I.T.), where Edgerton earned his doctorate and taught for 41 years – was so named because Edgerton invented the stroboscope while a student there in 1931. A stroboscope is an electronic flash made up of a series of pulsing lights that can capture action up to 1/1,000,000 of a second. In Strobe Alley he displayed dozens of the photographs he made using the stroboscope. "High-speed" photography, according to Edgerton, is defined as "single exposure cameras that take photographs with exposures shorter than 1/10,000 of a second," and both of the photographs here were made at exposure speeds of 1/1,000,000 of a second.

**Louis Ducos
Du Hauron**

Self-Portrait
Deformation,
ca. 1888

Albumen print
GIFT OF EASTMAN
KODAK COMPANY,
EX-COLLECTION
GABRIEL CROMER
81:2913:0001

Edgerton's life's work using the strobe captured elements of movement to a degree previously unheard of, thus providing irrefutable evidence of the properties of a variety of substances when acted upon with force.

Describing his famous 1934 photograph of a man kicking a football, Edgerton explained: "I decided one day that I don't have a picture of somebody kicking a football and that it would be interesting to see what would happen. We don't waste any time with football at M. I. T., so I called up Harvard – it's a school up the river here a ways. ... So I went up there and we went into a dark room. I took three pictures – bang, bang, bang. I messed up two in the developing, but I got a good one. The ball accelerated so quickly it left the dust suspended in the air." The football itself made the picture. As it was kicked it pushed together two electrical wires that completed a circuit, which released the strobe flash.

Edgerton first showed the photograph of a 0.30 caliber bullet piercing an apple in 1964 during a lecture entitled "How to Make Applesauce at MIT." In this instance the strobe was tiggered by the sound wave of the bullet. Both the entry and exit of the bullet are shown surprisingly to be outward explosions; moments later, the apple collapsed completely. As he would later tell it, Edgerton had to use only one apple to achieve this remarkable image. Unmindful of the technical distinctions between strobes and regular electronic flashes, the unpretentious Edgerton said, "There are still purists who argue that you have to use the word 'stroboscopic' in a special way. But I don't go for that at all. I say if everybody calls them 'strobe,' I'll call them 'strobe.'" Both in his words and images Edgerton made scientific photography more accessible to a broad audience, creating images at once aesthetically pleasing and scientifically revolutionary.

Harold E. Edgerton
American,
1903–1990

Wesley E. Fesler
Kicking a Football,
1934

Gelatin silver print
GIFT OF THE
PHOTOGRAPHER
76:0111:0007

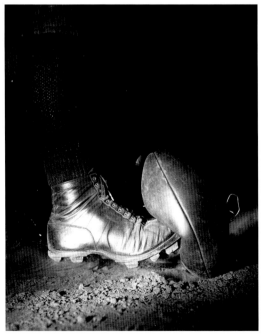

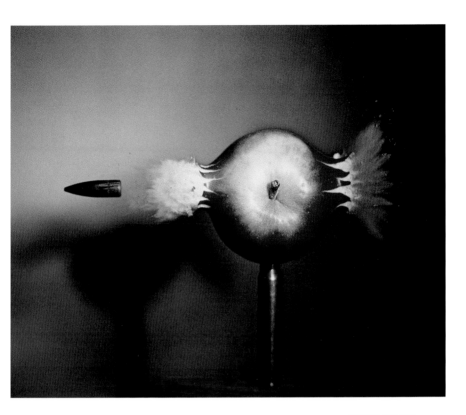

Harold E. Edgerton

.30 Bullet Piercing
an Apple, 1964. A Micro-
second Exposure of a Bullet
Travelling 2800 Feet per
Second. 1964; Print ca.
1984–1990, by Boris Color
Lab, Boston

*Color print, dye imbibition
(Dye Transfer) process*
GIFT OF THE HAROLD AND
ESTHER EDGERTON FAMILY
FOUNDATION
96:0347:0007

Photography's Public and Private Lives

Photography made the larger visual world collectible, and in the 19th century, one of the most popular places in which to collect evidence of that world was in the photographic album. From professional photographers such as Baldus to anonymous amateurs, people assembled albums of photographs for a variety of reasons: to commemorate specific events or travels, to validate social standing by associating their own images with those of celebrated people, and to create visual family trees by uniting family members who might be scattered far and wide.

Families constructed their histories through the selection and presentation of images. Sometimes these photographs documented rites of passage or lesser events, especially as photographs became more readily available and the portrait sitting became less formal and less costly. The assemblage of photographs in an album forged relationships between images that preserved collective memories and revealed both how we were and how we wished to see ourselves. Photographic albums often created a fiction by preserving an idealistic memory of the lives depicted, showing everyone and everything at their best. Each album, however, reveals the intimate longings and interests of the person who assembled the images and reflects a shared desire to construct order in life through the arrangement of images.

The Eastman House collection contains hundreds of these public and personal histories, including a rare volume known as the Victor Hugo album. The French Romantic author and poet Victor Hugo and his family were exiled to the isle of Jersey between 1851 and 1870, in part for his denouncement of Napoleon III. In 1854, Hugo and his wife Adele assembled an album of 41 prints made between 1852 and 1854 as a New Year's gift for Mademoiselle Euphémie Barbier, the daughter of house guests they had been hosting.

Their album was handsomely presented in a burgundy morocco leather binding, with full gilt embellishments. The album opens intimately with a written dedication from Hugo and a piece of algae from the isle of Jersey enclosed in a glassine envelope to remind the recipient of the common ground and poignant times they had shared. The sitters themselves signed many of the prints, with an additional few scattered inscriptions identifying people and places once thought important enough to photograph and preserve, but now forgotten.

Attributed to Charles Hugo and Auguste Vacquerie
French, 1826–1871 &
French, 1819–1895

Victor and Charles Hugo Leaning out Two Windows of Hugo House, ca. 1853

Salted paper print
GIFT OF EASTMAN KODAK COMPANY, EX-COLLECTION GABRIEL CROMER
79:0023:0004

(right)
**Attributed to
Charles Hugo and
Auguste Vacquerie**
French, 1826–1871 &
French, 1819–1895

Enfant le Flô,
ca. 1850–1854

Salted paper print
GIFT OF EASTMAN
KODAK COMPANY,
EX-COLLECTION
GABRIEL CROMER
79:0023:0008

A glimpse of the poet and his eldest son, Charles, leaning out of second-story windows at the family's home (page 307), records a private moment as they overlook the greenhouse where Madame Hugo customarily took her afternoon rest. Charles Hugo and Auguste Vacquerie are credited as the camera operators, albeit under Victor Hugo's artistic direction.

Charles had traveled to Caen for two weeks to learn photographic processes, and he and Vacquerie took up photography as a way of filling their days at Jersey. The pictorial quality of their intimate photographs perfectly complemented their Romantic artistic visions. Vacquerie wrote of his collaborator: "Charles has the gift of doing what he wants. Photography is ... wonderful, it's a machine that defies Rembrandt, a science that produces art. ... The sun produces the form, but it is Charles who frames it."

With Victor suggesting poses and group arrangements, Charles and Vacquerie photographed their surroundings and neighbors on the island. Family, friends, and servants are all included in Hugo's carefully orchestrated construction of the familial ideal in the face of political and artistic exile. Their Romantic sentiment is evident in the portrait of a local girl, "Enfant le Flô," gently clasping her dark garment and staring ponderously away from the camera. Seated against a simple backdrop, the pale child is a study in chiaroscuro, light and dark. Mainly, however,

**Attributed to
Charles Hugo and
Auguste Vacquerie**

The Hand of
Madame Hugo,
ca. 1850–1854

Salted paper print
GIFT OF EASTMAN
KODAK COMPANY,
EX-COLLECTION
GABRIEL CROMER
79:0023:0010

they photographed their home and themselves: Victor himself figured in numerous portrait studies in the album, although, curiously, no image of Mme. Barbier was included. Intimate details, such as Madame Hugo's hand, are shared and savored for their simple beauty.

Hugo was keenly aware of his public persona and the importance of documenting this difficult time in his life: Victor, Charles, and Vacquerie had planned a publication of verse, drawings, and photographs from this period, but it was never realized.

Other photographic albums were compiled for very different reasons. Thomas Mackinlay worked for a firm that sold music and made pianos in London. His interest in photography grew out of seeing a collection of letters and portraits of composers and musicians. As an amateur photographer, Mackinlay first tried his hand at daguerreotypy in the 1840s, but without much success. Active in the Society of Antiquaries, Mackinlay became familiar with early photographers such as Dr. Hugh Diamond, and in 1853 he became, along with Diamond, one of the founding members of the Photographic Society in London, a group of devoted amateurs and professionals later renamed the Royal Photographic Society.

As part of another amateur group, the Photographic Exchange Club, Mackinlay participated in two print exchanges. Members of such

Thomas Mackinlay
English, 1809–1865

Walkway, ca. 1855

Albumen print
MUSEUM PURCHASE
68:0087:0021

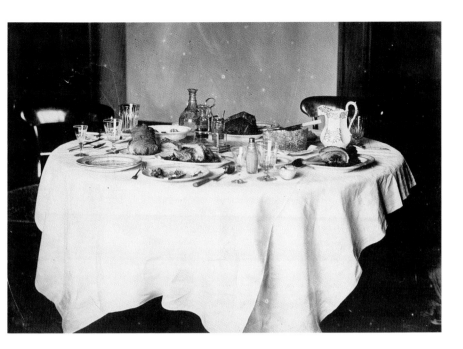

organizations would make a number of prints of an image and submit them in order to share their work with colleagues and learn about what others were doing. Often members would assemble the exchanged prints into albums such as *Pictures of the Photographic Exchange Club*, which includes Mackinlay's image of a walkway from around 1855.

Henry Alexander Radclyffe Pollock's image of a table evidencing the remains of a repast was included in another exchange club album from 1856. Pollock was a scientific experimenter and photographer and the son of Sir Jonathan Frederick Pollock, P. C., Lord Chief Baron of the Exchequer, a photographer and president of the Photographic Society. Henry's brother, Arthur Julius Pollock, was also a photographer whose work is represented in the museum's collection. Henry photographed his father's activities and preserved many of those images in a family album, but also shared some of the photographs with his Photographic Exchange Club members, who would surely have known of the senior Pollock's photographic work. This image, "After Luncheon," depicts the aftermath of one of his father's luncheons "on the circuit." As much a document that depicts a class and its activities as it is an absentee

Henry A. R. Pollock
English, 1826–1889

After Luncheon,
ca. 1856

Salted paper print
MUSEUM PURCHASE
68:0088:0038

portrait of his father, the image implies rather than represents the human presence. As a document, the photograph is reminiscent of some of Talbot's early visual inventories from *The Pencil of Nature* such as "Articles of China" (see page 92).

Pets were integral members of many households and thus frequently warranted equal treatment in the photographic process. "From the beginning of the Middle Ages ... the more [the dog] was loved the more artists began to regard it as an interesting subject," wrote one historian. Photography's popularity also coincided with the phenomenon of caring well for household pets in the 19th century. An anonymous portrait of a young smiling girl holding her dog epitomizes this kind of casual use of photography and preserves a fleeting moment in both of their lives that would never be revisited. The innocence, optimism, and spontaneity associated with photography, which was immediately put into service to record the natural world, is reflected in the openness of this portrait.

Children were also important subjects as parents clamored to preserve their progeny through photographs, especially given that their countenances were much quicker to change during their growing years; without photographs, those visual memories would be lost forever. The Walter family of Rochester, New York, assembled an album of their own family portraits around 1889, including the two pictured at right. A commercial photographer with a studio adjacent to his home, James P. Walter photographed his children against the elaborate painted studio backdrops and props in fictional tableaux. These devices were first made popular around 1870 as a means to "narrate" the portrait and were implemented by professional and amateur alike. This charming pair

Unidentified photographer
English, active 1850s

Girl with Dog,
ca. 1853

Salted paper print
GIFT OF ALDEN
SCOTT BOYER
81:1263:0037

shows his daughter Florence with a dropped basket of eggs, wiping her eye in mock despair over her misfortune. In the companion image Florence kneels to re-gather the eggs, looking directly at the camera, determined to triumph over her temporary adversity. In just two frames Walter constructed a story, transforming a portrait sitting into a small fable. Walter was also skilled at composition and balance: Florence's white pinafore and the eggs provide bright visual contrast against the neutral, woodsy backdrop. The cabinet-card-sized photographs – about 5-1/2 by 4 inches – were inserted into an album for their final presentation. In the Walter album, each page was made up of a decorative, arched, gold-edged overmat printed with green leaves. The photographs were inserted from the bottom and framed by the mat, the popular style at the time. The album was covered with red velvet and closed with a metal clasp to complete the elegant presentation and provide a permanent home for the family photographs.

In Victorian England the assemblage of photographic albums was popularly women's work, and upper-class women often indulged their artistic proclivities in the animated construction of their visual family histories. These albums were then frequently shared among family members and handed down, from one generation to the next. Julia

James P. Walter
American, active
1880s–1890s

Florence Walter with Dropped Basket of Eggs (left), ca. 1889

Florence Walter Putting Eggs in Basket (right), ca. 1889

Albumen print cabinet cards
GIFT OF EDNA
L. TICHENOR
85:0972:0006
85:0972:0007

Leicester created a photomontage that illustrates an idyll of country living. Images of stately mansions, woods, lakes, and well-dressed men and women at leisure make up this constructed landscape. A whimsical portrait of Viscount Lumley, the Earl of Scarbrough, and Mr. G. Thompson utilizes montage in a carriage scene that is gleefully oblivious to accuracy of scale. Nevertheless, the relationship between the subjects is clearly established, and the scene is animated by the conflation of photographs and watercoloring.

Because early photography was monochromatic, the use of watercolor provided a means by which to integrate the photographic image into a world of color. In the Campbell family album, an elaborate watercolor of a sitting room interior is constructed around photographic portraits of family members. As identified by handwritten captions under the image, Clara Wellesley reads by the "light" of the window, Sarah Napier sits at her spinning wheel, Annabel O'Grady takes tea by the hearth while Cuckoo Gordon pours, Nancy Swetenham looks down from the frame above the mantle, and "Jack," the beloved dog, sleeps soundly at their feet. While most albums were not so elaborate, these examples are among the finest of the genre, revealing both the artistic talent and playfulness found in photographic albums

Although photographs on paper were favored by the more artistic practitioners, the general public still desired cased – yet inexpensive – likenesses. As the popularity of the daguerreotype waned in the 1850s, newer, less-expensive media were developed to satisfy the market for photographs. In 1854, Boston scientist James A. Cutting received three patents for making glass positives, which were dubbed

Julia Leicester
English?,
active 1870s

English Portrait and Landscape Photomontage,
ca. 1870

Albumen print photomontage
MUSEUM PURCHASE
78:0805:0096

**Constance
Sackville West**
English, active 1860s

Viscount Lumley;
Earl of Scarbrough;
Mr. G. Thompson,
1867

*Albumen print
photomontage
with watercolor
embellishment*
MUSEUM PURCHASE
76:0151:0026

Unidentified artist
English?,
active ca. 1870s

Cuckoo Gordon,
Annabel O'Grady,
Nancy Swetenham,
Sarah Napier,
Clara Wellesley,
and "Jack," ca. 1870s

*Albumen print
photomontage
with watercolor
embellishment*
MUSEUM PURCHASE
72:0043:0093

ambrotypes, or imperishable pictures. Used primarily for portraiture, they were made to resemble the more expensive, intimate, and more technically complex daguerreotype. Sometimes referred to as "glass daguerreotypes," ambrotypes were produced in the same standard sizes and were matted, framed, and cased the same. Not without their detractors, ambrotypes were also called "black, nasty, filthy, ghastly, dead, inanimate, flat, shade[s] of shadows," and further derided for their tendency to "burst, break, peel, turn, [and] change all colors (but the natural one)...." But such opposition did not decrease their popularity, and, as time has proven from these examples, such criticism was not always accurate.

Cutting's "invention" was nothing more than a collodion negative on glass mounted against a black background, a practice already used in England and France. Collodion, viewed by reflected light, is light gray in tone; against a black ground, the image appears as a positive, albeit with a limited tonal range. This bisected view of a double portrait ambrotype

Mathew B. Brady
American, 1823–1896

Portrait of an Unidentified Couple, ca. 1860

Ambrotype with applied color
GIFT OF
FLORENCE MAHON
81:2522:0001

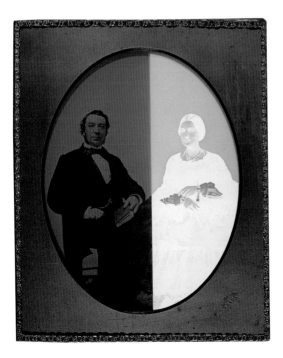

by Mathew B. Brady demonstrates the negative-positive duality of the ambrotype image with and without black backing. The Eastman House collection contains eight Brady ambrotypes among the nearly 150 works by this 19th-century master. Collodion could also be applied to other materials, including leather, slate, mica, and paper, and the Eastman House holds examples of each of these applications.

The museum's collection includes more than 1,300 ambrotypes. Though they are mostly portraits by professional photographers, the museum also holds a rare ambrotype of the Genesee River in Rochester made by George Eastman when he was learning photography from George Monroe in 1877. Ambrotypes were used to create records of places and events. This view of a Connecticut

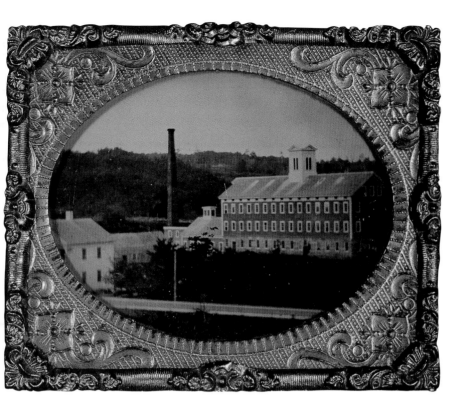

cotton mill displays the medium's impressive capacity for clarity of detail rivaling that of the daguerreotype. The elaborate gilded mat reinforces the importance of the image, which was likely commissioned by the mill's owner.

Indisputably, however, it was the portrait that most captivated the American imagination as the young nation clamored to preserve its collective likeness through photography. Inexpensive and easily accessible, photographic portraits were available to virtually everyone, either to share with loved ones or to keep near and to marvel at the young medium's ability to render such an accurate likeness. One popular genre was the occupational portrait, allowing the proud sitter to represent his or her skills, usually through the inclusion of the tools of their particular labor. A portrait of a man with a hammer represents his abilities as a blacksmith without portraying his

Unidentified photographer
American, active 1860s

View of Cotton Mill Building, Rockville, CT, ca. 1860

Ambrotype
GIFT OF
DONALD WEBER
95:2641:0001

handiwork, while a portrait of a woman with a broom indicates her station as a domestic laborer. Like Saint Lucy's eyes on a plate or Saint Sebastian's arrows in Renaissance art, the hammer and broom are the modern iconography of these otherwise anonymous subjects.

Painter and photographer Isaac Rehn's portrait of a mother with her two daughters and son is a handsome portrayal of the family. The absence of the father from the group suggests that this may be the photographer's family.

The domestic dynamic involved non-family members as well, and these relationships were also portrayed in photographs. A portrait of a young black woman holding a white child reveals her role as a household servant, possibly a slave. While her presence is strong and undeniable as she engages the camera directly, the focus of the image is decidedly upon the fancily dressed child.

In another kind of "family" portrait, a small white dog lies recumbent on a fern-patterned cloth (page 320). Clearly a beloved pet, the small animal comports itself for the camera as though it is fully familiar with photographic etiquette.

Isaac A. Rehn
American, active
1840s–1870s

Family Group, 1855

Ambrotype
GIFT OF 3M
COMPANY, EX-
COLLECTION LOUIS
WALTON SIPLEY
77:0267:0019

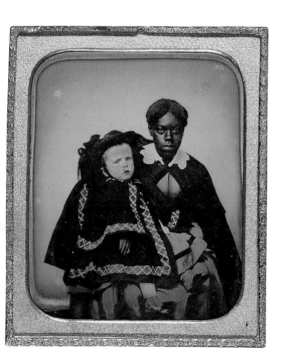

Unidentified photographer
American, active 1860s

*Portrait of Black Woman
Holding White Child*, ca. 1860

Ambrotype
GIFT OF DONALD WEBER
95:2687:0001

Unidentified photographer
American,
active 1850s

Small White Dog,
ca. 1858

Ambrotype
MUSEUM PURCHASE,
EX-COLLECTION
ZELDA P. MACKAY
69:0205:0041

For such popular portraiture, ambrotypes virtually replaced daguerreotypes from the time they were introduced until around 1861, when the less-expensive cartes-de-visite and tintypes replaced them. Belying its name, the tintype is actually made on a thin sheet of iron, enameled black. Iron was cheap and plentiful as well as lightweight and durable. The public coined the name, favoring it over the more cumbersome terms ferrotype and melainotype, as tintypes were initially called. Its muted tonality is similar to that of the ambrotype and was thus its natural successor.

A tintype of an adorable black puppy huddled against the high back of a fainting couch is another example of the importance of beloved pets as photographic subjects. Such images possess a timelessness and immediacy for contemporary viewers.

The Eastman House collection has about 2,800 tintypes, including two portraits of George Eastman: one at three years of age and another as a teen. The museum holds in its technology collection a variety of apparatus employed in the making of these popular images. The remnants of a Wisconsin tintype studio came to the museum in 1951 as a part of the Alden Scott Boyer collection. Included in the inventory were cameras

Unidentified photographer
American, active 1870s

Dog in Chair, ca. 1870

Tintype
GIFT OF ALDEN SCOTT BOYER
82:1523:0002

and equipment; studio props, including a posing chair and headrest; a painted backdrop; and plates, cardboard mounts, and chemicals.

The most popular-sized tintype was about 2-1/2 x 4 inches, roughly the same size as the carte-de-visite image. The tintype of a woman looking at framed tintype portraits in a studio (page 322) provides a sense of

(right)
Unidentified photographer
American,
active 1880s

Two Women Fencing,
ca. 1885

Tintype
82:1414:0001

(left)
Unidentified photographer
American,
active 1870s

Woman Looking at Framed Tintype Portraits, ca. 1870

Tintype
72:0030:0001

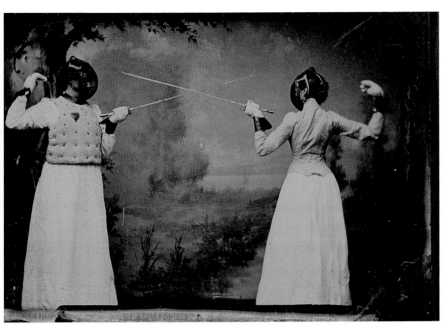

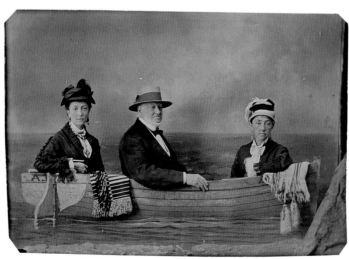

**Unidentified
photographer**
American,
active 1870s

*Two Women and
Man in Studio Prop
Boat*, ca. 1875

Tintype
GIFT OF 3M COM-
PANY, EX-COLLEC-
TION LOUIS
WALTON SIPLEY
77:0268:0025

(left)
**Unidentified
photographer**
American?,
active 1870s

*Man and Child's
Hands*, ca. 1875

Tintype
78:0829:0010

(right)
**Unidentified
photographer**
American?,
active 1870s

*Hand-Operated
Device*, ca. 1870

Tintype
MUSEUM PURCHASE,
HORACE W. GOLD-
SMITH FOUNDATION
FUND
83:0121:0001

scale for the images and also of possible presentation, as she ponders the images and her potential portrait before her own "formal" sitting. "Two Women Fencing" (page 323) is a staged joust between unlikely sparring partners in full skirts set against a painted landscape. "Two Women and Man in Studio Prop Boat" (page 323) is an example of the lengths to which photographers could go using props in the studio to represent more complex, outdoor leisure activities. While transparent in its artificiality, the setting nevertheless conveys the sense of a recreational outing, even if their solemn expressions do not.

The curious image of a man and child's hands is displayed in a fancy cardboard mat, a popular presentation for tintypes, which did not need to be protected in hard cases like ambrotypes and daguerreotypes. A photograph of what appears to be a hand-operated pump has a sense of scientific practicality, while the portrait of a woman looking into a mirror (right) slyly references the "mirroring" aspect of photography.

The first popular card-mounted photographs were cartes-de-visite, small images that were originally pasted on the back of engraved calling

**Unidentified
photographer**
American,
active 1870s

*Woman Looking into
Mirror,* ca. 1870

*Tintype with
applied color*
78:0829:0013

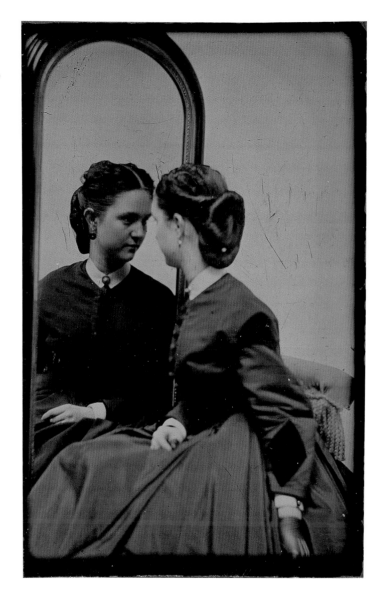

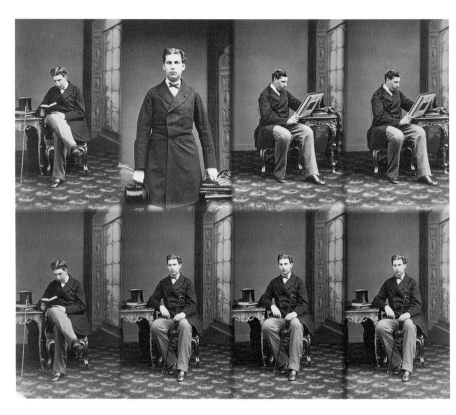

**André-Adolphe-
Eugène Disdéri**
French, 1819–1889

Duc de Coimbe (?),
ca. 1860

*Albumen print, uncut
carte-de-visite sheet*
81:2326:0011

cards. In 1854 Parisian photographer André-Adolphe-Eugène Disdéri patented his invention to "take a glass plate which can contain ten images ... make [a] negative, either all at once or image by image; then ... use this negative to make ten prints all at once." It would seem that Disdéri modified his initial estimate, as cartes-de-visite were usually produced in series of eight per negative, demonstrated in this example of an uncut sheet of cartes by Disdéri himself. Numerous accounts suggest the existence of the carte format much earlier, but Disdéri receives and deserves the credit for its eventual success. As the celebrated French portrait photographer Nadar remarked: "... by giving infinitely more for infinitely less, [Disdéri] definitively popularized photography." Cartes-de-visite remained so until the late 1860s, sparking "cartomania," or "photomania," and revolutionizing the business of photography.

According to history, embellished with a good dose of legend,

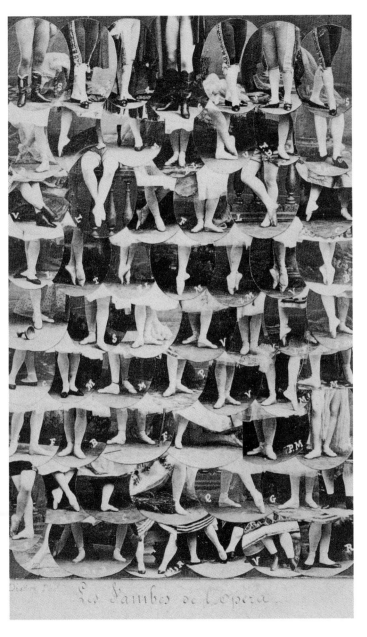

André-Adolphe-Eugène Disdéri

Les jambes de l'opéra (The Legs of the Opera), ca. 1870

Albumen print carte-de-visite
GIFT OF EASTMAN KODAK COMPANY, EX-COLLECTION GABRIEL CROMER
81:1226:0002

Napoleon III stopped en route to Italy to have his portrait made at Disdéri's Paris studio. Using the carte-de-visite process, Disdéri made and sold thousands of copies of the monarch's portrait, thus determining the success of the carte overnight. Cartes of royalty remained a staple of many photographers' businesses. Their success was astounding: In England alone 10,000 cartes of Prince Albert were sold the week after his death in 1861. Even with such an extraordinary level of consumption in Europe, the desire to preserve photographic memories of departing soldiers during the American Civil War and pioneers migrating to the west shifted the center of carte production to the United States.

Widely collected, convenient to handle, easy to display, and diverse in their subject matter, cartes could serve as a tie between loved ones or be simply whimsical, like this playful image of a top hat suspended in space, made at Buel's Gallery in Pittsfield, Massachusetts. Perhaps an early advertisement or a symbol that now lies mute, this carte is among the 10,000 that are in the museum's collection.

Buel's Gallery (Pittsfield, Massachusetts)
American, active 1860s–1870s

Top Hat, ca. 1870

Albumen print carte-de-visite
MUSEUM PURCHASE
69:0183:0156

"Spirit" photography was a phenomenon that began in Boston in 1861. In these "shadow pictures," as some photographers called them, it was claimed that ghosts would appear on the negative unbeknownst to the photographer until the image was developed. Celebrities as diverse as the bereft and widowed Mary Todd Lincoln and novelist Sir Arthur Conan Doyle championed this photographic offspring of the popular "mediumistic clairvoyance" that swept through the latter half of the 19th century. The photograph

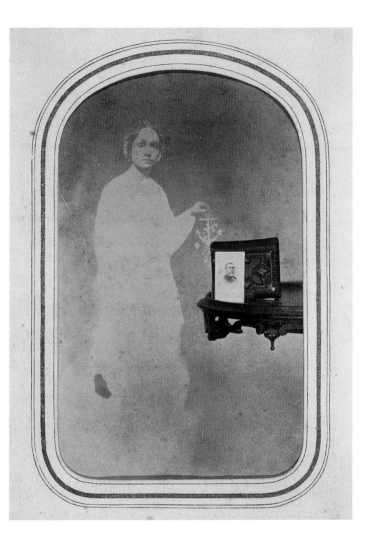

**Unidentified
photographer**
American,
active 1860s

*Spirit Photograph –
Woman's Spirit
behind Table with
Photograph*, ca. 1865

*Albumen print
carte-de-visite*
MUSEUM PURCHASE,
EX-COLLECTION
ROBERT A.
SOBIESZEK
68:0325:0004

of a woman's "spirit" standing behind a table that holds another framed photograph (page 329) shows a vivid example of a "spirit's" presence. In actuality, many photographers merely superimposed separate images, as in this example in which the photographer left more than half of the frame free to accommodate his "unexpected" subject.

In 1862, Scotsman G. W. Wilson introduced the cabinet-size photographic print mounted on a card, about three times the size of a carte-de-visite. Four years later the cabinet card was introduced in England and the United States. Its greatest appeal was that its larger size rendered more facial detail than the smaller carte. Albums appeared in 1867 that could accommodate both formats. Although about 15 different portrait formats were eventually introduced, only the carte-de-visite and cabinet card proved successful.

Paul Nadar
French, 1856–1939

Dancer in Costume Holding Eggs,
ca. 1890

Albumen print cabinet card
82:1228:0004

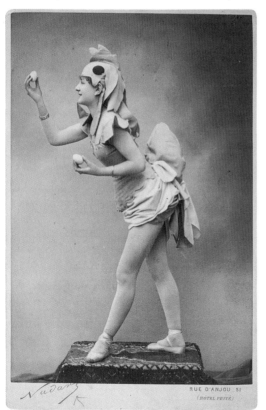

By 1890, Nadar had all but relinquished the photographing responsibilities at his studio to his son, Paul, who made this charming portrait of a costumed dancer holding eggs.

On the other side of the Atlantic, the well-regarded New York photographer Abraham Bogardus, who had bought his first daguerreian outfit in 1846 and opened his own gallery in New York, took to the card format despite his initial resistance against it. Bogardus trafficked in the highly popular genre of "freak" photography, including portraits of Tom Thumb and his wife. When clients complained that his portraits of them made them look like the devil, Bogardus retorted that he had "never met the devil and cannot say whether they ressemble [*sic*] him." Of the carte-de-visite format, he stated: "Too small: a man

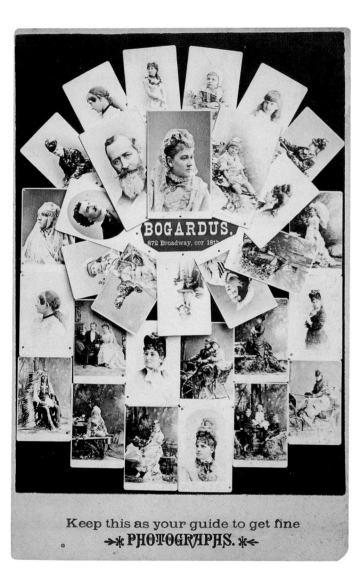

Keep this as your guide to get fine
→✳ PHOTOGRAPHS. ✳←

Abraham Bogardus
American,
1822–1908

"Keep This as Your
Guide to Get Fine
Photographs,"
ca. 1885

*Albumen print
cabinet card*
82:0679:0001

standing against the shaft of a column, his face the size of two pinheads. I laughed upon seeing it, scarcely thinking that before long I would be producing them at the rate of a thousand a day." On a cabinet card advertisement for his studio, Bogardus managed to squeeze 30 individual photographs into an especially small image area, effectively reducing the images to a fraction of the carte-de-visite format.

The proliferation of illustrated newspapers, magazines, and books signaled the beginning of the end for the carte-de-visite and cabinet card as photographic images became increasingly accessible through these alternate media. While patrons still had their own likenesses made, they were less inclined to collect individual photographs of famous or otherwise interesting subjects. Photomechanical processes made these reproductions cheaper and more accessible than card photographs.

Careers of artists like Honoré Daumier had been made through the reproduction of their work as lithographs in illustrated newspapers and journals. Daumier's caricature of Nadar precariously photographing from his balloon capitalized both on the international notoriety of the eccentric photographer as well as the popular mania for the medium itself, represented by a landscape populated almost entirely by photography studios. Nadar's fame rivaled that of his illustrious sitters, and the combination of his name with theirs proved lucrative, selling many larger prints for his studio. Nadar's portrait of celebrated

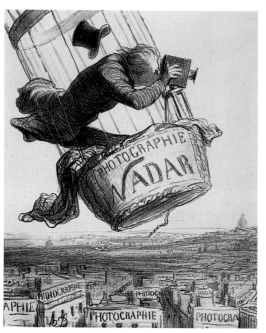

Honoré Daumier
French, 1808–1879

Nadar élevant la photographie à la hauteur de l'art (Nadar Elevating Photography to the Level of Art), May 25, 1862

Lithograph
GIFT OF EASTMAN KODAK COMPANY, EX-COLLECTION GABRIEL CROMER
82:2383:0001

Nadar
(Gaspard Félix Tournachon)
French, 1820–1910

Georges Sand, ca. 1860

Print ca. 1880 by Goupil et Cie Woodburytype
97:1957:0001

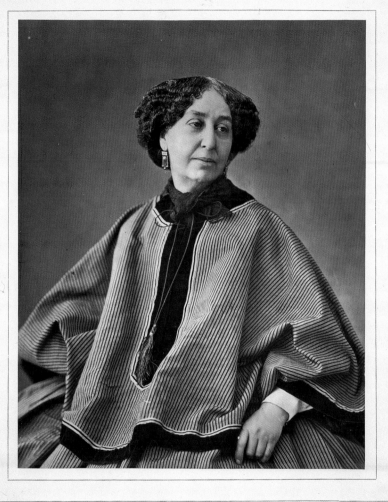

120, boul. Magenta. — Paris. Phot. Goupil et Cᵒ. Cliché Nadar.

GEORGES SAND

Née à Paris, le 5 juillet 1804, morte à Nohant, le 8 Juin 1876.

**Nadar
(Gaspard Félix
Tournachon)**
French, 1820–1910

Mademoiselle
Delna, Mademoi-
selle Bonnefoy et
Monsieur LaFarge,
Mademoiselle
Jeanne Harding,
ca. 1860

Albumen print
MUSEUM PURCHASE
70:0139:0002

writer Georges Sand is a Woodburytype that was part of "Galerie contemporaine, littéraire, artistique" a serial publication of 241 Woodburytypes distributed by the firm Goupil et Cie. in Paris.

Stars of the stage, too, were Nadar's subjects. Mademoiselle Delna, Mademoiselle Bonnefoy, Monsieur LaFarge, and Mademoiselle Jeanne Harding are names unfamiliar to modern viewers, but for contemporaries, the multiple views of comic actors in various guises mounted together on a single numbered card served as an advertisement. Nadar's portrait of an unidentified young woman in costume, striking a dramatic pose of supplication, is an endearing portrait of the actress as ingenue.

With the popularity of lithographic reproduction, photography began to be editorialized and serialized, just like popular novels of the day that were published in weekly or monthly installments. Photography also figured prominently in contemporary writings and thus had a level of familiarity with the general public that no other art form could claim. Edmond de Beaumont was the lithographer and the Maison Martinet the publisher of the series *Dialogues Parisiens*. An inscription under the image of this colored lithograph is a flirtatious dialogue between a young mistress and her older male companion; she stands beside him holding a stereo viewer. The text reads: " – *Comme c'est joli ..., mon ami, toutes ces vues ...; on croirait y être!...* – How lovely it is ..., my love, all these views ...; one believes that one is there!... – *Je suis de ton avis ..., aussi, cet été, au lieu d'aller visiter la Suisse, comme tu m'avais demandé, je t'acheterai des vues de ce pays que tu t'amuseras a regarder au travers de ta lorgnette!...* – I agree with you ..., also, this summer, instead of going to visit Switzerland, like you asked me, I'm going to buy you views of that country so you

Edmond de Beaumont
French, active
ca. 1850s

Dialogues Parisiens,
ca. 1855

Lithograph with applied color
GIFT OF EASTMAN
KODAK COMPANY,
EX-COLLECTION
GABRIEL CROMER
82:2373:0004

can amuse yourself by looking through your opera glasses!..." Photography had become commonplace, an instantly familiar subject in popular imagery, and here the suggestion that the stereographic view could substitute for the real thing was being lampooned.

The introduction of the stereograph image created the next great wave of popularity in photography. Though the stereograph image had existed since the early days of photography, it was not widely produced until the early 1850s. It vied for popularity with the carte-de-visite during the 1860s, and by the late 1930s, countless millions of stereographs had been sold worldwide. During the 1880s stereoscopes were even sold door to door, like encyclopedias, by college students moonlighting as traveling salesmen.

Stereographs reached the height of their popularity in the 1870s and were a common diversion in fashionable Victorian parlors, providing hours of entertainment and edification through the diversity of the subject matter depicted. Their content increasingly reflected Victorian morals, mores, and humor. Although every conceivable subject, from architecture to zeppelins, was given the stereographic treatment, some of the more popular applications were constructed narratives, miniature comedies, and dramas played out in the stereo viewer, either on a single card or a sequential group.

Alfred Silvester was a master of fine tinting and specialized in genre scenes. His sensitively hand-colored image of a woman dreaming about

Alfred Silvester
English,
active ca. 1850s

The Dream of the
Wedding, ca. 1858

*Albumen print
stereograph with
applied color*
GIFT OF ALDEN
SCOTT BOYER
84:1434:0001

her wedding day (page 337) is a fine example of the strong narrative appeal that could be constructed through the photographic image. The superimposition of the minister and betrothed pair kneeling before him is visible to the viewer just beyond the conveniently tied-back drape. The dream scene conspicuously lacks color in order to emphasize its representation of a fantasy state separate from the color-coded "reality" of the sleeping woman in her sitting room. While reminiscent of spirit photography, Silvester's subtle work has survived the test of time, remaining movingly convincing in its manipulation of the medium for the sake of narrative. The museum's collection holds over 35,000 examples of the stereographic art.

Landscapes were also a popular subject for the stereograph image. Stereographs, because of their unique three-dimensionality, were perhaps most effective in scenes that rendered perspective. Charles Warren Woodward of Woodward Stereoscopic Company was a Rochester, New York, based publisher of stereoscopic views, who specialized in landscapes of the American West and New York State scenery. "Arnold Park" is from the series *Rochester and Vicinity*, which was offered for sale in 1876 at $1.50 per dozen views. The deep perspective of the street appears infinite in the stereoscope viewer, and the trees lining the street veritably dance along its length when viewed in stereo. The close-up view of a decorative urn in the left corner further emphasizes the dramatic depth of this view, making this a highly successful example of the format.

Charles Warren Woodward

American, 1836–1894

Arnold Park, ca. 1876

Albumen print stereograph
MUSEUM PURCHASE
81:8716:0024

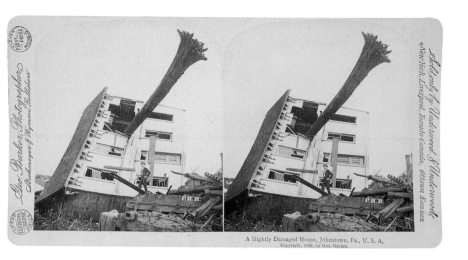

A Slightly Damaged House, Johnstown, Pa., U. S. A,
Copyright, 1889, by Geo. Barker.

While idyllic views such as "Arnold Park" held vast appeal, the after-
math of natural disasters of every conceivable magnitude – earth-
quakes, volcanic eruptions, floods, tornadoes, hurricanes, tidal waves,
and cyclones – were also photographed, and the stereograph brought
the scope of these tragedies into view with vivid detail. George Barker
was a prize-winning Canadian landscape photographer famous for his
more than 800 views of Niagara Falls. Barker's images, made for a sur-
vey on the effects of commercial and industrial development, led to the
establishment of park lands on both sides of the river. A prolific photog-
rapher, Barker operated Barker's Stereoscopic View Manufactory and
Photograph Rooms above his variety store, in which he also sold
souvenirs and curios.

Barker traveled to other states including Georgia, Kentucky, and Flori-
da to make photographs of landscapes and disasters. After the infa-
mous Johnstown flood of 1889, Barker went to Pennsylvania to photo-
graph the results of the damage that had claimed many lives. Almost
20 photographers made stereographs of the aftermath of this tragedy.
Among Barker's views were some stereographs with "posed" victims.
"A Slightly Damaged House, Johnstown, PA ..." is an oddly jocular title,
but was undoubtedly marketed to appeal to the public's macabre fasci-
nation with disaster.

George Barker
American,
b. Canada,
1844–1894

A Slightly Damaged
House, Johnstown,
PA., U.S.A., 1889

*Gelatin silver print
stereograph*
GIFT OF HENRY OTT
81:5912:0003

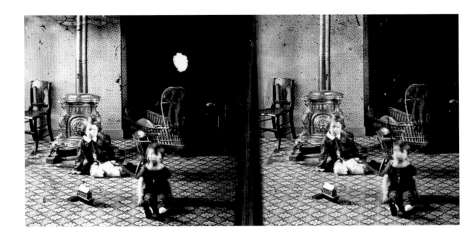

Edwin Emerson
American, 1823–1908

Children by Wood-stove, ca. 1861

From a collodion on glass negative
GIFT OF EDITH EMERSON
80:0678:0027

Not everyone relied on commercial photographers to provide them with photographic views of the world. In no other artistic medium have amateurs made as significant a contribution as in photography. Even before the introduction of the Kodak camera made photography widely available, intrepid practitioners equipped themselves with photographic outfits and set about recording their lives and surroundings with the same skills as the professionals. Amateurs were founding members of nearly every early photographic society, creating forums in which to share ideas, formulas, and images with like-minded enthusiasts.

Edwin Emerson was a professor of rhetoric and belles lettres at Troy University in Troy, New York. His college roommate, an amateur photographer and chemistry professor, introduced Emerson to the medium. Within a month of his arrival in Troy, Emerson purchased photographic equipment from E. and H. T. Anthony and Company in New York, and photography remained a lifelong interest. Emerson was a member of both the Amateur Photographic Exchange Club and the Photographic Society of Philadelphia. More than 100 of Emerson's images and 80 of his negatives are held by the museum, given by Emerson's granddaughter, Edith. These two images from Emerson's original stereograph negatives are family photographs made in Troy. They reveal a striking sensitivity to light and shading. Two children sit on the floor by a wood stove illuminated by light softly flowing into the room from outside of the frame. In a portrait of two women seated near a window, the strong sunlight bathes the women in a warm, shadowy glow.

After leaving Troy in 1862 Emerson toured Europe, collecting work by Oscar Gustave Rejlander, a leading artistic photographer who made elaborate combination prints involving multiple negatives, including "The Two Ways of Life" and "Head of St. John the Baptist in a Charger" (see page 360).

Evidencing an eye for the dramatic – if, perhaps, not quite on Rejlander's level –, John Coates Browne photographed stars of a children's play dressed in their ghoulish costumes (page 342). Browne was an amateur photographer and a charter member of the Photographic Society of Philadelphia, regularly exhibiting his work there. In 1884 he wrote the *History of the Photographic Society of Philadelphia* and contributed frequently to the national magazine the *Philadelphia Photographer*. His photograph of a sleeping dog on a porch (page 342) revisits the perennially favorite photographic subject of man's best friend. More than 100 of Browne's negatives were acquired in 1975.

Samuel Fisher Corlies was another early member of the Photographic Society of Philadelphia, established in 1862 and still in existence. Corlies participated in the photographic excursions that were sponsored for its members. His 231 glass plate negatives, many annotated with the type of collodion or gelatin emulsion used, the date and location where the image was made, and often exposure information, are held by the museum. From a display of freshly caught trout to a group of photographers on an outing (page 343), Corlies carefully documented the events of his life, leaving a valuable photographic glimpse into another era. Both Browne's and Corlies' images presaged the informal photographic attention that would be given to everyday events by the snapshot

Edwin Emerson

Two Women Seated in Room, ca. 1861

From a collodion on glass negative
GIFT OF EDITH EMERSON
80:0678:0030

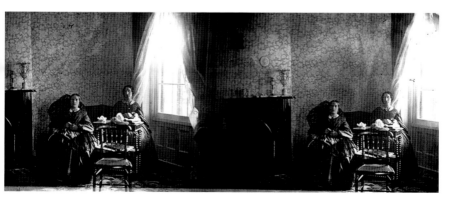

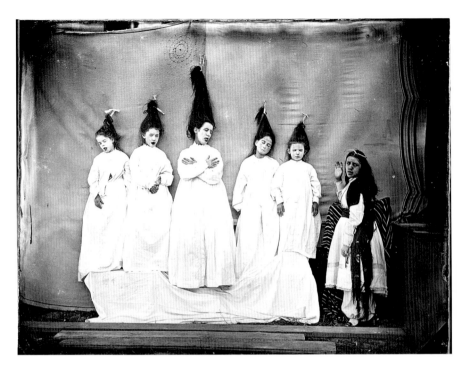

John C. Browne
American, 1838–1918

A Children's Play,
ca. 1866

*Modern gelatin silver
print from the original
collodion on glass
negative*
MUSEUM PURCHASE
75:0130:0043MP

John C. Browne

Dog Asleep on Porch,
ca. 1866

*Modern gelatin silver
print from the original
collodion on glass
negative*
MUSEUM PURCHASE
75:0130:0044MP

Samuel Fisher Corlies
American, 1830–1888

Trout and Rod, 1880

*From a gelatin
on glass negative*
GIFT OF THE 3M
COMPANY, EX-
COLLECTION LOUIS
WALTON SIPLEY
77:0703:0016

Samuel Fisher Corlies

Four Photographers
Group in Parlor at
Enfield Glen, 1885

*From a gelatin
on glass negative*
GIFT OF THE 3M
COMPANY, EX-
COLLECTION LOUIS
WALTON SIPLEY
77:0706:0001

Frederick Church
American, 1864–1925

*George Eastman on
Board the S. S. Gallia,*
February 1890

*Albumen print
(Kodak # 2 snapshot)*
GIFT OF MARGARET
WESTON
81:1159:0026

camera, although their materials were the same as those used by professional photographers.

Not long after these images were created, the medium of photography was transformed by an invention that completely altered the means by which photographs were made, and the visual world would never be the same. Possibly the biggest blow to the card photograph and to studio photographers in general was the introduction of the box camera.

While on a transatlantic trip, Frederick Church photographed inventor and Eastman Kodak Company founder George Eastman with a No. 2 Kodak box camera, the same model that Eastman also holds. Eastman had sold insurance and worked for a bank before devoting himself to photography, first by selling dry plates. In 1892 the Eastman Dry Plate and Film Company was reorganized as the Eastman Kodak Company. The name Kodak, according to Eastman, "was a purely arbitrary combination of letters ... a word that would answer all the requirements for a trade name ... short; incapable of being misspelled so as to destroy its identity, [and with] a vigorous and distinctive personality."

"You press the button, we do the rest," was Kodak's advertising slogan, first published in 1888. The camera's instructions could not have been simpler: 1) Pull the cord. 2) Turn the key. 3) Press the button. The No. 1 Kodak was a small box – 3-1/4 by 3-3/4 by 6-1/2 inches – that came loaded with roll film for 100 exposures. Each image was 2-5/8 inches in diameter. The initial cost was $25, and around 13,000 were sold in the first year. After the film was exposed, the customer mailed the camera back to Kodak, which returned it reloaded with film for 100 more exposures and the 100 mounted prints, at a cost of $10. For the first time in the history of the medium, the means of photography could be put into the hands of any man, woman, or child.

Sir John Herschel coined the term "snapshot" in 1860. A British

Richard K. Albright
American,
active 1880s

Descending
Vesuvius, ca. 1888

*Albumen print
(Kodak # 1 snapshot)*
GIFT OF MRS.
RAYMOND ALBRIGHT
74:0250:0048

(left)
Unidentified photographer
American,
active 1890s

Samuel Castner, Jr.,
ca. 1890

*Albumen print
(Kodak # 1 snapshot)*
GIFT OF 3M COMPA-
NY, EX-COLLECTION
LOUIS WALTON
SIPLEY
82:1797:0009

(right)
Unidentified photographer
American,
active 1890s

Conesus Lake,
August 1893

*Albumen print
(Kodak # 1 snapshot)*
81:1294:0018

hunting term referring to shooting from the hip without careful aim, it was adapted to mean "the possibility ... of securing a picture in a tenth of a second. ..."

Richard K. Albright's photograph, "Descending Vesuvius" (page 345) is an example of a Kodak snapshot. Among the 38 Kodak snapshots that Albright made in Europe are, predictably, "Ascending Vesuvius" and simply "Vesuvius. Raymond," made at the summit. The button was probably pushed by a passerby or Albright's wife, whose daughter-in-law donated the collection of images to Eastman House.

Samuel Castner, Jr., was also the subject of one photographer's snapshot, standing directly in line with the tree and path in the center of the frame. Without the need for a darkroom, tripod, or other additional equipment, snapshots were able to record more fleeting moments than had previously been possible. They allowed the camera to record images from vantage points where larger cameras could not physically go, such as just above water level at Conesus Lake, New York, where four happy and bobbing heads made lasting memories of their holiday in the summer of 1893.

Early Kodak cameras did not have viewfinders, so the phrase "point and shoot" was no exaggeration. Thus new photographers were required to make their pictures by essentially guessing at framing, which accounts for this portrait of a baby in a carriage escorted by a woman whose head is only half-visible. The early Kodak snapshots were also round in format, because the inexpensive, wide-angle lens was distorted

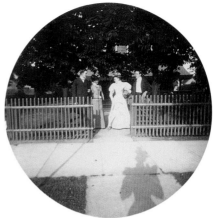

around the outer edges. Eastman equipped the first three models of the camera with a circular mask to disguise it, giving the images a kind of "bull's-eye" aesthetic. The circular format was changed after 1896 to the more familiar rectangular formats.

Although men had previously far outnumbered women as photographers – even though many women had been employed on the production end – Kodak cameras were aggressively marketed to women. The museum's technology collection has numerous examples of these cameras, which later were sometimes marketed with matching lipsticks and compacts. The "Kodak Girl," introduced in the 1890s, was a ubiquitous advertising tool: sporty women traveled the globe, Kodak in hand. The snapshot of two men and two women standing by the entrance gate of a front yard was made by a woman, judging from the telltale puffed-sleeve shadow cast in the foreground as she made the exposure.

In 1900 Eastman introduced the Brownie camera, named after the popular cartoon characters and originally intended to be used by children. It cost only $1, and more than 100,000 were sold in the first year. Eastman had envisioned the Kodak camera as "a photographic notebook." He said: "Photography is thus brought within reach of every human being who desires to preserve a record of what he sees. Such a photographic notebook is an enduring record of many things seen only once in a lifetime and enables the fortunate possessor to go back by the light of his own fireside to scenes which would otherwise fade from memory and be lost."

(left)
Unidentified photographer
American,
active 1890s

Baby in Carriage,
ca. 1895

*Gelatin silver print
(Kodak # 2 snapshot)*
81:2862:0093

(right)
Ellen Dryden (attrib.)
American,
active 1880s–1890s

Two Men and Two Women in Yard,
ca. 1889

*Gelatin silver print
(Kodak # 2 snapshot)*
GIFT OF GEORGE
B. DRYDEN
81:2167:0056

Artful Ambitions

From the time of its invention, photography was embroiled in an ongoing debate over whether or not this mechanical medium could produce art. The great era of the calotype in France marked the first concentrated application of the medium by various artists as a fine art and not the handmaid of painting and drawing. Among the French calotype artists, the most ardent proponent and practitioner to explore photography's artistic capabilities was Gustave Le Gray. Trained as a painter in the studio of Paul Delaroche, Le Gray taught photography to Henri Le Secq, Charles Nègre, Adrien Tournachon (all of whom trained as painters), and others.

Although his photographic career lasted only a dozen years, Le Gray was one of the most influential practitioners of the 19th century. He became a founder of the Société Héliographique, the world's first photographic association, and published a handbook for artists titled *A Practical Treatise on Photography* that was so widely consulted that it was also published in England and the United States. It included rules for posing sitters in order to produce the liveliest portraits as well as procedures for technical manipulations. Declaring his disdain for rampant commercialism and his commitment to the application of photography as an art form, Le Gray wrote: "The future of photography does not lie in the cheapness but in the quality of a picture. If a photograph is beautiful, complete, and durable, it acquires an intrinsic value before which its price disappears entirely. For my part, it is my wish that photography, rather than falling into the domain of industry or of commerce, might remain in that of art. That is its only true place, and I shall always seek to make it progress in that direction."

Around 1855 Le Gray began to photograph at the Mediterranean port of Sète. His seascape of the sun setting over the water is a spectacular rendering of light and the nuance of shadow and reflection. At that time the chemicals used in photography were more sensitive to blue and ultraviolet light, so in exposing the negative for the water to look natural, the sky was rendered as a flat gray. To obviate this problem and to produce results such as "The Great Wave," Le Gray combined two negatives, one exposed for the water and the other exposed for the sky. Occasionally Le Gray would reuse the same negatives, and one can see the same formation of clouds appearing in different images.

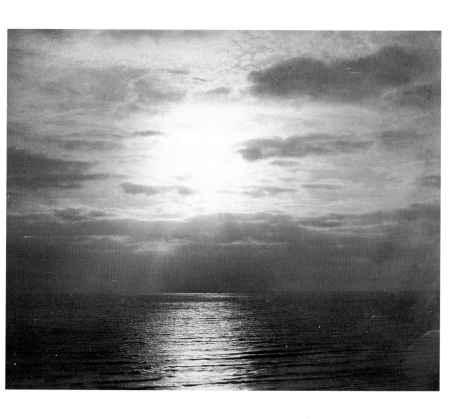

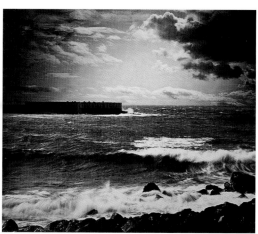

Gustave Le Gray

The Great Wave,
Sète, ca. 1857

Albumen print
GIFT OF EASTMAN
KODAK COMPANY,
EX-COLLECTION
GABRIEL CROMER
82:1589:0001

Gustave Le Gray
French, 1820–1882

Seascape, ca. 1855

Albumen print
GIFT OF EASTMAN
KODAK COMPANY,
EX-COLLECTION
GABRIEL CROMER
81:1442:0001

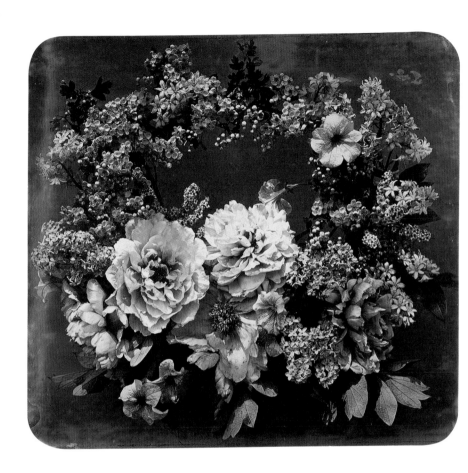

Adolphe Braun
French, 1812–1877

Camellias and Lilacs,
1856

Albumen print
GIFT OF EASTMAN
KODAK COMPANY,
EX-COLLECTION
GABRIEL CROMER
81:1005:0004

Not a fine artist in the academic tradition per se, Adolphe Braun came to photography from a background in textile design. As the head of a textile mill, he took up photography around 1853 in order to create a "collection of studies for artists who used floral motifs." He later established his own design house specializing in textiles and wallpapers, as floral designs were extremely popular in Second Empire France. The Eastman House collection holds approximately 60 of these floral studies, most in an album of 52 albumen prints, including this floral still life artfully presented to an oval shape. His wreath-like arrangement of "Camellias and Lilacs" reveals an artist's sensibility in the arrangement of nature's most stunning offerings. The collection also contains nearly 200

Adolphe Braun

Floral Still Life, ca. 1857

Albumen print
MUSEUM PURCHASE
67:0045:0006

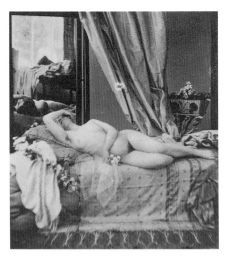

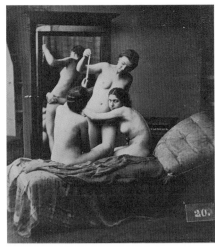

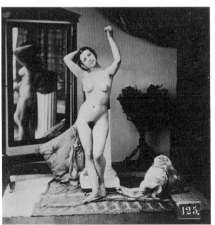

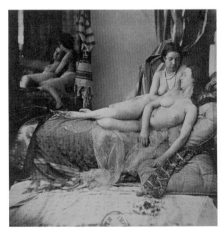

Louis-Camille d'Olivier
French, 1827–after 1870

Composition avec nu
(Composition with Nude), 1853–1856

Salted paper prints
MUSEUM COLLECTION, BY EXCHANGE
85:1007:0024 (top left)
85:1007:0027 (top right)
85:1007:0005 (bottom left)
85:1007:0014 (bottom right)

(right)
**Louis-Camille
d'Olivier**

Étude d'après nature
(Nature Study),
1853–1855

Salted paper print
MUSEUM COLLEC-
TION, BY EXCHANGE
85:1009:0002

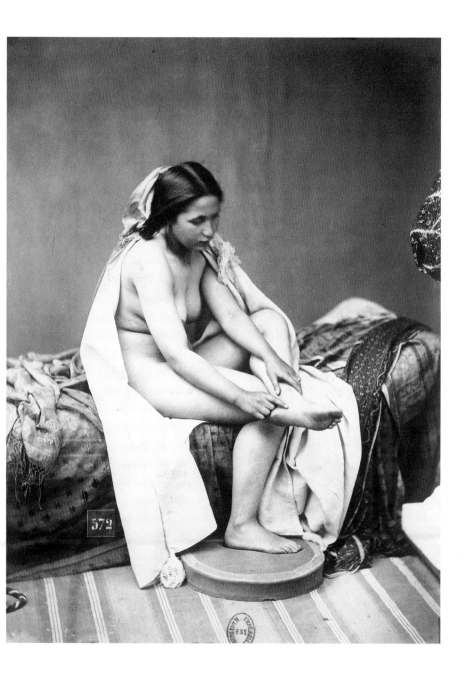

of Braun's images, representative of his artistic and business endeavors, including art reproductions and stereographs.

Another subject that was a favorite of the calotype artists was the female nude. Louis-Camille d'Olivier was a painter and photographer who established a commercial firm, the Société Photographique, which specialized in nude studies. Rather than merely present the women's bodies as *académies*, d'Olivier frequently depicted them in bedroom or toilette scenes, both alone and in groupings. The erotic nature of his work is evident in their languid poses of abandonment and pleasure as the models caress one another or themselves (pages 352 and 353). The inclusion of underarm and pubic hair and bare, dirty feet was shockingly frank and unconventional within the genre of traditional nude studies, adding an element of realism to d'Olivier's work.

By comparison, Eugène Durieu's nudes are more classical and chaste. Durieu was a lawyer and government administrator who started to photograph around 1845, assisting Baron Jean-Baptiste-Louis Gros in making astronomical daguerreotypes. Along with Le Gray, Durieu was a

Eugène Durieu
French, 1800–1874

Female Portrait (left),
Nude (top right),
*Female Portrait with
Bird* (bottom right),
ca. 1855

Salted paper prints
GIFT OF EASTMAN
KODAK COMPANY,
EX-COLLECTION
GABRIEL CROMER
79:0079:0062 (left)
79:0079:0063
(top right)
79:0079:0064
(bottom right)

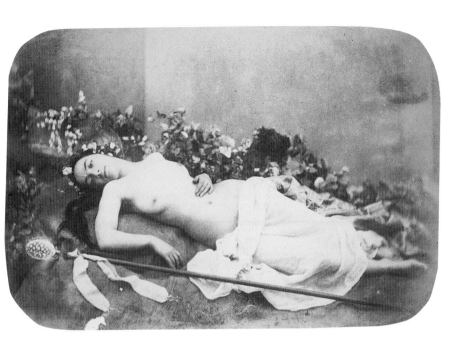

founding member of the Société Héliographique. As a member of the Commission des Monuments Historiques, Durieu was introduced to the practical and artistic merits of the calotype medium, declaring that "the future of Photography lies in paper." He is best known for his nude and costume studies for artists. The Romantic painter Eugène Delacroix, who met Durieu around 1850 after the latter had retired from his government post, is believed to have suggested this subject matter and helped pose many of his nudes. Delacroix later used Durieu's photographs from which to sketch. A group of images from *Photographie*, Durieu's personal album of 119 prints that is now in the Eastman House collection, suggests the subtlety and mastery of his art. An elegant portrait of a woman seated in profile, shoulders bare, mounted opposite one of a rare, smiling nude model with her arm upraised and another of a model holding a bird, demonstrates Durieu's open and experimental approach to the medium as well as the genre. In another view, an odalisque whose lower body is modestly yet seductively draped turns her head toward the camera. She acknowledges the viewer through the self-consciousness of her pose and gaze, submitting to voyeuristic fantasy.

Eugène Durieu

Reclining Nude with Scepter, ca. 1855

Salted paper print
GIFT OF EASTMAN
KODAK COMPANY,
EX-COLLECTION
GABRIEL CROMER
79:0079:0107

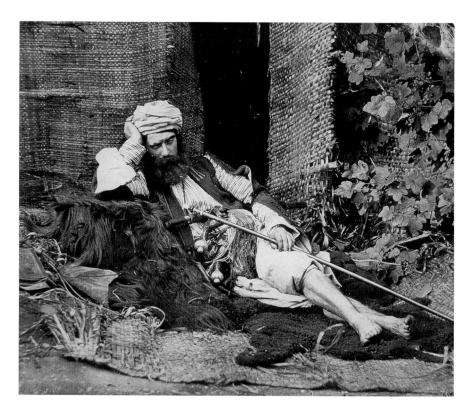

William M. Grundy
English, 1806–1859

Arab Reclining, 1857

Albumen print
GIFT OF G.C.
MONKHOUSE
76:0288:0045

Her left hand resting just below her breast is as deliberate as it is charmingly natural.

The recumbent pose was not exclusive to female models and French photographers. British amateurs also avidly pursued the artistic possibilities of the medium with very different subject matter. William Morris Grundy was a member of the Royal Photographic Society who illustrated the 1861 book *Sunshine in the Country: A Book of Rural Poetry* housed in the Menschel Library. Like many British contemporaries, he traveled and photographed in Egypt, exhibiting several of these images with the exotic title of "Turkish Scenes." Grundy's portrait "Arab Reclining" does not appear to be an Arab at all but rather a model posed in an Arab costume. His bare calves and feet are meant to suggest a kind of sensual abandon, especially to Grundy's Victorian British audience.

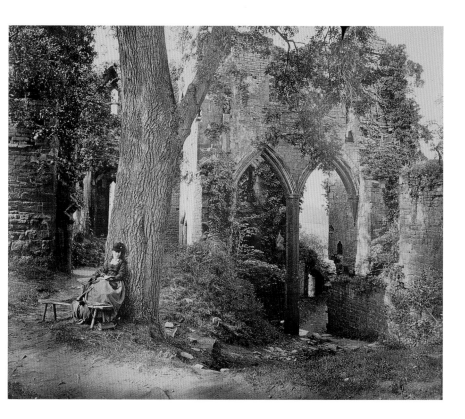

Captain George Bankhart was a founder of the Leicester and Leicestershire Photographic Society and was its president from 1887 until 1889. His views of Tintern Abbey and the countryside around his home are in the museum's collection. Bankhart's deliriously cluttered view of "Goodrich Castle from inside the Ruins" was published by the Amateur Photographic Association. Foliage and bricks overlap and intertwine as if grown up together, with perfectly intact arches revealing more complex views beyond. At left a woman rests against a tree that grows right out of the top of the picture frame. She holds an open book, suggesting a bucolic retreat.

Photographic artists often were not content to record the scene before them as nature presented it. Rather, they sought to perfect nature, believing it was the photographer's "imperative duty to avoid the mean, the bare, the ugly, and to aim to elevate the subject, to avoid awkward

Captain George Bankhart
English, 1829–1916

Goodrich Castle from inside the Ruins, ca. 1870

Albumen print
MUSEUM PURCHASE,
EX-COLLECTION
A. E. MARSHALL
82:2556:0001

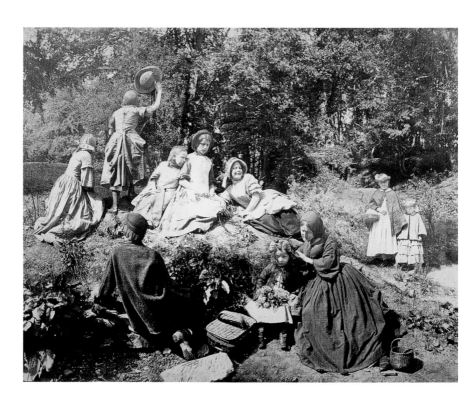

Henry Peach Robinson
English, 1830–1901

A Holiday in the Wood, 1860

Albumen print, combination print
GIFT OF ALDEN SCOTT BOYER
70:0192:0001

forms and to correct the unpicturesque," as Henry Peach Robinson wrote in 1869. Robinson became one of the most vocal proponents of photography as a fine, or "High Art." He wrote numerous treatises on the subject and applied his theories to some of the most remarkable manipulated images of the 19th century.

"A Holiday in the Wood" is a composite print from six different negatives. Robinson described the complexities of working with both weather and a recalcitrant medium, a reminder that success in early photography was dictated by more than the artist's eye: "The year 1860 was the wettest, or one of the wettest, years of the century ... *A Holiday in the Wood*... was produced under great difficulties. The figures were done on the only two fine days of April. Then everything was kept ready to drive to Kenilworth for the Woodland background, on the first fine day – which did not occur until 12 September. I had to wait five months."

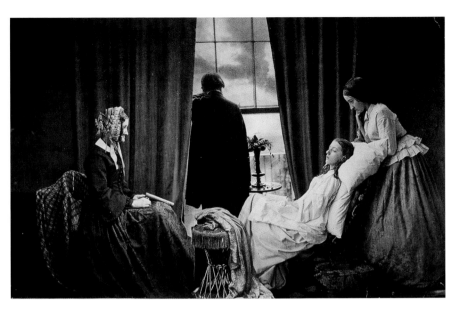

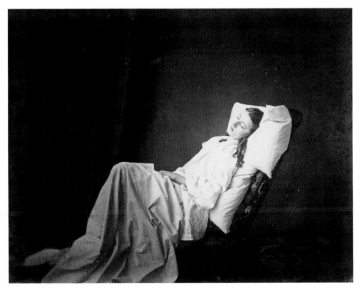

Henry Peach Robinson

Fading Away, 1858

Albumen print, combination print
GIFT OF ALDEN
SCOTT BOYER
76:0116:0001

Henry Peach Robinson

She Never Told
Her Love, ca. 1858

Albumen print
MUSEUM PURCHASE
75:0091:0001

"Fading Away," Robinson's most famous image, which one critic called "an exquisite picture of a painful subject" (page 359) is a composite print from five negatives, and Robinson's staff made an astounding 200 prints before an assistant accidentally ruined the negatives. Robinson appended a verse from Percy Bysshe Shelley's poem *Queen Mab* to the print. "She Never Told Her Love" is a variant of the central image of the fading girl posed by Robinson's favorite model, Miss Cundall; it takes its title from Shakespeare: "She never told her love/But let concealment, like a worm i' the bud,/Feed on her damask cheek."

Oscar Rejlander was Robinson's contemporary, friend, and eventual rival, especially regarding the debate over whether such blatant manipulation in photography was an acceptable means to an artistic end. Given photography's claims to veracity, Rejlander, who was trained as a painter in Rome, originally took up photography to aid his painting. Like Robinson, he wrote often and eloquently about photography, championing it as a High Art medium. Often called "The Father of Art Photography," Rejlander produced what is perhaps the best-known composite print image of the 19th century: "The Two Ways of Life," made from 30 negatives. Making an about-face in 1859, Rejlander stated: "I am tired

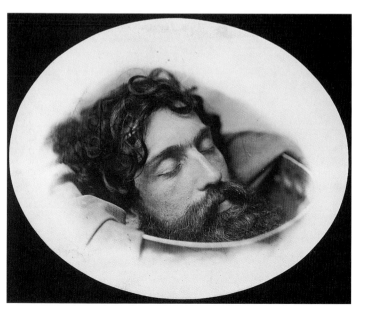

Oscar Gustav Rejlander
English, b. Sweden, 1813–1875

Head of St. John the Baptist in a Charger, ca. 1859

Albumen print, combination print
MUSEUM PURCHASE, EX-COLLECTION
A. E. MARSHALL
81:1791:0003

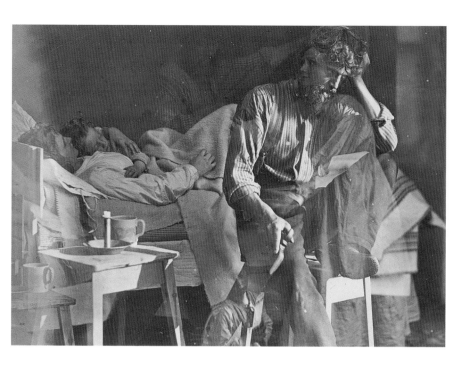

of photography-for-the-public, particularly composite photographs, for there can be no gain and there is no honour, only cavil and misrepresentation. My next exhibition will be composed only of landscapes, ruins covered with ivy, and, of course, portraits." Instead, one of his next images was the "Head of St. John the Baptist in a Charger" made from two negatives. Despite the gruesome scene, Rejlander depicted St. John's countenance in a peaceful, almost resting fashion, explaining that he wanted to portray the expression of "holy resignation" he believed St. John would have wanted to wear upon meeting his Maker. Robinson described Rejlander's tenacious approach to securing the model for St. John: "Rejlander saw his head on the shoulders of a gentleman in the town. ... The curious thing is, that he did not so much see the modern gentleman as always the picture which the head suggested. It was some months before the artist ventured to ask the model to lend his head ... and years before he obtained his consent."

"Hard Times" appeared in at least two versions; in this one, an image of a carpenter, his wife, and child is superimposed over a similar

Oscar Gustav
Rejlander

Hard Times,
ca. 1860

Albumen print
MUSEUM PURCHASE,
EX-COLLECTION
A. E. MARSHALL
72:0249:0042

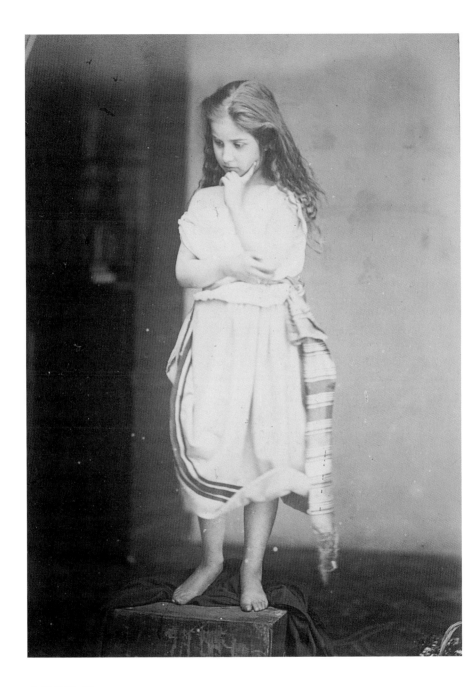

view, suggesting the mental torment afflicting the man unable to provide for his family. Rejlander also photographed local children in dramatic tableaux, such as this study (left) of a pensive girl posing on a box.

No photographer excelled with photographs of children, particularly young girls, more than Lewis Carroll. Carroll, the pseudonym of mathematician and writer Charles Lutwidge Dodgson, was the author of *Alice's Adventures in Wonderland* and its sequel *Through the Looking-Glass*. Taking up photography around 1856, Carroll was an avid practitioner for 25 years. Alexandra "Xie" Kitchin was the daughter of the Reverend George William Kitchin and the godchild of Queen Alexandra. She was one of Carroll's favorite models; Carroll stated that the way to guarantee excellence in a photograph was "to get a lens and put Xie before it." He began to photograph her in the late 1860s. Many of Carroll's portraits of Xie depict her in costume. Here the young girl reclines upon a bamboo chaise holding an umbrella aloft in this remarkably candid and self-assured portrait.

Lewis Carroll
(Rev. Charles
Lutwidge Dodgson)
English, 1832–1898

Xie Kitchin with
Umbrella, ca. 1875

Albumen print
MUSEUM PURCHASE
83:1546:0002

(left)
**Oscar Gustav
Rejlander**
English, b. Sweden,
1813–1875

*Pensive Young Girl,
Posing on a Box,*
ca. 1860

Albumen print
MUSEUM PURCHASE,
EX-COLLECTION
A. E. MARSHALL
72:0249:0002

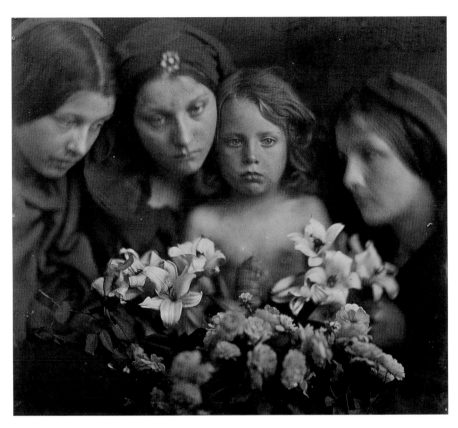

Julia Margaret Cameron
English, b. India, 1815–1879

"Wist Ye Not That Your Father and I Sought Thee Sorrowing?," 1865

Albumen print
GIFT OF EASTMAN KODAK COMPANY, EX-COLLECTION GABRIEL CROMER
81:1121:0027

The community of artistic photographers in Britain was a small one; Rejlander and Carroll are believed to have instructed Julia Margaret Cameron in photography to some degree. Both men had photographed Cameron, her family, and her home, Dimbola, at Freshwater on the Isle of Wight. Born in India and raised in France and England, Cameron came to photography somewhat late in life at age 49. Literature, Renaissance and pre-Raphaelite painting, and the Bible were primary influences on Cameron's work. In a letter to Sir John Herschel, Cameron plainly stated her intention to align photography with the High Art movement: "My aspirations are to ennoble Photography and to secure for it the character and uses of High Art by combining the real & Ideal sacrificing nothing of Truth by all possible devotion to Poetry & beauty." Sir John Herschel was a family friend and mentor, and it was he who

Julia Margaret Cameron

Henry Taylor, 1865

Albumen print
GIFT OF EASTMAN
KODAK COMPANY,
EX-COLLECTION
GABRIEL CROMER
81:1119:0001

kept Cameron abreast of photographic developments long before she took it up as an avocation.

"Wist Ye Not That Your Father and I Sought Thee Sorrowing?" (alternately titled "The Return after Three Days") is loosely based on the New Testament story of Christ's visit at age 12 to the temple. Evocative rather than illustrative, Cameron's image is a metaphorical representation of spirituality.

The poet Sir Henry Taylor was one of Cameron's most frequent male sitters; he posed as Kings Lear, David, and Ahasuerus, and even as Rembrandt, whose paintings Cameron occasionally emulated. Ten Taylor portraits are in the Eastman House collection. Here Cameron depicts the poet as Prospero, the duke of Milan from Shakespeare's *The Tempest*. He is a wise sage, brow deeply furrowed in thought, his unruly beard suggesting that he had no time for such trivial concerns as grooming.

Like many Victorian ladies, Cameron was an avid maker of photographic albums, which she sent to friends, mentors, and family.

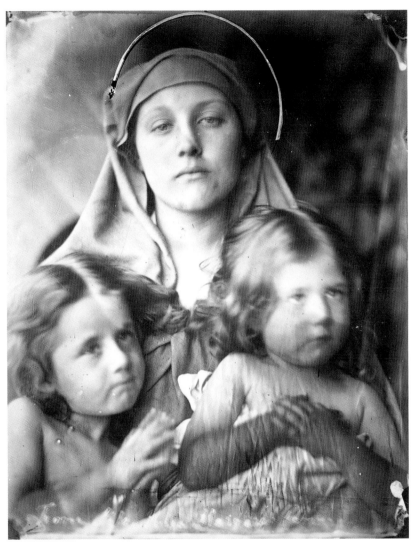

Julia Margaret Cameron
English, b. India, 1815–1879

Mary Hillier, Elizabeth
and Kate Kuhn, 1864

Albumen print
GIFT OF AN ANONYMOUS DONOR
71:0109:0031

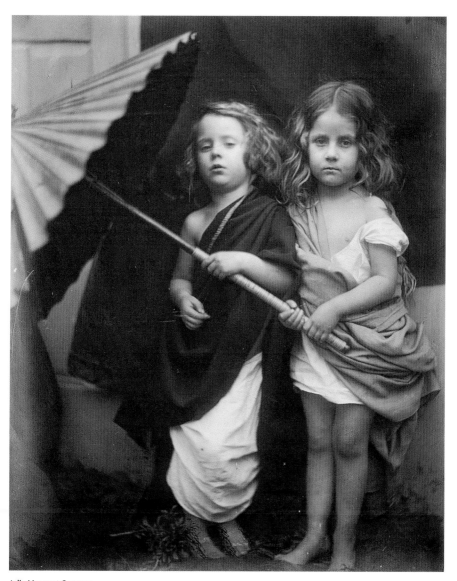

Julia Margaret Cameron
Paul and Virginia, 1864

Albumen print
GIFT OF AN ANONYMOUS DONOR
71:0109:0035

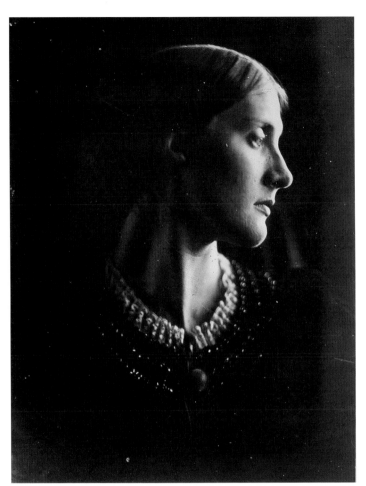

(right)
Julia Margaret Cameron

Vivien and Merlin,
1874

Albumen print
MUSEUM PURCHASE
LIBRARY COLLECTION
74:0087:0005

Julia Margaret Cameron
English, b. India,
1815–1879

Mrs. Herbert
Duckworth as
Julia Jackson,
ca. 1865–1866

Albumen print
GIFT OF ALDEN
SCOTT BOYER
81:1129:0003

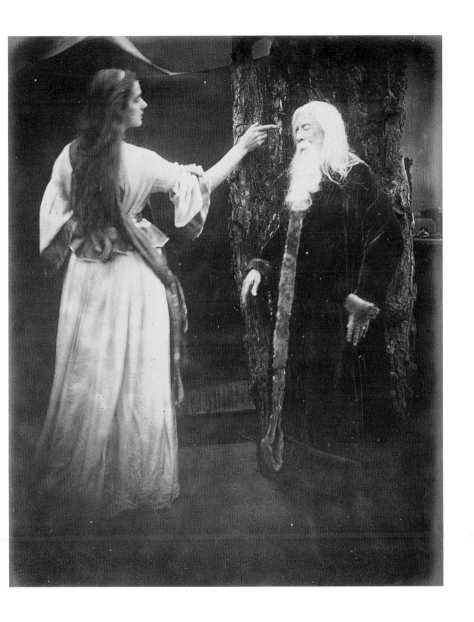

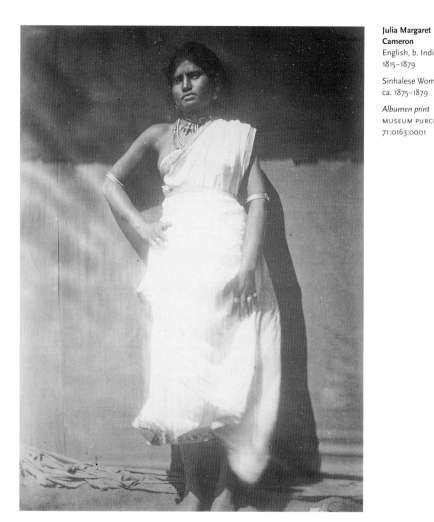

Julia Margaret Cameron
English, b. India, 1815–1879

Sinhalese Woman, ca. 1875–1879

Albumen print
MUSEUM PURCHASE
71:0163:0001

The Eastman House collection includes more than 150 images by Cameron, including the album of photographs that she presented to her mentor, the painter George Frederick Watts, which is one of the earliest known Cameron presentation albums. Cameron's maid, Mary Hillier, whom she called "one of the most beautiful and constant of my models," and Elizabeth and Kate Kuhn, daughters of the island's fortkeeper, are transformed into a Madonna and children for one portrait (page 366); she included this grouping in the Watts album. Cameron even painted the halo around Hillier's head directly onto the negative to imbue the scene with a sense of holiness.

"Paul and Virginia" (page 367), posed with Freddie Gould, a fisherman's son, and Elizabeth Kuhn, takes its inspiration from Jacques-Henri Bernardin de Saint-Pierre's 1787 romantic morality tale about two children, *Paul et Virginie*, which was highly popular among Victorian audiences. The pivotal scene in the drama is a shipwreck off the coast of the French colony of Mauritius, in which Virginia dies because, in her modesty, she refuses to remove her clothing to be rescued. This is one of Cameron's more literal if not entirely factual interpretations, with the oriental-style umbrella and scattered vegetation on the floor meant to suggest the tropical setting of the novel.

"Mrs. Herbert Duckworth as Julia Jackson" (page 368) is a striking portrait of Cameron's beloved niece and her most frequent subject. This portrait was made shortly before Jackson's marriage to Herbert Duckworth, a lawyer. Jackson would later become the mother of writer Virginia Woolf and artist Vanessa Bell from a second marriage. The significance that Cameron places upon Jackson's imminent marital status is evident from the title that already identifies the woman in relation to her husband.

"Vivien and Merlin" (page 369), with Cameron's husband Charles playing the role of Merlin and Miss Agnes as Vivien, is an illustration for Alfred, Lord Tennyson's epic poem *Idylls of the King*. Cameron had undertaken the illustrations of the highly popular work as a source of income. Tennyson was another family friend at Freshwater whom Cameron frequently photographed. Following a reversal of fortune, her family returned to Ceylon in 1875. There Cameron photographed only sporadically. Her work included a series of portraits of native people, mostly servants and plantation workers, that included this seemingly ethnographic study of a Sinhalese woman standing against a plain fabric backdrop.

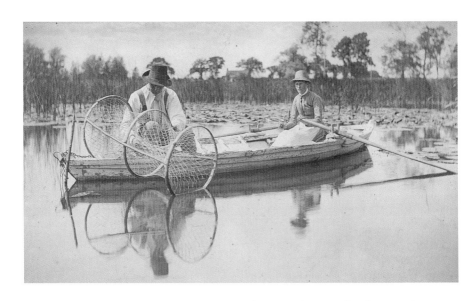

Peter Henry Emerson was born in Cuba, raised in the United States, and went to England to school at age 13. A gentleman photographer, Emerson burst onto the scene as an outspoken critic of Robinson's *Pictorial Effect in Photography*, Rejlander's contrived images, and Cameron's "out-of-focus" work. He believed that photography did not need to emulate painting and painterly effects in order to be considered an art form. Rather, he believed that the inherent strengths of the medium should be utilized to their maximum potential. The Eastman House collection includes 340 images by Emerson, who was inarguably the most vocal proponent of photography as an art form in the 19th century. One of his main tenets was that of differential focus, meaning that photography should imitate ocular vision. That is, that a photograph should be in sharp focus where the eye directs its attention and have less sharpness around the edges to simulate peripheral vision. In 1889 he published *Naturalistic Photography*, which set forth the causes of truth and realism that could be achieved only through "pure" photography.

The Norfolk Broads, according to one historian, were regarded "[f]rom the 1840s at least ... as a primitive paradise, teeming with game, vivid with fragrant flowers, and the home of the last free men in England." By the time Emerson photographed there, the Broads had become a popular holiday resort for tourists. His 1887 publication *Life and*

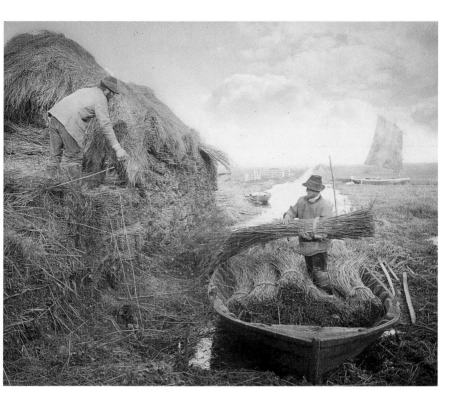

Landscape on the Norfolk Broads was, in part, an attempt to photographically preserve a way of life threatened by encroaching modernization and urbanization. Luxuriously illustrated with platinum prints, it was the first of several books that he would produce on life in East Anglia.

Emerson, as a member of what he termed "an anthropological aristocracy," focused his camera upon the "natives," the peasant fishermen and local landowners of the region. Purporting to depict an authentic way of life, Emerson was not above asking subjects to "change and equip themselves in less pretentious manner" of dress when their fashion did not suit his own ethnographic vision. He usually offered beer or a couple of coins to induce his subjects to pose. Both "Setting the Bow-Net," an image of a man and woman readying their net for the water, and "Ricking the Reed," in which men pile stacks of reeds onto boats to be transported, emphasize the handicraft of labor, directly refuting the industrialization that was rapidly transforming the region.

Peter Henry
Emerson

Ricking the Reed,
ca. 1885

Platinum print
GIFT OF WILLIAM
C. EMERSON
79:4338:0011

"The Clay-Mill" is a scene from *Pictures of East Anglian Life*, which was published in 1888 with photogravure illustrations. In this volume, Emerson "endeavoured in the plates to express sympathetically various phases of peasant and fisherfolk life and landscape which have appealed to [him] in nature by their sentiment or poetry." "East Coast Fishermen" is a posed portrait of three seafaring men: ruddy, proud, and, as dramatized in the photograph, carrying on the tradition of their forefathers.

By January 1891 Emerson had become frustrated with the medium, particularly after discovering that his naturalistic views had no basis in science. He refuted his prior claims to art in an article "To All Photographers," which he later expanded into a pamphlet titled *The Death of Naturalistic Photography*, which firmly positioned photography as a science rather than an art form.

In 1892 Emerson's old rival H. P. Robinson became a cofounder of the Linked Ring Brotherhood, a group of photographers whose pro-art philosophy, which benefited from Emerson's dramatic reversal of opinion, led them to break away from the Royal Photographic Society and form their own photographic coalition. Emerson's early writings had already deeply influenced the aesthetics of many photographers, in particular the American Alfred Stieglitz, who founded the Photo-Secession movement in the United States in 1902.

Peter Henry
Emerson
English, b. Cuba,
1856–1936

The Clay-Mill,
ca. 1886

Photogravure print
GIFT OF ALDEN
SCOTT BOYER
81:1295:0026

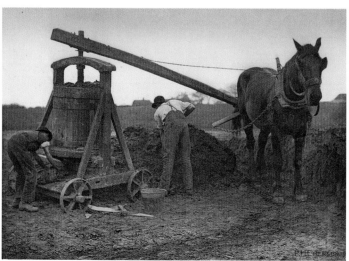

(right)
**Peter Henry
Emerson**

East Coast
Fishermen, ca. 1886

Platinum print
GIFT OF WILLIAM
C. EMERSON
82:2532:0047

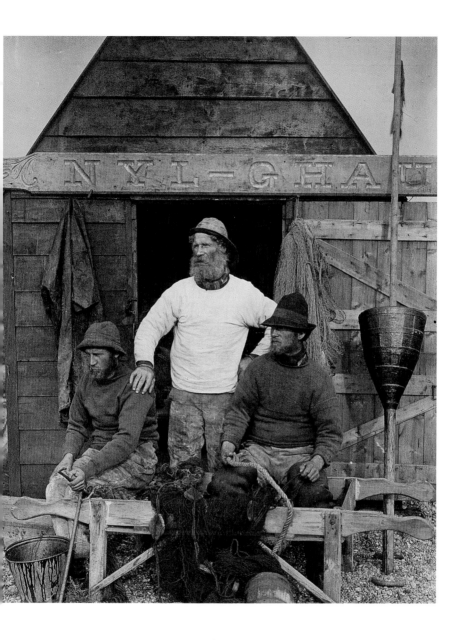

Frederick H. Evans
English, 1853–1943

Kelmscott Manor:
Attics, ca. 1897

Platinum print
MUSEUM PURCHASE,
EX-COLLECTION
GORDON CONN
81:1198:0005

(right)
Frederick H. Evans

Lincoln Cathedral
from the Castle, 1898

Platinum print
MUSEUM PURCHASE,
EX-COLLECTION
GORDON CONN
81:1198:0100

A bookseller by trade, Frederick Evans started to photograph around 1882. A proponent of "pure" photography and devotee of the platinum process, he modestly stated: "I have not been courageous enough as yet to try anything (if there is anything) beyond platinotype [platinum print]... I am more interested ... in making plain, simple, straightforward photography render, at its best and easiest, the effects of light and shade that so fascinate me. ..." Architecture was his primary subject. "Kelmscott Manor: Attics," made in William Morris's birthplace shortly after his death, is a study in light, shadow, and angle. "Lincoln Cathedral from the Castle" is a very different approach, remarkable for the way in which the cathedral rises above the foreground buildings with a muted tonality that makes it appear almost otherworldly. Evans was renowned for such images. In 1901 he was elected a Fellow of the Linked Ring. In an essay for *Amateur Photographer* three years later, Evans offered this advice to photographers: "... try for a record of an emotion rather than a piece of topography. Wait till the building makes

you feel intensely. ... Try and try again, until you find that your print shall give not only yourself, but others who have not your own intimate knowledge of the original, some measure of the feeling it originally inspired in you. ... This will be 'cathedral picturemaking,' something beyond mere photography. ..."

Lesser-known but no less successful were Evans' first photographic investigations using photomicrographic techniques, as evidenced by his "Tr. Sec. Spine of Echinus" of a specimen magnified 40 times. This image won the Royal Photographic Society Medal for photomicrography in 1887. In its perfection of form, it resembles a cathedral stained glass window, perhaps setting the stage for Evans' later, more famous work.

In 1889 the bookseller (Evans did not retire until 1898) met the young illustrator Aubrey Beardsley, with whom he traded books for drawings. Evans was responsible for securing Beardsley's first assignment, illustrating *Morte d'Arthur*. In turn, Beardsley sat for Evans, who made two successful exposures during a rather laborious sitting. The drawings of satyrs that border the mounted photograph are Beardsley's handiwork.

In November 1944, a year and a half after Evans's death, Alvin Langdon Coburn praised his predecessor's contributions during a symposium on Evans' work. "Evans laboured in the dawn of pictorial photography's fight for recognition as a means of personal expression. The fight is won now, but whenever and wherever the tale is told ... the name of Evans will be remembered as one of the champions of the purity of photography who worthily contributed to the final victory." In 1963 the Royal Photographic Society (RPS) and Eastman House jointly organized a major retrospective of Evans' work curated by then Eastman House director and RPS Fellow Beaumont Newhall. There are over 200 works by Evans in the collection.

This is a private portrait study by Frederick H. Evans

Aubrey Beardsley.

Julia Margaret Cameron was not the only woman to excel at photogra-
phy in the 19th century. American Catherine Weed Barnes Ward took up
photography at age 35, setting up a darkroom in the attic of her family
home. In 1890 she became an editor for *The American Amateur Photogra-
pher,* having written a column titled "Women's Work." A vocal advocate
for women photographers, Ward used her editorial position to further
her cause, declaring: "Good work is good work whether it be by a man or
a woman, and poor is poor by the same rule." In the next decade, Ward's
advocacy would be realized as an astounding number of women entered
the photographic profession. The Eastman House has more than 2,000
negatives and lantern slides by this pioneering photographer, most of
which were made during trips to England and Scotland. Among them
are "Dale Abbey Hermitage," a delightful view enlivened by the gaggle
of young boys peeking around the edge at left and maneuvering them-
selves into the frame. She also photographed an assemblage of Talbot's
cameras on the grounds of Lacock Abbey, gathered together like curi-
ously static performers in an unnamed play.

"It is not in man, even in f/64 man, to overlook the unnaturalness of joinings in photographic pictures, and the too visible drawing-room drapery air about attractive ladies playing at haymaking and fishwives," wrote George Davison, deriding the artificiality of art photography. Davison was a founding secretary of the London Camera Club and initially an avid proponent of Emerson's naturalistic philosophy. He soon developed his own theories; in a paper delivered to the Royal Academy of Arts, he suggested that diffusion rather than selective focus was the ideal means to convey impressionistic effects. His first diffused photograph was "The Onion Field," which he made using a pinhole camera and exhibited in 1890 at the Annual Exhibition of the Royal Photographic Society, where it was awarded a medal. Davison's method eliminated any point of sharp focus in the entire image, which greatly disheartened Emerson. He publicly renounced Davison's paper, referring to him derisively as an "audit clerk," Davison's former profession. However, in 1892 Davison was, along with Robinson, one of 15 founder-members of the Linked Ring.

George Davison
English, 1854–1930

The Onion Field,
1889

Photogravure print
GIFT OF ALVIN
LANGDON COBURN
67:0080:0006

Robert Demachy was a wealthy French banker who was passionate about music, painting, cars, and photography. By 1880 photography had become his avocation; he joined the Société Française de photographie and two years later founded the Photo-Club de Paris. He was elected a member of the Linked Ring and made an honorary member of the Royal Photographic Society and later became a member of the Photo-Secession. An advocate of the gum bichromate process, Demachy was the leading pictorialist photographer in France and author of *Pure Photography Is Not an Art,* rejecting Evans' approach. "We cannot do better than to take as a guide the effects of etching and water colors, freshness, strength, boldness and delicacy combined," he wrote. "In the Fields, Plumarch. A Breton Landscape" is an oil print, a technique Demachy took up around 1910.

Heinrich Kühn was a student of botany and medicine before devoting himself to photography around 1888. His initial foray was in photomicrography. Working in Vienna, Kühn began to make portraits and conduct research on the gum bichromate process, all the while developing his

Robert Demachy
French, 1859–1936

In the Fields,
Plumarch. A Breton
Landscape, ca. 1910

Oil print
GIFT OF C. J. CRARY
81:1146:0001

(right)
Heinrich Kühn
Austrian, b. Germany,
1866–1944

Tonwertstudie (Tonal
Value Study), 1929

Photogravure print
MUSEUM PURCHASE
78:0565:0003

Heinrich Kühn

Alfred Stieglitz,
MCMIV, 1904

Oil transfer print?
MUSEUM PURCHASE
78:0565:0006

pictorialist style. He was an active experimenter who wrote frequently about non-silver processes. In 1897, he and several Vienna Camera Club colleagues formed the Cloverleaf (or Trifolium) group, specializing in gum prints. This work attracted the attention of Alfred Stieglitz, who published their images in *Camera Work* and whom Kühn, in turn, photographed. Like Demachy, Kühn was elected to the Linked Ring Brotherhood.

His subject matter remained personal: "Tonwertstudie" (right) is a sensuous back view of a woman, her wide-brimmed hat and full-sleeved dress framed in the center of the composition like fluid architecture against the shadowy background. The subject is "Miss Mary" Warner, his children's English nanny. "Dame mit Pfingstrosen (Emma Kühn-Katsung – Wife)" (page 386) is a portrait study of the artist's wife, incorporating elements of his still-life work into the subtle composition. By comparison, "Gummibaum" (page 387), a still life of a potted rubber tree nestled in a warm shaft of light, is formal yet mysterious and evocative in its isolation, and more than hints at modernist concerns. In its simplicity and directness, the humble house plant is a portrait of calm domesticity. Kühn's statement that "the apparatus, the soulless machine, must be subservient, the personality and its demands must dominate. The craftsman becomes an artist..." clearly identifies his belief in the art of photography.

In describing the sophisticated lighting involved in making "Tête de Gorgone," Émile Joachim Constant Puyo said: "As [an] example of localized lighting,... (the model's head was stuck through a rough paper), I wanted to have the orbits plunged in shade, the forehead and nose well-lighted, and altogether a strong light making the osseous frame stick out. A lamp enclosed in a screen and placed at a distance of fifty centimeters above the forehead

(left)
Heinrich Kühn
Austrian, b. Germany,
1866–1944

Dame mit
Pfingstrosen
(Emma Kühn-
Katsung – Wife)
(Woman with
Peonies), ca. 1900

*Gum bichromate
print*
MUSEUM PURCHASE
71:0061:0008

Heinrich Kühn

Gummibaum
(Rubber Tree),
ca. 1910

*Bromoil transfer
print?*
MUSEUM PURCHASE
78:0565:0002

produced the effect; the dominant lights are well placed on the frontal bone and on the bridge of the nose. Try to obtain the same effect with only daylight." His choice of subjects was part of the "decadent imagination," which he shared with other artists of the 1890s. A French pictorialist, Puyo cofounded the Photo-Club de Paris with Demachy.

Baron Wilhelm von Gloeden, a German-born photographer who worked primarily in Taormina, Sicily, was a devotee of classical antiquity and the male nude. He began photographing the male nude around 1890, and no one was more successful at making these images acceptable than the baron. His iconographic alignment with a time-honored tradition was a sanctioned means through which to explore eroticism in art, and von Gloeden met with great financial success with this work. "Two Boys with Vases of Roses" includes vaguely Roman costuming, bronzed young flesh, and overripe flowers to connote a sensual abandon that recalled the works of popular painters like Sir Lawrence Alma-Tadema.

Émile Joachim Constant Puyo
French, 1857–1933

Tête de Gorgone (Gorgon's Head), ca. 1898

Gum bichromate print
MUSEUM PURCHASE
83:2344:0001

Baron Wilhelm von Gloeden
German, 1856–1931

Two Boys with Vases of Roses, 1913

Albumen print
GIFT OF J.J. CONMEY
67:0027:0001

An Art of Its Own

Despite the best efforts of Le Gray, Cameron, Emerson, and countless other photographers, by the 1890s photography had still not achieved the level of artistic acceptance that was granted to painting. Museums did not regularly collect or exhibit it.

In 1887 Emerson had been the judge of *Amateur Photographer*'s Holiday Work competition. He awarded the prize to an American photographer studying in Germany: Alfred Stieglitz. Upon Stieglitz's return to the

Edward J. Steichen
American, b. Luxembourg, 1879–1973

"Photo-Secession,"
1905

Painting on board
80:0297:0001

United States three years later, he found a thriving amateur community, but nothing that compared with the European devotion to the medium as a fine art. He joined the Society of Amateur Photographers of New York, at whose gallery he exhibited photographs such as "The Terminal" (right), made using a hand-held camera during a New York City snowstorm. Up until then, artistic photography had been associated with soft-focus, pictorialist work, which resembled painting and drawing. Stieglitz's work offered a more everyday realism in its innovative subject matter and approach.

In 1893 he became the editor of *American Amateur Photographer*. When the Society of Amateur Photographers and the New York Camera Club merged in 1897, Stieglitz became the chairman of the publication committee. He started *Camera Notes*, "the official organ of the Camera Club," a quarterly journal illustrated with hand-pulled photogravures.

This journal brought Stieglitz into contact with photographers Gertrude Käsebier, Edward Steichen, Eva Watson-Schütze, and Clarence White. In March 1902 Stieglitz organized an exhibition of pictorial photographs for the National Arts Club in New York, which he titled *American Pictorial Photography, Arranged by "The Photo-Secession."* The name derived from his desire to secede from the dominant amateur communities of the camera clubs and to align with photographic art splinter groups such as the British Linked Ring Brotherhood. With the early writings of Emerson as an unofficial guide, the Photo-Secessionist movement was born. In 1902 Stieglitz resigned from *Camera Notes*, and in December of that year he published the first issue of *Camera Work*, one of the most influential publications in the history of photography.

Alfred Stieglitz
American,
1864–1946

The Terminal
(New York), 1893

*Transparency,
gelatin on glass
(lantern slide)*
PART PURCHASE AND
PART GIFT OF AN
AMERICAN PLACE,
EX-COLLECTION
GEORGIA O'KEEFFE
83:0660:0018

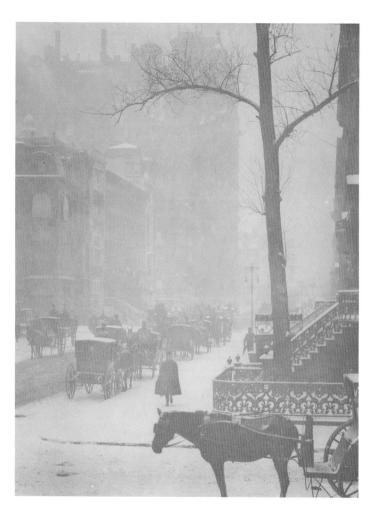

Alfred Stieglitz
American, 1864–1946

The Street – Design
for a Poster, 1903

Photogravure print
MUSEUM PURCHASE,
EX-COLLECTION MUSEUM OF
MODERN ART, NEW YORK
74:0052:0071

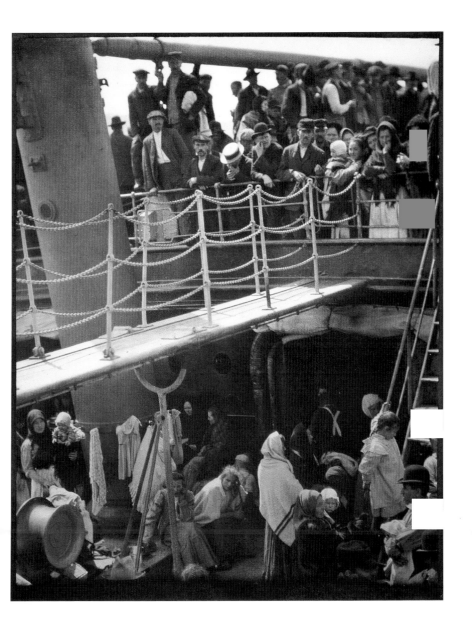

The Eastman House collection includes nearly 200 photographs by Stieglitz. "The Street – Design for a Poster" (page 392) is a wintry scene anchored by the verticality of the bare tree at right, a harbinger of the influence Japanese prints would soon have on his work. His most famous image, "The Steerage" (page 393), made on board a ship traveling from New York to Europe, was published in both *Camera Work* and *291*. About it Stieglitz wrote: "The scene fascinated me ... I saw shapes related to one another – a picture of shapes, and underlying it, a new vision that held me: simple people, the feeling of ship, ocean, sky, a sense of release that I was away from the mob called 'rich.' Rembrandt came into my mind and I wondered would he have felt as I did."

Edward Steichen, a painter and self-taught photographer who has been called "the acknowledged standard-bearer of the Photo-Secession," was the most frequently published and discussed photographer in *Camera Work*. At his urging, in 1905 Stieglitz opened the Little Galleries of the Photo-Secession at 291 Fifth Avenue, eventually simply called "291," as a forum for the Photo-Secessionists' work. There Stieglitz also exhibited modern European painting, drawing, and sculpture. Steichen's Photo-Secession painting (page 390) for Stieglitz's Little Galleries fittingly shows Stieglitz holding his camera before him, stepping toward greatness. Steichen's "Self-Portrait," of him wearing an

Edward J. Steichen

American, b. Luxembourg, 1879–1973

Self-Portrait, 1901

Photogravure print
LIBRARY
COLLECTION

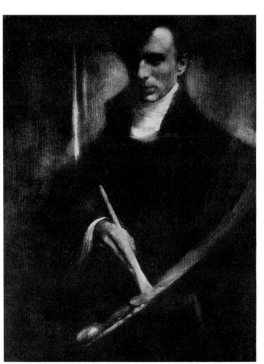

Edward J. Steichen

Eleanora Duse,
New York, 1903

Platinum print
MUSEUM PURCHASE,
MRS. EDWARD
STEICHEN
81:3030:0002

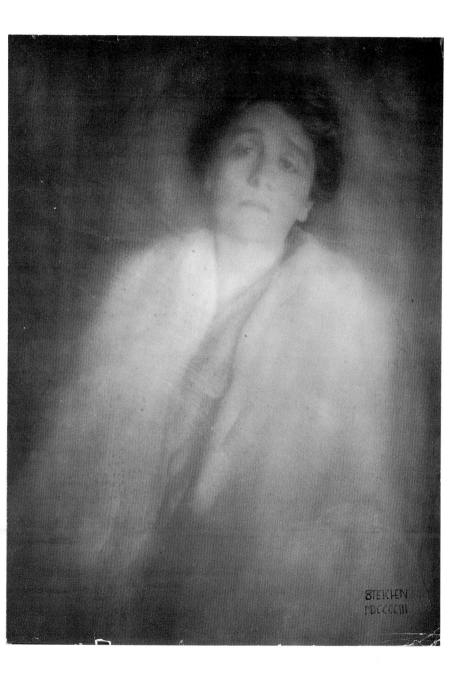

STEICHEN
MDCCCCIII

artist's smock and holding a palette and brush, is a bold declaration of his role in carrying forth the tradition of high art through the new medium. His portrait of Eleanora Duse, the Italian actress (page 395), is an atmospheric rendering in hushed tones, a whispered likeness. The museum holds more than 4,000 photographs by Steichen, spanning his entire career but primarily representative of his work for the publisher Condé Nast.

One of the most respected and talented members of the pictorialist movement was the Massachusetts bibliophile and publisher Frederick Holland Day. Through his firm, Copeland and Day, he published works by the infamous Irish writer Oscar Wilde and English artist Aubrey Beardsley. An avid advocate of photography as an art form, Day wrote about fine art photography for *Camera Notes*, *The Photogram*, and *Amateur Photographer*. He was elected to the Linked Ring in 1895.

Alvin Langdon Coburn reminisced on how Frederick Evans came to make Day's portrait of him dressed in an Algerian costume: "Holland Day had been to Algiers to make some 'native' photographs, and he returned with a number of Arabic costumes, and so one evening we dressed up in some of them, and went to call on Evans. ... Evans' housekeeper nearly fainted away when she opened the door and beheld us. Evans, however, rose to the occasion and did the obvious and entirely correct thing – he photographed us!"

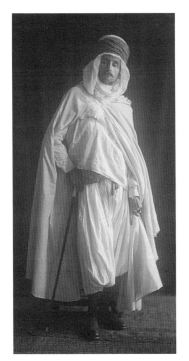

Frederick H. Evans
English, 1853–1943

F. Holland Day in Algerian Costume, 1901

Platinum print
MUSEUM PURCHASE, EX-COLLECTION GORDON CONN
81:1198:0083

Day's "Nubian Chief," published in Stieglitz's *Camera Notes* in 1897 with the title "An Ethiopian Chief," was not one of his Algiers "native" photographs but rather one of the *Nubian* series portraits of black men that he had made several years earlier in Massachusetts. Day was passionately interested in the colonial conflicts in Ethiopia and Algeria, and his sympathy for his subject –

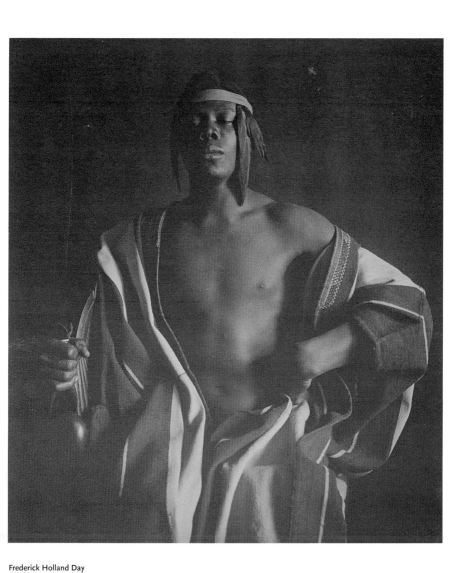

Frederick Holland Day
American, 1864–1933

Nubian Chief, 1897

Platinum print
GIFT OF 3M COMPANY,
EX-COLLECTION LOUIS
WALTON SIPLEY
77:0211:0001

however inaccurately rendered – is evident. Photographed from below, the anonymous sitter gazes imperiously at the viewer, commanding respect and attention through his bearing and Day's pictorially effective use of costume, even if the striped North African robe and headdress of black pigeon feathers were not authentic to the subject.

Day frequently made self-portraits as well, taking his inspiration from literary sources including the Bible. Rarely did he present himself as himself, preferring instead to assume guises and ethnicities that were not his own. Day's most ambitious and controversial work was *The Seven Last Words*, in which he depicted himself as Jesus Christ crucified on the cross. He had begun collecting reproductions of religious art following a trip to Europe in 1890; at the Prado in Madrid he found "the best of Van Dyck's sacred things ... Rubens' religious pieces, too. And Ribera and Murillo and Velázquez til one's eyes watered with admiration." He wanted to address in photographs what artists had long explored in paint – sacred subject matter. Nothing if not a perfectionist, Day starved himself for weeks to achieve the look of the emaciated body

of Christ during his final days. Focusing only on his tortured face topped by a crown of thorns, the images are an emotional and psychological approximation of Christ's ultimate trial. Each of the images is titled with Christ's plaintive words as he spoke to God about his imminent fate. As Day's friend Frederick Evans explained it, Day had "a mirror attached to the camera so that he could see his expression at the time of exposure; he made the exposure himself, so the whole effort was a purely personal one. ... It was a unique effort, inspired by the utmost reverence and carried out with extraordinary success."

Although Day was aware of the potential problem of presenting a sacred subject as mere mortal flesh, he exhibited the series in 1898 in Boston and again at the Philadelphia Salon. Meeting with criticism both from the public and his colleagues in the art world, Day's images suggested his own "artistic martyrdom" for venturing into such taboo territory. To his critics he wrote: "There will always be narrow minds to question the rights of portraying sacred subjects in any medium: to them the less said the better; but to those who criticise only the photographers' right to these subjects, I can advise but patience – give us time to get out of our drill work, to get into man's estate, so to speak, with our new theme, and then speak your harshest."

Although Stieglitz had initially published and supported Day's work, they became bitter rivals when Stieglitz would not lend his support to Day's idea of establishing an "American Association of Pictorial Photographers." In response, Day mounted his *New School of American Photography* exhibition in London and Paris, showing his own work along with that of the leading pictorialist photographers of the day.

Originally an accountant in Ohio, Clarence H. White began to photograph in 1893. Completely self-taught, White received almost immediate recognition when his work was exhibited in the first Philadelphia Photographic Salon (1898), where he met Day and Gertrude Käsebier. He also organized exhibits for his Newark (Ohio) camera club, showing the work of Steichen and Robert Demachy. He was elected to the Linked Ring in 1900, and two years later White became one of the co-founders of the Photo-Secession, with Stieglitz, Coburn, and Käsebier. Light, and the absence of it, were hallmarks of White's work. He explained: "My photographs were less sharp than others and I do not think it was because of the lens so much as the conditions under which the photographs were made – never in the studio, always in the home or in the

open, and when out of doors at a time of day rarely selected for photography." Two images, "Morning" and "Girl with Mirror," directly bear out this claim.

White's greatest legacy beyond his photographs was his teaching. He moved to New York in 1906 and started teaching the following year at Columbia University Teachers College, where he taught its first courses in photography. After opening a summer school in Maine, in 1914 he founded the Clarence H. White School of Photography in New York. There his students included Margaret Bourke-White, Paul Outerbridge, Ralph Steiner, and Doris Ulmann. In 1916, along with Käsebier and Coburn, he cofounded the Pictorial Photographers of America.

Eva Watson, later Watson-Schütze, had studied painting and modeling at the Pennsylvania Academy of the Fine Arts with Thomas Eakins before opening her own studio. Although she was a professional photographer, her six photographs submitted to the Philadelphia Photographic Salon of 1898 introduced her to Stieglitz; two years later

Clarence H. White
American, 1871–1925

Morning, 1908

Photogravure print
78:0708:0003

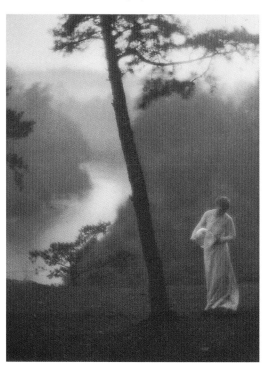

Clarence H. White

Girl with Mirror, 1898

Varnished platinum print
79:4378:0001

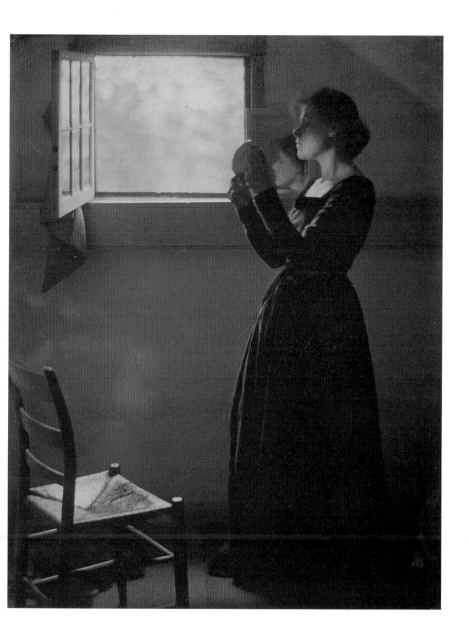

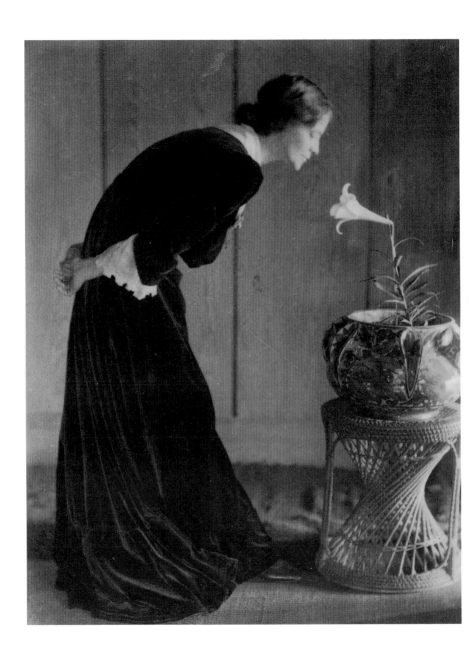

(left)
Eva Watson-Schütze
American, 1867–1935

Woman with Lily,
ca. 1903

Platinum print
GIFT OF FRIEDA
SCHÜTZE
81:1786:0046

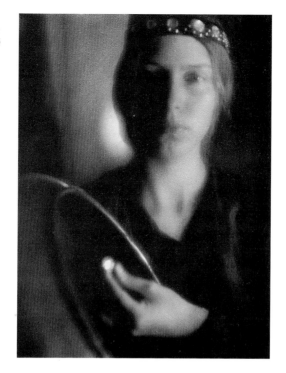

George H. Seeley
American, 1880–1955

The Firefly, ca. 1907

Photogravure print
78:0708:0008

she served as a juror. She, too, was elected to the Linked Ring and the Photo-Secession. Reminiscent of White's work, her "Woman with Lily" is a romantic portrayal of universal womanhood and the sacredness of the domestic realm.

George H. Seeley of Stockbridge, Massachusetts, was influenced by both Day and White. Having exhibited 14 prints in the First American Photographic Salon at New York, which was organized in opposition to Stieglitz and the Photo-Secession, he nevertheless received Stieglitz's attention. Stieglitz invited him to join the Photo-Secession, reproduced his images in *Camera Work*, and exhibited his prints at 291. "The Firefly" is one of his most famous and delicate compositions. In 1910 the Albright Art Gallery in Buffalo, New York, hosted the International Exhibition of Pictorial Photography, which became the highlight of both the Photo-Secession's goals and Seeley's career.

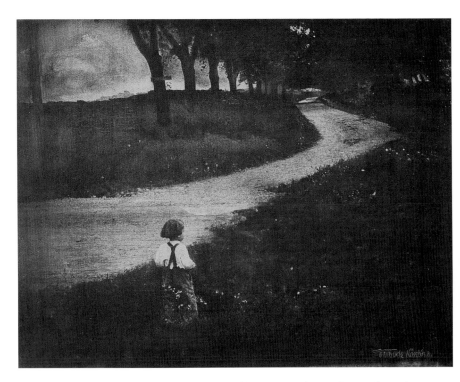

Gertrude Käsebier
American, 1852–1934

Road to Rome, 1903

Gum bichromate print
GIFT OF MINA
TURNER
70:0058:0016

After raising her three children, Gertrude Käsebier took up photography. She studied painting and photography in Brooklyn, New York, and opened a photographic portrait studio on Fifth Avenue near 32d Street. Stieglitz, White, and Evans were among her sitters. In 1900 Käsebier was the first woman elected to the Linked Ring Brotherhood; two years later she became a cofounder of the Photo-Secession when, at the opening of the first Photo-Secession exhibition at the National Arts Club in 1902, she and Stieglitz had the now often-repeated exchange: "What's this Photo-Secession? Am I a photo-secessionist?" He asked in return, "Do you feel you are?" "I do." "Well, that's all there is to it." Fourteen of her prints were included in the exhibition.

The first issue of *Camera Work* was devoted to Käsebier's work, yet her images were also widely published in the popular press. "Road to Rome," posed by her grandson Charles, was derived from the story *The Roman Road* by Kenneth Grahame. In it the protagonist reminisces about a country road in an English town that he and the other children

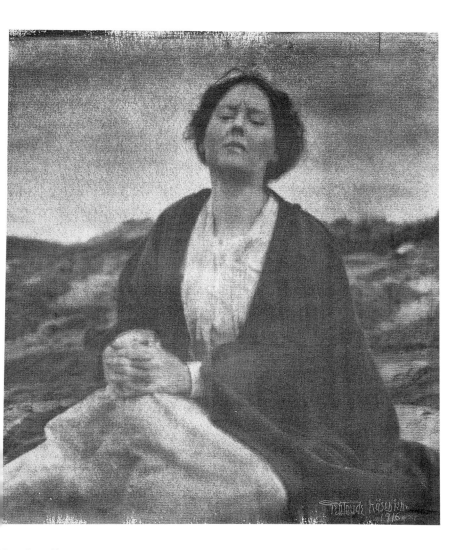

Gertrude Käsebier

The Heritage of Motherhood,
ca. 1904/print 1916

Gum bichromate print
GIFT OF HERMINE TURNER
71:0042:0033

often wandered: "'All roads lead to Rome,' I had once heard someone say; and I had taken the remark very seriously, of course, and puzzled over it many days. There must have been some mistake, I concluded at last; but of one road at least I intuitively felt it to be true." Of its allegorical meaning regarding the imaginations of artists and children Käsebier once explained that in the picture the boy sees "a wild rose. There is also a lamb tethered to a bush, and a duck floats idly on the water." Such interpretation of symbolic meaning beyond what is visible in the picture would become the essence of many photographers' work in this period.

Käsebier also produced various photographic "cycles." One was devoted to the theme of motherhood. The photographer Joseph Keiley called "The Heritage of Motherhood" (page 405) "one of the strongest things that she has ever done, and one of the saddest and most touching I have ever seen." Made while visiting Day at his summer home in Maine, it is a moody and melancholy portrait, full of solemnity and the weight of responsibility that hung over Käsebier's personal life at the time. "Lollipops" (page 409), made several years later, is its emotional counterpart.

When Käsebier photographed the sculptor Auguste Rodin in his studio in 1906, he was the world's most famous living artist, having

Gertrude Käsebier
American, 1852–1934

Auguste Rodin, 1906

Platinum print
GIFT OF HERMINE
TURNER
71:0042:0063

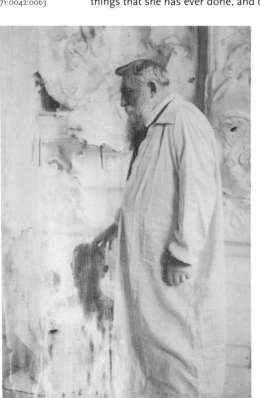

Gertrude Käsebier

Gargoyle in Latin Quarter, ca. 1910

Gum bichromate print
GIFT OF HERMINE
TURNER
71:0042:0026

(above)
Gertrude Käsebier
American, 1852–1934

Newfoundland, 1912

Platinum print
GIFT OF HERMINE
TURNER
74:0060:0017

Gertrude Käsebier

Child on Dock, 1912

Platinum print
GIFT OF HERMINE
TURNER
74:0060:0010

Gertrude Käsebier

Lollipops, 1910

*Modern gelatin silver
print from original
gelatin on glass
negative*
GIFT OF MINA
TURNER
72:0019:0057MP

created masterpieces such as *The Kiss* and *The Thinker*. She later re-
vealed that "Rodin was a terrible man when it came to photographs.
When he knew he was going to be photographed, he'd stiffen into the
most grotesque and absurd postures ... [but] I caught him in one of his
moments. He was relaxed and brooding. He didn't know he had been
photographed until it was all over."

Coburn reminisced that "The Latin Quarter [in Paris] was at that peri-
od a place of romance. You could dine at little restaurants where artists,
afterwards famous, paid for their meals by painting mural decorations
on the walls!" Käsebier's "Gargoyle in Latin Quarter" (page 407) is
a playful image of a woman leaning over a parapet, overseeing and

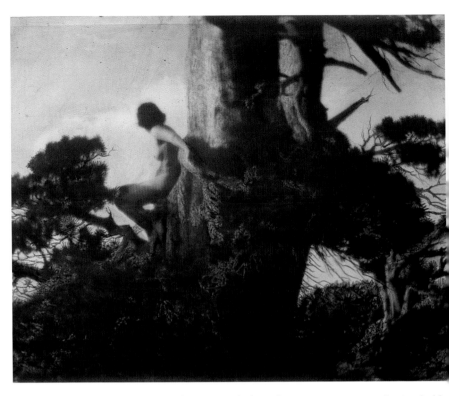

Anne Brigman
American, b. Hawaii,
1869–1950

The Pine Sprite, 1911

*Gelatin silver film
interpositive reworked
from earlier negative,*
ca. 1940
GIFT OF WILLARD
M. NOTT
76:0055:0008

absorbing the vibrant scene below. The Eastman House collection holds 124 photographs and 75 negatives by Käsebier, most of which came to the museum from her family.

By 1902 Ann Brigman was exhibiting and publishing her photography, merely a year after taking up the medium. Upon receiving a copy of the first issue of *Camera Work*, she promptly wrote to Stieglitz to proclaim her enthusiasm, and thus began a lifelong friendship with him. She became a Fellow of the Photo-Secession in 1906, the only photographer living west of the Mississippi to earn that distinction. Her work was published regularly in *Camera Work* and shown at 291.

During an eight-month visit to New York in 1910, Brigman attended Clarence White's first summer class in photography in Maine, receiving special instruction in landscape photography. Back west, her primary studio was the Sierra Nevada mountains, where she photographed herself, her family, and friends in the landscape. A pioneer of photographing

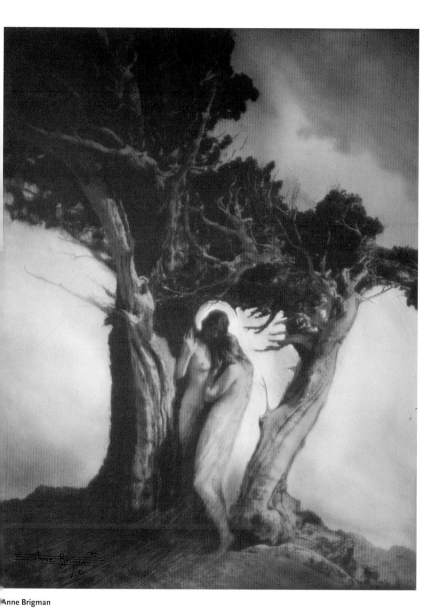

Anne Brigman

The Heart of the Storm, 1902

Gelatin silver print

GIFT OF WILLARD M. NOTT

81:1013:0035

the female nude in the landscape, Brigman conveyed the power of the relationship of humans communing with nature. At times mystical and symbolic, images such as "The Pine Sprite" (page 410) embody Brigman's ideal. "The Heart of the Storm" (page 411) made early in her career, depicts a guardian angel figure giving comfort to a woman within a stand of California western juniper trees. Working directly on the negative, Brigman added a halo around the head of one figure, and wispy strokes to suggest a diaphanous, wind-swept gown on the other. This image is likely a metaphor for the personal and professional challenges that Brigman was facing, suggesting that an inner muse would be her protector and guide.

A self-portrait in the studio reveals the artist in her element. From her original negatives, Brigman made interpositives that she reworked by hand, and from these created another negative from which she would print. She freely manipulated the medium to achieve her desired effect. "My etching tool is one of my closest allies. With it, all that is useless is etched away," she stated, unapologetic in the face of purist criticism. "I've swung far from the straight and narrow path of straight photography. ... I've done some hokus pokus that would make the shadow of Daguerre haunt me for a heretic."

"The Cleft of the Rock" shows a slender sylph emerging from a crevice, her white body like a shaft of light against the rocks. The museum

Anne Brigman
American, b. Hawaii,
1869–1950

A. B. in Studio,
ca. 1915

*From a gelatin on
nitrocellulose sheet
film negative*
GIFT OF WILLARD
M. NOTT
76:0055:0213

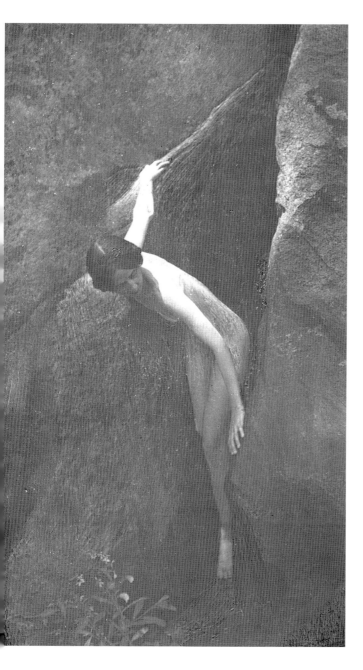

Anne Brigman

The Cleft of the
Rock, 1912

*Gelatin silver glass
interpositive reworked
from earlier negative,
ca. 1940*
GIFT OF WILLARD
M. NOTT
76:0055:0032

(right)
Alvin Langdon Coburn

Wapping, 1904

Gum platinum print
GIFT OF ALVIN
LANGDON COBURN
67:0146:0183

Alvin Langdon Coburn
British, b. United
States, 1882–1966

The Copper Plate
Press, 1908

Gum platinum print
GIFT OF ALVIN
LANGDON COBURN
67:0155:0092

holds more than 900 negatives, interpositives, and prints by Brigman.

In 1898 Alvin Langdon Coburn met Frederick Holland Day, a distant cousin. Day then instructed him and encouraged him to pursue a photographic career. Coburn, in turn, taught Day how to print, later describing the "dim red glow of a dark-room [as something] which Dante would have revelled in as a bit of local colour for his best-known poem ...". Despite his wicked humor about the darkroom experience, Coburn was a meticulous printer in the media of platinum, gum, and gravure. He selected as the frontispiece for his 1966 autobiography his self-portrait working the copper plate press, clearly identifying his affinity for and mastery of the photogravure process.

Along with Steichen, Coburn assisted Day in organizing the *New School of American Photography* exhibition in London in 1900 and later worked in Käsebier's studio. Breaking with his influential mentor, Coburn became the youngest of the founding Photo-Secessionists in 1902. Showing the influence of Japanese art, "Wapping" is a delicately balanced photograph, which he made in London and published in his 1909 book, *London*. "One of the conditions of harmony in architecture, as in life, is to avoid the monotony of regularity and excessive repetition Exact equality of division lacks mystery. A rhythm that may not be

completely fathomed, a beauty that eludes the mind's grasp yet is manifestly of exquisite proportions, this is the secret of the marvellous power of the progression of the Golden-mean," wrote Coburn in 1941.

His subject matter was diverse; it included portraiture, as in this image of a seductively posed Miss Anderson, who is seated on the arm of a chair, her right arm extended, invitingly open. The writer Gertrude Stein also sat for Coburn in 1913; her portrait reflects a more mature style compared with the earlier work. The Flat Iron Building, called "a new Parthenon" for its aesthetic popularity with photographers, was also photographed by Steichen and Stieglitz, whom Coburn acknowledges emulating. In Coburn's view (page 418), made in the late evening, the foreground is punctuated by men walking along the street, their silhouetted forms framed by the spidery winter trees. The building itself anchors the composition in the distance. "Grand Canyon" (page 419) is a landscape infused with wonder and spectacle, as though a divine light is shining down from the heavens. Coburn photographed in the American West in 1911 and 1912.

"In the spring of 1904 I had a very memorable and fruitful interview with Perriton Maxwell, editor of *Metropolitan Magazine*, New York. I was an ambitious young man on the point of sailing for my second visit to

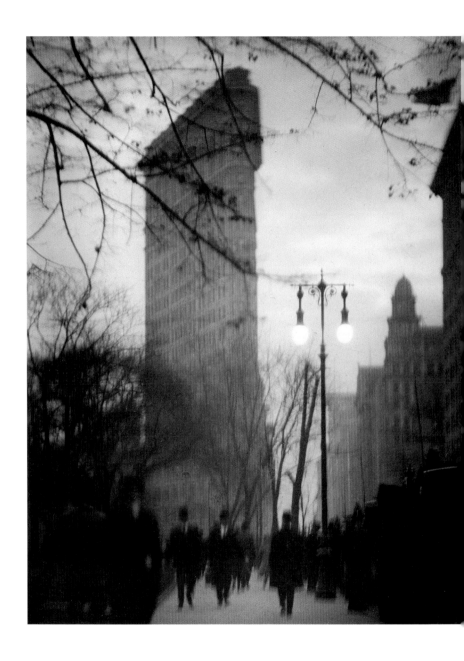

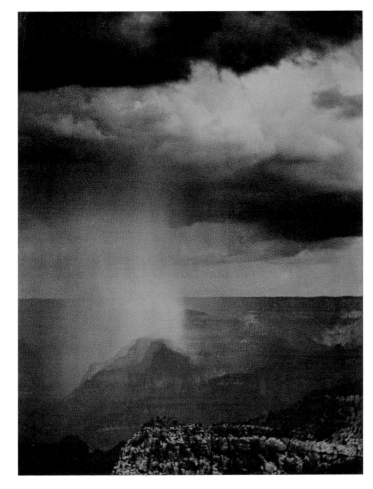

London, and I asked Maxwell to let me have a list of English authors and artists to photograph during my sojourn to the greatest city in the world," Coburn wrote in his autobiography. George Bernard Shaw, the first to be photographed, was the model for "Le Penseur," a direct homage to Auguste Rodin's sculpture of the same title that was completed in 1906. It was unusual that a famed author such as Shaw would pose in the nude, though he himself was an avid photographer, and the pose was his suggestion. The image generated considerable commentary in the press, but the immodest Shaw did not mind, saying waggishly: "[T]hough we have hundreds of photographs of [Charles] Dickens and [Richard] Wagner, we see nothing of them except their suits of clothes with their heads sticking out; and what is the use of that?"

The novelist Henry James, like Coburn an American expatriate, was a major influence on Coburn. He photographed James several times beginning in 1905, including this pensive profile, which Coburn included in *Men of Mark*, published in 1913. He eventually published a second volume, *More Men of Mark*. These publications owed a thematic debt to Cameron's series of *Famous Men*, which were inspired by Thomas Carlyle as well as a prevailing public fascination with noteworthy individuals. At James' invitation, Coburn also provided the frontispieces for 24 volumes of the collected edition of James' works.

Coburn emigrated to England in 1912, eventually becoming a British citizen. His work became increasingly "straight," that is, characterized by unmanipulated, crisp prints. In 1913 he wrote: "I wish to state very emphatically that I do not believe in any sort of handwork or manipulation on a photographic negative or print." In the complexity of overlapping shadows and

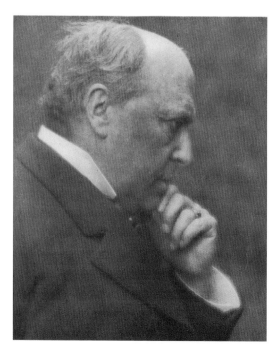

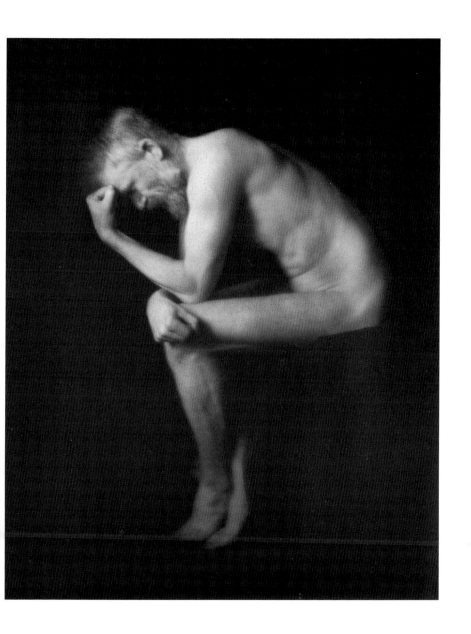

reflections, "The Octopus, New York," perhaps Coburn's most famous image, resembles a combination print, but it is not. He was inspired by his work in the Grand Canyon to ascend the heights of Manhattan's skyscrapers to obtain this view. Recognizing his achievement, Coburn described the work as "a composition or exercise in filling a rectangular space with curves and masses. Depending as it does more upon pattern than upon subject matter, this photograph was revolutionary in 1912."

Coburn's work became increasingly abstract as he became influenced by the symbolist movement. He also became involved with a group of artists known as Vorticists led by the poet Ezra Pound. His "Vortograph of Ezra Pound" (page 425) was achieved by placing the lens inside of three facing mirrors. "Liverpool Cathedral under Construction" (page 424) is a complex riot of intersecting angles, reveling in the texture of materials as well as the dynamism of the viewpoint.

Coburn was one of the few leading pictorialists who was able to shift his focus to the more modern approach that emerged following the demise of the Photo-Secession. As the repository of the Coburn archive,

Alvin Langdon Coburn
British, b. United States, 1882–1966

Station Roofs, Pittsburgh, 1910

Gelatin silver print
GIFT OF ALVIN LANGDON COBURN
67:0147:0001

(left)
Alvin Langdon Coburn

The Octopus, New York, 1912

Platinum print
GIFT OF ALVIN LANGDON COBURN
67:0144:0289

the Eastman House collection includes more than 1,000 photographs, as well as 17,000 negatives, illustrated books, and personal papers.

Elias Goldensky was a Russian-born photographer who settled in Philadelphia with his family in 1891. He learned the medium from his father, who had a studio in Russia. Goldensky's first job was as a retoucher in a photography studio; within a year, he went to work for Frederick Gutekunst as a retoucher and printer. He was also an actor, founding a Russian dramatic society in Philadelphia that performed

until at least 1905. As a studio photographer, Goldensky photographed Philadelphia notables and visiting celebrities, including this provocative portrait of author Maxim Gorki, earning him the moniker "the photographers' photographer." He was active in professional photographic associations, which enabled him to socialize and share ideas with other photographers. He participated in at least five professional and amateur camera organizations, which brought him into contact with photographers such as Gertrude Käsebier. In *Camera Notes*, the critic Sadakichi Hartmann likened Goldensky's work to that of Day and Stieglitz, the two leading pictorialists of the time. His "Male Nude" is a sensuous, sinuous modeling of the subject rendered in deep, muted browns.

Paul Lewis Anderson, an engineer, took up photography in 1907 after seeing copies of *Camera Work*. Within three years, he had quit his job and opened a portrait studio. Although his photographs never made it to the pages of *Camera Work*, Anderson became part of a small but active post-Secession movement to carry on the pictorialist tradition.

Pictorial photography, according to Anderson, was defined as "opening the eyes of the average individual to the beauties of art — making it an everyday affair instead of the privilege of the exceptionally favored ones — and arousing an interest in natural beauty, together with a

Elias Goldensky
American, b. Russia, 1867–1943

Maxim Gorki,
ca. 1910

Platinum print
GIFT OF 3M COMPANY, EX-COLLECTION LOUIS WALTON SIPLEY
77:0116:0002

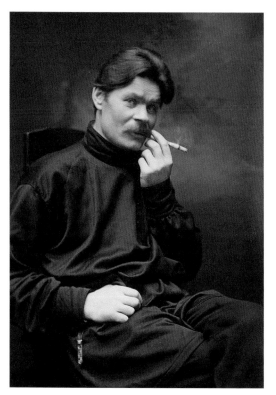

Elias Goldensky

Male Nude, ca. 1915

Carbon print
GIFT OF 3M COMPANY, EX-COLLECTION LOUIS WALTON SIPLEY
77:0251:0062

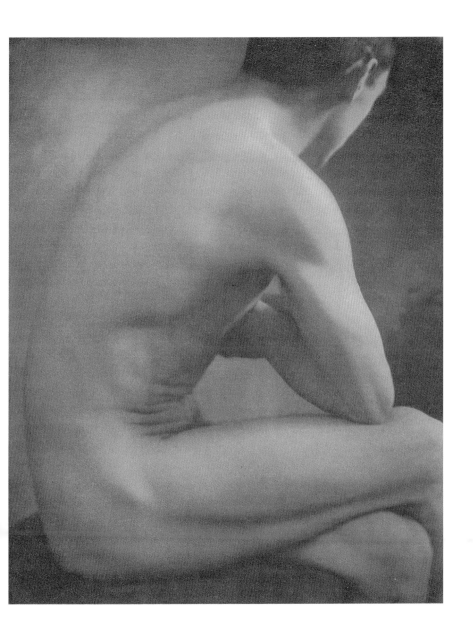

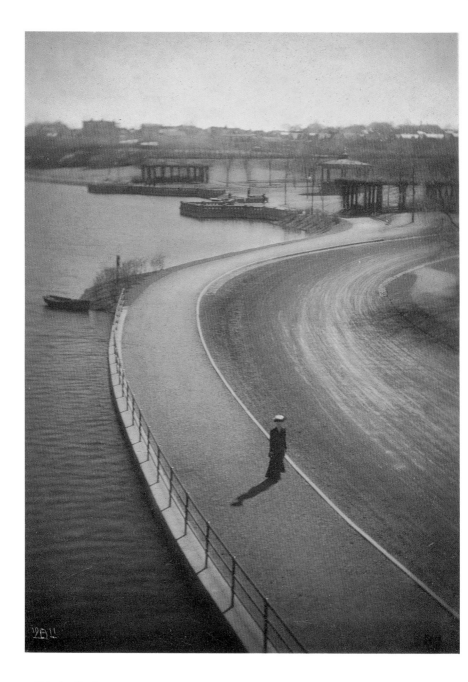

sensitiveness to design and to values which cannot fail to aid in the intellectual and moral progress of the race." Beginning in 1914 he taught at Clarence White's School of Photography and authored several photographic books. The museum's collection contains over 500 photographs by this master of the Pictorialist print. "Branch Brook Park" and "Woman Boarding Double-Decker Bus" are two of Anderson's works, both redolent with solitude and quiet. Anderson is said to have maintained that the test of a good picture is to hold it upside down to see if the composition remains strong. A simple test of his theory applied to his own images reveals a sophisticated symmetry that is not as apparent when viewed in its correct orientation.

Doris Ulmann was a native of New York City and studied teacher training with Lewis Hine at the Ethical Culture School. She also studied photography with Clarence White at his school. Ulmann soon joined the Pictorial Photographers of America and became a professional portrait photographer in New York. Her passion was to photograph the folk cultures of the American South, particularly in the Appalachian Mountains

and the predominantly black southeast coastal communities of Georgia and South Carolina known as Gullah. "Group at Church Meeting" captures a congregation's choir in a moment of rapturous prayer, revealing to a larger public an intimate moment not customarily shared with outsiders. "South Carolina," a portrait of an elderly black woman standing in a window, is as sympathetic as it is romantic. As Ulmann explained: "A face that has the marks of having lived intensely, that expresses ... some dominant quality or intellectual power, constitutes for me an interesting face."

The distinctive properties of the platinum prints that Ulmann favored were a gentle complement to her subjects. Although her work was marked by a pictorialist atmosphere, Ulmann's approach to her subject was documentary, a distinction that positions her work on the ever-widening gulf between the past and the present, pictorialism and modernism. There are 147 Ulmann photographs in the Eastman House collection.

In a similar vein, Edward Curtis's photographs of what he termed "the vanishing races" of North American Indians west of the Mississippi owe their painterly, romantic style to pictorialism and the Photo-Secessionists, but,

Doris Ulmann
American, 1882–1934

Group at Church Meeting, ca. 1930

Platinum print
MUSEUM PURCHASE, EX-COLLECTION JOHN JACOB NILES
70:0089:0010

Doris Ulmann

South Carolina, ca. 1929–1930

Platinum print
GIFT OF 3M COMPANY, EX-COLLECTION LOUIS WALTON SIPLEY
77:0215:0074

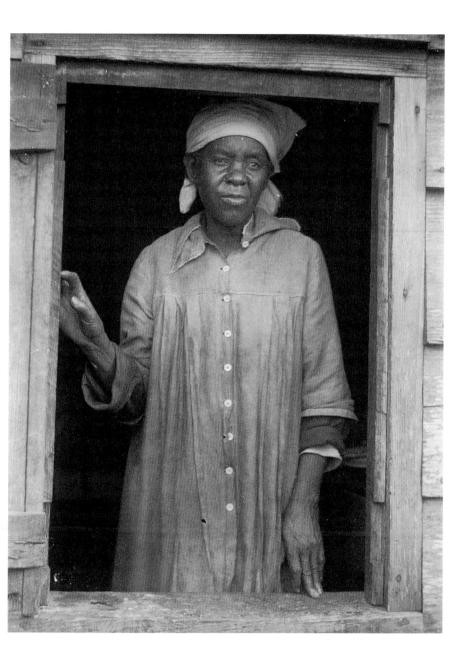

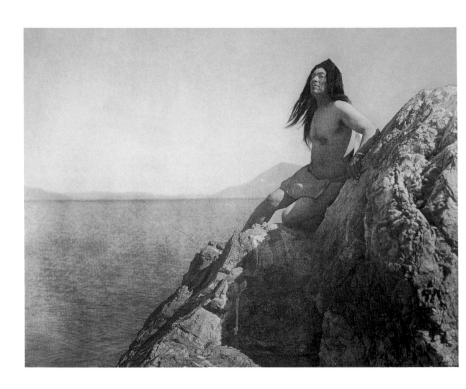

Edward S. Curtis
American, 1868–1952

On the Shores of
Clear Lake, ca. 1924

Photogravure print
MUSEUM PURCHASE
72:0001:0001

like Ulmann's, his intent was largely documentary. Curtis began his photographic career in a commercial studio in Seattle, Washington. His interest in Native American culture developed around 1896, and until 1927 he traveled the country making images for his monumental, 20-volume study, *The North American Indian*. With accompanying portfolios for each volume, the series included 2,222 photogravures, of which the Eastman House holds nearly 100. While an image like "Washo Baskets" is a straightforward still life of extraordinary handicrafts rendered with the modernist clarity of detail that the subject demanded, Curtis did not always rely on veracity to preserve a likeness of a culture. "On the Shores of Clear Lake" and "Bow River – Blackfoot" are highly contrived images of Native American life, which, for the most part, no longer existed when Curtis set about to photograph it. Nevertheless, his images are beautifully rendered, if fictional, portraits that represent a romantic recreation of America's past.

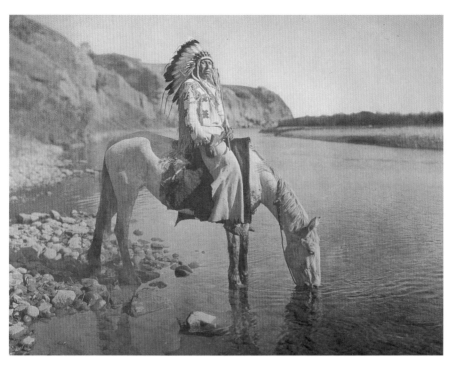

Edward S. Curtis

Bow River –
Blackfoot, ca. 1926

Photogravure print
74:0033:0029

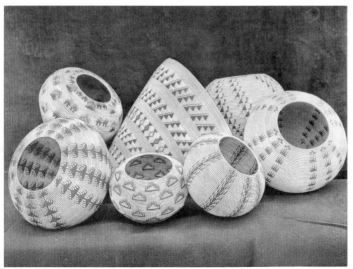

Edward S. Curtis

Washo Baskets,
ca. 1924

Photogravure print
MUSEUM PURCHASE
72:0001:0032

Our Modern World

By the 1890s faster films, better lenses, hand cameras, and the availability of commercial developing and printing services not only made it much easier to make photographs, but to make photographs that captured a wider range of the events of everyday life. This fueled another huge explosion in photographic practice; first by significantly expanding the number of amateur photographers and then by irrevocably altering and expanding the nature and practices of professional photography. A greatly expanded world of images – very different in concept and in form – suddenly became an inextricable part of the visual world. Boundaries that previously had distinguished photographic practices from one another simply fell away under this overwhelming flood of new imagery. Simultaneously, a changed and often startling world greeted photographers. Skyscrapers, public street lights, telephones, automobiles, and airplanes had not existed a generation earlier. It was a world in radical

**William M.
Van der Weyde**
American,
1871?–1929

Elaine Golding,
Swimmer, ca. 1900

*From a gelatin on
glass negative*
GIFT OF NEW YORK
PUBLIC LIBRARY
74:0056:1079

transformation, and speed, movement, and energy appeared at the heart of the age.

William Van der Weyde, working as a professional photographer in New York at the turn of the century, made news with his pioneering experiments in the new genre of picturesque urban night photography. The images on pages 434 to 437 are just five selected from the 1,461 gelatin on glass negatives in the museum's collection. They show his willingness to photograph anything and everything from baseball players to executions, and to forgo

**William M.
Van der Weyde**
American,
1871?–1929

Electric Chair at Sing
Sing, ca. 1900

*From a gelatin on
glass negative*
GIFT OF NEW YORK
PUBLIC LIBRARY
74:0056:0386

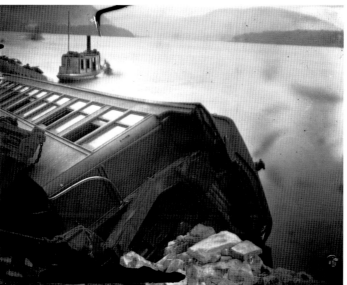

**William M.
Van der Weyde**

Harrison NY,
RR Wreck,
ca. 1900

*From a gelatin on
glass negative*
GIFT OF NEW YORK
PUBLIC LIBRARY
74:0056:0086

(far left)
**William M.
Van der Weyde**
Dog Training,
ca. 1900

*From a gelatin on
glass negative*
GIFT OF NEW YORK
PUBLIC LIBRARY
74:0056:0316

traditional ideas of composition, content, and style in order to get the most descriptive picture in the hopes that his photograph would be published in one of the illustrated magazines of the day.

After obtaining a doctorate in classical philology at the University of Jena, Arnold Genthe visited America in 1895, traveling as a tutor for a wealthy German family who owned land in San Francisco. Falling in love with the "... energy, [and] freedom of thought and action ..." that he found in America, Genthe stayed on after his employer returned to Germany. After reading in a guidebook about San Francisco's Chinese quarter named Tangrenbu, Genthe, like other non-Chinese, was drawn to what was considered the mysterious world of Chinatown. He first tried sketching its inhabitants, but then turned to photography in order to capture his reluctant subjects. "An Unsuspecting Victim" presents a romantic view of Genthe's activities there. The dandified figure of Genthe, embraced by light and clasping in his hands a box camera, assumes center stage while a bearded acquaintance looks on. The "unsuspecting victims" are the Chinese child and elderly man who are disappearing into the picture's dark and mood-filled background. In his autobiography, Genthe noted that the reclusive residents of Chinatown were frightened of being photographed and that he had to sneak photographs with a hand camera. Although he was a regular visitor to Chinatown – he took some 200 images there, mostly during holidays – Genthe surreptitiously recorded his subjects with a voyeuristic eye for the exotic and the novel. He went on to pursue portrait photography as a profession and gained admittance to San Francisco's cultured social

Arnold Genthe
American,
b. Germany,
1869–1942

An Unsuspecting
Victim, ca. 1899

Gelatin silver print
MUSEUM COLLEC-
TION, BY EXCHANGE
72:0044:0013

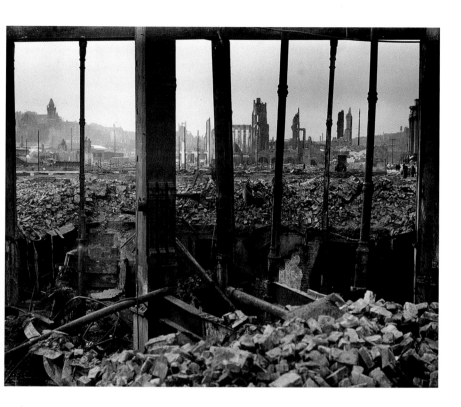

and arts communities. His elegant pictorial style of photography, evident from his early picturesque work in Chinatown, earned him numerous accolades and commissions.

In 1906 Genthe produced some of his most candid and documentary photographs. On April 18 of that year, San Francisco was devastated by an earthquake and fire that destroyed the city and left the majority of its inhabitants homeless. With the exception of Genthe's Chinatown negatives, which were locked up in a bank vault, the earthquake destroyed his studio, equipment, and five years of accumulated work. Undaunted, he obtained an inexpensive hand camera and joined the four newspaper photographers and the half dozen others who spent the next few days photographing the devastated city. In addition to his autobiography, Genthe produced several illustrated books, including *Pictures of Old Chinatown* (1909). The museum's collection holds 29 photographs and almost a dozen books written or illustrated by Genthe.

Arnold Genthe

San Francisco Earthquake and Fire, 1906

Print by Ansel Adams, 1956
Gelatin silver print
GIFT OF CALIFORNIA
LEGION OF HONOR
73:0043:0001

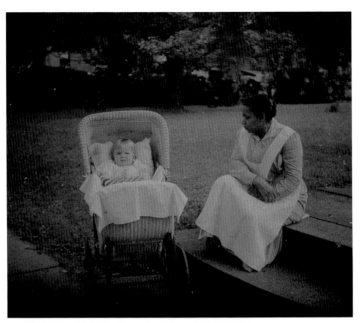

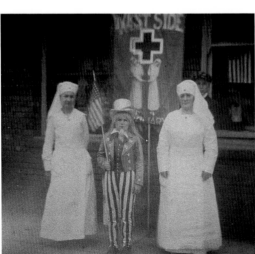

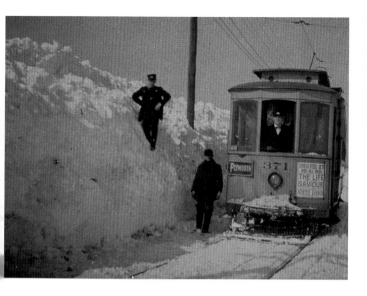

Color was one of the numerous improvements made in photography at the turn of the century. Awkward and complicated by today's standards, several workable systems of color photography were available to the rare professional and dedicated amateur willing to cope with the attendant difficulties. The Autochrome process, perfected by the Lumière brothers in France in 1907, attracted attention from both amateurs and professionals. Heinrich Kühn and Jean Tournassoud in Europe and Arnold Genthe, Edward Steichen, and Alfred Stieglitz in America all worked with the process.

In Rochester, New York, Charles Zoller, a former furniture dealer who had turned to selling lantern slides, learned the Autochrome process around 1908 and began making Autochromes abroad and then in his hometown. In 1915 he began giving lectures to civic and professional groups, illustrated with the many Autochrome slides he had made. The illustrated lecture played a large role in public education and entertainment during this period, and professional lecturers often made a good living on the lecture circuit. Zoller also photographed Rochester's activities, events, celebrations, and the many gardens of "The Flower City." The museum's Zoller collection contains almost 3,900 Autochromes, 450 lantern slides, and 4,000 negatives.

Floyd W. Gunnison was a commercial photographer who lived and worked in the town of Canandaigua, in upstate New York, from 1908 until at least the mid-1920s. He was known for "... making a specialty of home portraiture and interior and exterior commercial work." This pragmatic extension of commercial photographic practice was commonplace. Gunnison's work is similar to that of other photographers working in small towns: photographs of local commercial enterprises; records of celebrations, ceremonial events, and weddings; and portraiture. His photographic style portrayed as much of the subject with as little subjective interpretation by the photographer as possible. Thus, the compositions are frontal, direct, static, and balanced. The subjects are normally centered and surrounded with enough space so that essential forms (whether a bathroom interior or a community band standing in front of a theater) are easily discerned and understood. However, Gunnison would at times deviate from his usual approach to elicit a more interesting perspective, as seen in his "Store Front," with its

Floyd W. Gunnison
American, 1882–1943

Interior of Bathroom,
ca. 1915

Modern gelatin silver print from the original gelatin on glass negative
GIFT OF CHARLES CARRUTH
67:0126:0025MP

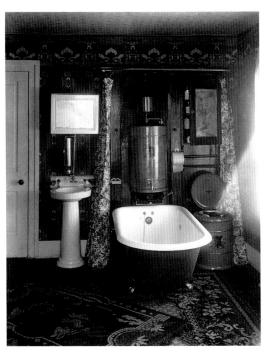

oblique angle of view. Gunnison worked in a distilled form of documentary photography, conveying clear, straightforward messages. He, like other small-town commercial practitioners, created an unprecedented catalogue of America's vernacular landscape, which today is prized by scholars and public alike for its cultural and historical information. But such acknowledgment was long in coming. Consequently, only a small percentage of work by these previously unsung practitioners was collected or preserved. In Gunnison's case, the museum holds 124 glass plate negatives and has made a set of modern gelatin silver prints from them.

By 1900 nearly every city, large and small, and even many towns,

Floyd W. Gunnison

*Band outside Temple
Theater,* ca. 1915

*Modern gelatin silver
print from the original
gelatin on glass
negative*
GIFT OF CHARLES
CARRUTH
67:0126:0038MP

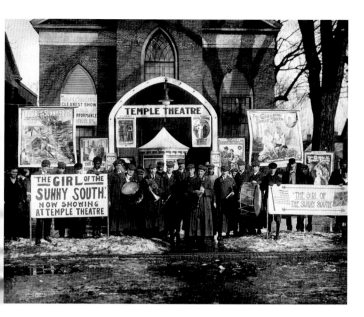

Floyd W. Gunnison

Store Front, ca. 1915

*Modern gelatin silver
print from the original
gelatin on glass
negative*
GIFT OF CHARLES
CARRUTH
67:0126:0035MP

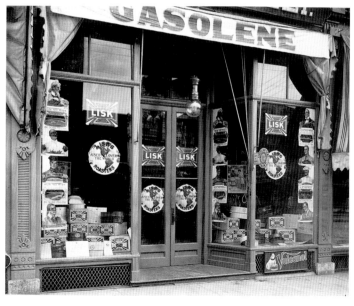

had established libraries, museums, local historical societies, civic booster organizations, or preservation groups, all interested in compiling or maintaining visual archives of events or buildings of local historical significance. In 1875 an organization called the Society for Photographing Relics of Old London was formed in London, which took as its mission the task of documenting and publishing photographic records of endangered and architecturally significant buildings. For 12 years the society commissioned a photographer to document these structures and then, on subscription, published carbon prints of this work at a rate of six (later 12) per year, for a total of 120 prints. Carefully researched captions were included with the photographs in later editions. Between 1875 and 1878 the partnership of Alfred and John Boole made the photographs, and from 1879 to 1886 the work was completed by Henry Dixon with his son Thomas. The museum holds this two-volume portfolio.

Henry Dixon
English, 1820–1893

Great Saint Helen's, London, 1882

Carbon print
MUSEUM PURCHASE
76:0048:0111

Paris, the beautiful "city of lights," had a long and storied tradition of visual documentation, with many publications, organizations, and institutions providing a base of support for this type of commercial photography. During the 1880s and 1890s, large, well-organized picture agencies such as Neurdien or Albert Hautecoeur

Eugène Atget
French, 1857–1927

Impasse des Bourdonnais (1e Arr), 1908

Albumen print
MUSEUM PURCHASE
81:0951:0014

provided, at a reasonable price, both tourists and private and public institutions with very professional, well-printed, and detailed topographic views of almost any recognized building. At the turn of the century one photographer who made a modest living working on the margins of this field of endeavor was an ex-actor named Eugène Atget. He worked as an independent entrepreneur, taking occasional small assignments from the Bibliothèque Nationale, the Archives Photographiques du Palais-Royal, the Société d'Iconographie Parisienne, and other organizations wanting to fill in the gaps of their picture collections. Atget also sold prints door to door to decorators, shop owners, and artists in need of source material. Atget's resources were limited, and his technique was thought to be antiquated and awkward even when he began in the 1890s. Atget found little financial success amid the host of more professionally run firms of topographic photographers that Paris supported.

Forced by economics and perhaps by his own nature, Atget concentrated his attention on the unspectacular, the overlooked, the previously disregarded features of daily life. He photographed the edges and corners of Paris diligently and incessantly until his death in 1927. Atget worked out a private photographic approach and visual style that drew from both the documentary and pictorial photography traditions he had

Eugène Atget
French, 1857–1927

Femme, 1925–1926

Matte albumen print
MUSEUM PURCHASE,
EX-COLLECTION
MAN RAY
76:0118:0006

(right)
Eugène Atget

Versailles, Coin de
parc, 1902

Albumen print
MUSEUM PURCHASE,
EX-COLLECTION
MME. LOUETTE,
VIA KODAK PATHÉ
78:1628:0040

inherited, combining features of both into a new, unique vision that changed the possibilities of visual expression for several generations of photographers. His prints, filled with halation flares, distorted perspectives, blocked vistas, and overlapping images, are simultaneously incompetently realized topographical photographs and transformative, brilliant art. Atget could infuse a sense of drama and brooding mystery equally into his views of the ancient, decayed gardens of a deposed king or into an indigenous storefront tableau arranged to commemorate a circus giant. Late in his life, a postwar generation of artists and writers attracted to new studies of man's unconscious mind took up Atget's mysterious and haunting images with extraordinary enthusiasm. Known as surrealists, these individuals recognized in Atget an untethered vision similar to their own and pronounced his work a precursor to their own. The museum holds nearly 500 images by Atget, ranging from the informational to the poetic, from the mundane to the extraordinary.

An album of 148 snapshots taken around 1910 of airplanes, airplane races and wrecks, and airplane models built and tested by the photographer, a French teenager named Jacques-Henri Lartigue, is held by the museum. Lartigue's interests mirrored the trends of the world around him. He loved the speed and drama of the new cars and airplanes and the exuberant, playful life of his large and active family. He loved to photograph all of these things. The son of a wealthy and indulgent banker, Lartigue had been given a camera in 1901 when he was seven years old and was encouraged to use it. With his youthful curiosity for recording the flux of activities around him and with a child's disregard for any "acceptable" standards of photographic practice, Lartigue made photographs that were banal, outrageous, funny, and, far more frequently than one would expect, simply wonderful.

Jacques-Henri Lartigue
French, 1894–1986

Mon plus petit model (9 cm. envergure) Il a bien marché (My Smallest Model [9cm. Wingspan] It Worked Well), 1910

Gelatin silver print
MUSEUM PURCHASE
76:0044:0105

As soon as photography became cheap and easy to use and making photographs came into the hands of thousands of visually and artistically untrained individuals, the possibilities of the medium exploded. Along with the millions of prosaic images made at this time, there are thousands of interesting and, extraordinary images depicting all sorts of unusual and bizarre objects, events, and activities that were a part of the human experience previously not thought worthy of the labor and cost of photographing. By 1910 a 16-year-old with a camera could show his model airplanes, demonstrate his love of flight, even convey his passion for life. It was another step, and an important one, in the democratization of information and the growing role of photography in communication.

Jacques-Henri Lartigue

Lalihan et Vachlin
sur Antoinelli
(Lalihan and Vachlin
on Antoinelli), 1910

Gelatin silver print
MUSEUM PURCHASE
76:0044:0066

Jacques-Henri Lartigue

Vols
*Model Airplane in
Flight*, 1910

Gelatin silver print
MUSEUM PURCHASE
76:0044:0102

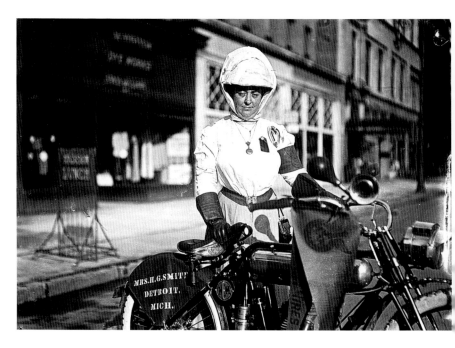

Nathan Lazarnick
American, b. Russia,
1879–1955

*Mrs. H. G. Smith
Detroit, Mich.,*
ca. 1916

*From a gelatin on
nitrocellulose sheet
film negative*
GIFT OF GEORGE
LAZARNICK
81:3051:0748

At the turn of the century the automobile was big news. Auto trade fairs, cross-country endurance trips, and speed races were all followed in the mass media and photographed avidly by professionals and amateurs. George Eastman House has over 1,800 gelatin on glass negatives from the files of Nathan Lazarnick, most of which depict automobiles being raced, tested, or displayed. Lazarnick was working as a professional photojournalist in 1899. This was the age of speed, and photojournalism was a profession that had to keep up with the world it was recording. Content was more important than form. The ability to capture the subject was more important than compositional skill. Traditional canons of composition, style, even printing quality were expanded or ignored by the imperatives of photojournalistic practice. As a result, a new body of imagery came into being, depicting blurred, truncated shapes and blocked forms of hastily seen things in granular and poorly printed images. But the excitement and drama of these events seemed heightened with these new forms of presentation. Later generations of photographers and artists responded to these innovative photographic practices and incorporated them into their own work.

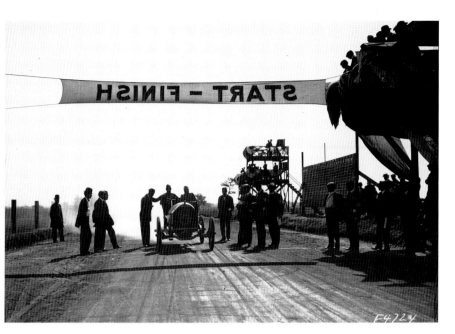

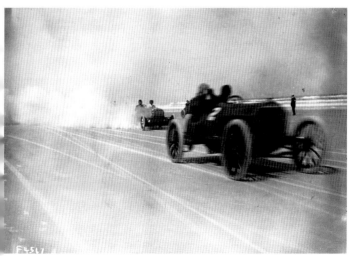

Nathan Lazarnick

*Thomas Derhart and
J. B. Lorimer,* 1908

*From a gelatin on
nitrocellulose sheet
film negative*
GIFT OF GEORGE
LAZARNICK
81:3051:0848

(left)
Nathan Lazarnick

*Autos Racing
on Beach,* ca. 1916

*From a gelatin on
nitrocellulose sheet
film negative*
GIFT OF GEORGE
LAZARNICK
81:3051:0754

Frederick W. Brehm
American,
1871/2–1950

*Police Officers with
Horses, Motorcycles,
and Police Van,*
ca. 1915

Gelatin silver print
77:0619:0047

This frieze of policemen superbly equipped to chase down any poten-
tial lawbreakers on horseback, by motorcycle, or by motorcoach was
taken with a Cirkut panoramic camera by Frederick W. Brehm. Brehm
trained as a cabinetmaker in the 1890s. He began to photograph in 1892
and by 1900 was working as a special designer for camera companies.
In the ensuing years, Brehm came to specialize in the development of
the panoramic camera, in particular the Cirkut, the most widely used
panoramic camera of its day.

In 1917 Brehm joined Eastman Kodak Company and worked there
until his retirement in 1945, serving as manager of several divisions of
the company. He also pioneered the development of photographic in-
struction at several colleges in New York State. The museum holds 70

large panoramas by Brehm in its collections. These prints range from 2 to 10 feet in length and include views of the Genesee River and downtown Rochester and large groups of people at employee picnics or trade meetings. The museum also holds a 19-foot-long, 360-degree panoramic view of Washington, D.C., taken about 1910. Approximately 50 smaller panoramas (8 to 12 inches long), 40 other hand-colored photographs made in Scotland in 1909, 60 gelatin silver prints of flowers and gardens taken in the 1930s, and 600 glass negatives and positives constitute the remainder of the Brehm collection. The museum's technology collection holds two Cirkut cameras from this era, as well as eleven others made between 1907 and World War II. Brehm's innovative design would pioneer systems used in high-speed aerial cameras for decades to come.

Ch. Chusseau-Flaviens
French?, active
1890s–1910s

Russie celeb. Mme.
Kropinsky (Russian
celebrity, Madam
Kropinsky),
ca. 1900–1919

*From a gelatin
on glass negative*
GIFT OF KODAK
PATHÉ
75:0112:1633

George Eastman House has a collection of more than 10,800 original gelatin on glass negatives by Ch. Chusseau-Flaviens, which it received from Kodak Pathé in France. While little is known about this vast collection of work, its diversity suggests it may be a picture file gathered from the work of more than one individual. In the early years of the 20th century, large caches of images were being accumulated by nascent photo agencies such as Underwood & Underwood, Paul Thompson, and others to meet the demands of an emerging picture press. America, France, England, Germany, Portugal, Hungary, and other countries each had an active and flourishing press, which published illustrated weekly or monthly magazines. Almost all of these magazines had an illustrated section given some generic name such as "The World in Pictures," which showed celebrity, society, or political figures, or depicted celebratory events including gala balls, races, or more serious news. These publications demanded an immense quantity of "news" photographs each week and fostered the

Ch. Chusseau-Flaviens

Angleterre suffragette
(English Suffragette),
ca. 1900–1919

From a gelatin on glass negative
GIFT OF KODAK PATHÉ
75:0112:2134

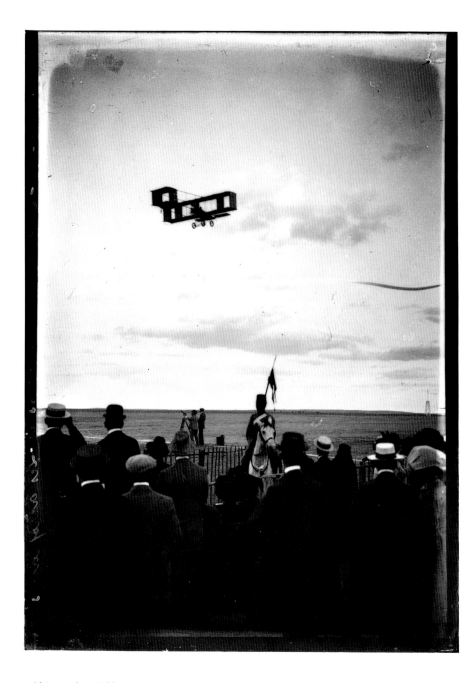

(left)
**Ch. Chusseau-
Flaviens**
French?, active
1890s–1910s

Égypte Aviation
à Héliopolis – les
aéroplanes (Egyptian
Aviation at Heliopo-
lis – The Airplanes),
ca. 1900–1919

*From a gelatin
on glass negative*
GIFT OF KODAK
PATHÉ
75:0111:4780

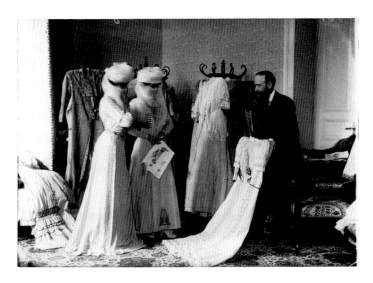

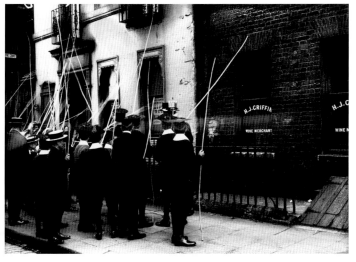

(above)
**Ch. Chusseau-
Flaviens**

Égypte Dames de
harem chez le cou-
turier (Egyptian
Harem Women at
the Dressmaker's
Shop),
ca. 1900–1919

*From a gelatin on
glass negative*
GIFT OF KODAK
PATHÉ
75:0112:3756

**Ch. Chusseau-
Flaviens**

Angleterre manifes-
tation (English Pub-
lic Demonstration),
ca. 1900–1919

*From a gelatin on
glass negative*
GIFT OF KODAK
PATHÉ
75:0112:3984

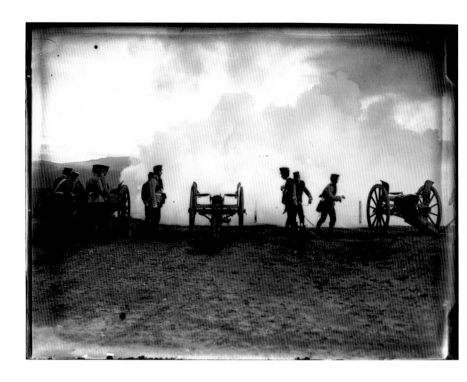

Ch. Chusseau-Flaviens
French?, active
1890s–1910s

Espagne Artillerie
(Spanish Artillery),
ca. 1900–1919

*From a gelatin on
glass negative*
GIFT OF KODAK
PATHÉ
75:0112:2511

growth of picture agencies that could quickly deliver a wide choice of photographs.

These images represent the work of one or more photojournalists working from the 1890s until just before World War I, depicting social and political figures and events throughout Europe and the colonial empires in the Near East and the Far East. Featured subjects included activities of the leisured classes or "society," political unrest in Spain and England, and the prewar buildup of European military forces. Events such as these no longer had to be staged for the photographer, which led to the notion that the camera could act as an unobtrusive witness to real events taking place in the world. This reliance on the camera as eyewitness would gain momentum in the decades ahead, helping to shape in thought and practice the developing fields of photojournalism and mass media.

Photographers had documented the aftermath of warfare as early as 1846, but World War I was the first war in which photography had an

Ch. Chusseau-Flaviens

Serbie Prince son Professor/Serbie
(Serbian Prince and His Professor),
ca. 1900–1919

From a gelatin on glass negative
GIFT OF KODAK PATHÉ
75:0112:0283

important strategic function. Aerial photographs of enemy fortifications were used to help form battle plans. Beyond that important direct use, the unprecedented scale and length of this war required a larger measure of public support, and every belligerent nation developed an apparatus to control the nature and direction of public information about the conflict. Though this ca. 1915 heroic charge of a headless officer fabricated from a collage of disparate images stands in sharp contrast to the scenes of war by Rudolf Tauskey, both images serve a similar function. The gallant cavalryman, able to don the head of anyone appropriate to the occasion, is designed to inspire public pride in a nation's military might. In it, a modern airplane is juxtaposed against the officer's "inaccurately" charging stallion (Muybridge's studies of the 1870s showed that horses simply don't run like this), while Tauskey's images depict American troops in the mud and under fire in the trenches at the front lines. Just two from a group of seventeen 8 x 10-inch positive images on glass, these were probably designed for public display and would have been used to garner public support for the war.

During World War I, propaganda was used with an intensity and thoroughness never seen before, and photography played an important part of this informational/propaganda effort. Every country established a corps of "official" military photographers, and the scale of coverage

Unidentified artist
French?, active
ca. 1910s

Military Montage,
ca. 1915

*Gelatin silver print
with applied color,
combination print*
78:0842:0001

(right)
Rudolf Tauskey
American?, active
1910s

*Soldiers in Trench,
World War I,* ca. 1916

*Transparency, gelatin
on glass*
GIFT OF MRS.
RUDOLF TAUSKEY
89:0154:0011

(above)
Rudolf Tauskey

*Explosion at Night,
World War I*, ca. 1916

*Transparency, gelatin
on glass*
GIFT OF MRS.
RUDOLF TAUSKEY
89:0154:0016

was unprecedented. The American Expeditionary Forces came to France very late and were only a small part of this conflict, yet the United States Signal Corps made over 75,000 photographs and shot "miles of motion picture film." There were also dozens of accredited and unaccredited photojournalists, such as Jimmy Hare and Donald Thompson, who managed to photograph in spite of heavy censorship. All the established organs of mass media were reconfigured to support the "war effort." Hundreds of carefully selected photographs appeared in the many illustrated weekly magazines, multivolume illustrated histories of the war were published while it was still being fought (or soon thereafter), and the new genre as well as the older field of stereography was employed for propagandistic ends.

George Eastman House holds an album of 65 photographs depicting the activities of the U.S.A. School of Aerial Photography at the Eastman Kodak Company in Rochester, which trained almost 2,000 soldiers

Unidentified photographer
American, active 1910s

"Illustrated Lectures Are an Important Part of Instruction," 1918

Gelatin silver print
GIFT OF DWIGHT R. FURNESS
81:1702:0013

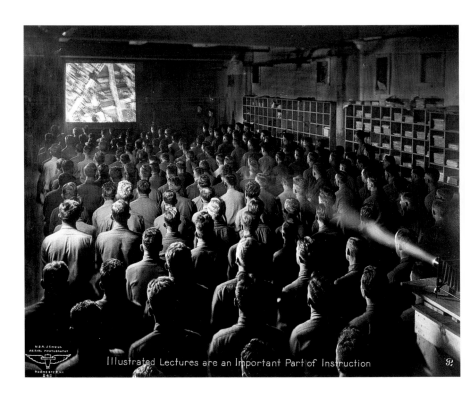

Illustrated Lectures are an Important Part of Instruction

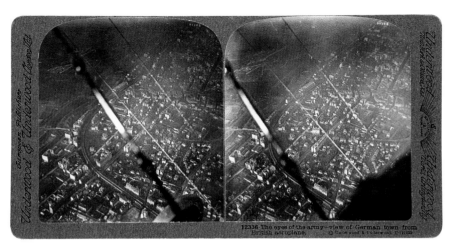

12336—The eyes of the army—view of German town from British aeroplane. © Underwood & Underwood. U-121029.

between March 1918 and the end of the war. The museum also holds approximately 800 stereo views depicting the events of World War I. These are from various series titled "European War," "War of the Nations," or "World War," issued by Underwood & Underwood and the Keystone View Company.

By the early 1880s stereos were considered old-fashioned, and their popularity had sharply declined. Elmer and Bert Underwood, working in Ottawa, Kansas, began selling stereo views door to door through commissioned salesmen. This worked so well that by 1894 the company had grown into an immense international business, with four factories producing ten million photographs a year from their huge file of negatives. These images had been acquired by wholesale purchases of earlier stereomakers' stocks or were made by the company's hired photographers. The firm pioneered the concept of issuing boxed sets about specific topics or events, some containing up to 300 photographs. These sets contained extensive and well-written information and commentary on the stereo views' subjects, and by the beginning of the 20th century the stereo had become an important tool in public education and a vital contributor to the growth of mass media.

Oskar Weitzman served in the Austro-Hungarian army during World War I. The museum holds 76 of his photographs depicting a variety of military aircraft, including zeppelins and balloons.

Burden & Salisbury's "Mabel Pays by Check" (page 468) and Irving

Underwood & Underwood
American, active 1882–1923

The Eyes of the Army – View of German Town from British Aeroplane, ca. 1914

Gelatin silver print stereograph
GIFT OF THE UNIVERSITY OF ROCHESTER
83:1795:0336

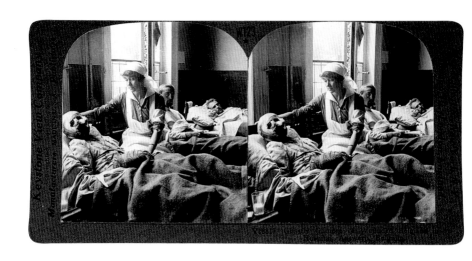

Keystone View Company
American, active
1892–1970

Ghastly Glimpse of
Wounded Belgians
in Hospital, Antwerp,
Belgium, ca. 1916

*Gelatin silver print
stereograph*
76:0147:0123

(below)
Keystone View Company

Repairing Field
Telephone Lines
during a Gas Attack
at the Front, ca. 1916

*Gelatin silver print
stereograph*
76:0147:0243

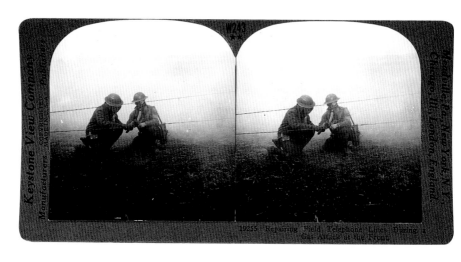

Oskar Weitzman
Austrian, 1898–1947

Parachute Jump/
Portrait of Soldier,
ca. 1916

Gelatin silver print
postal card
GIFT OF MRS. OWENS
83:1542:0061

Burden & Salisbury
American, active
1900s–1920s

Mabel Pays by
Check, 1923

*Transparency, gelatin
on glass (lantern
slide) with applied
color*
97:1949:0015

Mabel pays by check

Underhill's extraordinary images of commonplace objects are examples of yet another permutation in commercial photographic practice: advertising photographs, made in the context of the explosion of mass media. While not a completely new idea (canny businessmen had hired photographers to promote everything from machine guns to canned goods in the 19th century), the tremendous growth in number and circulation of popular illustrated magazines supported by advertising revenues put a new and different emphasis on this type of imagery. "Mabel's" financial practices were brought to the Rochester, New York, public as lantern slides in a little series of 19 narrative episodes, each containing image and text. These were shown in a story form familiar to an audience that by now was experienced at going to "the movies."

(right)
Irving S. Underhill
American,
1872–1960

*Accountants Hand-
book,* ca. 1915

*Modern gelatin silver
print from original
gelatin on glass
negative*
GIFT OF FRED
LOWENFELS
79:1994:0217MP

Irving Underhill's photographs seem to a contemporary eye to have a hyperreal insistence on the medium's factuality and a postmodern sensibility of visual staging and incongruous juxtaposition. However, this effect is accidental. Having worked at a commercial studio in New York since 1896, Underhill sold news photographs to illustrate feature articles in magazines, including *World's Work,* while also making studio photographs for the advertisements found in the same magazines. Backgrounds and any other "unnecessary information" in his photographs would have been blocked out by a retoucher to create space for the advertisement's text.

(left)
Irving S. Underhill
American,
1872–1960

Wrenches, ca. 1915

*Modern gelatin silver
print from original
gelatin on glass
negative*
GIFT OF FRED
LOWENFELS
79:1994:0313MP

Irving S. Underhill

*Metal Object –
Machine Part,
ca. 1915*

*Modern gelatin silver
print from original
gelatin on glass
negative*
GIFT OF FRED
LOWENFELS
79:1994:0291MP

"Refrigerator" (page 472) depicts a seemingly affable but decidedly strange conjunction of two cultures. The young lady showing the ice cube tray to unidentified Bornese men is Osa Leighty Johnson, who was something of a self-made celebrity in the 1920s and 1930s. In 1940 Osa Johnson released the film *I Married Adventure,* honoring her husband Martin, who was accidentally killed in 1937. The film was essentially a

compilation of scenes from the ten adventure/exploration entertainment feature films and innumerable educational films depicting their travels to exotic areas of the world, including *Among the Cannibals of the South Pacific* (1918) and *Trailing African Wild Animals* (1923). More than a film title, *I Married Adventure* was the theme of the Johnsons' lives; they made their living by establishing themselves as celebrity adventurers through their prodigious works.

One function of a celebrity is to publicly experience and share the unusual and interesting features of existence as a surrogate for the average person. The three images shown here of this engaging young woman so clearly enjoying her work while playing directly to the camera's gaze and the audience beyond may help explain just why the Johnsons were so admired by the public. In the early 1920s they went to East Africa, where they organized safaris to find and photograph wild animals. In 1924 they visited Rochester, New York, and successfully approached George Eastman to gain his support for a major photographic and film expedition. They returned to Africa with a battery of still and motion picture cameras. After three years, they returned to the United States in 1927 to present a popular and profitable series of lectures and film showings, from which they made over $100,000. In 1932 the Johnsons bought two private planes, which allowed them even greater mobility to conduct their animal filming in Africa. The museum holds over 9,500 glass negatives, largely documents of these trips. A copy of the film *Chronicles of an African Trip* (1927), about George Eastman's visit to the Johnsons in Africa, is held in the museum's motion picture collection.

Osa & Martin Johnson
Americans, active 1917–1937

Refrigerator, ca. 1920

From a gelatin on glass negative
85:1263:0053

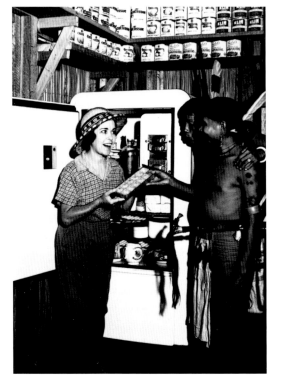

(above)
Osa & Martin Johnson

Osa and Airplane,
ca. 1918–1936

From a gelatin on glass negative
85:1268:0010

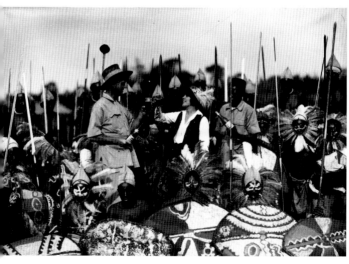

Osa & Martin Johnson

Champagne,
ca. 1921–1927

From a gelatin on glass negative
85:1262:0567

The Object Photographed

In the final two issues of *Camera Work*, Alfred Stieglitz published 17 pictures by the American photographer Paul Strand. "The White Fence, Port Kent, New York" was made in 1916, a crucial year for Strand, who made the startling transition from what he called "Whistlering" (after the painter James Abbott McNeil Whistler) to modernism. Strand's photogravure stands between the two traditions, at once focusing on the graphic symmetry of the white fence against the dark grass, yet playing against the vaguely picturesque buildings in the background. The medium was being redefined by a new approach to picture-making, suggested by Stieglitz's description of Strand's work as "[d]evoid of flim-flam; devoid of trickery and any 'ism'; devoid of any attempt to mystify an ignorant public, including the photographers themselves. These photographs are the direct expression of today."

Charles Sheeler

Bucks County Barn,
ca. 1916

Gelatin silver print
MUSEUM PURCHASE
81:1758:0021

Charles Sheeler
American, 1883–1965

Ship Funnel, 1927

Gelatin silver print
MUSEUM PURCHASE
81:1757:0002

Following the landmark *International Exhibition of Pictorial Photography* at the Albright Art Gallery in Buffalo, New York, the Photo-Secession movement soon dissipated, partly due to numerous fallings-out between Stieglitz and the other photographers, but primarily because the painterly, romantic imagery of pictorialism was being supplanted by a newer, more aggressive aesthetic. Modernism triumphed clarity of detail over atmospheric renderings, and unfettered reality over fabrication. Strand, who had studied with Lewis Hine at the Ethical Culture School, had been heavily influenced by the modern art that Stieglitz increasingly exhibited at his 291 Gallery. "The Lathe" (page 475) a close-up view of heavy machinery, is nearly abstract in its subversion of scale and focus on form, surface, and light.

Charles Sheeler, primarily a painter, collaborated with Strand on the film *Manhatta* in 1921. He photographed a ship's funnel (page 476), transforming the mechanism of the machine into cubistic lines and

circles. Similarly, his "Bucks County Barn" (page 477) transcends its vernacular subject to become a formal study in texture, line, and the subtle tonal range of whites that photography is capable of rendering.

Alfred Stieglitz's "Paula, Berlin" (page 478) was made early in his career, during the same year that he saw, for the first time, works by Louis-Jacques-Mandé Daguerre, William Henry Fox Talbot, and Julia Margaret Cameron in the Jubilee exhibition in Vienna, a celebration of the 50th anniversary of the public announcement of photography. The geometric striations of light and shadow that infiltrate the romantic, pictorialist-style portrait presage Stieglitz's later, more modernist style evidenced in "Grape Leaves and House, Lake George" (page 479). Clapboard siding on the summer cottage echoes the horizontal patterning in "Paula," while opposing porch pillars anchor the composition at either side with a sophisticated sense of framing and symmetry that can only be achieved through the precision of the photographic instrument.

Alfred Stieglitz
American,
1864–1946

Portrait of R.
Rebecca Strand, 1923

Gelatin silver print
PART PURCHASE AND
PART GIFT OF AN
AMERICAN PLACE,
EX-COLLECTION
GEORGIA O'KEEFFE
74:0052:0087

In 1916, during a summer visit to Oaklawn, the family summer home at Lake George, Stieglitz made a series of photographs of Ellen Koeniger, photographer Frank Eugene's niece (see page 480). Clad in a clinging, wet swimming costume, Koeniger is an ebullient, athletic muse. Stieglitz's sharp-focus image made in brilliant sunlight couples warmth and spontaneity with formal investigation and libidinous longing. Several years later, he neatly bisected the Manhattan skyline in "Spring" from the *New York* series (page 481). The bottom half of the composition is cast in deep shadow; rising up in crisp, delineated sunlight, the city's skyscrapers exert a forceful balance and energy that is almost the visual opposite of Koeniger's bathing form.

A portrait of Rebecca Strand (wife of Paul Strand) holding her breast in the water is a textural wonder. The top half of her body is so finely drawn that every goose bump on her flesh is rendered with sensuous precision, while the submerged half dissipates in waves of muted

Alfred Stieglitz

Georgia O'Keeffe,
1933

Gelatin silver print
PART PURCHASE AND
PART GIFT OF AN
AMERICAN PLACE,
EX-COLLECTION
GEORGIA O'KEEFFE
74:0052:0065

abstraction from the light-filled water that gently surrounds her. No
trace of the photographer's earlier soft-focus pictorialism is present
in these images.

The portraits of Strand and Koeniger anticipate the direction of
Stieglitz's series of photographs of his wife and greatest muse, the
painter Georgia O'Keeffe. Stieglitz met O'Keeffe in 1916 at 291
Gallery; he first photographed her the following year. O'Keeffe's
highly expressive hands represent both her artistry and her passion.
The physicality of these women is more direct and sexually charged

Alfred Stieglitz
American,
1864–1946

Clouds, Music No. 1,
Lake George, 1922

Palladium print
PART PURCHASE AND
PART GIFT OF AN
AMERICAN PLACE,
EX-COLLECTION
GEORGIA O'KEEFFE
74:0052:0067

Alfred Stieglitz

Hedge and Grasses,
Lake George, 1933

Gelatin silver print
PART PURCHASE AND
PART GIFT OF AN
AMERICAN PLACE,
EX-COLLECTION
GEORGIA O'KEEFFE
74:0052:0095

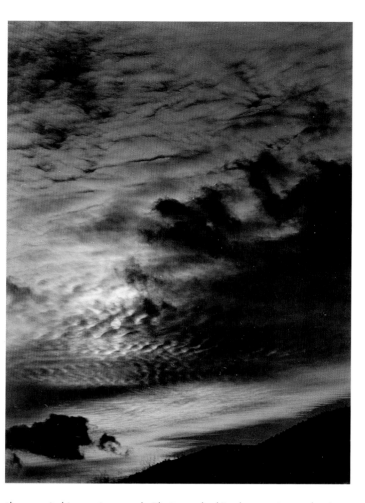

Alfred Stieglitz

Equivalent, 1929

Gelatin silver print
PART PURCHASE AND
PART GIFT OF AN
AMERICAN PLACE,
EX-COLLECTION
GEORGIA O'KEEFFE
74:0052:0020

than any in his previous work. Photographed in close-up to emphasize details over the whole, their portraits convey an aspect rather than a likeness.

Believing that the object photographed had to be understood before it could be successfully rendered, Stieglitz embarked in 1923 on a series of cloud studies that he called "Equivalents." He wrote: "I had told Miss O'Keeffe I wanted a series of photographs which when seen by [composer] Ernest Bloch he would exclaim: 'Music! music! Man, why that is music!'" This image of a mackerel sky equates the riotous natural

formations with the photographer's emotional state and transcends the abstract formality of the composition. "Clouds, Music No. 1, Lake George" (page 484) was part of a series of ten cloud photographs that he directly identified as visual music. While not an "Equivalent" per se, Stieglitz's landscape "Hedge and Grasses, Lake George" (page 484) finds formal communion with this very personal body of work.

In 1911 Johan Hagemeyer emigrated from Holland with a degree in pomology (the science and practice of fruit growing). He had been an avid snapshot photographer in Holland and was introduced to the artistic potential of photography through copies of *Camera Work* he saw at the Library of Congress. Hagemeyer then traveled to New York to meet Stieglitz. Suitably encouraged by his visit to pursue photography, in 1917 Hagemeyer moved to Los Angeles, where he met Edward Weston. Through their friendship, Hagemeyer was introduced to some of the leading photographic artists in the region. Although Hagemeyer's initial work was pictorialist in style, he, too, evolved toward a more modernist style. Along with Weston, he was keenly aware of carrying forth the artistic legacy that Stieglitz had established. "[P]hotography has certain inherent qualities which are only possible with photography – one being the delineation of detail … why limit yourself to what your eyes see when you have such an opportunity to extend your vision?" wrote Weston about a conversation with Hagemeyer that he recorded in his journal in 1923. The two had been struggling to define the essence and direction of the medium.

By 1924 Hagemeyer, who had established a studio in Carmel-by-the-Sea in northern California, had clearly absorbed Weston's perspective from the previous year. Less a gasoline station than

Johan Hagemeyer
American,
b. Holland,
1884–1962

Modern American
Lyric – (Gasoline
Station), 1924

Gelatin silver print
GIFT OF DAVID
HAGEMEYER
81:1301:0076

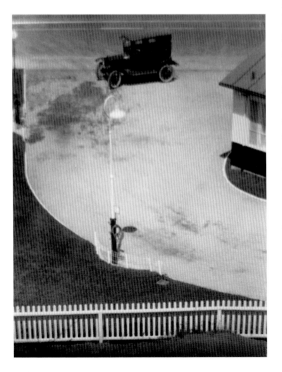

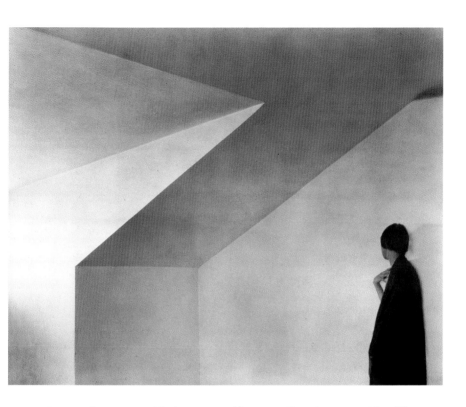

a sweeping arc of gray against black punctuated by a row of graphic white fence, Hagemeyer's image "Modern American Lyric – (Gasoline Station)," made from a startling bird's-eye vantage point, transformed the commonplace subject into extraordinary pattern and design. As he explained, "I am interested in everything contemporary and believe that we should live in our own time – seeing the beauty of today instead of worshipping the past."

From as early as 1921, Weston had begun evolving his modernist approach; five years earlier he plainly stated his preference for the previsualization of straight photography: "Get your lighting and exposure correct at the start and both developing and printing can be practically automatic." His 1921 "Attic, Glendale, California" is nearly pure geometry and tone, defining space completely through light and form. Even the figure of the woman on the right forms a black triangle against the wall; her upraised, bent hand forms another triangle in front of her.

Edward Weston
American, 1886–1958

Attic, Glendale,
California, 1921

Platinum print
MUSEUM PURCHASE,
EX-COLLECTION
BRETT WESTON
66:0070:0052

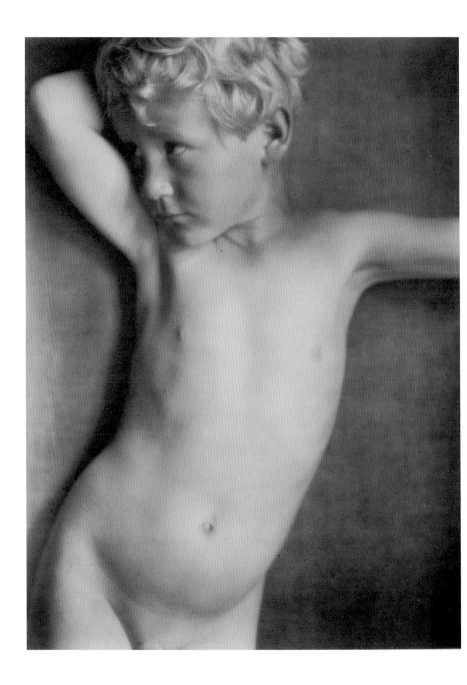

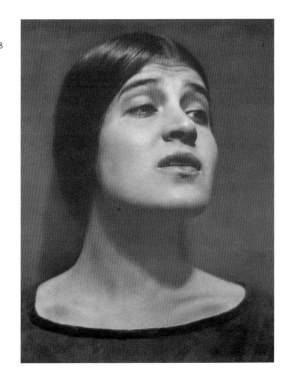

Weston was born in Highland Park, Illinois, and received his first camera from his father at age 16. From his very first roll of film, Weston approached photography seriously, and by the age of 20 had already published his work. In 1906 he went on a vacation to California to visit his sister and remained there. Almost immediately after his arrival, he settled on photography as a profession. In 1911 he established "The Little Studio" in Tropico (now Glendale). In 1922 Weston photographed his young son Neil in the nude. This is not the irrepressibly cute children of his commercial work; rather it is an exploration of form that recalls nothing less than classical sculpture. Although he met Stieglitz in New York that November and called their meeting "an important contact at a moment of my life ...," the already successful Weston seems not to have been directly influenced by the established master of the medium.

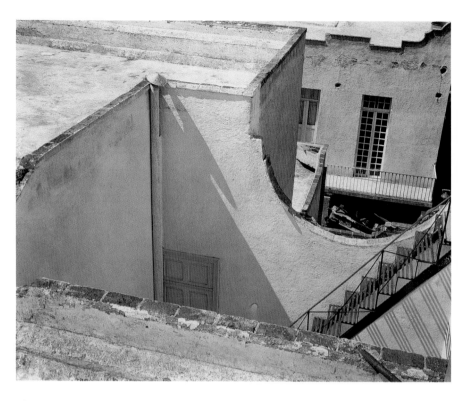

Edward Weston
American, 1886–1958

Mexico, 1924

Platinum print
MUSEUM PURCHASE,
EX-COLLECTION
BRETT WESTON
74:0061:0009

Tina Modotti was Weston's muse and lover; they met in late 1921 when she was an actress in Los Angeles, married to the artist Roubaix de l'Abrie Richey (Robo). By 1923 Weston had set sail for Mexico with his eldest son Chandler, with Tina at his side; Robo had died of smallpox some months before. "Tina Modotti Reciting Poetry" (page 489) is one of three dozen photographs Weston made of Modotti while she recited, emphasizing the sensual expressiveness of her slightly open mouth and raised eyebrows.

In Mexico with Modotti, Weston flourished, expanding his subject matter beyond what he had previously explored. An architectural study of the rooftops of town photographed "from the azotea" (roof) flattens the space into a two-dimensional drawing of light and texture. "Excusado" is a close-up of a porcelain commode. Filling the frame, Weston monumentalized the mundane, describing it as "Modern Classicism." Though all of these prints are platinum, the favored medium of

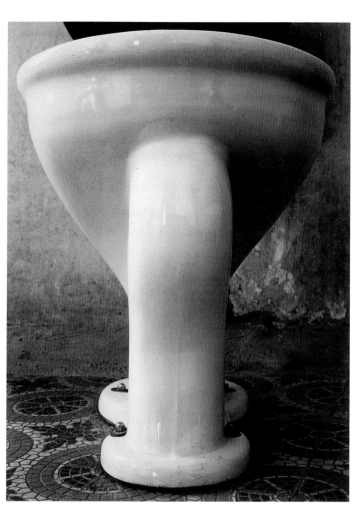

Edward Weston

Excusado, 1925

Platinum print
MUSEUM PURCHASE,
EX-COLLECTION
BRETT WESTON
74:0061:0064

pictorialism, in Weston's hands it is employed for its capacity for clarity and its wide range of tonality. In his photographs of Armco Steel (see page 492), he clearly recognized the extraordinary modernity of his industrial subject matter and brought to it a modernist eye, which reduces the architecture to elemental lines and forms.

In late 1929 Weston began his celebrated series of abstract compositions of eggplants, cabbages, peppers, and whatever else could be employed first as art and then as supper. "Pepper No. 30" (page 493)

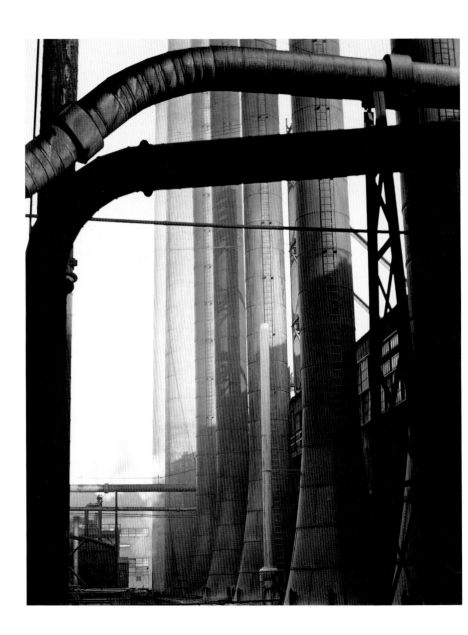

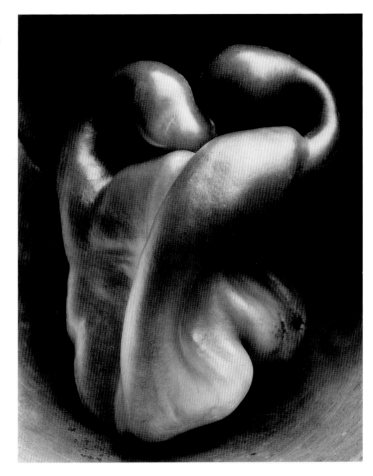

Edward Weston

Pepper No. 30, 1930

Gelatin silver print
MUSEUM PURCHASE
74:0061:0024

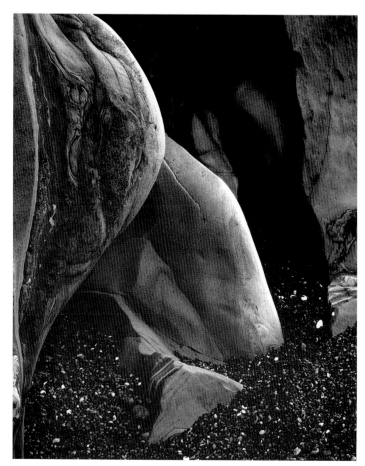

(right)
Edward Weston

Nude, 1936

Gelatin silver print
MUSEUM PURCHASE
74:0067:0005

Edward Weston
American, 1886–1958

Eroded Rock, Point
Lobos, 1930

Gelatin silver print
66:0070:0009

wrestles against itself inside a tin funnel that Weston used as a back-drop; the tension captured in the natural form has been isolated and enhanced by Weston's careful framing. Altogether, he made at least 30 negatives of the peppers over a four-day period.

After nine of Weston's photographs were hung in the *Group f/64* exhi-bition at San Francisco's de Young Memorial Museum in 1932, Weston was crowned the leader of the Group f/64. Sharp-focus negatives from a large-format camera, contact printed onto high-gloss paper, and record-ing optimum tone and detail was the preferred aesthetic of the f/64 photographers, who included Ansel Adams, Imogen Cunningham,

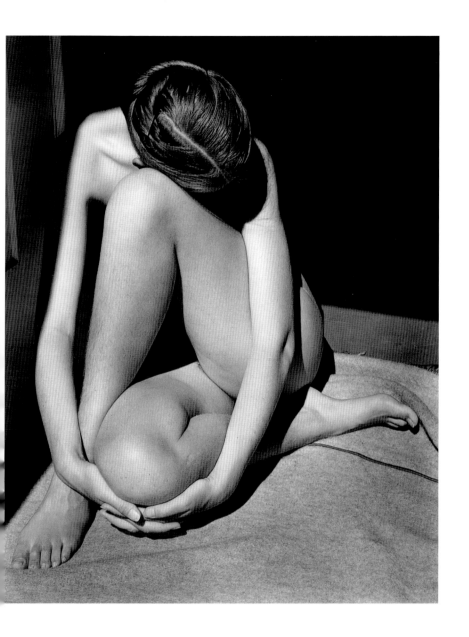

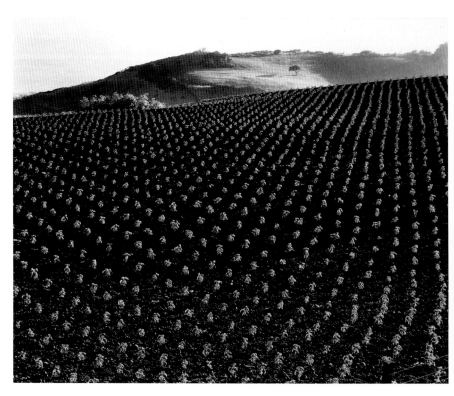

Edward Weston
American, 1886–1958

Tomato Field, 1937

*Print made in 1953
by Brett Weston*
Gelatin silver print
MUSEUM PURCHASE
74:0061:0072

and Weston's son Brett. Their name derived from the smallest lens aperture, which produces the greatest depth of field and detail.

In 1934 Weston met the 20-year-old Charis Wilson, the daughter of his neighbor, at a Carmel concert. "Perhaps C will be remembered as the great love of my life. Already I have achieved certain heights reached with no other love," wrote Weston of Charis, who would become his second wife and most frequent subject. In her 1998 memoir, Wilson described how the now-iconic image (page 495) came about, giving a rare glimpse at the perspective from the other side of the camera, and somewhat demystifying the process: "I think it was Edward's suggestion that I try sitting just inside the bedroom doorway. He was probably tired of the old gray army blanket I insisted upon lying on if I was out in the full sun. He saw what he wanted right away, but in the narrow section of sun deck outside the door it was difficult to set up the eight by ten to fit all of me in the picture and at the same time have the camera placed

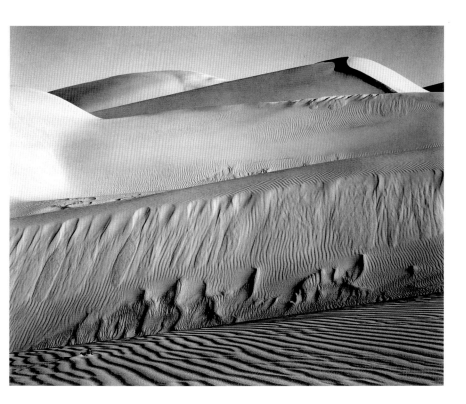

where he could operate it. In the end, he had to compromise and put up with the heavy shadow on the right arm; it was that or lose the picture. When I ducked my head because the sun was blinding me, Edward said, 'Hold it!' and made the exposure."

In 1937 Weston became the first photographer to be awarded a John Simon Guggenheim Memorial Fellowship. His proposal was to complete "The Making of a Series of Photographic Documents of the West," as his project was eventually called. "It seems so utterly naïve that landscape – not that of the pictorial school – is not considered of 'social significance' when it has far more important bearing on the human race of a given locale than the excrescences called cities. By landscape, I mean every physical aspect of a given region – weather, soil, wildflowers, mountain peaks – and its effect on the psyche and physical appearance of the people," Weston wrote the following year. He made three visits to the "Tomato Field" in Big Sur, California, before making this exposure,

Edward Weston

Dunes, Oceano, 1936

Gelatin silver print
MUSEUM PURCHASE
74:0061:0053

so that the light would render each individual plant distinct against the dark soil. It was the most difficult print Weston made during the two Guggenheim years. Another photograph, of the sand dunes at Oceano (page 497), reveals a palette of textures ranging from smooth stillness in the distance to variegated markings drawn by the wind, one layered on top of the other in a two-dimensional plane that recalls sedimentary rock. The museum holds more than 250 images by Weston.

The museum also owns 28 prints by Weston's muse, assistant, and sometime collaborator, Tina Modotti. An accomplished photographer in her own right, Modotti was born in Italy but immigrated to America with her family in 1913. They settled in San Francisco, where she worked in a textile factory and as a dressmaker before her marriage to Robo, who introduced her to the artistic community. Modotti met Weston in 1921 and learned photography from him; she decided to pursue it seriously when the two of them moved to Mexico in 1923. Through Weston, Modotti met Hagemeyer, Dorothea Lange, Imogen Cunningham, and Roi Partridge (Cunningham's husband). Though influenced by these artists, Modotti's style developed with more of a social concern.

Tina Modotti
American, b. Italy,
1896–1942

Woman of Tehuan-
tepec, ca. 1929

Gelatin silver print
74:0061:0159

Actively engaged in politics, she was involved with the Mexican Revolutionary Party and was a member of the Communist Party. Her sympathy for workers was frequently expressed through her portraits of the men and women who labor. Modotti was also keenly aware of the potential of labor to usurp the individual, which she depicted in a portrait of two men with enormous bundles strapped to their backs. Their loads are so heavy

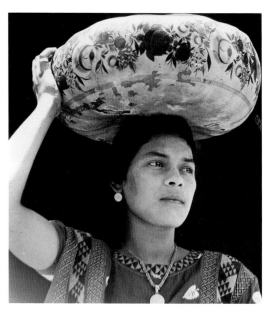

Tina Modotti

Two Men Carrying
Large Loads on
Backs, ca. 1927–1929

Gelatin silver print
74:0061:0164

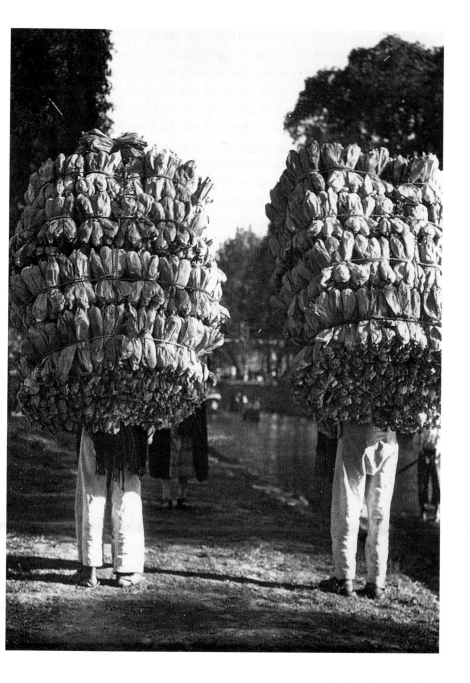

that they are stooped over, their faces obscured; the bundles not only envelop them but also dominate the frame. Through Modotti's eye, "Woman of Tehuantepec" (page 498), photographed from slightly below, is bestowed with an almost regal air, the large bowl suggesting not so much a vessel of transport as an elaborately patterned crown. A matriarchal society, the community of Tehuantepec must have been especially compelling for the fiercely independent Modotti. The images she made there represent the last significant burst of photographic energy in her career. "In my case life is always struggling to predominate and art naturally suffers ... I put too much art in my life ... and consequently I have not much left to give to art," Modotti wrote to Weston.

Modotti's photographic career was brief; after being deported from Mexico for her political activities, she made her way to Moscow between 1931 and 1934, and it was there that she gave up photography. In her only published statement on photography, Modotti concluded: "Photog-

Imogen Cunningham
American, 1883–1976

Designer and Design
(Roi Partridge), 1915

Platinum print
MUSEUM PURCHASE
77:0760:0043

raphy, precisely because it can only be produced in the present, and because it is based on what exists objectively before the camera, takes its place as the most satisfactory medium for registering objective life in all its aspects, and from this comes its documental value. If to this is added sensibility and understanding and, above all, a clear orientation as to the place it should have in the field of historical development, I believe that the result is something worthy of a place in social production, to which we should all contribute."

A close friend of Weston and acquaintance of Modotti, Imogen Cunningham bought her first camera in 1901 at the suggestion of Gertrude Käsebier, whose Photo-Secessionist work had

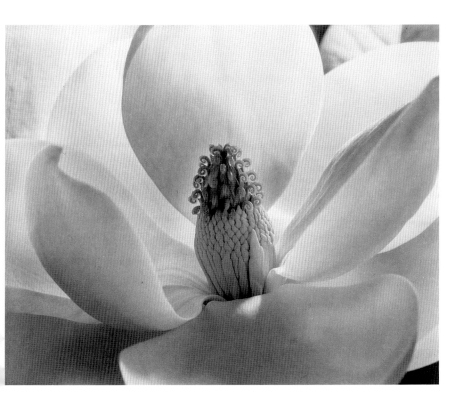

greatly influenced Cunningham. With a degree in chemistry and after a two-year stint as a printer in Edward Curtis's Seattle studio, she set up her own portrait studio, specializing in romantic, pictorial-style portraits and figure studies. Her nudes of her husband, the etcher Roi Partridge, were among the first nudes taken of a male in the landscape, for which she received both praise and prudish condemnation. "Designer and Design" is an early portrait of Partridge photographed against the backdrop of one of his designs influenced by the Arts and Crafts movement.

Throughout her career Cunningham made her living as a portrait photographer. Her sitters included the photographers Ansel Adams, August Sander, Stieglitz, and Weston. Although she joined a pictorialist photographer's group in 1923, 13 years later Cunningham would become a founding member of the Group f/64, and it was this sharp-focus, highly detailed style that defined her career. Between 1922 and 1929 Cunningham, an avid gardener, produced a series of plant and flower studies.

Imogen Cunningham

Magnolia Blossom, 1925

Gelatin silver print
MUSEUM PURCHASE
77:0760:0061

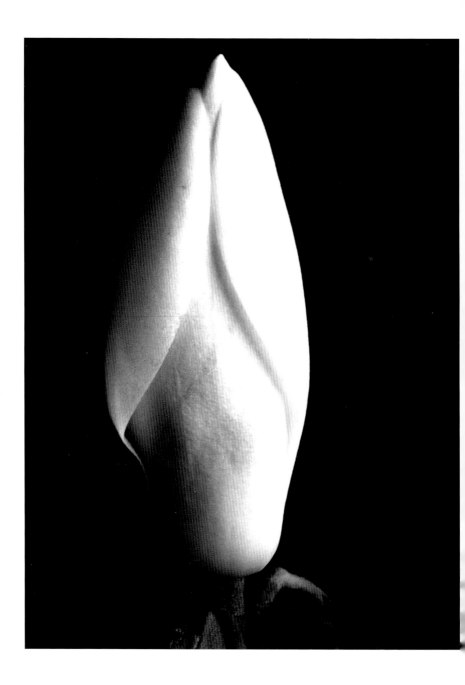

"If one decides upon the medium of photography, why attempt to soar in the realm of imagination?... There are plenty of the subtleties of life right on earth, which need delicate interpretation. ..." "Magnolia Blossom," Cunningham's son recalled, was brought home and sat in a vase for three days before his mother photographed it (page 501). She monumentalizes the flower, giving no reference or hint at its decorative purpose in the vase. Through her close-up vantage point, Cunningham reveals information about the flower that is not apparent to the casual eye. The stamen recalls human anatomy, its sensual curlicues resembling pubic hair. The eroticism and sexual metaphor in the flower images are subtle yet evident. "Magnolia Bud" and "Figures No. 1" show a striking similarity in the treatment of organic form. In each, Cunningham isolates the shape in order to reveal its essence. "Photography began for me with people and no matter what interest I have given plant life, I have never totally deserted the bigger significance in human life. As document or record of personality I feel that photography isn't surpassed by

Imogen Cunningham
American, 1883–1976

Figures No. I, 1923

Gelatin silver print
MUSEUM PURCHASE
77:0760:0056

(left)
Imogen Cunningham

Magnolia Bud, 1929

Gelatin silver print
MUSEUM PURCHASE
77:0760:0021

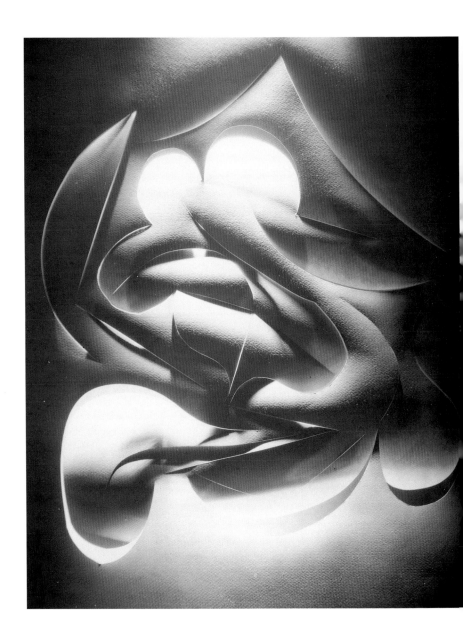

(left)
Francis Bruguière
American, 1879–1945

Abstract Study # 7,
ca. 1930

Gelatin silver print
GIFT OF ROSALINDE
FULLER
81:1089:0023

any other graphic medium," Cunningham wrote. "The big discussion as to whether it is an art or not was settled for me as well twenty years ago." There are nearly 100 prints by Cunningham in the Eastman House collection, most of which were acquired directly from the photographer.

For a brief period after the birth of her twin sons, Cunningham went to work in the San Francisco studio of Francis Bruguière. Bruguière was a student of music, painting, and poetry. Around 1905 he visited New York City, where he met Stieglitz and began to study photography. Almost immediately, Bruguière became a member of the Photo-Secession, but his work gradually began to develop a modernist inclination, first through experiments with multiple exposures and abstraction. Bruguière became the official photographer of the Theater Guild, and this position influenced his dramatic use of light to create mood. Around 1925 he began to experiment with cut-paper abstractions, which he would then photograph. "Abstract Study # 7" revels in the play of light and motion created by the precise cuts in the paper. While the cut paper is the catalyst, the real actor in the image is the light itself, which dances around the surface, reinventing spatial relationships. The image

Francis Bruguière

*Woman with Arm
against Wall*, ca. 1925

Gelatin silver print
81:1090:0020MP

Ralph Steiner
American,
1899–1986

Ham & Eggs, 1929

Gelatin silver print
MUSEUM PURCHASE,
CHARINA FOUNDA-
TION PURCHASE
FUND
96:0760:0001

of a woman with her arm raised against a wall (page 505) is radical in
its selective focus; while her arm and the backdrop are finely delineated,
the woman's dramatically out-of-focus face is a masklike distortion,
thus transforming her likeness into an abstraction. More than 400
prints and negatives by Bruguière are in the Eastman House collection.

"The Ham and Eggs picture represents my revolt when a food editor
of a women's magazine set before my camera a plate of raggedly
trimmed ham and two runny eggs. I ran out to buy six dozen eggs, in-
duced the editor to trim both ham and eggs into perfect Euclidean cir-
cles, and made my version of that classic dish," explained Ralph Steiner
about this photograph. His statement reveals not only his originality
and playful irreverence, but also the enormous precision, symmetry,
and attention to detail that he brought to the photographic medium.
An alumnus of the Clarence White School of Photography, Steiner made
his living in advertising photography. Nevertheless, the rigorous sense

Paul Outerbridge
American, 1896–1958

Piano, 1924

Platinum print
GIFT OF THE
PHOTOGRAPHER
70:0375:0001

of graphic design that he used in his commercial work was also applied
to his art, blurring the distinction between work for hire and work from
the heart. Interestingly enough, the repetitive, fragile perfection of the
egg became a potent image for many artists, figuring prominently into
the work of Paul Outerbridge, who claimed to have made more than
4,000 images of the subject.

Paul Outerbridge began to focus on photography seriously as a stu-
dent of Clarence White in 1921. He had worked as a painter and design-
er and brought these sensibilities to his photographic work. Taken from

an oblique angle, the piano that he practiced on as a child is considered two-dimensionally, as a flat plane of dynamically intersecting angles. The influence of cubism is strongly evident in the deceptively complex still-life image pictured on page 507.

Representing a photographic movement on the other side of the Atlantic, Albert Renger-Patzsch was a generation younger than – and worlds apart from – the pictorialist aesthetic in photography. He was a pioneer of modern German photography, occasionally being referred to as "the German Weston." Renger-Patzsch received a degree in chemistry but soon turned his efforts toward photography. Renger-Patzsch received his start as a professional photographer when he was asked to contribute photographs to the first two volumes of the series *Die Welt der Pflanze (The World of Plants)*. "Echeoeria," a close-up investigation of a succulent plant, is an example that calls to mind Cunningham's flower studies. Nature would become the dominant theme in his later work. In 1926 Renger-Patzsch contributed photographs to the book *Das Chorgestühl von Kappenberg (The Choir Pews of Cappenberg)*. "Gewölbe in Danziger Marienkirche" is reminiscent of that body of work; the organic decoration in the chapel emulates his interpretation of the plant form in "Echeoeria." Renger-Patzsch became Germany's leading photographer in the 1920s, and his book *Die Welt ist schön* an influential treatise on modernist photographic practice.

**Albert
Renger-Patzsch**
German, 1897–1966

Gewölbe in Danziger
Marienkirche
(Vaulting in the
Marienkirche,
Danzig), ca. 1930

Gelatin silver print
MUSEUM PURCHASE
80:0546:0016

**Albert
Renger-Patzsch**

Echeoeria, 1922

Gelatin silver print
MUSEUM PURCHASE
80:0546:0008

"Slaughterhouse" by Ch. Chusseau-Flaviens, whose work is discussed on page 456, displays a remarkably surreal sensibility in choice of subject matter. The presentation of the butcher standing amidst his gruesome work is framed by death on one side and a shadowy, mysterious figure on the other. It is, however, as a document of labor that Chusseau-Flaviens's work anticipates that of August Sander, who set about to make a document of the people of his native Westerwald, near Cologne, Germany.

"Man of the Twentieth Century" was the title Sander gave to his life-long photographic project. Sander divided the world into 45 "types" and photographed subjects from all walks of life, such as "Jungbauern, West erwald" (page 512). "Nothing seemed to me more appropriate than to project an image of our time with absolute fidelity to nature by means of photography. ... Let me speak the truth in all honesty about our age and the people of our age," Sander wrote in an essay formally announcing the project. "Pastry Cook" is a forcefully honest representation of a proud working man, rendered without aggrandizement but with dignity and honor. Yet Sander's work was suppressed by the Nazi regime because his vision of the German people did not fit the Aryan mold. The 41 Sander prints in the museum's collection are from this same project, which occupied Sander until his death.

Ch. Chusseau-
Flaviens
French?, active
1890s–1910s

Slaughterhouse,
ca. 1900–1919

*From a gelatin on
glass negative*
GIFT OF
KODAK PATHÉ
75:0111:0005

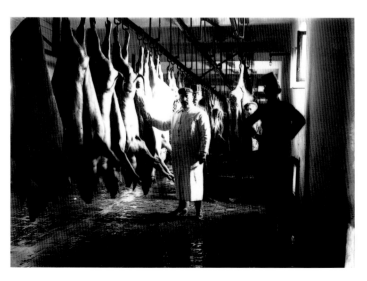

(right)
August Sander

German, 1876–1964

Konditor, Köln
(Pastry Cook,
Cologne), 1928

*Print by Gunther
Sander from the orig
nal negative, ca. 197*
Gelatin silver print
MUSEUM PURCHASE
71:0072:0005

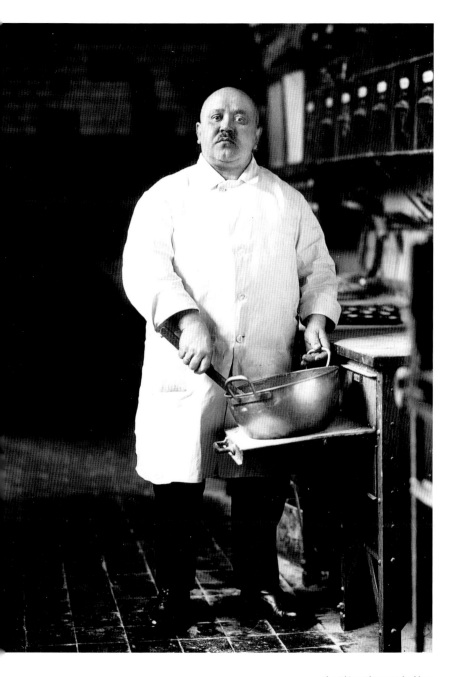

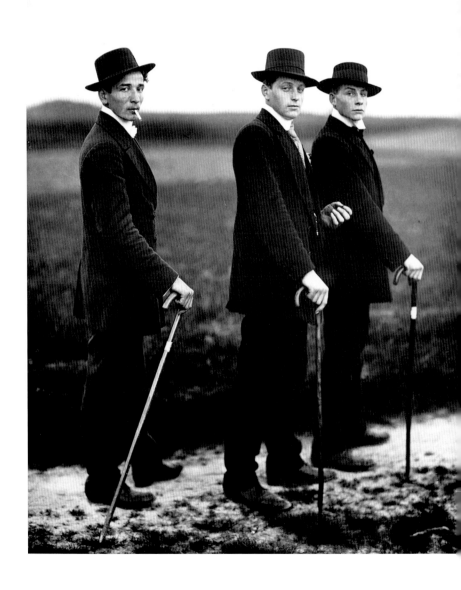

(left)
August Sander
German, 1876–1964

Jungbauern, Wester-
wald (Young Farm-
ers, Westerwald),
1913

*Print by Gunther
Sander from the
original negative,
ca. 1971*
Gelatin silver print
MUSEUM PURCHASE
71:0072:0002

Helmar Lerski was a Swiss actor who did not take up photography until age 40, and by accident — his wife was a photographer, and one day he used her studio to photograph the members of his acting troupe. His belief that "the modern portrait photographer should strive, with the help of his own feeling for light, to express himself in a completely personal manner, create his own style, and deliver with every portrait his visiting card ... in order that he can be recognized in every one of his pictures," is embodied in the monumentalized portrait heads that he created. The dramatic directional lighting he employed suggests no natural light source, but seems to emanate like heat from the subject.

**Helmar Lerski
(Israël Schmuklerski)**
Swiss, b. France,
1871–1956

Deutsche Haus-
gehilfin (German
Housemaid),
ca. 1928–1931

Gelatin silver print
MUSEUM PURCHASE
81:1289:0003

The Object Photographed | 513

Alexander Rodchenko was a Russian painter and graphic designer who became a leading constructivist artist in Moscow. He initially began to incorporate photography through photomontage; this montage made to illustrate the epic poem "Pro Eto" ("About This") by Vladimir Maiakovskii was constructed from photographs Rodchenko commissioned from Abram Shterenberg and other images taken from magazines. The unlikely combination of a dinosaur, a cityscape turned on its side to resemble a burst of sound, a man seated in a chair watching intently, a hausfrau, a klieg light, and the mysterious numbers "67-10" create a disjunctive narrative. Soon thereafter, Rodchenko began to make his own photographs, which were characterized by unusual vantage points, such as his view of a city street in Moscow.

Alexander Rodchenko
Russian, 1891–1956

Montage, ca. 1923

Photomechanical reproduction
MUSEUM PURCHASE
LIBRARY COLLECTION
77:0400:0001

Поддало
из шнура
скребущейся ревности
времен троглодитских тогдашнее чудище.

Fellow Russian El Lissitzky was an architect, graphic artist, and photographer. Like Rodchenko, he also participated in the Constructivist movement, establishing a group in Düsseldorf, Germany. During a period in Berlin, Lissitzky became involved with artists at the Bauhaus School of Design, including Herbert Bayer. Lissitzky's work was overtly political in a way that was unprecedented in creative photography. Toward the end of his career, he received a commission to design Stalinist propaganda. The result was the book given to leading party members to commemorate the Seventh Congress of Soviets in 1935, *Industry of Socialism. Heavy Industry for the Seventh Congress of Soviets.* A cutout in a sea of Soviet workers frames a portrait of Lenin, and with a turn of the page, frames the head of Stalin as well.

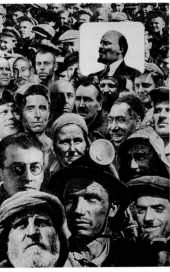

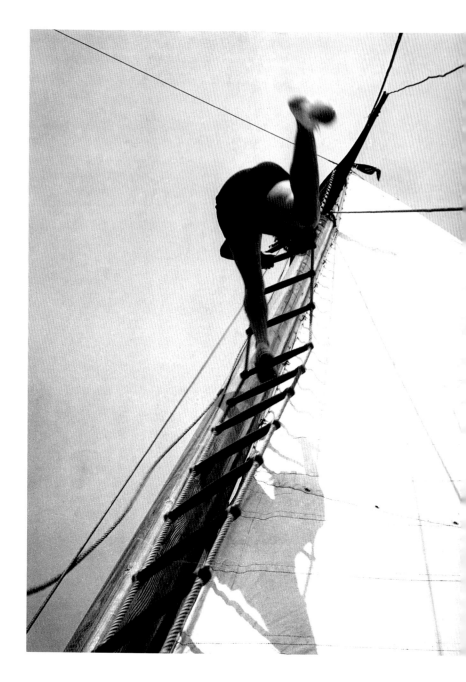

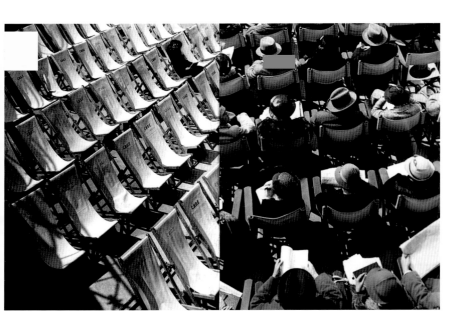

"The reality of our century is technology: the invention, construction, and maintenance of machines. To be a user of machines is to be of the spirit of this century. Machines have replaced the transcendental spiritualism of past eras." Although he was a sculptor, painter, graphic and stage designer, writer, and teacher, no other medium but photography would – or could – define the artistic philosophy of László Moholy-Nagy, the author of this quote. Influenced by the Russian constructivists, Moholy-Nagy did not believe that the art of the past was relevant to modern times, but through the use of machines man could forge a new language to represent his own day and age. Ironically, he never considered himself a photographer, but rather a painter. In Berlin he became acquainted with Lissitzky and accepted a position teaching at the Bauhaus, where he became founder and director of the photographic department. "Chairs at Margate" is both humorous and ponderous, playing with negative and positive space by juxtaposing empty chairs photographed on the diagonal with occupied seats in horizontal rows photographed from above and behind. "Sailing" defies logical perspective and shows a figure, photographed from below, perched on a ladder on a ship's mast, right foot precariously aloft as if the figure itself is about to set sail without the boat.

László Moholy-Nagy
American,
b. Hungary,
1895–1946

Chairs at Margate,
1935

*Gelatin silver print
diptych*
MUSEUM PURCHASE,
EX-COLLECTION
SYBIL MOHOLY-NAGY
81:2163:0006

(left)
László Moholy-Nagy

Sailing, 1926

Gelatin silver print
MUSEUM PURCHASE,
EX-COLLECTION
SYBIL MOHOLY-NAGY
81:2163:0046

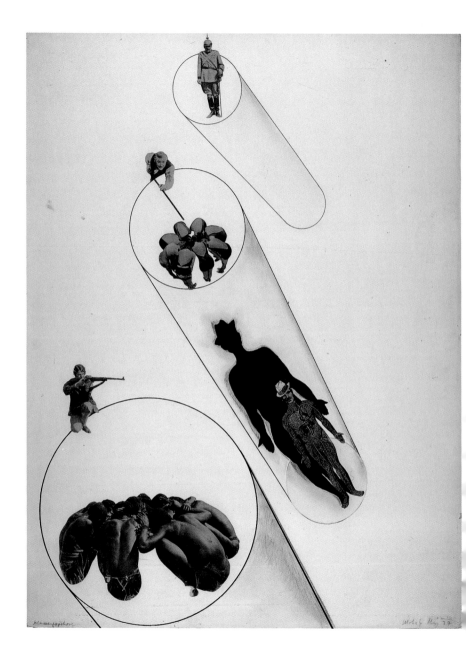

(left)
László Moholy-Nagy
American,
b. Hungary,
1895–1946

Massenpsychose
(Mass Psychosis),
1927

*Collage with photo-
mechanical and
drawn elements*
MUSEUM PURCHASE,
EX-COLLECTION
SYBIL MOHOLY-NAGY
81:2163:0049

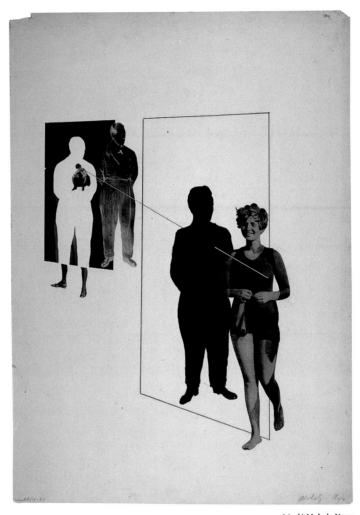

László Moholy-Nagy

Eifersucht
(Jealousy), 1927

*Collage with photo-
graphic/photome-
chanical and drawn
elements*
MUSEUM PURCHASE,
EX-COLLECTION
SYBIL MOHOLY-NAGY
81:2163:0011

László Moholy-Nagy
American,
b. Hungary,
1895–1946

Photogram, 1939

Gelatin silver print
MUSEUM PURCHASE,
EX-COLLECTION
SYBIL MOHOLY-NAGY
81:2163:0016

Moholy-Nagy called his photomontages "fotoplastiks," referring to what he viewed as the pliant nature of the medium. In "Massenpsychose" (page 518) the sense of unease is a reflection of the tumultuous political climate in Germany and the vulnerable status of the artist in relation to it. There is a flayed human figure stands, encroached upon by his own menacing shadow and threatened by a woman wielding a rifle; above his head another figure with a pool cue takes aim at a group of women, huddled together in the same manner as the tribal group below. Standing watch over the entire composition is a uniformed military guard.

"Eifersucht" (page 519) is one of his most famous fotoplastiks, in which a smiling, athletic woman in a swimsuit is shadowed by the artist himself. A crouching woman framed within the artist's silhouette takes aim with a rifle at the two figures' hearts. The standing woman's

expression belies the underlying menace; through repetition of silhouettes and figures and an economy of graphic design, Moholy-Nagy's desire, coupled with jealous regard, is palpable.

 Although the basic principle of the photogram process was employed by some of photography's earliest practitioners such as William Henry Fox Talbot and Anna Atkins, many consider that, along with El Lissitzky and Man Ray, Moholy-Nagy was one of its inventors. "The organization of light and shadow effects produce a new enrichment of vision," he wrote about one of his photograms. Although certain visual elements appear familiar, the overall effect is dynamic and completely abstract. Advocating a "New Vision" in photography, Moholy-Nagy wrote: "... it cannot be too plainly stated that it is quite unimportant whether photography produces 'art' or not. Its own basic laws, not the opinions of art critics, will provide the only valid measure of its future worth."

László Moholy-Nagy

Photogram, ca. 1924

Gelatin silver print
MUSEUM PURCHASE,
EX-COLLECTION
SYBIL MOHOLY-NAGY
81:2163:0014

The 80 works by Moholy-Nagy in the Eastman House collection are an important holding, most of them acquired from the artist's second wife, Sybil Moholy-Nagy.

A Bauhaus colleague of Moholy-Nagy, Herbert Bayer was initially interested in typography and graphic design. "Just as typography is human speech translated into what can be read, so photography is the translation of reality into a readable image," Bayer maintained. "Photography presents above all a document. It was false to overlook the new possibilities. We must adopt it, and put it to work, like pigment and brush. The control is not in the manipulation of the brush, but in the complete technical realization of what is seen." He took up photography, in part, to explore the geometry found in natural forms that could be recorded with the camera. He, too, experimented with photomontage and collage. "Legs in Sand" and "Riding a Bicycle" were both made during Bayer's Bauhaus tenure. The former radically crops the figure sitting in the sand just below the waist; the tanned legs disembodied are like found sculpture of another order. The bicycle handlebar and light, photographed from above and dramatically cropped, animate the vehicle as it seems to race along the road without its rider.

Germaine Krull studied photography in Munich before opening a portrait studio in Berlin. She also made photographs of architecture and industry; cranes, ships, machinery, and vertical lift bridges were her subject matter. She became acquainted with André Kertész and with Man Ray, who told her, "Germaine, you and I are

Herbert Bayer
American, b. Austria, 1900–1985

Legs in Sand, 1928

Modern gelatin silver print from the original negative
78:0071:0109MP

the greatest photographers of our time, I in the old sense and you in the modern one." Having moved to Paris, fascinated by metal constructions and desiring to portray their power, strength, and precision, Krull photographed the Eiffel Tower as an assignment for *Vu* magazine. She published 64 of those images as the book *Métal* (page 524). Both the photograph of the tower and the graphic typography of *Métal*'s cover evoke the dynamic movement of steel harnessed and shaped into complex geometric art. As Florent Fels wrote in the book's preface, "From above, it appears that one disengages a bit from terrestrial contingencies. One glides in thought along the length of the tower right up to the point of her sister the shadow which lies like the stylus of a sundial." The museum's Menschel Library contains this and eight other books by Krull.

John Heartfield was a painter and cofounder of the subversive Dada movement in Berlin, Germany, which was born just before the end of World War I. Born Helmut Herzfeld, he adopted the Anglicized name to protest the rabid German nationalism and Anglophobia that devel-

Herbert Bayer

Riding a Bicycle,
ca. 1925

*Modern gelatin silver
print from the original
negative*
78:0071:0133MP

oped following Germany's defeat in World War I. The Dada artists were closely tied to the revolutionary political struggle; "Use Photography as a Weapon!" was their slogan. Photomontage would become the means through which the Dadaists disseminated their messages as posters, book jackets, illustrations, and propaganda. It is they who are credited with coining the word *photomontage*. Heartfield taught himself, cutting up photographs and reassembling them to create images with highly charged political content. After joining the German Communist Party, Heartfield's imagery became more strident. "Diagnose," reproduced in the antifascist magazine *AIZ* (*Arbeiter Illustrierte Zeitung,* or *Worker's Illustrated Newspaper,* which also published Modotti's work), is a biting attack on those who, blindly following orders, made up the Nazi party; the text under the image reads: "How did the man get this curvature of the spine?" "That is the organic result of the endless 'Heil Hitler!'" Altogether, Heartfield published 237 relentlessly satirical photomontages in *AIZ* between 1930 and 1938.

Germaine Krull
French, 1897–1985

Cover of *Métal,*
ca. 1929

*Photomechanical
reproduction*
MUSEUM PURCHASE
LIBRARY COLLECTION

**John Heartfield
(Helmut Herzfeld)**
German, 1891–1968

Diagnose (Diagnosis), ca. 1935

Rotogravure print
MUSEUM PURCHASE,
EX-COLLECTION
BARBARA MORGAN
76:0076:0027

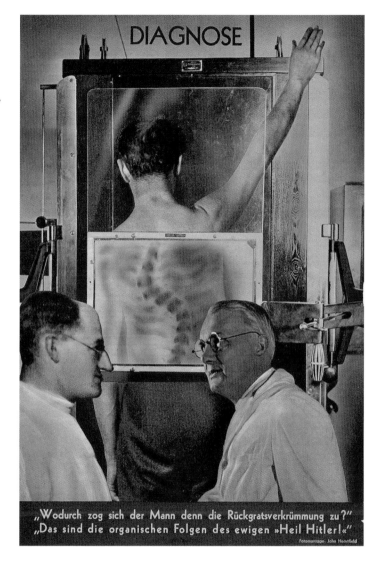

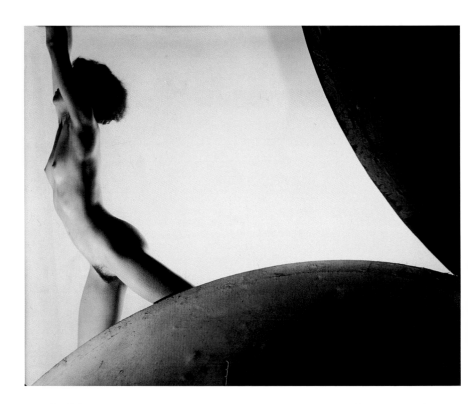

Frantisek Drtikol
Czechoslovakian,
b. Bohemia,
1883–1961

Nude Study, ca. 1929

Platinum print
MUSEUM PURCHASE
76:0136:0001

Frantisek Drtikol wanted to be a painter, but his father chose photography for his vocation. After working in various studios in Europe, Drtikol opened his own studio in 1907. He flourished as a landscape and portrait photographer influenced by the symbolist and Art Nouveau styles while employing pictorialist techniques and media. He began his nude studies around 1914, among the first ever made in Bohemia, developing a dynamic style relating the female form to purely geometric arcs drawn by light and shadows. Gradually, Drtikol approached a more modernist style. "Nude Study" equates the curves of a woman's slender body with the two arched forms that balance the right half of the composition. An earlier work, "The Bow," shows an elongated figure draped across an arc, the woman's body conforming to the shape and becoming a part of it. "Composition" is among the most dynamic; the posing figure activates the image, her forward thrust echoed by the sweeping lines of the background.

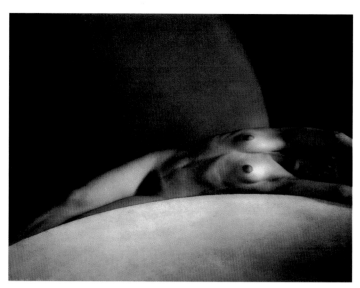

Frantisek Drtikol

The Bow, 1921

Pigment print
GIFT OF MRS.
ALEXANDER
LEVENTON
83:2424:0004

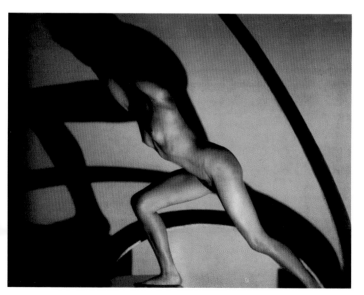

Frantisek Drtikol

Composition, 1929

Pigment print
GIFT OF DR. E. P.
WIGHTMAN
83:0454:0001

André Kertész
American,
b. Hungary,
1894–1985

Mondrian's Pipe and Glasses, Paris, 1926

Gelatin silver print
MUSEUM PURCHASE
80:0805:0002

Hungarian-born André Kertész moved to Paris in 1924. He met artist Piet Mondrian in 1926 and began a series of photographs of artists and their studios. "[I] instinctively tried to capture in my photographs the spirit of his paintings. He simplified, simplified, simplified," Kertész told a friend. He made a compelling portrait of Mondrian, photographing his pipe and two pairs of eyeglasses on a tabletop. In 1936 Kertész moved to New York, where he photographed from the window of his twelfth-floor apartment on Washington Square. He had adopted this high vantage point back in Hungary around 1913 or 1914. "July 9, 1978. No. 20" was made looking down on the rooftop of another building. The geometrically dynamic composition is punctuated by the figure of a woman lying on her stomach sunbathing below. These two photographs were made more than 50 years apart, evidence of Kertész's remarkable longevity and his continued ability to see things in a new way.

André Kertész

July 9, 1978. No. 20,
1979

Gelatin silver print
MUSEUM PURCHASE
80:0806:0002

Florence Henri
American, 1893–1982

Composition No. 10,
1928

Gelatin silver print
MUSEUM PURCHASE
73:0241:0001

In 1927 Florence Henri studied photography at the Bauhaus under Moholy-Nagy and became friends with Bayer and his wife, photographer Irene Bayer. Afterwards, Henri established a studio in Paris. Explaining her unapologetically formalist aesthetic, Henri said: "What I want above all in photography is to compose the image as I do with paintings. It is necessary that the volumes, lines, the shadows and light obey my will and say what I want them to say." Her still life "Composition No. 10" of a mirror, ring, and ball is compelling for the way in which shapes become doubled and redefined by intersecting with seams and bending with angles. Mirrors became an integral element in Henri's work. Reminiscent of Alvin Langdon Coburn's Vortographs (see page 425), she described her attraction to the device: "I use mirrors to introduce the same subject seen from different angles in a single photograph so as to give the same theme a variety of views that complete each other and are able to expound it better by interacting with each other."

Man Ray began his career as a commercial artist and painter in New York. There he visited Stieglitz's 291 Gallery, where he was exposed to

the cutting edge of modern European art. Under Stieglitz's guidance Man Ray taught himself photography and initially employed it because he could find no one to make satisfactory photographic reproductions of his paintings. After meeting Marcel Duchamp, who became his collaborator and lifelong friend, he moved to Paris, where he connected with the Dadaists. Man Ray set up a portrait studio and quickly made his name as the premier portrait photographer, especially of artists and intellectuals – the movers and shakers of Parisian intellectual life. Soon his circle of acquaintances and interests turned to surrealism. Man Ray's photograph "Typewriter" evidences the surrealist primacy of the object itself. "... I ask you, how can we ever get together on the question of beauty?... [T]he Artist, even when copying another, works under the illusion that he is covering new ground which he imagines no one has

**Man Ray
(Emmanuel
Rudnitzky)**
American,
1890–1976

Typewriter, ca. 1925

Gelatin silver print
MUSEUM PURCHASE
WITH NATIONAL
ENDOWMENT FOR
THE ARTS SUPPORT
74:0140:0001

covered before him. He is then necessarily discovering a new beauty which only he can appreciate, to begin with ... *the success with which the Artist is able to conceal the source of his inspiration, is the measure of his originality.*" Indeed, the typewriter, a tool of language, proved irresistible to Modotti and Steiner.

Not long after relocating to Paris, Man Ray began experimenting with the photogram. According to his autobiography, he discovered the technique by accident while working in the darkroom. Dadaist Tristan Tzara, a frequent collaborator, dubbed them "Rayographs" after him. As Tzara wrote: "When everything we call art has become thoroughly arthritic, a photographer ... invented a force that surpassed in importance all the constellations intended for our visual pleasure. ... It is a spiral of water or the tragic gleam of a revolver, an egg, a glistening arc or the floodgate of reason, a keen ear attuned to a mineral hiss, or a turbine of algebraic formulas?" Man Ray

Man Ray (Emmanuel Rudnitzky)
American, 1890–1976

Rayograph, 1950

Gelatin silver print photogram
MUSEUM PURCHASE
81:1662:0002

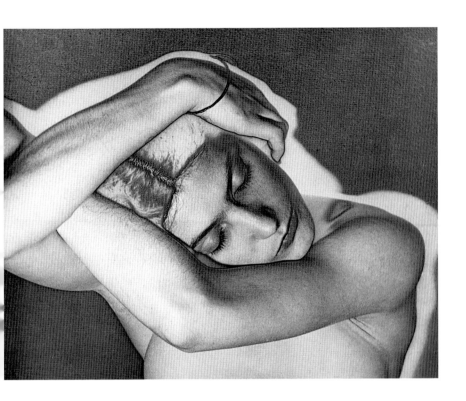

continued to make photograms throughout his career; this example (left) was made while the artist was living in Los Angeles. Although Man Ray believed the individual components used to create the image were irrelevant, the recognizable shape of binoculars utilized here was surely a sly reference to the distinctions between human and photographic vision.

The Sabattier effect was another photographic technique that Man Ray utilized and would become a signature of his work. Though often misidentified as solarization, the Sabattier effect occurs when a photographic print is exposed to light during the development process. This produces a partial reversal of tones, particularly in the highlight areas. This, too, Man Ray claimed to have come upon by accident in the darkroom. When applied to a portrait, the effect is to create a psychological landscape, essentially endowing the subject with a visible aura.

Man Ray (Emmanuel Rudnitzky)

Solarization, 1929

Solarized gelatin silver print
MUSEUM PURCHASE, EX-COLLECTION MAN RAY
81:1662:0001

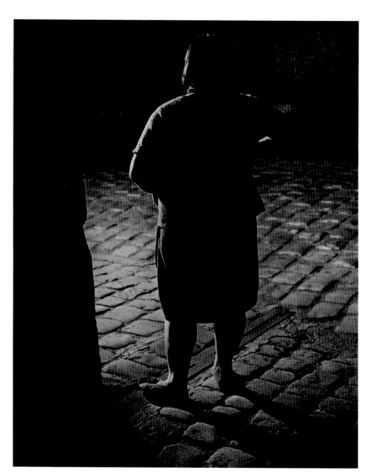

**Brassaï
(Gyula Halasz)**
French, b. Hungary,
1899–1984

Streetwalker, Place
d'Italie, ca. 1932

Gelatin silver print
77:0749:0012

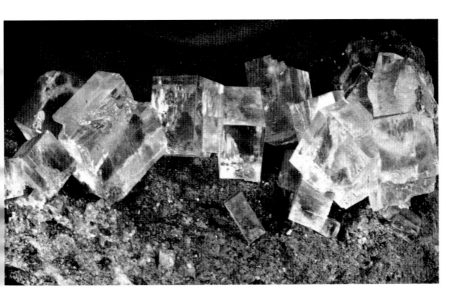

Brassaï, né Gyula Halasz, got his start in photography with Kertész's assistance around 1930. In his 1976 publication *The Secret Paris of the 30's*, the Hungarian painter-writer turned photographer Brassaï wrote in the chapter "Ladies of the Evening": "In the thirties, the rue Quincampoix had [a] specialty: it was full of fat girls. ... Contrary to the mobility streetwalkers usually display, they waited, immobile and placid, along the sidewalk like a row of caryatids. ... One day I took a room in a hotel across the street and watched from my window these odalisques and the men who would stroll past them ten or more times ... before stopping in front of their choice." "Fille de joie Quartier les Halles" is one of two views of a woman which Brassaï published alongside this text. The image subverts the coquettish fantasy image of the prostitute, revealing instead the slow banality of the profession. His portrait of the prostitute supports his later statement: "I invent nothing, I imagine everything. I have never looked for subjects that are exotic or sensational in themselves. Most of the time I have drawn my images from the daily life around me. I think that is the most sincere and humble appreciation of reality, the most everyday event leads to the extraordinary." "La Maison que j'habite, ma vie, ce que j'écris," a photograph of crystal formations, was published in André Breton's 1937 surrealist novel *L'Amour Fou*.

**Brassaï
(Gyula Halasz)**

La maison que j'habite, ma vie, ce que j'écris (The House Where I Live, My Life, That Which I Write), 1937

Photomechanical reproduction
LIBRARY COLLECTION

Claude Cahun was an artist, writer, poet, and leftist activist involved with the surrealist movement in Paris. Much of her photographic work relies on photocollage; frequently she photographed herself, reconstructing her image through explorations of gender and identity both personal and political. Although little is known about her, her work is found in two publications. *Aveux non avenus* (*Unavowed Confessions*), published in 1930, is an illustrated literary work, and she also lent her photographs to *Le coeur de pic*, a book of poems by Lise Deharme. Both images here were included in *Aveux non avenus;* visually and thematically complex, both have a disturbing, fractured quality to them.

In "Cards, Chessboard, Hands" Cahun plays with notions of gender relationships through the metaphor of games. Serious card players know that spades, on which a masculinely dressed figure labeled Pallas (another name for Athena, the goddess of wisdom) appears, rank higher than hearts (a symbol of love), on which an androgynous female figure is superimposed. Conversely, the grinning chess "king" is shown falling off the board, shadowed by a cigar-smoking figure, presumably the "player," that presides over the proceedings. Finally, a female hand wearing a band on the ring finger stays a provocatively gloved hand that attempts to reveal the markings on the card lying face down on the chessboard. Cahun's image is heavily coded with subtext.

An ambiguous, ominous inscription in the upper left corner of "Portrait de Mademoiselle X" reads: "Here the executioner takes on the airs of a victim. But you know what to believe. Claude." She includes many images of herself: being strangled; behind prison bars on which there is a heart-shaped keyhole; her lips

Claude Cahun
(Lucy Schwob)
French, 1894–1955

Cards, Chessboard,
Hands, 1930

Photogravure print
MUSEUM PURCHASE
LIBRARY COLLECTION
85:1406:0007

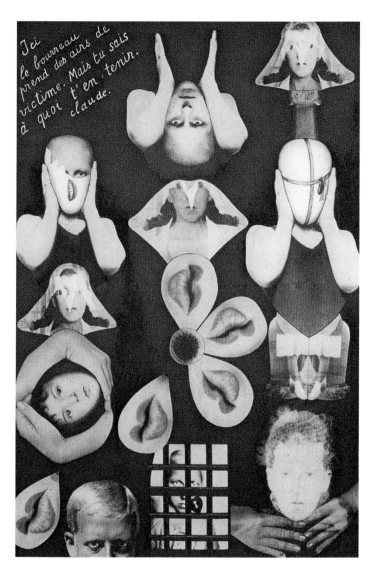

superimposed on the petals of a flower that is, in fact, losing its petals, evoking the "she loves me, she loves me not" game. It also includes images that evoke the "hear no evil, see no evil, speak no evil" maxim. Given that the Nazis arrested Cahun and her female lover for "subversive" activities, it is reasonable to read this image as a commentary on their persecuted lesbian relationship. The Menschel Library is fortunate to have a copy of her important, evocative publication.

Cahun's provocative work is a counterbalance to the misogynistic overtones in Hans Bellmer's images of female doll bodies. A student of drawing and typography, Bellmer was largely self-taught in photography. He started the doll series around 1934, when these two images were made, in part as sculpture. Photography added another element to these explorations of psychology and form. In 1947 he published a book of 15 of the images, *Les jeux de la poupée*, with poems by Paul Eluard. Bellmer used dolls that could be taken apart and reassembled; as he described it: "As in a dream, the body can change the centre of gravity of its images. Inspired by a curious spirit of contradiction, it can add to one what it has taken from another: for instance, it can place the leg on top of the arm, the vulva in the armpit, in order to make 'compressions,' 'proofs of analogies,' 'ambiguities,' 'puns,' strange anatomical 'probability calculations.'" The photographs were hand-colored with

Hans Bellmer
French, 1902–1975

The Doll, ca. 1934

*Gelatin silver print
with applied color*
MUSEUM PURCHASE,
ALVIN LANGDON
COBURN FUND
LIBRARY COLLECTION
82:1894:0006

lurid hues of green and pink. As dolls are the playthings of little girls, the suggestion of sexuality and violence directed at and coming from the subject is disturbing and never fully resolved in Bellmer's work.

In one image, the parts are assembled to suggest the doll is seated on a chair, facing the viewer. Its disheveled blond hair is lewdly suggestive; the face is almost swallowed up by the enormous, bulbous breasts, and the torso is defined by swollen labia that protrude from between the legs. There are no arms, and the

doll's only visible eye is a heavy-lidded blank space. Eluard's poem accompanying this image reads: "You never hear her talk of the country, of her parents. She is afraid of a negative reply, she fears the kiss of a silent mouth. Agile and liberated, gentle mother-child, she demolishes the cloaks of the walls which surround her and paints daylight in her own colours. She frightens animals and children. She turns cheeks paler and the grass a more cruel green." The implication through text and photograph is that the doll is the antagonist in a narrative; Bellmer is Humbert Humbert with a camera.

"Born with the photographic feeling" is how André Kertész described himself, Käsebier, Stieglitz, White, and Manuel Alvarez-Bravo. Alvarez-

Hans Bellmer

The Doll, ca. 1934

Gelatin silver print with applied color
MUSEUM PURCHASE,
ALVIN LANGDON
COBURN FUND
LIBRARY COLLECTION
82:1894:0005

Manuel Alvarez-Bravo
Mexican, b. 1902

Gorrion, Claro
(Bright Sparrow),
ca. 1938–1940

Gelatin silver print
GIFT OF FREDERICK
MYERS
78:0637:0013

(right)
Manuel Alvarez-Bravo

El umbral (The
Threshold), 1947

Gelatin silver print
GIFT OF FREDERICK
MYERS
78:0637:0014

Bravo was born in Mexico City, the grandson of a photographer. He studied painting and music before taking up photography and was acquainted with Weston and Modotti. "Gorrion, Claro" is an image of a semi-nude young woman lying on a rooftop delineated by uneven lines of white paint. "El umbral" depicts a woman's feet as they hesitate, almost dancing, over puddles on the ground. Because of the deep, rich black tonality in the print, the identity of the liquid is not clear; it could be water, it could be urine, or it could be blood. The ambiguity adds an ominous element to the photograph, encouraging the viewer to construct his or her own meaning. Both images are like dream states, simultaneously representing the familiar and the unexpected. "The invisible is always contained and present in a work of art which recreates it. If the invisible cannot be seen in it, then the work of art does not exist," he explained. Alvarez-Bravo is the most famous Latin American photographer in the medium's history, his career spanning more than 70 years. The Eastman House collection includes 62 prints of his pioneering work

Photography Sells

After World War I Edward Steichen returned to civilian life disheartened by the horrors of armed conflict. Unwilling to continue making art in his prewar manner, Steichen pursued ways to make photographs that could be expressive of the new age. From 1919 to 1921 he worked incessantly to increase his understanding of the physical and conceptual properties of the medium. Wanting to learn, as he said in *A Life in Photography*, "... a method of representing volume, scale, and a sense of weight," Steichen created images such as "Pears and an Apple" in which the straightforward presentation of the subject lifts the image into the realm of abstract form. He further reasoned that "... if it was possible to photograph objects in a way that makes them suggest something else entirely, perhaps it would be possible to give abstract meanings to very literal photographs." Thus he began to construct images using simple, everyday objects, which functioned as symbols representing abstract concepts such as Einstein's Theory of Relativity, about which he made the photograph "Space-Time Continuum." Ultimately, Steichen felt that he was less successful with this approach, but it led him to a close study of natural forms and patterns of growth that held his attention for the rest of his life. Many photographers,

Edward J. Steichen
American, b. Luxembourg, 1879–1973

Pears and an Apple, 1920

Gelatin silver print
BEQUEST OF EDWARD STEICHEN BY DIRECTION OF JOANNA T. STEICHEN
79:2024:0006

Edward J. Steichen

Space-Time Continuum, 1920

Palladium and ferroprussiate print
BEQUEST OF EDWARD STEICHEN BY DIRECTION OF JOANNA T. STEICHEN
79:2487:0002

Edward J. Steichen
American, b. Luxembourg, 1879–1973

Camel Cigarettes, ca. 1927

Gelatin silver print
BEQUEST OF EDWARD
STEICHEN BY DIRECTION OF JOANNA
T. STEICHEN
79:2408:0001

particularly in Europe (e. g., the surrealists), would continue to create similar experimental photographs over the next two decades.

In 1980 Joanna Steichen, widow of Edward Steichen, directed a bequest of the photographer to deposit a collection of his photographs with the museum. More than 3,000 images made up this gift, which augmented an existing collection of works by the photographer, as well as 1,000 pictures taken during World War II when Steichen directed a photographic team for the U. S. Navy. The museum's Menschel Library holds copies of all books written or illustrated by Steichen including an original set of *Camera Work* magazine, which contains many high-quality photogravure reproductions of his early pictorialist work. Over 180 of the prints in the bequest are advertising photographs.

In 1925 Steichen returned to New York City from Europe, where he began working as a commercial photographer for Condé Nast publications and for the J. Walter Thompson advertising agency, whose clients

included the Eastman Kodak Company and the Steinway Piano Manufacturing Company. He established an identifiable personal style in his commercial photography. Essentially, he did this through two related strategies. First, he hardened his focus, immediately placing his imagery in the camp of the modernists and rejecting the older pictorialist soft-focus imagery that was dominating high-fashion photography at the time. Then he attempted to lend an air of naturalism to the advertisements by choosing models and depicting situations that seemed to be based in the real world. Steichen's interest in formal values kept breaking through, and there are few photographs in which the compositional relationship of light, pattern, and form is not meticulously considered.

In 1926 Steichen was invited to do a series of designs for silk fabrics. He chose ordinary household items, such as thumbtacks and matches (a radical choice at the time), as subjects for semiabstract photographs. The later "Camel Cigarettes" advertisement (page 544) utilized the

Edward J. Steichen

*Steinway and Sons
Piano Advertisement,*
ca. 1936

Gelatin silver print
BEQUEST OF EDWARD
STEICHEN BY DIREC-
TION OF JOANNA
T. STEICHEN
79:2411:0002

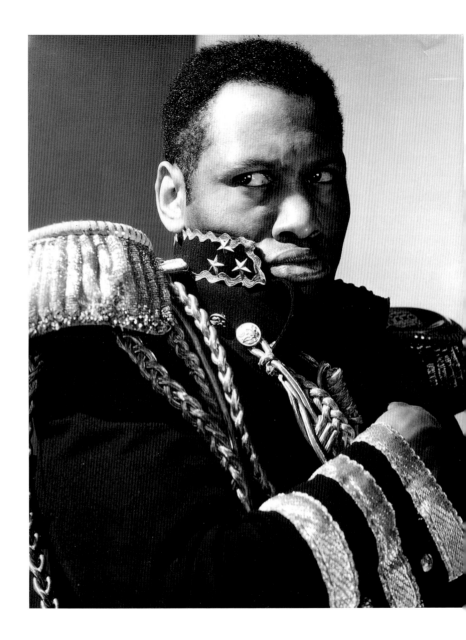

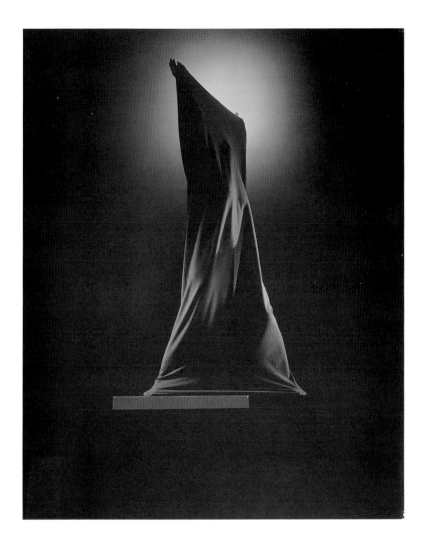

Edward J. Steichen
American, b. Luxembourg,
1879–1973

Paul Robeson in
"The Emperor Jones", 1933

Gelatin silver print
BEQUEST OF EDWARD STEICHEN BY
DIRECTION OF JOANNA T. STEICHEN
79:2322:0001

(above)
Edward J. Steichen

Martha Graham, 1931

Gelatin silver print
BEQUEST OF EDWARD STEICHEN BY
DIRECTION OF JOANNA T. STEICHEN
79:2184:0003

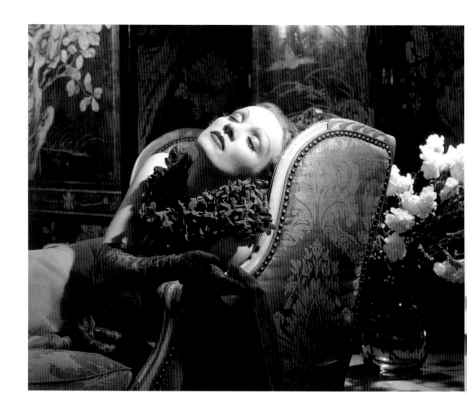

same strategy, and the very look of the ad would have shouted "avant-garde sophistication" to its viewer in the late 1920s.

In 1925 Steichen was hired by Condé Nast to make celebrity portraits for *Vanity Fair* magazine and fashion photographs for *Vogue*. These two magazines held indisputable reign over the world of high fashion, high society, and the "smart set" from the 1910s until World War II. Society figures, theater and film actors, authors, noted artists, and even political figures all came to Steichen to be photographed for these magazines, until he closed his studio in 1938.

In 1925 Steichen also began photographing with electric studio lights for the first time, and, as the images reproduced here illustrate, he developed a more theatrically inspired approach. How far Steichen moved from his pictorialist past is evident when his bold portraits of Paul Robeson and Martha Graham (pages 546 and 547) are compared

Edward J. Steichen

Greta Garbo, 1928

Gelatin silver print
BEQUEST OF EDWARD
STEICHEN BY DIREC-
TION OF JOANNA
T. STEICHEN
79:2176:0001

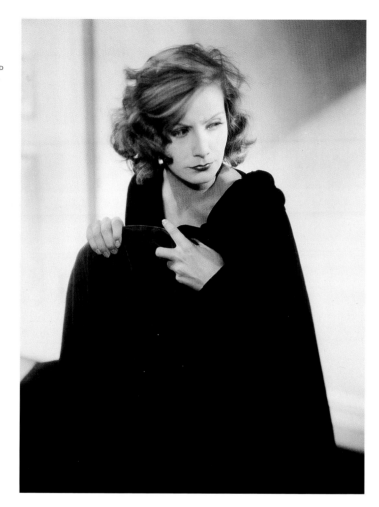

with his reserved soft-focus portraits of himself and Eleanora Duse (pages 394 and 395). Driven by the commercial mandate to be timely and to make photographs with "impact" (the byword of 1920s advertising photography), Steichen's photographs assumed a more stylized presentation. He infused his commercial work with the progressive ideals of design drawn from the major art movements of the day, including the streamlined forms of Art Deco and the elemental constructions of cubism. Steichen was held in high regard by his contemporaries, his background and work, encompassing numerous photographic genres, brought a cachet to the medium, thus elevating the status of commercial photography and its practitioners. In a nation reeling from the horrors of the Great Depression, and where ironically the illusion of celebrity and style played an ever more dominant role, the photographer's reputation became increasingly important in selling photographs.

Edward J. Steichen
American, b. Luxembourg, 1879–1973

Steichen's Pond from the Porch of His House, 1957

Color print, chromogenic development process
BEQUEST OF EDWARD STEICHEN BY DIRECTION OF JOANNA T. STEICHEN
79:2497:0167

In 1910 Steichen began breeding delphiniums, an activity he contin-
ued on his estate in Connecticut throughout the 1930s. Flowers were a
passionate interest of his, keeping him "… in contact with nature, and
[his] hands in contact with the soil. …" In 1936 Steichen exhibited his
hybrid delphiniums at the Museum of Modern Art. During World War II,
Steichen's ties with that museum strengthened as he directed several
thematic exhibitions for the institution. After the war, at age 67 he was
hired as director for the museum's department of photography, a posi-
tion he held for the next 15 years.

In the mid-1950s Steichen decided to photograph again, limiting him-
self to what could be seen from the windows of his home in Redding,
Connecticut. This soon turned into a self-assigned project of several
years' duration. He compiled a series of photographs focused on a
shadblow tree he had planted. This, in turn, transmuted into a motion
picture film project, documenting the changing seasons, climates, and
moods mirrored by this small tree set by a small pond. The museum
owns 24 color prints of his delphiniums as well as over 350 negatives,
snapshots, and prints from the shadblow tree group.

Edward J. Steichen

Delphiniums, 1940

*Color print, dye
imbibition process*
BEQUEST OF EDWARD
STEICHEN BY DIREC-
TION OF JOANNA
T. STEICHEN
79:2474:0005

Cecil Beaton's images of an elegant and pampered upper class were taken in the 1930s, at a time when the world suffered the terrible dislocations of an economic depression and the lines of the British social order were being radically redrawn. Sir Cecil Beaton, born to a middle-class family in England, learned to sketch and paint at Harrow, then took up photography at St. John's College, Cambridge, before leaving without a degree in 1925. After some false starts in business, Beaton began a career as a portraitist, where he was "taken up" by Edith Sitwell and introduced to high society, and in the late 1920s, to the world of high fashion.

Cecil Beaton
English, 1904–1980

Marlene Dietrich,
ca. 1930

Gelatin silver print
80:0146:0002

Beaton was first hired by the British *Vogue* magazine as a cartoonist, but soon began photographing for them as well as for the American and French editions of *Vogue* after 1928. Beaton was competing against already well-established fashion photographers such as Edward Steichen in New York City and George Hoyningen-Huene in Paris, but soon he

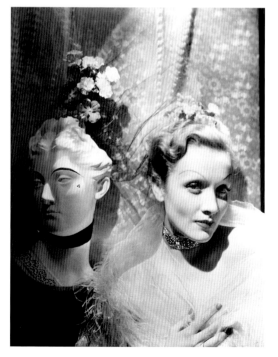

developed an eccentric style of presentation that helped establish his own photographic identity. Readily admitting the influences of Man Ray and Francis Bruguière, Beaton's photographs were busy, cluttered, richly varied, filled with incongruities, and with enough visual references to surrealism to lend them an air of artistic seriousness. This brash pastiche seemed to fit the age; his inventive, witty, and very stylish

Cecil Beaton

Paula Gellibrand,
Countess De Maury,
ca. 1930

Gelatin silver print
MUSEUM PURCHASE
73:0190:0004

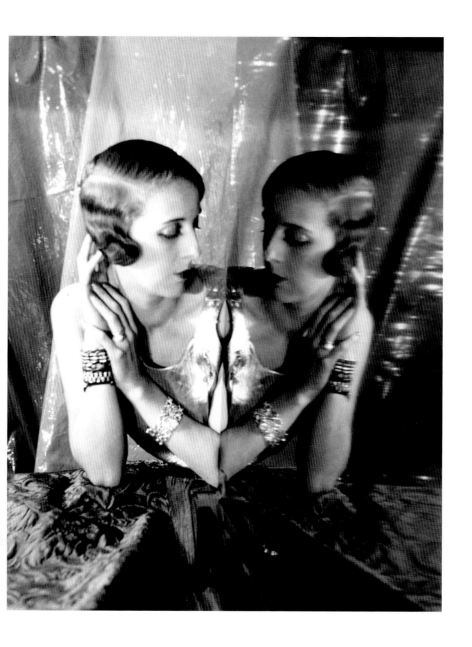

photographs caught on. Beaton himself would go on to become the most successful British society photographer, to write and illustrate almost 40 books, and to work in costume and set design for dozens of productions in both the theater and films, winning awards for *Gigi* and *My Fair Lady*. He received a knighthood in 1972, conferred on him by his most illustrious sitter, Queen Elizabeth II.

The museum holds nearly 25,000 images by Nickolas Muray in its collection, including photographic prints, negatives, transparencies, and advertising tear sheets. Most of the prints are black-and-white studio portraits of celebrities from the 1920s, when Muray maintained a studio in New York City's Greenwich Village. These are supplemented by approximately 60 color prints of film stars from the 1940s and 1950s, and about 300 color prints from advertising projects by Muray, including approximately 70 prints from when he worked for *McCalls Magazine* beginning in 1939. This collection provides the opportunity to look into the changing styles and techniques of a major American illustrative and advertising photographer who was working from the 1920s to the 1960s.

Nickolas Muray learned lithography, photoengraving, and photographic chemistry at a graphic arts school in Hungary before immigrating to New York City in 1913, where he quickly obtained a job as a

(right)
Nickolas Muray

Babe Ruth, ca. 1927

Gelatin silver print
GIFT OF MRS.
NICKOLAS MURAY
77:0188:2448A

Nickolas Muray
American,
b. Hungary,
1892–1965

Babe Ruth
Holding Baseball,
ca. 1927

Gelatin silver print
GIFT OF MRS.
NICKOLAS MURAY
77:0188:2449

photoengraver for Condé Nast, the publisher of *Vogue* and *Harper's Bazaar* magazines. In 1920 he opened a portrait studio in his home in Greenwich Village while continuing to work as a photoengraver. In 1921 *Harper's Bazaar* asked him to do a celebrity portrait, and soon his portraits were being published in every issue of the magazine and his fashion and product photographs in a host of others. By 1925 Muray was an established celebrity photographer with a growing reputation. His early portraits, such as "Gloria Swanson" ca. 1922 (page 555), were photographed in a pictorialist style, with a softened focus that placed emphasis on form over line, balanced masses over depiction of detail, mood over information. Muray also learned the Carbro color process in the 1920s and became one of the first professionals to employ color in fashion and advertising photographs in the 1930s.

At a time when the nation was steeped in economic depression, and then war, advertising photography was used to sell the "American way of life." From the 1930s to the 1950s, advertising photography in the United States responded to nationalistic values that often went beyond the selling of a specific product, as in Muray's "McCalls Magazine,

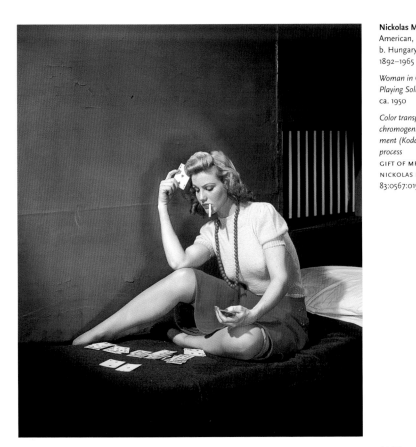

Nickolas Muray
American,
b. Hungary,
1892–1965

Woman in Cell,
Playing Solitaire,
ca. 1950

Color transparency,
chromogenic develop-
ment (Kodachrome)
process
GIFT OF MRS.
NICKOLAS MURAY
83:0567:0151

(right)
Nickolas Muray

McCalls Magazine,
Homemaking Cover,
1939

Color print, assembly
(Carbro) process
GIFT OF MRS.
NICKOLAS MURAY
71:0050:0038

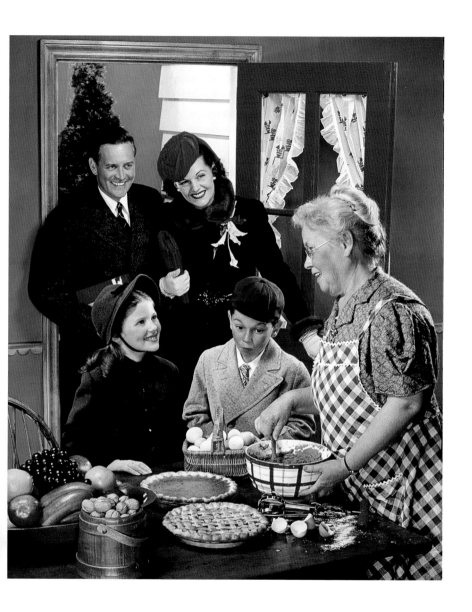

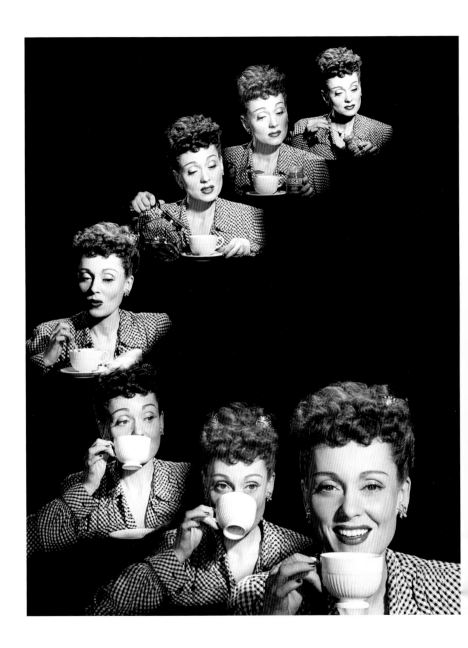

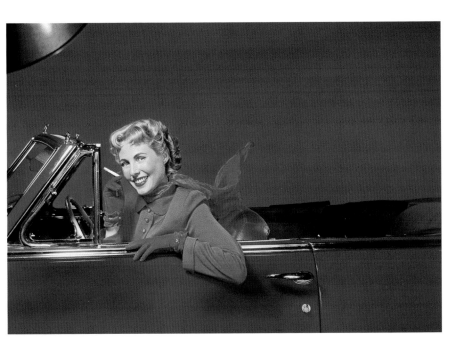

Homemaking Cover" (page 559). In this photograph, the idealized realm of middle-class domesticity is touted in a sharply focused, Carbro color tableau. This kind of presentation was a testament to the growing power of mass media to shape cultural attitudes.

For more than four decades, Victor Keppler was one of the United States' best-known advertising photographers. Largely self-taught in photography, he began his career in advertising in 1926 as a freelancer known to be able to tackle the most difficult commercial assignment. In fact, Keppler's trademark slogan, conferred upon him by an advertising agency, was "It *can* be done – call Keppler." One of the secrets to Keppler's success was his ability to adopt a modernist propensity for experimentation in order to create new looking, alluring images. His photograph of Martha Scott drinking coffee in an ad for Nescafe is a photomontage of sequenced vignettes with a narrative flow and constructed action similar to that found in motion pictures.

In the 1930s Keppler carved out a reputation as an innovator in color advertising photography, specifically the eye-riveting Carbro process. His "Woman in Convertible" is a spectacular achievement in which a

Victor Keppler
American,
1904–1987

*Camel Cigarette
Advertisement –
Woman in Convertible*, 1951

*Color print, assembly
(Carbro) process*
GIFT OF 3M COMPA-
NY, EX-COLLECTION
LOUIS WALTON
SIPLEY
77:0292:0027

(left)
Victor Keppler

*Actress Martha Scott,
Ad for Nescafe*, 1946

Gelatin silver print
GIFT OF THE
PHOTOGRAPHER
76:0241:0145

Victor Keppler
American,
1904–1987

Carter Corsets, 1938

Gelatin silver print
GIFT OF THE
PHOTOGRAPHER
76:0241:0209

(right)
Victor Keppler

Housewife in Kitchen, ca. 1940

*Color print, assembly (Carbro)
process*
GIFT OF 3M COMPANY,
EX-COLLECTION LOUIS
WALTON SIPLEY
77:0292:0011

dominant color and its corresponding hues playfully dazzle the viewer's eye while enticingly conveying the commercial message. The museum holds 1,300 black-and-white and color photographs, 12,000 proof prints and negatives by Keppler, as well as his studio account books.

In 1923 Australian-born Anton Bruehl viewed an exhibition of photographs by students of Clarence White. This chance encounter proved to be life-altering for him. Bruehl began studying with White, and by the decade's end, he, along with other students of White (including Ralph Steiner and Paul Outerbridge), were prominent New York advertising photographers. Like his contemporaries, Bruehl took many of White's teachings to heart, including releasing commercial illustration from the constraints of older pictorial conventions. This is evidenced in "Top Hats," an advertisement for Weber and Heilbroner, a men's apparel chain, in which modernist, clear-edged forms and a streamlined perspective set the stage for a fanciful and dynamic assembly line of elegant attire. The year this photograph was made, 1929, proved pivotal in Bruehl's career; not only did "Top Hats" win an elite advertising award, but his work was featured in the landmark *Film and Foto* exhibition in Stuttgart, Germany.

In the 1930s Condé Nast hired Bruehl as its chief color photographer, and in 1935 they published a

Anton Bruehl
American,
b. Australia,
1900–1982

Top Hats
*Ad for Weber and
Heilbroner*, 1929

*Modern gelatin silver
print from the original
negative*
76:0095:0016MP

Anton Bruehl

Dance from a Nightclub Act, ca. 1943

*Color print, dye
imbibition (Kodak
Dye Transfer) process*
MUSEUM PURCHASE
WITH NATIONAL
ENDOWMENT FOR
THE ARTS SUPPORT
75:0146:0001

brochure of his photographs with the almost embarrassingly frank title *Color Sells*. In fact, Bruehl's mastery of advanced color processes, as reproduced here in "Dance from a Nightclub Act" (page 565) a tableau for *Esquire* magazine, set his work apart from other color practitioners of his day, leading his editors to opine that "color is like dynamite – dangerous, unless you know how to use it."

Lejaren à Hiller started photographing in 1899, but wanted to be an artist. He studied at the Art Institute of Chicago and stated that "... photography paid most of the expenses during these years though I was fairly successful as an illustrator for American magazines." Hiller drew or painted more than 1,000 covers for *Munsey's Magazine* and scores of other popular illustrated magazines from about 1904 to 1914. By 1900 Hiller was attempting to convince magazine editors to let him make illustrations photographically rather than by hand, and eventually he was allowed to try. By 1915 his photographic illustrations had appeared in dozens of magazines from *Cosmopolitan* to the *Saturday Evening Post*, and he was widely credited with establishing what "... amounts to an entirely new field in picturemaking, to wit: Photographic Illustration."

The museum holds 390 items, including prints, 144 negatives, some lantern slides, and tear sheets by Hiller.

"Ambroise Paré" is one of 23 of Hiller's prints held by the museum from a series called *Surgery Through the Ages*. Consisting of approximately 200 images, this

Lejaren à Hiller
American,
1880–1969

War Bonds Campaign (Spy), ca. 1943

Gelatin silver print
GIFT OF 3M COMPANY, EX-COLLECTION
LOUIS WALTON
SIPLEY
78:0953:0036

Lejaren à Hiller

Ambroise Paré,
1517–1590 A. D.,
ca. 1927–1938

Gelatin silver print
GIFT OF 3M COMPANY, EX-COLLECTION
LOUIS WALTON
SIPLEY
77:0081:0004

series was created for the pharmaceutical company Davis and Geck from 1927 through 1950. These tableaux illustrate accomplishments or activities of personalities throughout the history of medicine. Used first in advertisements, on posters displayed in drugstores, and in well-printed gift portfolios for clients, 70 of the images were also published in a book in 1944. The poster design for the war bonds campaign was a departure for Hiller, not because his studio patriotically turned their publicity skills to war preparedness work during World War II (for every major studio did that), but because it is a photomontage. Almost all of Hiller's other incredibly complex images are carefully constructed studio tableaux.

The glamorous portrait of movie star Jean Harlow and the shocking character study "Human Relations, 1932" were taken by William Mortensen just a few years apart. From 1921 to 1930 Mortensen worked in Los Angeles, where he operated a portrait studio located at the West-

William Mortensen
American, 1897–1965

Jean Harlow, ca. 1927

Modern gelatin silver print from the original negative
GIFT OF 3M COMPA-
NY, EX-COLLECTION
LOUIS WALTON
SIPLEY
78:1643:0027MP

ern Costume Company. There he worked as a still photographer for several film studios, photographing movie actors and extras in their film costumes and making publicity portraits. In 1932 he left this work to open the Mortensen School of Photography, teaching more than 3,000 students over the next 30 years. He also wrote nine books and numerous articles on photographic practice, technique, and theory, and became an influential spokesman for the

William Mortensen

Human Relations,
1932

Gelatin silver print
GIFT OF DR.
C. E. K. MEES
80:0479:0024

HUMAN·RELATIONS·1932

Arnold Newman
American, b. 1918

Kuniyoshi, 1942

Gelatin silver print
GIFT OF HAROLD
KAYE
80:0529:0014

(right)
Arnold Newman

George Grosz, 1942

Gelatin silver print
MUSEUM PURCHASE
73:0039:0005

late-pictorialist aesthetic. In his style, approach, and conception of the medium's uses and values, Mortensen stood in almost direct opposition to every tenet advocated by modernist photographers after 1920. In his own creative photography, Mortensen focused on "character studies." He presented basic human concepts by portraying them in elaborately costumed metaphorical or allegorical genre scenes, which he created by posing and photographing professional models, then manipulating his negatives or prints at will to achieve the graphic image he desired. The museum holds two portfolios comprising a total of 45 prints and 55 negatives by Mortensen from which the museum has made 43 prints.

These portraits of the Japanese-American still-life painter Yasuo Kuniyoshi and the expatriate German artist George Grosz were taken by Arnold Newman in 1942, during a period of intense creativity for this young artist still uncertain about choosing photography as a profession. Yet these early portraits reveal what would become the hallmark of

Arnold Newman
American, b. 1918

Dr. J. Robert
Oppenheimer, 1948

Gelatin silver print
GIFT OF HAROLD
KAYE
80:0529:0001

Newman's approach to portraiture: beautiful composition, an inclina-
tion for formal, clear-eyed perspectives, and an intuitive ability to elicit a
sitter's personality. As was his habit, Newman located his sitters in their
own living or work spaces, which added a degree of psychological depth
to his portraits. The personalities of Kuniyoshi and Grosz, and even a
sense of each man's artistic style, are intimated in the ways in which
Newman has related the pose of the figures to the character of their inti-
mate surroundings. This kind of presentation, and Newman's work in
particular, led to the coining of the term "environmental portraiture."

Newman acknowledges as early influences the photographs he saw in *Vanity Fair* and the work of the Farm Security Administration (FSA) photographers, particularly Walker Evans. For a celebrity photographer to study earlier work from *Vanity Fair* was to learn about historical precedents, but Newman's interest in the FSA photographers led him to infuse his work with a quiet humanity. Throughout the 1930s and 1940s the FSA photographers were the most visible and clearly defined practitioners of socially committed documentary photography in America. Their purpose was to present a more human picture of social problems in the hope of bringing about social and political change. Newman's work displays a similar seriousness of purpose – a respect for the dignity of the sitter. Eschewing the conventional presentation of celebrity fixed on glamour and fame, Newman prized the portrait that presented not the fleeting illusions of celebrity, but the enduring and defining features of an individual's character and life. Since the 1940s Newman has been recognized as one of the world's leading portraitists. The museum holds 222 photographs by Arnold Newman, with more than a third drawn from the first decade of his career.

Arnold Newman

Igor Stravinsky at Rehearsal, New York City, 1966

Gelatin silver print
GIFT OF THE
PHOTOGRAPHER
92:1036:0027

Public Record

Lewis Wickes Hine
American,
1874–1940

Young Russian
Jewess, Ellis Island,
1905

Gelatin silver print
GIFT OF THE PHOTO
LEAGUE, NEW YORK,
EX-COLLECTION
LEWIS WICKES HINE
77:0177:0148

"Young Russian Jewess" and "Italian Family on Ferry Boat" are photographs of immigrants at Ellis Island, the entry port into the United States for millions of immigrants at the turn of the century. In 1904 Lewis Wickes Hine, a teacher at the progressive Ethical Culture School in New York City, began to make photographs of immigrants as part of the school's teaching program. He continued to photograph at Ellis Island until 1909 and returned there after he became a professional photographer. The museum holds over 100 images of Ellis Island immigrants in its collection. These are among its collection of 3,800 negatives and over 6,000 prints by Hine.

At the turn of the century, the United States was experiencing a period of Progressive social reform that permeated almost every layer of educated thought in the country, ranging from social and educational theory to political reform in all levels of government. Hundreds of public and private agencies and organizations were established to confront the social problems arising from the new industrialized urban environment. This new social activism found its voice in pursuits as diverse as putting flower pots in tenement windows to the work of international organizations such as the Red Cross and the Salvation Army. Through exhibitions and publications, reform issues became a major focus in hundreds of illustrated magazines that were flourishing at this time. Educators, agencies, and organizations wanted to document their charitable and social activities, and the popular press provided an active market for socially concerned documentary photographs.

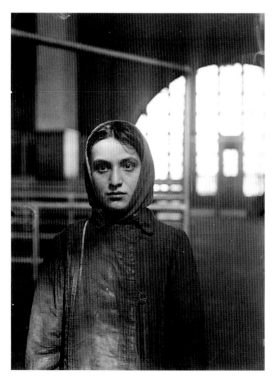

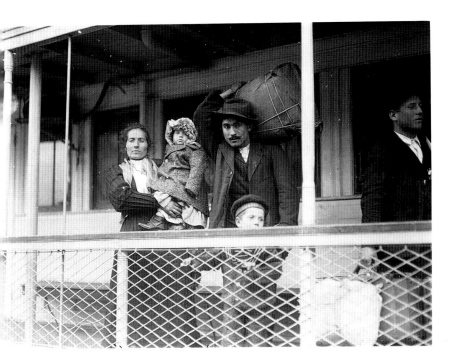

Encouraged by fellow educators and sociologists, Lewis Hine, who had obtained a degree in Education from New York University in 1905, gave up the relative security of a teaching position for the life of a documentary photographer. His work at Ellis Island, followed by studies of tenement life in New York City, earned Hine high regard from social activist groups eager for photographic illustrations to support their causes.

In 1906 Hine began working for the *Charities and the Commons* magazine as well as for the National Child Labor Committee (NCLC) and other social organizations. From 1908 to 1918, he made many photographic trips on behalf of the NCLC, documenting children at work on farms and in factories, textile mills, and mines. He would then furnish his images for exhibitions, lectures, and a wide variety of publications. Hine instinctively understood the persuasive power of photographs as illustrative documents that, when united with explanatory text, provided in his words, a "... lever... for the social uplift."

In 1918 Hine left the National Child Labor Committee and was hired

Lewis Wickes Hine

Italian Family on Ferry Boat, Leaving Ellis Island, 1905

Gelatin silver print
GIFT OF THE PHOTO
LEAGUE, NEW YORK,
EX-COLLECTION
LEWIS WICKES HINE
77:0177:0169

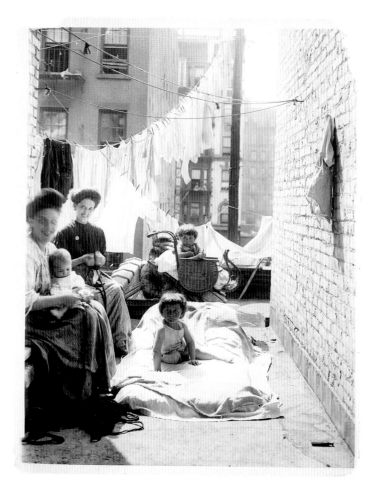

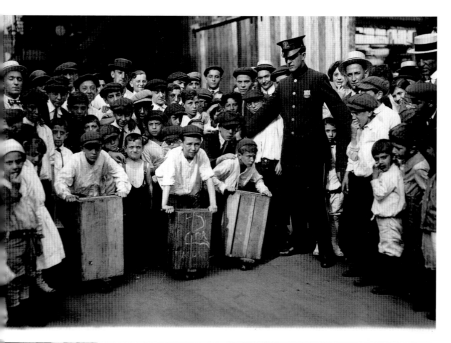

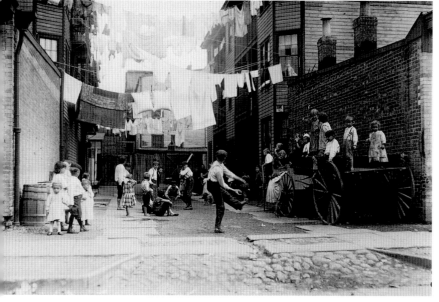

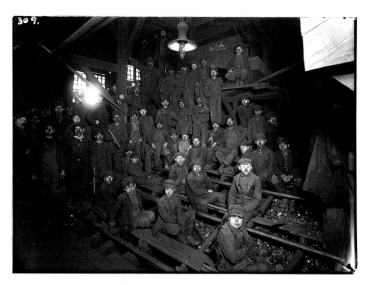

Lewis Wickes Hine
American,
1874–1940

Breaker Boys in
Coal Chute, South
Pittston, Penn-
sylvania, 1911

*From a gelatin on
glass negative*
GIFT OF THE PHOTO
LEAGUE, NEW YORK,
EX-COLLECTION
LEWIS WICKES HINE
85:0081:0021

Lewis Wickes Hine

Spinner Girl,
ca. 1908

*From a gelatin
on glass negative*
GIFT OF THE PHOTO
LEAGUE, NEW YORK,
EX-COLLECTION
LEWIS WICKES HINE
85:0079:0021

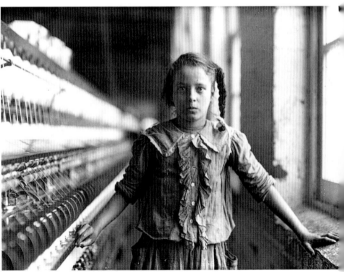

Lewis Wickes Hine

Newsie. Child Labor,
ca. 1912

*From a gelatin on
glass negative*
GIFT OF THE PHOTO
LEAGUE, NEW YORK,
EX-COLLECTION
LEWIS WICKES HINE
85:0083:0012

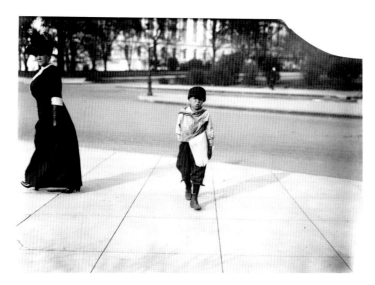

Lewis Wickes Hine

1 am. Pin Boys
Working in Subway
Bowling Alleys. Every
Night. 3 Smaller
Boys Were Kept out
of the Photo by the
Boss, 1910

Gelatin silver print
GIFT OF THE PHOTO
LEAGUE, NEW YORK,
EX-COLLECTION
LEWIS WICKES HINE
77:0185:0010

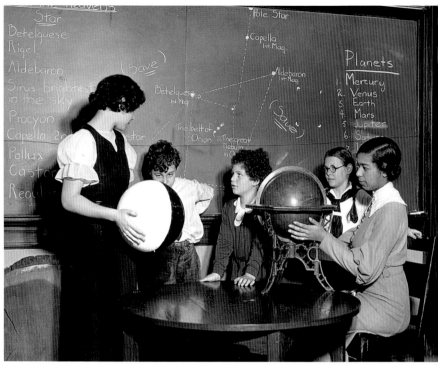

Lewis Wickes Hine
American, 1874–1940

Finding Out What
Caused That Recent
Eclipse, Ethical Culture
Schools, ca. 1935
Gelatin silver print
GIFT OF THE PHOTO
LEAGUE, NEW YORK,
EX-COLLECTION LEWIS
WICKES HINE
78:1016:0001

Lewis Wickes Hine

Health. Children
under Sunlamps,
ca. 1925
Gelatin silver print
GIFT OF THE PHOTO
LEAGUE, NEW YORK,
EX-COLLECTION
LEWIS WICKES HINE
78:1042:0117

by the American Red Cross (ARC) to photograph the devastation caused
by World War I in Europe. For two years, Hine documented the ARC re-
lief efforts, providing promotional images for their activities abroad. Fol-
lowing his work in Europe and for the next two decades, Hine obtained
smaller assignments from a variety of educational and social agencies.

From 1904 to 1920, Hine's photography focused on the human
predicament in the industrialized world, which gave his work a deeply
humanistic cast based on social reform. In later years, Hine's photogra-
phy underwent a substantial change, in large part due to the nature of
his clients whose assignments had more to do with promotional docu-
mentation of an agency's programs than revealing social ills. For exam-
ple, in "Finding Out What Caused That Recent Eclipse ..." and "Student
Hairdressers, Bordentown School," (page 582) Hine created photo-
graphs that illustrated the organizations' activities and accomplish-
ments, depicting the children as clients, there to receive services.

It is abundantly clear from his writings, his personal history, and his

Lewis Wickes Hine
American,
1874–1940

Kindergarten
Students with
Hammers, ca. 1930

Gelatin silver print
GIFT OF THE PHOTO
LEAGUE, NEW YORK,
EX-COLLECTION
LEWIS WICKES HINE
78:1021:0030

Lewis Wickes Hine

Student Hair-
dressers, Borden-
town School,
ca. 1935

Gelatin silver print
GIFT OF THE PHOTO
LEAGUE, NEW YORK,
EX-COLLECTION
LEWIS WICKES HINE
78:1020:0020

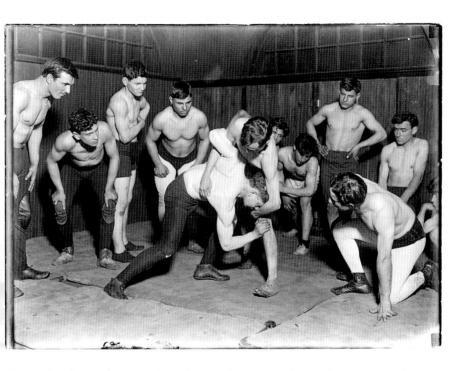

Lewis Wickes Hine

A "Wrestling-Club" in a Social Settlement in One of Our Large Cities, 1910

Gelatin silver print
GIFT OF THE PHOTO LEAGUE, NEW YORK, EX-COLLECTION LEWIS WICKES HINE
78:1023:0070

choice of profession that Hine deeply believed his work could provide change in a world in desperate need of social reform. It is equally clear that he was morally outraged about the conditions he photographed, that the sight of five-year-old children working 12-hour days in unsafe and unsanitary factories offended him and roused his sympathy. Hine never presented the subjects of his photographs as victims. The weary children are always allowed their dignity, allowed to face the camera on their own terms, to present their own sense of self, no matter what the circumstances. Throughout his career, Hine's photographs were affirming images, even when he photographed dehumanizing situations.

After World War I, Hine foresaw that there would be fewer commissions for social documentary photographs and he began to define himself as an interpretive photographer and redirected his consuming interest in the theme of labor to meet the progressive values of a new era.

In the years between the two world wars, a movement developed in the visual arts that portrayed the benefits of the United States' thriving industrial capitalism while focusing on the worker immersed in a new

machine age. Artists such as Joseph Pennell, John Sloan, and Joseph Stella took up this dynamic theme for a time, and photographers, including Margaret Bourke-White and Peter Stackpole, built their careers by following a similar course. As for Hine, he had photographed industrial workers as early as 1907 when he worked on Paul Kellogg's groundbreaking sociological study, "Pittsburgh Survey." His decision "to portray the human side of industry" met with public and financial success. Hine undoubtedly felt that he was still contributing to social betterment by positively portraying the role of the worker. His decision kept him current with the times, and the change was immediately recognized by astute observers. He received commissions from labor unions and industry alike. His eye-catching portraits of master mechanics working amid the bold forms and dramatic surroundings of heavy industry won him prizes and awards, and his work was exhibited in art clubs and reviewed in art magazines – new artistic and public venues for him. However, the stock market crash of 1929 and the onset of the Great Depression severely cut into his income, and he began to experience financial difficulties.

In May 1930 Hine was offered a commission to photograph the construction of the Empire State Building. It is likely that the commission came through the auspices of one of his neighbors, Richard Shreve, a principal in the architectural firm that designed

Lewis Wickes Hine
American,
1874–1940

Seaman's Strike,
ca. 1925

From a gelatin on diacetate film negative
GIFT OF THE PHOTO LEAGUE, NEW YORK, EX-COLLECTION LEWIS WICKES HINE
85:0330:0031

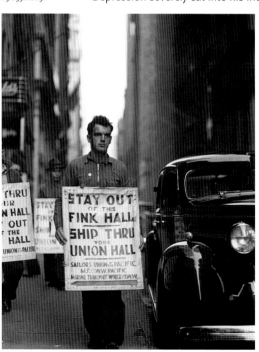

Lewis Wickes Hine

Power House
Mechanic, 1920

Gelatin silver print
GIFT OF THE PHOTO LEAGUE, NEW YORK, EX-COLLECTION LEWIS WICKES HINE
78:0999:0013

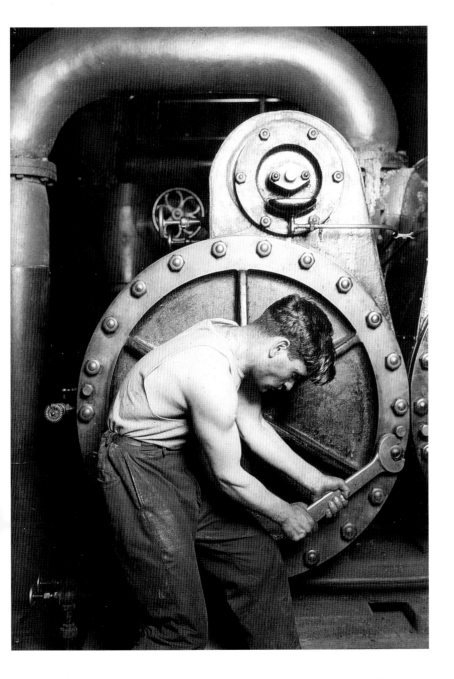

the building. Hine photographed construction workers, following them up into the sky as the building rose to its height of 102 stories, the tallest building ever erected up to that time. As in years past, his photographs seemed exceptionally modern to his audience. The strong graphic forms of the girders and struts of the building's framework and the sharply oblique perspectives forced upon Hine by necessity as he photographed his subjects from above and below, all appeared to voice an exciting new photographic vision. Since the construction of the Empire State Building was a particularly newsworthy event, Hine's photographs were seen and discussed by a wide audience. They were published in European art magazines, where they were featured as an expression of the American avant-garde. Photographers who were aligned with the new objectivist and constructivist movements in art were especially attracted to this work. In 1932 the Empire State photographs were gathered together in the critically acclaimed book *Men at Work*. The museum holds approximately 500 images from this series.

Lewis Wickes Hine
American,
1874–1940

Riveters Working
on Mooring Mast,
Empire State
Building, 1931

Gelatin silver print
GIFT OF THE PHOTO
LEAGUE, NEW YORK,
EX-COLLECTION
LEWIS WICKES HINE
77:0158:0007

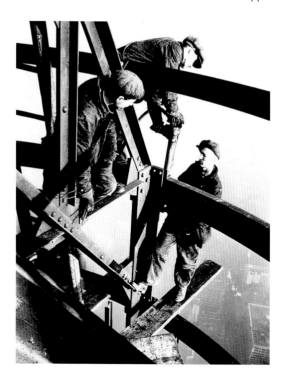

Lewis Wickes Hine

*Man on Girders,
Mooring Mast,
Empire State
Building, ca. 1931*

Gelatin silver print
GIFT OF THE PHOTO
LEAGUE, NEW YORK,
EX-COLLECTION
LEWIS WICKES HINE
77:0161:0038

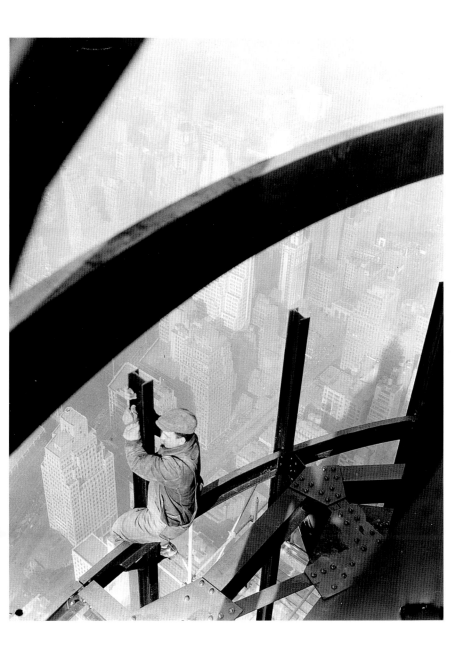

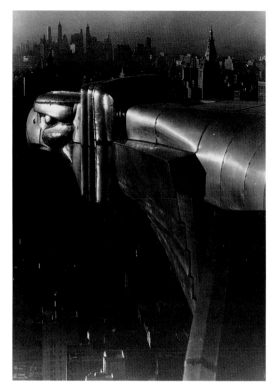

Margaret Bourke-White began her career as an advertising and industrial photographer in Cleveland in 1927. She developed a modernist approach, with dramatic use of perspective, light, and shadow on hard-edged industrial shapes, to create photographs that merged fact with the potent language of abstraction. In contrast to many American photographers who documented the world of industry, Bourke-White infused a grandeur into her industrial images, forging a personal style that was wholly contemporary and dramatic. Her photographs, born of an aesthetic appreciation for machinery that led her to claim that "a dynamo is as beautiful as a vase," lent a sense of power, authority, and glamour to structures previously viewed as unsightly or destructive. This work was immediately appreciated among her clientele of corporate industrialists. When Henry Luce started a magazine for business leaders in 1930 titled *Fortune*, Bourke-White was the first photographer he hired.

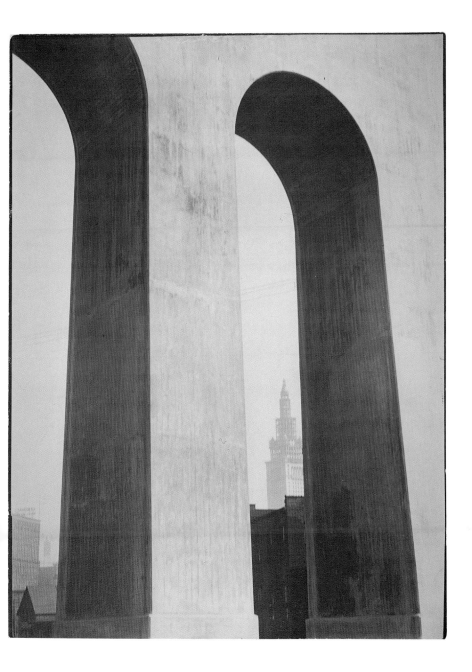

From 1929 to 1936, Bourke-White worked in New York City jointly as an advertising photographer and as a photographer for *Fortune*. In November of 1936 Henry Luce, encouraged by the success of his earlier magazines *Time* and *Fortune*, introduced a photographically illustrated weekly magazine named *LIFE*. The first issue's cover and lead story were by his ace photographer, Margaret Bourke-White, who had transferred from its sister journal to become one of the first four staff photographers for *LIFE*. The lead story for the inaugural issue was to be about the building of the Fort Peck Dam in Montana, but Bourke-White confounded expectations. The magazine's editors thought she would produce a group of "... construction pictures as only Bourke-White could take them. What the Editors got was a human document of American frontier life which, to them at least, was a revelation." The first issue of *LIFE* exceeded even the most hopeful expectations; the magazine became a publishing phenomenon. Before the advent of television, *LIFE* reached an unparalleled status in American society as a source of information and entertainment – a position it held until the 1960s. For the next 33 years, Bourke-White was regarded as one of the most famous and well-respected *LIFE* photojournalists at a time when working for the magazine was considered the pinnacle of the photojournalistic profession. The Menschel Library holds all of her books, and the photography collection holds 335 photographs and the 1934 photogravure portfolio *U. S. S. R. Photographs*. Approximately 50 of

Margaret Bourke-White
American, 1904–1971

March of the Dynamos, 1928

Gelatin silver print
71:0155:0114

the collection's prints date the time from before she worked for *LIFE*, and 11 prints are from the first *LIFE* essay on the Fort Peck Dam.

In addition to being a prolific photographer, Bourke-White was also a writer, a special bonus in the eyes of many a publisher and editor. She wrote or co-authored ten books from her many assignments to far-ranging places or politically troubled regions throughout the world. Significant among these are her works on Germany and the Soviet Union during the tumultuous 1930s; her pictures taken as a World War II combat photographer in Italy; and her firsthand account of India's struggle for independence in the late 1940s. Due to her exalted position in the pantheon of photojournalism, Bourke-White has, in turn, been the subject of a half-dozen monographs, a scholarly biography, and a not-so-scholarly movie starring Farrah Fawcett.

In the mid-1930s, Bourke-White adapted her style to changes in photojournalistic practices and thought, working in a more socially committed documentary mode. She replaced the heroic grandeur found in her

Margaret Bourke-White

Steel Liner, Fort Peck Dam, Montana, 1936

Gelatin silver print
71:0155:0074

Margaret Bourke-White
American, 1904–1971

At the Time of the Louisville Flood, 1937

Gelatin silver print
66:0079:0008

(right)
Margaret Bourke-White

Khadeeja Feroze Ud-din, a Deputy Directress of Education, Veils Face and Hands in the Presence of Men, ca. 1947

Gelatin silver print
81:1002:0012

earlier images of booming industrial power with a candidness born of her contact with the homeless and poor during the Great Depression. For example, in the *LIFE* photograph "At the Time of the Louisville Flood, 1937," Bourke-White depicts with great irony a line of hungry, displaced people waiting for food in front of a billboard pronouncing the United States' status as having the "world's highest standard of living."

Throughout her career, Margaret Bourke-White was an integral force in the rising tide of photojournalism as it defined its role as both a specialized discipline and a legitimate form of mass communication. Her photographic acumen enabled her to keep step with her time, adapting her visual skills to meet the demands of her audience and subject, as in this late portrait of Khadeeja Feroze Ud-din. Featured in the book *Halfway to Freedom*, this portrait of Pakistan's new deputy directress of education demonstrates Bourke-White's skills at magnifying, through light and pyramidal form, a dramatic and mysterious portrayal of a woman veiled and gloved in accordance with the beliefs of her Muslim faith.

After experimenting with urban abstractions in the late 1920s, Walker Evans brought a strengthened vision to bear on American vernacular architecture. He photographed with a dispassionate, formalist large-camera precision and an austere classic vision so powerful that it forced the photographic community to reevaluate the virtues of both his subject matter and his photographic practice. In "View of Morgantown, West Virginia, 1935" and "Furniture Store Sign, Birmingham, Alabama, 1936," he transformed the mundane, the overlooked, and even the disdained objects of the world into coherent, expressive, even beautiful images. At the same time, he made candid 35mm photographs of ordinary people he found in the street walking or standing around doing very little. These photographs were not about any specific event, activity, or ceremonial function, but they referred instead to the ordinary people themselves and the ways people relate to their immediate surroundings. By making powerful and moving art out of ordinary and everyday objects, Evans helped to effectively change American creative photographic practice in the 1930s.

An austere man, suspicious of social or political groups and slogans, Evans was a key figure in effecting a transformation from the

Walker Evans
American, 1903–1975

View of Morgantown, West Virginia, 1935

Gelatin silver print
MUSEUM COLLECTION, BY EXCHANGE, EX-COLLECTION ROY STRYKER
73:0013:0041

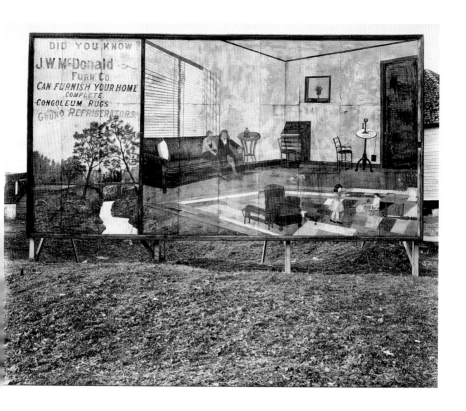

Walker Evans

Furniture Store
Sign, Birmingham,
Alabama, 1936

Gelatin silver print
MUSEUM PURCHASE
71:0006:0001

domination of modernist abstraction to the rise of socially committed documentary photography. When Roy Stryker, chief of the Historical Section for the Farm Security Administration (FSA), developed an idea to create a pictorial record that would capture the effects of the Depression on American life, he turned to Evans to help him discover what photography's role could be in this project. Equally drawn to the visual strength of Walker Evans' work and to the compassionate humanity of Dorothea Lange's photographs, Stryker felt that both photographers' approaches were critical to the success of his project, and so he hired both to work for his fledgling organization.

Evans worked for the FSA for only 18 months; his association with Stryker ended due to personal differences. His photographic output was limited, but the photographs themselves exerted an extraordinary influence on both his colleagues and subsequent generations of

Walker Evans
American, 1903–1975

Burroughs Family,
Hale County,
Alabama, 1936

Print by James Dow,
ca. 1971
Gelatin silver print
MUSEUM PURCHASE
72:0017:0011

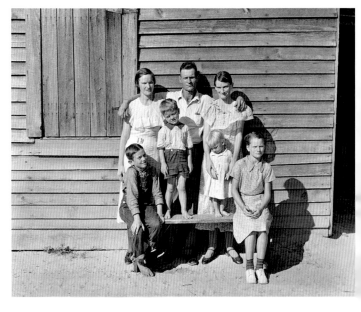

Walker Evans

A Miner's Home,
Vicinity Morgan-
town, West Virginia,
1935

Print by James Dow,
ca. 1971
Gelatin silver print
GIFT OF JAMES DOW
76:0191:0010

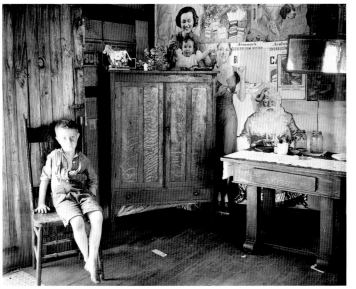

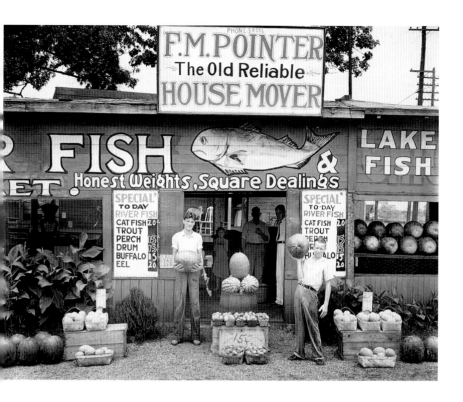

photographers. Evans' influence was particularly felt with his two books, *American Photographs*, published in 1938, and *Let Us Now Praise Famous Men*, published in 1941. *Let Us Now Praise Famous Men* began as a magazine assignment in 1936 about a family of tenant farmers in the South. When it was published, accompanied with text by James Agee, it received a puzzled critical response. Gradually, however, the combination of Agee's fervid, poetic prose and Evans' lucid and painfully acute photographs began to be recognized as a creative work of great power. Both books are now considered classics, models of the art of photographic book illustration.

In the early 1930s Dorothea Lange ran a small portrait studio situated on a busy street in San Francisco. She said that as the Depression deepened she could see the tide of homeless, jobless men as they aimlessly drifted by her windows. Like many other artists of the time, Lange began to shift her art-making practices in response to the hardships

Walker Evans

Roadside Stand,
Vicinity Birmingham,
Alabama, 1936

*Print by James Dow,
ca. 1971*
Gelatin silver print
GIFT OF JAMES DOW
76:0191:0032

overwhelming the country. Dorothea Lange was soon working out in the streets, photographing the homeless, as seen in her photograph "White Angel Bread Line ...". In 1935 Paul S. Taylor, an economics professor at the University of California, was asked by the State of California to create a report of the state's pressing migratory labor problem. He hired Lange to make visual records to support the field studies his team was conducting. She was placed on the payroll as a typist, since there was no provision for a project photographer. Together, Taylor and Lange compiled a scientifically directed study on this social problem, complete with statistical figures and analyses, quotes from the migrants, and moving, powerful, and convincing photographs depicting the difficulties that many migratory workers were experiencing. This new amalgam tying together scientific records and humanistic, expressive photographs that "put a human face on the statistics" proved to be the model for future practices of the Farm Security Administration photography unit and a great many other documentary efforts for decades to come.

Dorothea Lange
American, 1895–1965

White Angel Bread Line, San Francisco, 1933

Gelatin silver print
MUSEUM COLLECTION, BY EXCHANGE
74:0024:0017

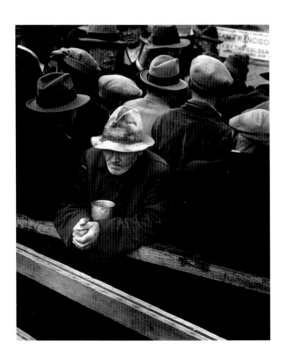

Dorothea Lange

Migrant Mother, Nipomo, California, 1936

Gelatin silver print
GIFT OF AN ANONYMOUS DONOR
73:0095:0001

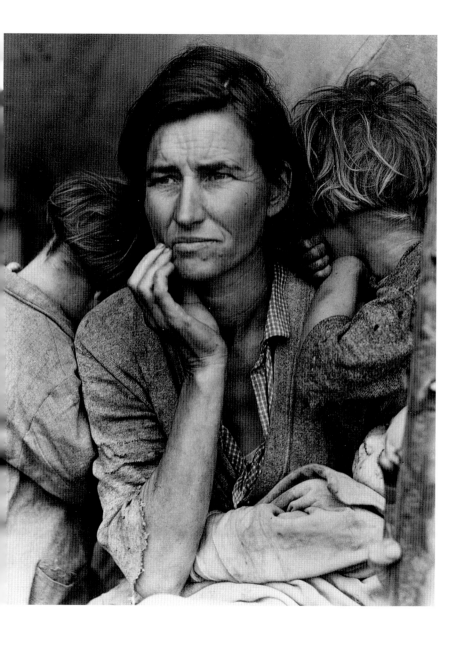

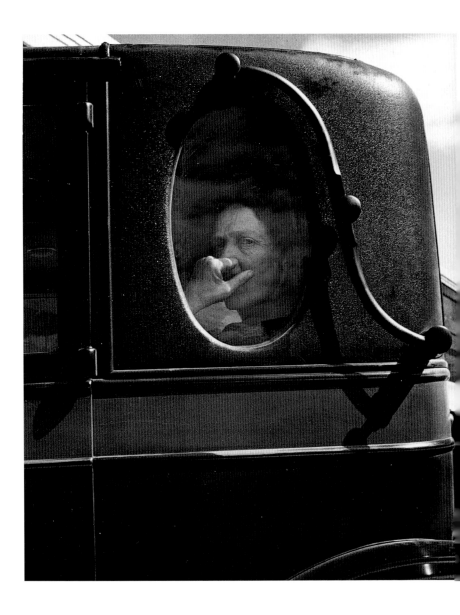

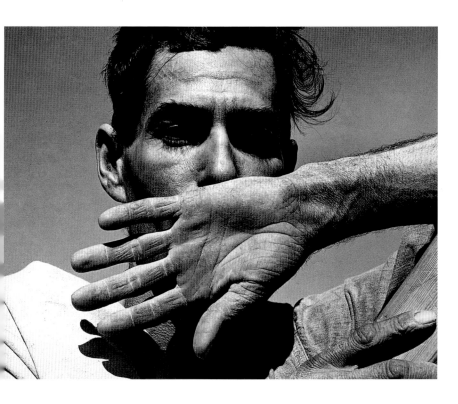

The museum holds more than 60 photographs by Dorothea Lange, approximately half of which are drawn from the FSA years and the others taken in the 1950s. A small woman with a limp from a childhood bout with polio, Dorothea Lange could walk right up to an individual from a proud, reserved people, stick a rather large and awkward camera in their face, and photograph them from an extraordinarily intimate distance. The results were photographs that were simply more powerful and humane than anyone else was making. Knowing that her best photograph would be the one that made the most powerful human statement, Lange would take many photographs in any promising situation and work until the best-possible image was made. She worked very hard on her composition and framing, and, when she could, on the quality of her printmaking. None of these things are prerequisites to traditional documentary practice. All of them, however, are concerns of a working artist.

(above)
Dorothea Lange
American, 1895–1965

Migratory Cotton
Picker, Eloy, Arizona,
1940

Gelatin silver print
MUSEUM PURCHASE
81:1484:0010

Dorothea Lange

Funeral Cortege, End
of an Era in a Small
Valley Town, Califor-
nia, 1938

Gelatin silver print
79:2636:0001

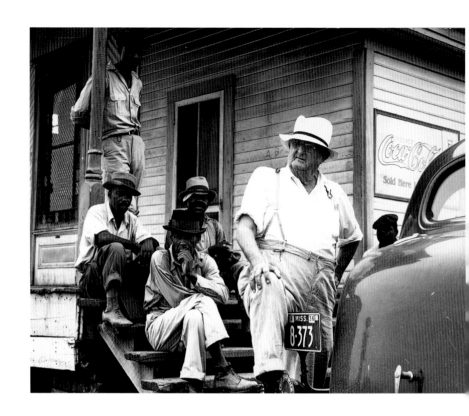

Dorothea Lange
American, 1895–1965

Plantation Owner
and His Field Hands
near Clarksdale,
Mississippi, 1936

Gelatin silver print
GIFT OF THE
PHOTOGRAPHER
80:0751:0003

The photograph reproduced here was taken by Lange in 1936, during
an extended trip through the South while she was employed by the
Farm Security Administration. Lange composed the image so that its
informational content as detailed in the title "Plantation Owner and His
Field Hands near Clarksdale, Mississippi" is suffused with an emotional
charge derived from the instinctual reading of body language and spa-
tial clues. She took this photograph from a low angle and composed it
so that everything fit into a shallow, enclosed, and confined space, with
all visual sight lines leading to the figure of the dominating white man,
surrounded by, yet separated from, the subsidiary figures of the black
field hands. The owner, shown with his hand confidently on his knee,
possessively leaning on his automobile – a symbol of wealth and
prestige – dominates the picture, just as he dominated the world
he inhabited.

Arthur Rothstein
American, 1915–1985

Cattle Skull, Bad
Lands, South
Dakota, 1936

Gelatin silver print
GIFT OF THE
PHOTOGRAPHER
76:0137:0002

Arthur Rothstein, a former student of Roy Stryker's, was the first photographer hired by Stryker to work for the FSA. Rothstein's initial tasks were to copy documents and photograph agency events while Stryker puzzled out the development of the agency's photographic project. Rothstein became a valuable member of the FSA, quickly learning to make the kind of images that Stryker wanted: images that were both informative and symbolic of general conditions throughout the devastated country. His "Cattle Skull, Bad Lands, South Dakota, 1936" popularly symbolized the disaster gripping rural America, embodying the drought and dust storms that drove so many farmers off their land and into migratory labor.

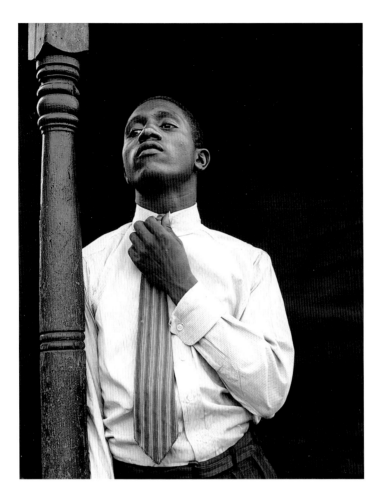

(right)
Arthur Rothstein

Colored Balcony,
Birmingham,
Alabama, 1940

Gelatin silver print
GIFT OF GRACE
ROTHSTEIN
89:1475:0018

Arthur Rothstein
American, 1915–1985

Saturday Night,
Birmingham,
Alabama, 1940

Gelatin silver print
GIFT OF THE
PHOTOGRAPHER
76:0137:0025

In 1940 Rothstein left the FSA and began a distinguished career as a photojournalist, first on assignment for *Look* magazine, in which the two images reproduced here were featured. *Look*, *Friday*, *PM*, *LIFE*, and a host of other illustrated magazines in the late 1930s drew many of their photographers from the FSA and the Photo League, at the same time absorbing many of the humanistic principles that drove the documentary approach in American photography. The museum's collection holds approximately 150 photographs by Rothstein, many of them taken between 1938 and 1948.

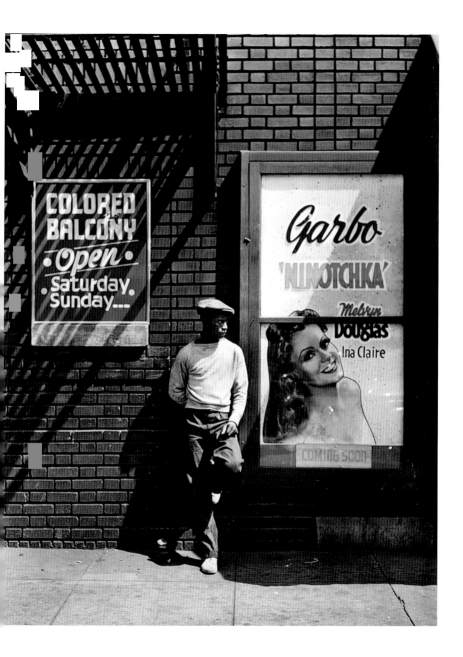

Esther Bubley
American, 1921–1998

Esso Research Center, Linden, New Jersey. Mechanic Oils Mechanism in a Micromax Recorder Which Is Used with the Infra-Red Gas Analyzer, ca. 1945

Gelatin silver print
GIFT OF STANDARD OIL OF NEW JERSEY
80:0209:0004

Harold Corsini
American, b. 1919

Shoe Repair Shop, Cushing, Oklahoma, ca. 1950

Gelatin silver print
GIFT OF STANDARD OIL OF NEW JERSEY
81:2930:0011

Esther Bubley

Entomology Labora-
tory Assistant Sprays
Insecticide into a Fly
Chamber. Bayway
Refinery, Linden,
New Jersey, ca. 1940

Gelatin silver print
GIFT OF STANDARD
OIL OF NEW JERSEY
80:0536:0010

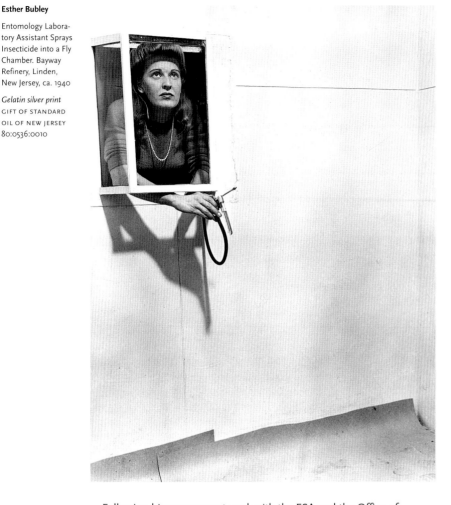

Following his government work with the FSA and the Office of War Information, Roy Stryker found corporate support from Standard Oil of New Jersey to continue his work providing a photographic documentation of contemporary America. He hired a group of young photographers, fed them economic and social information, and assigned them particular subjects. The Standard Oil Project lasted until 1950, employing up to 20 photographers who took an astonishing 67,000 photographs. The museum holds 129 pictures

by 19 of these project photographers including Esther Bubley and Harold Corsini.

During the 1960s, the photographer Aaron Siskind donated to the museum approximately 140 photographs by six members of the Feature Group, a circle of advanced photographers that Siskind organized under the auspices of the Photo League of New York during the 1930s and 1940s. He also gave 300 negatives and 600 of his own photographs from this period to the museum.

The Photo League was a unique and influential organization of amateur and professional photographers primarily interested in producing documentary photography of social significance. Equipped with rudimentary darkroom facilities, it also offered classes in both introductory and intermediate photography, as well as upper-level workshops, feature groups, and production groups designed to work on long-term documentary projects for exhibition or publication. Most of the League's membership comprised New Yorkers born on the Lower East side of Manhattan, in Brooklyn, or the Bronx; most were first-generation Americans, Jewish, and poor. Funds to support the League came from membership dues, class fees, and proceeds from parties that were organized

Lucy Ashjian
American, active
ca. 1930s

*Group in Front of
Ambulance,* ca. 1935

Gelatin silver print
GIFT OF AARON
SISKIND
73:0079:0002

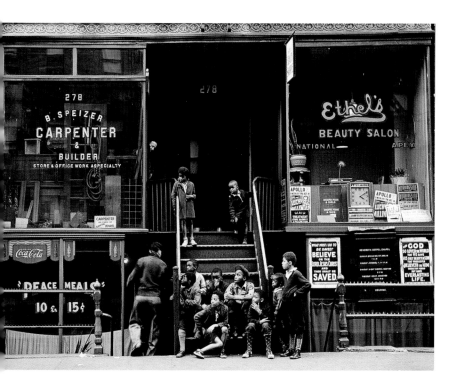

throughout the year. At its height, membership in the Photo League numbered from 80 to 200 persons.

In the late 1930s, this improbable organization became a leading center of photographic activity in America, with lectures, exhibitions, and activities that exerted an impact far greater than could ever have been anticipated. An extraordinary number of individuals who started at the League went on to exceptional careers in photography. In 1936 Siskind gathered several younger League photographers together into a group to produce visual documentary projects on various social topics. The largest of these was the "Harlem Document" project. Each week the group, consisting of photographers Lucy Ashjian, Harold Corsini, Morris Engle, Sol Fabricant, Beatrice Koslofsky, Richard Lyon, Jack Manning, and Siskind, met with Michael Carter, a black sociologist, who offered background information and introductions in Harlem. The group would photograph during the week, meet and critique their

Jack Manning
(Jack Mendelsohn)
American, b. 1920

Harlem Street Scene,
1937
Gelatin silver print
GIFT OF AARON
SISKIND
73:0081:0023

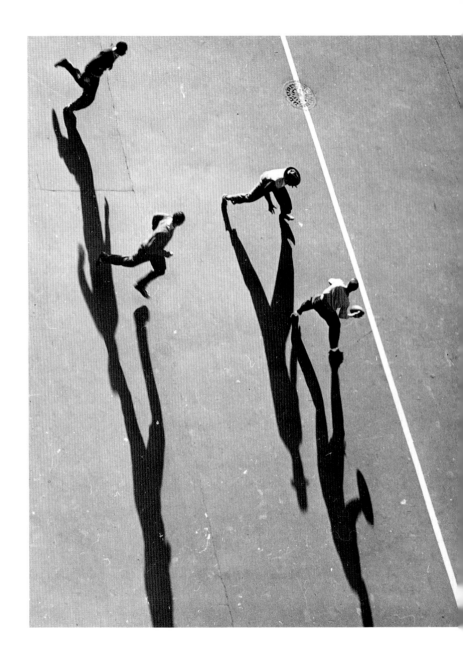

(left)
Harold Corsini
American, b. 1919

Playing Football,
ca. 1935

Gelatin silver print
GIFT OF AARON
SISKIND
69:0073:0012

Aaron Siskind
American, 1903–1991

Savoy Dancers,
Harlem, ca. 1937

Modern gelatin silver
print from original
gelatin on safety base
sheet film negative
GIFT OF THE
PHOTOGRAPHER
81:0751:0031MP

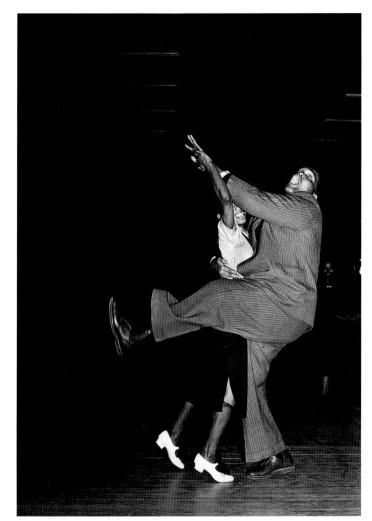

efforts, then return to Harlem again. The final "Harlem Document" was exhibited in 1940 in Harlem and elsewhere in New York City.

Andreas Feininger, the son of German painter Lionel Feininger, taught himself photography while practicing architecture in the early 1930s. Feininger worked for the Dephot photo agency in Germany. Fleeing the Nazis, he moved back to France and then to Sweden before finally immigrating to the United States, where he went to work for the Black Star photo agency. "When not on assignment, I roamed the streets of New York with my camera, trying to document every aspect of what to me was the greatest, the most exciting city on earth," Feininger wrote of his approach to photographing in his newly adopted home. His crowded, exuberant photograph of Times Square reflects the social energy of the era with an undercurrent of the political turmoil that had brought him there. A later image of a parade on lower Broadway dominated by an American flag displays a breathtaking patriotic fervor. By the early 1940s much of American photojournalism became involved in what was called "war preparedness work," and virtually all social documentary practice was subsumed into this patriotic effort. Feininger also worked for the Office of War Information, and from 1943 to 1962 as a *LIFE* magazine photographer. "I am a maker of picture books since I hardly ever take single pictures," Feininger wrote. He published more than 50 books, and the museum holds more than 675 of his photographs spanning his entire career.

Andreas Feininger
American, b. France, 1906–1999

Corner Times Square and 42nd Street, Midtown Manhattan, 1940

Gelatin silver print
GIFT OF THE
PHOTOGRAPHER
78:0606:0298

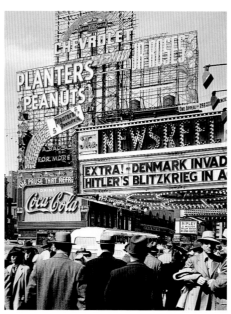

Andreas Feininger

Parade on Lower Broadway, 1952

Gelatin silver print
GIFT OF THE
PHOTOGRAPHER
78:0606:0099

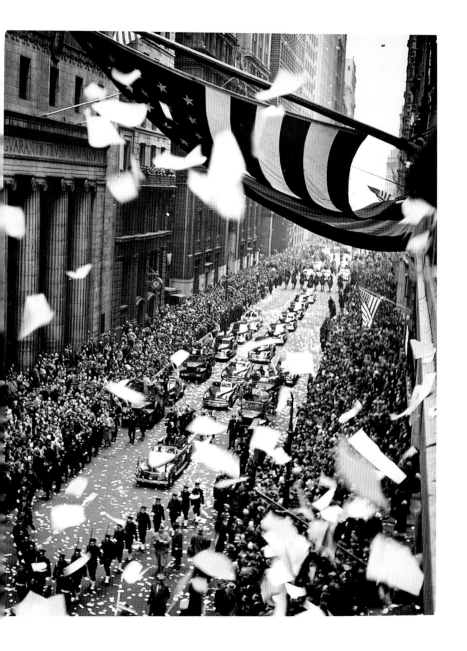

The photographic career of Berenice Abbott was long and prodigious. It measured the scope and breadth of many 20th-century photographic movements, with its preoccupation with documentary realism, surrealist evocation, commercial portraiture, and scientific documentation. But no matter the subject she portrayed, Abbott believed in her role as a privileged eyewitness to a rapidly changing modern world. For her, the fidelity of the camera marked its particular ability to seize upon the moment at hand, gathering within its gaze the traces of larger cultural appearances and concerns.

Born in the United States, Abbott moved to Paris in the early 1920s during the height of an artistic and literary resurgence. There she worked as a studio assistant for another American expatriate, Man Ray, absorbing a heady atmosphere primed with surrealist thought. At the same time, Abbott met the elderly and destitute Eugène Atget, saving his photographic archive from ruin and, thus, single-handedly saving his reputation from obscurity.

Berenice Abbott
American, 1898–1991

Horse in Lincoln
Square, 1930

Gelatin silver print
MUSEUM PURCHASE
67:0006:0001

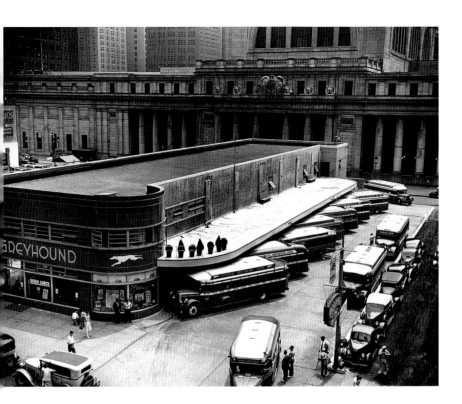

In 1929 Abbott returned to the United States, deciding to settle in New York City. For the next two decades, she prowled the city she described as "the truest phenomenon of the twentieth century." In images like "Horse in Lincoln Square," Abbott betrays the avant-garde sensibilities she learned abroad, choosing a bird's-eye view and disjunctive form and space to suggest both the mystery and the exceptional that are contained within mundane, everyday appearances.

In 1935 Abbott was appointed head of the Changing New York unit of the Federal Art Project, a relief agency formed to benefit artists. This project provided Abbott with a measure of institutional support, allowing her to expand and formalize her evolving documentary approach. In "Greyhound Bus Terminal," she continued to incorporate a high viewpoint as an active compositional element, but the earlier mysterious sense of the unforeseen has been replaced with a strong informational content, giving weight to the documentary purpose of the image.

Berenice Abbott

Greyhound Bus
Terminal,
July 14, 1936

Gelatin silver print
MUSEUM PURCHASE
71:0021:0014

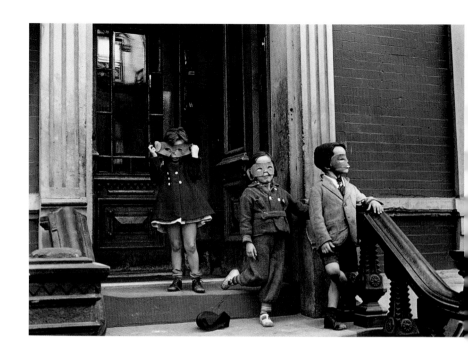

Helen Levitt
American, b. 1918

New York, 1939

Gelatin silver print
MUSEUM PURCHASE,
CHARINA FOUNDA-
TION PURCHASE
FUND
93:0519:0001

During the 1940s, Helen Levitt walked around the streets of New York on self-imposed "assignments," photographing children at play and children's drawings, as seen in the two images reproduced here. Inspired by Henri Cartier-Bresson, and with advice and help from Walker Evans, Levitt used an unobtrusive 35mm camera that allowed her to respond to fleeting moments without altering the essential nature and spirit of the activity she observed. While Levitt's work shared the same subjects and a similar style of directness and candor found in documentary photography, her images are more personal, lyrical, and poetic in their approach.

In the 1940s Levitt collaborated with writer James Agee on a book of her photographs titled *A Way of Seeing*, which was finally published in 1965, ten years after Agee's death. Influenced by Agee, who gained renown as a film critic, Levitt turned to documentary filmmaking, collaborating with Agee and Janice Loeb on the motion picture *In the Street*. In 1949, she participated in the filming of *The Quiet One*, considered a classic of documentary filmmaking.

Helen Levitt

New York City, 1938

Gelatin silver print
MUSEUM PURCHASE,
CHARINA FOUNDA-
TION PURCHASE
FUND
93:0522:0001

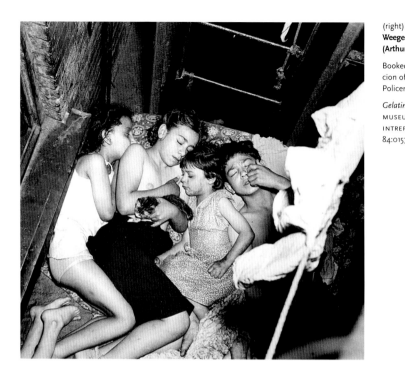

(right)
**Weegee
(Arthur H. Fellig)**

Booked on Suspicion of Killing a Policeman, 1939

Gelatin silver print
MUSEUM PURCHASE,
INTREPID FUND
84:0157:0003

**Weegee
(Arthur H. Fellig)**
American, b. Poland,
1899–1968

Tenement Penthouse, ca. 1940

Gelatin silver print
81:2076:0001

Arthur Fellig, better known by his pseudonym "Weegee" or "Weegee the Famous," as he frequently described himself, was the son of an immigrant pushcart vendor. He worked as a dishwasher, then as a darkroom technician at Acme News for 12 years before becoming a freelance news photographer in 1935 at age 36. He kept police radios in his car and apartment, and his car trunk was always full of camera equipment. This allowed him to respond quickly to police calls, and he often arrived at the scene before the police. Fellig epitomized the stereotype of the hardnosed, cigar-smoking police reporter, dispassionately documenting murders, fires, and domestic tragedies with his 4 x 5 Speed Graphic and on-camera flashgun. "Many photographers live in a dream world of beautiful backgrounds. It wouldn't hurt them to get a taste of reality to wake them up," Fellig once said. Indeed his harshly lighted and hastily composed photographs certainly do have "a taste of reality." Sometimes they go beyond the customary bounds of news reportage photography to display the overlooked, but unforgettable, moments of human existence.

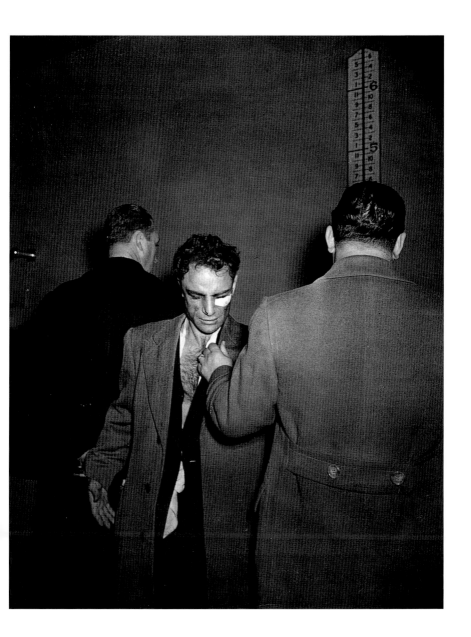

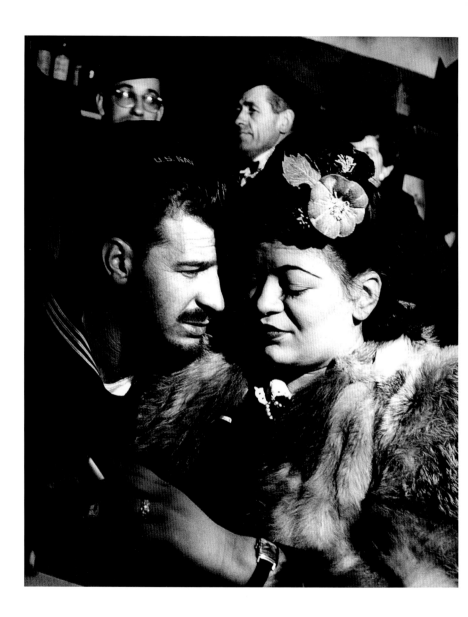

(left)
Lisette Model
American, b. Austria,
1901–1983

Sailor & Girl,
Sammy's Bar,
New York, 1940

Gelatin silver print
MUSEUM PURCHASE
80:0470:0003

Berenice Abbott once wrote: "It is a large order to look at life unblinkingly in the midst of general confusion. [Only a few do this well.] I believe Lisette Model's seeing to be in the foreground of this elite group." Escaping the Nazis, Lisette Model left her native Austria for France, then immigrated to the United States in 1937. She took up photography to make a living, setting aside her earlier training in classical music. Model worked as a freelance magazine photographer and taught photography in New York City. Recognized for her monumental street portraits, Model's approach displays her direct, ironic, and compelling gaze.

Lisette Model

Lower East Side,
N.Y., ca. 1955

Gelatin silver print
GIFT OF ANSEL
ADAMS
81:1502:0001

Will Connell
American, 1898–1961

Hands and Baby,
ca. 1937

Gelatin silver print
GIFT OF THOMAS
J. MALONEY
79:4227:0001

(right)
Edward Farber
American, 1915–1982

*The Flag Is Passing
By. Citizens Day Rally,
Milwaukee,* 1941

Gelatin silver print
GIFT OF THOMAS
J. MALONEY
89:0423:0002

From the late 1930s to the 1950s Tom Maloney's populist publications *U. S. Camera* and *U. S. Camera Annual* were the most important and influential magazines on photography in the United States, providing a showplace for all aspects of photographic practice and thought, from advertising to art, newspaper journalism to scientific research. The pure eclecticism of his publications demonstrated the enormous vitality, diversity, and importance of photography during this period. The photographs seen here, by Will Connell, a professional photographer and teacher of photography in California, and Edward Farber, a photographer for the *Milwaukee Journal* during the 1940s, illustrate the emphasis on humanistic values and affirmative democratic ideology that were staples of America's self-definition during the war years. In 1974 Maloney donated to George Eastman House 250 photographs by more than 100 photographers who had been featured in his magazines.

In 1939 Lou Stouman studied at the Photo League with Sid Grossman, crediting his mentor with inspiring his passionate, lifelong interest in photography. A documentarian, Stouman early on described his work as "street photography," as seen in a work drawn from his Times Square project of the 1940s. In contrast to contemporary documentary practice and thought, Stouman eschewed political content in his work, focusing instead on appearances and the immediacy of the scene at hand.

Stouman was not alone in his decision to work in a non-political, documentary style. He was joined by others, including Larry Silver, who demonstrated a humanistic intent and populist leanings in his work. Born in the Bronx, Silver moved to Los Angeles as a student in 1954. The world he found there provided new subjects unlike those photographed by Photo League professionals, which had earlier impressed him. Immersing himself in West Coast culture, Silver created a photographic series about Southern California bodybuilders at Muscle Beach, whose way of life was little known outside their own community.

Candid Witness

This news photograph of Charles Lindbergh standing in front of his airplane, *The Spirit of St. Louis*, at the end of the first solo transatlantic flight is notable for being an early form of transmitted photographic imagery. Popularly known as wire photos, photographs transmitted over telegraph or telephone lines from a news agency to newspapers around the world were first introduced in 1907. It was not until the 1920s that the system became commercially feasible. The Bartlane system, founded by Harry Bartholomew, head of the art department for the London *Daily Mirror*, and Robert McFarlane, an English research engineer, was an early transatlantic system that translated photographs into patterns of perforations on a paper tape for telegraph transmission. The technology was discontinued at the beginning of World War II as other systems were perfected. And while many of them are still in use, they are rapidly being eclipsed by digital technologies.

Transmitted photographs were among the many new technologies emerging throughout the 1920s to improve the speed and scope of photographic reportage. They were just one part of the complex equation that helped to create the global phenomenon of print mass media. With the help of new cameras and the emergence of news associations, illustrated magazines, and newspapers, the photograph surpassed the written word as the primary means of mass communication.

Bartlane
(Bartholomew &
McFarlane)
English, active
1920s–1930s

Lindbergh and Plane,
May 20–21, 1927

*Gelatin silver print,
transmitted image*
GIFT OF MAYNARD
MCFARLANE
68:0323:0042G

Born to a wealthy family, Dr. Erich Salomon obtained a doctorate in law from the University of Berlin before World War I. He struggled to make a living in the inflation-driven chaos of Weimar Germany, finding a position with a publishing house. In 1926 he bought an Ermanox, an unobtrusive hand camera, and began to photograph political functions that were considered off-limits to the press. Salomon's elegant bearing and social graces gained him access to diplomatic meetings, as depicted here in "Summit Meeting ...". It also awarded him the respect and acceptance of his subjects, who came to depend on Salomon's pictures as a public record of their work. More than any other photographer of his day, Salomon defined a new style of reportage that prized the spontaneous and the direct. His work was called "candid" photography and was eagerly sought by a host of illustrated weekly magazines.

Although Salomon became a celebrity in his own right, he did not escape the terrors of World War II. Interned at Auschwitz, he, his wife, and son were killed there in 1944.

Erich Salomon
German, 1886–1944

Summit Meeting in 1928. The Architects of Franco-German Rapprochement, Aristide Briand and Dr. Gustav Stresemann, Meet in the Hotel Splendide in Lugano with British Foreign Minister, Sir Austen Chamberlain. From left to right: Zaleski, Poland; Chamberlain; Briand; Scialoia, Italy, 1928

Gelatin silver print
MUSEUM PURCHASE
81:1926:0001

The figure of Robert Capa, née Andréi Friedmann, looms large in the history of photojournalism. He is remembered as the quintessential war photographer, having traversed the historical tides of civil revolution in Spain and the large-scale combat of World War II. Through pictorial magazines such as *LIFE*, his unparalleled work showed with great sensitivity the human drama of combat, its agonies, and its triumphs.

Capa came to photography as a young man, politically attuned to the civil discord then raging throughout the European continent and his homeland of Hungary. Working as a darkroom assistant in Berlin in 1931, he was given his first photojournalistic break – to photograph a political gathering in Copenhagen where Leon Trotsky was to speak. Robert Capa had to slip into the meeting, which was closed to press photographers, and, like Erich Salomon before him, surreptitiously get his photograph. Carrying the new Leica 35mm camera, Capa seized upon a portrait of Trotsky as the spellbinding orator, caught up in the fervor of a highly charged political moment. This portrait, reproduced below, became Capa's first published work, printed in the popular German illustrated weekly *Berliner Illustrierte Zeitung*.

**Robert Capa
(Andréi Friedmann)**
American, b.
Hungary, 1913–1954

Leon Trotsky,
Copenhagen, 1931

Gelatin silver print
66:0080:0005

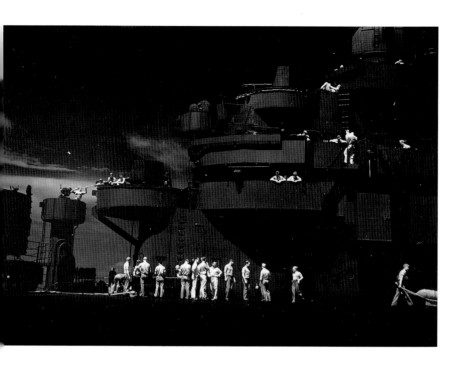

When the United States entered the war in 1941, Edward Steichen, then 62 years old, approached the Department of the Navy for permission to form a small special unit of photographers to document the role of Naval aviation. Aware of the value that positive propaganda would have at home, the Navy took the unusual step of accepting Steichen's offer. This unit, consisting of Horace Bristol, Paul Dorsey, Barrett Gallagher, Fenno Jacobs, Victor Jorgensen, Charles Kerlee, Wayne Miller, John Swopes, and Steichen himself, was for the most part handpicked by Steichen from professional photographers, who were then commissioned into the Navy. The unit worked independent from all official naval photographic services. Steichen went aboard the U.S.S. *Lexington* as it joined the strike force supporting the attack on Kwajalein Island in the South Pacific in 1943. This dramatic photograph, playing the hulking mass of the aircraft carrier's superstructure against the intent figures of the sailors preparing for the air strike, imparts both the sense of massive military power and intense, concentrated human purpose.

Edward J. Steichen
American, b.
Luxembourg,
1879–1973

Aboard the U.S.S.
Lexington: Preparing
for the Strike on
Kwajalein, 1943

Gelatin silver print
GIFT OF JOANNA
T. STEICHEN
74:0025:0732

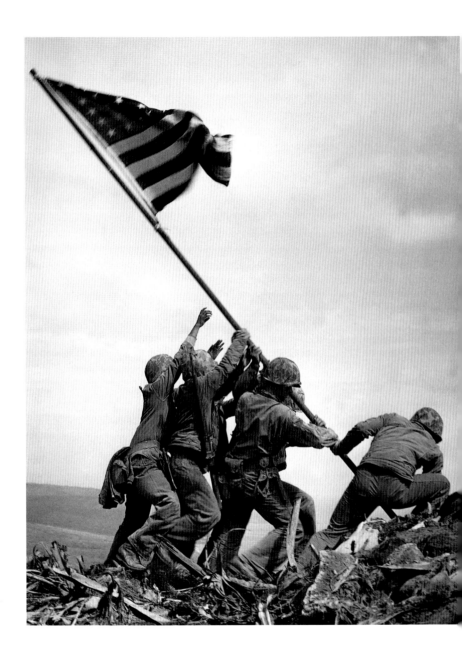

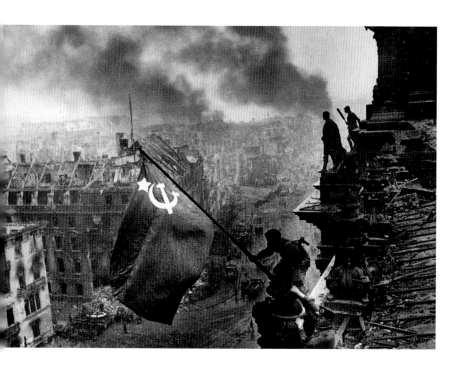

Yevgeny Khaldei
Russian, 1917–1997

Berlin, 1945

Gelatin silver print
MUSEUM PURCHASE,
FORD MOTOR
COMPANY FUND
96:0359:0004

(left)
Joe Rosenthal
American, b. 1911

Old Glory Goes up
on Mt. Suribachi,
Iwo Jima, 1945

Gelatin silver print
GIFT OF THE
ASSOCIATED PRESS
81:1678:0001

On February 19, 1945, the United States Marines invaded Iwo Jima, a tiny, critically strategic island in the South Pacific. By the fifth day of the invasion, the marines had swept the Japanese defenders from the beach and its commanding volcanic cone. While fighting continued for another month, the Battle for Iwo Jima had been won. A group of soldiers was detailed to replace the first small flag placed on the mountain with a larger, more visible one. Joe Rosenthal, an Associated Press photographer, came ashore with the group and photographed them as they raised the new flag. His photograph immediately became a national icon, transmitted around the world as the quintessential symbol of American victory.

In Europe, Yevgeny Khaldei, a member of the Soviet news agency TASS, saw Rosenthal's photograph and drew on it to make an equally dramatic image of Soviet triumph. During the fall of Berlin, Khaldei and several combat soldiers made their way to the Reichstag roof where he

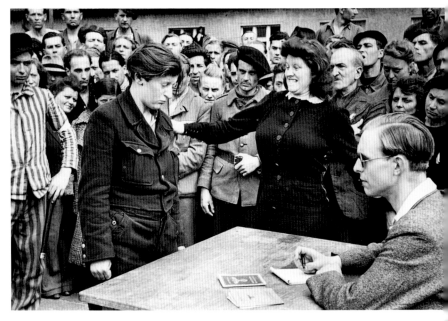

Henri Cartier-Bresson
French, 1908–2003

Dessau: Exposing a Gestapo Informer, 1945

Gelatin silver print
MUSEUM COLLEC-
TION, BY EXCHANGE
73:0057:0002

(right)
Unidentified Associated Press photographer
American?, active 1950s

Army Troops See Atomic Blast, 1951

Gelatin silver print
GIFT OF THE
ASSOCIATED PRESS
92:0902:0012

found "a good angle," gave his homemade flag to a soldier to wave, and created this memorable photograph.

In the years immediately following World War II, photojournalism played a greater role in the mass media, defining the dawn of a perilous age born of unprecedented human conflict and scientific invention, as seen in Henri Cartier-Bresson's "Dessau" and an unidentified photographer's "Army Troops See Atomic Blast." Though the images on these two pages are separated by geography, nationalistic concerns, and time, both communicate the consequences of a war that shook the foundation of modern civilization and its rationalist underpinnings.

A renowned photographer and filmmaker, Henri Cartier-Bresson was 36 years old when he took the "Dessau" photograph. He had spent much of the war as a prisoner before escaping and joining the French Resistance movement. Shaped by his war experiences, Cartier-Bresson took up a more socially involved photography, seizing upon the telling gesture or, what was termed the "decisive moment," rendering the dark and haunting narrative of betrayal and retribution.

Perhaps more than any other press image of its time, the towering inferno of an atomic blast epitomized a new world order – the United

States' new global power, the Cold War, and the frightening specter of nuclear war.

In 1962 Edward Steichen, then the most powerful taste-maker in American photography, wrote about W. Eugene Smith's "The Thread Maker": "This image of a woman weaving in a Spanish village has some of the splendor and grandeur of Spanish painting – of Velasquez, Goya and El Greco." Steichen's statement expressed a view that many in reportage photography held: Photojournalism in addition to being a tool of news-gathering could also be a creative practice resonant with the qualities of fine art. More than any other photographer of his generation, W. Eugene Smith attempted to realize this goal, through classically rendered works of technical virtuosity and emotional intensity.

W. Eugene Smith
American, 1918–1978

The Thread Maker, 1951

Gelatin silver print
80:0338:0001

Smith's genius at making photographs that were both dramatic and artistic kept his reputation aloft, but for him the more important photographic format was the narrative essay, the combination of images and

text to illuminate a specific topic. He believed that the more developed photographic essay was capable of providing a larger understanding of the human story. His skill at crafting essays that were intellectually stimulating and emotionally moving defined the high points of photojournalistic practice during the 1940s and 1950s.

Firmly believing that the photographer should maintain editorial control, Smith left *LIFE* magazine in 1954 when he reached an impasse with the picture editors over the presentation of his essay on Dr. Albert Schweitzer. In later years, Smith served as a mentor to a new generation of photographers who developed their work outside the framework of institutionalized photojournalism.

W. Eugene Smith

Pittsburgh Steel
Worker, 1955

Gelatin silver print
MUSEUM PURCHASE
WITH EASTMAN
KODAK COMPANY
FUNDS
81:1935:0001

W. Eugene Smith

Lambarene, French
Equatorial Africa,
1954

Gelatin silver print
MUSEUM PURCHASE
66:0023:0013

Bill Brandt
English, b. Germany,
1904–1983

Parlour Maids,
London, ca. 1936

Gelatin silver print
MUSEUM PURCHASE
77:0745:0011

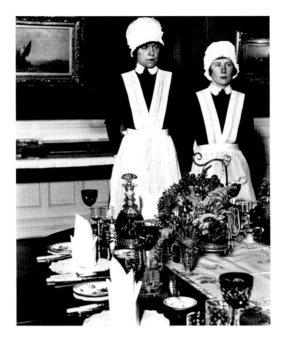

(right)
Bill Brandt

Belgravia, London,
1951

Gelatin silver print
MUSEUM PURCHASE
77:0745:0018

During the 1920s Bill Brandt's formative years in photography were largely shaped by a circle of friends who were part of the surrealist movement in France. He spent a few months in the studio of Man Ray, producing little, but taking in the intellectual life that flourished around him. In 1931 Brandt settled in England and there began his prodigious career, first as a photojournalist, and later as a fine art photographer. Unlike other photojournalists of the day, Brandt prized the square format of the Rolleiflex camera over the rectangular format of the popular 35mm camera. His "Parlour Maids, London," a variant of which is published in the book *The English at Home*, introduces a spirited irony into Brandt's look at the British class system. After World War II, Brandt re-dedicated his photographic career to investigating themes that portrayed the poetic sensibilities then displayed in contemporary art photography. Building on his surrealist roots, Brandt's "Belgravia, London" revels in the turbulent distortion of form and space, transforming and invigorating the time-honored, universal subject of the female nude.

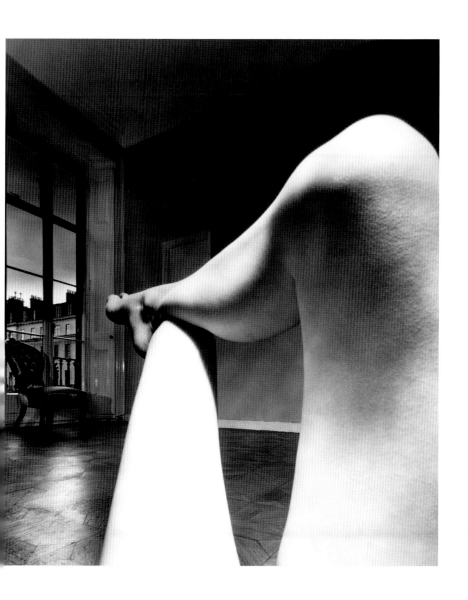

The Visual Mind

Once photography had become accepted as a viable art medium, pho-
tographers began to push the boundaries of perception beyond the
merely "seeable." The most influential photographer who advocated
this pursuit in both word and image was Minor White. After receiving a
degree in botany from the University of Minnesota, White was appoint-
ed "creative photographer" with the Works Progress Administration. In
1955, after he began studying comparative religions, a profound sense
of spirituality permeated White's work. The Eastman House collection
holds 155 prints by White, including a 117-image, autobiographical se-
quence titled *Sequence 13: Return to the Bud* (originally titled *Ashes Are
for Burning*). The narrative sequencing of images, which White called a
"cinema of stills," was his preferred method of presenting photographs.
"Lake Road, Rochester" is an image of two construction tarpaulins

Minor White
American,
1908–1976

Lake Road,
Rochester, 1957

Gelatin silver print
77:0369:0095

Minor White

Mission District,
San Francisco, 1949

Gelatin silver print
77:0369:0025

Minor White
American,
1908–1976

The Three Thirds,
1957

Gelatin silver print
72:0250:0001

draped in front of a cement wall; a ladder extends upward between them. The movement of the fabric is both animated and elegiac, like the rapid, nervous flapping of a trapped hummingbird.

The thin, vertical format of "Mission District, San Francisco" (page 639) demonstrates the artist's ability to select the essential element from his larger negative in order to convey the desired feeling. The radical cropping also suggests that, in White's view, the only thing that should not be manipulated in the creation of a successful photograph is the artist's vision. Both images were part of *Sequence 13*. "I always photograph found objects; excepting portraits, all of my photographs are of found objects ... the best of them have always been photographs that found themselves," he wrote in 1957, the year that *Sequence 13* was first exhibited at Eastman House. "When I look at pictures I have made, I have forgotten what I saw in front of the camera and respond only to what I am seeing in the photographs." According to White, there are two ways to be creative: "... the first is accomplished by *photographing the subject itself in such a way that its character is revealed;* the second is accomplished by *choosing a subject to photograph which will illustrate an idea heretofore existing only in the mind of the photographer.*"

Minor White

Sun & Rock, 1948

Gelatin silver print
73:0063:0009

"The Three Thirds" can be read as a literal title, referring to the three distinct formal elements in the print: clouds reflected in a window, plaster oozing through a boarded up opening, and a jaggedly broken window pane. By titling the work "The Three Thirds," White implies that the image is to be understood as the sum of its parts, therefore representing a whole. Throughout his life, White would return to the tripartite form that held spiritual as well as formal significance for him. "Sun & Rock" is an image from the sequence *Song without Words*, which White created to reflect the turmoil he was feeling regarding his homosexuality. At one time curator of exhibitions at George Eastman House and editor of its journal *Image*, White was an extremely important photographer, publisher, and educator, referred to by a contemporary as "the very archetype of the artist-as-guru ... enclosed in a mysterious penumbra of spirituality." Alfred Stieglitz, Edward Weston, and Ansel Adams had been his mentors; Carl Chiarenza and Paul Caponigro became his students. In 1952, along with Ansel Adams, Dorothea Lange, Barbara

Morgan, and Beaumont and Nancy Newhall, White founded the influential *Aperture* magazine and was its editor for 23 years.

Born in San Francisco, Ansel Adams trained as a concert pianist. His first photographs were made using a Kodak Brownie camera during a visit to Yosemite Valley with his parents in 1916, which he described as "a culmination of experience so intense as to be almost painful. Since that day ... my life has been colored and modulated by the great earth gesture of the Sierra." He returned every summer, becoming a mountaineer and, more important, conservationist – which is ironic, perhaps, in that Adams' grand images have inspired increased tourism in the National Parks. In 1927 Adams made one of his most famous images, "Monolith, the Face of Half Dome" (page 645). The image is part of an Adams portfolio in the Eastman House collection, which the Sierra Club published in 1959.

In 1930, after meeting Paul Strand and finding his negatives to be a revelation, Adams decided to pursue photography as a career. Probably

Ansel Adams
American,
1902–1984

Lake Cliffs, Kaweah
Gap, Sierra Nevada,
ca. 1932

Gelatin silver print
72:0065:0074

surprising to many people, Adams's earliest images were pictorialist in style, soft-focus and romantic. Then, in 1931, he wrote in his diary: 'Awoke in a kind of vision. It was like the Annunciation! Suddenly I saw what photography could be ... a tremendously potent pure art form," and Adams abandoned his pictorialist style. The following year, he became a founding member of the Group f/64, advocating the expressive potential of straight photography. "Lake Cliffs, Kaweah Gap, Sierra Nevada" demonstrates the full range of the medium's potential in tonal range and clarity of detail. In 1940 Adams became one of the founders of the department of photography at New York City's Museum of Modern Art – the first museum ever to have a department dedicated to the medium as a fine art. The following year, he made "Moonrise, Hernandez, New Mexico" a signature Adams image. This print reveals that Adams's art was as calculated as that of the most ardent technician. Rather than evoke the day's-end melancholy of "sunset," Adams titled

Ansel Adams

Moonrise, Hernandez, New Mexico, 1941

Gelatin silver print 74:0082:0001

Ansel Adams
American,
1902–1984

Surf Sequence III,
California Coast,
ca. 1940

Gelatin silver print
72:0065:0020

the image "Moonrise." Likewise, he printed two versions of the image: one in which the sky is rendered a dusky gray, closer to how it appeared at twilight, and this more famous version in which Adams printed the sky much darker. This helps create a dramatic, almost otherworldly contrast that highlights every cross in the tiny cemetery seen at the lower edge of the picture.

A photograph such as "Surf Sequence III, California Coast" reveals Adams's musical background. As he himself explained about the importance both of pre-visualization and darkroom technique: "The negative is the score, the print is the performance." In its layers of almost pure white to black with every nuance of gray in between, the sea veritably resonates with a full scale of sound. Of his work, Adams wrote: "Who can define the moods of the wild places, the meanings of nature in domains beyond those of material use? Here are the worlds of experience beyond the world of the aggressive man, beyond history, and beyond

(right)
Ansel Adams

Monolith, the Face
of Half Dome, 1927

Gelatin silver print
MUSEUM PURCHASE
81:1018:0001

Harry Callahan
American,
1912–1999

Eleanor, Chicago,
1953

Gelatin silver print
81:1135:0002

science. The moods and qualities of nature and the revelations of great art are equally difficult to define; we can grasp them only in the depths of our perceptive spirit." Eastman House has nearly 300 photographs by Adams, indisputably America's best-known photographer.

Harry Callahan's work is represented in the Eastman House collection by almost 100 images. Callahan was an engineer for Chrysler Corporation and became interested in photography as a hobby. Then, during a couple of weekend sessions at the Detroit Photo Guild, he saw Ansel Adams's work, which made him realize the potential of the medium. In 1945 Callahan spent six months in New York concentrating on his newly chosen profession; the following year, László Moholy-Nagy appointed him instructor at the Institute of Design in Chicago. Callahan's photographs of his wife Eleanor are among the most personal, lyrical, and poignant portraits in the history of the medium.

Harry Callahan

Detroit, ca. 1947

Gelatin silver print
MUSEUM PURCHASE
81:1131:0001

He photographed her from the beginning of their marriage in 1936. In his image of Eleanor, made in Chicago, she stands in perfect alignment with the telephone pole in the exact center of the composition. The cars and architecture are slightly off-balance, intentionally preventing this from being a perfectly symmetrical composition. An image of a pencil-fine branch against pure snow simply titled "Detroit" belies its urban name and is a triumph of abstract minimalism. "[I]t's the subject

Frederick Sommer
American, b. Italy,
1905–1999

Eight Young
Roosters, 1938

Gelatin silver print
MUSEUM PURCHASE
71:0112:0002

(right)
Frederick Sommer

Moon Culmination,
1951

Gelatin silver print
MUSEUM PURCHASE
72:0006:0001

matter that counts. I'm interested in revealing the subject in a new way to intensify it. A photo is able to capture a moment that people can't always see." Callahan's explanations were like his photographs – succinct and elegant.

In 1935, for health reasons, Italian-born landscape architect Frederick Sommer settled in Arizona, and in the 1930s his encounters with Alfred Stieglitz and Edward Weston encouraged him to pursue photography more seriously. Sommer's early imagery had strong Surrealist overtones; although he was never part of any acknowledged art movement, he did work with Man Ray and Max Ernst, photographing the latter on a trip to Arizona. The anatomy of chickens proved to be a recurring subject for Sommer; "Eight Young Roosters" is an anatomical grid of eviscerated parts, displayed not so much for their shock value as for their strange, repellent beauty. "Moon Culmination" shows a torn and weathered picture of a dancing couple that time and nature has blended into

Aaron Siskind
American,
1903–1991

Martha's Vineyard
107, 1954

Gelatin silver print
MUSEUM PURCHASE
81:2343:0020

Aaron Siskind

Chicago, 56, 1960

Gelatin silver print
MUSEUM PURCHASE
81:2343:0007

rock. Through such an unlikely juxtaposition, Sommer finds commonalities of poetic and universal form in vastly disparate objects.

"I have brought to my picturemaking, qualities of expression that come out of my experience of music and literature. My belief in the meaning of abstract expression came from my love of music," Aaron Siskind told an interviewer. His photographs of rocks at Martha's Vineyard and graffiti on a wall in Chicago appear a world apart from his previous documentary work, yet they share his extraordinary sense for the telling gesture and poised balance. Throughout a prodigious career that led him from documentary to abstract photography, Siskind remained an influential presence on the American art scene, first at the Photo League and later as an instructor at the Institute of Design in Chicago through an invitation from Harry Callahan. For further discussion on Siskind, see page 608.

The metaphorical relationship between music and photography

Wynn Bullock
American,
1902–1975

The Tide Pool, 1958

Gelatin silver print
MUSEUM PURCHASE
81:1072:0018

Carl Chiarenza
American, b. 1935

Untitled # 32, 1962

Gelatin silver print
MUSEUM PURCHASE
80:0339:0005

that Ansel Adams and Aaron Siskind found was also sensed by Wynn Bullock, Carl Chiarenza, and Paul Caponigro. Wynn Bullock worked as a professional singer before studying photography at the Los Angeles Art Center. His images have been hailed as evocative and almost mystical. One such photograph (page 651) challenges the viewer's understanding of the subject through its abstract ambiguity in which formations in a tidal pool are transformed into a celestial landscape.

Carl Chiarenza said of his own images: "The landscapes that appear in my photographs are about ideas about the land through time; they are, for me, landscapes of the mind ... as mysterious and as full of unknown forces as [they have been] through history." Abandoning recognizable subject matter early on to photograph crystalline structures, Chiarenza showed the spiritual influence of his teacher, Minor White, in his work. Visually, his photographs find communion with Siskind's abstract images. (Siskind's influence was so important that Chiarenza

Paul Caponigro
American, b. 1932

West Hartford,
Connecticut, 1959

Gelatin silver print
MUSEUM PURCHASE
WITH NATIONAL
ENDOWMENT FOR
THE ARTS SUPPORT
80:0212:0002

wrote a biography about him in 1982.) "Untitled # 32" transcends the specificity of the thing photographed, going beyond mere surface to reveal what cannot be seen. The deep, rich blacks in Chiarenza's prints represent not the absence of light, but rather, a spiritual presence.

Just as Chiarenza's passion for music, especially Beethoven, has informed his photographic work, so too did Paul Caponigro's early music studies influence his own sense of rhythm and movement in photographs. Also a student of Minor White, Caponigro cites Weston, too, as an important inspiration. "West Hartford, Connecticut" is a landscape of delicate balance. "To listen is to be brought to oneness/To listen is to awaken the greater love/And gently part the barriers to true seeing/The eye of truth providing the wedge/For the barriers to break and the inner ear to listen," wrote Caponigro. These photographers expanded the notion of what a photograph can mean, challenging the viewer to read beyond the surface of the object depicted and investigate the possibilities of the medium revealing more than the thing itself. Although visually very different, this work laid the conceptual groundwork for the experimental work of the 1970s and beyond.

America Seen

After World War II, a growing number of photographers began to
seek ways to achieve a personal vision. Many went into the streets with
35mm cameras and used an approach that became defined as "avail-
able-light photography." Prints with more pronounced photographic
grain, harsher contrast, and out-of-focus, truncated forms helped to im-
part a sense of immediacy to an image. Louis Faurer made his living as
a fashion photographer from 1947 to 1969, working for *Harper's Bazaar*
and other magazines in New York City. During the late 1940s and 1950s
Faurer, like his friend Robert Frank, spent much of his free time pho-
tographing the ever-changing streets of New York City, seeking poetic
images from the flux of urban living.

Roy DeCarava worked in New York City as a commercial artist and il-
lustrator from 1944 to 1958, and after that as a freelance photographer.
On his own time he photographed in the streets of Harlem, where he
lived, gradually building an oeuvre of often melancholic, but always
evocative, humane images. His 1955 book *The Sweet Flypaper of Life*,
with text by Langston Hughes, provided a rare and early opportunity
for an African-American artist to find a public voice in America.

William Klein
American, b. 1928

Gun 2, near the
Bowery, New York,
1955

Gelatin silver print
MUSEUM PURCHASE,
LILA ACHESON
WALLACE FUND
85:1058:0003

Demobilized in Paris in 1948, William Klein studied art, meeting the painters Fernand Léger, Bill Max, and expatriate Americans Ellsworth Kelly and Jack Youngerman. In the early 1950s Klein began to experiment with hard-edged, abstract painting. Although visually different, this work would influence his gritty, no-nonsense approach to street photography. In 1954 he returned briefly to New York City where he photographed extensively in the streets. An image of three children grinning for the photographer as an adult points a toy gun at one child's head intimates the undercurrent of violence and loss of innocence that Klein found in his wanderings through the city. The subject of children and guns was one to which Klein returned many times, clearly drawn to the jarring juxtaposition of violence and play. His description of the city as "... this mixture of beauty, tenderness, idiotic brutality and incomprehensible menace" is also embodied in this image, which shatters the illusion of idyllic childhood. Klein's book *New York,* published in 1956, combined a radical, almost visceral layout with a harsh inking of Klein's high-contrast, light-flared, granular prints. Klein has published 15 other photographic books of his own design and directed more than 20 films.

David Heath
American, b. 1931

Vengeful Sister,
Chicago, 1956

Gelatin silver print
MUSEUM PURCHASE
WITH EASTMAN
KODAK COMPANY
FUNDS
80:0366:0001

In 1947, at age 16, David Heath saw Ralph Crane's *Bad Boy's Story*, a classic photo essay about a child in an orphanage in *LIFE* magazine. Heath himself had spent his childhood in a series of orphanages and foster homes. Consequently, this photo essay would prove to have a commanding influence on his decision to become a photographer. Like Crane, Heath worked in terms of narrative groups of images. As his primary subject, he chose to address the impact that the powerful forces of isolation and community had on the human spirit, as seen in the haunting image "Vengeful Sister, Chicago." Throughout his career, Heath's work has been strongly autobiographical. His approach was very much in step with the time when the turbulent voice of the subjective "I" took center stage in the visual and literary arts. "For me," Heath wrote, "the act of photographing is no more than making notes, diaristic notes...." Profoundly moved by Robert Frank's *Les Américains*, Heath recognized that the book format provided the proper structure for his photographic art. His book, *A Dialogue with Solitude*, which he finished in 1961 but wasn't printed by an independent publisher until 1965, pushed the extended photographic essay form into a personal and poetic dimension that was unusual at that time and is still rarely seen today.

Lee Friedlander described his photographic practice in the early 1960s as documenting "the American social landscape and its conditions." This statement was only partially true; more accurately, his photographs are about a dialogue between the observer and the American social landscape and its conditions, as seen in "New York City," an image from Friedlander's self-portrait series. This series, in which the photographer's shadow or reflection intrudes into the image, contains a device reminiscent of certain literary conventions found in modern fiction since the time of Molière. It is an autobiographical device that allows the "author" to introduce personal commentary into the very heart of the narrative. Friedlander frequently employed this device to assert his presence into images that might otherwise be read as documentary records. As he once noted: "... I was finding myself at times in the landscape of my photography. I might call myself an intruder. At any rate [my photographs] came about slowly and not with plan but more as another discovery each time. ..." In the end, Friedlander's photographs are as much about personal observation as they are about the medium itself. Like his friend and fellow photographer Garry Winogrand, Friedlander worked to understand what the world looks like when photographed;

Lee Friedlander
American, b. 1934

Galax, Virginia, 1962

Gelatin silver print
MUSEUM PURCHASE
WITH NATIONAL
ENDOWMENT FOR
THE ARTS SUPPORT
81:0303:0002

in other words, how reality is transformed through the medium of photography into something else – something that will always be a picture and may occasionally become art.

Throughout his career, Friedlander's approach to picture-making involved taking numerous photographs and putting them together in groups. From within these distinct groups, a theme would slowly emerge. Thus, Friedlander seeks photographic content and meaning not in a single image, but as they evolve from the discoveries made during the act of photographing and subsequently compiling images. While this dialectic of question and response was familiar to painters as they worked and reworked sketches for their paintings, it was far from common in photographic practice before the 1960s. In earlier photographic practice, the photographer simply sought to find the single "best" image. As the potential of books and museum exhibitions developed in the 1960s as venues of artistic communication, Friedlander and others could more readily think about finding their answers within the process of building an extended body of work rather than by defining themselves with single, iconic images.

Lee Friedlander

New York City, 1966

Gelatin silver print
MUSEUM PURCHASE
84:0837:0004

Garry Winogrand
American,
1928–1984

New York City, 1972

Gelatin silver print
GIFT OF ARTHUR
GOLDBERG
83:0151:0050

Although he began to photograph in 1948, Garry Winogrand didn't begin to develop serious ambitions for his work until the early 1960s. He would become the most existential photographer of his generation, creating a vision that stressed the authenticity of the fleeting moment, and the clarity of purpose that could emerge from within that moment. For him, the very act of taking photographs was the essence of experience, as he sought the extraordinary in the commonplace. But it was also a gamble; a gamble based on producing a huge number of photographs from which a successful image or a thematic body of work might emerge. Winogrand photographed prodigiously, even obsessively, as evidenced in his later years. At the time of his death in 1984, Winogrand had more than 2,500 rolls of exposed but undeveloped film in his possession, 6,500 rolls of developed but unproofed film, and 3,000 additional rolls with apparently unedited contact sheets. In other words, during his final five or six years, he made over a third of a million pictures that he never bothered to study after making the exposure. The photography collection holds 129 photographs by Garry Winogrand, including a set of 85 prints from the *Women Are Beautiful* series made in the 1960s.

Garry Winogrand

Coney Island,
ca. 1960

Gelatin silver print
MUSEUM PURCHASE
WITH EASTMAN
KODAK COMPANY
FUNDS
81:2077:0001

(left)
Garry Winogrand

San Marcos,
Texas, 1964

Gelatin silver print
MUSEUM PURCHASE
66:0058:0006

Bruce Davidson
American, b. 1933

Two Youths, Coney
Island, 1958–1959

Gelatin silver print
MUSEUM PURCHASE
80:0244:0032

Bruce Davidson's "Two Youths, Coney Island" is from a photographic essay on a Brooklyn youth gang that he worked on nearly every day for 11 months between 1958 and 1959. Davidson knew he wanted to be a photographer from the age of ten. Talented and lucky, his first photo essay was published in *LIFE* while he was still in college, and he was elected to the prestigious Magnum photo agency before the age of 25. His early influences were W. Eugene Smith, Henri Cartier-Bresson, and Robert Frank. His aspirations were to be an editorial photojournalist like Smith, and, like Smith, his practice was in his words, "... to work intensively with one group of people for one small period of time. ..." This in-depth concentration allowed Davidson to become more familiar with his subject and, in turn, for his subject to become more comfortable in front of his camera. From Cartier-Bresson, Davidson took a deep and basically positive humanistic stance. And, like Robert Frank, Davidson brought a poetic sensibility to an available-light style of granular, unfocused, harshly blocked tones, in order to depict outlaw or fringe elements in American society. The museum holds 67 photographs made by Davidson from 1958 to 1966.

Like Bruce Davidson, Danny Lyon has concentrated much of his attention on marginalized persons in American society. While still at the University of Chicago, he began photographing civil rights activities in the South for the Student Nonviolent Coordinating Committee, then in 1964 he returned to Chicago and began a four-year project to photograph a motorcycle gang, which was published in the book *The Bikeriders* in 1968. Between 1968 and 1991 he published several additional books and made films that he wrote, filmed, and edited. During 1967 and 1968 he photographed inside Texas prisons, ultimately producing the revelatory book *Conversations with the Dead: Photographs of Prison Life, with the Letters and Drawings of Billy McCune #122 054*. In subsequent years, Lyon has been drawn to homeless children in South America, the poor in Haiti, the working class in the American Southwest, and to documenting his own family. He has always been an advocate for the people he photographs. His choice of social topics, his working practices, the direction of his career, and even the public venues he has chosen have always functioned as an alternative to standard, "establishment" media practice.

Danny Lyon
American, b. 1942

Cal, Elkhorn,
Wisconsin,
ca. 1965–1966

Gelatin silver print
MUSEUM PURCHASE,
CHARINA FOUNDA-
TION FUND AND
FUNDS PROVIDED
BY MR. & MRS.
ROBERT A. TAUB
90:0003:0043

Danny Lyon
American, b. 1942

Building Shakedown,
ca. 1967–1968

Gelatin silver print
MUSEUM PURCHASE
71:0160:0003

While Danny Lyon documented his subjects from a sympathetic position, attempting to depict aspects of their lives with compassion and clarity, Larry Clark's view of nonconformity is more extreme.

A self-acknowledged drug addict, Clark photographed his own hermetic world of teenage drug addiction in his hometown of Tulsa, Oklahoma. His book *Tulsa*, published in 1971 by an independent publisher, was clearly autobiographical, and the photographs were direct and unsentimental without any moralizing or journalistic flourishes as seen here in "Man with Baby." It was a somber, powerful look into a previously unexplored world that was seemingly hidden from view.

The book caused a sensation within the photographic community, prompting many in the field to explore autobiography as the primary orientation for their work. Clark became an important member of a generation of photographers who worked to cast light on their particular lifestyle considered by mainstream America to be in opposition to traditional cultural values. He continues this approach in his current work as a filmmaker. The museum's holdings include a complete set of the 50 prints that were used to make *Tulsa*.

Larry Clark
American, b. 1943

Man with Baby,
ca. 1965

Gelatin silver print
MUSEUM PURCHASE
72:0136:0039

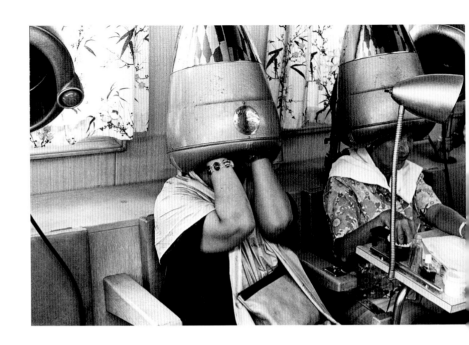

Joel Meyerowitz
American, b. 1938

*Women under
Hairdryers*, ca. 1964

Gelatin silver print
GIFT OF THE
PHOTOGRAPHER
78:0851:0020

Joel Meyerowitz studied painting in college and was working as an art director in New York City in 1962 when, inspired by Robert Frank's work, he began to make photographs. In 1966 he stated, "I find it strangely beautiful that the camera with its inherent clarity of object and detail can produce images that in spite of themselves offer possibilities to be more than they are ... a photograph of nothing very important at all, nothing but an intuition, a response, a twitch from the photographer's experience." Throughout the 1960s Meyerowitz, working in black and white with a 35mm camera, exercised his intuition along city streets and public spaces to find instances of the extraordinary, the bizarre, and the surreal in everyday life. In the 1970s, Meyerowitz took up color, larger cameras, and a more formalized style, helping advance two new photographic movements, "New Topographics" and "New Color," that flourished during the decade. He later said, "...[the small camera] taught me energy and decisiveness and immediacy ... The large camera taught me reverence, patience, and meditation." The photography collection holds 34 of Meyerowitz's early black-and-white photographs.

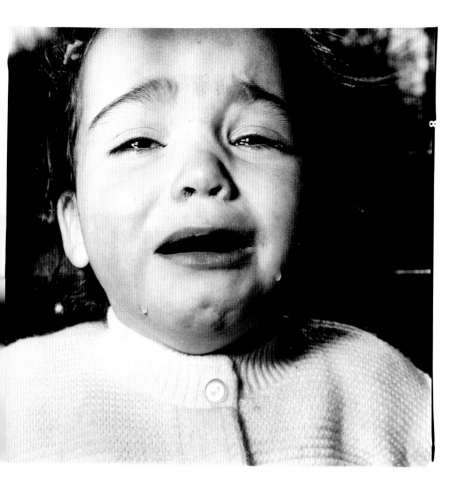

"A photograph is a secret about a secret. The more it tells you the less you know," Diane Arbus once noted. Arbus's uncanny ability to empathize with her subjects and thus extract startling moments of honesty from them produced some of the most confrontational and compelling portraits in the history of the medium. This extreme close-up of a child provides no visual escape or relief for either subject or viewer. In its stark frontal exposition, the photograph challenges the comfortable notion of blissful childhood to reveal its real terrors and fears, forcing the viewer not merely to look, but to see. As a photographer, Arbus was utterly daring, challenging herself to unveil the hidden realm of the human psyche.

Diane Arbus
American, 1923–1971

A Child Crying,
New Jersey, 1967

*Print 1988, by
Neil Selkirk.
Gelatin silver print*
MUSEUM PURCHASE,
CHARINA FOUNDA-
TION FUND
89:0358:0001

Bill Burke
American, b. 1943

How Many?
Kentucky State Fair,
Louisville, 1975

Gelatin silver print
GIFT OF THE
PHOTOGRAPHER
80:0343:0005

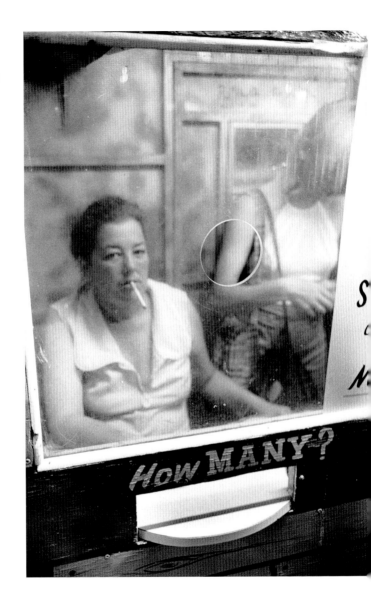

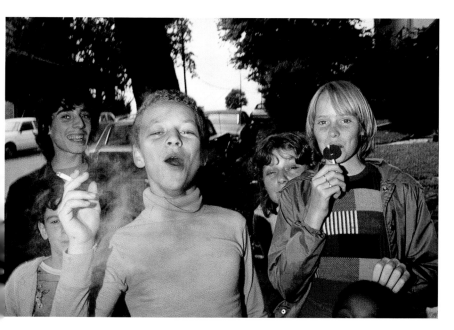

In a sense, both Bill Burke's "How Many?... " and Mark Cohen's "Group of Children" exemplify the logical end of several conceptual ideas that were fueling the "Street Photography" movement that was flourishing after World War II and the earlier documentary practice that preceded it. If photography is the most democratic of art forms, the one most tied to the very structure of democratic ideals, then it makes perfect sense to make photographs of "the people." The subject common to both Burke's and Cohen's art is the ordinary person involved in unexceptional, everyday events. By the early 1970s Mark Cohen, who ran a portrait studio in Wilkes-Barre, Pennsylvania, had become a street photographer of the vernacular who mined the mundane for photographs of mystery and beauty. The museum holds 127 of Cohen's images.

Bill Burke has also spent his career photographing the average citizen, the common face in the crowd. However, he has traveled to uncommon places to do this; the backwoods of Kentucky and West Virginia, the countryside of Brazil, and later the embattled land of Cambodia. But in each of these seemingly exotic places, he has always sought out the common citizen engaged in the daily activities, whether ordinary or notable, that give definition to the vast realm of human experience.

Mark Cohen
American, b. 1943

Group of Children,
ca. 1977–1978

Color print, chromogenic development (Ektacolor) process
MUSEUM COMMISSION WITH SUPPORT FROM THE EASTMAN KODAK COMPANY
78:0641:0034

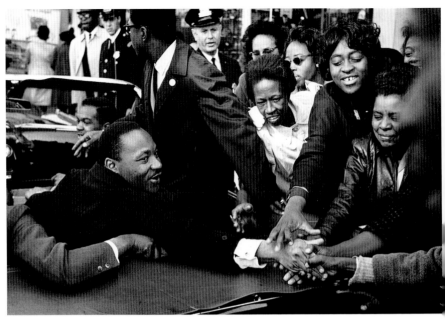

Leonard Freed
American, b. 1929

Dr. Martin Luther
King, Jr. Greeting
His Supporters after
He Received the
Nobel Peace Prize
in 1964, Baltimore,
MD, 1964

Gelatin silver print
GIFT OF THE
PHOTOGRAPHER/
MAGNUM PHOTOS,
INC.
88:0459:0003

The World Beat

In his 1991 book *Powerful Days*, Charles Moore stated that "Pictures can
and do make a difference. Strong images of historical events do have an
impact on society. ... The cry for freedom is heard from South Africa to
the Soviet Republics. We must not give up our own struggles in this
great country for increasing democracy and equality for all people." This
social perspective has fueled Moore's work as well as the work of others
featured in this chapter. These photographers directed their talents to-
ward the "hot" end of photojournalism, into the line of fire. Leonard
Freed, Charles Moore, and Flip Schulke each began to photograph the
Civil Rights movement in the American South in the 1960s as routine
assignments. Leonard Freed, a Magnum photojournalist, was gathering
materials for his book *Black in White America*. Flip Schulke was sent to
photograph Martin Luther King, Jr., for *Jet* magazine. A Montgomery,
Alabama, newspaper sent Moore to report on King's civil rights cam-
paign. For each of these photographers, their assignments turned into
a mission and an extended commitment to photograph the political
and social changes that were dividing American society.

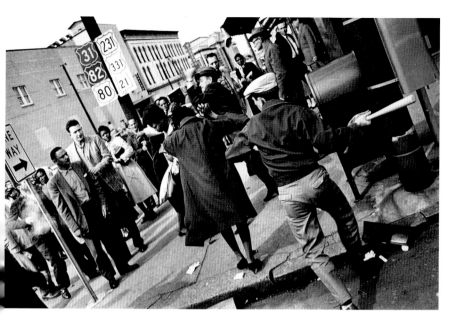

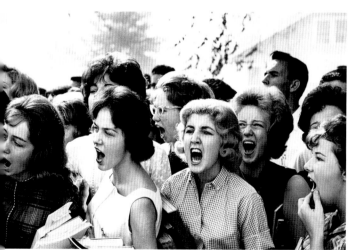

Charles Moore
American, b. 1931

Man Swinging Club
at Black Woman on
Montgomery, Alaba-
ma Street Corner,
ca. 1960–1961

Gelatin silver print
MUSEUM PURCHASE,
CHARINA FOUNDA-
TION FUND
88:0463:0002

(left)
Flip Schulke
American, b. 1930

White Students
in Birmingham
Demonstrate against
Integration in Their
High School,
September 1963

Gelatin silver print
GIFT OF THE
PHOTOGRAPHER
88:0397:0001

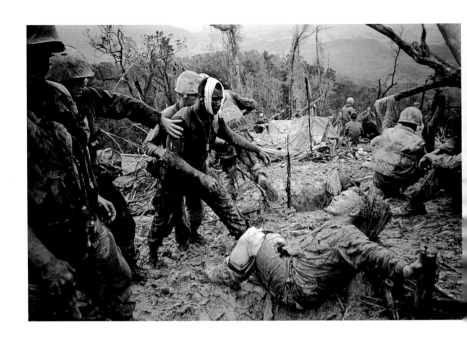

Larry Burrows
English, 1926–1971

Reaching Out, The DMZ (During the Aftermath of the Taking of Hill 484, South Vietnam), 1966

Print by F. Tartaro, 1987. Color print, dye imbibition (Kodak Dye Transfer) process
MUSEUM PURCHASE, FORD MOTOR COMPANY FUND
87:0390:0001

"Reaching Out, The DMZ ..." by Larry Burrows and "Khe Sanh ..." by Robert Ellison show the extraordinary immediacy and intimacy that photojournalists were able to achieve in their coverage of the Vietnam War. By the 1960s, 35mm cameras and color film had replaced the larger press cameras and black-and-white film to become the standard for magazine photojournalists. Photojournalists also began to put themselves in harm's way much more often than in the past. During World War II, Robert Capa and W. Eugene Smith's working in the midst of actual combat was considered to be beyond journalistic practice, but in ensuing years, many photographers routinely exposed themselves to dangerous situations, none greater than Vietnam. Burrows photographed the Vietnam War from 1962 until he was killed there in 1971. His photographic essay *Yankee Papa 13* (*LIFE,* April 16, 1965) is considered a hallmark of photojournalism, as is his color image "Reaching Out ...". Robert Ellison joined the Black Star photo agency and went to Vietnam, where he photographed the North Vietnamese Tet Offensive in Khe Sanh in 1968, before being killed two weeks later.

Robert Ellison
American,
1945–1968

Khe Sanh, Vietnam
War, 1968

*Print 1988. Color
print, chromogenic
development (Ekta-
color) process*
MUSEUM PURCHASE,
CHARINA FOUNDA-
TION FUND
88:0463:0001

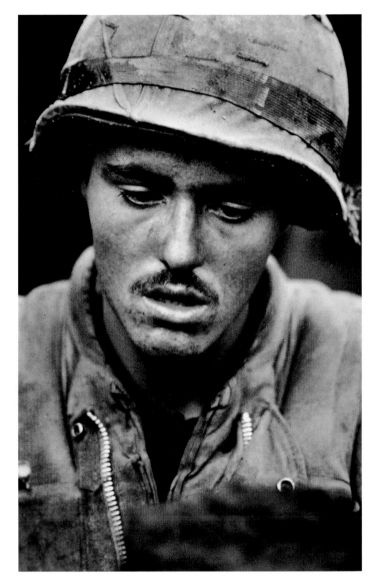

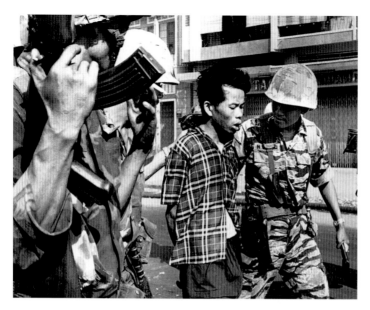

The photographs of Larry Burrows and Robert Ellison, among others, brought the agony and insanity of war home to the American people with a new immediacy and graphic power. In a guerrilla war with no fixed battle lines, neither the Vietnamese nor the American governments were able to exercise the degree of censorship imposed in earlier conflicts. This was certainly the case with Eddie Adams's 1968 "Vietcong Arrested," part of a series of photographs of a roadside execution. The series was made after a fire fight in the An Quang Pagoda in Saigon. The prisoner, supposedly a Vietcong lieutenant captured in the battle, was led to Brigadier General Nguyen Ngoc Loan, Vietnamese chief of police, who, without warning, pulled out a pistol and shot him in the head. The climactic image, also included in the museum's collection, became a universal symbol of the vicious nature of the war. As a result, it served to polarize public opinion about America's participation and its foreign policies.

Back in America, the national debate over the Vietnam War spilled into the streets, as depicted in Benedict J. Fernandez's photographs of anti-war protesters and pro-war supporters demonstrating in New York City. Fernandez captured the rallies, protests, and leaders that dominated the social landscape of the 1960s. The museum holds 114

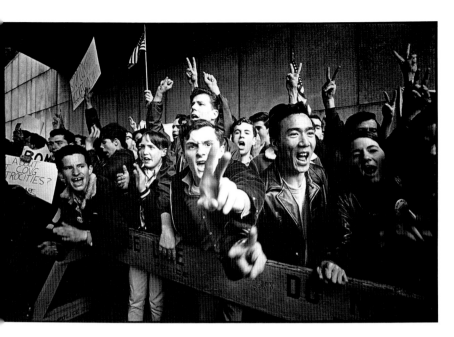

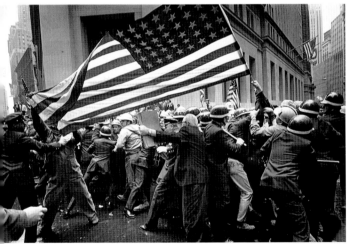

(left)
**Benedict J.
Fernandez**

Pro-Vietnam-War
Demonstration,
New York, 1970

Gelatin silver print
GIFT OF THE
PHOTOGRAPHER
96:0350:0014

photographs by Fernandez, including more than 50 photographs relating to Dr. Martin Luther King's life.

These two photographs by Don McCullin, "Cyprus" and "British Soldiers ... Londonderry" portray the violence of two of the many factional conflicts that have raged throughout the world since World War II. McCullin worked his way out of a London slum to become one of the most highly regarded photographers in Great Britain. He was introduced to a wider world and to photography while serving in the Royal Air Force in the 1950s. Back in England and working as a laborer, McCullin began to photograph his friends in a London youth gang. When a murder made the gang newsworthy, McCullin showed his "snaps" to a newspaper editor who was perceptive enough to publish them and to hire him as a stringer. In 1964 McCullin was sent on assignment by the London *Observer* to cover the civil war in Cyprus. His photographs, taken in the midst of the bitter house-to-house fighting and showing the suffering of the war's victims, won awards and international recognition for McCullin. He was hired by the London *Sunday Times* in 1967 and worked as a photojournalist for the next 20 years, photographing poverty in England and famine

Don McCullin
English, b. 1935

Cyprus, 1964

Gelatin silver print
MUSEUM PURCHASE,
FORD MOTOR
COMPANY FUND
88:0273:0001

and warfare in the Congo, South Vietnam, Cambodia, Biafra, India, Pakistan, the Sahara, Northern Ireland, Beirut, and elsewhere.

In 1989 McCullin summarized his work: "I don't believe you can see what's beyond the edge unless you put your head over it; I've many times been right up to the precipice, not even a foot or an inch away. That's the only place to be if you're going to see and show what suffering really means. ... I've spent fourteen years getting on and off aeroplanes and photographing other people's conflicts. I will never get on another aeroplane and go photograph another country's war." In spite of this promise, in the early 1990s McCullin went to war again, photographing Saddam Hussein's attacks on the Iraqi Kurds. McCullin, in seeking a larger audience, has published many books of his work throughout his career. *The Destruction Business* (1971), *Is Anyone Taking Notice?* (1973), *The Homecoming* (1979), *Hearts of Darkness* (1980), *The Palestinians* (1981), *Beirut: A City in Crisis* (1983), and *Don McCullin: Sleeping with Ghosts* (1996) are representative of his efforts.

Raymond Depardon's "Christian Phalangist Militiaman ..." (page 678) and Gilles Peress' "Pro-Shariatmadari Demonstration ..." (page 679)

Don McCullin

British Soldiers Dressed Like Samurais Charge Stone-Throwing Youths, Londonderry, 1970

Gelatin silver print
MUSEUM PURCHASE, FORD MOTOR COMPANY FUND
88:0273:0002

were both taken during the political turmoil wracking the Middle East in the late 1970s. Both men were top-ranking French photojournalists working for independent photo agencies. Each utilized the faster, better 35mm cameras and lenses available by the 1970s to place themselves in the middle of the tumultuous events they were photographing. Being at the heart of a conflict had become standard photojournalistic practice. Moreover, it was encouraged by many of the fighting factions, who hoped to air their cause in the world press.

Both photographs were taken with wide-angle lenses, allowing a greater depth of field at faster shutter speeds. As the name implies, the wide-angle lens encloses an expanse of space that is broader than normal human vision, exaggerating spatial perspective. It also renders very close and very distant objects in focus simultaneously. This allows the photographer to dramatically heighten, in both composition and mood, the startling action occurring in front of the camera. The result can be clearly seen in "Militiaman ..." in which Depardon has visually merged the rifleman in the foreground of his photograph with the source of enemy fire coming from a distant building.

Peress uses similar compositional strategies in his photograph to

Raymond Depardon
French, b. 1942

Christian Phalangist Militiaman Fires to Cover Himself as He Races for a New Position in the Shattered Streets of Beirut, 1978

Gelatin silver print
MUSEUM PURCHASE,
FORD MOTOR
COMPANY FUND
88:0459:0001

collapse the spatial structure of the image into one dynamic field of view. The almost abstract shapes of the truncated heads in the bottom foreground space are balanced against the cropped head of the ayatollah on the poster; these are counterbalanced against the middle and distant groups of men, some armed. This composition presents a complex and tense image, metaphorically suggesting the complexity and uncertainty of the political situation in Iran following the Shah's abdication and the American hostage crisis.

Depardon and Peress have both published several books and directed various documentary films. Peress's book, *Telex: Iran: In the Name of Revolution*, features 100 photographs with captions derived from his telegrams to his photo agency to present his sense of alienation as he watched and waited through the long days of the political crisis. More than simple reportage, this publication extends its message to encompass compelling personal commentary.

Mary Ellen Mark and Donna Ferrato documented social issues afflicting America in the 1980s. While both began their careers as general magazine photographers, each was drawn to addressing complex social

Gilles Peress
French, b. 1946

Pro-Shariatmadari
Demonstration,
Tabriz, Iran,
ca. 1979–1980

Gelatin silver print
MUSEUM PURCHASE,
FORD MOTOR
COMPANY FUND
85:0760:0001

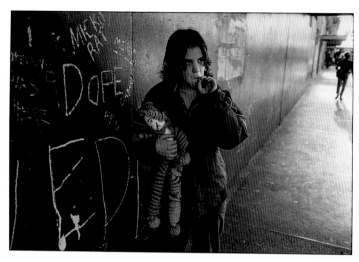

Mary Ellen Mark
American, b. 1941

Lillie with Her
Rag Doll – Seattle,
Washington, 1983

*Print by Sarah
Jenkins, ca. 1991*
Gelatin silver print
GIFT OF THE
PHOTOGRAPHER
97:2695:0028

Mary Ellen Mark

The Damm Family
in Their Car, Los
Angeles, California,
1987.

*Print ca. 1991 by
Sarah Jenkins*
Gelatin silver print
GIFT OF THE
PHOTOGRAPHER
97:2695:0054

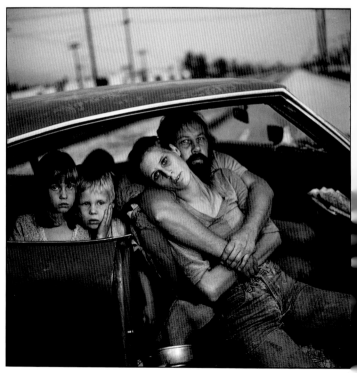

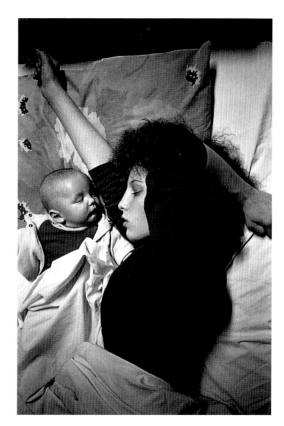

Donna Ferrato
American, b. 1949

First Night in
Shelter, February,
1987

Gelatin silver print
GIFT OF THE
PHOTOGRAPHER
88:0461:0001

themes that had previously not found a voice in print mass media. Ferrato wrote in the preface to her 1991 book *Living with the Enemy* that she began to photograph domestic violence in 1981, but could not find a magazine editor willing to print anything about the topic until after 1986. Mary Ellen Mark was faced with a similar obstacle. Her unprecedented book on the harrowing lives of homeless children, entitled *Streetwise*, was published in 1988, five years after the start of the project. For both Ferrato and Mark, photojournalism involves not only a commitment to revealing social problems, but engaging and altering prevailing public opinion.

In 1979, at age 32, Susan Meiselas became only the second woman to win the coveted Robert Capa Prize for photojournalism with a breakthrough body of work documenting the Nicaraguan revolution. In

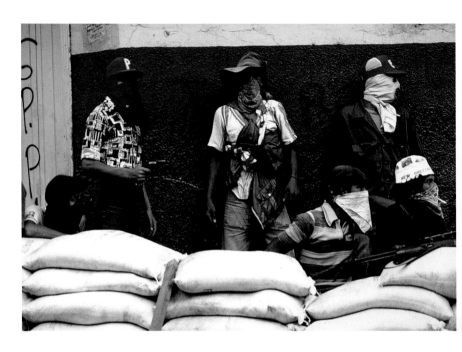

Susan Meiselas
American, b. 1948

Awaiting Counter-
Attack by the Guard
in Matagalpa,
ca. 1978–1979

*Color print, chromo-
genic development
(Ektacolor) process*
GIFT OF THE
PHOTOGRAPHER/
MAGNUM PHOTOS,
INC.
88:0459:0009

color-saturated photographs such as "Awaiting Counter-Attack by the Guard in Matagalpa," she emphasizes the psychological and physical suspense that accompanies the pause before an impending battle. Meiselas went to Nicaragua without an assignment and with little understanding of the language or the civil crisis there. What she did know was that it was a story largely ignored by the international press. When recognition did occur, her photographs served to define Nicaragua's upended political scene and shape the world's knowledge of it.

Unlike other photojournalists, past or present, Meiselas never hides her sympathy or allegiance to a specific cause or group when photographing in highly charged situations, as in her depictions of Nicaraguan rebels. She has always been aware of the photograph's power to elicit strong emotions and to sway public opinion. In ensuing years, Meiselas has made the political and social landscape of Latin and Central America a personal pursuit, including coordinating the efforts of photographers in El Salvador and gaining for them greater international exposure.

The development of faster color printing technologies for magazines and newspapers made color photojournalism a practical endeavor in

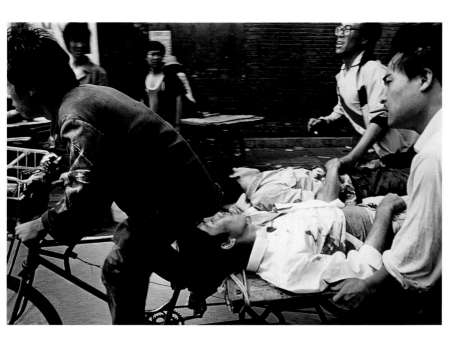

the 1970s. Since then, color photographs have gradually replaced black-and-white in most illustrated magazines and in many newspapers. A young photographer practiced in the psychological power of color photography is the Chinese photojournalist Liu Heung Shing, who was on assignment for The Associated Press during the student demonstration at Beijing's Tiananmen Square, and its subsequent suppression by Chinese authorities.

Born in China in 1951, Heung Shing studied journalism and political science at Hunter College in the United States. By the mid-1970s he was covering political hot zones for *Time* magazine. Like many of his contemporaries, including several cited in this publication, Heung Shing's use of color photography helps to collapse the psychological distance between the subject photographed and the viewer. This, coupled with the dramatic authenticity of color, not only integrates the overall composition of the photograph, but ensures the emotional scope and depth of the action at hand, as seen in Heung Shing's "Rescue Bullet Wounded ...". His use of color accentuates the violent context of the scene, thus creating a memorable emblem of civil strife.

Liu Heung Shing
American, b. Hong Kong, 1951

Rescue Bullet Wounded – A Rickshaw Driver Fiercely Paddled [sic] the Wounded People with the Help of Bystanders to a Nearby Hospital Sunday. P. L. A. Soldiers Again Fired Hundreds of Rounds towards Angry Crowds Gathered outside Tiananmen Square at Noon, June 1989

Color print, chromogenic development (Ektacolor) process
GIFT OF THE
ASSOCIATED PRESS
90:0466:0026

Peers and Predecessors

By the late 1960s the battle had been waged and (mostly) won over photography's status as a fine art. The medium had successfully imitated painting, and it had also come into its own, exploring its unique capabilities. Universities had established photography departments and programs; the Museum of Modern Art established a department of photography in 1940, and Eastman House opened its doors to the public in 1949. Several of the photographers discussed in this chapter, Thomas Barrow, Robert Fichter, and Joe Deal, worked at Eastman House at some point, which provided them access to the extraordinary wealth and scope of photographic history housed there. Others, such as Paul Berger, Betty Hahn, Les Krims, Joan Lyons, Bea Nettles, and Jerry Uelsmann, attended school, taught, or lived in Rochester, benefiting directly from the vibrant photographic community, including Visual Studies Workshop and the Rochester Institute of Technology.

With photography having made significant inroads into the academy of High Art, photographers began to use the medium to address what

Robert Heinecken
American, b. 1931

Mansmag, 1969

Offset lithographs in form of a booklet
GIFT OF THE
PHOTOGRAPHER
79:4389:0001

Thomas F. Barrow
American, b. 1938

*Television Image
Montage,* 1969

*Toned gelatin
silver print*
MUSEUM PURCHASE
70:0167:0002

museums and universities traditionally did not: popular media. After all, most people experienced photographs every day through television, newspapers, and magazines and were unfamiliar or unconcerned with the academic debate over whether or not this medium with such practical applications was capable of the same expressive qualities as painting. Informing this generation was also the precedent set by John Heartfield, László Moholy-Nagy, and Alexander Rodchenko, who used found images, text, and graphic design to convey political and personal messages through work that was not necessarily conceived as fine art.

Common to all of this work was dependence on the notion that people believe what they see in a photograph. "Because I was never in a school situation where someone said 'This is the way a photograph is supposed to look,' I was completely free to cut them up, combine them, or do anything. ... Some of my enthusiasm for the photograph was based on the fact that there was some residual illusion of reality in it always, no matter what I did to it," wrote Robert Heinecken, who was trained as a printmaker. "Mansmag" is part photomontage, part subversive performance. Using stock images from softcore pornographic houses and pages from women's fashion magazines, Heinecken montaged the porn images through the offset printing process and rendered the images as negatives. He thus blurred the distinctions between different types of cultural representation, leaving the viewer to contemplate the conflicted visual messages that the media feed women versus those they feed men.

Thomas F. Barrow's early work was also a commentary on popular media, in this instance on television, or "cathode ray canvas," as it has been called. Like Heinecken, Barrow used pornographic images, in this

Robert W. Fichter
American, b. 1939

Astronaut Still Life,
ca. 1974

*Cyanotype and gum
bichromate print*
MUSEUM PURCHASE
WITH NATIONAL
ENDOWMENT FOR
THE ARTS SUPPORT
74:0222:0004

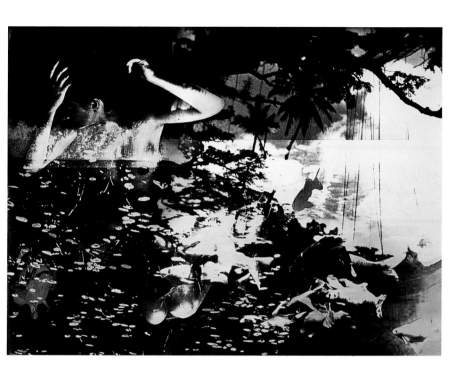

Bea Nettles
American, b. 1946

*Floating Fish
Fantasy,* 1976

*Van dyke print with
applied color*
MUSEUM PURCHASE
77:0387:0003

instance placed over a TV screen tuned to a soap opera. With the light produced by the TV, he rephotographed the montaged relationships – and meanings – that were newly created. The hypnotic layering of images that occurs on a TV screen in the split second when one frame changes to another also informs the work.

Robert Fichter's "Astronaut Still Life" uses the iconography of boy's toys and war games to construct an image of alienation and obliteration. A student of Jerry Uelsmann, Fichter stated, "I am a student of photography – not a photographer," referring to his use of the medium only as a means to an end. The clashing, acidic colors of the print send a chilling message of America's persuasive might expanding into new frontiers.

Fichter, Bea Nettles, and Betty Hahn used some of the older photographic processes – cyanotype, Van Dyke, and gum bichromate – to communicate their contemporary messages. The techniques imbue the work with a deliberate nostalgia, while also denoting the hand of the

Betty Hahn
American, b. 1940

Broccoli, 1972

*Gum bichromate on
fabric with applied
stitching*
MUSEUM PURCHASE
73:0044:0002

maker. Nettles created "Floating Fish Fantasy," (page 687) a densely
layered image that transforms elements of landscape into an imaginary
dreamscape. The subtle hand-coloring on the rich Van dyke print adds
an autographic dimension.

Nettles' imagery has been categorized as so-called "women's work,"
which emerged around this time to expand the acceptable limits of
media. Paper photographs stitched together, photographs on fabric –
these were some of the methods she and others employed. In a propi-
tious coincidence, Nettles' first camera was one that her grandmother
received from having bought a sewing machine.

Betty Hahn's "Broccoli," from her *Gum Bichromates on Fabric* series,
is a witty variation on the more traditionally defined "floral" images
in the history of art as well as those revered vegetables portrayed by
Edward Weston. A gum bichromate print on fabric, the image has been
embellished with embroidery thread, a craft that is traditionally associat-
ed with women. By combining these various media, Hahn claims each
of them as a valid means of expression, creating an object with no
precedent in art but with a rich history.

Although artists have always made self-portraits, the work of
Joan Lyons revels in the plasticity of the medium, utilizing alternative

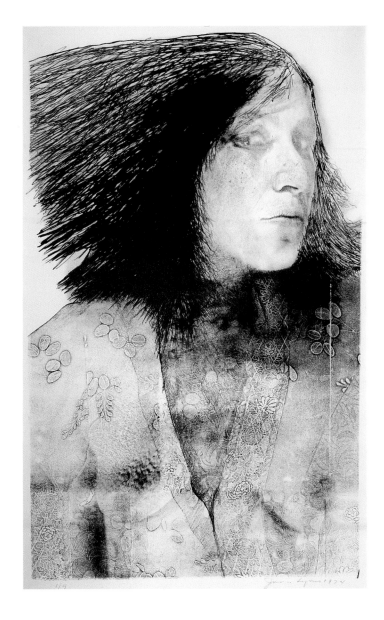

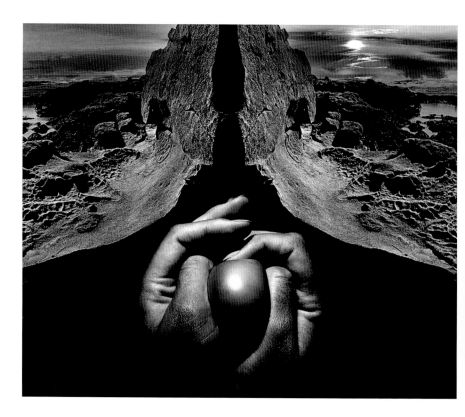

Jerry N. Uelsmann
American, b. 1934

Hands with Round Object in Mountainscape, 1970

Gelatin silver print
MUSEUM PURCHASE
73:0051:0002

imaging machines. As she defines it, her work exemplifies the "difference between autobiographical and personal and ideas that seem universal and common ... experiences that will be understood. ..." Lyons does not consider her series of portraits done on an early-model photocopier to be self-portraits. "The machine does funny things and I could make portraits of myself on that machine that make me look sixteen years old or make me look eighty-three. It's a different person each time."

For Jerry Uelsmann, the darkroom is a laboratory of technical and psychological exploration. Uelsmann credits Minor White as being one of his "photographic godfathers." His montaged images are as seamless as they are fabricated, challenging the viewer's beliefs about the veracity of the photographic image.

About his own portrait in his *Photo-Transformations* series, Lucas Samaras wrote: "Each click of the shutter suggests an emotional and

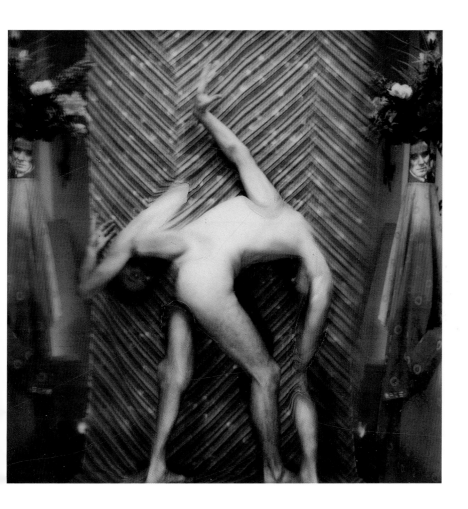

visual involvement and contains the potential of establishing greater rapport with some quintessential aspect of the subject and my feelings toward it, both conscious and preconscious." Samaras utilized the popular Polaroid SX-70 camera that produces a small, square instant image, a one-of-a-kind color photograph. Most commonly used for snapshots, the expressive possibilities of the Polaroid print are transformed through Samaras's use of homemade filters that radically alter color and his manipulation of the emulsion during development to produce the figurative distortions.

Lucas Samaras
American, b. Greece, 1936

Photo-Transformation, 1976

Color print, internal dye diffusion transfer (Polaroid SX-70) process
ALVIN LANGDON COBURN MEMORIAL FUND BY EXCHANGE
83:0617:0002

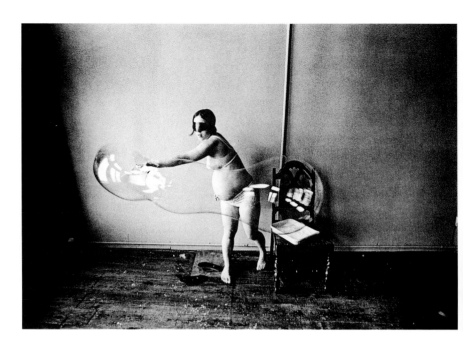

Les Krims
American, b. 1943

*Pregnant Woman
Making Large Soap
Bubble,* 1969

*Toned gelatin silver
(Kodalith) print*
78:0516:0022

The bizarre humor of Les Krims is an anomaly in the photographic canon. The incongruous and unexpected elements of "Pregnant Woman Making a Large Soap Bubble" make sense from a formal perspective: the huge, elongated bubble that the woman creates echoes the form of her belly. The subject elements conjure up different images from photographic history: the mask recalls Pierre-Louis Pierson's portrait of the Countess de Castiglione; the fluid orb recalls the delicate balance of Anne Brigman's "The Bubble." However, what is most compelling is Krims' art of the setup, the complete staging of a scene that defies both logic and necessity. The absurdity of the wearing of a mask, the subject's gesture, the mundane functionality of the underwear that suggests undress rather than academic nudity, and even the decision to locate the action next to a pipe running vertically down the wall contribute to an overall sense of reality being tampered with for the sake of the photograph.

Masks take on a different meaning in the work of Lexington, Kentucky, optician Ralph Eugene Meatyard. He, too, set up scenes for the camera. An image of his children and wife sitting in bored postures on

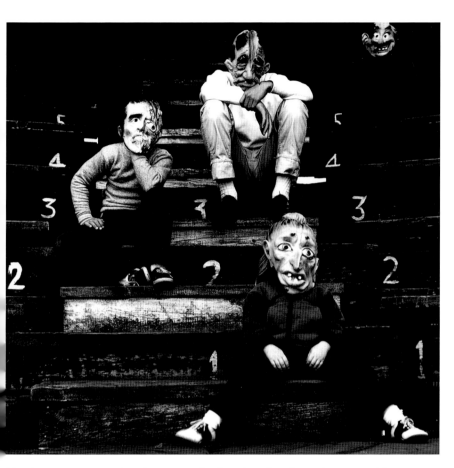

bleachers assumes another dimension of reality when they don Halloween fright masks, so jarring compared with their casual poses. Particularly poignant is the way in which these grotesque masks, worn by children, reveal their own father's intense look at his mortality. The title, "Romance (N) from Ambrose Bierce, No. 3," lends a literary allusion to this image. What could have been a simple snapshot of Meatyard's children and wife becomes a meditation on persona and collective memory. Bierce defined romance as "fiction that owes no allegiance to the God of things as They Are," and Meatyard's fictional "romances" pay their own allegiance to the power of memory and imagination.

Ralph Eugene Meatyard
American, 1925–1972

Romance (N) from Ambrose Bierce, No. 3, 1962

Gelatin silver print
MUSEUM PURCHASE WITH EASTMAN KODAK COMPANY FUNDS
80:0467:0001

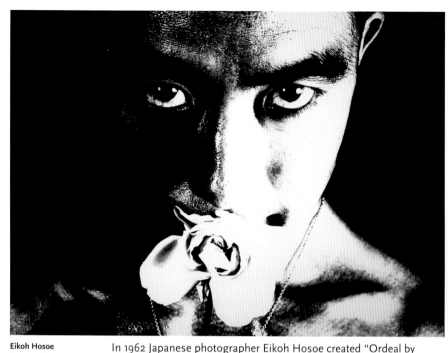

Eikoh Hosoe
Japanese, b. 1933

Ordeal by Roses,
1962

Gelatin silver print
MUSEUM PURCHASE
75:0119:0003

(right)
Ralph Gibson
American, b. 1939

*Snake around Man's
Neck*, 1972

Gelatin silver print
MUSEUM PURCHASE,
CHARINA FOUNDA-
TION PURCHASE
FUND
90:0701:0014

In 1962 Japanese photographer Eikoh Hosoe created "Ordeal by Roses" from the series *Killed by Roses*, with the celebrated Japanese author Yukio Mishima as his model. Hosoe defined the project as "an effort at destruction of iconoclasm ... it also involved great respect for my subject. Destruction should be followed by reconstruction, and the project actually grew into a subjective documentary of Mishima based on my own imagination and vision of truth." A portrait of Mishima holding a rose up to his nose and staring piercingly at the viewer is less a likeness than a state of mind. Mishima described the experience of being photographed: "The world to which I was abducted under the spell of his lens was abnormal, warped, sarcastic, grotesque, savage, and promiscuous ... yet there was a clear undercurrent of lyricism murmuring gently through its unseen conduits."

A similar world of unseen meaning permeates Ralph Gibson's "Snake around Man's Neck," from the series *Days at Sea*. (This series was published as a book, the third in a trilogy of books by Gibson.) For its radical use of perspective, the image owes a debt to Rodchenko and Moholy-Nagy. The figure is deliberately rendered as an uneasy abstract pattern.

Robert Adams
American, b. 1937

Tract House, Westminster, Colorado, 1974

Gelatin silver print
GIFT OF THE
PHOTOGRAPHER
77:0149:0006

In the early 1970s a particular aesthetic developed among photographers traveling in the West and Southwest. Theirs was an industrial and suburban landscape of architecture and land reorganization that redefined the mythical, heroic Western landscape as a contemporary reality. Robert Adams wrote that his hope as a photographer was "to discover a tension so exact that it is at peace." "Tract House, Westminster, Colorado" is not critical of its subject but rather seeks to find beauty in what is before the photographer, even the cookie-cutter, vernacular architecture of late-20th-century suburban sprawl. In 1975 the *New Topographics* exhibition at George Eastman House introduced this aesthetic, and even more lasting, the label that was aptly applied to this body of work that examined the new American landscape. The Eastman House exhibition featured, among others, the work of Robert Adams, Lewis Baltz, Joe Deal, Frank Gohlke, and Stephen Shore.

Gohlke was a student of Paul Caponigro; he wrote: "The best landscape images, whatever their medium and whatever other emotions

Frank Gohlke
American, b. 1942

Landscape,
Albuquerque,
New Mexico, 1974

Gelatin silver print
MUSEUM PURCHASE
WITH NATIONAL
ENDOWMENT FOR
THE ARTS SUPPORT
77:0055:0004

Joe Deal
American, b. 1947

Untitled View
(Albuquerque), 1974

Gelatin silver print
GIFT OF THE
PHOTOGRAPHER
77:0118:0001

they may evoke ... propose the possibility of an intimate connection with a world to which we have access only through our eyes, a promise containing its own denial." His landscape of Albuquerque, New Mexico, is all concrete and sky, which dwarf the noisier signs of civilization that line the horizon. What unifies all of these photographers' work is the conspicuous absence of humans coupled with the palpable force of human presence in these deeply inhabited worlds.

Joe Deal credits his time working at the Eastman House, first as a security guard and later as director of exhibitions, with changing his perception about the possibilities of photographs through the vast range of images that passed before his eyes. Of his landscapes, including the untitled view overlooking Albuquerque (page 697), Deal explained: "I ... wanted to deal with more ordinary, contemporary structures that weren't special and see what could be done. ... My problem was to find a different way of photographing this new subject matter that wouldn't satirize it. It was more of an accident that I was up on a hill and looked down and could see the houses in the context of the landscape rather

Lewis Baltz
American, b. 1945

South Corner, Riccar America Company, 3184 Pullman, Costa Mesa, 1974

Gelatin silver print
GIFT OF THE PHOTOGRAPHER
78:0515:0017

than just singling out the details of the architecture. I could get more distance and there was a feeling of greater objectivity in that."

Like Deal, Lewis Baltz steadfastly maintains a cool distance from personal expression or emotion throughout his work. In images such as "South Corner, Riccar America Company, 3184 Pullman, Costa Mesa," even the title, so precise as to be almost clinical, echoes the detached objectivity of the image.

Stephen Shore was largely self-taught in photography, although he studied at one time with Minor White. Shore's work has virtually always been distinguished by his use of saturated color, which makes images such as "Holden St., North Adams, Massachusetts" instantly recognizable, but equally as important, also makes them formal constructs of photographic color and detail.

John Pfahl puts a particular spin on the landscape photograph. "Shed with Blue Dotted Lines, Penland, North Carolina," from the series

Stephen Shore
American, b. 1947

Holden St., North Adams, Massachusetts, July 13, 1974

Color print, chromogenic development (Ektacolor) process
GIFT OF BARNABAS MCHENRY
85:1240:0001

John Pfahl
American, b. 1939

Shed with Blue
Dotted Lines,
Penland, North
Carolina, June, 1975

*Color print, chromo-
genic development
(Ektacolor) process*
MUSEUM PURCHASE
77:0119:0001

Altered Landscapes is both a visual pun and a reinvestigation of the two-dimensional picture plane. The dotted lines are actually placed in the landscape, not added later to the print, as might be assumed. He further explains: "Locations for the photographs were chosen for their 'picturesque' qualities, their formal structure, and their referential possibilities. The added elements suggest numerous markmaking devices associated with photographs, maps, plans, and diagrams. On different occasions, they may pointedly repeat a strong formal element in the landscape, they may fill in information or utilize information suggested by the scene, or they may be only arbitrarily related to the scene but refer instead to the process of making a photograph."

"Kaanapali Coast, Maui, Hawaii" from the series *Picture Windows* investigates the devices we use to interpret, rather than experience, nature from the window that frames a spectacular view to the photograph itself, which frames them both. "Bethlehem # 16, Lackawanna, New York" from the series *Smoke*, presents the awful beauty of industrial waste and pollution; Pfahl seduces the viewer with Turneresque color but is careful to include just enough of the smokestack to remind the viewer of beauty's subjectivity. Eastman House is fortunate to have been chosen by the artist as the repository for his life's work.

John Pfahl

Bethlehem # 16,
Lackawanna, N.Y.,
1988

Color print, chromo-
genic development
(Ektacolor) process
MUSEUM PURCHASE,
CHARINA FOUNDA-
TION FUND AND
MATCHING FUNDS
90:0066:0001

John Pfahl

Kaanapali Coast,
Maui, Hawaii,
March 1978

Color print, chromo-
genic development
(Ektacolor) process
GIFT OF THE
PHOTOGRAPHER
95:1562:0001

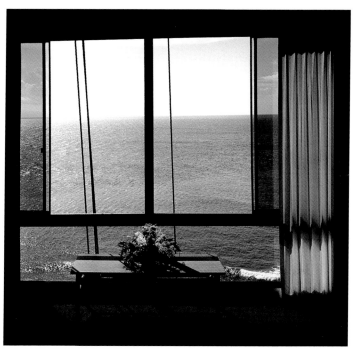

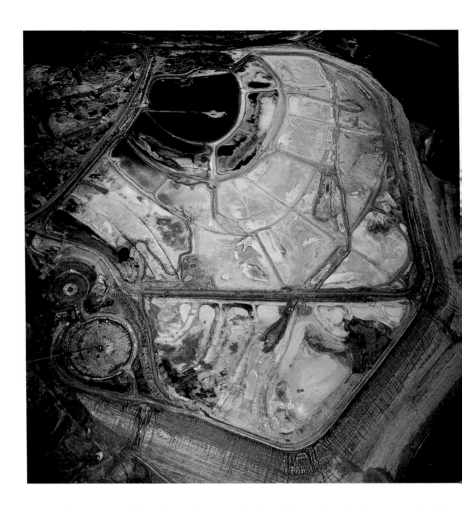

Emmet Gowin
American, b. 1941

Copper Ore Tailing,
Globe, Arizona, 1988

*Split-toned gelatin
silver print*
MUSEUM PURCHASE,
CHARINA FOUNDA-
TION FUND AND
MATCHING FUNDS
90:0012:0001

The seductive beauty of industrial waste has also been examined by Emmet Gowin. Gowin was a student of Harry Callahan at the Rhode Island School of Design, whose work appealed to Gowin because of "a poetry of feeling and intimacy and the revelation of a secret, unrecognized dimension in the commonplace." A meticulous printer, Gowin infuses a disturbing image such as "Copper Ore Tailing, Globe, Arizona" with a rare luminosity. These aerial photographs began as a study of the nuclear landscape. "Even if we could turn back the nuclear clock, the attitude that humankind has had toward nature is based

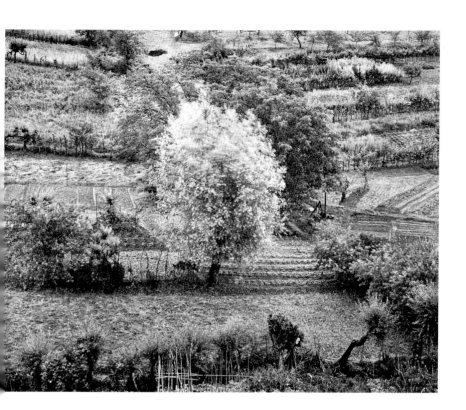

Emmet Gowin

Siena, Italy, 1978

Gelatin silver print
MUSEUM COLLEC-
TION, BY EXCHANGE
85:0519:0002

argely on dominance, ownership, and a concept of right founded on
a misunderstanding. We have believed that we could do as we wished
with the earth without substantially affecting ourselves," Gowin wrote.

An earlier work, "Siena, Italy," owes a debt to Frederick Sommer,
whom he met in 1967 and whose horizonless landscapes were another
major influence on Gowin's work. "Don't let anyone talk you out of
physical splendor," Sommer once counseled, and Gowin's imagery is
the artistic manifestation of the mentor's admonishment. Gowin has
long exhibited a respect for the natural world and those who investigate
it: "I find that I'm in harmony with the physicists, the scientists. I find
them to be the most poetic people of our age. ... I feel the most tender
language is coming from them. ... I require a non-aggressive approach
to positive solutions that have as their subject the unity of life."

Like Tom Barrow and Robert Fichter, John Baldessari is an artist who

John Baldessari
American, b. 1931

Embed Series: Cigar
Dreams (Seeing Is
Believing), October,
1974

*Retouched gelatin
silver print*
MUSEUM PURCHASE
76:0185:0001

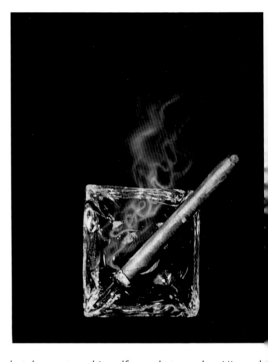

uses photographs but does not see himself as a photographer. His work belongs to the world of conceptual art that emerged in the late 1960s. It owed its roots to Symbolism and its successors, Dada and Surrealism. Photography is an appealing medium to Baldessari because of its ubiquity and ordinariness. "I just want to challenge the boundaries set up by each convention. The irony comes through as a by-product. I don't consciously set out to be ironic. And I have enough appreciation of the traditions to preserve them. But I don't consciously work for beauty," he wrote The *Embed Series*, which he began in 1974, is a comment on the coding of consumer messages in advertising. According to Baldessari, the series deals with "the embedding of words, and occasional images, within the photographic image. A variety of means were employed – airbrushing, brush, double-exposure, etc. ... Another motivation was to test the idea of subliminal motivation. Can I really get one to believe the messages I have hidden about imagining, dreaming, fantasy, wish, and hope?" Embedded in the triptych "Cigar Dreams" are the words "seeing is believing," which also function as an ironic comment on photography itself.

John Baldessari

Embed Series: Cigar
Dreams (Seeing Is
Believing), October,
1974

*Retouched gelatin
silver print*
MUSEUM PURCHASE
76:0185:0002

John Baldessari

Embed Series: Cigar
Dreams (Seeing Is
Believing), October,
1974

*Retouched gelatin
silver print*
MUSEUM PURCHASE
76:0185:0003

Paul Berger's work utilizes sequential narrative and the format of popular news magazines to challenge the assumption of truth not only in photographs but also in captions. "Seattle Subtext – Photography" mimics the layout of *Time* magazine. The text under his vaguely ominous park view reads: "Untitled no. 237 – 'Let's see ... it's a park ... in France ... no, in Italy ... yeah, I think it's in Italy. ...'" French text below it repeats the comment in the third person. Using appropriated language and images from video and television, family photographs, his own still photography, and printouts of his computer cataloging system, Berger assembled a cacophony of images that call to mind the daily barrage of disparate messages that are connected through their visual proximity to one another and the recipient's layered reception of them. As Berger explained: "I would feel aligned with Constructivism in that photographs are so context-bound – in our daily encounter with them, a lot of the content we get from them is from where we see them and how we see them. A coherent photographic work is possible only when the art activity is correlating those parts into a new context that is clear, or definite."

Paul Berger
American, b. 1948

Seattle Subtext –
Photography, 1981

Gelatin silver print
MUSEUM PURCHASE
84:0837:0008

Englishman Victor Burgin's work concerns itself with the construction of meaning not only through the evidence of the image – in this case, found in art historical referents and Hollywood cinema – but also through the way in which images are discussed and evaluated in the museum context. "The Bridge – Venus Perdica" is a photograph based on Sir John Everett Millais's 1852 painting of the drowned Ophelia from William Shakespeare's *Hamlet*, and the character of Madeleine from Alfred Hitchcock's film *Vertigo*. "The history of representations in the West is flooded with watery images of women. This image by Millais ...'Susanna Bathing'... The question is not so much one of relations between men and women. ... The question ... is ... how men and women are constructed in difference." Burgin further explains his choice of appropriation: "The gallery has been the site of the production of images of relations between men and women. The gallery can be a site of

Victor Burgin
English, b. 1941

The Bridge – Venus
Perdica, 1984

Gelatin silver print
MUSEUM PURCHASE,
INTREPID FUND
85:0516:0001

Dieter Appelt
German, b. 1935

Die Befreiung der
Finger (Liberation of
the Fingers), 1979

Gelatin silver print
MUSEUM PURCHASE,
FORD MOTOR
COMPANY FUND
85:0675:0006

interrogation of those same images. The images which belong to the history of art, to the history of cinema, to the history of photography, become trapped, like flies in amber, in meanings given to them by the institutionalized forms of discourse: art history, photography history, and art criticism. We can return to these images and we can reopen them, we can 'reopen the case.'"

"Making time visible and thus comprehending time" are the primary foci of the German artist Dieter Appelt's photographic work. "Die Befreiung der Finger" is from the series titled *Erinnerungsspur (Memory's Trace)*. "A snapshot steals life that it cannot return. A long exposure [creates] a form that never existed," Appelt wrote; his images are layered fragments of thousands of exposures of manual time-lapse photography taking hours to complete. The photograph is thus revealed to be not only an instantaneous, split-second capture, but also capable of expressing stasis and permanence in a single frame.

Hiromi Tsuchida is a Japanese photographer a generation younger than Eikoh Hosoe. His *Hiroshima* series documents the objects found after the devastation of the nuclear bombing in 1945 by the United States. Beginning in 1975, Tsuchida interviewed and photographed "hibakusha," the survivors; in 1978 and 1979 he photographed the relics of the landscape within a three-kilometer radius of the bomb site; and in 1980 he photographed the documents in the Hiroshima Peace Memorial Museum. "Lunch Box" is from this last work. The emotional impact of the deformed object as still life silently bespeaks the horrors visited upon the human victims.

On the other end of the spectrum, Jan Groover's formalist

Lunch box

Reiko Watanabe (15 at the time) was doing fire prevention work under the Student Mobilization Order, at a place 500 meters from the hypocenter. Her lunch box was found by school authorities under a fallen mud wall. Its contents of boiled peas and rice, a rare feast at the time, were completely carbonized. Her body was not found.

Hiromi Tsuchida
Japanese, b. 1939

Lunch Box, 1982

Gelatin silver print
GIFT OF THE
PHOTOGRAPHER
90:0700:0005

Jan Groover
American, b. 1943

Untitled, # 78.4,
1978

Color print, chromo-
genic development
(Ektacolor) process
MUSEUM PURCHASE,
MARGARET T. MOR-
RIS FOUNDATION
FUND, IN MEMORY
OF DR. WESLEY T.
"BUNNY" HANSEN,
WITH NATIONAL
ENDOWMENT FOR
THE ARTS FUNDS
89:0355:0001

(right)
Anne Turyn
American, b. 1954

Untitled, 1984

Color print, chromo-
genic development
(Ektacolor) process
GIFT OF THE
PHOTOGRAPHER
89:1119:0003

Richard Avedon
American, b. 1923

Igor Stravinsky,
Composer, New York
City, November 2,
1969

*Gelatin silver print
(triptych)*
MUSEUM PURCHASE
WITH NATIONAL
ENDOWMENT FOR
THE ARTS SUPPORT
76:0046:0001

still-life composition (page 410) is an update of Edward Weston and Paul Strand's early formalist images. Distorting scale and ignoring functionality, Groover reinvents these familiar forms with intense colors that heighten the reality of the objects photographed.

An admirer of Baldessari's work, Anne Turyn uses narrative in her photographs like a storyteller. "Untitled" from the series *Illustrated Memories* (page 711) shows a bureau top with a ghost image on a turned-off TV and a gleaming photograph of an unidentified man. Was the photograph left behind? Is this someone's home or a motel room? By photographing absence and constructing fiction, Turyn deliberately and provocatively presents unanswerable questions.

"A photographic portrait is a picture of someone who knows he's being photographed, and what he does with this knowledge is as much a part of the photograph as what he's wearing or how he looks. He's implicated in what's happened, and he has a certain real power over the result," wrote Richard Avedon. Avedon creates portraits that are raw and confrontational, compelling in the physical information they reveal about the subject. Photographed in the studio against a white backdrop, the triptych of composer Igor Stravinsky presents a striking visage of old age and the physical accumulation of life. The subtle transformation that occurs from frame to frame suggests the slow, deliberate passage of time and the camera's ability to capture such evocative, often fleeting nuances of human character. On the other hand, Avedon's portrait of pianist Oscar Levant is an animated, energetic explosion of raw emotion revealed before the photographer's unerring lens.

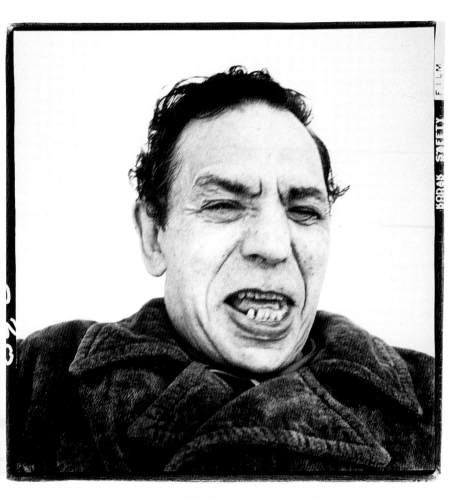

Avedon uses no filter or mask to soften the penetrating gaze of the camera. His uncompromising portraits reveal both likeness and psychology, but the tension lies in discovering whose psychology is on display, the subject's, the photographer's, or the viewer's. Therein lies the power of Avedon's portraits. The element of celebrity and the automatic familiarity that the average viewer brings to Avedon's photographs adds another dimension. Unlike those portrayed in Galerie Contemporaine or in Alvin Langdon Coburn's book *Men of Mark* (see page 420), the late-20th-century celebrity is not only photographed and collected because

Richard Avedon

Oscar Levant, Pianist, Beverly Hills, California, April 9, 1972

Gelatin silver print
GIFT OF THE PHOTOGRAPHER
76:0047:0002

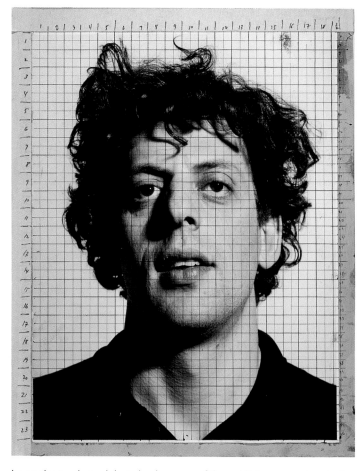

he or she is admired, but also because of the public's consuming desire
to see something about a person that he or she might not necessarily
have wanted the viewer to see.

Avedon's portraiture influenced the younger artist Chuck Close, who
worked in a similar, large format with the same unrelenting pursuit
of detail and stark isolation of a subject against a white background.
"Working Photograph for Phil" is a photograph of composer Philip
Glass. Contrary to convention, Close presents the portrait as a gridded
image rather than what might be perceived as a more complete, fin-
ished work, emphasizing the degree to which the portrait is broken

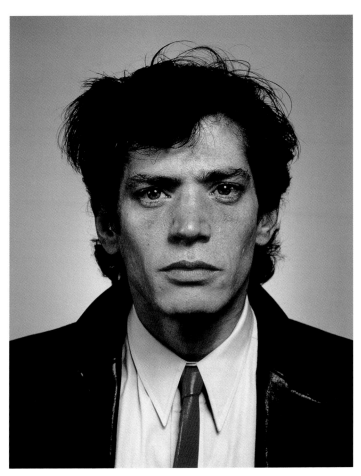

Neil Winokur
American, b. 1945

Robert Mapple-
thorpe, 1982

*Color print, chromo-
genic development
(Ektacolor) process*
GIFT OF THE
PHOTOGRAPHER
83:2325:0002

down and segmented into consumable and comprehensible parts.
By deliberately showing as the finished work what would ordinarily be
regarded as a preparatory study, Close suggests that what the viewer
gleans from a portrait is not a whole picture but rather many smaller
parts that he or she, not the photographer, then constructs into a whole.

Neil Winokur's vivid color, straightforward, life-sized, head-and-shoul-
ders portrait of photographer Robert Mapplethorpe relies in part on
Mapplethorpe's notoriety and self-constructed photographic persona
for its power and resonance. Aligning himself outside the artistic canon,
Winokur states: "The graduation headshot or the police mugshot or my

Robert Mapplethorpe
American,
1946–1989

Ajitto, 1981

Gelatin silver print
MUSEUM PURCHASE,
INTREPID FUND
83:2336:0001

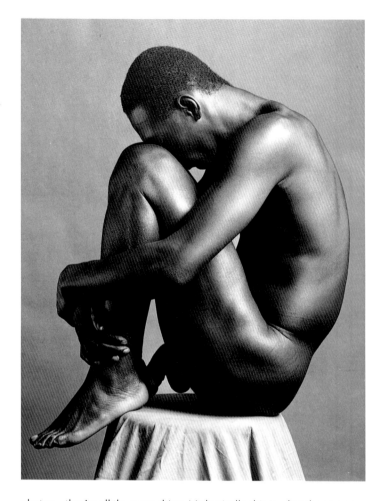

photos – they're all the same thing. It's basically, this is what the person looks like. I will tell you nothing about them. You can make up your own story about this person, because that's all the information you really have." Winokur supplies the viewer with the necessary visual information – and then leaves it to the beholder to create his or her personal meaning.

Robert Mapplethorpe's own photographs, in turn, have been compared to the stark formalism of Edward Weston's images. Flowers and the human form are his primary subjects. His diptych of Ajitto seated atop a draped pedestal like some piece of ebony sculpture unabashedly

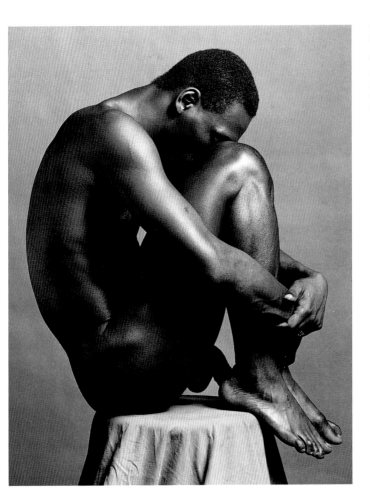

Robert Mapplethorpe

Ajitto, 1981

Gelatin silver print
MUSEUM PURCHASE,
INTREPID FUND
83:2336:0002

proclaims this male form to be a work of art ordained both by pose and photographic enshrinement. Mappelthorpe updates the genre of the nude study by using the black male body, a subject rarely seen, much less celebrated, over the course of the history of photography. Ajitto's pose is reminiscent of other nude studies by F. Holland Day; here the mirroring effect of the diptych pairing diminishes the sitter's individuality and emphasizes his role as an iconographic type. Furthermore, the deliberate inclusion of the black man's genitalia transforms Mapplethorpe's work from classicism to fetishism, treading the fine line

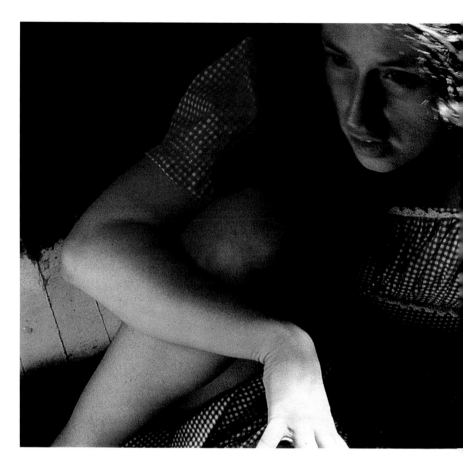

between celebration and exploitation. Given the stereotype of hyper-sexuality attributed to black subjects, Mapplethorpe's image is loaded with cultural as well as personal associations.

"Ralph Eugene Meatyard was one of only a few photographers who had any sort of influence on my 'photographic' roots. ... I believed in his bizarre, fictional world," wrote Cindy Sherman. Sherman emerged as one of the most important artists of the 1980s for her ongoing investigations using her own body as a catalyst for cultural commentary, but her staged narratives also owe a debt to Les Krims' fictional narratives constructed for the camera. Like Baldessari, Sherman prefers to think of herself as an artist who uses photography rather than as a photographer. In an early

Cindy Sherman
American, b. 1954

Untitled #85, 1981

*Color print, chromo-
genic development
process*
MUSEUM PURCHASE,
L.A.W. FUND
83:1576:0001

untitled work, she is seated on a kitchen floor in her gingham dress that, with its puffed sleeves and smocked bodice, brings to mind the small-town innocence of Dorothy in the film *The Wizard of Oz*, yet an expression of blank bewilderment is frozen on her face. While there is no actual story being illustrated, Sherman's work relies on the viewer's cultural literacy to supply the narrative. Her posture, expression, and costume are codified and recognizable to contemporary viewers: The implication of threat and the woman's vulnerability are obvious and compressed into heightened melodrama like a two-hour made-for-television movie.

Nan Goldin's *Ballad of Sexual Dependency*, a project she termed her "public diary," documents the intimate lives of the photographer and

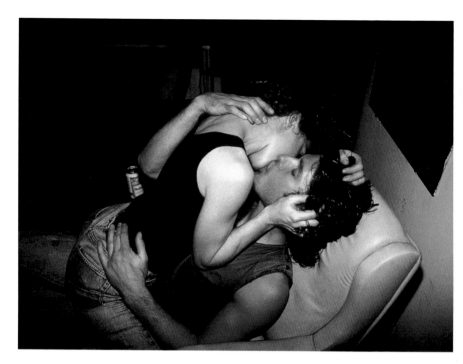

Nan Goldin
American, b. 1953

Rise and Monty on
the Lounge Chair,
N.Y.C., 1988

*Color print, silver dye
bleach (Cibachrome)
process*
MUSEUM PURCHASE,
CHARINA FOUNDA-
TION FUND
88:0615:0002

her friends. "Rise and Monty on the Lounge Chair, N.Y.C." makes the
private public. The complete disregard for the camera's presence indi-
cates its complete saturation in their lives; the subjects neither notice
nor seem to care that through a friend a viewer has been invited into
their moment. Goldin's images are remarkable for their candid honesty,
providing glimpses into her world and that of her friends that universal-
ly resonate. Like Larry Clark, Goldin defines her life as art through the
act of photographing. "... I hope it transcends the specific world in
which it was made and applies to the whole nature of the relationships
between men and women," wrote Goldin of her *Ballad*, which in its vari-
ous presentations encompassed still photographs, slide shows, and
soundtracks.

Lorna Simpson's coolly detached and deliberately impersonal image
"Counting" references African-American history and the legacy of slav-
ery, labor, and the toll that both take on the black female body. Segments
of time that recall work shifts are listed alongside a woman's silent
mouth and neck, emphasizing both her value as a worker (how, indeed,

Lorna Simpson
American, b. 1960

Counting, 1991

Photogravure with silkscreen
MUSEUM PURCHASE
95:2875:0001

she "counts") and her lack of voice. An accounting of the materials of labor both personal and economic and a chronology of enslavement are juxtaposed with images of a smokehouse and a neatly coiled braid of hair. Unlike captions, the words in "Counting" do not define the images, but they carry double meanings that refer to the subjects. "Twists," "Locks," and "Bricks" not only represent the physical objects in the photographs but also evoke the obstacles that have traditionally faced black women in the United States as well as the strength that was required to endure them.

Japanese photographer Michiko Kon's "Cuttlefish and Sneaker" is a construction at once fascinating and grotesque. The sneaker is not made of canvas but of fish; the laces are squid tentacles. The most immediate referent in art history is the work of Giuseppe Arcimboldo, the 18th-century Italian painter who constructed portraits out of vegetables and animal parts. Conveniently, Kon's studio in Tokyo is near the fish market; she has carefully laid the fish skin over the basic structure of the high-top athletic shoe. The photograph is essential to the object's meaning, proof of its strange reality. Kon's images challenge us as viewers to look carefully, to pay attention to the distinction between what we see and what we believe we see. The persistent belief in photography's

Michiko Kon
Japanese, b. 1955

Cuttlefish and
Sneaker, 1990

Gelatin silver print
MUSEUM PURCHASE,
FORD MOTOR
COMPANY FUND
92:0386:0003

truth is at the crux of these images. They are also meant to confuse the senses: although we experience photographs visually, we experience fresh fish primarily through touch and smell. That these senses are strongly triggered by her photographic image challenges our assumptions about how we experience the world – through actual encounter or our memories of it.

"I want to express myself and keep sensitive by implementing all the bodily senses such as taste, touch, hearing, sight and smell," Kon states without claiming primacy for any. On the other hand, Zeke Berman is primarily "interested in how we see, how we apprehend the world through our eyes." "I originally made sculpture, but became attracted to placing a camera between myself and what I make. The result is a kind of distancing that transforms a physical construction into an optical one." Optics and perception are Berman's tools: "You have a subject, you use a lens, you make an image. This is an obvious and powerful schema for a procedure that generates images." Like Kon, Berman is interested in the relationship between vision and knowledge: how we see, and how the camera and the photograph inform that act of seeing.

Zeke Berman
American, b. 1951

Inversion, 1991

Gelatin silver print
MUSEUM PURCHASE,
CHARINA FOUNDA-
TION FUND
92:1039:0001

"Inversion" takes the mundane and recognizable image of cup and saucer and literally turns it on its head.

Suzanne Bloom and Ed Hill began working together as MANUAL in 1974. "Lore/Lure" takes a 1940s advertising image from *LIFE* magazine as its basis to construct a commentary on consumerism and gender marketing. Advertising "lures" the consumer, while what is sold is "lore," the equivalent of wives' tales or falsehoods. In doubling the image, the woman is enlarged, but computer pixellation has rendered her out of focus, literally blurring her identity. Using a computer, MANUAL digitally superimposes an outline of the model home, conspicuously without doors or windows, strongly implying that there is no way out of this particular domestic trap.

Similarly, Barbara Kruger's "Untitled" image takes a stock image of a man placing a wedding band on a woman's finger and overlays the statement: "You are a captive audience" as a critique on the unquestioning acceptance of the patriarchal order, especially when it promises jewelry. The bracelet on the woman's wrist suggests that she has already been co-opted; the ring is icing on the wedding cake. Kruger's text also indicts the viewer, who also buys into the narrative, anxious to find out what happens next. Kruger's background as an editor for women's

**MANUAL
(Suzanne Bloom &
Ed Hill)**
American, b. 1943 &
American, b. 1935

Lore/Lure, 1987

*Color print,
chromogenic
development
(Ektacolor) process*
MUSEUM PURCHASE,
CHARINA FOUNDA-
TION FUND
88:0264:0003

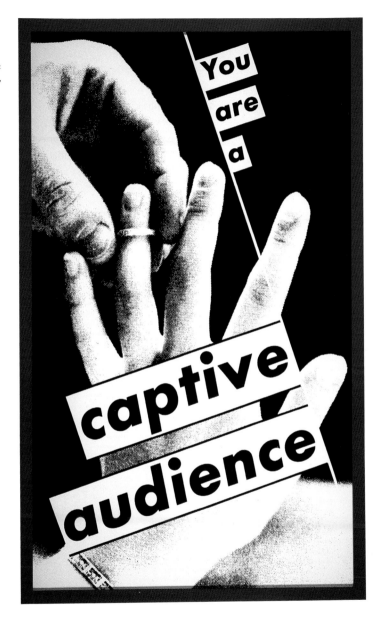

(right)
Bill Jacobson
American, b. 1955

Songs of Sentient
Beings, # 1530, 1995

Gelatin silver print
MUSEUM PURCHASE,
CHARINA FOUNDA-
TION PURCHASE
FUND
97:0643:0001

Joyce Neimanas
American, b. 1944

Face Lift, 1993

*Computer-generated
color ink-jet (Iris) print*
MUSEUM PURCHASE,
WARREN AND
MARGOT COVILLE
FUND
93:1506:0003

fashion magazines informs her design and layout and how effectively a simple, strong graphic and a bold written statement together communicate a message. Graphically, her work is reminiscent of Rodchenko and Heartfield – Kruger creates feminist, postmodern propaganda that strikes at cultural icons.

Joyce Neimanas is a mixed-media artist and alumna of the Art Institute of Chicago, where she teaches today. "Face Lift," from the series *Legends of the Powerless*, layers images of women taken from different eras and imposes on them a looking-glass or portrait oval of - reflection. The text that the image "speaks" – "Were you talking to me" – derives, in part, from dialogue in the motion picture *Taxi Driver*, in which taxi driver Travis Bickle faces the mirror and gives his famous one-sentence soliloquy, "You talkin' to me?" over and over again, growing more agitated, aggressive, and dangerous. Adapted here in the past tense, Neimanas' words suggest that through the agency of the woman remaking herself in her own image, the implied threat no longer exists.

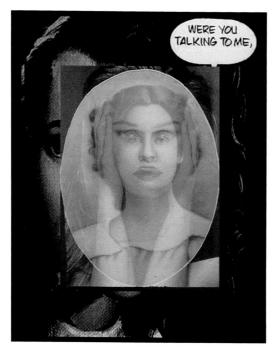

Bill Jacobson describes his haunting images as "statement[s] about personal desire and collective loss,... drawing on feelings around the tentativeness and vulnerability of life in the age of AIDS. ... I hope to create floating, fragile objects that evoke ghosts and spirits of a rapidly disappearing segment of the population." Their painterly quality calls to mind the work of the pictorialist photographers of the turn of the 20th century. "Songs of Sentient Beings, # 1530" shows the slender form of a man from the back, quietly retreating into the background. "I believe their faded quality is a reflection of how the mind works – struggling to hold onto memories as they dim," he

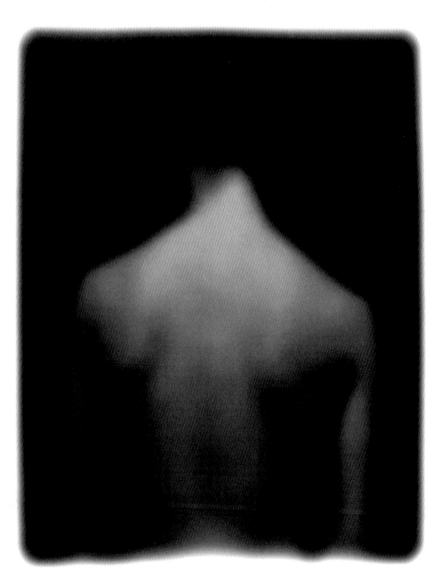

explains. In their hushed eloquence, Jacobson's images affirm the emotional impact of the photograph and illuminate that which was invisible.

Photographs affirm who we are in many ways; one of the most basic is by merely depicting our likenesses, individually as well as collectively. "Who defines beauty?" Joan Myers asks. Approaching 50, Myers looked around and wondered where her likeness was. The aging female body is virtually never depicted in popular culture, and being a member of a group that never sees its likeness is an oddly disorienting experience. Anne Noggle and Imogen Cunningham created series of portraits of older men and women. Myers, whose previous work consisted largely of landscapes, joined their company with the series "Women of a Certain Age." She photographed the women nude, removing the specificities of culture and class that clothing carries. While "June" obviously agreed to pose nude, she carefully covers her softly aging flesh, a gesture that reminds the viewer of the personal difficulty of transcending barriers and breaking taboos while the hint of a defiant smile begins to form at her lips. "I use my camera to explore possibilities, the messages and histories expressed in other women's bodies. I wish less to define than to reveal," says Myers.

Joan Myers
American, b. 1944

June, 1993

Platinum-palladium print with watercolor wash
MUSEUM PURCHASE, CHARINA FOUNDATION PURCHASE FUND
94:1231:0005

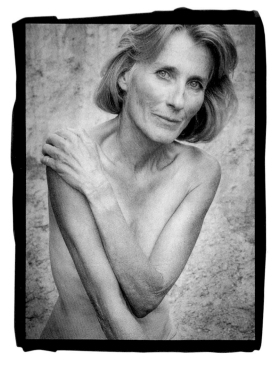

For all the technical and artistic advances photography has achieved since 1839, in this era of digital and electronic imagery the work of Abelardo Morell leaves photography where it began, making images using the camera obscura. Instead of a box, Morell transforms entire rooms into receptacles of light images; his aperture is a 3/8-inch opening in a covered window. "Camera Obscura Image of Houses across the Street in Our Bedroom" reveals the process at its most rudimentary; an upside-down, inverted image appears in the camera

obscura projection, and this is what Morell photographs using a large format view camera on a tripod; the exposures take about eight hours. '[T]he very basics of photography could be potent and strange," Morell explained how he came to use the oldest principle of photography itself. "So why not make pictures about the medium itself?"

Some 160 years later, photographers have both returned to the medium's roots and expanded its possibilities beyond Daguerre's and Talbot's wildest dreams, claiming every application in between as rich and exciting means to discovery and creation. Indeed, photography itself has proven to be the most experimental, compelling, accessible, and complex of any artistic medium; its applications are far-reaching and personal, instantly familiar and spectacularly new. For 50 years, Eastman House has gathered together the medium's masterpieces as well as its anonymous gems, preserving the past and promoting the future of images that record and interpret the world and our dreams of it.

Abelardo Morell
American, b. Cuba, 1948

Camera Obscura Image of Houses across the Street in Our Bedroom, 1991

Gelatin silver print
MUSEUM PURCHASE, FORD MOTOR COMPANY FUND
95:2068:0001

Appendix

Glossary

Additive color *See* Color, additive

Albumen print Albumen prints are the most common type of photographs from the 19th century and were the first photographic prints in which the image was suspended on the surface of the paper instead of being embedded in the fibers of the paper. The process involves coating a sheet of paper with albumen (egg white), which gives the paper a glossy, smooth surface. The albumenized paper is sensitized with a solution of silver nitrate, then exposed in contact with a negative, generally a **collodion on glass negative.** Albumen prints are **"printed-out,"** meaning that the image is created solely by the action of light on the sensitized paper without any chemical development. The printing-out process requires long exposures and results in prints that are susceptible to fading. Despite these problems, the ability to capture fine detail and the relative ease of producing many prints from a single negative helped hasten the replacement of direct-positive processes, such as **daguerreotypes** and **ambrotypes,** by negative-positive processes. Albumen prints, which were invented in 1850 by Louis-Desiré Blanquart-Evrard, replaced **salted paper prints** as the dominant type of photograph; they were, in turn, replaced by **gelatin silver prints** in the 1890s.

Ambrotype Ambrotypes are sharply detailed, one-of-a-kind photographs on glass, packaged in protective cases similar to those used for **daguerreotypes.** An ambrotype is essentially a **collodion on glass negative** that is intentionally underexposed so that the negative image appears as a positive image when viewed against a dark background. The process for making ambrotypes was patented in the United States in 1854 by James Ambrose Cutting. Ambrotypes (and the closely related **tintypes**) soon replaced the more expensive daguerreotypes as the favored process for portrait photography. The process has the additional benefit of being non-reflective, making ambrotypes easier to view than daguerreotypes. The popularity of ambrotypes was short-lived, however, and the process was soon displaced by the growing popularity of the negative-positive process of collodion on glass negatives and **albumen prints.**

Bichromated colloid A bichromated colloid is any one of a number of viscous substances, such as gelatin or albumen, that has been made light-sensitive by the addition of a bichromate, most commonly potassium bichromate ($K_2Cr_2O_7$). Bichromated colloids harden when exposed to light and become insoluble in water; this is the principle behind many of the non-silver-based photographic processes, such as **carbon prints** and **gum bichromate prints,** and most **photomechanical** processes. The effect of light on bichromates was discovered by Mungo Ponton in Scotland in 1839, and the hardening effect of light on bichromated colloids was first described by Alphonse Poitevin in France in 1855.

Cabinet card The cabinet card – a popular format for 19th-century photographs – is a photograph mounted on heavy card stock and measures approximately 6-1/2 x 4-1/4 inches. Cabinet cards are usually studio portraits, and cabinet cards of celebrities, a favorite subject, were widely collected in the last quarter of the 19th century. The format was introduced in 1866 and soon surpassed the smaller **carte-de-visite** format in popularity. Cabinet cards lost much of their popularity after 1900 and largely disappeared by the end of World War I.

Calotype negative The calotype negative is a paper negative and was the first negative to rely on the chemical development of a latent image. The process was patented in England in 1841 by William Henry Fox Talbot. It was an advancement on Talbot's first paper negatives, called photogenic drawings, that were produced solely by the effect of light on light-sensitive paper. The chemical development process meant that calotype negatives required much less exposure time than photogenic drawings. One calotype negative could be used to make many prints (at the time, **salted paper prints**), and this negative-positive process was the direct antecedent to modern photography. The longer exposure time and the lack of precise image details made calotypes less popular than **daguerreotypes** for portraiture, but calotype negatives and salted paper prints were popular during the 1840s for many other photographic practices, such as architectural and view photography. Calotype negatives were largely replaced by **collodion on glass negatives** in the mid-1850s.

Carbon print A carbon print is a **pigment print** that relies on the use of a **bichromated colloid** mixed with a pigment (usually carbon black) for the formation of the print image. Carbon prints are noted for their permanence and their rich and glossy dark tones. To make a carbon print a sheet of paper is coated with bichromated gelatin mixed with carbon black. The paper is exposed in contact with a negative; the gelatin hardens in proportion to the amount of light received. After exposure, the paper is pressed in contact with a second sheet of paper that has been coated with an insoluble gelatin layer. When the two sheets are soaked together in water, the first sheet floats free and the unhardened gelatin washes away, with the carbon image transferred in relief to the second sheet. The carbon print process was patented in France in 1855 by Alphonse Louis Poitevin, and reached the height of its popularity between 1870 and 1910.

Carbro print A Carbro print is an assembly of three bichromated gelatin tissues, each pigmented with one of the primary **subtractive colors,** cyan, magenta, or yellow. The image on each tissue is formed as a result of a chemical reaction that occurs when the bichromated gelatin tissue is placed in contact with a silver bromide print. The silver bromide prints, each made from a black-and-white separation negative (see **Color, additive**) cause the tissues' gelatin to harden in proportion to the density of the print. The unhardened gelatin is then washed away. When these tissues are placed in exact register onto a paper support, they combine to produce a full-color (tricolor) photograph. The Carbro process, patented in 1905 as the Ozobrome, was adapted from **carbon printing** techniques developed in the 1850s. Though monochromatic Carbro prints were made, this process is best known through its vivid three-color images. Carbro prints are also noted for their image permanence.

Carte-de-visite The carte-de-visite – a paper photograph mounted on card stock measuring approximately 4 x 2-1/2 inches – was the most popular format for portrait photography in the 19th century. A carte-de-visite was roughly the same size as the visiting cards that gave the format its name. Cartes-de-visite were often exchanged between friends and family members and were collected in specially made albums. The format became popular in the late 1850s when a technique was developed for making multiple negatives on a single glass plate (thereby reducing the cost of portrait photography), and it remained popular through the 1860s. The

larger **cabinet card** format gradually eclipsed the popularity of the carte-de-visite.

Chromogenic development process	*See* Color transparency, chromogenic development process
Cibachrome	*See* Color, silver dye bleach print
Collodion	*See* Negative, collodion on glass
Collotype	*See* Photomechanical, collotype print

Color, additive The principle of additive color demonstrates that all the colors of light can be made by combining different proportions of the three primary colors of light: blue, green, and red. (These colors are the complementary colors of the primary **subtractive colors**: yellow, magenta, and cyan.) When the three additive primary colors are mixed equally, the result is white light. **Autochrome plates** and color television images depend on this principle. When white light passes through a filter colored one of the primary additive colors, the filter transmits only that color of light and absorbs the other colors. Black-and-white photographic negatives exposed through such filters are called "separation negatives." Separation negatives are required in color photographic processes such as **Carbro** and **dye imbibition.**

Color, Autochrome plate Autochromes are color transparencies on glass plates that are viewed either in special viewers called diascopes or projected onto a screen. The first practical color process, Autochromes were one of the few commercially successful **additive color** processes. Autochromes were made by coating a glass plate with a mosaic of minute potato starch grains dyed to approximate the primary additive colors of light. This was then coated with a panchromatic silver emulsion. Exposed in a camera so that the color mosaic filtered the light before it reached the emulsion layer, the plate was processed to create a black-and-white positive. This, in combination with the color mosaic, created the illusion of a full-color positive image. Autochrome plates were manufactured from 1907 to the 1930s by the

Lumière brothers, who also figure prominently in the early history of motion pictures.

Color, chromogenic development print

A chromogenic development print is made on photographic paper that has three silver emulsion layers sensitized to the primary **additive colors** of light. During development, dye couplers bond with the exposed and developed silver halides to produce complementary **subtractive color** dyes. The silver is bleached away, leaving a full-color positive image. Due to chemical impurities in the dyes, chromogenic prints are not as stable as prints made with other techniques.

Color, dye imbibition print

A dye imbibition print is a color print made of dyes transferred from three gelatin matrices onto a sheet of paper coated with gelatin. To make a dye imbibition print, three separation negatives are made (see **Color, additive**). From these negatives, gelatin matrices are created that are capable of absorbing and releasing dyes of the primary **subtractive colors.** When placed in exact registration on the paper, the transferred dyes create a full-color image. The process was favored for the high degree of control over the final print image that it offered photographers. Dye imbibition prints are noted for their permanence, and the black-and-white matrix film used in the process is more stable than chromogenic color film so that new dye imbibition prints could be made many years after the original print was made.

Color, internal dye diffusion transfer print

An internal dye diffusion transfer print is a one-of-a-kind, "instant" color photograph most commonly marketed by the Polaroid Corporation. The process uses a multi-layered film pack that includes an image-receiving layer, a reagent-collecting layer, and layers sensitized to the primary **additive colors** alternating with layers of primary **subtractive color** dyes. The film pack is ejected from the camera immediately after exposure, breaking open a pod of reagent that starts the development process. The exposed silver in the additive color layers blocks the diffusion of the complementary subtractive colors upward to the image-receiving layer, while the reagent-collecting layer turns opaque, masking the residual silver and dyes that did not diffuse to the image-receiving layer. Dye diffusion prints are favored for the instant results they provide and for particular image manipulation techniques that are possible during the development process.

Color, silver dye bleach print A silver dye bleach print, such as a Cibachrome print, is made on paper containing three emulsion layers, each sensitized to one of the primary **additive colors** of light, and each containing a full density of the complementary **subtractive color** dye. During development, the silver and the unnecessary dyes are selectively bleached away, leaving a final positive print. The process is used for making prints from color transparencies and is noted for its stability, image clarity, and color saturation. Interest in the process dates to the early years of the 20th century, but it wasn't until the introduction of Cibachrome materials in 1963 that the process became widely available.

Color, subtractive The principle of subtractive color concerns the creation of any color by subtracting (in varying proportions) one or more of the primary subtractive colors – yellow, magenta, and cyan – from white light. The primary subtractive colors are the complementary colors of the three primary **additive colors** – blue, green, and red. Most modern color photography processes rely on the principle of subtractive color.

Color transparency, chromogenic development process A chromogenic color transparency is a positive image made on glass or film in which three silver emulsion layers sensitized to the primary **additive colors** are exposed to light. During the developing process, dye couplers bond to the exposed silver halides to produce complementary **subtractive color** dyes. The silver is bleached away, leaving a full-color positive image. The chromogenic development process is the most common contemporary color photography process and is used for negatives, transparencies, and prints. Due to chemical impurities in the dyes, chromogenic prints are not as stable as other color printing techniques.

Cyanotype A cyanotype is a photographic print distinguished by its bright blue color. Cyanotype images are embedded in the fibers of a paper support, instead of being suspended on top as in **albumen prints** or **gelatin silver prints.** Like albumen prints and **salted paper prints,** cyanotypes are **"printed-out,"** meaning that the image is created by the action of light alone on light-sensitive paper, without the use of chemical developers. The process involves soaking a sheet of paper in a solution of iron salts, then exposing the paper in contact with a negative. The part of the paper exposed to light turns blue, while the unexposed areas remain

white. The image is fixed by washing the paper in water, which rinses off unexposed chemicals and intensifies the blue color. The process was invented in 1842 by Sir John Herschel.

Daguerreotype Daguerreotypes are sharply defined, highly reflective, one-of-a-kind photographs on silver-coated copper plates, packaged behind glass and kept in protective cases. Introduced in 1839 by Louis-Jacques-Mandé Daguerre, the daguerreotype process was the first commercially successful photographic process and is distinguished by a remarkable clarity of pictorial detail. Although early daguerreotypes required exposures of several minutes, advances in the process quickly reduced exposure times, to the relief of many sitters. Daguerreotypes were popular through the 1840s and into the 1850s, especially for portrait photography; they were primarily replaced by less-expensive and more easily viewed **ambrotypes** and **tintypes,** as well as by the improved negative-positive techniques of **collodion on glass negatives** and **albumen prints.**

Developed-out *See* Gelatin silver print

Dye imbibition print *See* Color, dye imbibition print

Gelatin silver print A gelatin silver print is produced on paper coated with a gelatin emulsion containing light-sensitive silver salts. Like **albumen prints,** gelatin silver print images are suspended on a paper's surface as opposed to being embedded in its fibers. Unlike albumen prints, however, gelatin silver prints are "developed-out" instead of "printed-out"; the paper registers a latent image that becomes visible only when developed in a chemical bath. The developing-out procedure allows for much shorter exposure times than printing out and results in an image less susceptible to fading. Developed at the end of the 19th century, gelatin silver printing has been the dominant black-and-white photographic process of the 20th century.

Gelatin silver glass interpositive A gelatin silver glass interpositive is a positive image that is made from a negative and printed on a glass plate. It serves as an intermediate stage that gives the photographer who wishes to retouch the photograph a positive image on which to work. The interpositive can be drawn on, scratched, or otherwise manipulated, then used to make another negative. The final print is made from the second negative.

Gum bichromate print A gum bichromate print is a **pigment print** often characterized by broad tones and a lack of precise pictorial detail. The process relies on the principle of **bichromated colloids** hardening on exposure to light. It calls for coating a sheet of paper with sensitized and pigmented gum arabic, then exposing the paper in contact with a negative, whereupon the gum hardens in proportion to the amount of light received. After exposure, the paper is soaked in water to dissolve the unhardened gum, leaving a positive image on the paper. The technique was invented in the 1850s but was largely forgotten until the 1890s when it was adopted by many pictorialist photographers who reveled in their artistic control over the final image, often working the surface of the print with brushes in a painterly fashion. Like other pigment prints, gum bichromate prints have no light-sensitive metals susceptible to deterioration and are thus noted for their image stability and permanence.

Gum platinum print A gum platinum print combines the fine tonal gradations found in the platinum process with the deep shadow areas possible in **gum bichromate prints.** To make a gum platinum print, a lightly exposed and fully developed **platinum print** is coated with sensitized and pigmented gum arabic and re-exposed under the same negative used to make the platinum print. The pigmented gum hardens in proportion to the amount of light it receives during exposure. The process flourished in the early part of the 20th century when many photographers engaged in complex processes that required hand-rendered manipulations in order to bolster their claims of photography's artistic properties.

Kodak snapshot The term "Kodak snapshot" applies to photographs taken with Kodak snapshot cameras introduced by the Eastman Dry Plate and Film Company (later named the Eastman Kodak Company) in 1888. These cameras had a fixed focus lens and a set shutter speed and were preloaded with roll film for 100 exposures. All that was required of photographers

was to expose and advance the film. The snapshot cameras were marketed to a new and growing amateur photography market with the slogan, "You press the button, we do the rest." Indeed, once all exposures were made, the photographer sent the camera back to the factory where the pictures were printed and the camera reloaded. Both prints and camera were then returned to the photographer. The term "snapshot" was first applied to photography by Sir John Herschel in 1860 to describe "the possibility ... of securing a picture in a tenth of a second of time."

Lantern slide *See* Transparency, gelatin on glass

Mechanical lantern slide *See* Transparency, gelatin on glass

Negative, collodion on glass Collodion on glass negatives – the dominant type of negative for much of the 19th century – are noted for greater image detail and shorter exposure times than **calotype** negatives. The clarity and reproducibility of collodion negatives coupled with **albumen prints** helped spell the demise of the **daguerreotype** and **ambrotype** as the favored processes for portrait photography. First described by Frederick Scott Archer in 1851, the process revolutionized photography in the second half of the 19th century and remained popular until about 1880, when collodion negatives were displaced by **gelatin on glass negatives**. Collodion on glass negatives were made by coating glass plates with collodion, a sticky substance to which light-sensitive silver salts could adhere. The sensitized plates were exposed in a camera, then developed in chemical baths. The majority of collodion on glass negatives were "wet-plate" negatives; the plate had to be coated and sensitized immediately prior to exposure and then developed shortly after exposure, before the plate could dry. This required view photographers to carry all of their chemicals and equipment with them in the field. Although ways to slow the drying time of the collodion were developed, thereby allowing the plates to be prepared farther in advance of their use, these so-called "dry-plate" collodion negatives produced inconsistent results and required longer exposure times than wet-plate negatives, hampering efforts to commercially produce and market such plates.

Negative, calotype	*See* Calotype negative

Negative, gelatin on glass

Gelatin on glass negatives are produced by coating glass plates with an emulsion of gelatin mixed with light-sensitive silver salts. Introduced in 1871 by Richard Leach Maddox, the process was an advancement on the collodion process, as gelatin negatives were up to ten times more sensitive to light than **collodion on glass negatives**. Even more important, gelatin on glass negative plates could be made well in advance of actual use, meaning that for the first time negative materials could be manufactured rather than having to be prepared by the photographer. Commercially available glass plates were first manufactured in 1875, and gelatin soon displaced collodion as the dominant negative process. The convenience and availability of gelatin on glass negatives helped create the large amateur photography market in the 1880s.

Negative, gelatin on nitrocellulose sheet film

Nitrocellulose negatives are created using sheets of nitrocellulose film as a support for a light-sensitive gelatin emulsion. Efforts to find a flexible and transparent medium on which to make negatives led to the introduction of nitrocellulose roll film by the Eastman Dry Plate and Film Company in 1889. (The process was actually developed by the Reverend Hannibal Goodwin in 1887, though he didn't receive credit for his invention until 1914.) The portability of nitrocellulose roll film compared to the cumbersome glass plates made photography increasingly convenient to amateurs. For the professional, improvements in manufacturing techniques in the early 1900s led to larger film sizes and the introduction of nitrocellulose sheet film in 1913. Because nitrocellulose is highly flammable and subject to deterioration, it was no longer used as a support material after 1950.

Oil print

An oil print is produced on a sheet of paper coated with an unpigmented **bichromated colloid**. After contact printing, the paper is soaked in water so that the unexposed areas absorb water and swell. The areas of the unexposed colloid that have absorbed water (the highlights) reject the application of a greasy ink that is daubed on the paper with a brush. The exposed, hardened areas of the colloid (the shadows and midtones) accept the ink, creating the final image. The process was developed in

1904 by G. E. H. Rawlins. It was used by photographers seeking greater control over the final print image than was offered by conventional photographic techniques.

Palladium print

A palladium print is similar in appearance to a **platinum print** with its matte surface and subtle tonal gradations. Like platinum prints, palladium print images are embedded in the fibers of the paper support, not suspended on its surface as in **albumen prints** or **gelatin silver prints**. To make a palladium print, a sheet of paper sensitized with iron salts is exposed in contact with a negative until a faint image is formed. In development, the iron salts are replaced with palladium, and the image becomes more pronounced. Commercially made palladium papers were introduced in 1916 in response to the rising cost of platinum during World War I, but the cost of palladium rose to prohibitive levels in the 1920s, and the manufacture of palladium papers ceased. Like platinum prints, palladium prints are noted for having greater stability than silver-based prints.

Photogenic drawings

See Calotype negative

Photogram

The most elemental of photographic techniques, the photogram is made without the aid of camera or lens. It is produced by placing objects in contact with the surface of sensitized paper or film and then exposing it to light. The resultant image, after processing, reveals a photographic tracing of the object's form, with dark tonality in areas exposed to light, and light tonality in unexposed areas. Made by early practitioners such as Anna Atkins and William Henry Fox Talbot and modernists such as Man Ray and László Moholy-Nagy, the photogram has proved to be an enduring method of discovery and transformation.

Photogravure

See Photomechanical, photogravure print

Photomechanical, collotype print

The collotype relies on the effect of light on **bichromated colloids** and the mutual repulsion of water and oil-based ink. To make a collotype, a printing plate is first coated with bichromated gelatin. After exposing the plate under a negative, the plate is washed in water, causing the gelatin to swell into the reticulated pattern that is the hallmark of

collotypes. When the damp plate is inked, the unhardened gelatin (which forms the highlights) repels the ink, while the hardened gelatin (which forms the shadows) accepts it. The inked plate is then printed on paper. The fine reticulation of the gelatin allows for subtle midtones, often making collotypes difficult to distinguish from silver-based photographs except under magnification. The development of the collotype and other photomechanical processes in the second half of the 19th century was an important technical achievement that allowed for the distribution of photographic reproductions in books.

Photomechanical, photogravure print

Photogravure printing is a form of intaglio printing, in which a photographic image is chemically etched into a copper plate. When the plate is inked, then wiped clean, the ink remains in the pits of the plate and is transferred to a sheet of paper during the printing process. In the photogravure process, the printing plate is first dusted with a resin, creating a random dot structure that allows for the continuous tones of the original photograph to be reproduced. The plate is then coated with bichromated gelatin and exposed in contact with a positive photographic transparency. The printing plate is etched in those areas where the gelatin remains unhardened (forming the shadows), but not in those areas where the hardened gelatin acts as a resist (forming the highlights). William Henry Fox Talbot experimented with photogravure as early as 1852, but the process was not widely used until the 1870s, when Karl Klic developed a way of satisfactorily dusting the plates with resinous powder. Around the turn of the 20th century, photogravure was embraced by pictorialist photographers who admired the beautiful reproductions the process allowed. Perhaps the ultimate achievement of photogravure printing is to be found in the pages of *Camera Work,* published by the photographer Alfred Stieglitz from 1903 to 1917.

Photomechanical, Woodburytype

Woodburytypes are distinguished from other photomechanical processes by the fact that they are continuous-tone images. The process involves exposing unpigmented bichromated gelatin in contact with a negative. The gelatin hardens in proportion to the amount of light received. When the gelatin is washed, the unexposed portion dissolves, leaving a very fine and hard relief of the image. Under extremely high pressure, this relief is pressed into a sheet of soft lead, producing a mold of the image. This mold is then filled with pigmented gelatin and

transferred to paper during printing. The process was invented in 1864 by Walter Woodbury and achieved acclaim for its exquisite rendering of pictorial detail and its permanency.

Physionotrace engraving

A physionotrace is made by the use of a mechanical system that scratches a profile onto a copper plate as the operator traces a sitter's profile cast on a sheet of glass. After tracing the profile, features can be added to the plate, which is then inked and printed. Invented in 1786 by Gilles-Louis Chrétien, the process was the first mechanical means for making multiple prints of a portrait.

Pigment print

A pigment print involves any one of a number of photographic processes (such as **carbon prints** and **gum bichromate prints**) that utilize pigments and **bichromated colloids** rather than metal salts in the creation of print images. Pigment printing processes were first developed in the 1850s and were popular because they were more permanent than metal-based processes. They also allowed for a greater control of the appearance of the final print image.

Platinum/ palladium print

A platinum/palladium print combines platinum and palladium solutions in order to conserve the amount of the more expensive platinum used to make the print. See **platinum print** for more information.

Platinum print

A platinum print is distinguished by its matte surface and subtle tonal gradations. Like **salted paper prints**, platinum print images are embedded in the fibers of the paper, not suspended on the surface of the paper support. To make a platinum print, a sheet of paper sensitized with iron salts is exposed in contact with a negative until a faint image is formed. In development, the iron salts are replaced with platinum, and the image becomes more pronounced. Because of the tonal range and surface quality of platinum prints, many fine art photographers of the late 19th and early 20th century preferred the process over **gelatin silver prints**. The platinum printing process was developed in the 1870s, and commercially made platinum papers were available until the rising costs of platinum during World War I made the process prohibitively expensive. Platinum prints were replaced by the similar, but less-expensive, **palladium prints.** Platinum prints are the most stable of all the metal-based prints.

Polaroid print *See* Color, internal dye diffusion transfer print

Printing-out *See* Albumen print, Cyanotype, or Salted paper print

Salted paper print Salted paper prints were the earliest photographic prints on paper. They are often distinguished by their lack of precise image details and matte surface. Salted paper print images are embedded in the fibers of the paper, instead of being suspended on the surface of the paper, as in the later **albumen prints** and **gelatin silver prints.** Salted paper prints were "printed-out" in contact with paper negatives; the image was formed solely by the action of light on metal salts, without chemical developers. The **printing-out process** required long exposure times for producing a positive print. The process for making salted paper prints was developed by William Henry Fox Talbot in the 1830s, and salted paper prints were common until the mid-1850s, when they were eclipsed in popularity by albumen prints.

Silver dye bleach print *See* Color, silver dye bleach print

Stereograph A stereograph comprises two nearly identical photographic prints that have been recorded with a specially designed camera that has two lenses eye-width apart. Stereograph negatives are exposed simultaneously and later printed on heavy card stock. When a stereograph is viewed through a special viewer called a stereoscope, the viewer sees the image with a third dimension, giving a sense of depth and "reality" to the scene. They were a popular form of entertainment from the 1850s to the 1920s. In the 20th century stereography found renewed popularity in the form of Viewmaster reels and viewers.

Subtractive color *See* Color, subtractive

Tintype A tintype is a non-reflective, one-of-a-kind photograph on a sheet of iron coated with a dark enamel. Its most common use was for portrait photography. Like **ambrotypes**, tintypes rely on the principle that underexposed collodion negatives appear as positive images when viewed against a dark background. Less expensive and more durable than

either ambrotypes or **daguerreotypes**, tintypes did not require protective cases and were often kept in simple paper frames or folders. Tintypes first appeared in the United States in 1856 and remained popular well into the 20th century.

Transparency, gelatin on glass (lantern slide) A lantern slide is a gelatin silver positive image on a glass plate that is projected onto a screen with the use of a slide projector, or "magic lantern." Before photography, lantern slide images were either stenciled or drawn, but in the 1850s, photographic lantern slides with albumen positive images became available. Beginning in the 1870s, gelatin silver lantern slides were commercially produced to meet the ever-increasing public demand. Lantern slides were used for popular entertainment, education, scientific study, and travelogues.

Transparency, gelatin on glass (mechanical lantern slide) A mechanical lantern slide is two or more separate lantern slides in one holder or frame. The movement of one slide over a second slide produces motion or the appearance of motion when projected onto a screen.

Woodburytype *See* Photomechanical, Woodburytype

Alternative Image II: Photography on Nonconventional Supports.
Sheboygan, Wis.: John Michael Kohler Arts Center, 1984.

Arnold, Harry John Philip. *William Henry Fox Talbot: Pioneer of Photography and Man of Science.* London: Hutchinson, 1977.

Auer, Michèle, and Michel Auer. *Encyclopèdie internationale des photographes de 1830 à nos jours.* Hermance, Switzerland: Editions Camera Obscura, 1985.

Baldwin, Gordon. *Looking at Photographs: A Guide to Technical Terms.* Malibu, Cal.: John Paul Getty Museum in association with British Museum Press, 1991.

Becchetti, Piero. *Fotografi e fotografia in Italia 1839–1880.* Roma: Edizioni Quasar, 1978.

—. *La fotografia a Roma dalle origini al 1915.* Roma: Colombo, 1983.

Brettell, Richard R., Roy Flukinger, Nancy Keeler, and Sydney Mallett Kilgore. *Paper and Light: The Calotype in France and Great Britain, 1839–1870.* Boston: D. R. Godine in association with The Museum of Fine Arts, Houston and the Art Institute of Chicago, 1984.

Browne, Turner, and Elaine Partnow. *Macmillan Biographical Encyclopedia of Photographic Artists and Innovators.* New York: Macmillan, 1983.

Bruce, Chris, and Andy Grundberg. *After Art: Rethinking 150 Years of Photography; Selections from the Joseph and Elaine Monsen Collection.* Seattle: Henry Art Gallery; distributed by University of Washington Press, 1984.

Bruce, Roger R., ed. *Seeing the Unseen: Dr. Harold Edgerton and the Wonders of Strobe Alley.* Essays by James Enyeart, Douglas Collins, and Joyce E. Bedi. Rochester, N. Y.: International Museum of Photography at George Eastman House; Cambridge, Mass.: distributed by Massachusetts Institute of Technology Press, 1994.

Buerger, Janet E. *The Era of the French Calotype.* Rochester, N. Y.: International Museum of Photography at George Eastman House, 1982.

—. *French Daguerreotypes.* Chicago: University of Chicago Press, 1989.

Bunnell, Peter C., Maria B. Pellarano, and Joseph B. Rauch. *Minor White: The Eye That Shapes.* Princeton, N. J.: The Art Museum, Princeton University in association with Bulfinch Press and Little, Brown & Co., 1989.

Bunnell, Peter C., ed. *A Photographic Vision: Pictorial Photography, 1893–1923*. Salt Lake City: Peregrine Smith, 1980.

Carlebach, Michael L. *The Origins of Photojournalism in America*. Washington, D.C.: Smithsonian Institution Press, 1992.

Coburn, Alvin Langdon. *Alvin Langdon Coburn, Photographer; An Autobiography*. Edited by Helmut Gernsheim and Alison Gernsheim. New York: Dover Publications, 1978.

Coe, Brian. *The Birth of Photography: The Story of the Formative Years 1800–1900*. London: Ash & Grant, 1976.

—. *Colour Photography: The First Hundred Years, 1840–1940*. London: Ash & Grant, 1978.

Coe, Brian, and Paul Gates. *The Snapshot Photograph: The Rise of Popular Photography, 1888–1939*. London: Ash & Grant, 1977.

Coke, Van Deren. *Avant-Garde Photography in Germany, 1919–1939*. New York: Pantheon Books, 1982.

Collins, Douglas. *The Story of Kodak*. New York: Harry N. Abrams, 1990.

Conger, Amy. *Edward Weston: Photographs from the Collection of the Center for Creative Photography*. Tucson: Center for Creative Photography, University of Arizona, 1992.

Daniel, Malcolm. *The Photographs of Édouard Baldus*. New York: Metropolitan Museum of Art; Montreal: Canadian Centre for Architecture; distributed by Harry N. Abrams, 1994.

Darrah, William Culp. *Cartes de Visite in Nin[e]teenth Century Photography*. Gettysburg, Pa.: W. C. Darrah, 1981.

—. *The World of Stereographs*. Gettysburg, Pa.: W. C. Darrah, 1977.

Davis, Keith F. *Désiré Charnay, Expeditionary Photographer*. Albuquerque: University of New Mexico Press, 1981.

Dixon, Penelope. *Photographers of the Farm Security Administration: An Annotated Bibliography, 1930–1980*. New York: Garland, 1983.

Doherty, Jonathan L. *Lewis Wickes Hine's Interpretive Photography, The Six Early Projects*. Chicago: University of Chicago Press, 1978.

Doherty, Jonathan L., ed. *Women at Work, 153 Photographs by Lewis W. Hine*. Rochester, N. Y.: George Eastman House; New York: Dover Publications, 1981.

Earle, Edward, ed. *Points of View, The Stereograph in America: A Cultural History*. Essays by Howard S. Becker, Thomas Southall, and Harvey Green. Rochester, N. Y.: Visual Studies Workshop Press in collaboration with the Gallery Association of New York State, 1979.

Eauclaire, Sally. *The New Color Photography*. New York: Abbeville Press, 1981.

Eder, Josef Maria. *History of Photography*. Translated by Edward Epstean. Originally published 1932. New York: Dover Publications, 1978.

Ehrens, Susan. *A Poetic Vision: The Photographs of Anne Brigman*. Santa Barbara, Cal.: Santa Barbara Museum of Art, 1995.

Elliott, David, ed. *Photography in Russia, 1840–1940*. London: Thames and Hudson, 1992.

Enyeart, James. *Brugière: His Photographs and His Life*. New York: Alfred A. Knopf, 1977.

Evans, Martin Matrix, and Amanda Hopkinson, eds. *Contemporary Photographers*. 3rd ed. New York: St. James Press, 1995.

The Extended Document. Rochester, N.Y.: International Museum of Photography at George Eastman House, 1975.

Fabian, Rainer, and Hans-Christian Adam. *Masters of Early Travel Photography*. New York: Vendome Press, 1983.

Fielder, Jeannine, ed. *Photography at the Bauhaus*. Cambridge, Mass.: Massachusetts Institute of Technology Press, 1990.

Finkel, Kenneth. *Nineteenth Century Photography in Philadelphia: 250 Historic Prints from the Library Company of Philadelphia*. New York: Dover Publications, 1980.

Fleming, Paula Richardson, and Judith Luskey. *The North American Indians in Early Photographs*. New York: Harper & Row, 1986.

Flukinger, Roy. *The Formative Decades: Photography in Great Britain, 1839–1920*. Austin: University of Texas Press in cooperation with the Harry Ransom Humanities Research Center and the Archer M. Huntington Art Gallery, 1985.

Frank, Robert, and Alain Bosquet. *Les Américains*. Paris: R. Delpire, 1958.

French Primitive Photography. Introduction by Minor White; commentaries by André Jammes and Robert Sobieszek. Millerton, N.Y.: Aperture, 1969.

Fuller, Patricia Gleason. *Alternative Image: An Aesthetic and Technical Exploration of Non-conventional Photographic Printing Processes*. Sheboygan, Wis.: John Michael Kohler Arts Center, 1983.

Fulton, Marianne. *Eyes of Time: Photojournalism in America*. Essays by Estelle Jussim, Colin Osman, Sandra S. Phillips, and William Stapp. Boston: New York Graphic Society and Little, Brown & Co. in

association with International Museum of Photography at George Eastman House, 1988.

—. *Mary Ellen Mark, 25 Years.* Boston: Little, Brown & Co. in association with International Museum of Photography at George Eastman House, 1991.

Fulton, Marianne, ed. *Pictorialism into Modernism: The Clarence H. White School of Photography.* Texts by Bonnie Yochelson and Kathleen A. Erwin. New York: Rizzoli International Publications; George Eastman House in association with The Detroit Institute of Arts, 1996.

Gardner, Alexander. *Gardner's Photographic Sketchbook of the Civil War.* Unabridged republication. New York: Dover Publications, 1959.

Gee, Helen. *Photography of the Fifties: The American Perspective.* Tucson: Center for Creative Photography, University of Arizona, ca. 1980.

George Eastman House: International Museum of Photography and Film, Rochester N. Y. Photographers Biography File.

Gernsheim, Helmut. *The Origins of Photography.* New York: Thames and Hudson, 1982.

—. *The Rise of Photography, 1850–1880: The Age of Collodion.* Revised 3rd ed. New York: Thames and Hudson, 1988.

Gernsheim, Helmut, and Alison Gernsheim. *L.J.M. Daguerre: The History of the Diorama and the Daguerreotype.* New York: Dover Publications, 1968.

Goldschmidt, Lucien, and Weston J. Naef. *The Truthful Lens: A Survey of the Photographically Illustrated Book, 1844–1914.* 1st ed. New York: Grolier Club, 1980.

Green, Jonathan. *American Photography: A Critical History, 1945 to the Present.* New York: Harry N. Abrams, 1984.

Green, Jonathan, ed. *Camera Work: A Critical Anthology.* Millerton, N. Y.: Aperture, 1973.

Greenhill, Gillian. "The Jersey Years: Photography in the Circle of Victor Hugo." *History of Photography* 4, no. 2 (April 1980): 113–120.

Greenough, Sarah, and Juan Hamilton. *Alfred Stieglitz, Photographs and Writings.* 1st ed. Washington, D. C.: National Gallery of Art, 1983.

Grundberg, Andy, and Kathleen McCarthy Gauss. *Photography and Art: Interactions Since 1946.* Fort Lauderdale, Fl.: Fort Lauderdale Museum of Art; New York: Abbeville Press, 1987.

Gutman, Judith Mara. *Through Indian Eyes.* New York: Oxford University Press; International Center for Photography, 1982.

Haas, Robert Bartlett. *Muybridge: Man in Motion*. Berkeley: University of California Press, 1976.

Hager, Michael, Rick McKee Hock, and Ruth Rosenberg-Naparsteck. "A Portrait of Rochester: Through the Lens of Charles Zoller." *Rochester History* 50, no. 1 (January 1988).

Hales, Peter B. *William Henry Jackson and the Transformation of the American Landscape*. Philadelphia: Temple University Press, 1988.

Hambourg, Maria Morris, Françoise Helibrun, and Philippe Néagu, et al. *Nadar*. New York: Metropolitan Museum of Art; distributed by Harry N. Abrams, 1995.

Hambourg, Maria Morris, and Christopher Phillips. *The New Vision: Photography Between the World Wars*. New York: Metropolitan Museum of Art; distributed by Harry N. Abrams, 1989.

Hannavy, John. *Roger Fenton of Crimble Hall*. London: Gordon Fraser, 1975.

Harker, Margaret F. *Henry Peach Robinson: Master of Photographic Art, 1830–1901*. New York: B. Blackwell, 1988.

—. *The Linked Ring: The Secession Movement in Photography in Britain, 1892–1910*. London: Heinemann, 1979.

Haworth-Booth, Mark. *The Golden Age of British Photography, 1839–1900: Photographs from the Victoria and Albert Museum ...* Millerton, N.Y.: Aperture in association with the Philadelphia Museum of Art; distributed in U.S. by Viking Penguin, 1984.

Hine, Lewis. *Men at Work, Photographic Studies of Modern Men and Machines*. 1932. Reprint. New York: Dover Publications; Rochester, N.Y.: International Museum of Photography at George Eastman House, 1977.

Hirsch, Julia. *Family Photographs: Content, Meaning, and Effect*. New York: Oxford University Press, 1981.

Homer, William Innes. *Alfred Stieglitz and the Photo-Secession*. Boston: Little, Brown & Co. and New York Graphic Society, 1983.

Hurley, Forrest Jack, and Robert J. Doherty, eds. *Portrait of a Decade: Roy Stryker and the Development of Documentary Photography in the Thirties*. Baton Rouge: Louisiana State University Press, 1972.

Jammes, André, and Eugenia Parry Janis. *The Art of French Calotype, With a Critical Dictionary of Photographers, 1845–1870*. Princeton, N.J.: Princeton University Press, 1983.

Jenkins, William. *New Topographics: Photographs of a Man-Altered*

Landscape. Rochester, N.Y.: International Museum of Photography at George Eastman House, 1975.

Johnson, Osa Helen. *I Married Adventure: The Lives of Martin and Osa Johnson*. Garden City, N.Y.: Garden City Publishing Company, 1940.

Johnson, William S. *Nineteenth-Century Photography: An Annotated Bibliography, 1839–1879*. Boston: G.K. Hall, 1990.

Jussim, Estelle, and Cheryl Brutvan. *A Distanced Land: The Photography of John Pfahl*. Albuquerque: University of New Mexico Press in association with Albright-Knox Art Gallery, 1990.

Johnston, Patricia. *Real Fantasies: Edward Steichen's Advertising Photography*. Berkeley: University of California Press, 1997.

Keppler, Victor. *A Life of Color Photography: The Eighth Art*. New York: W. Morrow & Co., 1938.

Kraus, Rosalind, and Jane Livingston. *L'Amour Fou: Photography and Surrealism*. Washington, D.C.: Corcoran Gallery of Art; New York: Abbeville Press, 1985.

Knapp, Ulrich. *Kühn: Photographien*. Salzburg: Residenz Verlag, 1988.

Lahs-Gonzalez, Olivia, and Lucy Lippard. *Defining Eyes: Women Photographers of the Twentieth Century*. St. Louis, Mo.: St. Louis Art Museum, 1997.

LéCuyer, Raymond. *Histoire de la Photographie*. Paris: Baschet, 1945.

Lemagny, Jean-Claude, and André Rouillé. *A History of Photography: Social and Cultural Perspectives*. Translated by Janet Lloyd. New York: Cambridge University Press, 1987.

Lewinski, Jorge. *The Camera at War: A History of War Photography from 1848 to the Present Day*. New York: Simon and Schuster, 1980.

Livingston, Jane. *The New York School: Photographs, 1936–1960*. New York: Stewart, Tabori and Chang and Professional Imaging, Eastman Kodak Company, 1992.

Lloyd, Valerie. *Roger Fenton, Photographer of the 1850s*. London: South Board Bank, 1988.

Lorenz, Richard. *Imogen Cunningham: Ideas without End, A Life in Photographs*. San Francisco: Chronicle Books, 1993.

Lukitsh, Joanne. *Cameron, Her Work and Career*. Rochester, N.Y.: International Museum of Photography at George Eastman House, 1986.

Lyons, Nathan. *Photography in the Twentieth Century*. New York: Horizon Press in collaboration with George Eastman House, 1966.

—. *Towards a Social Landscape.* New York: Horizon Press in collaboration with George Eastman House, 1967.

—. *Vision and Expression.* New York: Horizon Press in collaboration with George Eastman House, 1969.

Maddow, Ben. *Faces: A Narrative History of the Portrait in Photography.* Photographs compiled and edited by Constance Sullivan. Boston: New York Graphic Society, 1977.

Manchester, William. *In Our Time: The World as Seen by Magnum Photographers.* New York: American Federation of Arts in association with Norton, 1989.

Marbot, Bernard. *After Daguerre: Masterworks of French Photography, 1848–1920, from the Bibliothèque Nationale, Musée de Petit Palais.* New York: The Metropolitan Museum of Art, 1980.

Margolis, Marianne Fulton. *Camera Work: A Pictorial Guide with Reproductions of All 559 Illustrations and Plates. Fully Indexed [from the original magazine edited by] Alfred Stieglitz.* New York: Dover Publications; Rochester, N.Y.: International Museum of Photography at George Eastman House, 1978.

—. *Muray's Celebrity Portraits of the Twenties and Thirties: 135 Photographs by Nickolas Muray.* New York: Dover Publications; Rochester, N.Y.: International Museum of Photography at George Eastman House, 1978.

Martin, Rupert. *Floods of Light: Flash Photography, 1851–1981.* London: The Photographers' Gallery, 1982.

McCauley, Elizabeth Anne. *Industrial Madness: Commercial Photography in Paris, 1848–1871.* New Haven: Yale University Press, 1994.

Michaels, Barbara L. *Gertrude Käsebier: The Photographer and Her Photographs.* New York: Harry N. Abrams, 1992.

Mulligan, Therese, Eugenia Parry Janis, April Watson, and Joanne Lukitsh. *For My Best Beloved Sister Mia: An Album of Photography by Julia Margaret Cameron: An Exhibition of Works from the Hochberg-Mattis Collection.* Albuquerque: University of New Mexico Art Museum, 1994.

Muybridge, Eadweard. *Muybridge's Complete Human and Animal Locomotion: All 781 Plates from the 1887 Animal Locomotion.* Introduction by Anita Ventura Mozley. New York: Dover Publications, 1979.

Nadeau, Luis. *Encyclopedia of Printing, Photographic, and Photomechanical Processes: Containing Invaluable Information on Over 1500 Processes.* Fredericton, New Brunswick, Canada: Atelier L. Nadeau, 1994.

Naef, Weston J., and James N. Wood. *Era of Exploration: The Rise of*

Landscape Photography in the American West, 1860–1885. Boston: New York Graphic Society, 1975.

Naylor, Colin, ed. *Contemporary Photographers*. 2nd ed. Chicago: St. James Press, 1988.

Neubauer, Hendrik. *Black Star: 60 Years of Photojournalism*. Köln: Köneman, 1997.

Newhall, Beaumont. *The Daguerreotype in America*. 3rd ed. New York: Dover Publications, 1976.

—. *Frederick H. Evans*. Rochester, N. Y.: George Eastman House, 1964.

—. *The History of Photography from 1839 to the Present*. Revised ed. New York: Metropolitan Museum of Art; distributed by New York Graphic Society, 1982.

Newhall, Nancy. *This Is the Photo League*. New York: The Photo League, 1949.

Newhall, Nancy Wynne. *Peter Henry Emerson: The Fight for Photography as a Fine Art*. New York: Aperture, 1975.

Nir, Yeshayahu. *The Bible and the Image: The History of Photography in the Holy Land, 1839–1899*. Philadelphia: University of Pennsylvania Press, 1985.

O'Neal, Hank. *A Vision Shared; A Classic Portrait of America and Its People, 1935–1943*. New York: St. Martin's Press, 1976.

Onne, Eyal. *Photographic Heritage of the Holy Land, 1839–1914*. Manchester, England: Institute of Advanced Studies, Manchester Polytechnic, 1980.

Ostroff, Eugene. *Western Views and Eastern Visions*. Washington: Smithsonian Institution Traveling Exhibition Service with the cooperation of the U. S. Geological Survey, 1981.

Panzer, Mary. *Philadelphia Naturalistic Photography, 1865–1906*. New Haven: Yale University Art Gallery, 1982.

Perez, Nissan N. *Focus East: Early Photography in the Near East, 1839–1885*. New York: Harry N. Abrams in association with the Domino Press, Jerusalem, and the Israel Museum, Jerusalem, 1988.

Peterson, Christian A. *After the Photo-Secession: American Pictorial Photography, 1910–1955*. New York: The Minneapolis Institute of Arts in association with W. W. Norton and Company, 1997.

Plattner, Steven W. *Roy Stryker: U. S. A., 1943–1950; The Standard Oil (New Jersey) Photography Project*. Austin, Tx.: University of Texas Press, 1983.

Points of Entry: A Nation of Strangers. Essays by Vicki Goldberg and Arthur Ollman. San Diego: Museum of Photographic Art, 1995.

Points of Entry: Reframing America. Essays by Andrei Codrescu and Terrence Pitts. Tucson: Center for Creative Photography, 1995.

Points of Entry: Tracing Cultures. Essays by Rebecca Solnit and Ronald Takaki. San Francisco: Friends of Photography, 1995.

Rinhart, Floyd, and Marion Rinhart. *The American Daguerreotype.* Athens, Ga.: University of Georgia, 1981.

Ritter, Dorothea. *Venise: Photographies Anciennes, 1841–1920.* Translation by Anne-Marie Mourot. London: Calmann & King, 1994.

Rosenblum, Naomi. *A History of Women Photographers.* 1st ed. New York: Abbeville Press, 1994.

— . *A World History of Photography.* New York: Abbeville Press, 1984.

Rosenblum, Naomi, Walter Rosenblum, and Alan Trachtenberg. *America and Lewis Hine: Photographs, 1904–1940.* New York: Aperture, 1977.

Sandweiss, Martha A. *Photography in Nineteenth-Century America.* Essays by Alan Trachtenberg, et al. New York: Harry N. Abrams, 1991.

Schaaf, Larry J. *Out of the Shadows: Herschel, Talbot and the Invention of Photography.* New Haven: Yale University Press, 1992.

Seiberling, Grace, and Carolyn Bloore in association with the International Museum of Photography at George Eastman House. *Amateurs, Photography, and the Mid-Victorian Imagination.* Chicago: University of Chicago Press, 1986.

Silverman, Jonathan. *For the World to See: The Life of Margaret Bourke-White.* New York: Viking Press, 1983.

Sipley, Louis Walton. *A Half-Century of Color.* New York: Macmillan, 1951.

Snyder, Joel. *American Frontiers: The Photographs of Timothy H. O'Sullivan, 1867–1874.* Millerton, N.Y.: Aperture, 1981.

Snyder, Joel and Doug Munson. *The Documentary Photograph as a Work of Art: American Photographs, 1860–1876.* Chicago: The David and Alfred Smart Gallery, The University of Chicago, 1976.

Sobieszek, Robert A. "An American Century of Photography, 1840–1940: Selections from the Sipley/3M Collection." *Camera* 57, no. 6 (June 1978).

—. *The Art of Persuasion: A History of Advertising Photography.* New York: Harry N. Abrams, 1988.

—. *Masterpieces of Photography from the George Eastman House Collections.* New York: Abbeville Press, 1985.

Sobieszek, Robert, and Odette M. Appel. *The Spirit of Fact: The Daguerreotypes of Southworth and Hawes, 1843–1862.* Boston: D. R. Godine, 1976.

Stapp, William F. "Souvenirs of Asia: Photography in the Far East, 1840–1920." *Image* 37, nos. 3–4 (fall/winter 1994): 2–53.

Steichen, Edward. *A Life in Photography.* Published in collaboration with Museum of Modern Art. Garden City, N. Y.: Doubleday, 1963.

Steinorth, Karl, ed. *Internationale Ausstellung des Deutschen Werkbundes: Film und Foto Stuttgart 1929.* Introduction by Karl Steinorth, foreword by Manfred Rommel. Stuttgart: Deutsche Verlags-Anstalt GmbH, 1979.

—. *Lewis Hine, Passionate Journey, Photographs, 1905–1937.* Texts by Anthony Bannon and Marianne Fulton. Zurich: Edition Stemmle in association with International Museum of Photography at George Eastman House, Rochester, New York, 1996.

Stevenson, Sara. *David Octavius Hill and Robert Adamson: A Catalogue of their Calotypes Taken Between 1843 and 1847 in the Collection of the Scotland National Portrait Gallery.* Edinburgh: National Galleries of Scotland, 1981.

Stuhlman, Rachel. "It Isn't Sanity, But It Sure Is Fun." *Image* 34, nos. 1–2 (spring/summer 1991): 22–28.

Sweetman, Alex. *Photographic Book to Photobookwork: 140 Years of Photography in Publication.* CMP Bulletin 5, no. 2, Riverside, Cal.: California Museum of Photography, University of California, 1986.

Szarkowski, John. *Photography until Now.* New York: Museum of Modern Art, 1989.

Szarkowski, John, and Maria Morris Hambourg. *The Work of Atget.* New York: Museum of Modern Art; Boston: New York Graphic Society, 1981.

Taft, Robert. *Photography and the American Scene: A Social History, 1839–1889.* New York: Macmillan, 1938.

Teitelbaum, Matthew, ed. *Montage and Modern Life: 1919–1942.* Cambridge, Mass.: Massachusetts Institute of Technology Press, 1992.

Thomas, Alan. *Time in a Frame: Photography and the Nineteenth-Century Mind.* New York: Schocken Books, 1977.

Thomas, Anne. *Beauty of Another Order: Photography in Science.* Essays by Marta Braun, et al. New Haven: Yale University Press in association with the National Gallery of Canada, 1997.

Thomas, Dr. G. *History of Photography, India, 1840–1980.* [Hyderabad]: Andhra Pradesh State Akademi of Photography, 1981.

Traub, Charles, ed. *New Vision: Forty Years of Photography at the Institute of Design*. Essay by John Grimes. Millerton, N.Y.: Aperture, 1982.

Treadwell, T.K., and William C. Darrah. *Stereographers of the World*. vols. 1–2. N.p.: National Stereoscopic Association, 1994.

Tucker, Anne. *Photographic Crossroads: The Photo League*. Ottawa: National Gallery of Canada for the Corporation of National Museums of Canada, 1978.

Van Haaften, Julia, and Jon E. Manchip White. *Egypt and the Holy Land in Historic Photographs: 77 Views by Francis Frith*. New York: Dover Publications, 1980.

Voignier, J.M. *Répertoire des Photographes de France au Dix-Neuvième Siècle*. Chevilly-Larue: Le Pont de Pierre, 1993.

Weinberg, Adam D., Eugenia Parry Janis and Max Kozloff. *Vanishing Presence*. Minneapolis: Walker Arts Center; New York: Rizzoli, 1989.

Welling, William. *Photography in America: The Formative Years, 1839–1900*. New York: Thomas Y. Crowell Co., 1978.

Weston, Edward. *The Daybooks of Edward Weston*. Edited by Nancy Newhall, foreword by Beaumont Newhall. 2nd ed. New York: Aperture, 1990.

White, Stephen. *John Thomson: A Window to the Orient*. New York: Thames and Hudson, 1986.

Wood, John. *The Art of the Autochrome: The Birth of Color Photography*. Foreword by Merry A. Foresta. Iowa City: University of Iowa Press, 1993.

—. *The Scenic Daguerreotype: Romanticism and Early Photography*. Iowa City: University of Iowa Press, 1995.

Wood, John, ed. *The Daguerreotype: A Sesquicentennial Celebration*. Iowa City: University of Iowa Press, 1989.

Worswick, Clark, ed. *Japan: Photographs, 1854–1905*. New York: Alfred A. Knopf, A Penwick Book, 1979.

Zannier, Italo. *Le Grand Tour: dans les Photographies des Voyageurs de XIXe Siècle*. Venise: Canal and Stamperia, 1997.

Photographers' Credits

The editors wish to thank copyright holders who greatly assisted in this publication, including photographers or their representatives, estates, agencies, foundations, and collecting institutions. Every effort was made to identify and contact individual copyright holders; omissions are unintentional. The following are credits for copyrighted material, listed by the photographer's last name.

Abbott: © Commerce Graphics, Inc., East Rutherford | **Adams**: © The Ansel Adams Publishing Rights Trust, Carmel | **Adams**: © The Associated Press, New York | **Adams**: © Robert Adams, Astoria | **Alvarez-Bravo**: © Manuel Alvarez-Bravo, Coyoacan | **Appelt**: © Dieter Appelt, Courtesy of Galerie Rudolf Kicken, Cologne | **Arbus**: Copyright © 1972 The Estate of Diane Arbus, New York | **Avedon**: © Richard Avedon Studio, New York | **Baldessari**: © John Baldessari, Santa Monica | **Baltz**: © Lewis Baltz and Stephen Wirtz Gallery, San Francisco | **Barrow**: © Thomas F. Barrow, Albuquerque | **Bayer**: © 2005 VG Bild-Kunst, Bonn | **Bellmer**: © 2005 VG Bild-Kunst, Bonn | **Berger**: © Paul Berger, Seattle | **Berman**: © Zeke Berman, New York | **Bourke-White**: © Estate of Margaret Bourke-White, Jonathan B. White, East Lansing; © Time Life Syndication, New York | **Brandt**: Bill Brandt © Bill Brandt Archive Ltd., London | **Brassaï**: © Gilberte Brassaï, Paris | **Brigman**: © The Oakland Museum of California, City of Oakland | **Bruehl**: © Estate of Anton Bruehl, Courtesy of Howard Greenberg Gallery, New York | **Bubley:** © Photographic Archives. Ekstrom Library, Universitiy of Louisville, Louisville | **Bullock**: © The Bullock Photography Trust, Carmel | **Burke**: © Bill Burke, Dorchester | **Burrows**: Courtesy Laurence Miller Gallery, New York | **Callahan**: Courtesy of PaceWildensteinMacGill, New York | **Capa**: © Cornell Capa, New York | **Cartier-Bresson**: © Helen Wright, New York | **Chiarenza**: © Carl Chiarenza, Rochester | **Close**: © Chuck Close, New York | **Cohen**: © Mark Cohen, Wilkes-Barre | **Corsini**: © Harold Corsini, Pittsburgh | **Cunningham**: © The Imogen Cunningham Trust, Berkeley | **Davidson:** © Bruce Davidson and Magnum Photos, Inc., New York | **Deal**: © Joe Deal, St. Louis | **DeCarava**: © Roy DeCarava, Brooklyn | **Depardon**: © Raymond Depardon and Magnum Photos, Inc., New York | **Drtikol**: © Ervina Boková-Drtikolová, Podebrady | **Edgerton**: © Harold and Esther Edgerton Foundation, 2005, Courtesy of Palm Press, Inc., Concord | **Ellison**: © Paul Stephanus, Wayne; Black Star, New York | **Evans**: © Evan Evans, Epsom Surrey | **Evans**: Library of Congress, Prints and Photographs Division, FSA/OWI Collection, LCUSF3 428 253A; LC-USF342–8091A; LC-USF342–894A; LC-USF342–890A, Washington, D.C.; © The Walker Evans Archive. The Metropolitan Museum of Art, New York | **Faurer**: © Louis Faurer, Howard Greenberg Gallery and Ferber, Chan & Essner, LLP., New York | **Feininger**: Photo by Andreas Feininger, *LIFE Magazine* © Time Inc., New York | **Fernandez**: © Benedict Fer-

nandez, North Bergen | **Ferrato**: Courtesy of Domestic Abuse Awareness Inc., New York | **Fichter**: © Robert Fichter, Tallahassee | **Freed**: © Leonard Freed and Magnum Photos, Inc., New York | **Friedlander**: © Lee Friedlander, New City | **Gibson**: © Ralph Gibson, New York | **Gohlke**: © Frank Gohlke, Southborough | **Goldin**: © Nan Goldin, New York | **Gowin**: © Emmet Gowin, Newtown | **Groover**: © Jan Groover, Montpon-Menesterol | **Hahn**: © Betty Hahn, Albuquerque | **Heartfield:** © 2005 The Heartfield Community of Heirs/VG Bild-Kunst, Bonn | **Heath**: © David Heath, Toronto | **Heinecken**: © Robert Heinecken, Chicago | **Henri**: © Galleria Martini & Ronchetti, Genoa, Italy | **Hiller**: © Visual Studies Workshop, Rochester | **Hosoe**: © Eikoh Hosoe, Tokyo | **Jacobsen**: © Bill Jacobsen, Courtesy of Julie Saul Gallery, New York | **Keppler**: © Herbert Keppler, New York | **Kertész**: Photo André Kertész © Ministère de la Culture-France, Mission du Patrimonie Photographique, Paris | **Khaldei**: © Anna Khaldei-Bibicheva and Leonid Khaldei, Moscow | **Klein**: © William Klein, Paris | **Kon**: Courtesy of Photo Gallery International/Sata Corporation, Tokyo; © Michiko Kon, Courtesy: Robert Mann Gallery, New York | **Krims**: © Les Krims, Buffalo | **Kruger**: © Barbara Kruger, Courtesy of Mary Boone Gallery, New York | **Krull**: © Fotografische Sammlung, Museum Folkwang, Essen | **Kühn**: © Kühn-Nachlaß, Birgitz | **Lange**: Library of Congress, Prints and Photographs Division, FSA/OWI Collection, LCUSF349058C; LC-USF34–9599C, Washington, D.C.; © The Dorothea Lange Collection, The Oakland Museum of California, City of Oakland. Gift of Paul S. Taylor, Oakland | **Lartigue**: Photographie J.H. Lartigue © Ministère de la Culture-France A.A.J.H.L., Paris | **Lazarnick**: Courtesy of the Detroit Public Library, National Automotive History Collection, Detroit | **Lerski**: © Fotografische Sammlung, Museum Folkwang, Essen | **Levitt**: © Helen Levitt, New York | **Lissitzky**: © 2005 VG Bild-Kunst, Bonn | **Lyon**: Courtesy of Danny Lyon and Edwynn Houk Gallery, Clintondale | **Lyons**: © Joan Lyons, Rochester | **Man Ray**: 2005 Man Ray Trust, Paris/VG Bild-Kunst, Bonn | **Manning**: © Jack Manning, Pearl River | **MANUAL**: © Suzanne Bloom and Ed Hill, Houston | **Mapplethorpe**: © The Estate of Robert Mapplethorpe. Used by permission. New York | **Mark**: © Mary Ellen Mark, Falkland Road, Inc., New York | **McCullin**: © Don McCullin, Somerset | **Meatyard**: © Christopher Meatyard, Lexington | **Meiselas**: © Susan Meiselas and Magnum Photos, Inc., New York | **Meyerowitz**: © Joel Meyerowitz, New York | **Model**: © Lisette Model Foundation, New York | **Moholy-Nagy**: © 2005 VG Bild-Kunst, Bonn | **Moore**: © Charles Moore, Shelbourne Falls | **Morell**: © Abelardo Morell, Brookline | **Myers**: © Joan Myers, Tesuque | **Neimanas**: © Joyce Neimanas, Chicago | **Nettles**: © Bea Nettles, Urbana | **Newman**: All photographs copyrighted by Arnold Newman, New York | **Outerbridge**: © Courtesy of G. Ray Hawkins Gallery, Santa Monica | **Peress**: © Gilles Peress and Magnum Photos, Inc., New York | **Pfahl**: © John Pfahl, Buffalo | **Renger-Patzsch**: © 2005 Albert Renger-Patzsch Archiv/Ann and Jürgen Wilde/VG Bild-Kunst, Bonn | **Rodchenko**: © 2005 VG Bild-Kunst, Bonn | **Rosenthal**: © The Associated Press, New York | **Rothstein**: © Photograph by Arthur Rothstein, New Rochelle | **Salomon**: © 2005 Peter Hunter, The Hague | **Samaras**: © PaceWildensteinMacGill, New York | **Sander**: © 2005 Die Fotografische Sammlung/SK Stiftung Kultur – August

Index of Photographers